THE PAINTINGS

OF

CORREGGIO

THE PAINTINGS OF

CORREGGIO

CECIL GOULD

ITHACA

CORNELL UNIVERSITY PRESS

MCMLXXVI

First published 1976 by Cornell University Press.

International Standard Book Number 0–8014–0973–X

Library of Congress Catalog Card Number 75-16813

Text printed in Great Britain by Euan Phillips, University Printer,
at the University Printing House, Cambridge.
Monochrome plates printed in the United States of America
by The Meriden Gravure Company, Meriden, Connecticut.
Colour plates reproduced in Italy by Scala, Florence
and printed in Great Britain at the Curwen Press, Plaistow.

TO

J · M · S

CONTENTS

The monochrome plates appear at the end of the book.

ILLUSTRATIONS

COLOUR PLATES

MONOCHROME PLATES
(*at the end of the book*)

FIGURES

2

I THE LIFE A QUIET MAN, UNCOMMUNICATIVE AND

brooding, wrapped up in the problems of his art and for ever impelled to seek out and solve the most difficult of them. Vasari's picture of Correggio the man has held the field as posterity's view of him to this extent, and some confirmation of the aloof image may perhaps be seen in the mere absence of a more convincing alternative. But as an artist Correggio was susceptible of differing and complex estimates. Though the idea of the virtuoso has been common to most assessments the variations in the course of four centuries have been considerable. What Correggio's art was to Stendhal, for instance, is very different from what it meant to Vasari, and our own view of it is different again. To Vasari he was little more than an interesting provincial. But in the seventeenth and eighteenth centuries Correggio was commonly regarded as the second greatest painter who had ever lived – after Raphael, but before Titian. And by the early nineteenth century, at least in the estimate of Stendhal, Correggio was bidding fair to overtake Raphael for the top place. Then reaction set in. To the twentieth century, in so far as it thinks about Correggio at all, he is primarily the great anachronism, a painter who, in an inexplicable way, seemed a century or more ahead of his time. We may go farther than our predecessors, perhaps, in elaboration of the traditional picture of the virtuoso by regarding him as a sheer wizard of paint, one who, like Velázquez or Vermeer in their different ways, might be in league with the devil, so inexplicable are the effects which they obtain.

In this way, perhaps, the image of the man and one of the images of the artist may be brought into focus. For the personalities of Velázquez and Vermeer are also inscrutable. Both of them, and Correggio too, give away little of themselves. All three are likely to have presented an extreme of reserve to the world, living for their work and for solving the problems which it posed. The eccentricities of conduct which Vasari was quick to pick up in order to enliven his history render his portrait of Parmigianino, for example, vivid and memorable. But though Vasari tried to learn of comparable foibles on the part of Correggio he could rake up no more than an improbable story of the painter's supposed avarice, and for all his efforts he was unable to trace a single likeness of him. If Correggio's personality thus eluded his earliest biographer it is hardly surprising if it continues to do so.

But in one solitary respect Correggio does perhaps, after all, give away a little of himself, and demonstrate that the aloofness of Vasari's image of him was not merely negative – that of a spectator rather than a participant – but a positive need to insulate himself in a withdrawn and secret place. Over and over again the figures in the pictures of his early and middle periods are shown in airtight settings. In the New York altarpiece (plate 8), the Uffizi *Holy Family with St. Francis* (plate 89), the Orléans and Hampton Court *Madonnas* (plate 91A and B), the National Gallery *School of Love* (plate 173), the Parma gallery *Scodella Madonna* (plate 105) and several

others no ray of light penetrates the dense foliage of the background, and even the more extensive landscape of the Prado *Noli me Tangere* (plate 98A) is a totally desolate, airless and enclosed space. A degree of secretiveness and of agoraphobia rare in a Renaissance painter is unequivocally suggested by these pictures.

One further suggestion may be made concerning Correggio the man. Though Vasari and many later writers either failed to trace a portrait of him or else put up unlikely candidates,[1] a far more probable one was – literally – staring them in the face, unrecognised, for centuries. The young man who peers out at us from the left of the Dresden *Madonna with St. Francis* (plates 11, 14, 15A) has that combination of peculiar gaze and slight retraction of one shoulder which is specific to the self-portrait, and which, with practice, is unmistakable. When it is borne in mind that the character thus honoured in the altarpiece is no other than the painter's name saint, S. Antonio, little doubt can be entertained concerning the identification, or that a measure of self-portraiture was deliberate. The result is as we might have expected Correggio to look: quizzical eyes, a large mouth half smiling, and a very alert but slightly timid expression. But it conspicuously lacks the god-like beauty of the young Parmigianino.

Much has been made, by Berenson and others, of Correggio's unheralded appearance, as it were from a painter's wilderness; and if Michelangelo is regarded as the culmination of Florentine art and Titian as his Venetian counterpart, the difference in Correggio's background is certainly marked. But it is only a half-paradox. Michelangelo or Titian – or, for that matter, Rubens or Rembrandt – may have represented the peaks of mighty ranges, but others of supreme stature did not. Velázquez' and Goya's achievements, for example, were almost as disproportionate to their immediate origins as Correggio's. It might be truer to say that the towering genius may spring up anywhere, and form himself from widely dispersed sources. It is rather the artist of moderate gifts and limited outlook who is liable to languish in a cultural waste but to improve himself if brought by circumstances in contact with greater talents.

In point of fact a certain degree of parallelism is not hard to find in respect of Correggio's origins. Like him, Raphael was born far from the main centres, and like him formed himself by drawing widely and voraciously from the surrounding luminaries. And whereas Raphael's art, in its maturity, was, among other things, a highly idiosyncratic and genial conflation of elements derived from Leonardo, Michelangelo and the Antique, Correggio drew from the same three, and added another: Raphael himself.

Regarded from this angle, indeed, Correggio out-Raphaels Raphael. Though it could not be

[1] As indicated in Ricci (1896, p. 328) most of the 'portraits' of Correggio derive either from a fresco on the west wall of Parma cathedral by Latanzio Gambara (*c.* 1530–73/4) or from a design attributed to Dosso Dossi. See also a later article by Ricci (i.e. 'Ritratto del Correggio', in *Rassegna d'Arte*, 1917, also A. C. Quintavalle 1970, p. 84, and R. Finzi, *Le Sembianze del Correggio*, 1954.

claimed that either Urbino or the town of Correggio could compare as centres of art with Venice, let alone Florence, it would also be true to say that they themselves could hardly be classed together. Urbino, after all, had been, under Federigo da Montefeltro, a minor centre of art and humanism of a remarkable kind, whereas the town of Correggio was hardly a centre at all. Situated in the Lombard plain, within sight of the Apennines in the south and (sometimes) of the Alps to the north, it had played some part, historically, in the ups and downs of the Lombardic city despotisms, and in the painter's youth the little court had given evidence of a marked poetic taste. But it had no school of painting of any consequence. Nor had the adjoining cities of Carpi, Novellara, Guastalla, or Reggio. But only slightly farther afield was Modena, where an interesting provincial painter, Francesco Bianchi Ferrari, had his studio. A little farther away still was Bologna, the scene of activity of the more considerable figures of Francia and, until 1506, of Costa. And within hailing distance were two artists of the first magnitude. Until his death in 1506 Andrea Mantegna was court painter to the Gonzaga at Mantua – less than thirty miles to the north of the town of Correggio. And at Milan, until 1499 and again between 1507 and 1513, lived Leonardo da Vinci.

Correggio's reaction to the talent which thus surrounded him at a distance was different from Raphael's. Raphael went out to it, and then tended to stay – in Perugia, Florence and finally Rome. Correggio went and returned. He must often have been in Mantua, if only because it is so near. But if, as seems quite likely, he also visited Milan and Rome, and conceivably also Venice, it was certainly not for long.

He never *settled* farther from his home than Parma, and that is little more than twenty miles away. We may, perhaps, see this as a confirmation of the shadowy image already suggested. Rather than run the risk of being swept off his feet by novel sensations the self-possessed artist quickly returned home, there to contemplate and digest the impressions from outside in his own time. If full cognisance of this trait had been taken in the past it is unlikely, as we shall see, that there would have been so lengthy a dispute concerning whether or not Correggio visited Rome.

The problems of the biographer of Correggio begin with the uncertainty concerning the date of his birth, and this is linked with a second imponderable, his apprenticeship. As long as Vasari's vague statement that Correggio was 'about forty' at the time of his death in 1534 was accepted, and as long as Mantegna, again on Vasari's authority, was thought to have died in 1517 there was no difficulty in accepting the tradition that Mantegna was Correggio's master. But towards the end of the eighteenth century Tiraboschi revealed that Mantegna had in fact died in 1506 – when Correggio, on Vasari's reckoning, would have been no more than twelve – and he also cast aspersions on the reliability of a tradition that Correggio had been the pupil of Bianchi Ferrari.[1]

[1] Tiraboschi 1786, p. 244.

The nineteenth-century biographers were thus faced with a vacuum as regards Correggio's apprenticeship. Pungileoni, in his great and unreadable work (1817–21), filled it by postulating a local painter, Antonio Bartolotti, as Correggio's master, and this was followed by other Italian writers such as Martini and Quirino Bigi. Towards the end of the century Morelli stressed the Ferrarese roots of Correggio's art, favouring apprenticeship to Costa and to Francia. Later, another Ferrarese, Dosso Dossi, was added to the list of formative influences. The Ferrarese trend was followed, with some modification, by Corrado Ricci in the first version (1896) of his influential monograph.

Suddenly, and very unexpectedly, the *status quo* appeared to be restored by the argument, first published in 1913 in the form of a footnote in a book on a different subject, that Correggio was born not later than 1489.[1] Adolfo Venturi thereupon rehabilitated the Mantegna apprenticeship and also refuted Tiraboschi's dismissal of the Bianchi Ferrari one.[2] As a corollary he revived the attribution to Correggio of the Mantegnesque pendentives in Mantegna's funerary chapel at Mantua. Ricci then veered, re-establishing Correggio in his second version (1930) as Mantegna's pupil, and supporting the re-attribution of the Mantuan pendentives. Despite the calling in question of the earlier birth date within a few years of its publication both it and the supposed Mantegnesque roots of Correggio's art have been fairly generally favoured since.

The crucial, and equivocal, document for the birth date is the contract for the altarpiece for the high altar of the church of S. Francesco at Correggio, dating from 30 August 1514 (see pages 174ff.). In this it is stated that Correggio entered into it with his father's consent. One faction has pointed out that in the case of persons under twenty-five the further permission of a magistrate was needed, whose absence on this occasion would indicate that the painter was then over that age and therefore born not later than August 1489.[3] The opposing lobby claim that in the town of Correggio artists were exempt from this ruling, coming of age at twenty-one, and that the traditional birth date of 1494 is thus confirmed.[4] On documentary and legalistic evidence deadlock would seem to have been reached. But on a different kind of evidence this part of the problem seems roughly soluble. The Detroit *Marriage of St. Catherine* (plate 1) is dateable, from the costume, around 1510–11, and looks unlikely to be the work of a youth of sixteen or seventeen. Though a definitive answer to the question is unlikely, a date of birth nearer to 1489 is therefore to be preferred.

The question of Correggio's apprenticeship to Mantegna – which would thus be possible –

[1] Luzio 1913, p. 112.
[2] A. Venturi 1915, pp. 405ff.
[3] Luzio 1913, p. 112.
[4] Roi 1921 and Testi 1922. In 1871 Carlo Malaspina (Battaglia, no. 1089, p. 31) claimed to have discovered a document with the painter's birth date – 30 September 1493.

will be discussed in the next chapter. Only one thing need be said about it here. It has no early warrant. It appears to have been published first by Scannelli, as late as 1657.[1]

Correggio's early career, so far as we can follow it from his surviving work, shows a steady progress from one commission to another more important, the success of each in turn leading to others, spreading the painter's fame and increasing the demand for his work. The Detroit *Marriage of St. Catherine* (plate 1) being a small altarpiece, shows that while still very young Correggio was being commissioned to carry out work of a certain importance, and within a very few years (in 1514) he signed the contract for what must have been the most enviable job of painting which his native town could give him, the high altar of S. Francesco (Dresden) (plate 11). Probably a little before this another altarpiece (now at New York) (plate 8) was commissioned for another church in Correggio. Then, if not before, came demands from farther afield. In 1514 there was a commission for painting the doors and podium of the organ at S. Benedetto Po, near Mantua, and in 1517 (at the latest) for an altarpiece for the church of Albinea, delectably situated in the foothills of the Apennines some ten miles to the south of Correggio. Almost immediately afterwards – in all probability – came the first of the commissions which were to bind Correggio to Parma for more than a decade. It has long been assumed that the responsibility – and the credit, inadequately recognised – for introducing the artist to the city rests with the somewhat flamboyant figure of Cavaliere Scipione Montino della Rosa. Exiled from Parma and on terms of friendship with the ruling family at Correggio, he had become aware of the young painter, and, after his own return to Parma in 1518, had summoned him there to decorate the suite of his sister-in-law, the formidable and aristocratic Gioanna da Piacenza, abbess of the convent of S. Paolo (see chapter IV). The fact that this was a Benedictine house and that the work had been preceded by another Benedictine contract – for S. Benedetto Po in 1514, and was immediately followed by another, and more considerable, one – for the decoration of the splendid new monastery church of S. Giovanni Evangelista (see chapters V and VI), a few hundred yards to the east of S. Paolo – is a convincing testimony to the snowball principle which was soon to show itself even more strikingly.

Correggio was working at S. Giovanni Evangelista by 16 August 1520, and had finished the main decorations by January 1524. During this period there occurred the turning point in his career, a phenomenon whose extent has never been fully grasped in all the centuries of writing on him. Quite simply, it was now – precisely at the end of the year 1522 – that he suddenly became famous, as it were, over night. This can be deduced from the flood of orders which descended on him at this time. On 14 October 1522, a native of Reggio, Alberto Pratonero, ordered the altarpiece which subsequently became the *Notte* (Dresden) (plate 107). A fortnight

[1] Scannelli 1657, p. 257.

later, 1 November, the fathers of S. Giovanni Evangelista added a further substantial item – the nave friezes – to the decorations which Correggio was already doing there. Only two days later (3 November) the authorities of the cathedral commissioned a vast scheme of decoration, evidently so that it should not be outshone by its neighbour, S. Giovanni Evangelista (see chapter X). This was far from all. The altarpiece known as the *Giorno* (Parma Galleria) (plate 157) was traditionally commissioned in 1523, while another, the *Scodella* (Parma Galleria) (plate 105), on the evidence of a double-sided drawing, was evidently started at this period. In the church of S. Giovanni Evangelista itself, a private chapel, of the Del Bono family, was re-inaugurated in 1524. It was furnished with frescoes and two paintings by Correggio (see chapter VII), which are unlikely to have been commissioned *later* than 1522. In addition, two separate and very important commissions from Mantua may be deduced as dating from not later than 1523. First, two mythologies for Federigo Gonzaga, of which the earlier in style of execution (the National Gallery *School of Love*) is datable to this period. Then another pair, for Federigo's mother, Isabella d'Este, is likely to have been ordered about 1523. We can also deduce a journey by Correggio to Bologna about the year 1522, perhaps in connection with a commission from the Hercolani family.

From all of this we may conclude that most of the work whose execution, in the event, occupied Correggio for the rest of the decade of the 1520s would have been commissioned more or less simultaneously at the end of 1522 or in 1523. Only one thing can account for it. The two main elements of decoration at S. Giovanni Evangelista – the apse and the cupola – were sufficiently far apart in the church to need separate scaffoldings. Evidently it was the unveiling of the first half which produced the volcanic effect which we have traced. The lack of a contemporary report of it, in itself regrettable, is perhaps explicable in the light of the even greater fame accorded to Correggio's subsequent works (as early as 1530 he is referred to in the Duomo archives as 'celeberrimo pittore' ('very famous painter')). Nevertheless it is still possible to trace the vital effect on him – a diminishing of the introversion – exerted by so great and so sudden a degree of recognition. After the mid-1520s he designed, with one exception, no more pictures in which all view of distant space is excluded.

We may note in passing that Correggio's patrons ranged over a wide variety of social levels. At the top were the Gonzaga – both Federigo and his mother, Isabella d'Este. But Vasari also specifies work for friends such as the doctor, Francesco Grillenzoni (the *Marriage of St. Catherine* (plate 161A), now in the Louvre) and Lomazzo, an apothecary of Reggio (the *Agony in the Garden* (plate 96A), now at Apsley House). In between were the notabilities of Parma – the Cavaliere della Rosa, the Cavaliere Francesco Baiardo (the National Gallery *Basket Madonna* (colour plate E)), probably the Prati family (*Ecce Homo* (colour plate J), now in the National Gallery) and others.

The period of maximum output and maximum domestic happiness was not to last long. Around the year 1530 a kind of nemesis clouded a career which had perhaps been too uninterruptedly successful. The death of Correggio's wife, thought to have occurred at this time (1528–30), together with some adverse criticism when the decoration of the Duomo cupola was unveiled in 1530, caused him to abandon the second half of the work there and return to his aged parents in Correggio. He had by then, after many years, honoured all his other commitments, and must have regarded a chapter of his life as closed.

The ensuing four years of premature retirement were to be Correggio's last. During them he worked on further undertakings for Federigo Gonzaga, who presented some of them – four mythological canvases – to the Emperor, Charles V. Correggio was also responsible for the decoration of his native city on one of the Emperor's visits to it. With his attention thus drawn to the painter in two separate ways it seems certain that Charles would have commissioned something of him direct but for Correggio's sudden and unexpected death on 5 March 1534. The mythologies which appealed to the Emperor so strongly must likewise, given a little more time, have gained Correggio princely patronage – Este, Della Rovere, Farnese – nearer home. Correggio's premature death may therefore be regarded from this point of view as not the least of the many extraordinary strokes of fortune that were granted so liberally to Titian.

The little that we know of the conditions of Correggio's life from contemporary documents, mainly unearthed by the Abate Pungileoni in the early nineteenth century, is not very revealing. No letters from him are known (apart from a possible fragment, not certainly in his writing, on the back of a drawing at Windsor – Popham no. 2); and with the exception of an observation on the size of his fee for painting the cupola of Parma cathedral there is not a single piece of writing from his pen which reveals any opinion at all. Though the patronymic is usually given as 'Allegri' the painter himself, both in the *Notte* contract and at S. Giovanni Evangelista, signs in the form 'Antonio Lieto da Correggio' (one might assume a double process, comparable with cockney rhyming slang – 'allegri' being latinised into 'laetus' and the latter then italianised into 'lieto').

His family appear to have been reasonably prosperous bourgeois, long established in Correggio, and it is known that his father's brother, Lorenzo, was a painter; also a cousin, Quirino. It is certain that Correggio himself came to be on terms of some intimacy with the widow of the ruling prince, the well-known and cultivated Veronica Gambara, as well as with other members of the family. In a letter of 1528 to Isabella d'Este Veronica speaks of the painter as 'our Master Antonio Allegri', and goes on to describe a picture of the Magdalen which he was then painting. This has been interpreted as illustrating the degree of intimacy enjoyed by Correggio with the ruling family. In addition, we may guess that the seemingly gratuitous information offered by

Veronica to Isabella may have been in answer to an enquiry by the latter concerning Correggio's progress – or the lack of it – with the pictures for her new Studiolo. Furthermore, we know that in the year of his death Correggio was a witness to the marriage settlement of Veronica Gambara's son. Probably in 1520, he himself had married one Girolama Merlini. A son, Pomponio, was born next year (it is that which gives the likely date for the marriage) and grew up, in the manner of the children of genius, a mediocrity. Three daughters followed. If the surviving documents reveal, in general, little of Correggio's way of life, in one respect they give an unequivocal pointer. When, after prolonged litigation, he was enabled to take possession of his wife's inheritance, as well as of a gift made to him by an uncle, he could be said to have enjoyed considerable private assets.

Though the short period of Correggio's adult life coincided with momentous political and military happenings in Italy – as well as with the beginning of the Reformation – he himself seems to have been affected the minimum. Some of the early biographers make much of an outbreak of plague at Correggio in 1511, but it seems to have left him unscathed. Later, when he first came to Parma, the city was under French occupation (1515–21) and was then besieged. But it would appear that Correggio was back in his home town at the time of the Parma siege, and there is no evidence of his suffering hardship previously on account of the occupation. It has indeed been suggested that a certificate of communion accorded to Correggio and his family by the Benedictines of S. Giovanni Evangelista at Parma in the spring of 1521 was intended to give him some protection against the local undisciplined soldiery. Whatever the intention may have been, the fact of his absence from Parma at the time of the siege may have been neither entirely coincidental nor irrelevant. But though we may sometimes get the impression that Correggio may have been one of those characters who neither court disaster nor obviously run away from it, but who simply happen not to be there at the time, this may be a false one. The extreme scarcity of reliable information on the events of his life is such that we are not in a position to come to a conclusion.

II THE EARLIEST WORKS THE DIFFICULT,

dangerous and sometimes unrewarding task of charting a great artist's beginnings by the process of going backwards from the earliest authenticated works was not seriously attempted in Correggio's case until Giovanni Morelli reconstructed, or rather codified, a fair portion of it, in instalments, at the end of the last century, and in the process achieved one of his most useful contributions to art scholarship.[1] Though it provoked some opposition (see Appendix C) it has lasted well. A much more recent attempt, by Roberto Longhi, to extend the process still farther back was rather less successful.[2]

Identification of Correggio's earliest work is necessarily bound up with the question of his apprenticeship. Initial instruction at Correggio with his uncle and perhaps Bartolotti would be plausible, but unproved and largely irrelevant. The tradition that he was Bianchi Ferrari's pupil in Modena is more likely to be reliable – because older – than that which would have him apprenticed to Mantegna.[3] Indeed, Scannelli's method of launching that particular theory may itself be suspicious, Scannelli being an idolater of Correggio and giving the impression that it was due to his thinking that only a giant could produce another giant. At the same time it was clear that a birth date nearer to 1489 than to 1494 – a dating which, on other grounds, we have already preferred – would not exclude the possibility that Correggio might have been apprenticed to both, starting, presumably, with Bianchi Ferrari and leading on to Mantegna shortly before his death in 1506. Let us therefore examine Correggio's earlier work in this light.

Mantegna was succeeded by Costa as court painter at Mantua. And it is a fact that paintings by Correggio which are datable to the years between about 1510 and 1520 or later show strong and undeniable influence of both these artists. One might therefore deduce that he had been the pupil, at Mantua, of Mantegna and Costa in succession. Unfortunately the respective influences seem to have reached Correggio in the reverse order. Those in which the influence of Costa is strongest, such as the National Gallery *Leave Taking* (plate 7A) or the two pictures of the *Marriage of St. Catherine* (Detroit and Washington) (plates 1 and 5B) are certainly earlier in date than those in which Mantegna's example is most clearly acknowledged – in the Madonna, for example, of the Dresden *Madonna with St. Francis* (1514–15) (plate 11) or the Brera *Nativity* (plate 22A) of similar date, or the decorative schemes of the Camera di S. Paolo (shortly before 1520) (colour plate B, plates 28–37) or of the S. Giovanni Evangelista apse (after 1520) (plates 38–40). How to account for this anomaly?

The proximity of the town of Correggio to Mantua, and Costa's residence in the latter might lead us to assume that the Costa influence of the years prior to about 1514 was due to Correggio's

[1] Morelli (Lermolieff) 1875 and 1880. [2] Longhi 1958.
[3] A. Venturi 1915, pp. 405ff.

presence at Mantua during some part, at least, of that time. As a large portion of Mantegna's life work was also there it would further show that the moderately gifted living can exercise a stronger hold on the young than the more gifted dead. The Mantegnesque influence of the 'teens probably presupposes further visits by Correggio to Mantua, though my own views on the solution to the problem of the Rome journey, as well as his tardy reaction to Raphael's *Sistine Madonna* (fig. 33B), suggest a remarkable ability on Correggio's part to store up impressions which he had received and not to use them until he felt the need to do so. Nevertheless, we may well wonder if Correggio may not have been employed at Mantua at some period after 1514. One possibility would be the mural of Francesco Gonzaga's horse which, according to Donesmondi, was painted by Correggio to Francesco's order, though the period is not specified, and Donesmondi is too late a source (1616) to be necessarily reliable.[1] The same source is the authority for associating Correggio with another project at Mantua, namely Mantegna's funerary chapel in the church of S. Andrea, and this is crucial to the problem. The decorations in the chapel bear a date of precisely the period in question – 1516. As some degree of preparation for it was already being made before Mantegna's death in 1506 and as the chapel is of no great size it must be assumed that there was an interruption in the execution of the work. There would therefore be a possibility that Correggio was called in at this time to supervise its completion. Unfortunately there seems to be no way of settling the point.

Donesmondi gives Correggio's share as the four pendentives and some angels in grisaille (no longer existing) over the altar window. He also states that Correggio was responsible for a number of paintings in the porch of the church, of which two – damaged roundels of the *Entombment* and the *Holy Family* – have recently been reattributed to him. Donesmondi seems to differentiate these from the work in the funerary chapel by mentioning that some of them were done 'in his early period when he imitated Mantegna' (it is to be noted that Donesmondi does not state that Correggio was Mantegna's pupil). If a distinction were intended it would imply that Correggio worked in the church at different times. Not only, however, can we not be sure that such a distinction *is* intended. It would have no real meaning, even if it were, as the four pendentives are just as completely in Mantegna's style as the two roundels from the porch. Kristeller said of them that even if Mantegna did not execute them himself 'the perspective treatment of the dome and of the pictures in the spandrels' are 'entirely in his manner'[2] and we may recall that the reattribution of the pendentives to Correggio was not entirely disinterested, but was linked with the 'politics' of the revised birth date. Neither in the pendentives nor in the roundels is there anything specific to Correggio as we know him. Though this would not prevent his

[1] Donesmondi 1616, p. 86.
[2] P. Kristeller, *Andrea Mantegna*, English edition, 1901, p. 333.

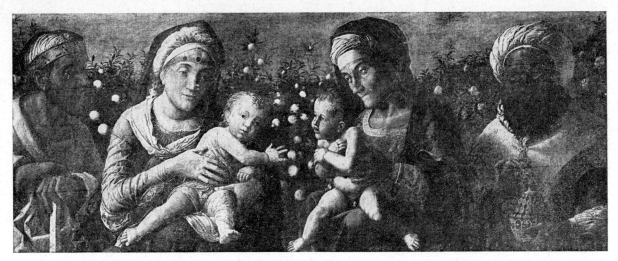

Figure 1
Mantegna, *Madonna and Child with St. Elizabeth and the Giovannino*

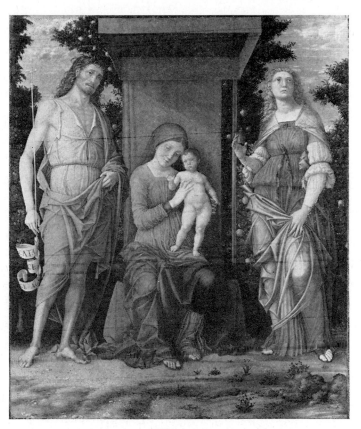

Figure 2
Mantegna, *Madonna and Child and Saints*

Figure 3
Costa, *St. Peter*

having been involved in their production in a supervisory capacity (which might be the easiest explanation of the legend perpetuated by Donesmondi) it provides no positive indication in favour of it, and we may note without further comment that Berenson never accepted the attribution of these works to Correggio.

We must naturally bear in mind that such pictures as have survived and are attributable to Correggio as of the period before about 1514 would only represent a portion of his actual output at that time, and in consequence may give a misleading view of his development. Nevertheless, the sum of the existing evidence indicates that the influence of Mantegna on Correggio was stronger in the 'teens than in the period immediately before: I remain doubtful, therefore, whether there was ever a still earlier phase, totally dominated by Mantegna, and if there were not there would be as little need as there is reliable evidence to postulate an apprenticeship to him.

Let us now return to the Detroit picture (plate 1), the most convenient pointer to Correggio's early style. It is a small altarpiece, painted for an unidentified destination (the strange buildings in the background might seem to give a clue to the intended location, but are more probably capricious, perhaps based on Dürer). A tentative attribution to Luini, made while the picture was in the collection of Charles I, gives one hint of its artistic origins. There is certainly something of the Milanese Leonardo, and the figure of the Baptist even seems to derive from a design by the master himself.[1] The X-rays (plates 2 and 3) show that at an earlier stage a hooded woman – perhaps St. Anne – blocked the view of the distant landscape on the right. The suppression of this idea has led to a characteristically Correggesque design. Right up to the time of the great altarpieces, the *Giorno* (Parma) (plate 157) or the *Notte* (Dresden) (plate 107), he favours a diagonal view of landscape – in cases where he permits the distant landscape to be seen at all – showing one side only, the view of the other side being blocked. The particular tree behind St. Anne is also one which will recur repeatedly. Another characteristic is to dispense with a throne for the Madonna. Here she squats on the ground, with her right knee down and her left up in order to support the child. Later, in the Dresden *Madonna with St. Sebastian* (plate 100) and the *Giorno*, her left leg will be brought unobtrusively across her right for the same purpose. The cause was evidently the tyranny of the landscape setting, in which a throne would sit awkwardly. Some faint echo of Mantegna may perhaps be traced in the St. Anne, and the Christ child seems based on one in a picture which certainly affected Correggio later – the Mantegnesque *Madonna and Child with St. Elizabeth and the Giovannino* in Mantegna's funerary chapel in S. Andrea at Mantua (fig. 1). But to see just how faint it is – and how essentially un-

[1] Pointed out by the present writer in the catalogue of the quincentenary exhibition of Leonardo da Vinci, Royal Academy, London, 1952, p. 27, n.64. The Leonardo design in question is Windsor 12,572. The pose, but not the angle of the head, was repeated by Dürer (B. 112).

A

Madonna and Child with St. Joseph and the Giovannino
Los Angeles, County Museum. See page 43

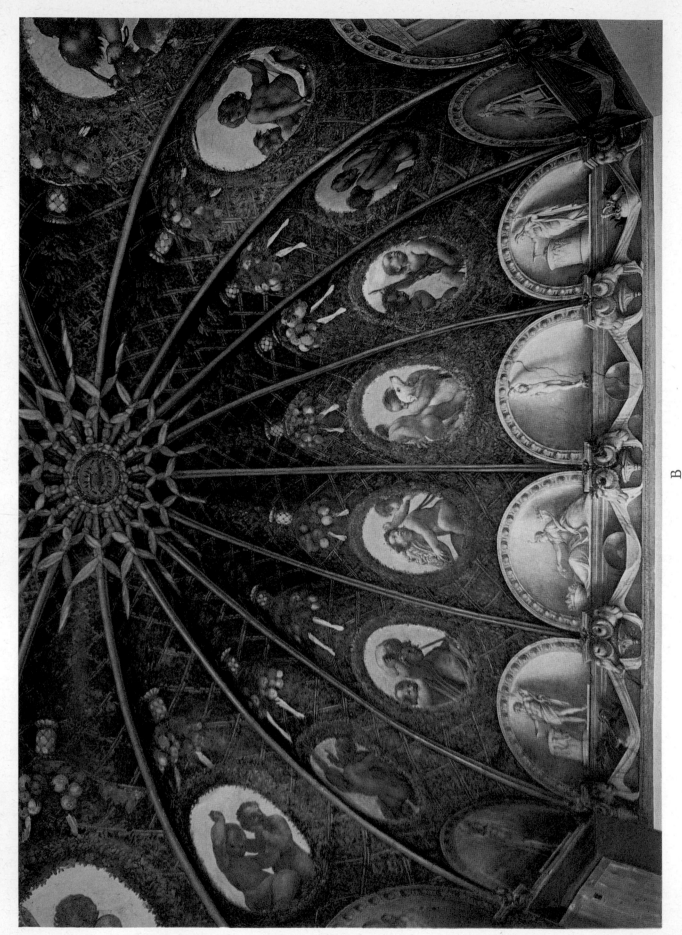

B

East wall, after 1972 restoration, Camera di S. Paolo

Parma. See page 51

Mantegnesque the picture – we have only to compare it with a Mantegna of similar size and type – the late altarpiece of the *Madonna and Saints* in the National Gallery (fig. 2). Though only a few years, in all probability, separate the two, Correggio already seems a whole age ahead. Vasari would have called the Mantegna, for all its magnificence, 'dry' and the Correggio 'modern'. That is to say, where Mantegna's draperies are angular, his colours local and his lighting nondescript Correggio shows fluent folds (and far fewer of them) in the draperies, darker and fewer colours and strong contrasts of direct light and shade; and the whole more unified. Above all, Correggio seems well on the way to defining volume by contrasts of light and shade and colour, with only the minimum help from the draperies. Here the Baptist's right shoulder is a case in point. St. Catherine's body, too, is fully three-dimensional with very few folds in the draperies (but these essential). In some of his later works, such as the St. Peter in the National Gallery polyptych (fig. 3), Costa had been aiming in this direction, but here Correggio already out-Costa's Costa.

It is this figure of St. Catherine which authenticates another Correggio of the early period – the *Judith* at Strasbourg (plate 5A). The two are so much alike that no further comment on the point is needed. The *Judith* is the first of Correggio's miniatures which we will consider. The painting of miniature size, conceived to accord with the scale, and exquisite in execution, was a genre which he made particularly his own. His essential neatness of hand (as a painter) was ideally adapted to it, and there follows a whole string of such pictures which explore various techniques and problems but of which none measures more than a foot or so in either direction. (Owing to the importance of the factor of scale in Correggio's style, and to the misleading impression created when pictures of different size are juxtaposed in reproductions of the same size, an attempt will be made in this book to clarify matters. The word 'miniature' is used to denote a picture in the region of 25 or 30 centimetres high, and 'cabinet size' for one of 50 or 60 centimetres or more high.)

In the Strasbourg *Judith* – exquisite in effect and handling, despite the gruesome subject – the definition of volume by means of light, with the minimum of drapery folds, is even more marked than in the Detroit picture. The use of weird lighting – in this case artificial – was an obvious challenge to Correggio's temperament. He took up this particular problem again at intervals, in the Brera *Nativity* (plate 22A), for instance, and finally in a group of pictures datable to the mid-twenties. The mulatto attendant in the *Judith* miniature is an element of the macabre which does not recur, and owes something, as does the picture as a whole, to Mantegna (painting of the same subject now at Dublin).

The cabinet-size *Madonna* in the John G. Johnson collection in Philadelphia (plate 6A) may perhaps date from before the Detroit *St. Catherine* (plate 1) – the only one, of those which seem

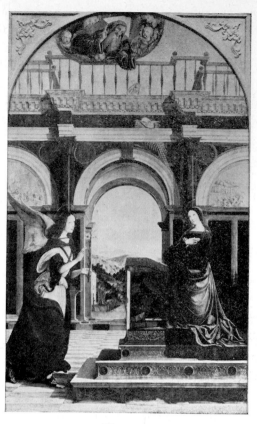

Figure 4
Bianchi Ferrari, *The Annunciation*

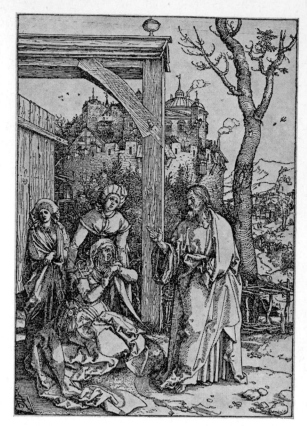

Figure 5
Dürer, *Christ taking Leave*

to me authentic, which looks as though it might. There is a hint of Mantegna in the St. Elizabeth, but the simplified and lyrical quality of the Madonna's draperies – and, indeed, of her features – is as foreign to him as is most of the Detroit picture. Rather they may to some extent recall Bianchi Ferrari, as we know him, for example in the *Madonna and Saints* in S. Pietro at Modena, or in the *Annunciation* of the Estense (fig. 4).

Two other exquisite miniatures containing respectively half-length and full-length figures, connect both with each other and with the Detroit *St. Catherine*. The half-length one – the *Holy Family* at Pavia (plate 5C) – is at present falsified by old varnish and evidently damaged. It represents perhaps the extreme of smooth modelling of volume by means of strong contrasts of light and shade, the draperies being almost entirely devoid of crinkles. The same is true of all but the figure of St. Catherine herself in what is certainly the masterpiece of the early miniatures – the Frizzoni *Marriage of St. Catherine* (plate 5B), now at Washington. If the Christ child in the

Detroit picture were to be enclosed in a rectangle it would be roughly the size of the whole of the Washington picture. Like the Pavia *Madonna* it has suffered somewhat, but the delicacy of its execution is still something to marvel at.

It is fascinating to compare it with the Detroit picture, owing to the identity of the subject. The two works are also, in all probability, of the same period, and the comparison leaves no doubt that at this stage of his life the young painter was more at home in miniatures than on a larger scale. In comparison with the Washington picture, the Detroit one creaks a little: the early attempt, which it represents, nearly but not quite successfully, to rise to the challenge of the altar form and strike an appropriate note of formality, has involved the sacrifice of the intimacy of the small version without quite gaining monumentality in compensation. Oddly enough, and almost miraculously in view of its minute size, the Washington picture is not only movingly intimate but also extraordinarily monumental. The solicitude shown by St. Dominic and, even more, by St. Francis, makes itself immediately felt. But the characters, bound together spiritually and emotionally in this solemn mood, have assumed, in a formal sense, a pattern which seems equally inevitable but must in fact represent much thinking and much ingenuity. St. Dominic on the right has to balance the combined forces of St. Catherine and St. Francis on the left. The diagonal inherent in the female saint's kneeling posture is continued through the face of the Virgin Mary to that of St. Dominic. The resulting tightly welded group is finally set off by the concentric semi-circles centering on St. Anne's head – the roundel and putti, picked out in gold paint at the top of the throne, the niche behind, and the moulding – again in gold – and elaborate garland which frame it.

Compared with this perfection, the *Christ Taking Leave* (National Gallery) (plate 7A) – considerably larger than the miniatures, but still little more than cabinet size – seems more experimental. And in a literal sense this is true. X-rays (plate 7B) reveal an earlier version, upside down from the present one, with a Christ standing, as Dürer had shown him in his print, in the *Marienleben* (fig. 5), of the same rare subject. The date – 1510 – on two of the other prints in this series thus gives a *terminus post quem* for Correggio's picture. It probably dates from not long after this, and has the incidental distinction, for an early work, that the attribution goes back to the eighteenth century. The experimental factor is also seen in another respect. The caesura in the centre between St. John and the Virgin Mary is evidently intended to enhance the drama, and, up to a point, does. But it remains slightly awkward, and we know from the X-rays that there was once another figure in this space. Another immaturity is Correggio's tackling of the perennial problem of grouping figures some of whom are seated and others standing. If the Madonna were to stand up she would be much taller than either the Mary who supports her or the St. John. The proportions of her body, too, are odd, with immensely long thighs.

3-2

Despite these shortcomings the emotional quality of the scene comes over with as complete success as in the Washington *St. Catherine* (plate 5B), and with a poignancy which Correggio was never again to achieve in the unheard-of brilliance and bravura of his later work. We can test this by comparing the picture with another of similar subject, also in the National Gallery – the rhetorical *Ecce Homo* (colour plate J, plate 161B), dating from a period towards the end of Correggio's career. The total submission of the Christ in the earlier work and the anguished indecision of the Virgin, protesting with her right hand and indicating resignation with her left, are set off by the solicitude of the two subsidiary characters, similar in mood to the St. Francis and St. Dominic of the Washington picture. We may also note, since the picture is in most respects so very different from the works of Correggio's maturity, that the facial type of Christ is already similar to that in the Prado *Noli me Tangere* (plate 98) of the 1520s.

Figure 6
Leonardo da Vinci, *Madonna and Child with St. Anne and the Giovannino* (cartoon)

In its treatment of form, too, the *Leave Taking* is of a piece not only with the Washington picture but with the Pavia, Strasbourg and Detroit ones. Here the strong contrasts of light and shade have ironed out even more of the crinkles in the draperies – in the female attendant's left shoulder, in Christ's shoulder and thigh or in the knees of the Madonna and of St. John, all of which are very three-dimensional but also very smooth. Leonardo had done this conspicuously in the cartoon now in the National Gallery, the influence of which I am inclined to see in the present picture (fig. 6). One of the consequences of this smoothness is to suggest thickness or

unyieldingness in the material portrayed. St. John's golden yellow robe looks almost as though it had been starched, and his face as though it were made of painted marble. In this picture we may also trace the beginning of a tendency which lasts throughout Correggio's life – a contrast between very smooth modelling where the limbs press against the draperies and an accumulation of folds where they hang free. At this stage, though, the emphasis is still on smoothness. The fact of the pillar's being unfluted underlines this (the pillar is in fact the end one of a colonnade of three, as we can see from the capitals) and the mood of simplification is echoed in the hauntingly desolate, almost lunar, landscape, glimpsed diagonally, and ending in a misty expanse which may be a lake, or a valley covered in cloud as seen from a high mountain. The treatment of the bushes on the left is astonishingly advanced. Here, if anywhere, something of Giorgione may have been transmitted, perhaps through Dosso.

The colours of the *Leave Taking*, with the emphasis on yellow and red and blue, play an important part in a dramatic sense, and illustrate an aspect of Correggio's art which rarely found an outlet, so many of his surviving pictures being of the static subject of the Holy Family. But when the occasion called for it, as here or in the Del Bono laterals (plates 79 and 84) he was very much alive to the power of colour to set the mood of the picture. Here the intense, even strident, colours fully accord with the tragic mood, and, to a large extent, create it. One is reminded of Nicolas Poussin's *Pietà* at Dublin, or Delacroix' picture of the same subject at Boston. In the *Leave Taking* a somewhat unusual feature is the colour of the Madonna's dress, not red (which is reserved for the cloaks of Christ and St. John) but magenta. Later on, Correggio temporarily dispensed with red wherever possible. The original of the cabinet-size *Madonna*,[1] known from versions in the Borghese (plate 6B) and at Washington (ex-Timken) must have shown similar forms to the *Leave Taking* – in particular, a curious tendency to break a long outline of drapery with a small notch – and may be thought to have been roughly coeval.

A comparable range of colours, but appropriately less intense in effect, is seen in the altarpiece now in the Metropolitan Museum (plate 8). Like the *Leave Taking*, but unlike all other major Correggio's, except for the Uffizi *Holy Family* (plate 89), the Del Bono laterals and the mythologies, this seems always to have been on canvas. The dating of the New York picture has been bedevilled by two false clues. It has been associated with a document of 1517, and it has been thought to derive from Raphael's *St. Cecilia* (Bologna), which cannot date from earlier than 1514–15. The problem posed by the documents is discussed in the catalogue entry for this picture. Any attempt to compare – no matter in what context – its slightly naive immaturity with the super-sophistication of the *St. Cecilia* seems misguided, and in fact the superficial resemblance, which is all they have, can be explained by postulating a common ancestor in some

[1] Catalogue B, page 278.

Peruginesque composition – already distant in the case of Raphael, and perhaps diluted through Costa as regards Correggio, though a relevant picture by Perugino himself was as near as Bologna (*Madonna in Glory and Saints*, now Bologna Gallery).

The Metropolitan altarpiece introduces for the first time a most important characteristic of Correggio – the agoraphobic exclusion of space by means of the dense bank of trees behind the four saints. But in other ways the picture has many points of contact with those we have been considering. The features of both female saints recall to some extent those of the Madonna in the Johnson picture (plate 6A), and the St. Peter might be the same model as the St. Joseph in the Detroit one (plate 1). As befits its greater scale – larger even than the Detroit picture, and much larger than all the others to date – some modification has had to be made in the system of the draperies, but the shoulders of St. Peter and of St. Margaret, and the Magdalene's bodice, remain smoothly three-dimensional.

The Metropolitan picture is the first full-scale altarpiece of Correggio which survives, and though clearly, in its totality, a somewhat unsatisfactory work it shows signs, in one especial way, of what was to come. The rhetoric embodied in the right-hand saint with his rolling eyes derives ultimately from Perugino, but looks ahead to the mature Correggio, where the rhetoric is already that of the Baroque.

The beautiful, but rather unphotogenic, half-length of *St. Anthony Abbot* at Naples (plate 10B) obviously fits into this context. He wears a gold cloak like St. Peter in the Metropolitan altar, and is set against similar impenetrable foliage. He is even similar to him in features, and this raises a further problem. For the similarity – which seems to me to contain an element, but not more than an element, of portraiture – extends to Correggio's only other single half-length male saint – the Madrid *St. Jerome* (plate 19B). These two were linked by Borenius, while Ricci (1930) associated the Madrid picture with the Hampton Court *Holy Family* (plate 91B), which on my reckoning is likely to date from not less than about seven years later than the *St. Anthony*. The problem is aggravated by the worn condition of the *St. Jerome*, which, while still giving an impression of the picture's authenticity, more or less eliminates what would otherwise be obvious – the difference of Correggio's touch in the periods *c.* 1513 and *c.* 1520. We can however, still see that whereas the frontal presentation of the *St. Anthony* is relatively primitive, that of the *St. Jerome* is far more complicated, as well as being unmistakably Leonardesque (there may also be some influence from Cesare da Sesto here). St. Jerome's red drapery would militate against a dating in the late 'teens, and the element of physiognomical resemblance to the *St. Anthony* makes me incline to think it earlier than that, rather than later. The resulting conclusion, that a dating for the Madrid picture in the mid 'teens – therefore two or three years after the *St. Anthony* – is the most reasonable is put forward with considerable reserve, as I can find no close

analogy. Nevertheless, the *St. Anthony* may confidently be used as yard-stick for a third work of similar type, the Washington *Young Christ* (plate 5D). In this case the Naples picture looks the more developed, and as the Washington one seems to use the features of the Baptist in the Dresden *Madonna with St. Francis* (plate 11) of 1514–15, but several years younger, I deduce that the *Christ* is likely to precede the *St. Anthony* by a short period. Though the physiognomical factor constitutes some indication of authenticity, the *Christ* has a hardness of touch which makes it the most unsympathetic of all the early works. A further design represented by the strange and beautiful drawing of a Pope and other figures (plate 10A) (Popham 4), discovered by Philip Pouncey, may record a lost painting of the period of the St. Anthony, though we have no proof that it reached the painting stage. As Pouncey pointed out, the Pope's features are those of the St. Anthony.

These few pictures, less than a dozen, which I would consider the earliest Correggio's, show an aspiring talent which was most completely at home on a miniature scale. It looks occasionally to Milan and sometimes to Mantegna. And to Costa – above all in the colouring – perhaps more emphatically than to either. The theory of some influence from Francia – even of apprenticeship to him – was a phenomenon of the Morelli period, and though it may not be entirely illusory I have never been confident of it. Similarly, the theory of Dosso's influence on Correggio was popularised by the young Berenson on the mistaken assumption that Dosso was the elder of the two. As in reality they were more likely to have been contemporaries any inter-action there may have been – for example, in landscape painting – would be likely to be more complicated.[1] Stronger than any of these real or imaginary roots, however, is the mark of great originality. The smooth, relatively unstylish figures, with tremendous emphasis on volume and tactile qualities, are as essentially foreign to Mantegna as they are to almost all earlier painters. In the coming years Correggio was to appreciate Mantegna as he never had before. But in the meantime there may have occurred the most decisive experience of his career.

[1] Dosso is first recorded at Mantua in 1512. This might be a channel for something of Giorgione's landscape style to reach Correggio. But there may well have been others, and, in any case, we do not know much of Dosso's own relationship to Giorgione.

III THE QUESTION OF THE ROME JOURNEY

WRITING IN THE 'FORTIES OF THE SIXteenth century Vasari said of Correggio that if he could have left Lombardy and seen Rome he would have been an even better painter than he was.[1] In a book published two years after Vasari's first edition, Ortensio Landi (1552) included, apropos of Correggio, the bald statement, 'he died young without having been able to see Rome'.[2]

The verdict, thus given, was not disputed for a long time, and, when it was, it seems to have been for the wrong reasons. In a manuscript by Sebastiano Resta (died 1714) it is stated that the phrase 'I too am a painter' ('son pittore anch' io') attributed to Correggio, was current in Bologna and Lombardy, evidently before the end of the seventeenth century.[3] The remark is said to have been made by Correggio when looking at a work of Raphael's, variously identified with the *St. Cecilia* (at Bologna), the *Sistine Madonna* (at Piacenza until the mid-eighteenth century) (fig. 33B) and the Farnesina frescoes (in Rome). The phrase subsequently became embarrassingly famous and was quoted by no less a person than Beethoven.[4] Though it can safely be seen as no more than a manifestation of north Italian local patriotism it was published by de Piles (1699) as an indication that Correggio had been to Rome,[5] and this view was vigorously held by Resta himself for interested reasons – he wanted to authenticate certain drawings in his possession of Roman subjects as Correggio's. It was not until the second half of the eighteenth century that Mengs produced a reasoned case for a Rome journey. Looking at the works of Correggio's maturity more intently and more dispassionately than anyone with comparably wide experience had ever done before, it seemed to him impossible that their creator had not seen the Roman frescoes of Michelangelo and Raphael.[6]

Since no more written evidence one way or the other has ever come to light – and is unlikely ever to do so – subsequent writers have felt at liberty to take which side they liked. But a certain element of local (Parmesan) patriotism is likely to have coloured the views of some of them, and this includes those of the most distinguished of modern writers on the subject, Corrado Ricci. The God-sent genius of the local boy was such that he had no need of inspiration from Rome. And such protestations in their turn may have elicited more pronounced opposition in the form of re-iteration of the case for the Rome journey than would otherwise have been published.

From a stylistic point of view the crucial issue is the cupola of S. Giovanni Evangelista (plate 44). Together with its pendentives it displays so perfect and so complete a blending of elements

[1] Vasari,...*Vite*..., 1550 edition, p. 582.
[2] Landi 1552, p. 498.
[3] Resta 1958, p. 45.
[4] Anderson 1961, p. 857.
[5] De Piles 1699; 1715 edition, p. 288.
[6] Mengs, *Opere*, 1780 edition; p 165 in 1787 edition.

derived from the Stanza della Segnatura and other works of Raphael, on the one hand, and the Sistine ceiling of Michelangelo, on the other, that knowledge by Correggio of these works must be taken as certain. But does such knowledge necessitate a visit? Eye-witness sketches and, in some cases, the sight of the artist's own drawings, or even his cartoons, are likely to have been a more normal channel for the transmission of artistic ideas in the Renaissance than is generally acknowledged, or than can be demonstrated. Would something of this kind be sufficient in the present case? Most people would think not. We should therefore look more closely at the source of the anti-Rome-ists' case, Vasari and Landi.

It seems clear from Vasari's words that he had not been informed as a fact that Correggio had not been to Rome. He does not, indeed, state it as being a fact. His account leaves no doubt in the mind of a reader acquainted with his methods that he was merely making a deduction. The passage in question is an illustration of a doctrine which Vasari expounds at intervals throughout his history, and categorically affirmed in the first edition of his biography of Correggio. There is an antagonism between draughtsmanship and painting. Those who are good at one are seldom equally good at the other. Draughtsmanship flourished at Florence, particularly among those Florentine artists who had seen the antiquities of Rome. If an artist, no matter how skilfully he handled pigment, was not a Florentine and had not come in personal contact with Roman antiquities he must inevitably fall short of perfection. Vasari, who had had very little time in Parma, and none in the town of Correggio, leaves no doubt that his hurried inspection of Correggio's paintings had led him to include him in this category. Correggio was to him an insecure draughtsman (this refrain was taken up by Dolce only seven years after Vasari's first edition, and has been repeated, parrot fashion, ever since). A visit to Rome, Vasari thought, would have corrected this shortcoming.[1] As to Landi, he was not primarily interested in art. His book certainly gives no indication that he understood it, and some that he did not. And though, unlike Vasari, he was a native of northern Italy, the fact that his book appeared only two years after Vasari's does suggest that he too was not, in this instance, relying on specific information, but merely on Vasari.

If we deduce from this, that no authentic information either affirming or denying a visit to Rome on Correggio's part was current in Parma in the 1540s may this not in itself be relevant? May it not be comparable with Sherlock Holmes' 'remarkable incident of the dog in the night

[1] Vasari's implication that Correggio was highly sexed ('si affligeva...più del dovere nel portare i pesi di quelle passioni che ordinariamente opprimono gli uomini' ('he suffered more than he should under the weight of those passions which normally oppress mankind')) would be (if that is what Vasari means) another instance of his deduction from studying Correggio's work. It should be stated that the interpretation advanced here of Vasari's view of Correggio, and of the influence of that view, applies primarily to Vasari's first edition. In the second he modified it to some extent.

time'? If so, which way does such a pointer point? Correggio, after all, was not strictly speaking a native of Parma. As a distinguished settler on a temporary basis from a neighbouring city, what he did in Parma was news. If he had visited Rome from there, even if he had first arrived there fresh from such a visit, could its prestige have been passed over in silence by the locals within a decade or so of his death? Hardly. If, therefore, we postulate a Rome journey, much would depend on when it occurred.

Among the modern protagonists of the journey, such as Thode, Gronau, Venturi or Longhi, there has been a tendency to place it just before the Camera di S. Paolo.[1] Underlying this assumption seems to be the idea that the sight of Rome exercised so powerful an effect on Correggio that it swept him off his feet and immediately revolutionised his style. Nevertheless, nothing of this kind seems to have occurred in the case of comparable visits which are documented. Other painters from the north of Italy or from Florence who are known or thought to have paid short visits to Rome include Lotto, Garofalo, Pordenone, Pontormo, Andrea del Sarto and Veronese, and in none of these cases, with the possible exception of Pordenone, was there an immediate and revolutionary transformation. Indeed, in some cases there has been considerable uncertainty as to exactly when the Rome journeys occurred. With this in mind let us therefore consider Correggio's work assignable to the period around the mid 'teens.

First, the Dresden *St. Francis* altarpiece (plate 11), his earliest documented work.

In comparison with the great altarpieces which Correggio painted in the 1520s, and perhaps also on account of the chance by which three of them have for more than two centuries hung beside it in the Dresden gallery, the *St. Francis* altar inevitably looks primitive and has therefore sometimes been underestimated by critics. But as it was the high altar of the principal church in Correggio's home town he may be expected to have put into it everything he had, and in fact it would have been a very considerable achievement for its period. The relationship of the figures to each other and to the surrounding space – defined at the sides by gigantic unfluted columns – is superior to anything in comparable altars by Perugino or Costa or Francia, and with the exception of Raphael's *St. Cecilia* and of some Venetian paintings it must for a time have been the most advanced thing of its kind north of the Apennines.

The system of draperies used in the *St. Francis* altarpiece continues that of the Metropolitan *Four Saints* (plate 8), and by doing so seems to constitute a denial of all that Correggio had evolved in his earlier work. Except in the knees of the two male saints on the left there is very little trace left of his previous fondness for smooth, crinkleless modelling. Emphasis on the long folds can, of course, constitute a major element in the design of a picture, and it seems possible that in this case Correggio may initially have associated the idea with size. The Metropolitan

[1] H. Thode 1898, G. Gronau 1907, A. Venturi 1915 and Longhi 1958.

altarpiece is larger than any of his earlier pictures, and the *St. Francis* Madonna larger still (in fact, the largest of all Correggio's altarpieces). But whether or not it was size which caused the abandonment of the older system it soon superseded it in the smaller pictures also.

Round the *St. Francis* altarpiece can be grouped a number of cabinet-size pictures and miniatures. The cabinet size *Madonna* (plate 16A), dramatically bought by Chicago in recent years is one.[1] The older type of relatively crinkleless drapery may indicate a date of origin slightly earlier than the *St. Francis*, but in other respects it is close to the central group of the altarpiece. The Christ child and the Madonna's left hand are indeed almost identical and the Madonna's face similar. In the half-length miniature at Los Angeles (colour plate A, plate 18A) the child again is almost identical with those in the *St. Francis* and Chicago pictures, and the Madonna's right hand and arm with those of Chicago. The background of the Los Angeles miniature contains two standard features of Correggio's repertory at this time – the unfluted column and the dense hedge or thicket. In another picture, the cabinet size *Madonna* in the Castello Sforzesco at Milan (plate 19A) the Madonna's features recall those in the Chicago picture, and the Giovannino, with the windswept hair and anxious expression, is very close to that at Los Angeles.

Contrasting inevitably with these Madonnas owing to its different subject, but closely related in details, is the Brera *Nativity* (plate 22A). It is Correggio's most elaborate landscape to date. Probably in no other picture in all his career are the figures so small in relation to the surround. This has led to, or been caused by, a narrative treatment of the subject, and this in turn has brought with it certain difficulties of composition which have, on the whole, been skilfully surmounted. Though the isolated Christ child is insufficient as a formal centre, the two halves of the composition hinge delicately on him. The picture is another of Correggio's periodical essays in strange lighting. Though dawn appears to be breaking in the background there is light coming from over the spectator's left shoulder, and presumably also from the star, which is almost directly overhead. The features of the Madonna (who has strangely wrapped her right hand in her cloak) are nearly identical with those in the Los Angeles miniature, and the angel who directs the shepherds, with his windswept hair and anxious expression, connects with the Giovannino both in that work and in the Castello Sforzesco picture, and also with the left-hand angel in another miniature, the Uffizi *Madonna* (plate 18C). The single unfluted column of the National Gallery *Leave Taking* (plate 7A) recurs prominently in the Brera picture.

By a strange chance Correggio's only other picture of this size and format has also found a home in the Brera. This is the *Adoration of the Kings* (plate 22B), a highly original essay in the traditional long-format treatment of this subject. The initial attribution of it to the young Correggio, by the young Berenson, was one of the latter's most brilliantly perceptive feats. The

[1] Laskin 1966.

picture's previous obscurity (it had been attributed to Scarsellino) is not entirely surprising. At first sight it has nothing in common with Correggio in any of his moods and phases, and though extremely beautiful in its own way it must in any case count as something of an oddity. The numerous figures in a smallish picture recall Mazzolino or Dosso, but the similarity does not go deep. The strange and far-fetched attitudes of many of the figures, and the violence of the perspective, strike a foreign note, as do the brilliant colours. They are as bright as those in the *Leave Taking*, but gayer and more festive, as befits the subject. More important, they include the prominent use of a cool colour (mauvish-grey in the negro king's cloak), a feature which will often recur in the works of the late 'teens. The Joseph is apparently the same model as the old foremost king in the same picture, and both seem the same as the Los Angeles Joseph. The Christ child is exactly like the Giovannino in the *Nativity*, and the draperies of the negro king similar to those of the Madonna in the Castello Sforzesco picture. The rhetorical expression of the kneeling king recalls in a strange way that of the Christ child in the *Hellbrunn Madonna* (Vienna) (plate 21B), a ruined work which also shows unusually bright colours (particularly the orange curtain). The ivy on the left in the *Adoration* is similar to that in the same relative position in the *Nativity*, and is almost identical with that, again on the left, in a further miniature, the National Gallery *Magdalen* (plate 24B). The unfluted pillars of the *Leave Taking* and *Nativity* also recur in the *Adoration* – this time very obviously a colonnade of three or four. Finally, the putti emerging in a cloud overhead recur in the Naples *Zingarella* (plate 23), a strange, and strangely famous work of small cabinet size, now half ruined, in which the oddly built Madonna, with huge head, hands and feet, and the Mantegnesque realism of the sleeping child, contribute to a hauntingly poetic impression.

These pictures are probably the most eclectic that Correggio ever painted. The period evidently marked the first crisis in his career, when his horizon mightily receded and the promising provincial turned himself, in fact, if not yet in reputation, into a national force. The derivations which his pictures show at this time are both extensive and complex. We must assume that Correggio was in the habit of sketching features which struck him in pictures painted by other artists – an example is his memory sketch of Michelangelo's *Leda* (plate 194A), brilliantly identified by the late A. E. Popham – and then of reverting to them, as well as to his own earlier studies, when composing a picture. A further instance of his repeating one of his own inventions, this time after an interval, and with a considerable reduction in scale, is the head of the Madonna in the Uffizi miniature (plate 18C), which repeats that of the Madonna in the Detroit *Marriage of St. Catherine* (plate 1).

Of the straight derivations, those from Mantegna are, in some cases, the most obvious. The Christ child in the Brera *Adoration*, for example, and the Giovannino in the Brera *Nativity*, are

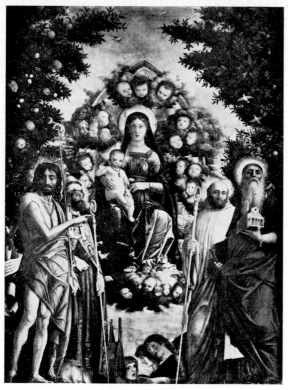

Figure 7
Mantegna, *Madonna and Child and Saints*

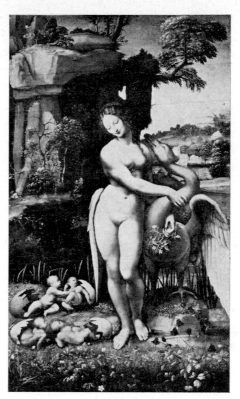

Figure 8
After Leonardo da Vinci, *Leda*

Figure 9
Leonardo da Vinci,
The Madonna of the Yarn-Winder

Figure 10
Raphael, *The Aldobrandini Madonna*

virtually quotations of one or both children in the Mantegnesque picture in Mantegna's funerary chapel at Mantua (fig. 1), of which Correggio had already made use in the Detroit picture. The St. Elizabeth in that work seems likewise to have inspired the same saint in the Brera *Nativity*. Similarly, Mantegna's Christ child in his Castello Sforzesco altarpiece (fig. 7) is repeated, as has recently been pointed out, in the Dresden *St. Francis* altarpiece and in the Chicago and Los Angeles pictures.[1] One direct derivation from Leonardo da Vinci is equally clear, though surprising. For there can be no reasonable doubt that the head, and, above all, the smile of his standing *Leda* (fig. 8) is behind the Madonnas in the *St. Francis* altar, the Chicago and Castello Sforzesco cabinet pieces and the Los Angeles miniature. Another instance is the Christ child in the Uffizi miniature (plate 18c), who seems to derive from his counterpart in Leonardo's *Madonna of the Yarn-Winder* (fig. 9).

There are also clear derivations from Raphael.[2] The flying putti in the *St. Francis* altarpiece and in the Brera *Nativity* seem to be variations on those flanking the dove in the *Disputa* (fig. 18). More surprisingly, the Los Angeles miniature almost repeats, in reverse, the main elements of the composition of Raphael's *Aldobrandini Madonna*

[1] Laskin 1966.
[2] Rumohr 1831, III, p. 118, had suggested unspecifically that Correggio had known the *Madonna of Foligno*, and Berenson 1901, pp. 20–38, suggested an indirect link between it and Correggio's *Madonna with St. Francis*.

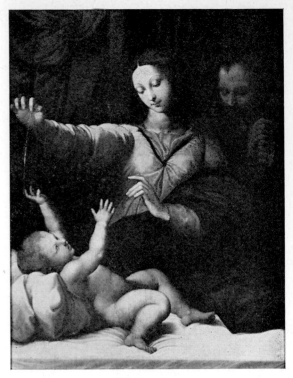

Figure 11
Raphael, *The Loreto Madonna*

Figure 12
Raphael, *Disputa* (detail)

(National Gallery) (fig. 10), with the addition of the St. Joseph located as in Raphael's *Loreto Madonna* (fig. 11), while those features in the Chicago and Castello Sforzesco pictures which are closest to the Los Angeles one are correspondingly close to Raphael (later, in the early 'twenties, Correggio did another variation on the *Aldobrandini Madonna* in the so-called *Madonna of Casalmaggiore*,[1] of which a ruined version is at Frankfurt (plate 90A)).

But in addition to these straightforward derivations – overlooking, for the moment, the channels whereby they can have reached Correggio – are others whose nature is ambiguous. One instance is the St. Francis in the Dresden altarpiece of that name. He is of Peruginesque type, but much nearer to Raphael's infinitely improved Peruginism of the upper tier of the *Disputa* (fig. 12) than to anything by Perugino himself. Or take the Madonna's outstretched right arm in the *St. Francis Madonna*. It may have been Leonardo who invented this motive. At all events he had used it in the *Virgin of the Rocks* (National Gallery), which had been commissioned in 1483 and which in Correggio's time was at Milan. But the motive had been incorporated by Mantegna in his *Madonna della Vittoria* (Louvre) (fig. 13) of 1495–6. Correggio must have known this picture almost by heart, whether or not he had also seen the *Virgin of the Rocks* in the original. But which of them was he quoting, or both? To the extent that Leonardo's Madonna has her thumb horizontal and Mantegna has hers up, Correggio is closer to Leonardo. But in his and Mantegna's Madonna it is her right hand, and in Leonardo's (significantly, perhaps, as he was himself left-handed) her left. As to the Madonna's attitude, the complexity is greater still. In the *St. Francis Madonna* the Madonna's legs, her right retracted, can be paralleled in those of the Madonna in the Leonardo cartoon (National Gallery) (fig. 6). But Raphael, by some means, had made a closer transcription of Leonardo's motive in his *Madonna of Foligno* (fig. 14). Which of these two, or both, does Correggio follow? Here again it is very difficult to decide, but in other paintings – the Madonna of the Brera *Adoration*, the Modena *Campori Madonna* (plate 26A) and the *Madonna of Albinea*[2] (copy, plate 25) it is certainly the Raphael of the *Foligno Madonna* and not the Leonardo of the Cartoon on which Correggio drew. Even more striking is the Baptist in the *St. Francis Madonna*. This motive of the pointing arm was, as far as I know, a development of Donatello's in sculpture, which in painting could count as another innovation of Leonardo's. But Correggio's Baptist is far closer to the same saint in Raphael's transcription of this Leonardesque motive as shown in the same *Madonna of Foligno* than to any of Leonardo's own uses of it. Furthermore, the gloreole of angels' heads, both in the *St. Francis Madonna* and in the Uffizi miniature, seems straight out of the *Foligno Madonna*.[3]

[1] Catalogue B, page 279.
[2] Catalogue B, page 278.
[3] Though it would be possible that Raphael's *Sistine Madonna* was already at Piacenza when Correggio painted his *St. Francis* altarpiece it seems unlikely that he knew the work at that time.

Figure 13
Mantegna, *The Madonna della Vittoria*

Figure 14
Raphael, *The Madonna of Foligno*

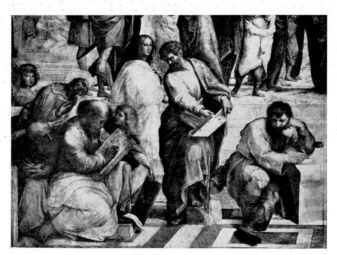

Figure 15
Raphael, *The School of Athens* (detail)

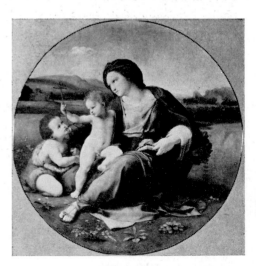

Figure 16
Raphael, *The Casa Alba Madonna*

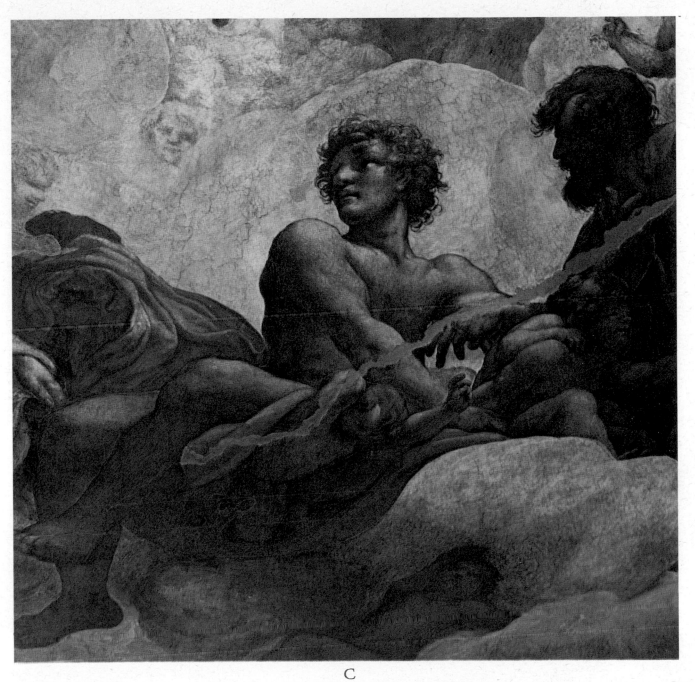

C

Apostle, from cupola fresco, S. Giovanni Evangelista
Parma. See page 67

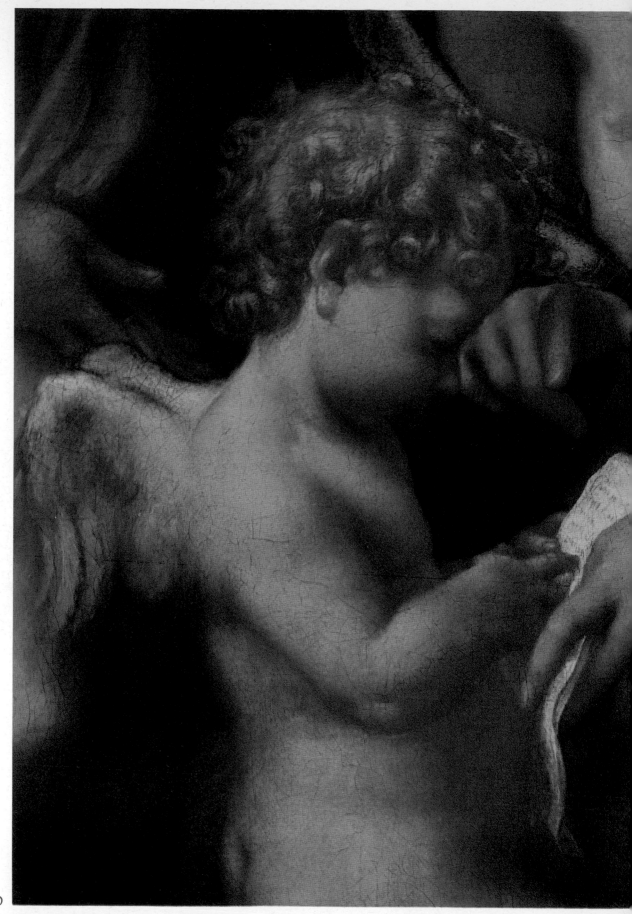

D
Detail of the School of Love. Cupid
London, National Gallery. See plate 173 and page 124

Let us take one more instance – the negro king in the Brera *Adoration*, whose elegant and emphatic *contrapposto* is perhaps the strangest and most un-Correggesque feature of all in that strange picture. This pose had been evolved by Leonardo for his standing *Leda* (partly drawing on a classical prototype) though the essential feature – the right arm held diagonally across the body – had occurred in his early Baptist drawing and had been borrowed, as we have seen, by Correggio in the Detroit *Marriage of St. Catherine*. Raphael had sketched Leonardo's composition (drawing now at Windsor) and used the pose (in reverse) in a drawing in the British Museum (Pouncey and Gere 27) and, in a male context, in the *School of Athens* (the man balancing a book on his upraised left knee on the spectator's left of the seated philosopher in the left foreground, fig. 15). Correggio too would have been capable of the seemingly incongruous transformation of female into male. But is this what he did? I suspect it was a complex derivation in that he had knowledge of both.

How do these observations affect our picture of Correggio's movements? The direct Leonardesque borrowings present little difficulty, and those from Mantegna none. It has already been suggested that Correggio must often have been at Mantua at various times in his youth and later life, and even if he had not visited Milan either by this time or ever, there would have been versions or drawings of the *Virgin of the Rocks* and the *Leda*, and perhaps also of the *Yarn-Winder Madonna* and the Leonardo cartoon, in a number of places in the north of Italy.[1] The derivations from works of Raphael in Rome are quite another matter. The *Disputa* and *School of Athens* were finished by the autumn of 1511. The Aldobrandini and Foligno *Madonnas* (the latter for the Roman church of S. Maria in Aracoeli) are not precisely dated, but datable around then. Of the group of pictures by Correggio which we have discussed only one, the *St. Francis Madonna*, is precisely dated. It was commissioned in August 1514, and finished in the next year. It is likely enough that the others in the group date from very few years before or after then. We must therefore assume either that accurate drawings or prints of at least two Raphael paintings and at least two large frescoes reached Correggio in Lombardy within less than three years of their execution, or that he himself visited Rome at this time. If we take into consideration the fact that Correggio's frescoes at S. Giovanni Evangelista, of 1520–24, also reveal detailed knowledge of Michelangelo's Sistine ceiling, which was not finished until October 1512, of Raphael's frescoes in S. Maria della Pace (usually dated *c.* 1514, but more probably of 1512),[2] and perhaps of Raphael's designs for the mosaics in the dome of the Chigi chapel of S. Maria del Popolo (date unknown; the whole dome was complete by 1516, so in view of the slowness of the mosaic medium the designs must date from long before);[3] and if, in addition, we bear in

[1] As indicated by the number of surviving old copies.
[2] Oberhuber 1962, pp. 32–3. [3] Shearman 1961.

mind that Correggio's Madonnas of the early 1520s quote from Raphael's Casa Alba (fig. 16) and Loreto (fig. 11) Madonnas of *c.* 1510–11, and that elsewhere he may show knowledge of the *Galatea* (? 1511–12), the critical period would be some time in 1513 or the first half of 1514. For what significance it may have, the frescoes in the Stanza d'Eliodoro of *c.* 1512–14 do not seem to be quoted by Correggio – unless it be claimed that the illumination in the *Release of Peter* was a factor in that of the Dresden *Notte* (plate 107) – nor any of Raphael's later work. In particular, the supposed influence of the *Psyche* Loggia in the Farnesina on the Camera di S. Paolo seems to me far more probably a case of independent derivation from Mantegna. But further influence from Michelangelo – in this case from his early marble *Pietà* in St. Peter's – may perhaps be traced in the small *Pietà* from the Eissler collection (New York) (plate 21A), which I should be inclined to date to the mid 'teens: it is not far from the *Zingarella* (Naples) (plate 23), underneath which X-rays have revealed another small *Pietà*.

In trying to reach a verdict we may note that the election of the new pope, Leo X, in March 1513 had drawn numerous visitors, artists and otherwise, to Rome. If we decide that the second contingency is the more probable we may also note that Leonardo was in Rome from the autumn of 1513, as, until 1516, was Michelangelo.[1] Above all, such a visit at such a time would leave a period of some five years for the prestige attaching to a Rome journey to die down before Correggio's arrival in Parma, where, we assume, the subject was not discussed. In any case, and with anyone, this is perhaps not easy to believe. But with so self-assured and reticent a character as Correggio seems to have been it is surely less improbable than it would be at other times and with other temperaments.

[1] S. J. Freedberg (*Painting of the High Renaissance in Rome and Florence*, 1961, p. 188) remarked *en passant* 'it may have been towards 1514 that Correggio was at least briefly resident in Rome'. In his *Painting in Italy, 1500–1600*, 1970, p. 180 he reverts to 1518–19.

IV THE CAMERA DI S. PAOLO AND RELATED PAINTINGS

THE RE-discovery of the Camera di S. Paolo (colour plate B, plates 28–37) – a small room in a former convent of Benedictine nuns at Parma – was one of the great events of the eighteenth century in the arts. Correggio's reputation was then near its peak, and Parma, as the main scene of his activity, figured prominently in the round of holy places to be visited by the cultivated tourist from the north of Europe. The idea that here, in the most unexpected place because the most obvious, was a totally overlooked major work of the master exercised an extraordinary fascination, and evoked, at first, a predictable degree of incredulity.

The reason for the almost universal ignorance of the room's existence was in reality simple. Its decoration had been commissioned by an abbess – Gioanna da Piacenza – who was jealous of dictatorial rights which she claimed had been granted her house in mediaeval times. If she had been less sure of herself, or subject to normal ecclesiastical supervision, it is unlikely that the scheme – of which the subject matter, being mythological, was surprising in a religious establishment, and particularly in a female one – would ever have been carried out. As it was, it may have contributed to later events. For on the death of the abbess the ancient immunity was revoked, the house was put under a strict *clausura* and virtually no sight-seers were admitted for more than two centuries. Though descriptions of the frescoes existed – a manuscript of 1598, still in the Parma library (Battaglia no. 795) and a printed reference in Barri's *Viaggio Pittoresco* of 1671 – the main obstacle was inaccessibility. A few allusions dating from the eighteenth century show that the *clausura* was still enforced, and only by a special act of favour, due less to his expert knowledge of Correggio than to his status as a court painter to the Spanish king, was Anton Raphael Mengs admitted.

It was not until shortly before the period when the Napoleonic upheaval swept away the stagnant traditions of monastic life in Italy that an authoritative and detailed account of the room was first published (1794).[1] In the meantime rumours had inevitably circulated that the reason for the long inaccessibility of the frescoes had been their erotic nature, and some degree of surprise, and even disappointment, was felt when it was seen that Diana was shown fully dressed, and that Endymion did not appear at all.

It is hardly surprising that nothing is known of the circumstance of the origin of the room or of its date. The room next to it was decorated by Alessandro Araldi (fig. 17A), who had already painted in the choir of the convent church, and it bears the date 1514. The abbess had died by 1524. As Araldi represented the older generation of painters in Parma it would, on that ground

[1] Affò 1794.

4-2

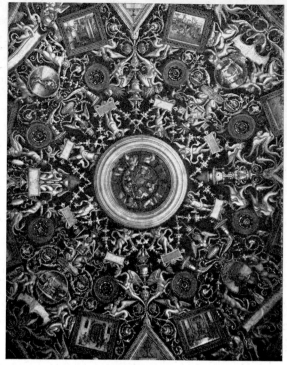

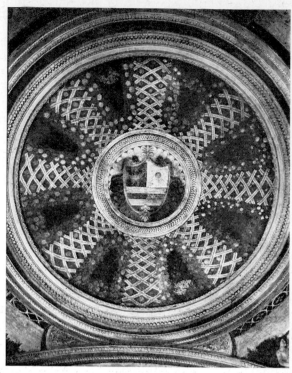

Figure 17A
Araldi, Ceiling in Convento di S. Paolo

Figure 17B
School of Mantegna, Vault of Mantegna's
funerary chapel

alone, be reasonable to assume that his room was the earlier, but even this would leave ten years, during which Correggio might have painted his. Though the astonishing maturity of Correggio's treatment of the putti in the Camera might be consonant with a dating as late as some time in the early 1520s, the painting of Diana over the chimneypiece (plate 33) accords so well, both in design and colour, with pictures dating from 1520 or shortly before – such as the Uffizi *Holy Family with St. Francis* (plate 89) or the *Albinea Madonna*[1] (copy, plate 25) – that that period, which is always agreed as the one in question, seems inescapable. If, as is usually assumed, it was the abbess's brother-in-law, Scipione Montino della Rosa, who obtained the work for Correggio, the operative year of its execution is likely to be 1519, as the ban of outlawry against Scipione in Parma was not lifted until November 1518.[2]

Correggio's scheme at S. Paolo may be seen as a conflation of genius of two easily accessible

[1] Catalogue B, page 278.
[2] Umberto Benassi, *Storia di Parma*, vol. III, p. 65. Ricci (1930, p. 47) dates the Camera 1518 on a combination of stylistic grounds – which are unconvincing – and 'because he remained for almost the whole of the following year at home' (i.e. in Correggio), which cannot be demonstrated.

prototypes. The first, inevitably, was Araldi's treatment of the adjacent room. Whether he wished to follow Araldi or to assert his independence he could not ignore the older man's work. And like any other painter both Araldi and Correggio would have observed the structural features of the rooms and evolved their decorative principles from them. Though of similar or identical size, the ceilings of the two – the principal decorative features in both cases, the walls being left bare, or almost bare, perhaps to be covered with tapestries – are structurally not the same. In Araldi's room there are three lunettes at the top of each wall. Vaulting ribs across the four corners then reduce the centre to an octagonal plan, the space which is thus enclosed being smooth (fig. 17A). In Correggio's room there are four lunettes per wall and between each of them vaulting ribs rise to the centre of the ceiling. Araldi covered his smooth space with elaborate grotesque decoration, interspersed with small reserves, alternately rectangular and circular, painted with biblical scenes in a ring round the centre feature. This is a real circular moulding enclosing a *trompe-l'oeil* view of putti and sky, obviously based on Mantegna's revolutionary work at the Camera degli Sposi at Mantua. Another Mantegnesque work was the second main inspiration of Correggio's Camera. This was the cupola of Mantegna's funerary chapel at Mantua, painted by his followers – part of it, as we have seen, perhaps executed under Correggio's supervision (fig. 17B). This cupola already combined the main decorative features of the vault of the Camera di S. Paolo, namely trellises interspersed with openings and decorated with fruit and foliage.[1] The first innovation of the Parma room is the series of putti seen through the openings. These derive not from Mantegna, but from Michelangelo's putti flanking the thrones of the prophets and sibyls on the Sistine ceiling (figs. 20D and 21). As the putti are not fully revealed, but are truncated by the oval openings, they may be considered a set of variations on Michelangelo's theme. They are the most broadly painted and the most advanced feature of Correggio's work at S. Paolo. Though they are quite separate from each other, a character in one sometimes reacts to something taking place in the next – e.g. the putto on the right of the left oval on the west wall who blocks his ears against the noise from the oval to the right (plate 32). This principle was to be developed at S. Giovanni Evangelista and the Duomo. Underneath, Correggio painted the lunettes to represent concave niches and simulated a series of sculptures in exquisite grisaille painting. Under them again he shows rams' heads and still-life paintings of domestic implements of extraordinarily delicate execution.

It is the enigmatic lunette paintings which raise most urgently the question of the subject matter and theme of the room, and it is here that the personality and taste of the patron, the

[1] Some influence from Leonardo's Sala delle Asse in the Castello Sforzesco at Milan has been postulated. S. J. Freedberg (*Painting in Italy, 1500–1600*, 1970, p. 180) proposes other influences which seem to me improbable. Of these, the supposed influence of the Psyche loggia at the Farnesina may, as I have suggested, be accounted for by independent derivation from Mantegna.

abbess Gioanna da Piacenza, are most in evidence. As with the decorative principles, the theme of Araldi's room is relevant also to Correggio's. Two themes are fairly obvious in the Araldi room. An allusion to the elements of fire and water, inscribed over the fireplace – with evident appropriateness to the former – is taken up by the three lunettes above that wall, two of which show women with flames, while the third depicts a pair of feet crossing a river. And in the lunettes in general there is a marked preference for the deeds of women. In addition to the two already mentioned there is one of a *Caritas Romana*, three more of the story of a priestess and her two sons, two of a woman killing a dragon and one of a woman with a unicorn. Both these themes recur in the Correggio room. Here the fireplace is inscribed IGNEM GLADIO NE FODIAS[1] (which seems defiant), while the feminist element is the solitary feature of the lunettes which is readily comprehensible. Out of the sixteen, no fewer than eleven depict women.[2] More striking still, the painting over the fireplace, the most conspicuous feature of the room, represents Diana, and that some degree of identification with the abbess was intended is shown by the fact that her coat of arms, incorporated into various parts of the room and consisting of three crescents, is echoed in the single one which Diana, properly, is shown wearing. One other point is clear. About half the putti in the ovals – those with hounds, horn and a stag's head – evidently allude to Diana as goddess of the chase.

For the rest, the meaning is so obscure that we must conclude that it was intended to be so. Nothing bears out this conclusion more convincingly than a perusal of the various attempts that have been made to interpret the allegory. When up to four totally different identifications have been made of the same figure in the individual lunettes we may question whether any of the published conclusions regarding the general meaning of the room can have any validity. It must also be admitted that the tendency of each successive commentator to assume that all his predecessors were wrong encourages confidence neither in them nor in him. At the same time, it would be contrary to the sum of the evidence to conclude that no meaning was meant. Rather, the message remains sibylline, as was intended.

The inscriptions over the doors – OIAVIRT. PERVIA (for 'omnia virtuti pervia' ('all is accessible to virtue'), a rather unspecific exhortation), and IO PL (an abbreviation of the Latin form – IOANNA PLACENTIA – of the abbess' name) – far from acting as clues, only aggravate the enigma,[3] which, in the circumstances, must be attributed to the patron, rather than to Correggio. The priority of the Araldi room with its similar iconographic conceits and similarly cryptic inscriptions leaves no doubt on this point. The attempts to interpret the complicated themes of the

[1] 'Do not poke a fire with a sword'.
[2] Popham (1957, pp. 15–16) suggested that a drawing of two women, then known only in a copy (the original later discovered at Budapest, I. Fenyö 1959), was for an earlier idea for part of the Camera.
[3] Panofsky 1961.

Camera, fascinating as they are to certain mentalities, are therefore of only secondary relevance to Correggio's own (they are summarised in the catalogue). In such circumstances the artist would have stood to the programme master as the composer of an opera to his librettist. He had to illustrate ideas not originally his own and draw his inspiration from them. Even here innumerable imponderables would remain. We know, from Verdi's letters on the subject of *Aida*, and from the Richard Strauss–Hofmannsthal correspondence, that, on those occasions at least, the composers altered the librettos, asking for them to be shortened or lengthened or adapted in other ways. They were not content to take what they were given. In the present case, the painting, obviously, was the work of Correggio, the idea, evidently not. Differences between the surviving drawings and the relevant portion of the painting prove that the painter was at liberty at least to vary the mode of presentation: the putti with the Medusa mask (E2) (plate 31), for instance,[1] are behaving differently in the preliminary drawing (plate 37B). But which of the parties – artist and programme master (the latter very possibly himself a combination of patroness and learned adviser)[2] – or both together – decided to illustrate a particular idea by a particular subject: which of them, or both, that is, selected the particular antique coin as pictorial basis of the individual lunettes, and decided the order of the series both of lunettes and putti is unlikely to be authoritatively explained. In his account, in his monograph on the Camera di S. Paolo, of the intellectual atmosphere of north Italy at this time, Panofsky indicated convincingly the probability that Correggio himself was affected by the scholarly approach to Antiquity. Nevertheless, the process of finding visual equivalents of someone else's elaborate allegorical ideas – or even of one's own – would always have been difficult and probably protracted. And when all such allowances have been made for the extraneous element in the Camera it must still be stressed that the decorative conception is likely to have been Correggio's own. Also that, decoratively, the extraneous element is relatively small. The lunettes take up relatively little space and are isolated both from each other and from the rest of the painting. The majority of the area is taken up by the semi-abstract trellises and leaves.

As regards the visual sources of the lunettes it was suggested from the beginning (i.e. Affò) that it was antique medals, and Ricci, in his second book, reproduced a series of eight of them. Others have been added later.[3] Of the rest, the Antique composition of the *Three Graces* (N3) (plate 29), which occurs in one of the lunettes not covered by the coins, was known in innumerable different forms, and in every case the actual source or sources, Antique or otherwise, which would have been used by the painter would be as impossible to pin down in this work as they

[1] I have numbered the lunettes clockwise on the four walls (north, south, east and west) of the room.
[2] As adviser Affò suggested (p. 46) the local Humanist, Giorgio Anselmi.
[3] Affò 1794 and Ricci 1930, facing p. 57. Also Panofsky 1961, p. 18.

are in others. Ricci also reproduced a relief, at Mantua, of an antique chariot as a likely source for that of Diana.[1] Another possibility would be the one in Peruzzi's ceiling of the Galatea room in the Farnesina. For the goddess's stance some acquaintance with Raphael's *Galatea* has been suggested, and the possibility could not be absolutely denied. But the attitude is merely a variation on that embodied in Leonardo's *Leda* (fig. 8), and in the figure in the *School of Athens* (fig. 15), acquaintance with both of which we have already traced in the negro king in the Brera *Adoration*, and which would therefore point to a common source as much as to a further direct borrowing. To some extent, too, the Diana composition must be considered to have evolved from a mysterious earlier project of Correggio's known from an exquisite drawing at Dresden of a draped female figure in a two-horse chariot (see Bibliography, Arb, 1962).

The Camera di S. Paolo is Correggio's earliest independent work in fresco, and it is characteristic of that mixture of good luck and good judgement which is typical of his career that the undertaking should have been of fairly modest extent, thus serving as training for later, more onerous work in the same medium. The Camera di S. Paolo, the S. Giovanni Evangelista and the Duomo frescoes, each one being greater and more difficult than the one before, thus constitute, in retrospect, a logical progression. Though we might expect to find traces of technical inexperience in the Camera there are very few of them. Only in the lunettes is there any trace of development apparent. Those on the south wall (seated philosopher, temple, three Fates and woman running with a child) (plate 30) are noticeably less delicate than the almost unimaginable refinement of the lunettes on the other walls. I suggest that Correggio started with the lunette on the left of the south wall and proceeded clockwise, ending on the right of the east wall. This can be tested from the photographs.

A point well illustrated by the *Diana* of the chimney-piece (plate 33) is the degree of truncation which Correggio was prepared to allow himself. In later pictures, such as the Del Bono *Lamentation* and *Martyrdom* (both in the Parma Galleria) (plates 84 and 79) it looks as though certain of the figures may always have been truncated, though in the case of paintings, such as this, on wood or canvas some cutting is always a possibility. But in the *Diana* no cutting can have occurred, and Correggio boldly omits all but the hind legs of the animals. It may be considered a foretaste of the photographic vision of Degas.[2]

The facial type of Diana with its severe oval, the absence of strong red in the colouring, and the tendency which this fresco shows to emphasise the linear sweep of the draperies, are features which recur in other works of the period. What that period was is most conveniently pegged

[1] Ricci 1930, facing p. 64.
[2] G. B. L. G-Seroux d'Agincourt (*Storia dell'Arte*, 1829, p. CCII, no. 1) invents the completion of the design in a line engraving.

by the fact that one of the group, the so-called *Madonna of Albinea*,[1] is documented as of the years 1517–19. Unfortunately the original is not known. It was removed from the church in the seventeenth century and has not been traced since. But a number of copies are extant, recording the main features, at least, of its appearance (plate 25). It was evidently a small altarpiece, of comparable size and shape to the Detroit *St. Catherine* (plate 1). To preserve the continuity of the landscape the Madonna has no throne, but a tree trunk behind her provides some degree of visual substitute.[2] The copies show a curious awkwardness both in the Madonna and the Christ child, as though the composition had been reversed. But as all the copies, to my knowledge, face in the same direction, some other explanation, presumably the copyists' incompetence, must be sought. It can also not be denied that all three main figures being female, makes for a degree of monotony. The oval of Diana's face is repeated here in the Madonna, together with a certain insistence – though less than in the Diana – on long linear patterns in the draperies. Some Raphaelesque reminiscences may again be traced in the Madonna's attitude, the *Foligno Madonna* (fig. 14) – by now far removed – and again Leonardo's *Leda* (fig. 8) or the *School of Athens* figure (fig. 15) (by now much closer to the latter) in the female saint (St. Lucy) standing on the right.[3] More important, the *Albinea Madonna* is an example of the compositional device – the diagonal within a rectangle – which Correggio was to continue to use for many years to come. Something of the kind was noticeable in the early Washington *St. Catherine* (plate 5B), and something again in the Los Angeles miniature (colour plate A), where the line from the Madonna's right hand, through the heads of the Giovannino and the Christ child, leads up to St. Joseph and encompasses the full diagonal of the picture.

One of the most conspicuous features of Correggio's art in the late 'teens is the virtual exclusion of red from his palette. A consequence is that the Madonna's dress, almost invariably red in Italian painting, now becomes mauve. It occurs, for instance, in the so-called *Campori Madonna* (Modena), a cabinet size picture, now somewhat damaged (plate 26A), whose derivation from Raphael's *Madonna of Foligno* (fig. 14) has long been remarked, and in which the proportions of the figures in relation to the surround (the familiar hedge) are perhaps closer to those of Raphael's cabinet size Madonnas than are any others of Correggio's. A peculiarity of this picture is the way in which the Christ child, still somewhat Mantegnesque, has wrapped the drapery round his right foot: also that, to support him, the Madonna has brought her left leg over her right, as she was to do later, in the Dresden *Madonna with St. Sebastian* (plate 100) and the Parma *Giorno*

[1] Catalogue B, page 278.

[2] As a curiosity we may note an earlier dethroning, in the interest of continuity of landscape, in an altarpiece of the Madonna enthroned, namely Filippino Lippi's Ruccellai altarpiece in the National Gallery.

[3] The Magdalen on the left is slightly reminiscent of the foreground figures in the Leonardesque *Resurrection* at Berlin, but not sufficiently so to postulate a connection.

(plate 157). The conspicuous use of mauve or violet is one of the features which link with this period a picture which, in its way, is as much an oddity in Correggio's oeuvre as the Brera *Adoration*. This is the *Madonna and Child with the Giovannino* (plate 27A) in the Prado (in this case it is again the Madonna's dress which is mauve). With the exception of the Naples *Zingarella* (plate 23), of similar dimensions – both are of small cabinet size – this is the first occasion when Correggio has tackled this subject on a small scale at full length (the *Zingarella* has only one child). It was a genre which greatly occupied the young Raphael, but it cannot be emphasised too strongly that Correggio shows no sign of reacting to Raphael's Florentine period,[1] and in the present instance the inspiration was quite different. It was patently Leonardo – by far the nearest that Correggio ever got to him. The setting itself is Leonardesque and unusual for Correggio, the distant landscape being framed by obstacles on both sides, and not on one only. The result is a kind of grotto, and the figures are in it. As to the Madonna, the upper part of her body literally repeats Leonardo's *Leda* (fig. 8) (far more closely than in the St. Francis (plate 11), Chicago (plate 16A) and Los Angeles (colour plate A) *Madonnas*) even to the plaited hair. And no one acquainted with Leonardo could be in any doubt of the origin of the Madonna's sandal, with its immense elaboration of interlacing and plaited forms. Even the draperies strike a strange note in Correggio. Perhaps because, inevitably, they were lacking in the *Leda*, Correggio seems to have drawn not on any of his own previous idioms but on a further extraneous one. The elaborate swirling pattern in the folds of the Madonna's skirt would be hard to parallel anywhere, but may owe something to Dürer's prints. Apart from the colour, the only feature in the Prado picture characteristic of Correggio at this or any other time is the type of Christ child, who recurs practically unchanged in the Hampton Court *Madonna* (plate 91B) and whose projecting forelock is almost a signature of Correggio's during the 'teens.

A picture which presents a problem of a different kind and which is problematically assigned to this period is the Leningrad female portrait (plate 26B). The Correggio portrait-attributions have not fared well. In the seventeenth century certain painters, such as Guercino and Nicolas Poussin, are known to have disliked painting portraits and never to have done so if they could help it. Judging by the lack of them, Correggio may have been of their number. Of individualised heads in his subject pictures the ones which most clearly give the impression of being portraits (apart from the putative self-portrait) are children – the Christ child in the *Giorno* (Parma) (plate 157) and in the Louvre *Marriage of St. Catherine* (plate 161A), or the little boy in the *Giorno* and in the Louvre *Allegory of Vice* (plate 182). It would be likely enough that some-

[1] Berenson 1901 (1908 edition, p. 27) indicated a resemblance between the St. Catherine in Correggio's *St. Francis* altarpiece and Raphael's *St. Catherine* (London, National Gallery), which may date from his Florentine period. But Berenson did not postulate a direct connection.

thing of the painter's own children had crept, perhaps subconsciously, into these heads. Among adults, the executioner on the left of the Del Bono *Martyrdom* (Parma Galleria) (plate 79), some of the Madonnas and some of the bald-headed saints in the altarpieces are fairly individualised. But the Leningrad portrait, which has a kind of signature, is, together with the donor in the Naples *sportello* (plate 167), the only single one whose attribution is acceptable.

It is impressive enough to cause regret that the painter did so little portraiture. Its date, however, is very puzzling, as the evidence seems conflicting. The dress, with the huge slashed sleeves, is similar to those in Titian's frescoes in the Scuola del Santo at Padua, which date from 1511, but the lady's hat is in line with fashion around the years 1518–22.[1] In theory this could mean that a portrait painted around 1511–12 had been altered at the sitter's request some years later in an attempt to bring it up to date. But it is very difficult, on stylistic grounds, to imagine that Correggio could have painted the sleeves which were fashionable around 1511 in the manner he has done at so early a date. In treatment they recall the Madonna's draperies in the Uffizi *Holy Family with St. Francis* (plate 89) and the ivy on the left of the Leningrad picture recurs – always in the same relative position – in the Brera *Adoration* (plate 22B) and the London *Magdalen* (plate 24B) which are dateable around the mid or later 'teens.

In the interests of clarity it may be well to summarise my views on the chronology of Correggio's surviving work which is dateable to the 'teens – at least to the extent, which is all that seems to me legitimate, of indicating the relationship of individual works to the few fixed points. Of the group which centres round the *St. Francis* altarpiece – and therefore around the years 1514–15 – the Chicago *Madonna* seems the most primitive, and therefore probably the earliest, and the Castello Sforzesco *Madonna* the most developed, and therefore probably the latest. In between are the Los Angeles and Uffizi miniatures and the Brera *Nativity* and – somewhere – probably the Madrid *St. Jerome* and the ex-Eissler *Pietà* (New York). The Vienna *Hellbrunn Madonna* and the Brera *Adoration*, through the latter's affinities with the Naples *Zingarella*, and through its incipient use of cool colours, seem to some extent a bridge with the next group – the almost redless pictures centring round the *Albinea Madonna* of 1517–19. Of these, the *Zingarella* seems the most primitive, the Prado *Madonna* the most developed and the Modena *Campori Madonna* and the London *Magdalen* in between. Intermediate between this group and the next – the beginning of the 1520s – is the Uffizi *Holy Family with St. Francis*. But before discussing it we must consider the great commission at S. Giovanni Evangelista.

[1] Communication from Stella Mary Newton.

V S. GIOVANNI EVANGELISTA (I): THE CHRONOLOGY OF THE WORK, THE LUNETTE AND THE APSE

Though the contract for the decoration of the church of S. Giovanni Evangelista at Parma has not survived, a considerable number of records of payments were unearthed by the Abate Pungileoni, and published by him in the second volume (1818) of his monograph. From reading these it seems, at first sight, to follow – and the documents have in fact always been read in this sense – that Correggio started by painting the cupola and then went on to do the apse. The fact that the latter was destroyed as early as 1587 and that it is now known only from copies and fragments seems to have deterred students from paying attention to its style. Certain deductions concerning this, however, may still be made; and they do not support the orthodox view of the chronology.

One has only to compare the central section of the fresco – Christ crowning the Virgin (plate 40A) – of which the original survives in the Parma gallery, with any of the apostles from the cupola (plates 46–55) to see this. The forms in the first are more 'open' and less Baroque than in the second, and the perspective far less audacious. It would therefore be logical, prima facie, to assume that the apse painting preceded that of the cupola – that Correggio, following his own cautious precedents, had proceeded from the less to the greater rather than vice versa.

The design of the apse fresco as a whole – as known from Aretusi's copy *in situ* (plate 39A) – seems to bear this out in one respect. At the top is an arbour comparable with that which Correggio had introduced into his preceding piece of decoration – at the Camera di S. Paolo – and derived, in both cases, from works of Mantegna and his school at Mantua. Such a device – somewhat contrived in the setting of an apse fresco, and backward looking in an evolutionary sense – would be surprising if it came after the depiction of unrestricted space which Correggio triumphantly achieved in the cupola, but would be intelligible if it preceded it.

Can such an assumption be reconciled with the documents (see pages 180–2)? They consist of two successive 'Giornali' (D and E) and the 'Libro Mastro H' which repeats the entries of the two 'Giornali' in more summary form and adds two which do not figure in them. The first payment is recorded on 16 August 1520 as having been made on 6 July 1520. On 23 January 1524 Correggio received an end payment and declared he had been remunerated in full.

Most of the records of payment do not specify the particular area of the painting in question. Specific references of this kind are only made on two occasions. First – the earliest of all the

documents – is the one dated 16 August 1520 (Giornale D). In this Correggio is described as 'pictore della cuba del choro' ('painter of the cupola of the choir'), and allotted 30 ducats for his 'lavorerio' ('workshop'). In a separate payment attached to this he is given 20 ducats 'Sopra la sua opera de pingere la cuba'.[1] In the 'Libro Mastro' the repetition of the first entry takes the form 'Antonio da Correggio...p. principio de pagamento de la pictura de la nostra cuba'.[2] The second is completely unspecific.

Secondly, in 'Giornale E' it is stated that 'M. Antonio da Corezzo depintore' received 35 ducats in two instalments (28 May and 28 July 1522) 'sopra la pictura de la Capela granda'. The 'Libro Mastro' repeats the words quoted here without alteration. Pungileoni mis-read 'Capela granda' as 'cupola granda'. The 'cappella grande' can in fact be taken as, in practice, roughly equivalent to 'choro' or choir in the architectural sense (or presbytery) with particular reference to the portion of it behind the altar (see Appendix E).

In addition to this, and the most valuable document of all, is a specification of work already done or to be done. It is not itself dated, but includes a reference to an agreement reached between the prior and the painter on All Saints' Day (1 November) 1522, concerning the nave frieze – evidently an after-thought, not included in the original project. The entries in this document are as follows: 130 ducats (subject, apparently, to possible adjustment) for 'la pictura et ornamento de la cuba de la gexia [chiesa] nostra'.[3] 65 ducats for 'la pictura et ornamento de la capela granda'. 6 ducats for work on the gilding of the cornices and frieze of the 'capela granda'. 6 ducats for work on the 'mazze de li piloni de la cuba e de li candelerj facto soto epsa'[4] (eight in number) and 66 ducats for the frieze round the body of the church.

The word 'cuba' may be taken as equivalent to 'cupola'. Two points may be made in this connection. First, that no specific word for 'half dome' occurs anywhere. Secondly, that the half dome of the apse was not the only thing that Correggio did in the choir. There was also the work on the cornice and frieze. In the present context, therefore, 'capela granda' would include both half dome and work on the cornice and frieze.

At this point attention may be drawn to the wording of the specification, where mention is made of 'la cuba de la chiesa', meaning – presumably – 'the cupola over the crossing'. Not only is it verbally distinct from 'la cuba del choro' of the first entry of 1520. It is difficult to see how 'la cuba del choro' could logically refer to the crossing cupola, since it is not over the choir (Appendix E). In default of a specific word in any of the documents for 'half dome' it would therefore be reasonable to assume that 'cuba del choro' means 'half dome in the apse' and, since

[1] 'In respect of his work of painting the cupola.'
[2] '...as first payment for painting our cupola.'
[3] 'The painting and decoration of the cupola of our church.'
[4] 'Strips of the piers of the cupola and the candelabra under them.'

it is named in the first entry, that this was where Correggio started. It is, indeed, the hasty assumption – and no other evidence – that 'la cuba del choro' meant the main cupola which has led to the universal opinion that Correggio started with the latter.

In any case it is impossible to establish a precise correlation between the order of work – regardless of whether the half dome preceded the cupola or vice versa – and the individual payments. If we postulate, in the orthodox manner, that Correggio started with the crossing cupola he would only have received 76 ducats (exclusive of 8 for a colt) by May–July 1522, when the payment for the 'capela granda' is made, whereas the sum allotted for the cupola in the classification was 130 ducats. Similarly, the payments from May–July 1522 to the end add up to 197, whereas the 'capela granda' is only scheduled as 65, and the nave frieze (which was certainly relatively late) 66. If, on the other hand, we assume that Correggio started with the half dome the payments up to and including the mention of the 'capela granda' amount to 111 ducats, whereas the 'capela granda' in the specification receives only 65. If we abandon, as it seems we must, the attempt to establish a precise correlation between the payment entries and the specification, but nevertheless assume that a vague relationship, whose working we cannot follow, may have existed, the fact that only 65 ducats were paid between July 1520 and April 1521, and that 217 were paid between April 1522 and June 1524, might suggest that the greatest and most expensive item, the cupola, came at the end. The fact that Correggio was absent from Parma in the autumn and winter of 1521 may not entirely account for the disparity, since during some of this time – the coldest months – we should not, in any case, expect a painter to be working in a church.

The evidence, such as it is, of the double-sided drawings seems to favour the relative chronology suggested here, but it is not absolutely conclusive in itself. Popham 28 (Louvre) (plate 43D) has on one side a study for the *Coronation* in the apse, but the frieze on the verso (plate 68C) could be either that of the nave or the choir. On the other hand, one of the pendentives – *Saints Jerome and Matthew* (plate 73A) – is connected with no less than three double-sided drawings, one of which is completely *un*ambiguous. On the verso side of one (Hammer collection) (plate 74A) is a very early design for the *Scodella* (Parma Galleria), of whose existence as a project we otherwise know nothing before 1524. The second (Popham 18, British Museum) (plate 74C) has on the other side a *Cupid Bound* (plate 178C), which can be connected vaguely with the *School of Love* (London). The third, and most interesting (Popham 34, Rotterdam) (plates 64C and 76B) combines a study for this pendentive with one for the nave frieze, which was not commissioned until November 1522. From this it follows that this pendentive, and probably therefore also the other three, would probably not have been painted before the summer of 1523. They may not have been designed until after the cupola was painted and would have been

among the last of Correggio's decorations at S. Giovanni. Moreover, if the pendentives were *not* painted next after the cupola there would have had to be simultaneous scaffolding in the cupola and apse. As this would have been uneconomical it would be more likely that the apse painting was finished before the cupola was begun.

Contrary to what has been assumed, therefore, the documents do not furnish conclusive evidence that the decoration of the cupola preceded that of the apse. They could be read as indicating the contrary, which, on stylistic grounds, seems more probable (the fact that at the Duomo, where likewise Correggio was commissioned to paint the choir as well as the cupola, he undoubtedly started with the cupola does not seem conclusive, or even admissible, evidence in the contrary sense).

It is also legitimate to wonder if the cupola was even structurally complete by 1520, since the only payments for building it date from as late as July 1518.[1] This revised sequence of work at S. Giovanni Evangelista would accord with the pattern of Correggio's early career in proceeding cautiously rather than rashly. Its importance is greater than might appear. I have suggested that most of the work executed by Correggio in the years 1523–30 would have been commissioned soon after, and as a result of, the terrific sensation caused by the unveiling of the first half of the S. Giovanni decorations at the end of 1522, which made the painter famous over night. We must now conclude that this crucial work was the apse fresco and not the cupola. And for those who profess to see a derivation of the S. Giovanni cupola from that of Pordenone formerly in the Cappella Malchiostro in Treviso cathedral – datable around 1519–20 – it would leave longer than has formerly been supposed for Correggio to have become acquainted with that work.[2]

Before undertaking the apse it seems likely that Correggio may have given proof of his skill in a trial piece – the small lunette of *St. John the Evangelist* in the north transept (plate 38A). This is not mentioned in the documents, and is appreciably less evolved in style than the other frescoes at S. Giovanni. As in the animal attributes in the larger frescoes the eagle in this one is of marked liveliness.

The subject of the apse fresco was the *Coronation of the Virgin*. This was not uncommon in altarpieces. For centuries the arrangement had been stereotyped to the extent that the two main figures were shown centrally, Christ seated on the right, the Virgin seated or kneeling on the left. In this form it had been painted as a lunette by Ridolfo Ghirlandajo (Cappella del Papa at S.

[1] Salmi 1918, p. 151. Ricci (1930, p. 68) says the cupola was plastered in 1519, but I can find no record of this in the documents published by Salmi.

[2] The MS. (seventeenth century) of Maurizio Zappata (cf. Battaglia nos. 81 and 806A) claims that the S. Giovanni cupola painting dates from 1523–4. But it is difficult to gauge the reliability of this statement, which has been generally ignored.

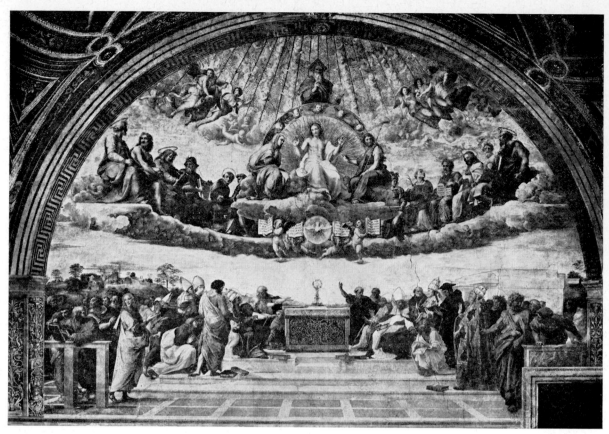

Figure 18
Raphael, *Disputa*

Maria Novella, Florence). Occasionally it had been treated in the half dome of an apse – for instance in a thirteenth-century mosaic at S. Maria Maggiore, Rome and, in fresco, by Lippo Lippi at Spoleto and by a Raphael follower at Trevignano (north of Rome – in this case the whole apse is painted). Nearer home, by Ambrogio Bergognone in the north transept apse of the Certosa di Pavia. But it is doubtful if any of these would have said much to Correggio even if he had known them. In the event his inspiration lay appropriately higher. Raphael's *Disputa* (fig. 18), like his *School of Athens*, is of lunette shape, but, unlike it, the space depicted in it is itself a concave semi-circle. It may seem characteristic of one great artist's reaction to the work of another that he should realise the potentialities adumbrated by it, but – inevitably, in this case – not realised. For the combination of simulated semi-circular concavity set in an actual semi-circular frame perfectly suggests a half dome. We can mentally transpose Raphael's *Disputa* into such a setting without the smallest difficulty. We shall see that the *Disputa* continued to be Cor-

reggio's main inspiration throughout the work at S. Giovanni Evangelista, dominating his thought in the apse, the cupola and the pendentives alike.

In Correggio's apse fresco the echoes of Raphael's composition are numerous. The forms of the Baptist, on Christ's left in both cases, are conceived on almost identical lines – seated with the right arm raised, the left (supporting the reed cross) resting on the left knee, the face turned to the spectator. The corresponding figure – St. John the Evangelist – on the opposite side of Correggio's fresco (the spectator's left) seems to have combined elements of two of Raphael's – his Virgin Mary, and the figure kneeling on the middle step in the left foreground. For the Christ, Correggio was at one stage fairly close to Raphael – to judge from the drawing in the Ashmolean museum (Popham 24r) (plate 41A) where his torso, as in the *Disputa*, is more or less parallel with the picture space (it is possible, as Popham suggests, that this Christ was cross-legged at one moment). At another stage, as witnessed by sketches at Poitiers (Popham 23) (plate 42B) and in the Seilern collection (plate 42A), as well as in a drawing at Rotterdam which includes the Virgin Mary (Popham 22) (plate 42C), Christ is seen sideways and raises both hands – the crown, inevitably, in his right while the sceptre extends backwards from his left. The strangeness of this idea was evidently too much for the artist, and in a further stage, shown in a drawing in the Louvre (Popham 25) (plate 41B), the sceptre reverts to its upright position as in the Oxford drawing, but Christ's left arm, supporting it, is now sharply foreshortened. Finally, in two drawings at Budapest (plates 41C and 43C) this left arm is allowed a gentler outline, and so it was in the finished fresco.

As in the *Disputa* the upper air in Correggio's apse fresco was peopled with putti emerging from the clouds. Of Correggio's four main figures (the Virgin, Christ and the two Saints John – two ecclesiastical worthies, identifiable as Saints Benedict and Maurus are also included, but less prominently), it is the Virgin who is farthest from Raphael, and, so far as we are able to judge from the surviving upper half of her body, and from Correggio's sketches, she was the most successful figure – the only one, perhaps, in which he surpassed Raphael. Raphael's Mother of God was on this occasion appropriately cowed by the majesty of Christ in the centre. But Correggio started by inducing such passion and such dynamism into his that in the end he was forced to modify it. A drawing in the Louvre (Popham 26) (plate 43B), and the Rotterdam sketch of the Virgin and Christ together, show astonishing fire and movement. In the milder form as finally realized the Virgin succeeds in dominating the composition. It is on her, and not on Christ, that the eye finally rests. It must have been the desire for this effect which caused the modification of the dynamism of the preliminary drawings. And this occurred at a very late stage; the sinopia of the fresco of the Virgin (plate 40B) retains more of the fire of the drawings than does the top paint.

5 G T P

It is difficult or impossible to study the apse fresco in any detail since the materials for doing so are so fragmentary. We must bear in mind that it would have been nearer to the crossing than the present copy and thus easier to take in in the same glance – almost – as the cupola, from a point at the east end of the nave. Whether the original apse immediately adjoined the existing choir bay nearest the crossing, or whether there was a short space in between is unknown. Since the new space is certainly wider than the original – and the half dome therefore larger – it would be a question whether Aretusi, in copying the fresco, retained the original scale of the figures and made up the difference by leaving more space between some of them, or whether he enlarged all of them. The latter seems the more probable.

It is a bitter reflection that the whole operation, the wilful and deliberate destruction of a major – indeed, crucial – work of Correggio, was unnecessary. Much later, the same problem of inadequacy of space arose at the church of the Steccata, a few hundred yards from S. Giovanni Evangelista – a church, incidentally, concerning whose structural stability Correggio had been consulted in August 1525. In this case a solution was found – early in the eighteenth century – which not only preserved Anselmi's apse fresco but, in a sense, positively enhanced the architecture of the church. By piercing large openings at the side of the high altar to communicate with the new retro-choir the altar itself was left intact and isolated and the half dome remained.

VI S.GIOVANNI EVANGELISTA (2): THE CUPOLA, THE CHOIR VAULT AND THE FRIEZES

THE SUBJECT OF THE fresco in the dome above the crossing of S. Giovanni Evangelista is the *Vision of St. John on Patmos* (plates 44–55). It has been suggested that the scene is the moment described in the life of St. John in the *Golden Legend*, when Christ and the disciples appear to the ninety-nine-year-old St. John and announce his approaching death. Christ floats in the centre. In his pose and his head, as well as in those of some of the apostles round the rim and some of the Old Testament figures in grisaille under the arches, a recollection of the Laocoön may be traced. His body is roughly on the main east–west axis of the church, his head nearest the west end, so that his body is the right way up to an observer standing where the nave joins the crossing and who is facing east and looking up. Behind Christ's head, and low down on the rim of the cupola, the aged St. John gazes ecstatically upwards (plate 52). He is on the west side of the cupola, so that he faces towards the east, and to be seen the right way up the spectator must look up from the chancel steps at the junction of the choir and crossing (even then he can only be seen with difficulty, so low down is he on the curvature and partly concealed by the cornices). St. John could see Christ the right way up, just as the observer advancing east up the nave can do so. It is only in order to see *him*, St. John, that the observer has to go on, and then look back. Immediately above St. John, two apostles look down at him. Their bodies are closely interlocked to form a compact group, both with each other and with him. There is thus a definite accentuation of the east–west axis, consisting of St. John, the two apostles above him, and the line of Christ's body; and this axis is emphasised on the far side of the rim – geographically the east, but facing towards the nave – by a young apostle who is distinguished by being the only beardless one, and who is by far the most striking and beautiful of them all (colour plate C, plates 48 and 50). This was evidently deliberate because of the importance of his position (we may note in passing that only St. Peter of the ring of apostles is accorded an attribute (plate 53): in consequence there is some uncertainty concerning the identity of the others).

Though in effect this young apostle is entirely in line with the Sistine *ignudi* his pose does not derive from that of any of them. It is one which Correggio had used for the angel on the extreme right of the apse fresco and was to use again in some of the putti in the cupola and in the corners of the pendentives (plates 70 and 71). Fischel suggested that he had taken it from Raphael's mosaic of an angel above the Diana figure in the vault of the Chigi chapel in S. Maria del Popolo.[1]

[1] Fischel, 1948 p. 323.

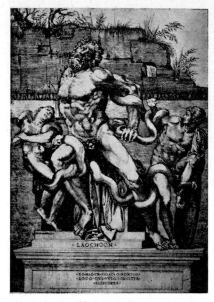

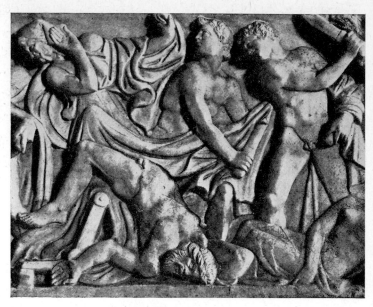

Figure 19A
The Laocoön (print by Marco
Dente)

Figure 19B
The Orestes Sarcophagus (detail)

It would not be absolutely impossible that Correggio might have been acquainted with Raphael's designs for these mosaics, but in fact the pose is a literal and direct derivation from a very different source – the Pylades figure, left centre, on the Antique Orestes sarcophagus (fig. 19B) on which Raphael also drew for his mosaic, and of which a version stood, in the sixteenth century, outside the Roman church of S. Stefano del Cacco. Fascinatingly enough, Raphael, in his mosaic, and Correggio, in his S. Giovanni Evangelista apostle, both chose to misread the original in the same way, by showing the legs to the spectator's left of the youth's body, where, in the sarcophagus, there *are* legs, but not his. The legs on the spectator's left in the sarcophagus are those of the dying Aegisthus, whose face is on the ground in the centre. Pylades' left

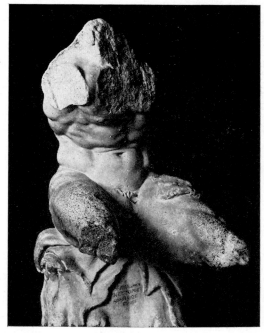

Figure 19C
The Belvedere Torso

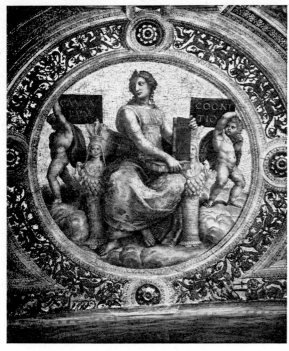

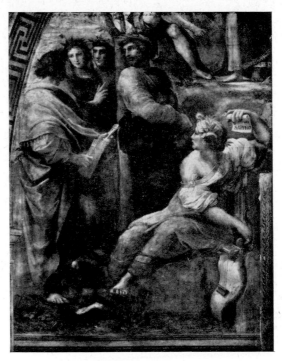

Figure 20A
Raphael, *Philosophy*. Detail of ceiling of Stanza
della Segnatura

Figure 20B
Raphael, *Parnassus* (detail)

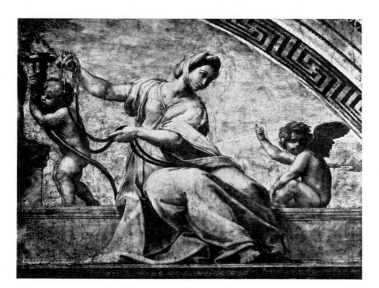

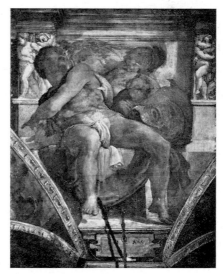

Figure 20C
Raphael, *Temperance*

Figure 20D
Michelangelo, *Jonah*

knee is seen just below his right wrist. His right leg is concealed. In another Raphael – the *Galatea* – the angle of the head of this Pylades figure is combined with the pose of the legs in Leonardo's *Leda* (fig. 8). Something of the Pylades pose is also found in many other Raphaelesque contexts – e.g. the *Philosophy* roundel (fig. 20A) on the ceiling of the Stanza della Segnatura in the Vatican, in the second figure from the left in the upper tier of the *Disputa* (fig. 12) and the foreground figure on the left of the *Parnassus* (fig. 20B), also, in reverse, in the *Temperance* figure in the Segnatura lunette (fig. 20C), as well as in Michelangelo's *Jonah* (fig. 20D). In the cupola the young apostle is actually the left-hand element in a group of two, but his opposite number is at a certain distance from him, so as not to detract from his effect. The remaining apostles, with one exception – a single one on the left of the pair above St. John –are also grouped basically into twos but with extraordinarily subtle links between the pairs – that is, both figures in a pair are linked with those nearest them in the flanking pairs, though not so closely as with each other.

The difficulty of composing a design of this elaboration is revealed by Correggio's surviving drawings, which show a fascinating alternation of accent between the groups and their components. There will be a composition sketch of two apostles together (Popham 14) (plate 54A) then studies, perhaps from nature, for one of them (Düsseldorf and Popham 11) (plates 54B and C) correcting the pose, then a further composition sketch incorporating the corrections (Popham 13r) (plate 49B) which incorporates the corrections of Popham 12 (plate 49A).

The desirability of imagining Christ the right way up both to St. John (in the fresco) and to the spectator facing east in the church explains one of the inconsistencies in the foreshortening. Christ's body must be imagined as inclined at about forty-five degrees, whereas the apostles round the rim are imagined as sitting upright. But even with them a certain licence has been taken. So as not to appear ridiculously foreshortened they are drawn from an eye-level not far below them, rather than from the level of the floor of the church, much lower down.

A further difficulty, however, has not been overcome. Owing to the huge size of the individual apostles they spread over a large area of the curvature and are therefore affected differently by it, the upper parts of their bodies being fairly fully revealed, but the lower portions – as the curvature sinks towards vertical – appearing telescoped to an observer below, an effect which would not apply to the apse fresco, as it would be seen from a distance. It was doubtless Correggio's realisation of this – too late – which was one reason leading him to adopt a much smaller scale for the figures on his next cupola, at the Duomo, even though the cupola itself is larger.

But even if in this, his first essay in the inconceivably difficult genre of cupola painting, Correggio was not able, in his preliminary planning, to foresee all the drawbacks it is clear that he did make appreciable allowance for viewing from a distance. The heads of the apostles, and

their individual features – eyes, nose, mouth – are enlarged, and this must always be borne in mind when looking at detail photographs. For the rest, the vocabulary is a miraculous blend of Raphael, Michelangelo, the Antique and Correggio's own earlier experience. The pose of the apostles may be considered a development from those in the upper tier of the *Disputa*, with the occasional borrowings from Raphael's prophets in S. Maria della Pace, but interpreted in the spirit of the *Creation of Adam* and the *Creation of the Sun and Moon* on the Sistine ceiling. And behind these are Raphael's and Michelangelo's own prime Antique sources at that period – the rhetoric of the *Laocoön* (fig. 19A) and the massive proportions of the Belvedere torso (fig. 19C). In the magnificent figures of the S. Giovanni cupola Correggio achieved a degree of nobility which he never approached again, but even here his innate puckishness is not entirely subdued. Michelangelo, for instance, would never have countenanced putti who brandish their backsides at the spectator, as several do (most blatantly, the one under St. Peter) and a number of other innuendi may be found on close inspection. As to the lighting, Correggio ignores the actual source – four small circular windows, now blocked in, in the drum. Instead, he assumes that the figures are lit by the aureole around Christ.

It remains to consider the possible prototype of the S. Giovanni cupola from the point of view of decoration. The ultimate presence of Mantegna's ceiling in the Camera degli Sposi at Mantua (of which a copy was noted by Eastlake in the palace at Correggio) has long been acknowledged, this being the earliest piece of consistent aerial illusionism, even though on an almost flat ceiling. Some influence from the apse fresco of Melozzo da Forlì, formerly in SS. Apostoli at Rome, has also been postulated at intervals since the time of Mengs in the eighteenth century, and also, more recently, of cupolas painted by Melozzo and his followers in the Forlì area and elsewhere.[1] Knowledge of Mantegna's work by Correggio must be taken as certain, together with pro- longed consideration by him of its consequences and possibilities. But all his and Melozzo's work, together with that of their following, had a characteristic which would probably have weighed against it with Correggio. It was unmistakably quattrocento. And though the cult of Dürer in Italy should be borne in mind in this connection, it can hardly be doubted that even the most enterprising quattrocento illusionism would have seemed archaic to anyone acquainted with the Sistine ceiling or the Stanza della Segnatura. By comparison with these, the Forlì cupolas, in particular, would be likely to have appeared outmoded provincial curiosities. At the

[1] Shearman 1961. Shearman's further attempt to derive the decorative principle of the S. Giovanni cupola from that of Raphael's dome in S. Maria del Popolo, Rome seems to me unconvincing, though I have already suggested (page 68) that Correggio may have been acquainted with Raphael's designs for individual mosaic panels in the cupola. It may be noted without further comment that there are four pendentives in the church of S. Nicolò at Carpi by a distant follower of Melozzo, namely Giovanni del Sega (reproduced Venturi: *Storia...*, VII, ii, figs. 72–5).

time when Correggio painted the cupola of S. Giovanni Evangelista only one other existed by a major painter in a cinquecento idiom – Pordenone's at Treviso. We have already suggested that the revised chronology of Correggio's work at S. Giovanni would at least permit of his knowing that work. But did he? Does his cupola suggest it? Can its infinitely greater accomplishment owe anything to Pordenone's relatively crude effort, particularly as the S. Giovanni cupola can now be considered the next and logical step after the apse fresco? Above all, if Pordenone could create the cinquecento illusionist cupola by re-interpreting quattrocento practice in the spirit of the Sistine ceiling could not Correggio, with his far greater talent, do so from the same premises independently of Pordenone? No final answer seems possible. Unlike my younger colleagues, I saw Pordenone's cupola in 1939 before it was destroyed, and looking back on my impressions, as well as at photographs, I can only conclude, as with the question of Correggio's supposed Mantegnesque roots, that a connection is possible, but not essential and not to be demonstrated.[1]

Owing to their position below the cupola the pendentive frescoes must date from after it. Of all Correggio's work at S. Giovanni Evangelista it is they whose influence was to be most far-reaching. The idea of utilising the four pendentives of a dome as setting for the four evangelists was not a new one. It had, for instance, already been exemplified in Mantegna's funerary chapel at Mantua. But this and other early allocations of this subject to this space bear no relation, stylistically, to the pendentives of S. Giovanni Evangelista. These are, simply, the prototype of the Baroque pendentive, the direct ancestor of thousands of others in paint or mosaic in almost every church built in the Roman Catholic world from the mid-sixteenth to the mid-eighteenth century. It is doubtful if even Correggio's cupola in the Duomo at Parma – let alone any other decorative work by another painter – exercised so enormous a degree of influence. Once again Correggio's point of departure seems to have been the upper tier of the *Disputa* (fig. 12) – inevitably Raphael's two end figures and those nearest them, since the pendentives each contain two major figures, an apostle and a father of the church. The foremost figure in the pendentive of

[1] A possible prototype – of a kind – may have been the west cupola of the nave of the church of S. Sisto at Piacenza. Correggio must certainly have known the church, as Raphael's *Sistine Madonna* was in it. The cupola is attributed to Bernardino Zacchetti who had been one of Michelangelo's *garzoni* on the Sistine ceiling. He is supposed to have been working at S. Sisto in 1517 but a quantity of other decorative work on the vaults there is also attributed to him (the attribution is mentioned by Tiraboschi (1786) who himself adds that it is unconfirmed). The west cupola is painted with a ring about half way up its curvature, the lower part of which is subdivided again into eight vertical compartments, each containing a seated figure. Only the area within the central ring is thus able to be treated as consistent aerial illusionism. In it a flying figure floats in the centre of a circle of other figures. The latter are recumbent, not, as at S. Giovanni Evangelista, seated. The central figure, likewise, is conceived quite differently from the S. Giovanni Christ. The fresco is now very damaged and difficult to see, but if, as is possible, it was in existence before 1520 it would have to be considered one of the foundations – though not an important one – on which the cupola of S. Giovanni Evangelista rested.

Saints Jerome and Matthew (plate 73) seems to derive, as Popham sugges- ted,[1] from a different work of Raphael – the prophet Daniel in the upper tier of the S. Maria della Pace fresco. Admit- tedly, Raphael's figure appears to de- rive in its turn from Michelangelo's Isaiah on the Sistine ceiling (fig. 21), and Correggio's arrangement of the legs, in the fresco as in all the prelimi- nary drawings, differs from both Raphael's and Michelangelo's. But the striking turn of the head in Correggio's fresco is closer to the S. Maria della Pace figure than to the Isaiah.

As in the cupola, playful putti, in the pendentives, emerge from the clouds, which, as in the *Disputa*, are imagined as sufficiently solid to bear the appre- ciable weight of the sages. By using a painted moulding (brilliantly simula- ted in *trompe-l'oeil*), and not real ones, to mark the edges of the triangular spaces Correggio was able to let the

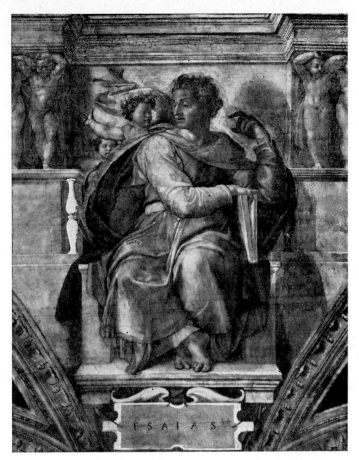

Figure 21
Michelangelo, *Isaiah*

clouds billow out over them in places, thus obscuring parts of them and enormously strength- ening the illusion. Like many of his innovations this became standard practice among seventeenth-century Baroque decorators. Unlike the cupola figures, where a degree of semi- nudity prevails which may or may not have shocked the older members of the community when the fresco was first revealed, the pendentive figures are voluminously draped. Throughout the output of the last decade of his life Correggio showed himself the super virtuoso of drapery as of almost every other branch of painting. And it is perhaps an indication that he had not yet reached complete maturity that the draperies in the pendentives, though foreshadowing the future to one who already knew it, do not yet show the extraordinary degree of originality and brilliance which was to come very soon afterwards in works such as the Del Bono *Lamentation*

[1] Popham 1957, p. 41.

(Parma Galleria) (plate 84) or the Budapest *Madonna del Latte* (plate 95). Only in Christ's draperies in the cupola is something – but not all – of Correggio's later expertise already present.

Relative immaturity of this kind cannot be found in the eight putti in the corners of the pendentives (plates 70 and 71). Here it is almost a case of the proto-Rococo supplanting the proto-Baroque. Of all Correggio's work at S. Giovanni they seem the most completely assured and foreshadow most clearly his style at the Duomo. They are purely decorative in effect. They hold ribbons attached to swags of fruit or leaves, and drape themselves over the *trompe-l'oeil* mouldings in a variety of provocative postures, most of which derive from the Pylades figure on the Orestes sarcophagus (fig. 19B). At the back of his mind Correggio may have been thinking also of the *ignudi* of the Sistine ceiling, but the sting has turned to sweetness.

Correggio's work in the Del Bono chapel of S. Giovanni Evangelista will be discussed in the next chapter. His remaining paintings in the church consist of the frieze and under-arch paintings of the cupola (both these in brown monochrome) (plates 56–61), the friezes of the choir and nave (plates 62–68), and the decoration of the cross vault of the choir (the latter in grey monochrome) (plate 69).

The monochrome decorations might be expected to start where those of the Camera di S. Paolo left off. But on account of their height above ground it is impossible to study them closely, and this factor must have weighed to some extent with the artist. No matter how conscientiously dedicated to his art he may have been it would have been a sheer waste of labour to give these paintings the almost inconceivable delicacy of finish which he lavished on the lunettes only a few feet above the spectators' heads at S. Paolo. As regards design, the nearest of the S. Giovanni monochromes to those of S. Paolo are the remains of the frieze on both sides of the choir. These were entirely hidden by the organ lofts. During the restorations of the early 1960s the lofts were removed and the frieze transferred and published by Signora Quintavalle who named it 'Christian Sacrifice' as opposed to the 'Roman Sacrifice' and 'Jewish Sacrifice' in the nave frieze.[1] The fragments are now (1971) in the adjoining monastery buildings. They show a lively frieze of grey putti on a dark blue ground but the execution is somewhat coarse. At the same time, Signora Quintavalle published photographs of the vault of the choir (the bay nearest the crossing). The four triangular spaces between the ribs were painted with figure subjects by Innocenzo Martini during some redecoration which followed the building of the new choir extension in the 1580s, and for this reason, no doubt, little or no attention had been paid to the arabesque decorations framing them and adjoining the ribs of the vault. Presumably it was assumed that they, too, were Martini's work. But throughout the rest of the church – in the

[1] A. G. Quintavalle 1965.

transepts and nave – there are similar arabesques which certainly date from the sixteenth century. For this reason it would be logical to assume that the choir vault was originally of the same kind, and that Martini merely filled in the centres of the triangular spaces which remain blank to this day in other parts of the church. There would therefore be no inherent improbability in thinking that if it was Correggio who designed the choir frieze it might also have been he who was responsible for the arabesques of the ribs, as Signora Quintavalle claimed, and as the photographs seem to confirm.

The nave frieze consists of twelve bands of decoration – one each above the six arches on either side, just below the springing of the vaults, together with a strip along the inside of the west wall at the same height. The bays are articulated by means of pilaster strips whose 'capitals' consist of flat upright rectangles which project slightly in front of the frieze and are decorated with putti – variations on two basic designs. The twelve bands of the frieze proper consist of twenty-four prophets and sibyls seated at the two ends of each band and painted in colour. (Popham suggested that his number 28v (plate 68c) represented an earlier design in the form of a *trompe-l'oeil* triforium but this may have been intended for the choir frieze.)[1] Between them are monochrome reliefs of sacrifices. There are only two different designs for the latter, which are repeated alternately. Popham published drawings for seven of the prophets and sibyls and for one of the sacrificial scenes (plates 62B and D, 63B and D, 64C, 66A, 67A and B). He was confident that these drawings were autograph and therefore assumed the frieze painting was also. The evidence of the drawings (and of the documents) proves Correggio's involvement, and perhaps execution of at least two of the sacrifices in the bands – one of each. Perhaps, in addition, the execution of all the prophets and sibyls – as they are all different – and of one each of the pairs of putti on the 'capitals' – an obvious recollection of Michelangelo's which flank the thrones of the Sistine prophets and sibyls. But it seems unlikely that a painter as occupied as Correggio should himself repeat his own designs on ten subsequent occasions, when assistants could have done so from his models. The conditions of inspection preclude the exercise of connoisseurship in an effort to settle the matter, so the question is likely to remain unanswered.

In the case of the brown monochrome paintings on the drum of the cupola the disadvantage of virtual invisibility demonstrably did not inhibit Correggio from pouring out his liveliest invention, whatever degree of finish may have been given to them (plates 60 and 61). Of all the decorations at S. Giovanni Evangelista they are, from their position, the most difficult to see. But photographs – and a sheet of preliminary studies in the Louvre (Popham 16) (plate 60B) – reveal a ravishing design in which animated variations on the theme of the evangelists' attributes – angel and lion, angel and eagle, steer and eagle, lion and steer – are painted as if in relief against

[1] Popham 1957, pp. 154–5.

an equally lively painted sculptural relief between the four circular windows. In this frieze the influence of the Antique seems undeniable, and a further point of interest is that a drawing which was once considered to be a preliminary study for it by Correggio is now attributed to Raphael in an unidentified context.[1]

The eight monochromes of single Old Testament figures – perhaps, from their position, the latest of all Correggio's work in the main portion of S. Giovanni – are slightly less difficult to see, being painted at the bases of the four arches of the crossing. So far as one can study them the quality of the execution appears uneven. *Samson* (plate 56A) seems the finest, at least in the orthodox sense, and some studio assistance would be a possibility in some cases. In others, the oddness of the result may have a different cause. The figure of *Daniel* (plate 59B), for instance, is a startlingly uninhibited design in which the wild exuberance of the draperies conceals the anatomy in a way which not even Bernini at the height of his powers outdid. Just as Velázquez seems to have felt himself at liberty to practise his more daring technical innovations on his portraits of the court dwarfs before venturing to do so on the king, so, conceivably, Correggio may have regarded these relatively secluded spots as a suitable place to give preliminary rein to the pent-up forces which were soon to be released in the Duomo cupola.

[1] Drawing in the British Museum, no. 1868-8-8-3180. The Antique sculpture of the *Boy with a Goose* (fig. 35C) may have been drawn on, though not so evidently as in the Duomo frieze.

VII S.GIOVANNIEVANGELISTA(3): THE DEL BONO CHAPEL

CORREGGIO'S work in the private chapel of the Del Bono family at S. Giovanni Evangelista – the fifth from the west end in the south aisle of the nave of the church – is unique in his oeuvre through including both oils and frescoes in close proximity. A tablet let into the floor records the date of the chapel's re-inauguration in 1524, and thus gives an approximate date for Correggio's contribution. Some degree of activity on one or both of his movable paintings for it may have overlapped at the beginning with the final stages of work on the decorations in the main body of the church, and later on may well have been to some extent concurrent with various outside commitments. But on the whole it would probably be roughly correct to regard the Del Bono chapel as the third, and final, chapter of Correggio's activity at S. Giovanni Evangelista. His contribution does not include an altarpiece. In the late eighteenth and early nineteenth centuries there was a small Francia *Madonna* described by Affò (1796) and Donati (1824)[1] on the altar, which may or may not have been there when Correggio started. What he did for the chapel consisted of two oblong canvases, and the design – at least – of the frescoes on the entrance arch.

The bases of the oblong pictures – or rather copies: the originals are now in the Parma gallery – are about twelve feet above the ground. The pictures are set in marble frames which look as though they date from the time of a later refurbishing of the chapel in the seventeenth century. For this reason we cannot positively state that they have not been cut, or that they are in their original positions, though everything points to the latter.[2] Though the canvases are of the same size, the scale of the figures in them is different. In the *Martyrdom of Four Saints* (plate 79), which has only four foreground figures, the scale is smaller than in the *Lamentation* (plate 84), which has five, though one of these – the Mary on the extreme left – is truncated. However, in every pair of pictures, without exception, which Correggio painted *as* a pair the scale of the figures in the two is not the same. Evidently he saw no reason to carry symmetry that far. But in other respects he gave careful consideration to the conditions in which the paintings were to be viewed, and herein lies the evidence that the two compositions were always in their present site and designed for it.

[1] I. Affò, *Il Parmigianino Servitor di Piazza*, p. 119, and Paolo Donati, *Nuova Descrizione della Città di Parma*, p. 39. Popham (1957, pp. 52–3) gives evidence for a large frame's having come from the *chapel*, but the Francia would have been too small for it.

[2] The relatively high situation of the copies as at present framed does not accord with the eye-level in the pictures, but this is not in itself necessarily an indication that the original position was different, since in his altarpieces Correggio always uses an artificially high eye-level. As regards the possibility of cutting, the early print of the *Martyrdom* by Francesco Dus (plate 83c) gives no indication of it.

In the *Lamentation*, on the left of the chapel as you enter it, the light is imagined as coming from the right, and in the *Martyrdom*, facing the *Lamentation*, from the left. This was in accord with normal Renaissance practice from the time of Masaccio on, whereby the light in paintings took its direction from the actual source of light – or at least the principal one – in the setting. This means that the optimum viewing point in the Del Bono chapel is not from the entrance but from the altar. We must advance to the altar and then stand with our back to it, facing the nave of the church, as though we were a priest facing the congregation in the chapel. This in its turn led to a further logical development. Preliminary drawings (plates 82, 83 and 88) show that Correggio started with a centrally planned composition in both cases. In the *Lamentation* the shaft of the cross was seen in the middle of the picture, and was accentuated by the standing figure of St. John draped round it. In the *Martyrdom* the two adult saints knelt, right and left, facing inwards, and the centre was marked by the angel hovering with the rewards of martyrdom above the decapitated children. In these drawings the light already comes from what was to be its actual direction in the chapel (this is clear in the detailed study – in the Louvre (plate 82B) – for the *Martyrdom*: the slight sketch in the British Museum (plate 88B) for the *Lamentation* is too summary for dogmatism on this, but contains no indication to the contrary). Evidently at this stage Correggio realised that the observation of the actual source of light could and should influence the pictures in a further way. If the spectator had to stand with his back to the altar to see them in the best light, the design, too, could be calculated from there. So the centralised plan was abandoned. The figures in the *Lamentation* pile up towards the left of the picture and those in the *Martyrdom* to the right. Viewed from the front, therefore, both pictures are asymmetrical in opposite ways. As a final logical step Correggio varies the degree of definition of the forms. The maximum precision is reserved for the focal points – the left hand of the female saint in the *Martyrdom*, the right hand of the Mary on the left in the *Lamentation*. The farther everything else is from here the less precisely it is painted. It may be considered an anticipation of the focusing camera or the spotlight, and it was to constitute an important item in Correggio's prodigious technique from now on.

The Louvre study for the *Martyrdom* has another point of interest, as it shows the female saint with her right hand to her bosom, as in the National Gallery *Madonna of the Basket* (colour plate E). In the finished picture this saint has both arms outstretched, the palms upwards. Correggio himself re-used this motive in the Apsley House *Agony in the Garden* (plate 96) from which, by some means, it seems to have been borrowed by Baroccio in his *Beata Michelina* and in his *Nativity*[1] (figs. 22 and 23) before becoming part of the seventeenth-century vocabulary – the normal way of expressing supplication. (It was pointed out by Pungileoni (I, page 148) that

[1] Vatican and Prado respectively.

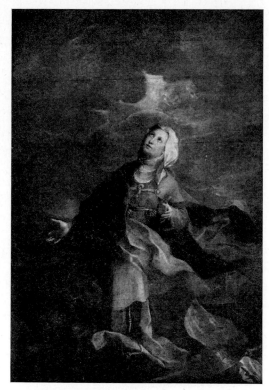

Figure 22
Baroccio, *Beata Michelina*

Figure 23
Baroccio, *The Nativity*

Domenichino had borrowed Correggio's female saint for his martyred *St. Agnes* at Bologna.) Raphael had hit on much of the essentials of the pose in his tapestry design of the *Stoning of Stephen* (fig. 24), though the hands are differently arranged. The fact that in the Louvre drawing the idea is clearly only embryonic would be some indication that Correggio worked it out independently of Raphael. (Though an example of the tapestry was at Mantua by the mid-sixteenth century, the series being mentioned in the will of Cardinal Ercole Gonzaga, who died in 1563, it is unlikely to have been there before Correggio painted the *Martyrdom*.)

The principle of unifying the separate elements in a decorative scheme – which, like most of Correggio's other innovations, was to become a standard practice in the seventeenth century – is also followed in the design of the frescoes on the entrance arch. On the right, as you enter the chapel, Saints John and Peter heal a cripple (plate 77C). On the left St. Paul is converted (plate 77B). In the latter fresco Christ does not appear. He is some feet away, on the crown of the arch, in an entirely distinct picture framed by ornamental putti (plate 77A). He is to be imagined as

seeing across these into the next frame.[1] For this roundel of Christ there are drawings by Correggio himself (at Chatsworth) (plate 78). This raises the question of the attribution of all three frescoed scenes, and contains, by implication, its solution. In theory it would be possible for two painters – Correggio, and, shall we say, Rondani, to whom the frescoes are traditionally attributed – to co-operate to the extent of the latter's designing a *Conversion of Saul* in which the figure of Christ is to be omitted, because it was to be included in a separate composition designed by the former. But the status of the parties on this occasion was not equal. We have already seen that by 1522 the Cathedral authorities, as well as a patron as far afield as Reggio, were competing with S. Giovanni Evangelista for Correggio's services. Since, therefore, it was he who designed the central roundel of the Del Bono arch,

Figure 24
After Raphael, *Stoning of Stephen*. Tapestry

and since one of the side scenes is actually dependent on it, the most probable course of events would be that Correggio, as senior and dominant painter, designed all three scenes. The further consideration that the Chatsworth drawings include part of the decorative surround of one of the scenes flanking the Christ roundel is certainly no evidence against this assumption. As to the execution, that of the *Conversion of Saul* seems the most brilliant, that of the *Saints Peter and John* the least. One can therefore make one's own guess as to the ratio of work as between Correggio and an assistant on this premise. For the present writer Correggio's own share in the execution of the second work would be confined, at the most, to the head of St. Peter.

[1] For some discussion of this principle cf. J. Shearman, 1961. I am not convinced by his attempt to derive Correggio's use of it from Raphael, particularly in view of the fact – admitted by Shearman – that the idea is already implicit in Mantegna's work at the Eremitani, Padua.

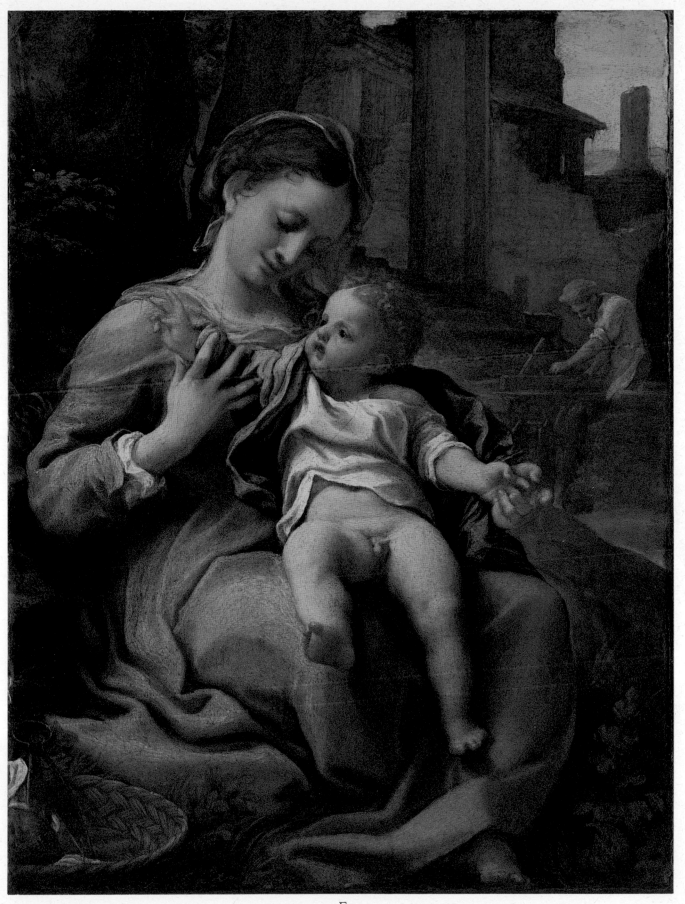

E

The Madonna of the Basket
London, National Gallery. See page 89

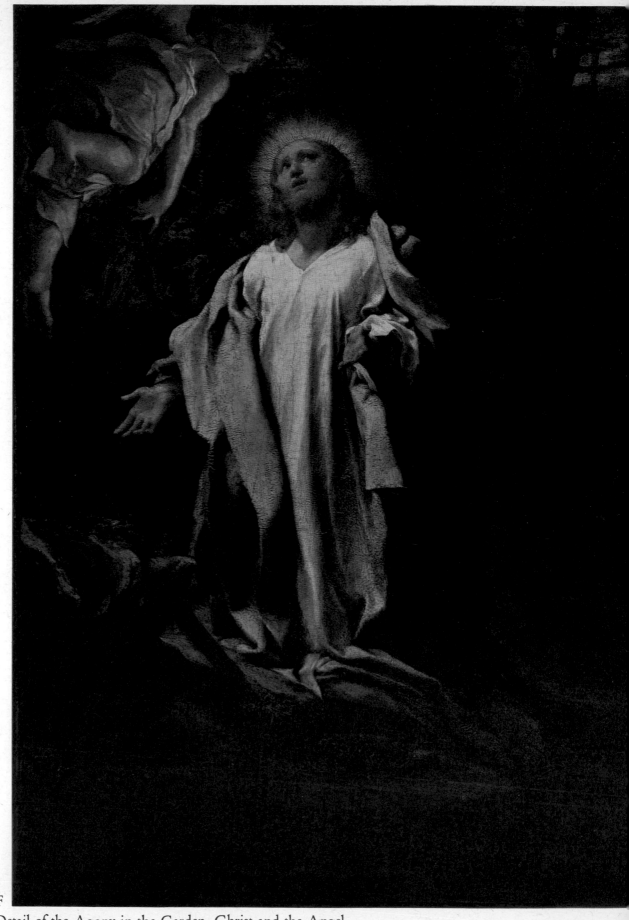

F

Detail of the Agony in the Garden. Christ and the Angel
London, Apsley House. See plate 96 and page 91

Nevertheless, the arch is inevitably a relatively minor work. The two lateral canvases must always have been the main decorative feature of the chapel and an important landmark in Correggio's development. Even before the sensational recent cleaning of these works it was possible to see that the handling differs somewhat in the two, softer and more painterly in the *Lamentation*, rather harder in the *Martyrdom*. This in itself would offer no support to Venturi's strange fancy that both pictures were substantially painted not by Correggio but by the same assistant. And although there may well have been, and probably was, a certain time lag between the execution of the two – enough to account for the difference of handling – I think it unlikely that it would have been as long as several years, as Gronau would have it. Certain stylistic features, for example, are common to both pictures – the flaky white draperies of Christ's loin cloth and of the shoulder drapery of the man in the background of the *Lamentation*, and the angel's drapery in the *Martyrdom*. The fact that this type of white drapery is also found in the Dresden *Madonna with St. Sebastian* (in St. Sebastian's loin cloth) (plate 100) – a picture in which the facial type of the angels supporting the throne recalls that of the flying one in the *Martyrdom* – reveals it as a link between the two laterals, and seems an indication that the interval separating the Del Bono pictures may have been sufficient to permit of the execution of the *Madonna with St. Sebastian*. (See pages 97–101). The latter, in essentials, is likely to have followed the *Lamentation* – which, for various reasons, has usually been thought the earlier – and to have preceded the *Martyrdom*, though in view of its greater size and elaboration it may to some extent have been intermittently concurrent with both. If, as seems likely, the sketch (Popham 62) (plate 139A) of a corpse, on the same sheet as an early study for the Duomo, is in fact for the *Martyrdom*, the latter could probably be dated to 1525, and the *Lamentation* to nearer the date of the restoration of the chapel in 1524. As we shall see, there are indications that the *Madonna with St. Sebastian* may have been in an advanced state by the autumn of 1524.

The Del Bono laterals are astonishingly Baroque, both in content and form. They are also the most dramatic pictures in the whole of Correggio's oeuvre, and considerably more so in the paintings than in the preliminary drawings which we have considered (in the drawing for the *Lamentation* even the action is different: there the holy women tend the body; in the painting they have abandoned it in wild despair). In both pictures colour is used emotionally. The blood reds and violets of the *Lamentation* are set off by the leaden background, while the frenzied blues and golds of the *Martyrdom* are heightened by the mountainous setting which looks like a forest fire, except that the flickering flames are blue. The flying angel in the *Martyrdom* may derive from a Raphaelesque source (see page 91) and the Christ in the *Lamentation* might be considered a development from that in a Correggesque design known in various versions, of which the one formerly in the Eissler collection is the best (see catalogue page 234). In the *Martyrdom* the female

Figure 25A
Jacopo della Quercia,
Madonna and Child

Figure 25B
Jacopo della Quercia, *Death of Abel and Sacrifice of Isaac*

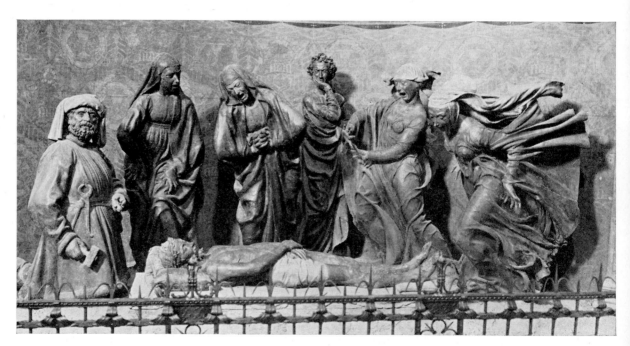

Figure 25C
Niccolò dell'Arca, *Pietà*

saint on the right – the focal point of the picture when seen from the altar – is a conception worthy of Bernini, and very like him, in which the folds of the super-imposed garments – cloak, dress and veil – assume their own animated patterns, creating calculated discords both with each other and with the forms of the body under them. Significantly, both these proto-Baroque paintings are likely to owe something to late Gothic sculpture.[1] The figure of the executioner in the *Martyrdom* could be paralleled by two in Jacopo della Quercia's reliefs on the facade of S. Petronio at Bologna (fig. 25B), and the draperies of the female saint in the same picture recall those of Quercia in general, though there is no exact prototype. In the *Lamentation* the truncated Mary on the left enters running, with both arms outstretched – a motive which probably derives from Niccolò dell'Arca's even more dramatic use of it in his terracotta group of the *Pietà* in S. Maria della Vita in Bologna. (fig. 25C). The deliberate contrast of the folded arms (of Mary Magdalene) also occurs in Niccolò dell'Arca's group (in the Virgin Mary). For the effect of the *Lamentation* on Bernini, see page 152.

In the *Lamentation*, and in the miniature and cabinet picture which are closely related to it – the *Madonna of the Basket* (London) (colour plate E) and *Madonna del Latte* (Budapest) (plate 95) – it is the white draperies, as the lightest in texture and the most luminous, which are given the most multifarious folds. They are of a marvellous, flaky quality such as only Lotto, of previous painters had adumbrated, and he only faintly. The heavier rose pink material of the Madonna's dress sets them off both through its colour and through its combination of long, bold folds and broad smooth areas.

[1] The word Gothic is here applied stylistically, not chronologically.

VIII THE SMALLER RELIGIOUS PAINTINGS OF THE EARLY AND MID-'TWENTIES

THE APSE AND CUPOLA OF S. Giovanni Evangelista were in a sense the crucial artistic experience of Correggio's career. In the sense, that is, that it seems to have been they which gave him the ability, and the confidence, to tackle anything thereafter. Largely as the result of the discipline to which he submitted there he emerged, by the middle of the decade, as possibly the most astounding virtuoso who has ever handled a brush. Everything which he did in this critical period of the early 'twenties is therefore of special interest, but it is not entirely easy to identify it. One of the difficulties is that several important commissions for altarpieces which Correggio accepted in the early 'twenties – the so-called *Notte* (Dresden), and *Scodella* (Parma Galleria) and perhaps the *Giorno* (Parma Galleria) – would only have been tentatively designed, at the most, around the time of the contracts and were not executed until later. Another is that Correggio's paintings which are datable to the mid-'twenties represent such an extreme of virtuosity that critics have tended to date the works which preceded them earlier than is justified, in order, as it were, to give him longer in which to develop.

A documented instance of this practice is furnished by the design of a painting, known in a ruined version at Frankfurt (plate 90A). This was discovered by Thode, who identified it with the so-called *Madonna of Casalmaggiore*. His own dating of it varied in his different publications. But Gronau and Ricci lent their authority to a dating around 1515. This was accepted for many years until Popham identified a sketch for the composition on a sheet connected with the nave frieze of S. Giovanni Evangelista (plate 90B) and therefore datable (as Thode had finally suggested) around 1522. With the Frankfurt picture – or its putative original – can be associated another of similar design at Orléans (plate 91A), and a third, somewhat less similar, at Hampton Court (plate 91B). Some direct influence from a Leonardesque source – the *Virgin of the Rocks* or one of its derivatives – has been postulated in the case of the Frankfurt picture. But as in the contemporary frescoes at S. Giovanni the influence of Raphael dominates in all three, though in a complex manner. It is partly indirect, through Correggio's own re-workings of Raphael's ideas, several years earlier. Thus, both the Frankfurt and Orléans pictures look back to Correggio's miniature at Los Angeles (colour plate A), and, partly through it, to its own sources – Raphael's *Aldobrandini* (fig. 10) and *Loreto* (fig. 11) *Madonnas*. In the Orléans picture a further derivation from another Raphael of the same period – his early years in Rome – is suggested by the motive of the Christ child taking the reed cross from the Giovannino (in the case of the

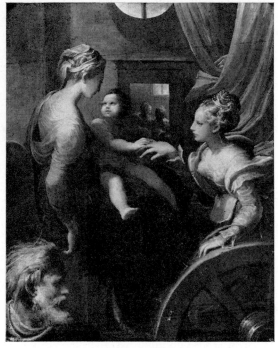

Figure 26A
Parmigianino, *The Marriage of St. Catherine*

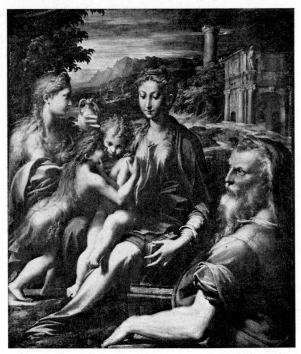

Figure 26B
Parmigianino, *The Holy Family*

Frankfurt picture the identity of the children could be disputed). This motive had been used by Raphael in his *Casa Alba Madonna* (fig. 16), and Correggio had already toyed with it in the Los Angeles miniature. The Hampton Court picture, in which the figures are more closely knit than in the Orléans and Frankfurt ones, also has an eye on the *Loreto Madonna* (in the St. Joseph) and re-uses Correggio's own Christ child from the Prado *Madonna* (plate 27A). The bearded male saint on the left is sufficiently like an earlier incarnation of some of the apostles on the S. Giovanni cupola, and the Madonna sufficiently like an earlier incarnation of the Venus in the *School of Love* (London) (plate 173) for a dating in the early 1520s to be as applicable to this as to the Frankfurt picture. The effect which the Hampton Court picture seems to have had on Parmigianino – who borrowed the saint on the left both in his *Marriage of St. Catherine* (National Gallery, fig. 26A) and in his Uffizi *Holy Family* (fig. 26B) is in itself an indication that Correggio painted the Hampton Court picture after he came to Parma, and not before.

If we compare these three *Madonnas* – or merely that at Hampton Court, since the condition of the others is unreliable – with one of similar type and size, such as the *Madonna del Latte* (plate 95) at Budapest, which I would date only about two years later, *c.* 1524, some idea may be obtained of the giant's stride made by Correggio within a very few years in the early 1520s.

The derivation in the Orléans *Madonna* of a motive from the *Casa Alba Madonna* of Raphael (fig. 16) brings us to the Uffizi *Holy Family with St. Francis* (plate 89) where something of the same derivation, though not so immediately obvious, may perhaps be traced in the combination of the prominence of the Madonna's left hand and the curious arrangement of her legs. It was doubtless reasoning of the kind which dated the Frankfurt *Madonna* to the mid-'teens that has led critics to fail to associate the Uffizi picture with a will of 1520, relegating it instead to the same period – 1515, or a little later. Admittedly, the Christ child is still Mantegnesque – though very similar to the one in the Prado and Hampton Court *Madonnas* – and the facial type of the Joseph is a development of his counterpart in earlier works such as the Brera *Adoration* (plate 22B) and the Los Angeles miniature. But Mantegnesque influence persists later still (e.g. in the S. Giovanni apse and even in the Duomo cupola), and the St. Joseph bears no more than a family resemblance to the others. On the other hand, the Madonna's face shows her as virtually the twin sister of the *Diana* of the Camera, which, as we have seen, is unlikely to date from earlier than 1519. It is a facial type which first, in all probability, occurs in the London *Magdalen* (plate 24B). Later, Correggio's Madonnas tend towards a less severe type, half portrait, half idealisation, seen at its most characteristic in the *Giorno* (Parma Galleria) (plate 157), the Uffizi *Madonna Adoring* (plate 99) and the Louvre *Marriage of St. Catherine* (plate 161A).

There are therefore grounds for dating the Uffizi *Holy Family with St. Francis* to 1520. It is a small altarpiece, comparable in type, and doubtless also in size (to judge from that of the copies) (plate 25) with the lost *Albinea Madonna*,[1] of 1517–18. In both pictures the design is inclined diagonally to the top of the frame (in opposite directions, and more steeply in the Uffizi picture) and in neither is there any appreciable movement of the figures within the depth of the picture. But the general effect is far more Correggesque in the Uffizi picture, mainly on account of the background – his own particular dense foliage, here broken with greater virtuosity than hitherto by shafts of sunlight. The terrain is imagined as steeply inclined, and in consequence St. Francis' feet are concealed. St. Joseph's robe is of the most violent mauve which, to my knowledge, Correggio ever permitted himself, but red has returned in St. Joseph's scarf.

Though the Uffizi picture is in fact of an incident – the miraculous nourishment of the Holy Family in Egypt – the presentation is that of the static type of Madonna and Child enthroned with Saints (though, as in the *Albinea Madonna* there is in fact no throne, but only a tree trunk as a visual substitute). Correggio's later altarpieces, as we shall see, consistently aim at diminishing the barriers between the two genres, but perhaps never again so completely as here.

The exceptional inclusion of St. Francis in the Uffizi picture was presumably by special wish of the patron. If we think it away we can see that the remainder of the design seems to have been

[1] Catalogue B, page 278.

the germ from which that of two others developed. To that extent, therefore, the Uffizi picture is an important and under-estimated work. One of the two was of identical subject, the so-called *Madonna della Scodella* (Parma Galleria) (plate 105). The early design for this (plate 104B), recently acquired by Dr Hammer for eventual presentation to Washington, is on the back of a study for one of the S. Giovanni pendentives and therefore datable around as little as two or three years later. In this drawing Correggio has reversed the direction of the diagonal of the composition by reversing the positions of the Virgin and St. Joseph. The latter's greater prominence in this picture, when compared with the Uffizi one, is due to the fact that the altar for which the *Scodella*

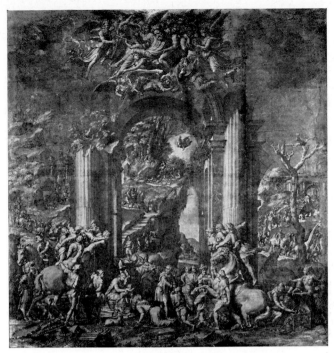

Figure 27
Peruzzi, *The Adoration of the Kings*

was designed was dedicated to him. This brought with it an ingenious solution of the problem of the Madonna's throne in the open air – if she is not in the centre she has no need of one, nor even of a substitute. Something of the Raphaelesque oddity of the Madonna's legs, splayed sideways in the Uffizi painting, remains in the Hammer drawing. And at this stage the glory overhead was evidently in a very embryonic stage.

The other picture, the germ of whose design seems to me to be found in the Uffizi *Holy Family* is of surprisingly different subject, namely the *School of Love* (London) (plate 173), though the picture probably dates from roughly the same period – *c.* 1523/4 – as the early design for the *Scodella*. The previous year – 1522 – had seen the inception of what became later one of Correggio's most celebrated compositions, the *Notte* (Dresden) (plate 107). In this case it is likely enough that the starting point was Correggio's own earlier painting of the same subject, the Brera *Nativity* (plate 22A). If so, it would soon have become apparent that the altarpiece form demanded something much more monumental. And study of the preliminary sketch in the Fitzwilliam Museum (plate 109B) suggests that at this stage, and for this reason, Correggio toyed momentarily with a somewhat surprising external source of inspiration. This was Peruzzi's grandiose cartoon of the *Adoration of the Kings*, now in the National Gallery (fig. 27). It

was drawn in Bologna, where Peruzzi had arrived in July 1521 and where he stayed for two years. At an earlier date Peruzzi seems to have been in contact with Cesare da Sesto, whose own painting of this subject, now at Naples, likewise includes an elaborate arch, and predates Peruzzi's cartoon and perhaps influenced it. The Fitzwilliam drawing probably, but not certainly, preceded the model for the altarpiece which is mentioned in the contract of 14 October 1522. The most interesting connecting link is the deep vaulted arch flanked by pillars in the centre of Peruzzi's composition. The Fitzwilliam drawing shows that Correggio originally envisaged a similar structure – there are traces of a second vaulted arch on the right, and perhaps of a second pillar on the left. In the end only the central pillar remained of the grand architecture (the small tree near it appears in the drawing *on top of* the architectural mouldings and a comparable tree had also figured in the Peruzzi) but it and the shepherd leaning against it strike the required note of monumentality and were to survive into the final composition, reversed, like the rest of it, and replanned on a receding diagonal. We may note at this point that the combined evidence of the Fitzwilliam drawing, of the Hercolani provenance of the Prado *Noli me Tangere* and the London *Madonna with the Basket* (which re-uses an idea of Jacopo della Quercia's) together with the apparent influence of Niccolò dell'Arca on the Del Bono *Lamentation*, renders at least one visit by Correggio to Bologna in the early 1520s extremely probable.

It does not seem possible to decide whether the nocturnal lighting which is the most striking feature of the *Notte* painting, and which, in a different form, had been incorporated in the Brera *Nativity*, was already envisaged at this stage. The drawing is non-committal in this respect.[1] What is curious is that Correggio's *Agony in the Garden* at Apsley House (plate 96), which has comparable illumination, is first reported (by Vasari) in the same city – Reggio – as the *Notte*, suggesting that the success of the first of them to arrive there conditioned the second. The *Notte* was probably commissioned first, but the *Agony* may well have been painted first. If, as seems plausible, Correggio painted the *Agony* (for which subject nocturnal lighting is not an absolute necessity, any more than it is for the Nativity) as preparation for the *Notte* it would be a curious coincidence that took it to the very place for which the *Notte* was destined. It is a teasing little problem to which no easy solution offers.

A picture which probably dates from this period – the early 'twenties – is the Naples miniature of the *Marriage of St. Catherine* (plate 92A). On the strength of a false inscription it is usually assigned to the late 'teens, but its relatively warm colouring would militate against this. So would the effect which it exercised on Parmigianino, whose own version of the subject

[1] The contract specifies that the picture is to contain figures 'secondo le misure et grandezza' ('according to the scale and size') indicated on a model drawing supplied. This provision would not seem to cover illumination, and in any case the artist may have felt at liberty to depart from the model. See also S. J. Freedberg, *Painting in Italy, 1500–1600*, 1970, pp. 491–2, n. 18.

(National Gallery, fig. 26) seems to derive from it, if we think away the incongruous background in the manner of Giulio Romano and the bearded foreground figure from Correggio's Hampton Court picture (plate 91B). Like the latter, the Naples picture is more likely to have been known to Parmigianino if painted in Parma than in Correggio.

The Naples picture evidently represents an attempt to execute a very small picture in a broad technique, with thick impasto. Correggio had already done this in the ex-Eissler *Pietà* (New York) (plate 21A). A little later he did the same again – and with greater confidence – in the *Madonna of the Basket* (London) (colour plate E). In addition, the Naples picture seems to show some awareness of Venetian practice in the 'teens – in the play of voluptuous and luxuriant draperies, as in the young Titian or in Palma Vecchio. The Madonna's face cuts the top of the Child's head – a device which Correggio had been using about this time in the background of the S. Giovanni Evangelista apse, and was to use again in the Duomo cupola, and finally in the period of the Dresden *Madonna with St. George* (plate 163). In the Naples picture the short-hand of the handling seems at first foreign to Correggio's neatness, but probably represents merely another aspect of his constant technical experimentation. The Naples *Marriage of St. Catherine* was to a most unusual extent in accord with taste in the sixteenth and seventeenth centuries, as we can see from the enormous quantity of old copies and unusually numerous early engravings. Though appearing as another oddity in the master's oeuvre it still seems extraordinarily felicitous, and its exquisite landscape anticipates that of the *Giorno*.

The S. Giovanni Evangelista period (1520–24) is likely also to have seen the painting of two isolated frescoes – the *Madonna della Scala* (plate 93) and the *Annunciation* (plate 94A) both in the Parma gallery. The former, a fragmentary but masterly composition, seems close to the impassioned and marvellously compact design of the Madonna in the S. Giovanni apse – closer to some of the preliminary drawings than to the fresco itself – while in the *Annunciation*, half ruined since the mid-sixteenth century, and perhaps more easily appreciated in the exquisite preparatory drawing in New York (plate 94B), the combination of the angel's voluminous drapery with clouds and baby putti is almost exactly of a piece with the S. Giovanni cupola and pendentives. The angel in this fresco recurs in a form too close for coincidence in Titian's painting of the same subject in the Scuola di S. Rocco (fig. 28). Neither picture is precisely dated, but as the Titian is always assumed to date from not before about 1530 we may deduce that he, and not Correggio, was the borrower.

Five further paintings of very high quality may be assigned to the mid-'twenties through analogies with the Del Bono laterals. In the National Gallery *Madonna of the Basket* (colour plate E, plate 97A), an example of broad treatment on a tiny scale, and constituting, with the Apsley

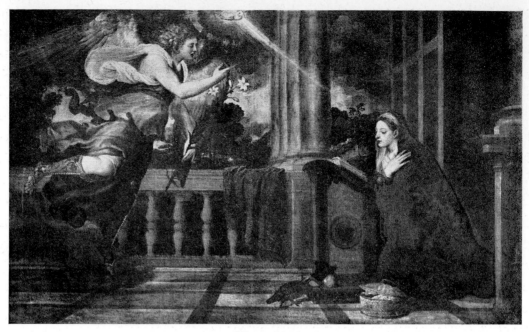

Figure 28
Titian, *The Annunciation*

House *Agony in the Garden* (plate 96, colour plate F), and perhaps the Dresden *Magdalen*[1] (plate 97C) Correggio's last word on the miniature, the Madonna's face virtually repeats those of both the Madonna and the St. John in the Del Bono *Lamentation*, while the St. Joseph in the one is closely related to the man descending the ladder in the other. Attention is concentrated on the Christ child in the *Basket Madonna* both by reason of the more numerous folds of his garments and through the greater precision and definition with which he is painted (the actual focal point is his projecting right foot). The manner in which he is enfolded by his mother so that no part of his body except his head projects beyond any portion of hers – even to her wrapping her left hand round his – is of extraordinary perfection, while the astonishing anticipation of eighteenth-century forms shown by the main figures is even echoed in the artificially rustic background. Yet here again Correggio is casting a backward glance, and this time the connection with Quercia is demonstrable. His sculptural group at S. Petronio (fig. 25A) has the same motive – the Madonna putting a garment on the child – as well as a comparable approach to the draperies and a comparable position of the Madonna's right hand. The similar picture at Budapest, the *Madonna del Latte* (plate 95), likewise seems (with the Louvre *Marriage of St. Catherine*, plate 161A) the perfection of Correggio's cabinet pictures, and in particular of the half length,

[1] Catalogue B, page 279.

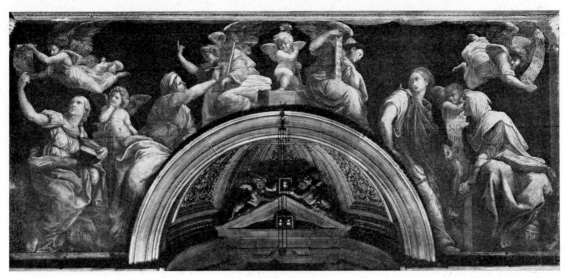

Figure 29
Raphael, *Sibyls*

that genre which he had inherited from Leonardo through Raphael, and on which he had worked so hard and so long. Here he has finally evolved his own totally personal version, and Leonardo and Raphael seem already far away.

The single miniature and two cabinet pictures which connect with the *Martyrdom* are less closely linked with it in a formal sense than are the *Basket Madonna* and *Madonna del Latte* with the *Lamentation*. But they share an interest in landscape and in strange effects of light (another which does so, and which is therefore probably contemporary, is the Louvre *Venus* (plate 177)). The Christ in the miniature – the Apsley House *Agony* (plate 96) – repeats, as we have seen, the pose of the female saint in the *Martyrdom*, the difference in mood being primarily indicated by the different types of drapery. Instead of theatrical agitation they hang as if in resignation. The hair and beard of the Christ are unusually blond.

The evolution of the female martyr from the different pose in the Louvre drawing is a good indication that the *Agony* followed the *Martyrdom* and not vice versa – though probably, in view of the implications of the study for the Christ (page 92), by only a short time. Another pointer in the same direction comes from the flying angels. The one in the *Martyrdom* was very probably Correggio's first essay in this genre, and it has been plausibly suggested that in it he drew on Raphael's angel who hovers above the Sibyl of Cumae on the left in S. Maria della Pace (fig. 29). This type remains unique in Correggio. In the *Agony* a new one appears, flying on a horizontal line, diagonally into the picture. This type reappears in a more extreme form in the

Notte, and to evolve it it seems likely that Correggio turned away from Raphael and towards Lotto, who had used similar forms in the altar of S. Bernardino at Bergamo, dated as early as 1521 (fig. 30). The *Agony* is datable, in any case, around the mid-'twenties through a drawing for the Christ (Popham 79) (plate 96B) whose verso has a study for the *School of Love*. The cumulative evidence of the fragmentary indications would thus favour a dating before the end of 1525, in all probability. The *Agony* bears witness

Figure 30
Lotto, *Angel*. Detail of S. Bernardino altar (1521)

to technical experiment – an attempt to evolve a more fluid technique – and for once Correggio has slightly over-reached himself. Too much medium has made the paint crack in places. The *Agony* is less broadly handled than the *Basket Madonna* of similar size, and is of an enamel-like delicacy which baffles analysis and description. Its striking asymmetry is not unprecedented in this subject: Mantegna had used it in his Verona predella (now at Tours). It evidently affected Titian's renderings (fig. 31) of the subject, and, either through them, or directly, or both, those of El Greco.

The particular virtuoso treatment of the outstretched hand – the female saint's left in the *Martyrdom*, Christ's left in the *Agony* – is a link with the Uffizi cabinet piece of the *Madonna adoring the Child* (plate 99). The treatment of the white draperies at the Uffizi Madonna's neck, too, seems to link the picture with this group – most closely, perhaps, with the *Agony*. Like the latter it makes great play with light effects – gentle here, appropriately violent in the *Agony* where the two main figures illuminate each other. The unusual thinness and smoothness of the pigment in the Uffizi picture may be regarded as a further experiment in technique, and one to which Correggio did not return for several years – in the late mythologies. On the other hand, the features first mentioned, and the magnificent swagger of the Madonna's draperies (whose outline, at her back, recalls that of Raphael's Madonna in the *Disputa* (fig. 18), in reverse) together with – above all – the extraordinary complexity of the foreshortening of the Christ child and the interest in lighting, ally the Uffizi picture firmly with works of the mid-'twenties.

The affinities of the other cabinet picture – the Prado *Noli me Tangere* (plate 98) – with the Uffizi *Madonna* were already indicated in the eighteenth century by Mengs (who did not care

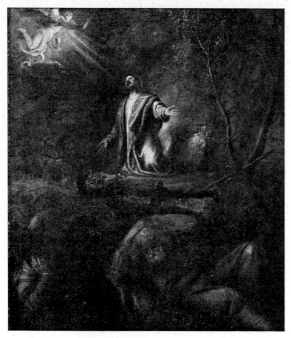

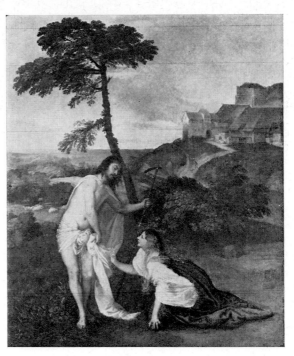

Figure 31
Titian, *The Agony in the Garden*

Figure 32
Titian, *Noli me Tangere*

for the Uffizi picture). They are most apparent in the subtlety of the lighting in the Prado picture, and an analogy with a work of perhaps a little earlier can be seen in the exaggerated attitude of Christ's upraised left arm (only partly attributable to repaint; here, for once, Vasari's accusation of faulty draughtsmanship does seem justified) which recalls that of St. Peter on the cupola of S. Giovanni Evangelista. For the rest, the Prado picture has a mysterious poetry which is found in no other of Correggio's paintings. It is close enough in arrangement – and in the accent on landscape – to Titian's picture of the same subject in the National Gallery (fig. 32) to make one wonder if Correggio knew it. The passionate Mary Magdalene, very different from Titian's timid one, will be met again in the *Giorno*.

She may indeed have been able to be re-met even earlier. The reclining *Magdalen*[1] (plate 97C), missing from the Dresden gallery since the Second War, is similar in type to her counterpart at Madrid, and, to judge from old photographs, also showed a comparably complex play of light, in this case striking the form through trees, as in the Louvre *Venus* (plate 177). More even than the Naples *St. Catherine*, the Dresden *Magdalen* struck an ecstatic chord in the man of feeling of the eighteenth century. The combination of sentimental religiosity and sensuality proved

[1] Catalogue B, page 279.

irresistible and gave rise to extraordinary panegyrics (including Diderot's, in the *Salons* of 1763 and 1767) and innumerable copies. It was therefore perhaps to be expected the reaction should come in the nineteenth century, the surprising feature being not so much that taste turned away from the picture as that it was roundly proclaimed a fake. In point of fact nothing is easier than to imagine Correggio, in his restless technical experimentation, selecting metal (the feature to which the nineteenth century objected) as support for a miniature designed to explore the extreme of delicacy of finish.

IX THE 'MADONNA WITH ST. SEBASTIAN', THE 'MADONNA DELLA SCODELLA' AND THE 'NOTTE'

THE CHRONOLOGY OF THE ALTARPIECES OF the 'twenties is the most difficult problem in Correggio's oeuvre. The *Notte* (Dresden) was commissioned, as we have seen, in October 1522, but as the chapel (in S. Prospero at Reggio) where it was to be set up was not inaugurated until 1530 – as recorded in an inscription still *in situ* – the picture need not have been delivered before then. In that year, too – in June – the *Madonna della Scodella* (Parma Galleria) was also set up, though, as we have seen, an early design for it is datable around 1523, and in the next year, 1524, a man bequeathed a small sum of money towards the expense of it. Unconfirmed tradition assigns the commission of a third altarpiece – the *Giorno* (Parma Galleria) – to 1523, and its setting up to 1528. (It may come as a surprise to realise that in that case it would have been the first altarpiece, in the strict sense, by Correggio to be set up in Parma since he settled there, some nine years before.) A fourth, the *Madonna with St. George* (Dresden), was copied, and therefore already finished, in 1530. In the case of the fifth, the *Madonna with St. Sebastian* (Dresden), there is no documentary evidence for the date, but other indications point to 1524.

When attempting to unravel the intensely complicated relative chronology the first consideration is that Correggio's work on the decoration of S. Giovanni and the Duomo is likely to have had precedence at least during the summer months. We know, from a clause in a contract in respect of frescoes at S. Maria della Steccata, that fresco painters were not forced to continue painting during the coldest months of the year in Parma,[1] and for Correggio, who was engaged on fresco work intermittently throughout the decade of the 'twenties, this factor must have been of the first importance in conditioning the pattern of his life. When it became too cold to continue work in the churches he would have been enabled to paint smaller pictures at home. As he had finished the main work at S. Giovanni by January 1524 and may not have started painting at the Duomo before the summer of 1526, or even later, such portions of the summers of 1524 and 1525 as would not have been filled by work on the cartoons for the Duomo (essentially also a summer job: provision for a chapel to do it in is made in the contract) would have been available for the altarpieces and smaller pictures, as well as the winter months.

The greater freedom from mural work which Correggio would have enjoyed during the mid-

[1] A. G. Quintavalle 1960, p. 85.

'twenties is witnessed by the relatively numerous movable pictures which are datable to that time. On my reckoning the following works would fall within this period of about two and a half to three years – the *School of Love* (National Gallery) (perhaps started a little earlier), Del Bono *Lamentation* (Parma Galleria) (perhaps also started a little earlier), *Madonna of the Basket* (National Gallery), *Madonna del Latte* (Budapest), *Madonna with St. Sebastian* (Dresden), Del Bono *Martyrdom* (Parma Galleria), *Agony in the Garden* (Apsley House), *Madonna Adoring* (Uffizi), *Noli me Tangere* (Prado), Louvre *Venus*, perhaps the Dresden *Magdalen*,[1] part of the *Madonna della Scodella* (finished later) and the *Notte* (perhaps finished a little later). If we find difficulty in believing that so much could be achieved in so short a time we may recall that Paolo Veronese, who does not give the impression of being a slap-dash worker in the sense that Tintoretto sometimes does, seems to have painted the *Consecration of St. Nicholas* (National Gallery) and two other altarpieces within the space of three months, while Correggio himself seems to have executed his largest altar – the St. Francis *Madonna* – in five months. Also, for what it is worth, we may note the tradition published by Tiraboschi (page 267) that Correggio painted the *Giorno* in six months.

As regards allocation of priority among the altarpieces, we might perhaps assume that clients outside Parma – the patrons of the *Notte*, the *St. Sebastian* or the *St. George* – might safely be kept waiting longer than those within it – the Del Bono, *Giorno* and *Scodella* commissions. But at least one of the outside patrons – the Pratonero of the *Notte* – demonstrably took the precaution of paying part of the fee in advance – as well as obtaining a *modello* – and in any case its destined site – Reggio – is not far from Parma. In that connection it is therefore slightly surprising that a job for somewhat farther afield – the *St. Sebastian* for Modena – seems to have been the first of the altarpieces to be finished, whether or not it was either commissioned or delivered first (on which we have no information). Only two external factors seem relevant to explain the various delays. In the case of the *Notte*, the church where it was set up was not finished, structurally, in every respect until after the date of the contract to Correggio. He would therefore have known that there was no point in executing the picture immediately. Even so, it is likely, on my dating of his painting, that there was some lack of co-ordination, since I think he would have finished it some years before it was set up in 1530. Secondly, the *Madonna della Scodella* was paid for by public subscription. If, as is apt to happen on these occasions, the money was slow to come in, the delay in executing the picture would be understandable. In point of fact, the *Scodella* is the only one of the altarpieces whose actual execution seems to have been sporadic and to date from different times. In all the others the style of painting is homogeneous. But though Correggio is likely to have started painting the *Scodella* by the mid-

[1] Catalogue B, page 279.

G

The Virgin and escort from the Duomo cupola fresco. Detail

Parma. See page 106

H Detail of figures on the Duomo cupola
Parma. See page 106

'twenties, parts of it cannot have been executed until shortly before it was unveiled in June 1530.

The Dresden *Madonna and Child with Saints Sebastian, Geminian and Roche* (plate 100) would have been the first monumental altarpiece which Correggio had undertaken since the *Madonna with St. Francis* (Dresden), about ten years previously, though the smaller ones of Albinea[1] and of the *Holy Family with St. Francis* (Uffizi) had intervened. In the long run, one of Correggio's greatest achievements was his contribution towards making the altarpiece representing a state approximate to the altarpiece of incident. He monumentalised the second and animated the first; and though his great contemporaries, Raphael, Sarto and Titian, were moving in the same direction at the same time, Correggio's contribution was perhaps the most radical. In the case of the St. Sebastian *Madonna*, by injecting his new-found dynamism into the static subject he went farther towards the Baroque altar of this type than even Titian, in his Pesaro *Madonna* dating from the same period. We have no indication whether Correggio ever saw the latter work, though it is possible that its predecessor, the Frari *Assunta*, may have been a factor in the evolution of the design of the cupola of Parma cathedral. But in the case of another altarpiece by Titian, the Resurrection polyptych (fig. 33A), Correggio's reaction does not seem to have been one of ignorance. On the contrary, he seems deliberately to have turned his back on it.

Domiciled, as he was in the 1520s, at Parma he would have been roughly equidistant from three major altarpieces by very great contemporaries. Raphael's *St. Cecilia* was at Bologna and his *Sistine Madonna* (fig. 33B) at Piacenza (now at Dresden). Titian's polyptych of the Resurrection was at Brescia. It is dated 1522.[2] The Raphaels are datable around the years 1513–16. It is reasonable to assume that Correggio would have been acquainted with all three of these pictures. I have never been confident of tracing significant influence of the *St. Cecilia* in Correggio, except perhaps in technique. His emphatic positive reaction to the *Sistine Madonna* will be discussed presently. In the case of the Titian, its most striking – and always most famous – element is the panel of St. Sebastian, and this saint also occurs with appropriate prominence in Correggio's altar of that name. If Correggio had gone out of his way to evolve as different a presentation of the same saint from Titian's as was possible, he could hardly have done so more effectively than he did – and this despite a measure of common ancestry. Titian's saint, as has often been pointed out, derives, like his Christ in the same polyptych, from the *Laocoön*, and perhaps also from a

[1] Catalogue B, page 278.
[2] Two smaller works of Raphael which were probably north of the Apennines in Correggio's time were the *Madonna del Divino Amore* (then at Meldola, now Naples) and the *Vision of Ezekiel* (then probably Bologna, now Pitti). In addition, the *Perla* (now Prado) was in Verona and though now recognised as of Giulio Romano's execution, was then considered Raphael's. Though there is not, to my knowledge, a record of when Titian's altarpiece reached Brescia, there would be no reason to assume undue delay. It exercised an appreciable effect on Brescian painters – e.g. Romanino's *Resurrection* at Capriolo.

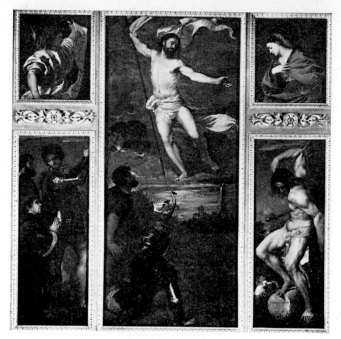

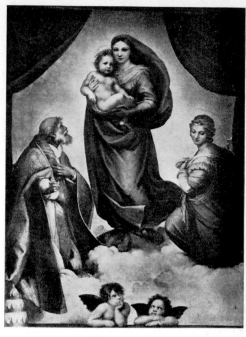

Figure 33A
Titian, *Resurrection polyptych*

Figure 33B
Raphael, *The Sistine Madonna*

derivative of it – Michelangelo's *Rebellious Slave* (Louvre). For the upper part of *his* St. Sebastian Correggio reverts to the Pylades figure on the Orestes sarcophagus (fig. 19B) which he had already used at S. Giovanni Evangelista. This time he reverses it, and, for the legs, is unable to exclude some degree of reminiscence of the Laocoön pose. The incident is an important pointer to the paths that the two artists were treading in the mid-'twenties. Both were then evolving a kind of proto-Baroque style, and in the event it was their work of precisely this period which became the principal foundation of the Baroque proper in the seventeenth century. Occasionally Titian seems to have borrowed an idea from Correggio, and very occasionally Correggio may have returned the compliment. We have also noted a bond they had in common, and which they shared with Michelangelo, among others – an inability to escape the *Laocoön* (fig. 19A). But in general they remained on roughly parallel courses with a wide gap between. The robust Venetian and the exquisite Emilian would have had very little in common temperamentally. And so, in the challenging field of the monumental altar, we find Correggio deliberately turning a blind eye to Titian and veering instead, as he had so often done before, to Raphael.

The structure of the *Madonna and Child with St. Sebastian* (plate 100) (for which – unique among the great altarpieces – no preliminary drawings have yet been identified) represented a

new and immensely influential variation on an established theme, the so-called Madonna in Glory, whose popularity in the north of Italy had been increasing in the opening years of the sixteenth century with the rise of the landscape background. The conventional Madonna Enthroned had not accorded with this. The throne was apt to look out of place in the open air, and its presence interrupted the sweep of the landscape. One solution, exemplified by Correggio in the Detroit, Albinea and Uffizi Madonnas, and in the *Giorno*, had merely deprived the Madonna of her throne, sometimes using a tree trunk as a visual substitute. In the alternative convention of the Madonna in Glory, the Madonna and Child were shown above, in the clouds, thus permitting an unbroken view of the landscape in the centre. Sometimes, no doubt, this will have referred to a specific vision experienced by one of the saints shown at ground level. But the frequency of this type of altarpiece north of the Apennines in the early sixteenth century, combined with the fact that in some cases the saints depicted are not recorded as having had such a vision, suggests that before long it is likely to have been used merely as an aesthetic convenience. In a sense this is also logical, as the saints are usually not shown looking at the visionary Madonna. She is there for the spectator's benefit, not theirs. Perugino's altarpiece at Bologna was a local example dating from the quattrocento, and more recent instances, by Dosso Dossi, were nearer still, at Modena. Nevertheless, Correggio's prime inspiration seems to have been, as so often before, Raphael's *Madonna of Foligno* (fig. 14). In this context the significant feature of it is the treatment of the two saints on the left. St. John the Baptist looks out at the spectator and motions him with his arm to look up at the vision. And St. Francis, kneeling in front of the Baptist, stretches out his right arm to the spectator in a gesture of invitation. We may therefore think of the action as taking place on three separate planes, the celestial vision above, the saints below, and ourselves as active participants, in front. Though the three are inherently separate, bridges are provided over the two gaps.

In the *Sistine Madonna* (fig. 33B) Raphael himself carried the process a step farther. By dispensing with the landscape which had so much encouraged the genre of the Madonna in Glory the three planes have become virtually two. The intermediate one is abolished except for a narrow ledge in the foreground of the picture. The saints have joined the vision in the clouds. We remain where we were, invited by the saint on the left – St. Sixtus – who stretches out his arm to us as the Baptist had done in the *Foligno Madonna*. But only one bridge, and not two, would now be needed to bring us to the Madonna.

The *Sistine Madonna* was close to Parma in Correggio's day, being at Piacenza. He must have known it well, and it can be seen as of equal importance with the *Foligno Madonna* in the evolution of the *Madonna with St. Sebastian*. The tendency which Raphael had exemplified in the sequence of the Foligno and Sistine Madonnas had been to bring the spectator into closer com-

munion with the Madonna and Child, and to this end the *Sistine Madonna* may be regarded as marking the more advanced stage of the two. Correggio's approach is more radical, but clearly follows. In both of Raphael's altarpieces one saint invites our participation, and in one of them – the *Foligno Madonna* – another saint motions us to look up at the Madonna. But in Correggio's altarpiece the same saint, St. Geminian, looks straight at the spectator, inviting him with his left hand to look at him, while his right redirects him up to the Madonna. This saint is in the immediate foreground and quite inescapable. And though he and the saints who flank him – Sebastian and Roche – are firmly on the ground, unlike Raphael's in the *Sistine Madonna*, the dividing line between them and the vision in the clouds is deliberately and cunningly smoothed. The spectator is violently sucked into the foreground and is then persuaded to slide by imperceptible degrees up to the Virgin.

What Correggio has done, in effect, has been to bring the Madonna in Glory down to earth. The conventional Madonna Enthroned was earth-bound. The conventional Madonna in Glory was air-borne, though sometimes her clouds hovered only just above the ground. Raphael had eased access to her, but it was still difficult. Now Correggio brings her right down and shows her as still divine but as accessible to anyone. It is this development which constitutes, by a tortuous chain, the main external evidence for dating the picture. For in his altarpiece painted in Rome in 1527 and now in the National Gallery (fig. 34) Parmigianino also brought the Madonna in Glory down to earth. And he left Parma in the autumn of 1524.[1] It had been suggested that the St. Jerome in his National Gallery altarpiece derives from the St. Roche in Correggio's picture, which may be the case, though the degree of resemblance is not very close and both figures have a common ancestor in the *Laocoön*.[2] But the other point is in fact virtually conclusive. Parmigianino, as so often, has taken an idea (in this case a revolutionary one) of Correggio's and then treated it differently. Access to his Madonna in Glory is even clearer than to Correggio's. Her clouds touch the ground in front of us, less encumbered with figures than in the *Madonna with St. Sebastian*. In consequence, I deduce that Correggio's picture was nearly if not quite finished by the autumn of 1524.

In the latter work everything is fluid; there is no straight line anywhere. As the Madonna has no solid throne she is forced to raise her left leg (which can be seen pushing out the skirt over her right) in order to support the child. The treatment of the wingless angels (who are frivolously half-hearted in their task of supporting the cloudy throne) recalls the angel of the Del Bono *Martyrdom*, and the Christ child is closely related to the one in the *Madonna of the Basket* (National

[1] The complicated evidence rests mainly on a deduction from Vasari that Parmigianino did not go to Rome until the plague was over, which was in the summer of 1524 (see S. J. Freedberg, *Parmigianino*, 1950, pp. 59–60).

[2] Popham 157, p. 79, n.3. He also mentions Anselmi's altar of 1526 as a derivation from Correggio's *St. Sebastian*. There may be some influence, but Anselmi's picture is not a Madonna in Glory.

Gallery). We may also note Correggio's favourite diagonal line – in this case from the upright St. Sebastian to the recumbent St. Roche – and the Leonardesque smile of the Virgin. For the rest, in this astonishing work the altarpiece ostensibly depicting a state has become inconceivably dynamic. In the eighteenth century Mengs still thought it looked 'modern'.

It may be considered a reflection on the mental processes of art historians that although the *Madonna della Scodella* has hung within a few feet of the *Martyrdom* at Parma for over a century and a half, none has fully grasped the affinities between them. On the other hand, the tendency to a relatively later dating of the *Scodella* – *c.* 1529/30 – has been more marked since Ricci himself had the original frame (which records the year 1530, in an inscription, as the date of unveiling) replaced on the picture in 1893.[1] Yet granted that Correggio seldom or never *quite* repeated every aspect of his style and technique in any two pictures; granted, also, that one of these is on canvas (the *Martyrdom*), the other (the *Scodella*) on panel; and granted, finally, that the subject matter is very different, I would suggest that the two main groups in the two pictures – St. Flavia and her executioner, on the one hand, and Joseph and Mary and the Christ child, on the other – are precisely comparable in the type and dynamism of the all-important draperies and in the effects of light on

[1] See Ricci 1896, pp. 285–6, quoting previous datings.

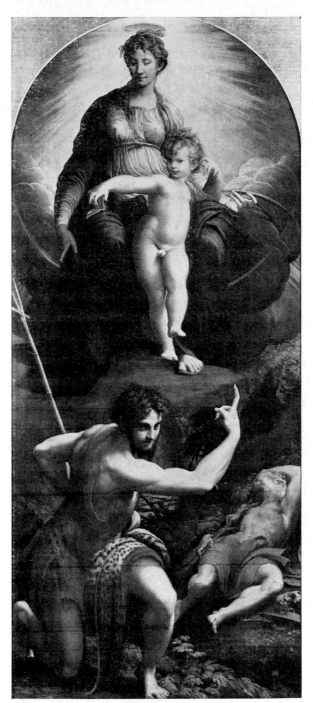

Figure 34
Parmigianino, *Madonna and Child with Saints*
(so-called *Vision of St. Jerome*)

them. Indeed, I would even suggest that in these essentials the *Martyrdom* is closer to the *Scodella* than to its own pendant, the *Lamentation*. And I would conclude that the execution of this part – the lower half – of the *Scodella* – immediately followed that of the *Martyrdom* in the mid-'twenties.[1] These three pictures, incidentally, are apparently the last – with the exception, unavoidable by reason of the story, of the Io (Vienna) – in which all view of distant space is excluded. After this Correggio becomes to that extent less introverted.

In the interval of perhaps a year or two between the Hammer drawing (*c.* 1523) (plate 104B) and the time when I assume that Correggio painted the lower half of the *Scodella* – *c.* 1525 – considerable development took place. Much of it is already visible in a further drawing in the Uffizi (plate 104C). The diagonal inherent in the fact that the seated Madonna is on a lower level than the standing Joseph is now emphasised by the limbs of the figures themselves. They are no longer self-contained, as they were in the Washington drawing. The Virgin now stretches out her right arm to bring up the bowl which the angel in the background is filling with drinking water. This starts – or ends, depending on which way you look at it – a strong diagonal, which is taken up by the outstretched right arm of the Christ child, by what one sees of his left, by St. Joseph's right hand (giving him the dates) and above all by St. Joseph's magnificently dynamic red-gold drapery. St. Joseph effectively and appropriately dominates the picture. In his final form, evolving, as he does, from his counterpart in the Uffizi picture of the same subject through a different arrangement in the Hammer drawing, he is closely related to the Apostles round the rim of the Duomo cupola; and more even than they he echoes (in reverse) the pose of Laocoön, translating its heroic agony into energetic benevolence. It is St. Joseph's drapery, or sash, which is the most violently proto-Baroque feature – and therefore the most indicative of the mid-'twenties as period of origin. But the essentials of the Madonna and Child group must date from a slightly earlier stage in the evolution of the picture, and not from a later one, as they are already more or less established in the Uffizi drawing, where St. Joseph's sash is only vaguely adumbrated.

The similarity of treatment between the figures on the ground in the *Scodella* and in the *Martyrdom* does not extend to the flying angels in the two works, which indeed seem to mark the beginning and the end of Correggio's series in this genre. We have seen that the Raphaelesque type of flying angel shown in the *Martyrdom* was superseded by the Lottesque recession of the angel in the *Agony*, which reappears in a more extreme form in the *Notte*. The central angel in the latter, violently foreshortened from the back, is flanked by others foreshortened from the

[1] Popham (1957, p. 87) follows the orthodox dating for the *Scodella* ('shortly before 1530') and indicates analogies between the Christ child and angels in the Duomo squinches. But they hardly go beyond the angle of the heads.

front. One of these – the one on the left – appears again only slightly modified in the Doria *Allegory of Virtue* (plate 179). In the finished picture (Louvre) (plate 180) this one is joined by a new variation – two more flying figures, also seen from the front, but considerably less violently foreshortened. Finally (omitting discussion of the Duomo angels, since the point concerns the angels' relation to the rectangle of the frame, and the latter does not exist at the Duomo) in the *Scodella*, yet another type emerges. Despite the animation of the angels there is very little recession, and the forms are of far greater elegance. If, in addition, we bear in mind that the early Hammer drawing shows the Holy Family recognisably related to their final form, whereas the glory overhead hardly even adumbrates the painted version, the most logical conclusion would be that while the figures on the ground in the *Scodella* are likely, in essentials, to date from the mid-'twenties the glory of angels overhead was probably not executed until much nearer the date of the picture's inauguration in 1530.

It was suggested earlier that Correggio may have painted the London *Agony* (plate 96) as an experiment for the lighting of the *Notte* (plate 107). In any case, it cannot be denied that there are affinities between the great *Notte* (Dresden) and not only the miniature *Agony*, but also with the cabinet size *Madonna Adoring* (plate 99). The two smaller pictures – and to some extent also the *Noli me Tangere* (plate 98) – can be included among the foundations on which the altarpiece rests. In all of them illumination plays an essential part, though it is gentler in the *Madonna Adoring* and *Noli me Tangere* than in the other two. The *Notte* may in fact be regarded as the culmination of Correggio's renewed interest in the depiction of strange lighting effects – that aspect of his art which is one of the main accents of the mid-'twenties. In this connection it is of some interest that in the *Madonna Adoring*, as in the *Notte*, Correggio reverts to his old idea of an unfluted column to facilitate the play of light. I suspect also that it was the desire to obtain the new light effects which caused him to experiment technically. For the blazing light of the *Agony* a very fluid medium, for the gentler illumination of the *Madonna Adoring* an impasto thinner than his usual, and for the dramatic contrasts of the *Notte* a thicker one.

When we consider these analogies between the *Notte*, on the one hand, and the *Agony* and the *Madonna Adoring*, on the other, and also those between the latter two pictures and the Del Bono *Martyrdom* (plate 79), the usual dating of the execution of the *Notte* to the latest 'twenties becomes highly improbable. One other consideration may be mentioned which fixes the Notte to the mid-'twenties – say *c.* 1525/6 – even more firmly. In the other main works of the period – the Del Bono laterals, the *Madonna with St. Sebastian* and the design for the Duomo cupola – what has appeared to art historians of the present century as the proto-Baroque peak of Correggio's art may also be seen as the extreme limit to which he gave rein to his love of

proposing and conquering inconceivable technical difficulties. How well the *Notte* fits this context! Together with the Duomo cupola it is the most tremendous, almost blatant, piece of virtuosity of them all. The simple original arrangement in parallel planes, shown in the Fitz-william drawing (plate 109B), is transformed into a violently receding diagonal, with the main figures at the end of it. This is accompanied by drastic foreshortening, not only of the most prominent figure, the shepherd (again the reversed Laocoön pose), but also of the angels over-head. The right leg of the nearest one is bent. We see the sole of his right foot, almost parallel with the picture plane and hardly foreshortened at all. Behind that is the calf of his leg, strongly foreshortened, and almost concealing the thigh. Next we are regaled with a display of his but-tocks, then a piece of drapery, and then his arms, splayed out on both sides, his left cutting across his face, of which we see the mouth, nose and left eye, all so steeply foreshortened as to be recog-nisable only with some effort. In addition, the head of the next angel on the right is so arranged that for a moment we may think it belongs to the first one. (Vasari said he thought these angels looked as though they had been rained from heaven, which reflects on his idea of the latter; had he said the same of the comparable feature in the *Scodella* I should have agreed with him.)

Nor is the foreshortening in the *Notte* the only cause of distortion. The bravura display of vivid illumination from the child – originally, perhaps, a Northern idea though it had recently been used in Italy by Lotto (in a small *Nativity* in the Siena gallery) – together with the near darkness elsewhere, imposes arbitrary contrasts which totally distort form and colours alike. Thus, the Madonna's bodice varies from crimson to pale pink according to how far various parts of it are from the child: the other clothes explore varieties of green and blue and grey, all set in a sea of grey brown. Forms, whether flesh or drapery, which project are hectically distinct, others virtually non-existent. None in this incredibly beautifully painted picture is a beautiful form in the classical sense, or even an individual form at all. Everything seems at first merely a component in an effect of magic light. On a more prolonged study, perhaps the most extra-ordinary and enduring achievement of the *Notte* lies in the monumentalising of the incident by a more fundamental method than monumentality of design alone. For the peasant figures have themselves been monumentalised, out-Murilloing Murillo.

The *Notte* is the only one of his altarpieces which may still be seen – even if only in a copy – in the setting which Correggio intended. Its elaborate architectural frame – presumably (on the strength of an autograph drawing (Popham 73) (plate 166A) for a frame of similar design for the Dresden *Madonna with St. George*) of the painter's own design – is still *in situ* in S. Prospero at Reggio, framing the seventeenth-century replacement. With none of the other great altars is even this much the case. The original architectural settings and the original frames are alike un-

known in the case of the *St. Sebastian* and the *Giorno*. The original frame and the original chapel of the *Scodella* both survive intact, but not united; and the copy in the original chapel has a makeshift frame. And though the wash drawing at Dresden, already mentioned, gives an idea of the master's plan for the frame of the *St. George*, the architectural setting has long since vanished without trace.[1]

[1] A curious feature of the *Notte* is the shepherd's dog, which was included in the early Fitzwilliam drawing but which, in the painting, gives the impression of having been added at the end. Thus, its face is almost indistinguishable from part of the manger, and may even have been that earlier, while its body is almost invisible in the darkness.

X THE DUOMO

THE CONTRACT BETWEEN COR-
reggio and the authorities of Parma cathedral is dated 3 November 1522. The original fee of 1,200 ducats was altered on the document itself to 1,000, but an extra hundred seems to have been allowed for expenses, making 1,100 in all. The subject of the frescoes is not specified, but was not to be of the painter's choice. Correggio undertakes to depict such subjects as will be given to him, imitating the life, or bronze or marble, according to the exigencies of the site and the function and appearance of the painting. It is not entirely easy to relate the terms used for the location of the various parts of the work to the actual architecture of the building. But I interpret the wording to mean that Correggio was to paint the cupola down as far as the four supporting arches, and then, in all probability, the same portions of the choir as were finally decorated by Mazzola Bedoli, namely the vault of the single bay, the arch of the apse, the half dome of the apse and the friezes. It appears from the documents recording payment to the artist that the work was regarded as falling into four stages, or quarters. The first can only have been the cupola itself, and the second the squinches (which are very large), with the pieces of vertical wall between them and the under-arch paintings. The main items in the third and fourth sections, which Correggio never carried out, would have been the choir vault and parts of the walls on the one hand, and the apse on the other. Though a memorandum of the contract speaks of 'tutto il coro' it is impossible to believe that it was ever intended that Correggio should fresco the *whole* of the two side walls. They are colossal in themselves, and would have made nonsense of the division of the work into quarters. Moreover, the contract of 1536 for Gandino del Grano to do the same job specifically excludes, at least for the time being, the main rectangular areas of the side walls from the surfaces to be decorated (Martini, 1865, page 181). The first surviving payment to Correggio was made on 25 November 1526, and the second and last on 17 November 1530.

The 1526 payment amounts to seventy-six gold ducats and thirteen Imperial soldi. It is specified as being 'pro completa solutione' ('on account for the complete payment') of 273 gold ducats, the agreed sum for the first quarter of the whole work. Pungileoni and some later writers assumed that this meant that it was the final payment for the first quarter. But a contemporary note attached to the document itself refers to it as being on account[1] and this is how I too would interpret it. As the final payment in 1530 is of 175 ducats and is specified as an end payment for the second stage, there must (at the rate of 275 ducats per stage) have been others of which no record has survived. Some of it would have been anticipatory payment – therefore in excess of the 550 ducats for the first two quarters – as the artist's family were compelled to refund 140 Imperial lire (twenty-eight ducats) no less than twenty-one years later (1551) for work

[1] R. Tassi 1968, p. 158.

which he never did.[1] We may note without further comment that at S. Giovanni Evangelista Correggio seems only to have received 272 ducats in all.

The structural preparations in the cupola – cleaning, repairing and plastering – were not contracted for until November 1523.[2] At that time Correggio would have been finishing his work at S. Giovanni. If the structural work was also seasonal and therefore not put in hand until the following spring or summer that would have retarded the start of the painting still farther. The payment of November 1526 to Correggio probably is a reliable indication that by then he had done *something*. Venturi seems to assume that half of this stage of the work (presumably the actual cupola) was then complete.[3] But this argument need not be valid, since it is based on the absence of records of payment in the years 1527, 1528 and 1529, and this is probably accidental. But one important conclusion seems certain. Though we do not know precisely when Correggio started painting at the Duomo, the design of the cupola itself – *The Assumption of the Virgin* (plates 110–139, colour plates G and H) – must date from not later than the mid-'twenties and therefore illustrates Correggio's style at that period and not at a later one.

For it seems clear from a double-sided drawing at Oxford (Popham 50) (plates 122A and B) – to which we will return – and abundantly confirmed by the totality of the other drawings and from the nature of the undertaking, that the planning of the whole of the cupola proper – down, at least, as far as the cornice below the round windows – was worked out as a unit and must therefore have been complete before any painting was done. This much – design and cartoon – must consequently date from the years 1525–26. But the large paintings in the squinches (plates 141–148) are separate both from each other and from all the rest. Their design could therefore have been postponed until it was needed – until after, that is, the completion of the painting of all the zone above them, perhaps as late as 1528–29. It is true that the small sketch (Popham 62r) (plate 139A) which contains an early idea for one of the standing apostles (above the main cornice) also has a sketch of a frieze, which *may* be an early idea for the Duomo frieze, which is below the main cornice. But it is not certain that it is for this frieze, and even if it were that would not prove that the designs for the squinches also dated from then.

What is undeniable is that the colours used in the squinch paintings are softer and more subtle than those higher up in the cupola, and therefore seem characteristic of a later phase of Correggio's style as a painter. But this would be the case whether the designs had been made immediately before the painting or several years before it. In essence the problem is: are the *designs* of the squinches characteristic of the Correggio of the mid-'twenties, that is, of the period of the

[1] Gronau 1907 (p. 163) unwarrantably assumes that the Duomo work continued after 1530. Venturi (*Storia*, p. 471) suggests the refund concerned gold leaf.

[2] R. Tassi 1968, p. 157.

[3] Venturi, *Storia*, IX, II, p. 469.

Del Bono laterals (plates 79 and 84), or of the period around 1528–29, that is, of the Dresden *Madonna with St. George* (plate 163)? If we consider the striking resemblance between the figure of St. Thomas on the south-west squinch (plate 145) and the central figure in the Louvre *Vice* (plate 182) – which I would date in any case around 1529 – we might conclude that the latter possibility is the more likely. But this may not be a true clue. The two figures in question are examples of a genre – the bearded male, sprawling with his legs apart – which appeared at various earlier stages – in the cupola of S. Giovanni, for instance, in several versions (most closely in the apostle two to the right of St. Peter (plate 46)) and again in the sleeping St. Roche in the *Madonna with St. Sebastian* (plate 100). The type could also be adapted to a standing figure, as in the St. Joseph of the *Scodella* (plate 105) or the apostles standing round the rim of the Duomo cupola (plates 123–135). Owing to Correggio's habit of repeating his own motives the mere fact of repetition is no guarantee in itself of proximity in time (and in these particular figures we must remember that much of what they have in common is due to ultimate dependence on the *Laocoön*). The nature of the repetition and the degree of the resemblance, together with similarities of treatment and other analogies, will therefore count for more. In the present case, however, the central figure in the *Vice* seems so much a conflation of the St. Thomas at the Duomo and of another of the squinch figures, namely the Baptist (plate 143), that I should be inclined to assume proximity of date, and therefore that the squinches may not have been designed, at least in detail, until shortly before they would have been needed, presumably around the years 1528–29 (we have seen the same principle may have applied to the S. Giovanni pendentives). But it will be seen that the indications are very slight, and the alternative hypothesis would remain open, particularly in view of the fact that none of the squinches show that deliberate truncation of part of one figure by the one in front of it which is a conspicuous feature of the *Madonna with St. George*.

In view of the structure of the building it can be assumed that the scaffolding which would have been erected for the painting of the cupola would not have been removed when the *Assunta* was finished, as the squinches and arches which are lower down were still to be painted. It therefore follows that when the adverse criticism was first voiced, the fresco – in the cupola – which caused it had been in existence for some time but had not been revealed.[1]

At S. Giovanni Evangelista Correggio had painted a single figure – Christ – against massed cherubs' heads in the centre of the cupola, a ring of eleven apostles round him and another single figure – the aged St. John – in the zone below. At the Duomo he also showed a single figure in the centre, and again (despite the ostrich-like assertions of the mid-nineteenth- and early

[1] A letter of 1559 from Bernardino Gatti says 'I have no wish to submit to the judgement of such persons: you know what was said to Correggio at the Duomo'. (Affò 1796, p. 25.)

twentieth-century critics, who, disturbed by the athletic pose, claimed him for an angel) it is Christ. But instead of eleven apostles the surrounding circle contains over fifty heads of the blessed, not all identifiable, but including figures from both Old and New Testaments. Slightly lower down, the Virgin Mary joins them, escorted by thirty or forty angels. Lower down again, instead of a single figure there are some twenty-nine youths who tend torches which rise from the angles of the octagon; and only at the lowest level of all are the apostles – gigantic figures, imagined as disposed round the drum of the dome, the enclosed octagonal abyss standing for the Virgin's empty tomb. While in both churches there are friezes painted in grisaille under the structural cornices, at the Duomo, in addition, there is a large, *trompe-l'oeil* cornice above the real one. In between is simulated architecture round the eight (real) circular windows – some-thing which does not occur at S. Giovanni in the cupola proper. Instead of a mild confirmation of the axis of the church of S. Giovanni through the line of the central figure and unobtrusive accents at both ends, the whole of the zone of the Duomo cupola containing the angels is tilted in the direction of the spectator advancing east from the nave, and this introduces a new and dynamic principle. At S. Giovanni Evangelista the apostles, being enthroned, were static, and even Christ, floating in the upper air as part of St. John's vision, is scarcely moving. But at the Duomo the tilt of the ring reveals the Virgin Mary sucked up in a whirlpool as though from the floor of the building, on to which Christ, in the centre, seems about to drop. The idea of forceful communion between the spectator and the figures in the painting – which Correggio had em-bodied at about the same time as the designs for the cupola in the altarpiece of the *Madonna with St. Sebastian* – is now applied to murals. Finally, instead of retaining the same scale for the figures throughout the cupola – as was virtually the case at S. Giovanni (Christ, being slightly farther away, is slightly, but only slightly, smaller) – Correggio uses three different ones at the Duomo, which diminish in abrupt stages from the colossal apostles through the youths to the angels, and thereby give an effective illusion that the farther figures are farther away than they are. The enormously greater complexity of the Duomo design needs no further emphasis.

Though the one obviously evolved from the other – and the opportunity to correct the faults of an initial attempt in a second soon afterwards, and to pursue the ideas adumbrated in it, was one which had been accorded to few great artists – the surviving drawings for the Duomo cupola are insufficient to allow us to plot the evolution in detail. The double-sided sheet at Oxford (Popham 50) (plates 122A and B) constitutes the main evidence.

Popham assumed[1] that the tall figures standing on the top of the parapet on the recto of this sheet were meant as apostles, and identified the figures seated lower down (close to sphinxes who were ultimately transformed, and banished to the frieze) as prophets. He dismissed the idea that

[1] Popham 1957, p. 75.

the latter could be apostles on the ground that, flanking the windows as they do, they would amount to a total of sixteen. A further point, not used by Popham, argues his case even more cogently, for the apostles were participants in the Assumption, which these figures assuredly were not. Popham also omitted to point out that the right-hand seated figure on the verso of the Oxford drawing seems to be female. Consequently, the series at this stage is likely to have envisaged an alternation of prophets and sibyls, as in the S. Giovanni Evangelista frieze, rather than only prophets. We may note that Correggio originally planned more elaborate painted architecture – pilasters in the Oxford drawing, and a kind of half column in a sketch at Haarlem (Popham 52v) (plate 122C) – than the surprisingly austere style as executed.

It is the element of violent participation in events overhead (as shown by the two large figures standing on the right of the parapet on the recto of the Oxford drawing) which gives further support to Popham's interpretation of them as apostles. But it is significant, and also characteristic of Correggio, that having evolved the attitude of the largest figure (in the centre of the sketch) in the context of the area just above the parapet, he reallocated something of it to one or more of the ephebes when the apostles were transferred to the lower level. In any event, it seems certain that the final position of the apostles, standing at the base of the painted parapet, was only decided at a late stage. As, in one instance, this appears to have resulted in obscuring one of the ephebes who was already fully evolved, Popham suggested it was 'an almost desperate expedient to overcome a miscalculation'.[1] It is the apostles in their present state which may, just conceivably, reflect some distant awareness of Titian's *Assunta*.

There is no evidence from the drawings that the Virgin Mary was ever in the centre of the ring – where, perhaps, we might expect to find her, since the subject of the fresco is her Assumption. Her present position, on the east side, is calculated so that she is framed by the nave arch as the spectator starts to mount the steps to the crossing.[2] Presumably this indicates that in this case and to this extent the painter set more store by the first impressions than by inspection from directly underneath.

The different scales used in the Duomo cupola for the figures in the different zones, and the areas of open space left between them, effectively correct the fault of S. Giovanni Evangelista, where the gigantic figures of the apostles, being sited halfway up the curvature, were differentially foreshortened by it. At the Duomo the apostles are perhaps even larger, but as they are depicted as standing, and are situated at the base of the cupola where the wall is nearly vertical, the problem was different, being more in the nature of ordinary foreshortening (in this case extreme). The torch-tending youths, though assumed to be standing higher up, are also imagined

[1] Popham, loc. cit.
[2] The existing steps are post-Correggio, but on account of the crypt there must always have been some.

as farther out, so that their heads are a little higher up in the curvature than those of the apostles. And by the time we reach the zone of the angels the critical area of curvature is past. In any case their scale is much smaller than that of the S. Giovanni apostles.

The faults of S. Giovanni Evangelista, then, have been eliminated. But at a price. The price of most Baroque decoration – which in essentials, the Duomo cupola already is – and of much of Baroque art in general, namely the impersonal, almost the inhuman. By imagining an eye-level far above the spectator's actual one at S. Giovanni, Correggio had been able to show the bodies, and above all the faces, of the apostles without exaggerated foreshortening. But at the Duomo he seems really to have calculated the perspective from something like the floor of the cathedral, eighty feet or so lower down. This can be confirmed from the fact that the painted cornice is so convincing that Queen Christina is said to have insisted on climbing up to it before she would believe it was false. (The narrow gilded moulding, or cornice, above the squinches is the only structural projection.) As a result, none of the faces of the main characters are fully visible, and in some of the clumps of angels the heads are not shown at all. All we see is their wildly cavorting – and wonderfully beautiful – legs – in poses which, like those of the angels in the *Agony* and the *Notte*, may owe something to Lotto's work of the early 1520s.[1] The jibe said to have been thrown in Correggio's face that all there was was a hash of frogs is at least comprehensible.[2] Even the apostles in the lowest zone, magnificently impressive as they are, are totally impersonal through the extreme foreshortening and consequent distortion of their features. In addition, they are even more unidentifiable than their counterparts at S. Giovanni Evangelista: they merely set the tone by their grandiloquent gestures and impressive silhouettes. The type and gestures of most of them hark back to the *Laocoön*, combined with further reminiscences of late Gothic sculpture in the draperies. The result of the marriage is, in essentials, the Baroque sky line figure. They include an effective piece of theatre. The two apostles nearest the Virgin shade their eyes. The radiance is too great for them – just as, in the *Notte*, that of the Christ child was too great for all *except* her. The Virgin Mary herself, higher up still, is seen from so far underneath that she must always have been difficult to discern, and is now almost impossible to see, as the pigment of her clothes has faded. As to the descending Christ, he is so distorted that the wishful thinking, which (till the beginnings of his beard were revealed by detail photography) would make an angel of him was at least understandable. For this reason the most satisfying element in the design of the cupola proper – that is, not considering, for the moment, the squinches – are the torch-tending youths, some of whom squat or sit on the parapet, while others stand behind them (colour plate H, plates 123–138). As they are imagined as farther back the foreshortening of the latter is less

[1] E.g. the altar of the *Madonna and Saints* at S. Bernardino, Bergamo (1521) (fig. 30).
[2] Tiraboschi 1786, p. 265.

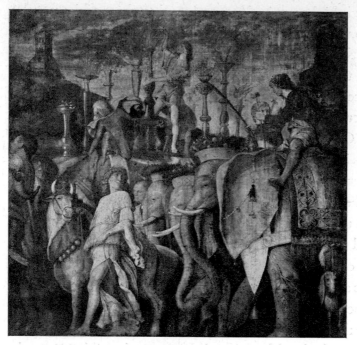

Figure 35A
Mantegna, *The Triumph of Caesar* (part)

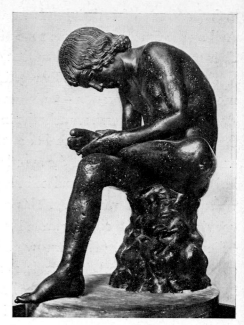

Figure 35B
Boy removing a Thorn (*Il Spinario*)

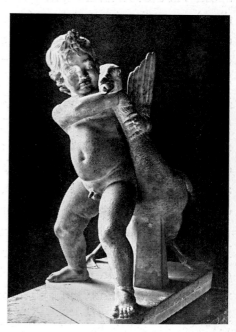

Figure 35C
Boy with a Goose

steep. In addition, they are permitted not to look at the celestial events overhead, but to mind their own business and even, in some cases, to look inwards towards the spectator. As a result their beauty is fully revealed. It is very great. Some memory, perhaps, of the Sistine *ignudi* lay behind them, as it may have done with the subsidiary figures in the pendentives of S. Giovanni, but here treated with even greater lightness and delicacy. It is assumed that they are taking part in a pagan funeral rite for the Virgin (the motive of the youths tending the torches has long been recognised as deriving from the scene with the elephants in Mantegna's *Triumph of Caesar*, fig. 35A)[1] and pagan, in the best sense, is what they are. The prototype of the standing youths was probably the Greek bronze *Adorante* now at Berlin. Of the youths who sit

[1] Ricci 1930, p. 107.

I

The Martyrdom of St. Sebastian from the Marriage of St. Catherine. Detail
Paris, Louvre. See plate 161 A and page 117

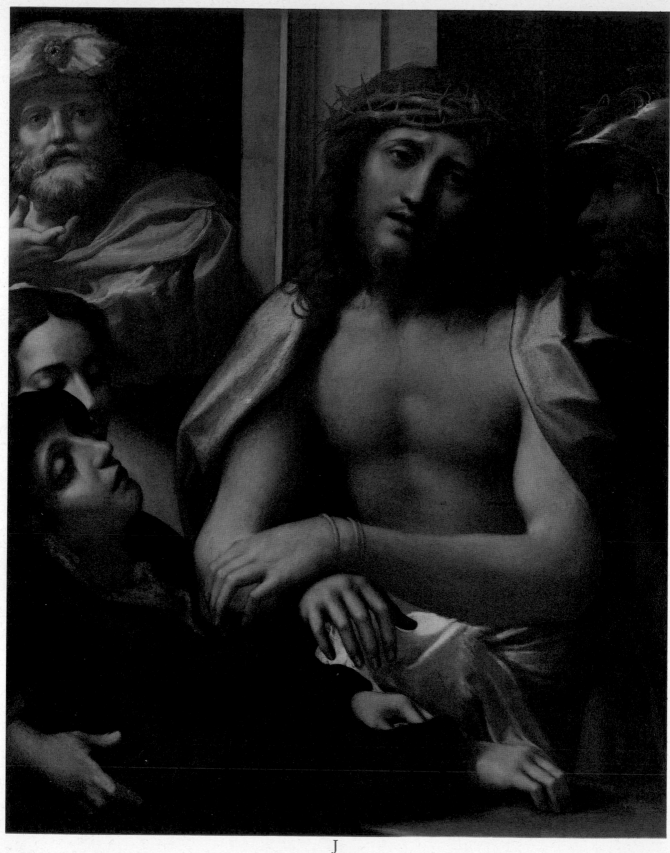

J
Ecce Homo
London, National Gallery. See page 118

on the parapet, one (best seen in the Louvre drawing, Popham 60, plate 134C) with his left foot over his right knee, is an obvious derivative of the *Spinario* (fig. 35B) – one of the most unavoidable Antiques to a man of the Renaissance, and of which a version is actually known to have belonged to Isabella d'Este at Mantua. Others vary this pose.

The bronzed bodies, lightly draped, are set off by the blue of the sky as the youths go about their ritual, igniting torches or sniffing incense in their fingers. Like the other figures in the cupola and as at S. Giovanni Evangelista they are imagined as lit, not by the real windows beneath them, but by an imaginary illumination at the top of the dome.

The technical procedure whereby these miracles were achieved is still obscure and likely to remain so. Some of the preliminary drawings are squared, and even the earliest of them – the Oxford sketch – takes account of the angles in the lower zones of the cupola (higher up it becomes roughly circular). With one possible exception, a small fragment,[1] no portion survives of the cartoons which must have been made for every component of the design. In order to draw them the artist would have been faced with the problem of depicting, with the utmost realism, aerial postures which would never be seen in real life. Clearly, inanimate models must have been used at some stage. In the mid-seventeenth century Vedriani[2] claimed that the sculptor Begarelli provided these, though as a source this is too late to be necessarily true. In modern times Meder considered that he had demonstrated this in principle by arranging a model figure in the attitude of one of the flying angels in the cupola and then finding that its appearance from different angles corresponded with other figures in the fresco.[3] Popham assumed that both here and at S. Giovanni Correggio had reversed a number of his drawings and cartoons for use in different contexts. But on this and other secrets of procedure there is little but surmise. Like almost every other element of the Duomo cupola the actual implementation of the design in cold paint on a curved surface high above the ground would have involved superb stage management.[4]

The friezes flanking the four round-headed openings under the cornice at the Duomo (plates 140A, 140B, 152, 153), and the single grisaille figures at the base of the north, south and west crossing arches (plates 154–156) (the decoration of the fourth, on the east side, is later) are comparable with the corresponding features at S. Giovanni. As at S. Giovanni – perhaps even more so – the friezes show evident influence of the Antique – apparently a series of variations on a version of the well-known *Boy with a Goose* (fig. 35C). At the Duomo both the grisaille figures and the friezes are more brilliant in execution, and lighter and less solemn in conception (the

[1] Popham, no. 71 (plate 150B). [2] Vedriani 1662, p. 50.

[3] Meder 1919, p. 552.

[4] I understand that Dr John Shearman, in a hitherto unpublished lecture, postulates actual influence from a theatrical performance.

sphinxes over the arched openings in the frieze, whimsically looking up at the events overhead, are an unexpected and extraordinary feature).[1] The same applies, *a fortiori*, to the Duomo squinches when compared with the pendentives of S. Giovanni. At the same time, the omission of Correggio, the super-virtuoso, to indulge in the more extreme complexities of architectural foreshortening seems at first surprising. At S. Giovanni Evangelista there is none within the cupola zone. And at the Duomo I have the impression that the *trompe-l'oeil* parapet – brilliantly conceived and executed, but limited in scope, was only included because the presence of real windows at this level would have impeded what was clearly, at this time, Correggio's main interest – the depiction of limitless space.

The subjects of the squinch paintings are four of the patron saints of Parma – Bernard, Thomas, Hilary of Poitiers and the Baptist (plates 141–148) – and their presence under the cupola painting of *The Assumption* (to which, in the form of Maria Assunta, the cathedral is dedicated) has suggested that the theme of the whole is 'The Glorification of the Five Patrons of Parma' (Maria Assunta being the first of them).[2] The squinch paintings, which are surmounted by huge and superb swags of painted fruit, and delimited at the top, as in the Camera di S. Paolo, by painted shell mouldings, are, from their position, the easiest to see of the Duomo decorations. The basic scheme is similar to that of S. Giovanni, and use is made of the same trick of allowing the clouds to invade the area of the painted mouldings (which in this case have astonishingly vivid contrasts of painted light and shade). But at the Duomo there is only one main figure per squinch, instead of two, and there is little solemnity left in them. Indeed, the incredible frivolity of the exquisite attendant angels – who are older than those at S. Giovanni and apparently include females – is only just within the limits of the decorum to be expected in a cathedral church. They are divinely beautiful and enchantingly naughty. What is more, they are aware of the presence of their fellows in the neighbouring squinches, and glance across at them or wave.

In addition to the difficulty of studying the Duomo cupola on account of its height the spectator must realise that he is seeing only a portion of Correggio's plan. As at S. Giovanni the apse would no doubt have been closely co-ordinated with the design of the cupola, so that each would have increased the effect of the other. It also seems likely that the apse would have been very different from the cupola. The design of the latter represented both the climax of the proto-Baroque in Correggio, and a catharsis in his personal development. It may also be regarded as perhaps the greatest *tour de force* in Italian art. Immediately afterwards, as we shall now see, his painting took a different, and perhaps more personal, direction.

[1] A. O. Quintavalle 1935, p. 240.

[2] For sphinxes in general cf. A. Chastel in *Atti del IV Congresso internazionale di studi umanistica*, Venezia, 1958 (Padua, 1959), pp. 179ff.

XI THE 'GIORNO', THE 'MADONNA WITH ST. GEORGE' AND OTHER RELIGIOUS PAINTINGS OF THE LATER 'TWENTIES

AFTER THE *NOTTE* AND the design for the Duomo cupola the demon of virtuosity for its own sake, or nearly, seems to have exhausted itself – at least as regards foreshortening and light effects. Certainly the *Giorno* (Parma Galleria) (plate 157) which, in my view, was the next of the great altarpieces in the order of execution – I would place it around 1527, which, in the absolute, is fairly orthodox dating – though brilliantly handled, is free of it. Though it is physically the smallest of the great altarpieces, I would agree with the verdict of centuries in regarding it as Correggio's masterpiece among them. There can at least be no doubt that in this work he was completely successful in creating an incident out of a state. St. Mary Magdalene caresses the Christ child as though she were St. Catherine being married to him (Vasari, by a significant slip, actually thought, in his first edition, that that was who she was) and St. Jerome presents his translation of the scriptures to the Christ child. It is supported for him by an angel – presumably the one who dictated it.

The evidence of a preparatory sketch at Christ Church, Oxford (Popham 75) (plate 160A) (unfortunately in itself undatable: the altar is said to have been commissioned as early as 1523) shows that the Magdalen cannot originally have been doing what she is in the finished picture, and suggests that the commission was merely to represent the Madonna and Child enthroned with Saints Jerome and Mary Magdalene. The devising of incidents to weld the persons together would have been of the painter's doing. The Christ Church drawing has been so much worked on that it is very difficult to read. But if we keep in mind the meaning of the finished picture it is possible to do so (see diagrams, plates 160B and C) and the result is pre-eminently enlightening on the subject of Correggio's creative processes.

In the first stage St. Jerome was in the position that was later occupied by the Magdalen. He is in close proximity with the Christ child, to whom he presses his face while proffering his book with his left hand. At this time the Magdalen must have been behind him, where there are some amorphous marks on the sketch.

Perhaps it was felt that this arrangement gave too little prominence to St. Mary Magdalene (the picture is supposed to have been commissioned by a woman). At all events, St. Jerome was moved to the extreme right (he is drawn there on top of his earlier form), leaving his earlier position free for St. Mary Magdalene. By this means, she became prominent enough, but he

was now too far from the Christ child to offer his book himself. It is therefore offered for him by the small angel who is introduced on the left of the picture. But this arrangement in its turn brought with it the disadvantage that in order to receive the book the Christ child had to turn his back on its donor. A further change was therefore made, transferring St. Jerome to the left and pushing his angel (now in front of him) farther into the picture. A small sketch recently discovered by J. Byam Shaw in Venice, shows both Madonna and Child facing left, and may have been drawn in this context (plate 160D).

A peculiarity of Correggio's methods of work is illustrated in two ways in the *Giorno*, namely his tendency to revert to one of his own inventions, regardless of whether he had fully realised it before, or only toyed with it. Thus the last two positions of St. Jerome – of at least three – resemble that which Correggio had contemplated for the shepherd in the *Notte* at Dresden from at least the time of the Fitzwilliam drawing (plate 109B). Secondly, the earliest – and discarded – idea for the design of the *Giorno* which we can deduce from the Christ Church drawing was realised soon after, as we shall see, in the Louvre *Marriage of St. Catherine* (plate 161A).

In the *Giorno* the genre of the Madonna Dethroned reaches perfection. She sits on a kind of grassy rock, in an even stranger attitude than in the Dresden *Madonna with St. Sebastian* (plate 100), her left leg up (as in the *Spinario*, fig. 35B), the left foot over the right knee to furnish support for the child. As in the Uffizi *Holy Family with St. Francis* (plate 89) and other works there is a marked diagonal movement in the frontal plane of the composition, from St. Jerome, high on the left, to the Magdalen, lower on the right, and this line is emphasised by the curtain above. Like the petals of a rose, the outer, enclosing forms – the curtain, the Magdalen's drapery and St. Jerome's right arm and leg – are long and relatively simple, yielding to tighter and tighter, and more and more intricate forms as they approach the centre. At the same time, the definition of the forms becomes sharper. It is an extreme case of Correggio's focussing technique.

The system of colouring in the *Giorno* is based on restriction of local colours but recurrence of the same ones in different parts of the picture. The red curtain, top right, is of the same colour as the piece of cloth which is seen both behind and in front of St. Jerome (his cloak). This in its turn is of almost the same colour as the Madonna's dress, of which the red is visible in her skirt, and (just) in glimpses of both sleeves. Similarly, her blue mantle, seen on her head, her shoulders and on her lap, where its dull, dark green lining is visible, is the same as St. Jerome's loin cloth and the little boy's towel on the extreme right. Again, the angel's gold tunic is the same as the Magdalen's cloak and as the vertical stripe, or slash, on her left shoulder. Only her cyclamen over-sleeve and skirt recur nowhere else.

The unusual thickness of the impasto was pointed out by Mengs, who thought the result

looked like wax colours fused over a fire. It seems to have been evolved in the *Notte* for special effects, and to have been retained for its own sake. The angel, and the Magdalen – a figure which both Rubens and Boucher might have envied – have come in for the most extravagant praise.

The extreme of sensual beauty, both of form and action, displayed by the latter is indeed only just within the bounds of decorum. With her right foot up, revealing the sole, she presses with her left, so that her head nestles against the Christ child's side – perhaps in anticipation, as Michael Levey has suggested, of her anointing of him. She supports his left foot, while his left hand touches her falling blond hair. The spectator is made to feel that he is doing the same.

The large cabinet-size *Marriage of St. Catherine* in the Louvre (plate 161A) is not only very close in handling to the *Giorno*, with similar thick pigment. It can be reliably dated between about six months and a year after it, for the simple reason that the Christ child in both is clearly a particular infant, clearly the same in both, and clearly that much older in the *St. Catherine*. The latter – Correggio's last rendering of the subject – is exceptional in his work as a half-length of relatively large size and also of an unusual shape, almost square. It is as if the patron had expressed a wish for the *Giorno* on a domestic scale.

The connection is in fact probably closer than might appear at first. For with his curious progression of two steps forward and one step back, Correggio seems, in the Louvre picture, to have realised something like his first design for the *Giorno* – as adumbrated in the Oxford sketch – which he had then changed. There, it will be remembered, he had apparently planned a triangular arrangement, with St. Jerome kneeling to the Madonna and the Magdalen standing somewhere behind him. This arrangement is followed precisely in the Louvre picture, with St. Sebastian in place of the Magdalen and St. Catherine in that of St. Jerome. Here the focal point – the clutch, in the centre, of three superimposed hands, the child's, the Virgin's and St. Catherine's – is much stressed. The mood of the picture is perhaps slightly more sombre than in the *Giorno*, the landscape in particular, including a distant but marvellously vivid view of the martyrdom of St. Sebastian (colour plate I) (in an attitude originally evolved by Correggio for a Bound Cupid) wilder and more summary. As in the *Madonna with St. Sebastian*, and the *Giorno*, the Madonna is here dethroned. She squats on the side of a ledge.

As we have seen in the full-length miniature of the same subject at Naples, so in this larger half-length picture the juxtaposition of the two voluminously-dressed, voluptuous young women – consider the inconceivably opulent folds of St. Catherine's golden robes, with her sword as attribute stuck in them – recalls Titian and Palma Vecchio. Whether Correggio was actually influenced, in the accepted sense, by Venetian practice would be arguable. But some sort of connection may well exist in the reverse sense, as Titian's so-called *Allegory of Alfonso*

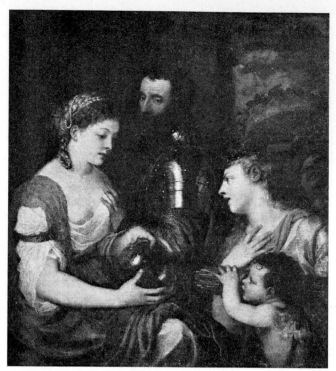

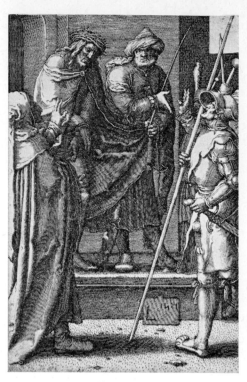

Figure 36
Titian, so-called *Allegory of Alfonso d'Avalos*

Figure 37
Dürer, *Ecce Homo*

d'Avalos (Louvre, fig. 36) repeats much of the design of Correggio's picture and is usually dated later.

A link between the *Giorno* and the Dresden *Madonna with St. George* – effectively the last of the great altarpieces – may be seen in the London *Ecce Homo* (colour plate J), whose handling is also close to that of the Louvre *St. Catherine*. In this strange work the turbaned and gesticulating Pilate on the left, who derives from a Dürer print (fig. 37), is painted in the thick and luscious technique of the *Giorno*, and even the colours of his slashed sleeve – gold and cyclamen – are the same as those of the Magdalen in that work. Some, if not all, of the upper part of Christ's body must have been laid in, and probably also painted, at this time. Then I assume there was an interruption. The X-rays (plate 162A) give evidence of astonishing changes – both of Christ's hands were altered and his cloak thrown back to reveal more of his chest. Another head – perhaps of the supporting Mary – was once just to the right of the present one, whilst her existing right hand was an afterthought, painted on top of the Madonna's dark cloak. The idea of Pilate presenting Christ in this way is itself strange. As the mob which condemned him is not shown the spectator is forced to identify himself with them – a highly disquieting idea. Though the

X-rays cannot clinch the matter, there would be at least a chance that some spectators may originally have been shown in the foreground, and that they were then replaced, as an after-thought, by the Virgin Mary who has, strictly, no business to be present on this occasion. It is she, together with the treatment of Christ's right hand, which, in their different ways connect with the *St. George* and with Correggio's late style. The Virgin's face is a mask, and the face of the Mary supporting her an abstraction. Furthermore, the Madonna's head truncates that of the woman behind her in a carefully calculated discord. As to Christ's right hand, it is painted in a smooth, alabaster-like technique which we have not seen previously, but which was to be the hall mark of Correggio's late style. This composition seems to have exercised an immediate effect on Rondani's fresco of the same subject in the Cappella Centoni of Parma cathedral (reproduced Popham 1957, fig. 41: the series commissioned in October 1527; completed February 1531).

All these features are to be seen in the *Madonna with St. George* (plate 163, colour plate K). It was painted for the Confraternity of St. Peter Martyr, the oldest of the Modena confraternities, and finished, as we have seen, by, or before 1530, when it was copied. The fact that another and junior Modena confraternity – of St. Sebastian – already had an altarpiece by Correggio is enough to explain the eagerness of the St. Peter Martyr confraternity to emulate them. Also, no doubt, why the second one is larger. Not only are the absolute dimensions greater. The figures in the *Madonna with St. George* are larger in relation to the frame than those in the *St. Sebastian*, and in consequence there is less space between them, and more over-lap.

After the earlier altarpieces the structure of the *Madonna with St. George* seems strangely ortho-dox. Having, in the *St. Sebastian*, terrestrialised the Madonna in Glory and, in the *Giorno* and elsewhere, dethroned the Madonna Enthroned, Correggio now reverts to a solid throne set in a kind of open loggia. As so often the main focal point is in an out-stretched hand – St. Peter Martyr's left. A secondary focal point is the Christ child's left foot. At the opposite end of the focal scale the painted sculpture in the top corners, and ornamental fruit between them (wittily supported by a painted moulding, simulating stone, simulating basket-work) represent the ex-treme of brilliantly calculated imprecision, like an out-of-focus photograph. In the *St. George Madonna* the Virgin is seated in a more normal attitude than in the *Giorno* or the *St. Sebastian*, to the extent at least, that both her feet are on the ground. But the device of emphasising her by means of the semi-circular arch overhead, and the wish that this should not be unduly high in relation to the standing saints, has resulted in her being given an unusually, and slightly un-pleasantly, squat foreshortening.

If, in design, the *Madonna with St. George* seems unadventurous after the previous altarpieces, in another respect it is the opposite. The contrast in technique with the *Giorno*, and indeed with all Correggio's earlier paintings, is astonishing – almost revolutionary. The *St. George* brilliantly

inaugurates Correggio's final manner. The paint is now thinner and much smoother, the contrasts of light and shade appreciably less. This seems an astonishing renunciation by Correggio of an absorbing interest. But it could be interpreted, like the introduction of the loggia, as a deliberate attempt to reform the distortions of colour and form of the *Notte*. As they were due to maximum contrasts of direct light and shade Correggio here makes more use of reflected light, which, in its turn, demands an enclosed space. As a result the local colours are more insistent, particularly three shades of red – scarlet in St. George's cloak, a bluer red in the Madonna's dress, and an intermediate, and paler, red in the Baptist's cloak. And there is much greater elegance of line. As the condition of the picture is almost perfect the result is perhaps the most miraculous and the most enjoyable of all Correggio's works, seen as a piece of craftsmanship.

Seen as craftsmanship indeed. But a price, the price of heartlessness, has been paid for the elegance, just as, a few years previously, a price was paid for virtuosity of foreshortening and illumination. In the *St. George* the excessively balletic stance of the Baptist was pointed out long ago by Berenson.[1] In general the figures are no longer even half real. They are idealised and generalised to the point of abstractions. Like all of Correggio's innovations this was to become general in the succeeding centuries; it is only noticeable now because of the contrast with his earlier work. Whereas in the *St. Sebastian* the head of St. Geminian, the patron saint of Modena, is almost a portrait of a bald, elderly man, in the *St. George* the generalised features of the same saint bear little direct relation to those of any specific human being. If we compare the Christ child with that in the *Giorno* the contrast of the real baby in the latter with the abstraction in the *St. George* is even more telling. The fact that the child in the *St. George* clearly derives, in attitude, from the one in the *Giorno* is also a convincing proof – if one were needed – that the *St. George* is the later work.

In other ways, too, the *St. George* derives from earlier altarpieces by Correggio. The stance and pointing arm of the Baptist draw the spectator into the picture, as St. Geminian did in the *St. Sebastian*. But less forcefully. Similarly, in the *St. George*, St. Geminian presents his model of Modena to the Christ child who stretches out his hand to receive it, as did the child in the *Giorno*. But less conspicuously. And both these ideas – characteristically of Correggio, since he had used both of them before – seem only to have been incorporated into the *St. George* at the last moment. In the Dresden wash-drawing (Popham 73) (plate 166A), whose main function seems to have been to clarify the relation of the picture to its destined frame, the Baptist is more upright (the latest in the series of Correggio's adaptations of the Laocoön pose) and the child seems to be turning away from St. Geminian.

This drawing also shows that another prominent feature of the painting was an afterthought.

[1] *Study and Criticism of Italian Art*, first series, 1908 edition, p. 24.

Whereas the foreground is empty in the drawing, in the painting it is filled with four putti. The nearest one has taken St. George's sword, while two of the others are putting his helmet on the head of the fourth. These putti truncate each other with calculated discords as do the foreground heads in the *Ecce Homo*, and a further link between the *St. George* and the *Giorno* may now be mentioned. The figure on the left of the Christ Church drawing (plate 160A) for the *Giorno* – the angel standing with the left leg raised and the right arm stretching across the body – was moved farther back and changed when the St. Jerome was transferred from the right to the left of the picture. But something of him now appears in the *St. George*, divided between two separate figures – the Baptist, situated on the left, like the figure in the Christ Church sketch, and the central putto who holds the helmet. Once again a change in mid-work results in some degree of reversion to an old idea.

The posture of St. George himself, his body, with one hand on his hip, facing diagonally inwards towards the Madonna, but his head turned over his shoulder, was another useful means of drawing the spectator into the picture. This device had been adumbrated in quattrocento altarpieces such as the Pesellino in the National Gallery (St. James, on the left), and in one form or another had run through altarpieces by Fra Bartolommeo, Raphael and Sarto, though never with quite such aristocratic elegance as Correggio shows. It is significant that when, in the seventeenth century, Guercino came to paint a replacement for Correggio's picture this was the figure which he changed the least (fig. 38).

The *Madonna with St. George* raises a puzzling point in the interaction of Correggio and Parmigianino. The extended right arm of the Baptist in the latter's *Vision of St. Jerome* (London) (fig. 34) is almost identical with that of the same saint in the *St. George Madonna*. We have seen that the motive of the pointing arm, associated with Leonardo, had been taken up by Raphael, and how, in the Dresden *St. Francis Madonna*, Correggio seems to have been nearer to Raphael's version of it in the *Madonna of Foligno* than to any original by Leonardo now known. The *Foligno Madonna* was also, and obviously, one of the sources of Parmigianino's altarpiece. His Baptist derives partly from the same saint in that work (the pointing arm), partly from Michelangelo (in the massive proportions) and partly from Correggio (the starfish-like fingers). I have also suggested that it was from Correggio's *St. Sebastian* that Parmigianino derived the idea of bringing the *Madonna in Glory* down to earth. But now the machine seems to go into reverse. In Correggio's *Madonna with St. George*, not only is the Baptist's arm and hand closer to Parmigianino's rendering than to anything in any of Correggio's own earlier work. The foremost of Correggio's putti, in addition, has something of the teasing quality of Parmigianino's Christ child, and perhaps even a little of his attitude. Too much should not be made of the latter, as no one could teach Correggio anything about painting putti. But it is a fact that both these features

– the Baptist's pose, and the putti – were, as we have seen, only introduced into the *St. George Madonna* as an afterthought. We are therefore led to the extraordinary conclusion that Correggio seems to have reacted to Parmigianino's reworking of multiple sources, most of which had already been drawn on by Correggio too, and one of which was Correggio himself. Correggio can never have seen Parmigianino's painting, which was done in Rome in 1527. But we can well imagine that Parmigianino, though not yet resuming residence in his home town, would be likely to have paid a visit to it after his return from Rome (there are some indications that he may have done so in 1529, which would accord well with the suggestion advanced here),[1] that he would have brandished drawings of his latest work and that Correggio, working on the *St. George Madonna*, may have modified it accordingly. The new elegance of the *Madonna with St. George* is attributable

Figure 38
Guercino, *Madonna and Child with Saints*

in general to the climate of Mannerism. Of the various possible channels of transmission I would lay the minimum stress on impulses which would have reached Parma from Siena by way of Anselmi, rather more on Giulio Romano and Mantua and most on the temporary return of Parmigianino.[2] Correggio's pictures of this period (the Allegories for Isabella d'Este are others) have something of the character of crisis, and I cannot entirely dissociate it from the death of his

[1] A payment is said to have been made to him then from the Steccata (see *Inventario degli Oggetti d'Arte d'Italia*, III, *Provincia di Parma*, 1934, p. 68).

[2] In connection with the motive of the pointing arm we may note Torbido's altarpiece at S. Fermo Maggiore, Verona of 1523 (reproduced Berenson, *Central Italian and North Italian Schools*, 1968, pl. 1872). The hand of the pointing angel on the left is of the Correggesque starfish type.

wife, which is thought to have occurred at this time (1528–30). After that, the reminiscences of Mannerist composition disappear. But the new technique, the smooth, alabaster painting with only light shadows, had come to stay, and indeed to increase, if it were possible, in refinement.

It does not seem possible to decide whether the *Scodella* glory of angels was painted just before or just after the *Madonna with St. George*. But as the latter was finished by 1530 and the former not installed until June of that year it is perhaps more likely that Correggio did not complete the *Scodella* (Parma Galleria) (plate 105) until after the *St. George*, and that in the former he deliberately reverted to some extent to his pre-St. George technique in order not to clash too violently with the lower half of the picture. The limbs of the angels in the *Scodella*, when examined from a ladder, are distinctly smoother and more alabaster-like than those of the Christ child lower down, and in general the tremendous elegance of the whole zone of the glory makes the Holy Family look even more earthy than the contrast in their stations demanded. At the same time the *Scodella* glory is less smoothly painted than the *St. George*. I assume that the angel who ties the ass on the right dates from the second period of work on the picture, as he has a good deal in common with several of the figures in the Berlin *Leda* (plate 190). It would also be possible that other details in the lower half were added or reworked during the second period.

The recently re-discovered *sportelli* at Naples with life-size figures are of a certain importance, as bearing a date – 1529 (plate 167). But though of considerable quality – particularly the elegant and noble St. Joseph (?) (rightly compared by F. Bologna with the St. Bernard of the Duomo squinch) – they are fairly slight and would not have occupied the painter for long.

And here, as they have come down to us, is the end of Correggio's religious panels. The triptych from the Misericordia at Correggio may have dated from after 1530, but it is lost.[1] The Firle *Veronica's Veil* (plate 172A) is probably late (it is in the alabaster technique), but slight, while a drawing in the Uffizi for an altarpiece with four saints, related by Popham (no. 78) (plate 194B) to a late commission (Panciroli), was apparently never carried out. This is regrettable, as the sketch is of great interest, suggesting that the painting might have had something of the fluent linear quality of the *Madonna with St. George*. The St. Anthony, standing on the left, recalls the St. Thomas in the Duomo squinch and the ultimate echoes of the Laocoön pose may be made out in the seated saints. An even more shadowy and unimaginable work would have been the decorations for one of Charles V's visits to the town of Correggio (1530 and 1532), vouched for in the seventeenth-century Zuccardi chronicle. In the event, the further development of Correggio's latest style can only be judged by the mythologies.

[1] Catalogue B, page 280.

XII THE MYTHOLOGIES

many insoluble questions in Correggio's career is the speculation whether, had he not accepted the commissions for S. Giovanni and the Duomo, which, in the event, fettered him to Parma for a decade, he might have taken full-time employment with the Gonzaga at Mantua – whether, in other words, Giulio Romano's job might have gone to him. The speculation arises from the consideration that pictures of mythological subject were ideally suited to Correggio's genius, that the demand for them at Parma, where there was no court, would have been slight and that the few which he did paint were probably all done to the order of the Gonzaga family at a distance. If Correggio had been permanently at Mantua (there is, incidentally, no evidence that the job was offered him) might there not have been more of them? There might indeed have been more than the four pairs which is all we have today. But it is probable that Federigo Gonzaga would have made other demands, architectural and no doubt theatrical, which might have been less congenial to Correggio than painting the cupolas.

Nevertheless there can be no real doubt that mythology was his greatest forte. His obsession with technical difficulties would probably have driven him to tackle any branch of art provided it posed enough of them. But only in mythology did his peculiar combination of elegance, sensibility and virtuosity find a completely suitable outlet.

If we leave out of consideration the Leningrad *Apollo and Marsyas*[1] which, despite an early attribution to Correggio, is always likely to remain controversial, and the design represented by the little drawing of a god and goddess, now in the British Museum (Popham 4*), which may not have led to anything, the earliest of his mythological canvasses would have been the *School of Love* (London) (plate 173, colour plate D). Its precise date is nevertheless uncertain, and has been disputed. But most critics would now probably agree in locating it at the end of the S. Giovanni period (a drawing in the British Museum, for one of the S. Giovanni pendentives, has on the back a sketch associable with the Anteros theme (Popham 18v) (plate 178C), and thus with the *School of Love*, while a sketch for the Cupid (Popham 79v) (plate 175D) is paired with one for the Apsley House *Agony*). Its pendant, the Louvre *Venus* (plate 177) (the so-called *Antiope*) would date, in any case, from slightly later. The marked interest in complex light effects which the latter shows would be understandable in a work of the mid-'twenties, roughly coeval (and in this respect comparable) with the Uffizi *Madonna Adoring* (plate 99), the *Agony* (plate 96), the Prado *Noli me Tangere* (plate 98) and the Dresden *Notte* (plate 107). The destined setting is likewise unknown, but the provenance of both pictures from Mantua in the seventeenth century indicates that they were for the Gonzaga, and at the period in question Federigo was enlarging his summer retreat at Marmirolo. This would therefore be a possibility.

[1] Catalogue C, page 288.

The background in the *School of Love* is a dense thicket of the familiar kind. The composition recalls that of the Uffizi *Holy Family with St. Francis* (if we think away the St. Francis on the right of that picture) (plate 89) and the affinity may once have been closer still. X-ray prints (plate 174) show a second head close to Mercury's which resembles that of Venus. As in the *Holy Family with St. Francis*, therefore, the female figure may have been seated, and the male standing on the spectator's left. Whether or not this was originally the case, it is certain, from a further *pentimento* revealed by the X-rays, that Venus was earlier shown looking down at the child Cupid, rather than gazing out at the spectator as she now does.

The *School of Love*, recently freed from the distressing yellow nineteenth-century English varnish, reveals beauties of touch of the highest order. Mengs was understandably rapturous over the delicacy of Cupid's wings and the way in which they seemed to grow naturally from his shoulders. Also over the beauty of his ash-blond curls. Perhaps more remarkable still – and certainly more difficult both to achieve and to analyse – the general tone of the picture is now revealed as having something of grey in it. This was to become more marked in the last four mythologies, and looking ahead to the eighteenth century, as it does, and as Correggio's mature art does so in so many other ways, it strikes a strangely sophisticated note in a sixteenth-century picture.

The *School of Love* illustrates at the outset what was to be the keynote, and in a sense, the most significant and interesting feature, of all Correggio's mythologies. Whereas in his religious pictures he was prepared, on occasion, to be frivolous, in these he is serious. In the Dresden *Madonna with St. Sebastian* (plate 100), for example, the angels are paying little attention to their task of supporting the Madonna's throne, in the *St. George* (Dresden) (plate 163) the infants in the foreground are frankly playing tricks, while the antics of some of the angels in the Duomo cupola hardly bear analysis. But in the mythologies, no matter how erotic the subject, the artist's approach is reverential. The tone is invariably tender and lyrical and nearly always without innuendoes.

In a seventeenth-century inventory, copies of the *School of Love* and the *Venus* are referred to as *Venerie Coeleste* and *Venerie Mundano*. The fact that Venus is winged in the London picture, and that the Cupid in it is already disarmed (his bow and arrows taken from him) and is being taught to read, unequivocally suggests a more spiritual form of love than is shown in the Louvre picture. It also emphasises that the two would have been commissioned as a pair, despite the larger scale of the figures in the Paris painting and its rather freer handling and more advanced *contrapposto*. Attention has recently been drawn to a description in the *Hypnerotomachia Poliphili* of reliefs, and to some actual bronze reliefs, symbolising in both cases the carnal and spiritual aspects of love by the education of Eros and Anteros.[1] We must conclude that whoever

[1] Soth 1964 and Verheyen 1965.

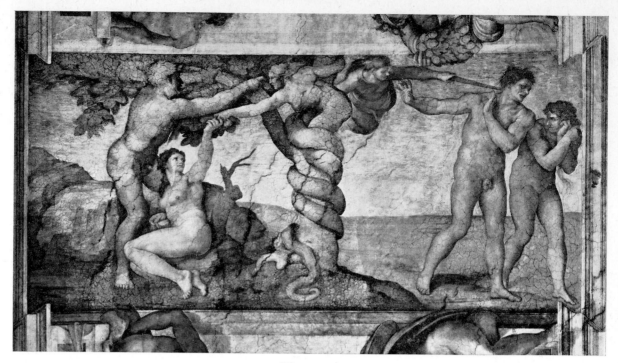

Figure 39
Michelangelo, *The Fall of Man*

gave details of the commission to the painter was aware of this idea, and that Correggio incorporated it in these pictures.

As they would have marked a new departure for him he would have been in need of some such guidance iconographically, and would likewise have had no obvious prototypes in the matter of visual arrangement. In the *School of Love* we have already suggested a derivation of the design from his own *Holy Family with St. Francis* (Uffizi). For the Louvre *Venus* the ultimate inspiration seems also to have been a religious work of a different but equally surprising kind, namely Michelangelo's fresco of the *Fall of Man* on the Sistine ceiling (fig. 39). The way in which the standing male figure extends his right arm over the reclining nude female in both cases convincingly bears this out, and we may marvel at Correggio's ability to make use of a prototype visually but to transform its meaning entirely. For no two works so superficially similar could be more different in content. The sense of guilt and unease conveyed by the sluggish attitudes of Michelangelo's couple is changed to rapturous delight. The beautiful satyr gently lifts the blue drapery. At the sight of the exquisite form he can hardly believe his good fortune.

If, in this superb picture, there is a fault it is one which it shares with Correggio's other major works of the mid-'twenties, such as the *Notte* or the designs for the Duomo cupola. The fore-

shortening of the Cupid is so extreme that the picture might look better without him, while Venus' head has brought with it a peculiar difficulty. If it were the right size its bulk, at that angle, would be insufficient. As it is, it would seem to be disproportionately large if she were to raise it.

The pair of mythological, or rather allegorical, paintings which we may consider next (the Louvre *Virtues* and *Vice* – plates 180 and 182) are exceptional in Correggio's oeuvre on account of their technique. They are also exceptional for Correggio as being allegories of a learned kind, doubtless at the request, and indeed to the specification, of Isabella d'Este, who had a well-known taste for such things, and among whose possessions these paintings were first recorded in the inventory of 1542. The fact that the writer of the latter document (as appears from the wording) did not himself fully understand the meaning of the allegories should have sufficed, one might have thought, to discourage subsequent attempts to interpret them. Anyone disposed to question the wisdom of this has only to collate the various 'interpretations' which have in fact been advanced in modern times, which, as with the Camera di S. Paolo, have shown little or no common ground except a tendency to disagree with each other. Like the riddle of the sphinx, pictorial allegories have always extended an almost irresistible invitation to self-destruction.

The peculiarity of the technique – tempera – of the Louvre allegories was presumably in order that Correggio's pictures should harmonise with the companion pictures by Mantegna, Costa and Perugino, which were in that medium. It would be possible that the unusual technique gave trouble to the artist – what was probably intended as a trial version of the *Virtues*, in the Doria gallery (plate 179), was broken off half-finished – and it certainly gave him no chance to show what he could do. We have only to compare the two Louvre allegories with any of the oils of Correggio's maturity to see why the tempera medium had been generally abandoned by artists within his life time. All the subtleties of finish, which by the delicacy of his gradated tones, he was able to give his oils are lacking in these stark, bright-coloured pictures. By reverting to an archaic medium he was denying himself much of what made him the painter he was.

And yet Correggio took great pains with the compositions. This is shown by three surviving drawings for the *Virtues* (Popham 89 and 90) (plates 181A and B). One of them indicates that the central figure was earlier planned as leaning, rather than sitting, as an element in a receding diagonal composition. In the end, despite obvious borrowings from the Antique, such as the figure with palm and laurel wreath who crowns the central one, the *Virtues* came out more or less like a Madonna Enthroned, and the result does remind us, more than any other of his paintings, of the most heartless of his Madonnas, the Dresden *St. George* (plate 163). It has much of its brittle quality, and the general appearance of the Suida drawing for it (plate 181B) strongly

reaffirms that awareness of Parmigianino which I have already traced in the *St. George*. Though the figure seated on the left repeats the posture of one of the apostles in the London *Agony in the Garden* (plate 96) – which shows further analogies with the Del Bono *Martyrdom* (Parma Galleria) (plate 79) of the mid-'twenties – I should be inclined, as I have already suggested, on the strength of the analogy with the *St. George*, and of the date – 1529 – on the Naples *sportelli* (plate 167) in the same medium, to assign the *Virtues* and *Vice* also to that year.

The somewhat arbitrary dating of these paintings to the last period of Correggio's life – after 1530 – and the general acceptance of this dating has probably been partly responsible for the failure of commentators in the past to realise that, despite absence of documentation, the period of commission can be deduced with a high degree of probability. For in the 1542 inventory they are noted as flanking the door at the end of the Studiolo ('dal capo de la porta ne la intrata') and this door was not constructed until Isabella transferred the contents of her Studiolo – including the decorations by Mantegna, Costa and Perugino – from the Castello to the Corte Vecchia. In a letter of 7 November 1522 Isabella's employee, Carlo Ghisi, recommends her, in order to make more space for the paintings, to wall up the door on the side wall of the new Studiolo (facing the door communicating with the Grotta) and make a new door 'dal capo'. A further letter of 25 February 1523 refers to Tullio Lombardo's design for what was evidently this door and to the desirability, in Isabella's opinion, of executing it quickly.[1] It was evidently not yet in existence at that time. If, therefore, it was the construction of the new door which created the spaces, and thus occasioned the need, for these pictures there is every likelihood of their having been commissioned at that time. It could be argued that Isabella might have thought first of a painter other than Correggio. This is indeed possible, but seems unlikely. A painter resident in Mantua – Costa, or Leombruno (who was in fact decorating another room in Isabella's suite), or, in due course, Giulio Romano – would have had no excuse for not executing such a commission, if it had been offered him. On the other hand, the *bruit* evidently caused by the unveiling of the first part of the S. Giovanni Evangelista decorations in the autumn of 1522 happening to occur precisely when the need arose for a further contribution to the Studiolo decorations seems, together with Isabella's liking for new talent, to tilt the balance effectively in Correggio's direction as the most likely first choice. Why, then, the delay of some six years – until the date postulated here, about 1529?

Several factors would have been relevant. This was the busiest period of Correggio's whole career, the time when his services were most in demand. Also, the fact that he is likely to have

[1] F. Gerola, 'Trasmigrazioni e vicende dei Camerini di Isabella d'Este', *Atti e Memorie della R. Accademia Virgiliana di Mantova*, 1929, p. 269. Also L. Negri, 'Giovanni Battista Covo', *Rivista d'Arte*, 1954 (published 1955), p. 87 and E. Verheyen, *The Paintings in the 'Studiolo' of Isabella d'Este at Mantua*, 1971, *passim*.

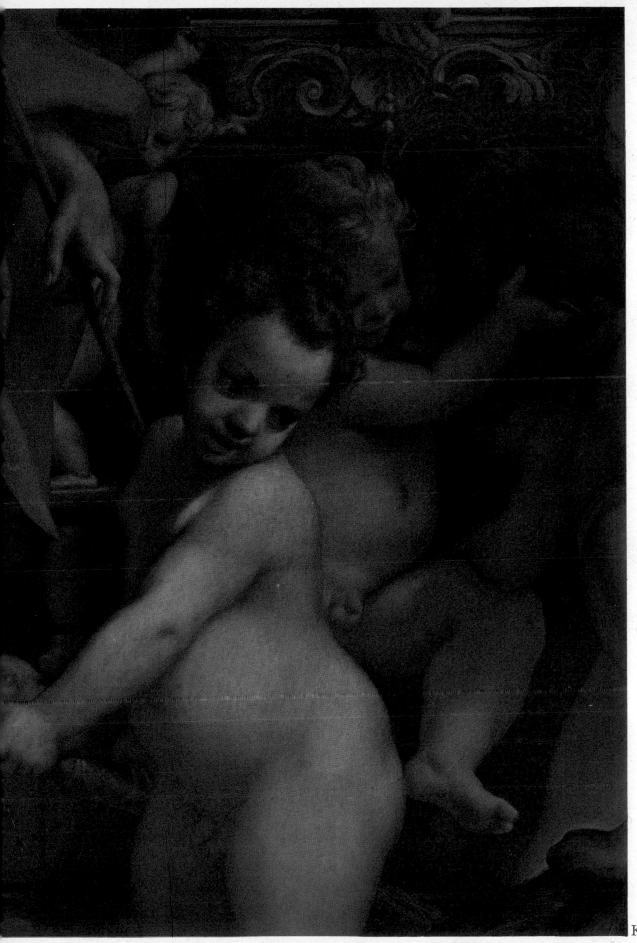

K

Madonna and Child with St. George. Detail
Dresden. See plate 163 and page 119

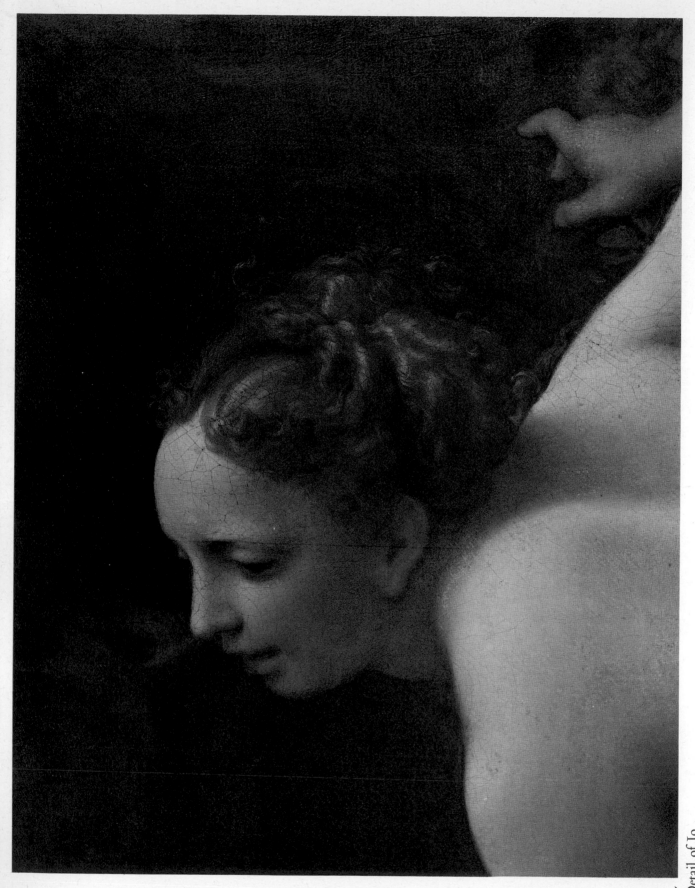

L
Detail of Io
Vienna, Kunsthistorisches Museum. See plate 183 and page 130

delivered the *School of Love* and the Louvre *Venus* to Federigo Gonzaga around the mid-'twenties suggests that he thought that if he satisfied the son, the mother (who, in any case, was away, in Rome, in the years 1525–27) might be kept waiting longer. At the same time, I have suggested that the long delays in executing the *Notte* and the *Scodella* were due as much to practical, external factors as to the pressure of work on Correggio. And it would be possible that a comparable consideration was contributory in this case too. For the carved marble frame for the new door, commissioned of Tullio Lombardo in 1523 may itself have taken some time to execute and deliver. And however confident an impatient employer might be that plans would be carried out exactly, it would have been prudent on the painter's part – with very little space to spare in the small room – to delay starting his canvasses until the new marble door frame was actually in position. In this connection it may be significant that Ricci (1930) – though not making this point – actually postulated a mistake in the dimensions to account for the existence of the Doria version of the Louvre *Virtues*. Though an exact dating cannot be absolutely established it may be assumed provisionally that Correggio would not have started work on the pictures until after Tullio Lombardo's door-case was installed, but that he may have taken *some* steps in this direction soon afterwards. I have already suggested that Veronica Gambara's well-known letter of September 1528 to Isabella d'Este may have been intended as a tactful reply to a discreetly veiled enquiry concerning the artist's progress on the two canvasses. If this were the case it would be a useful *terminus post quem* for the completion.

The *Vice* (plate 182) is slightly less unsympathetic in pictorial effect than the *Virtues*. In its general appearance it seems about as near to Giulio Romano as Correggio ever got. I have already indicated the relation of the central figure in it to two of those in the Duomo squinches, as well as the ultimate derivation of all three from the *Laocoön* (fig. 19A). In the present case that provenance attains its limit. Not only is the central figure in the *Vices* in the line of descent from Laocoön himself. His relation to the flanking figures also owes something to the Vatican marble. Indeed, the Louvre composition can be read as an almost obscene parody of the celebrated group, an act of vengeance on the work which had haunted Correggio's imagination for so long, perhaps as deliberately motivated as Titian's transformation of the participants into apes.

The elaborate drawing in the British Museum (Popham 91) (plate 181C) shows that the head of the boy in the foreground – who looks like the child with the jar on the extreme right of the *Giorno* (plate 157), a few years older – was an afterthought, just as were the putti in the foreground of the *St. George* (plate 163). The most successful part of the picture is the elaborate landscape, but to see to what extent Correggio was hampered by the medium we have only to compare it with the similar, but considerably more beautiful one in the background of the

Berlin *Leda* (plate 190). Popham drew attention to a sheet of studies at Bayonne and plausibly suggested that they were intended for a further picture in the Isabella series, perhaps to supersede Perugino's contribution.[1]

Mention of the *Leda* brings us to the four great *Loves of Jupiter*, an upright pair and two oblongs. The oblong pair – the *Danaë* (plate 188) (Rome, Borghese) and the *Leda* (Berlin) – are described by Vasari (inaccurately, as he was basing himself on hearsay) who adds that they were commissioned by Federigo Gonzaga to give to the Emperor Charles V. Vasari says nothing of the upright pair – the *Ganymede* (plate 186) and the *Io* (plate 183, colour plate L) (both Vienna). But part of his description of the *Leda* – the mention of water running over stones – applies better to the *Io*, and inasmuch as all four pictures are recorded, later in the sixteenth century, in Spain, and as from their subjects they were evidently planned as a series, there can be no real doubt that all four were presented by Federigo to the Emperor. That would not prevent any or all of them having been commissioned by Federigo for himself and then given to Charles, and it would indeed be possible to reconcile Vasari's statement with the remaining evidence on some such lines. We could assume, for instance, that the *Danaë* and *Leda* were, as Vasari says, commissioned on behalf of Charles, and the *Io* and *Ganymede*, whose narrow upright format and complementary lighting suggest that a specific site was envisaged, had been ordered by Federigo for himself, and were already finished when they were seen and admired by the Emperor. Federigo had then given them to him with the promise of two more.[2]

[1] Popham 1957, no. 86.

[2] Two different theories (Swoboda 1935 and Verheyen 1966) have been advanced concerning the original intended arrangement of these pictures. Swoboda, noting a certain continuity in the landscape of the *Leda* and the *Io*, assumed the former was the centre and that the *Ganymede* and *Io* flanked it. He actually used the word 'triptych', and assumed that the *Danaë* was meant to be flanked by two other narrow upright pictures, not executed or lost. However, the three landscapes in the *Ganymede*, *Leda* and *Io* are not entirely continuous, the scale of all three principal figures is different, and the idea of a mythological equivalent of the normal religious triptych is so odd that to sustain it it would be necessary to produce undoubted instances where it had occurred. This the writer made no attempt to do.

Mr Verheyen's essay was more elaborate. He starts (p. 160, n.1) with an attempt at precision in dating the mythologies. He accepts the date 1531 for the *Danaë* given on the print by Desrochers (twice misprinted 'Disrochers'; later on – p. 161, n.6 – the Spanish painter, Caxes or Cajes, is twice misprinted 'Coxes', while a reference to myself – p. 163, n.17 – conveys a misleading impression by omitting the word 'not'). Mr Verheyen assumes that this date was on the painting but came off in a cleaning. A Correggio painting bearing a date would indeed be a rarity, while a comparison of other eighteenth-century prints purporting to give the date of the painting leaves very little doubt that such dates were merely intelligent guesses (see Appendix B). Mr Verheyen continues his investigation by stating that the '*Io* and the *Rape of Ganymede* were painted in 1530' (p. 160). There is in fact no precise evidence of any kind on this point. On the strength of what Mr Verheyen sees as a stylistic resemblance between the *Giorno* and the *Leda* – which, to my eye, have nothing significant in common except Correggio's authorship – he then arrives at a date around 1527–8 for the *Leda*. He then proceeds to give the wrong provenance for the *Danaë*; though the Duke of Bridgewater was a member of the consortium which bought the Orléans pictures *en bloc* this one was never in the Bridgewater collection.

By piling hypothesis on hypothesis Mr Verheyen arrives at the conclusion (p. 169) that 'we may take it for

The occasion is likely to have been one of the Emperor's two visits to Mantua, in 1530 and 1532. Mengs misquotes Vasari to the effect that the gift was made on the occasion of the Emperor's Coronation, which was in 1530. But Vasari does not say this. If the interpretation of Vasari given above were correct the presentation can hardly have taken place on the Emperor's first visit to Mantua, as this was in March of 1530, and the *Ganymede* seems to derive from a figure in one of the Duomo squinches on which Correggio may still have been working at that time. On this theory, therefore, the operative visit of the Emperor is likely to have been his second, in November 1532.

A complication which is likely to have been irrelevant to the existing canvasses of the *Loves of Jupiter*, but which is often linked with them, springs from a letter written by Federigo Gonzaga to the Governor of Parma in September 1534, after Correggio's death. In it he says that Correggio had been working on many things for him and had been paid fifty ducats, apparently on account of some cartoons ('cartoni') of the *Loves of Jupiter*. Any work which he might have started therefore would be Federigo's property. Federigo received nothing on this occasion, the cartoons in question having apparently found their way to the artful Cavaliere Scipione Montino della Rosa, Correggio's old patron.[1] But it is unlikely that they were connected with the paintings. The latter could well have been painted without cartoons, and in the case of the *Ganymede*, at least, being from an existing design, a cartoon would hardly have been necessary. More conclusively, Federigo's letter implies that the cartoons in question were commissioned *per se* – perhaps for him to have woven into tapestries – whereas any cartoons which a painter may have chosen to use in order to paint in oil would only have been a means to an end. Very possibly one series followed on from another. Having given four pictures of the *Loves of Jupiter* to the Emperor, Federigo may have felt he wanted the same subject in another medium for himself. After Correggio's death and Federigo's failure to recover whatever the painter may have done it would be possible that the commission was transferred to another artist. A series of five large cartoons of this subject attributed to Giulio Romano passed through the collections of Queen Christina and Orléans, but it seems doubtful if the attribution to him can now be sustained, and if it could not they are less likely to be connected.[2] Much else concerning the origin of the four mythological paintings must remain hypothetical. But it is in every way likely that they date from the last four years of Correggio's life and that they represent his ultimate style as a painter.

granted that the Sala di Ovidio (of the Palazzo del Te) was planned as the setting for Correggio's *Amori di Giove*'. This, based on so many imponderables, seems to me no more than a remote possibility. On the other hand, Mr Verheyen's section on the available textual sources (p. 184) seems to be of value.

[1] Braghirolli 1872.

[2] The names of Perino del Vaga and Pellegrino Tibaldi have been tentatively suggested for the ex-Orléans cartoons.

The subject of all four pictures was, together with Michelangelo's *Leda*, to which we shall return, the most unequivocally erotic of any great art of the Renaissance. In two – the *Leda* and the *Io* – the actual coition is represented. The other two show the moments immediately before and after it. The fact that all four remain great art and not pornography is partly due to the extreme skill and delicacy of the painter, and partly also to the fact that none of them includes the form of a man, Jupiter having assumed various disguises – an eagle, a swan, a cloud, and a shower of gold – in order to further his designs. All the same, in the *Io*, where the human face and hand dimly emerge from the cloud, the balance is only retained by a hair's breadth.

As in the earlier mythologies, Correggio would have had few or no obvious visual prototypes at his disposal, and seems in the event to have turned to diverse and unexpected sources. After it was first pointed out by Tschudi[1] that the *Ganymede* repeats the angel under the figure of St. Bernard on the north-west squinch of the Parma Duomo (plate 141) somewhat hysterical doubts were cast on the authenticity of the former, as though Correggio were not in the habit of repeating his own motives. Nevertheless, the argument unconvincingly advanced by Ricci in support of this view – that the drapery fluttering upwards is appropriate to a descending figure (the angel) but not to an ascending one (Ganymede) – is at least a good indication that the angel came first. In the event Correggio found a better context for his own invention in the single figure than in the fresco. In the squinch design the angel is necessarily only loosely related to the complex mass of the other figures and clouds above him. But in the canvas Ganymede and the eagle are welded into a superb unity. The smooth outlines of the boy's legs and drapery are contrasted with the jagged feathers of the eagle – another magnificent example of Correggio's ornithological vivacity: the eagle is already licking the boy's wrist – and the dark feathers wonderfully set off the alabaster-like flesh.

The treatment of the latter, in the present painting as in the other three, represents a new peak of refinement in Correggio's technique. In his earlier nudes – in the *School of Love* (London) (plate 173) or the Louvre *Venus* (plate 177) – the flesh painting seems to owe something to the example of Leonardo and of his Milanese followers. But the alabaster flesh of the four *Loves of Jupiter* suggests a different inspiration, namely Lorenzo Lotto. Lotto had been evolving a technique of this kind at least a decade before (an example is his *Marriage of St. Catherine* of 1523 in the Accademia Carrara at Bergamo; another is his Bergamo (S. Bernardino) altarpiece of 1521 in which the flying angels, as we have seen, may have influenced Correggio's in the *Agony* and the *Notte*). There may have been still other works of this kind within Correggio's reach. Ganymede's features are different from those of the Duomo angel. They recall the features of the

[1] Tschudi 1880.

urchin in the foreground of the Louvre *Vice*, a year or two older still, and they seem to have been used again in a female context in the pendant to the *Ganymede*, the *Io*.

Here the pictorial source seems to have been the classical relief on the Ara Grimani at Venice (as Strzygowski pointed out in 1898)[1] (fig. 40), perhaps through an intermediary. In this case, possibly more strongly than in the others, it is almost impossible to believe that the picture dates from the 1530s, so completely is its exotic, hothouse atmosphere akin to the later eighteenth century. For Io's draperies Correggio returns to the crinkly type which he had evolved at the time of the Del Bono laterals.

A further, and most interesting, feature of the *Io* seems to have escaped the notice of commentators up till now. For here is another instance of

Figure 40
The Ara Grimani

Parmigianino's revenge - where Correggio, who had exercised so obsessive an influence on him, now in his turn reacts to the younger artist, and, moreover, in respect of one of Correggio's strongest points, hair. For we can hardly doubt that Parmigianino's highly individual treatment of it inspired the unusual complexity of Io's curls (and, though less conspicuously, also those of Ganymede), so different are they from Correggio's earlier treatment in outstanding examples such as Cupid in the *School of Love* (plate 173) or the Magdalen in the *Giorno* (plate 157), and so similar to Parmigianino's. In the *Leda* Correggio represents three consecutive stages of the seduction within the same picture, and though this simultaneous presentation of successive events had been usual in *cassoni* paintings and large frescoes, a number of critics, including Mengs,

[1] *Das Werden des Barock bei Raphael und Correggio*. Reiterated (as though independently) by Elfriede R. Knauer (*Zeitschrift für Kunstgeschichte*, 1970, pp. 61ff.). She also postulates a measure of derivation of the *Ganymede* from one or more of the versions of Leochares' bronze.

were misled into reading it literally
as representing distinct figures por-
trayed at a single moment. The design
seems to have evolved from that of
the Louvre *Vice*, transformed to an
oblong format, but with a similar
landscape.

The basic inspiration of the figure
of Leda herself was surely Leonardo's
famous composition of the same sub-
ject, adapted to a seated posture and
with the swan actually in possession.
The latter element raises a point of
great interest and complexity. Popham
was the first to draw attention to a
sketch of Leda and the swan in the
Louvre which he convincingly attri-
buted to Correggio as a free copy of
Michelangelo (Popham 84) (plate
194A). Michelangelo's original paint-
ing was taken to France by his pupil,
Antonio Mini, in 1531 (fig. 41), and
it would require little credulity to
suppose that on his way from Florence
he stopped somewhere within Cor-
reggio's reach, that he showed his
treasure to various people there and
that Correggio did a sketch of it from
memory. Though Michelangelo – un-
like Correggio – had shown Leda in

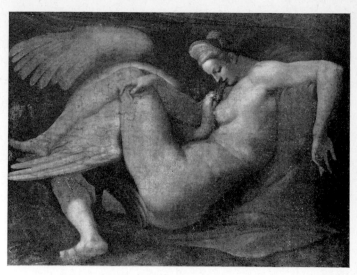

Figure 41
After Michelangelo, *Leda*

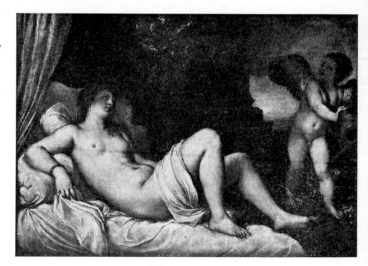

Figure 42
Titian, *Danaë*

profile, he had not scrupled – as Leonardo had – to depict the height of the concourse, and to
this extent Correggio had followed him.[1] And it seems just possible that Correggio had retained

[1] Another instance, perhaps known to Correggio, was in a wood-cut in the *Hynerotomachia Poliphili*
(Triumphus Secundus). For a discussion of the Leda theme see E. Knauer in *Jahrbuch der Berliner Museen*, 1969.
We may also bear in mind in this context that in 1524 Federigo Gonzaga had bought a painting of Leda by an
unnamed Spanish artist (Braghirolli, 1872, p. 328, n.1).

something of the pose of Michelangelo's *Leda* in his mind when painting not only his own *Leda*, but the fourth of his series, the *Danaë*, as well. For there does seem to be some inter-relation between Michelangelo and the various pictures of Danaë by both Correggio and Titian. The derivation of Titian's *Danaë* – at least in part – from Michelangelo's *Night* (in the Medici chapel) was first indicated by Wölfflin.[1] Michelangelo's *Night* and his *Leda* are almost the same figure, and Titian, who would certainly have known the *Night*, may also have had some knowledge of Michelangelo's *Leda*, and of Correggio's *Danaë* as well. His own *Danaë* (at Naples (fig. 42); a later version in the Prado) is just enough like Correggio's to make one wonder: he was in active correspondence with Federigo Gonzaga in the 1530s and visited Mantua on several occasions.[2] The matter raises too many imponderables to explore in detail, but, as a possible further facet of the strange and fascinating Correggio-Titian relationship seems worthy of mention.[3]

It should be pointed out – since the Correggio literature has omitted to do so – that it is at present necessary to take it to some extent on trust that the Borghese *Danaë* is identical with Correggio's original. There can be little or no doubt that the latter passed from the Orléans collection to that of Henry Hope. But not only is it not demonstrated that the Borghese picture was Hope's. Another version, belonging to the Udny's, was also being offered for sale in England as the original during the Napoleonic period. What one can see of the Borghese picture is of exquisite quality and gives no ground for suspicion. But in its present discoloured state, and under glass, it is not possible to see it adequately.

For the rest, there would seem some grounds for regarding the four great mythologies as Correggio's testament – the ultimate stage and highest point in the long but incredibly swiftly traversed course which he had taken in little more than twenty years. Danaë herself is the St. Catherine of the Louvre picture (plate 161A), slightly older and emphatically less voluptuous. She is thin, with long arms and sloping shoulders. The anxiety of her mood seems reflected in the design – a strange uneasy criss-cross, comparable with that used by Guido Reni in his *Atalanta and Hippomenes* (Naples). But in period the affinities of the four mythologies seem even later than that. Far beyond Guido, and beyond the Rococo too, they lie in the restrained elegance of the *style Louis seize*.

[1] Wölfflin 1924, p. 272.
[2] See J. Shearman, *Burlington Magazine*, 107, 1965, p. 174.
[3] Suida 1936. E. R. Knauer (*Jahrbuch der Berliner Museen*, 11, 1969, pp. 29–30) postulates influence of the Antique on the *Leda*.

XIII THE ART OF CORREGGIO

Correggio's career may be summarised as a struggle to master every technical device a painter could imagine, followed by another, less evident, struggle to prevent such mastery from mastering him. The same could be said of many other artists' careers, but applies with peculiar force to his. Though the relation of his art to that of his predecessors and contemporaries is likely to remain susceptible to fluctuations in interpretation and changes of accent, the main lines of its development seem moderately clear. Costa's influence, fairly strong in the early group centering round the Detroit and New York altarpieces and the London *Leave-taking*, did not last long. And from a very early stage there was also to be seen the influence of two – Leonardo and Mantegna – of the three or four others who were to have the most enduring effect on him. Leonardo's studies in light and shade stimulated an interest which was probably endemic in Correggio. Not only was he well aware of its power to augment the plasticity of his forms. He was, in addition, palpably fascinated by it on its own account, particularly during a moment in the mid-'twenties. Shafts of sunlight break through the thickets of the Louvre *Venus*, twilight casts long shadows over the placid landscape of the Prado *Noli me Tangere* and of the Uffizi *Madonna Adoring*, and competes with highly dramatic supernatural illumination in the London *Agony* and the Dresden *Notte*.

There was something else that Correggio took from Leonardo, something essential to the repertory of both – the smile. The fact of it, that is, rather than the form of it. In Leonardo's *Leda* – a design which affected Correggio crucially over a prolonged period – or in his *St. Anne* it has mysterious if not positively disquieting overtones, and in the hands of his Milanese followers it could degenerate into a revolting leer. But with Correggio it is no more than a part of the thoughtless charm of his angels.

Similarly, Mantegna's fascination with foreshortening infected Correggio and lasted throughout his career. It was to be the conditioning factor in his development as a decorator. Throughout the increasing complexities of the systems evolved in the Camera di S. Paolo, S. Giovanni Evangelista and the Duomo Mantegna's example can never be wholly ignored. Like Mantegna, too, and like another supreme decorator of a later generation, Paolo Veronese, Correggio was very much at home as a painter on a miniature scale, as well as on a very large one. In his case indeed, the miniature seems to have been his starting point.

It would also be possible that Correggio's study of Mantegna's art may have influenced him in a wider sense, by stimulating, if not actually implanting, that response to the challenge of inconceivable technical difficulty which was to condition so much of his art up to his penultimate period.[1]

[1] In this connection cf. F. W. Unger, *Correggio in seinen Beziehungen zum Humanismus*, 1862 (Battaglia no. 246). Also J. Shearman, *Mannerism*, 1967, *passim*.

At least we may bear in mind that the next distinguished visitor to Mantua, Giulio Romano, undoubtedly responded to this challenge during his residence there.

The third of the founding fathers – the Raphael of the early Roman period – was the most decisive influence on Correggio during his second – and unusually eclectic – period in the group centering round the Dresden *St. Francis Madonna*, and also in the early 'twenties as regards design. Raphael's Madonnas – and Raphael's transcriptions of Leonardo – crucially affected Correggio's half lengths, and Raphael's *Disputa* dominates the design of the S. Giovanni Evangelista frescoes. The impact of Michelangelo's Sistine ceiling seems to be marginally less, but no one could be unaware of it when looking at the S. Giovanni cupola.

In comparison with these, the influence of all other painters but two is unimportant. Dosso Dossi, whose supposed influence on Correggio was exaggerated by the young Berenson, may conceivably have affected his approach to landscape, but we have on real means of demonstrating it. The imagined influence of Beccafumi and Aspertini and Mazzolino were hobby horses of Longhi's,[1] which would have been peripheral and transitory at the most. The mysterious figure of Leonardo Leombruno is too shadowy to take into account, and Giulio Romano and Pordenone would have affected Correggio only minimally if at all. A visit by Correggio to Bologna, hitherto undetected, but which we have deduced for the early 1520s, is likely to have had considerable importance in his development. The influence which we have seen in the Del Bono laterals and the *Basket Madonna* from sculpture at Bologna by Quercia and Niccolò dell'Arca demonstrates once again the affinities between the latest Gothic and the incipient Baroque.

The first exception mentioned above was Lotto, whose flying angels and alabaster technique in flesh painting do seem to have influenced Correggio markedly. This is the more interesting in that in the eyes of both his contemporaries and of posterity Lotto was a less important painter than Titian, and yet Correggio seems to have been remarkably impervious to the latter, the only north Italian contemporary of his stature.[2] That is, in design. To what extent Correggio's development, particularly in his penultimate period, of the broad, *malerisch* manner of painting may have owed something to Titian, rather than to the Raphael of the *Sistine Madonna* or the *St. Cecilia*, or to what extent all three painters were the instruments of the *Zeitgeist*, I find impossible to decide. Finally, I have already suggested that towards the end of his life Correggio reacted to some extent to the elegance of the mature Parmigianino whose art he had decisively contributed to forming.

We do not, admittedly, know for a fact whether Correggio visited Venice, but it must be

[1] Longhi 1958.
[2] The hypothetical Lotto/Correggio relationship has been discussed at various times, notably by Morelli ('Munich and Dresden' 1891), Berenson (*Lorenzo Lotto*, 1895, pp. 163ff.) and Frizzoni (*Emporium*, 1896).

assumed that he had a general understanding of what Titian was doing and usually chose to disregard it. It may be that this was due to the particular ratio of similarity of temperament to dissimilarity which has led to comparable results on other occasions. The basic dissimilarity is obvious enough – the vigorous, masculine Titian as opposed to the refined, feminine Correggio. But the similarities are there too. As A. E. Popham pointed out, Correggio was by nature an untidy draughtsman. The beautiful neatness and finish of his paintings were wilfully imposed on relatively incoherent beginnings. Like Titian – as we now know from X-rays – Correggio frequently improvised on the canvas. As true painters, both started painting before they had fully worked out the design of the picture.

Correggio likewise seems to have ignored the work of the other great painterly painter among his contemporaries, Andrea del Sarto, though perhaps for a different reason. Correggio could not have been unaware of Titian – the Brescia polyptych alone would ensure that – but his image of Sarto, the trans-Apennine, may well have been vaguer.

One other source of a different kind, however, was drawn on, almost incidentally, from time to time – Dürer. Like other Italians of his age Correggio turned to him occasionally when faced with subject matter rarely treated in Italy. *Christ taking Leave* and *Christ shown to the People*, both now in London, are instances where the process demonstrably occurred, and the type of subject may itself be significant. For Dürer was not only useful in biblical scenes which were rare. His unrestrained northern emotionalism may be seen as another of the bridges between Gothic and Baroque. In Correggio's Del Bono *Lamentation* (Parma Galleria), for example, a quintessential proto-Baroque work, the clutching hands of the dead Christ are extremely rare in Italy but occur in Dürer's prints. Viewed in this light, we may conclude that Correggio and his great contemporaries – Raphael, Titian and others – who likewise reacted to Dürer, may have anticipated a certain satiety in their own art and that of their Italian contemporaries, and may have felt the need to re-animate it with an infusion of new blood.

In the Camera di S. Paolo, elements from Mantegna, Michelangelo and the Antique are brilliantly blended into an effect of great and beautiful originality. It was Correggio's first undoubted masterpiece. At about the same time, during which, surprisingly, he temporarily restricted his palette to cool colours, he was still experimenting in his panel pictures, looking at times to Raphael (most obviously in the Modena *Campori Madonna* but also in many others), to Leonardo (above all in the Prado *Madonna*) and, soon after, perhaps to the Venetians (in the Naples *Marriage of St. Catherine*). It was only after the S. Giovanni Evangelista frescoes had given him complete confidence that he took wing and produced his most astonishing work – the *Madonna with St. Sebastian*, the *Notte* (both Dresden), the *Giorno* (Parma Galleria), the Duomo cupola and the smaller religious pictures of the mid and later 'twenties. The apparent suddenness

of this burst into full mastery around the mid 1520s is perhaps the most extraordinary feature of Correggio's career.

The influence of the Antique on Correggio is more difficult to chart than that of his contemporaries. On the one hand, there is still incomplete evidence of what was where when, and, on the other, interest in the idea of Antiquity was all-pervasive during his life time. A still greater complication springs from the fact of both direct and indirect access to the same source. Just as Correggio was affected by Leonardo both directly and as seen through the eyes of Raphael, so he can be seen to react to the Antique both at first hand and also through Raphael's and Michelangelo's reworking of it. Nevertheless, the specific instances which can be demonstrated in all three of his frescoes, as well as in his mythologies and certain other work, may testify that in some form or other the Antique was a major impulse of his mature art. In particular, the *Laocoön* and the Orestes sarcophagus affected him profoundly, the former, indeed, almost obsessively.

Concerning Correggio's methods of work there is as little authentic information as with most others in the Renaissance, that is to say, nothing at all. Workshop assistance must be assumed at least in respect of the more mechanical preliminaries for S. Giovanni and the Duomo, and also, in all probability, in the visible result in the more repetitive passages. To what extent studio assistance may be visible in the easel pictures would be impossible to determine. In the rare cases of sub-standard execution, such as the Louvre *Virtues*, it may be Homer himself who nods.

Something was said earlier of Correggio's evident habit of reverting to his sketch books, and repeating not only his own motives but also those by other artists which had struck him. Thus he turns pagan into Christian – Antique sculpture into saints, Leonardo's Leda into the Madonna, or his own Cupid Bound into a martyred St. Sebastian – Christian into pagan – his own Holy Family into Venus, Mercury and Cupid, or one of his own angels into Ganymede – and Old Testament into erotic – Michelangelo's Adam and Eve into a Satyr uncovering Venus. He likewise makes one figure do for a personification of Vice, and for one or more of the patron saints of Parma, though in this case we are not sure which came first. These surprising transformations are likely to have been activated by genuine, if strange, visual associations. It seems highly unlikely that Correggio had any intention of commenting, still less of satirising, by so doing. Botticelli, after all, had based the design of his *Birth of Venus* on the *Baptism of Christ*.

How would Correggio have ended if his life had not been cut off in his forties? Some others who, like him, had sought out the most difficult from an early age were granted long lives but used them differently. Mantegna and Piero della Francesca, for instance, seem to have experienced a certain staleness in later life, while Bernini remained the tireless virtuoso to his eighties. More interesting is the case of those who, like Rembrandt, tire of technical virtuosity by early middle age and deepen their art accordingly. The image of Correggio in his forties,

with the extraordinary achievements of the cupolas and the great altars behind him retiring to his birthplace nevertheless seems to exclude further comparison with Bernini (except, perhaps, for the period of his eclipse in the 1640s).

In any event, these last four years are fairly mysterious. The four marvellous mythologies, the lost Jupiter cartoons and the odd small religious picture are not much, numerically, to set against the vast output of the 'twenties, and I cannot believe that a sufficient number of other works could have been painted in that time and could then have disappeared without trace to account for the disparity. Therefore I conclude that there was some measure of exhaustion as well as a degree of bitterness. But given a normal span of life Correggio might yet, perhaps, have recovered his full creativity.

It is here that the degree of distant parallelism with Titian, already suggested, may be considered again. For, like Correggio's, Titian's work in the 1520s now appears proto-Baroque; but instead of dying in the next decade he lived and painted for another forty odd years. Titian's proto-Baroque peak may be seen in the *Death of Peter Martyr*, finished in 1530. Thereafter he made a number of concessions in design to Mannerism from time to time. But throughout the second half of his life the pattern of his development suggests an increasing absorption with technique, in his case with the evolution of a proto-impressionist vision and reduction of local colours in favour of a pervading tone.

Correggio had also passed his proto-Baroque peak before his death. His experiences, with the Duomo cupola above all, had a salutary cathartic effect, eliminating the less sympathetic aspect of his genius – the urge to go one better, and therefore, after a certain point, too far. Having thus achieved the ultimate in that kind of dexterity that anyone could achieve, a calmer period seems to ensue, whose output included his greatest works in the religious field – a true maturity in the *Giorno* (Parma Galleria), and, in the Louvre *Marriage of St. Catherine*, even a kind of mellowness.

The new direction which Correggio's painting then took with the Dresden *Madonna with St. George* and the allegories for Isabella d'Este is, in its way, as unexpected and as puzzling as his sudden break into mastery some five years previously. The *Madonna with St. George*, through being purged of the excesses of the Duomo or of the *Notte* (Dresden), is also purged of their punch. Nevertheless, as I see it, it and the allegories represent both a new style and a new manner of painting. The new style, a degree of concession to Mannerism, seems to have been ephemeral. But the new elegance of painting, and perhaps a relative loss of vigour, lasted into the final period of the mythologies – *Danaë* (Rome), *Io* (Vienna), *Leda* (Berlin), *Ganymede* (Vienna). And here, if anywhere – in increasing refinement of technique, though without being proto-impressionist like the later Titian, or at least not in the same way, is a clue to what Correggio might have done,

given the time. Already at a previous stage he had, on one memorable occasion, seemed to anticipate a nineteenth-century painter. This was in the background of the Louvre *Marriage of St. Catherine* (colour plate I) where the summary brilliance of the handling recalls Delacroix. Now, in the late mythologies, whose spiritual climate is that of the *style Louis seize*, the mode of vision seems to adumbrate another nineteenth-century Frenchman. In my mind's eye I see Correggio painting more and more thinly, with greater and greater restriction of local colours, and steering his time-machine deeper and deeper into the future, till, by about the year 1550, his work might have looked something like a Eugène Carrière of greater genius.

XIV THE LEGACY IN THE CIN-QUECENTO

WITHIN THE SPACE OF A LITTLE MORE than a decade – from the beginning of the full mastery in the early 1520s until his death in 1534 – Correggio had painted a series of frescoes, religious pictures and mythologies which were arguably the most accomplished in the whole history of painting, and which were of such originality that it took something like two centuries before all their innovations were fully digested by other painters and fully understood by amateurs.

The varying nature of his influence, and the vicissitudes of his reputation, would provide matter for an entire book – a book very much larger than the whole of the present one. It is to be hoped that someone will undertake it. In the meantime the following summary sketch can hardly be omitted from the present context. Since, however, an attempt to trace an artist's influence is peculiarly liable to result in vague and subjective interpretation the present chapter, and the next, are intended, in the main, to concern themselves with three things and no more. First, to mention those painters who are specified in the early sources as having made a special study of Correggio. Secondly, to indicate specific works of art which undeniably owe something – usually in design, rather than in treatment – to specific paintings by Correggio. And finally to mention references to him in the more important published critiques, together with some indication of the attitudes taken towards him by the writers in question.

Outside Parma, even the greatest of his contemporaries could not wholly ignore him. If the eulogies of him put into the mouths of Titian,[1] and (by Vasari) of Giulio Romano[2] were true he cannot have lacked appreciation in the highest quarters within a very few years of his death. Yet such sentiments may have been partly lip service. Titian's ceilings for S. Spirito in Isola, it is true, and for the Scuola di S. Giovanni Evangelista, at Venice, have been thought to show traces of the effect of the Parma cupolas, and other vestiges may perhaps be seen in Pordenone's later ceilings – at Cortemaggiore and Piacenza.[3] Something, but the minimum, of the Duomo cupola may have crept into Giulio Romano's vault of the *Fall of the Giants* at Mantua, and a little of the Duomo apostles in those who contemplate the *Assunta* in the apse fresco of Verona cathedral, feebly executed from Giulio's designs. But all of these three artists were so fully formed before the time of the Parma cupolas that any effect the latter may have had on them

[1] Boschini 1660, pp. 15ff. Landor evidently drew on this in his imaginary conversation between Titian and Luigi Cornaro.

[2] Vasari IV, p. 115.

[3] Schulz 1968, *passim*. Attempts which have been made to trace Correggio's influence on the young Bronzino are not totally convincing (C. H. Smyth, *Bronzino as Draughtsman...*, 1971, p. 61).

was necessarily limited. The roughly parallel, but basically independent, course which, I have suggested, Titian followed in relation to Correggio, could also be assumed in respect of Pordenone's and Giulio Romano's relationship to him. The same consideration cannot be sustained in the case of Paolo Veronese, a generation younger. The fact that Correggio's ceilings exercised only a limited influence on his, and Correggio's other works even less, would be attributable partly to Veronese's temperament, and partly to his residence in Venice, where Titian's influence was inescapable. Of lesser contemporaries, or near-contemporaries, who were not natives of Parma, we may note Gerolamo da Carpi who, according to Vasari, went out of his way deliberately to model himself on Correggio.[1] In Novellara, the highly eccentric and fascinating Lelio Orsi combined elements of Correggio with others derived from Michelangelo and the north. His productions must have seemed sufficiently like Correggio's to certain eyes for one, at least, of them – the Borghese *St. Cecilia* – to bear for a long time a most surprising attribution to him. Of Modenese painters, Vasari (VI, page 481) notes that Niccolò dell'Abate incorporated the figure of the executioner from Correggio's Del Bono *Martyrdom* (Parma Galleria) in his altarpiece

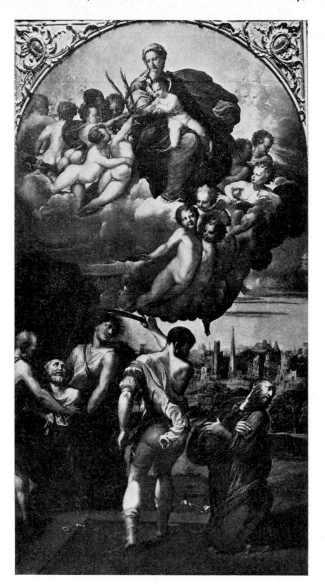

Figure 43
Niccolò dell'Abate,
The Execution of Saints Peter and Paul

of the *Execution of Saints Peter and Paul* – as indeed we can confirm (picture formerly at Dresden (fig. 43)). With other Lombard painters active in the late sixteenth century or early seventeenth, such as the Passarotti in Bologna, the Procaccini in Milan or the Modenese, Bartolomeo Schedone (a link between Correggio and the young Guercino), in Parma

[1] Vasari VI, pp. 470ff.

itself, elements from Correggio were combined with some from Parmigianino and other sources.[1]

Correggio's immediate following had left no great mark (we do not, incidentally, know which, if any, were his pupils in the strict sense). Of those who had worked with him or near him Gandino del Grano is a more insubstantial figure than Rondani, whose rare surviving works show a certain eccentric originality (oddly enough, one of his few signed works – the altarpiece now in the Parma gallery – shows him deriving – apparently – from a very ephemeral phase of Correggio himself, namely the Brera *Adoration*). But only Anselmi contrived to dispute with Mazzola Bedoli a few of the plum jobs in Parma around the middle of the century. Anselmi seems to have been an artist of greater facility than conviction, veering successively towards Correggio, Parmigianino and Beccafumi (his roots were in Siena) but capable at most times of a considerable bravura.

Within the school of Parma a prime factor at the beginning would have been the mere existence of Parmigianino. His relation to Correggio would have been comparable with Giulio Romano's to Raphael, or Van Dyck's to Rubens. In each case the brilliantly talented younger artist could not fail to be irked, and at times, perhaps, obsessed, with the shadow of the giant elder. In Parmigianino's case the obsession was probably more violent than with the other two. He seems to have spent much of his time trying, perhaps consciously, but usually unsuccessfully, to escape it, and it may even, in an indirect way, have contributed to the shortening of his life. We may also bear in mind that the mere presence in Parma of Correggio, an outsider, might cause resentment to a native Parmesan such as Parmigianino. As a young man Parmigianino had worked alongside Correggio in the Church of S. Giovanni Evangelista – on a significantly humbler assignment. At around the same time – in the early 1520s – he executed, almost defiantly, as it seems, his own exquisite variation on the Camera di S. Paolo at the castle of Fontanellato, near Parma. He then left Parma for Rome, not so much, perhaps, to see its marvels as to have a valid excuse for getting away from Correggio. In this he was only successful in the physical sense. The main work which he painted in Rome – the altarpiece now in London (fig. 34) – shows, as we have seen, evident influence of Correggio's Dresden *Madonna with St. Sebastian*, as well as that of Michelangelo, and of Raphael (who affected him almost as violently as did Correggio, but who had the advantage of being dead). After his return north of the Apennines, in 1527, Parmigianino, as we have suggested, must have paid at least one short visit to Parma. By now the influence was to some extent mutual. I have given my reasons for thinking

[1] A verse eulogy of Correggio by Fabio Segni, included by Vasari in his biography, constitutes, according to Battaglia, the germ of the phrase *pittor delle grazie* ('painter of the graces'), which, by the nineteenth century, was universally applied to Correggio.

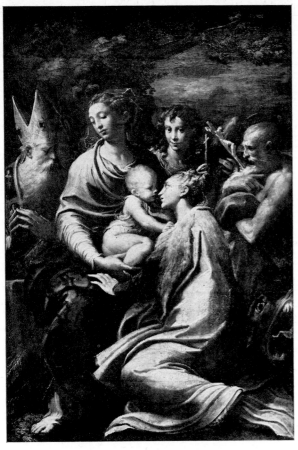

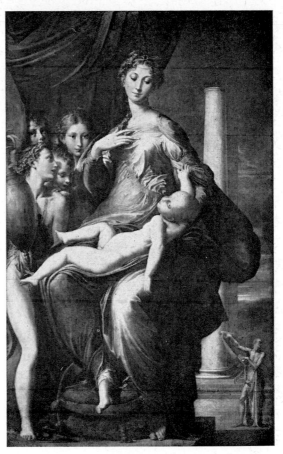

Figure 44
Parmigianino, *Madonna and Child with
St. Margaret and Other Saints*

Figure 45
Parmigianino, *The Madonna del Collo Lungo*

that Parmigianino's latest work to date may have caused Correggio to modify his *Madonna with
St. George* (Dresden). But this did not prevent the old magic of Correggio from reasserting itself
over Parmigianino. His *St. Margaret* altar, now in the Bologna gallery (fig. 44), is datable around
the latest 'twenties, and is an obvious paraphrase of Correggio's *Giorno* (Parma Galleria). We
have seen another such paraphrase of Correggio in the two versions of the *Marriage of St.
Catherine* (Correggio's in the Naples gallery, Parmigianino's (fig. 26A) in the London National
Gallery). In this case Parmigianino's Christ child, in particular, is virtually a direct quotation of
Correggio's. An even more fascinating instance is illustrated by Parmigianino's most famous
and most characteristic work, the *Madonna del Collo Lungo* (fig. 45). For this large picture, it
seems to me, is Parmigianino's attempt to rework in his own way a very small one of Correg-

gio's – the *Basket Madonna* (National Gallery). The basic motives of the large, sprawling child, the gesture of the Madonna's right hand and the pillar (supporting in the event nothing, regardless of whether or not Parmigianino had abandoned his earlier plan for a row of pillars supporting a pediment), together with the small male figure in the background in front of the pillar, reveal the derivation fairly plainly. In the evolution of one work from the other, however, strange transformations have occurred, in which shape gets the better of function. The curved outline of the tree trunk behind the head of Correggio's Madonna becomes a curved curtain, the half oval of the Madonna's work basket becomes half oval cushions, and the bunched left hands of Correggio's Madonna and of his child become a bunch of projecting drapery.[1] Any one who felt disposed to question this admittedly surprising visual derivation should bear in mind that the two pictures belonged to the same family. The Correggio is first recorded in the inventory, of *c.* 1561, of the collection of the Cavaliere Francesco Baiardo. Parmigianino's was commissioned by a lady referred to in the contract as 'Helena Baiarda filia magnifici et generosi equitis domini Andreae…' ' …daughter of the magnificent and munificent Lord Andrea'. The fact that the inclined neck of the Madonna in Correggio's painting is replaced by the attenuated, neo-Gothic one which has provided a nickname for Parmigianino's picture, suggests that to this extent he also had an eye on Correggio's own prototype for the *Basket Madonna*, namely the Quercia group at S. Petronio, Bologna (fig. 25A). At least, Parmigianino would have had occasion to know this work over a longer period than Correggio.

Nevertheless, Parmigianino declined to settle in his native town at this time – Correggio was still painting in the Duomo – and set up for the moment in Bologna. It was not until 1531 – when Correggio, significantly, had left Parma – that Parmigianino returned there. Even now his situation would not have been enviable. Though Correggio was no longer there in person his Duomo cupola had recently been unveiled, and it would be difficult to imagine a more daunting moment for any further piece of church decoration in Parma to be commissioned of anyone. Worse still, Parmigianino's subject, allotted to him for the apse of the new church of the Steccata, was the same as Correggio's at S. Giovanni Evangelista – the *Coronation of the Virgin*. Some of the surviving drawings show Parmigianino doing his best to evolve a composition as different from Correggio's as he could. In another (in the Parma gallery) he seems resigned to following him. Clearly Correggio's design was not to be avoided, except by doing nothing. And this, for whatever reason, is what Parmigianino in fact did. By procrastinating over the apse until the authorities lost patience and finally had him arrested he was able to concentrate on

[1] These observations concern the paintings in their realised state. Study of such preliminary drawings as have happened to survive suggests that the creative processes were intensely complicated, and that Parmigianino's compositions may sometimes have ended closer to Correggio than at the beginning.

the barrel vault of the choir, where he could, and did, throw overboard the whole system of aerial illusionism as evolved by Correggio. He did this first by stressing the architectural features of the vault. But not even Parmigianino could bring himself to renounce the sorcerer's offerings at a single stroke. There were stages in his anti-Correggiosity. At one point he toyed (as we see in a drawing in the Louvre, Popham 450) with the idea of permitting illusionist views through the square coffers in false perspective, before finally reverting to real gilt bronze rosettes.[1] Yet even now he could not evade the spell altogether. In the central band the hieratically conceived maidens, surrounded with exquisite and minutely detailed still life – sea shells, crabs, flowers, birds – set against a plain scarlet background like jewels in a Byzantine cope, constitute a shattering display of anti-Correggiosity. But it has long been recognised – and is, indeed obvious – that at the sides the under-arch paintings of Old Testament characters derive from Correggio's at S. Giovanni Evangelista.

In Parmigianino's last surviving work of importance – the altarpiece of the *Madonna and Child with Saints Stephen and the Baptist* – he seems by a superhuman effort to have succeeded in breaking the spell. But in the eyes of posterity it has caught up with him. For in this work he ignored Correggio's altars and seems instead to have sought part, at least, of his inspiration in the second of his sirens – Raphael; in this case the *Sistine Madonna*. And by a whim of Fate which, having neglected to add the last straw in the painter's lifetime, made good the omission later, not only does his picture hang with the *Sistine Madonna* at Dresden. So also does another partial derivation from the same Raphael – Correggio's *Madonna with St. Sebastian*.

Despite the tragic effect which Correggio exercised on Parmigianino's career the pendulum of taste swung for a time in the latter's direction. His art was easier to emulate than Correggio's, and by the mid-sixteenth century there were many painters who were turning out elegant elongations à la Parmigianino for every one who tried, even unsuccessfully, to base himself on Correggio. And though Parmigianino's own death occurred only six years after Correggio's, his cousin by marriage, Girolamo Mazzola Bedoli, perpetuated much of his tradition in a refined style in which Correggesque elements were at a disadvantage and which brought him local success over a longish career. Moreover Parmigianino himself had been at pains – as Correggio had not been – to propagate his designs in his etchings, as well as in Caraglio's engravings and the woodcuts of Antonio da Trento and others.

In decoration, the anti-Correggesque, anti-illusionist trend at Parma, launched by Parmigianino in the choir of the Steccata, and, almost simultaneously, by Correggio's one-time

[1] It has recently been suggested (M. F. dell'Arco, *Il Parmigianino*, 1970, *passim*) that Parmigianino's interest in these rosettes (which Vasari claimed he fashioned with his own hands) sprang partly from his fascination with alchemy.

colleagues, Anselmi and Rondani, at the Oratorio della Concezione (where the cupola is deco-
rated with architectural motifs) was continued by Bedoli and Anselmi. It is true that Bedoli made
some concession to illusionism in the choir vault of the Duomo (1538–44). But throughout the
middle years of the century the most significant decorative work being done in Parma was not at
the Duomo but at the Steccata, and there the progressively anti-Correggesque trend can be
charted precisely. The four great half domes in the apses were decorated in succession – first, An-
selmi's *Coronation of the Virgin* (in the east), dating from 1540–42, based mainly on Correggio's
fresco of the same subject in S. Giovanni Evangelista, though Giulio Romano, the greatest artist
in the locality after Correggio's death and Parmigianino's defection, was called in to advise.[1] Then
Bedoli's *Pentecost* (in the north) of 1546–53, which is only illusionist to the extent that the eye-
level is rather below the base of the painting. Next, Anselmi's *Epiphany* (in the west) of 1548–54,
completely non-illusionist, with an eye-level half way up. Finally, Bedoli's *Nativity* (south) of
the 1560s, with the eye-level more than half way up, and therefore the only one of the four
which has no need to fill the upper reaches with flying figures. This last fresco marks the
height of the anti-Correggesque in decoration in Parma, and by the time it was finished neo-
Correggism had started – in the central cupola of the same church of the Steccata. Significantly
enough, the movement did not originate in Parma but in the school of Cremona, which, in the
persons of Camillo Boccaccino and Giulio Campi, had been a beacon of illusionist decoration
in the middle years of the century, though based more on Pordenone and Giulio Romano than
on Correggio. Now it was a Cremonese, Bernardino Gatti, known as Il Sojaro, who brought
a kind of neo-Correggism back to Parma. Another Cremona-trained painter, the Brescian,
Lattanzio Gambara, executed soon afterwards (1571–73) a Correggesque *Ascension* in the
Parma Duomo. At the Steccata, we may note that Gatti made a significant departure from
Correggio's system at the Duomo – evidently to eliminate the feature that had given most
offense thirty or more years before. By seating his figures decorously on clouds, as Correggio
himself had done in his earlier cupola at S. Giovanni Evangelista, Gatti spared the spectator the
sight of the dangling legs of the angels in mid-air.

Nevertheless, there was, in the event, only one cinquecento painter who was really in sym-
pathy with Correggio's aims and at the same time of sufficient talent to embody something of
them, and he was not a decorator. This was the Urbinate, Federico Baroccio, and his case is an
extraordinary one, since it has been questioned if he ever saw any of Correggio's principal
paintings, and there is excellent authority (Bellori) for thinking that he had already managed to
absorb much of Correggio's essence merely by looking at his drawings.

[1] For documentation cf. F. Hartt, *Giulio Romano*, 1958, p. 247. Also L. Testi, *S. Maria della Steccata in Parma*,
1922, *passim*.

If Baroccio did indeed finally set eyes on Correggio's paintings (we have seen that he seems to have been cognisant of the London *Agony* and probably of the Parma gallery *Scodella*) it cannot have been until his style was well formed. His range of colours is totally different. Unlike any other artist before – mysteriously – Bernini, Baroccio had much of Correggio's particular feeling for the sheer abstract beauty of the shapes and patterns into which textiles can be made to fall, the flutterings, the cascades, the ridges and the troughs, long, short, straight or curling, alternately obeying and defying gravity and permitting, in the process, an enormous variety of modulations of colour. But whereas Correggio's colours tend to the rich and the harmonious, Baroccio's are sharper, and the contrasts sometimes excitingly strident. Nothing confirms more convincingly Bellori's statement that it was Correggio's drawings – rather than his paintings – which decisively formed Baroccio's style.[1]

[1] Bellori 1672, p. 173. Bellori actually uses the word 'pastelli', which implies a certain amount of colour. Nevertheless, only oils can fully convey oil colours. Olsen 1962, p. 57, n.110, quotes a MS. note according to which Baroccio is supposed to have visited Parma at an unspecified date.

XV CORREGGIO IN THE SEVEN-TEENTH CENTURY AND LATER

Baroccio may be considered the prototype of the great artists who were dependent on Correggio, and in the seventeenth century it is a striking fact that it was precisely the key figures – those who were themselves the most influential – who were decisively and most demonstrably affected by him – Annibale Carracci, Lanfranco, Baciccio, and even, by some means, Bernini himself. As the process developed complexities developed too, whereby the younger generation reacted both to their elders' interpretation of Correggio as well as directly to Correggio's work at first hand. We must nevertheless bear in mind that in seventeenth-century Rome though Correggio was indeed a god, he was something of an absentee one. He was inordinately revered but the papal city housed none of his key works.[1]

Annibale Carracci was born and brought up in Bologna (as he was later to be a pioneer of the great seventeenth-century genre known as classical landscape we may note in passing that Correggio's most remarkable anticipation of this form, the Prado *Noli me Tangere*, was at Bologna, in the Hercolani collection, in Annibale's childhood and then followed him to Rome). About 1585 the young Annibale Carracci visited Parma, and painted for a church there a *Pietà* which Bellori mentions as showing his study of Correggio (Annibale's picture is now in the Parma gallery). A famous letter, first published by Malvasia, says that Annibale on arrival was overwhelmed and even faltered in loyalty to Raphael, whose *St. Cecilia* had been the inspiration of his youth in Bologna.[2] Though the letter is now regarded as an old forgery it is probably a reliable indication of what the seventeenth century thought that Annibale thought. Annibale copied Correggio's *Coronation of the Virgin* in the S. Giovanni apse and was visibly affected by it when painting his own version of the subject (now Metropolitan Museum). He evidently stopped at Reggio on the way to Parma and carefully studied one of the most celebrated of Correggio's altarpieces, the *Notte* (Dresden). Afterwards he painted his own version of this subject in which, as Bellori says (page 86), 'Annibale respected the system of lighting used by Correggio in his *Nativity*, then at Reggio'. There can be little doubt that some of the copies after Correggio made by the Carracci and their pupils were later sold as originals, but I have the impression that Correggio was found harder to fake deliberately than was Titian. Later, soon after 1600, Giovanni Lanfranco followed the current trend of emigrating (from Parma) to Rome, where he produced *his* version. Though Bellori says that it was likewise done in imitation of

[1] At different times during the seventeenth century the following pictures were in Rome: *Noli me Tangere* (Prado), *Marriage of St. Catherine* (Louvre), *Danaë* (Borghese), *Leda* (Berlin) and probably *Madonna del Latte* (Budapest). Also, of course, various minor and attributed works.

[2] Bottari 1822, I, p. 118.

Correggio's *Notte* there is reason to believe that Lanfranco drew on Annibale's transcription, as well as on the original, though when he came to do another version some years later (Rome, S. Maria della Concezione) he reverted to Correggio as his prime inspiration. Though it would hardly be possible to count the number of Nativities painted in Rome in the seventeenth century in imitation, to some extent, of Correggio's *Notte* (at least following his system of illumination) the few key instances mentioned should give some idea of the complicated relationships involved.[1]

It was also the Carracci – Agostino, to be precise – who produced the first two adequate engravings after Correggio's paintings. One of these (plate 160E) – of the *Giorno* – still seems an obvious choice. The other (plate 162B) – of the *Ecce Homo* – may now appear surprising, but the picture was enormously admired at the time. The cupolas fared less well, graphically, doubtless because of the virtual impossibility of translating their polychrome three-dimensionality into two dimensions in black and white.

From his youth the young Lanfranco had been obsessed with Correggio's work at Parma cathedral. 'He became enamoured of Correggio's art' Bellori says 'and drew and painted from his works. And he was so wrapped up in the cupola of the cathedral at Parma that he made a small model of it in water colours and practised the grouping and the style of the figures seen from below in perspective'. When, after an experiment on a small scale in the Buongiovanni chapel of S. Agostino, Lanfranco created the Baroque cupola – that of S. Andrea della Valle in Rome, started in 1625 – Correggio was obviously and avowedly his model. In it, Lanfranco concentrated, as Gatti had done at the Steccata in Parma, more on cloud-borne than on flying figures, thereby conflating Correggio's two cupolas rather than following one slavishly. Lanfranco had the advantage – denied to Correggio in both of his cupolas – of a structural lantern to provide actual contrasts of light and shade. At this church the pendentives were painted not by him but by Domenichino. They are likewise based on those of Correggio, and likewise became, in their turn enormously influential. The influence of Lanfranco's cupola in seventeenth-century Rome was crucial, and inspired, among many others, that by Pietro da Cortona at the Chiesa Nuova which was then itself widely imitated. Though we are not sure if Cortona, in addition, had first-hand knowledge of Correggio's work at Parma, in the case of the leading decorator of the next generation, the Genoese, Giovanni Battista Gaulli, known as Baciccio, there is documentary evidence of it, and this is where the fascinating problem of Bernini's relation to Correggio appears in tangible form. For Baciccio was Bernini's particular protégé, the artist chosen by the great sculptor to embody his ideas in paint.[2]

[1] Schleier 1962. This section, like most of the present book, was written before I read Donald Posner's *Annibale Carracci* (1971) which treats of the Carracci-Correggio relationship in greater detail.

[2] Enggass 1964, *passim*.

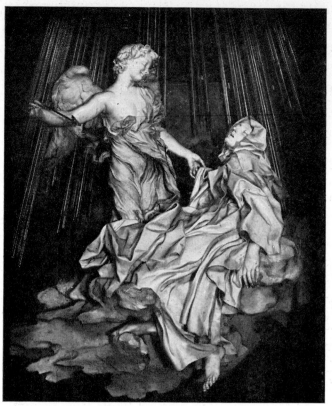

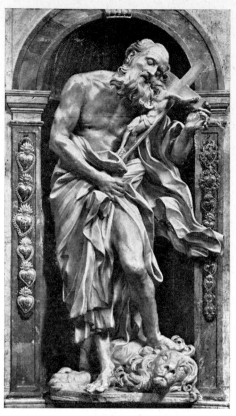

Figure 46
Bernini, *St. Teresa*

Figure 47
Bernini, *St. Jerome*

In 1666 Baciccio travelled from Rome to Parma with the express intention of studying Correggio in connection with the pendentives which he, Baciccio, had been commissioned to paint at the church of S. Agnese in Rome. We know from a letter that Bernini supported the idea of the journey and had very possibly originated it.[1] Bernini himself had just returned to Rome from his visit to Paris, and may have passed through Parma, at least on the outward journey. Though we have no evidence that he had been there before, it was already pointed out by Pungileoni,[2] early in the nineteenth century, that the angel in Bernini's *St. Teresa* (fig. 46), dating from the later 1640s, closely resembles that in Correggio's *Giorno* (Parma Galleria). Pungileoni might have carried the comparison farther. Not only is Bernini's angel almost the twin of Correggio's. The female figures – the Magdalen in the *Giorno*, St. Teresa in Bernini's group – are arranged on a similar diagonal in relation to the angels in both works, while St. Teresa herself, with her memorable, limp left hand, strongly recalls the Madonna in Correggio's Del Bono *Lamentation*

[1] Enggass 1964, pp. 9 and 182–3. [2] Pungileoni, I, p. 183.

(Parma Galleria). Viewed in this light, the St. Teresa group, Bernini's master-piece, can be considered a genial pastiche of Correggesque motives.

How are we to account for this phenomenon, whose very existence has been minimised hitherto? Admittedly, there were prints available in Bernini's time both of the *Giorno*, and of the *Lamentation* also. But there would also be a possibility that he had seen the paintings himself. Though there is no record of his visiting Parma before the Paris journey of 1665 (even then it is not specifically documented) the débâcle represented by the failure of his campanili for St. Peter's in the mid-1640s might well have been the occasion for his wishing to leave Rome for a time, and the *St. Teresa* group is datable to the later 'forties. Nevertheless, the *St. Teresa* is likely to be one of those cases where direct and indirect derivations have combined. Correggio's *Giorno* had lent itself to adaptation to ecstatic visions. In the Oxford drawing (Popham 75) (plate 160A) the place later taken by the Magdalen is filled by an ecstatic St. Jerome, who is astonishingly like Bernini's sculpted version of the same saint in ecstasy (Siena cathedral, Chigi chapel) (fig. 47). (I note the phenomenon without attempting to account for it.) Another of many ecstatic derivations from the *Giorno* – Annibale Carracci's *Vision of St. Francis* (fig. 48) may well have been a bridge between the *Giorno* and the *St. Teresa*, in addition to some direct influence.

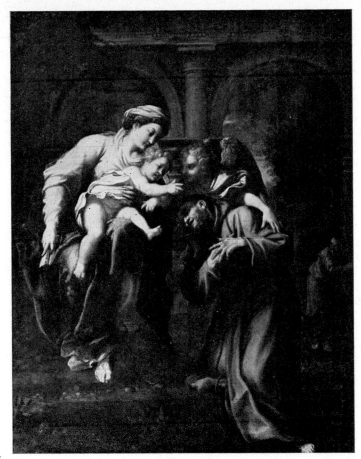

Figure 48
Annibale Carracci, *The Ecstasy of St. Francis*

In any case, however, the episode seems highly significant. More than any other sixteenth- or seventeenth-century Italian – even Baroccio – it is Bernini who, we feel, was most akin spiritually to Correggio; and the extent of the kinship, on the one hand, and Bernini's complete and perfect embodiment of Baroque Rome, on the other, is perhaps the clearest of all the many

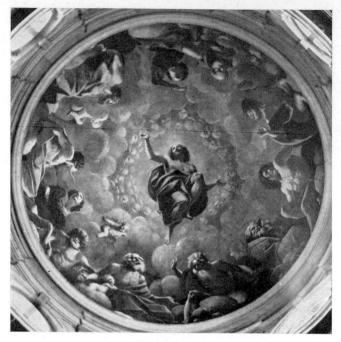

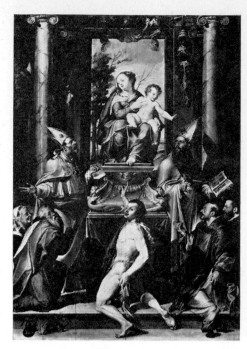

Figure 49
Sisto Badalocchio, *Cupola of S. Giovanni Evangelista*
(Reggio Emilia)

Figure 50
B. Passarotti,
Madonna and Child with Saints

indications of how astonishingly in advance of his time Correggio was.[1] Correggio's influence on other seventeenth-century sculptors would require a book to itself, in which to try to distinguish the direct from the indirect channels.

It is through the obvious and specific borrowings, such as those mentioned, that the extent of Correggio's influence in the seventeenth century is most conveniently demonstrated, but it would not be possible, or even desirable, to attempt to record all of them. The effect of the Duomo cupola, we have seen, was crucial. That of the *Madonna with St. Sebastian* (Dresden) may have been nearly as great, though more difficult to assess, while the *Notte* (Dresden) lay behind most *seicento* representations of that subject, the *Giorno* behind many saintly ecstasies and the *Scodella* (Parma Galleria) behind most Flights into Egypt. The cupola of S. Giovanni Evangelista and the Dresden *Madonna with St. George* proved less influential – doubtless because less Baroque – though Sisto Badalocchio, early in the *seicento*, did a successful pastiche of the former at Reggio (fig. 49),[2] and before that Bartolommeo Passarotti had used elements of the

[1] Bernini is said to have recommended the study of Correggio to French students in Rome (A. Bertini Calosso, *Il Classicismo di G. L. Bernini, L'Arte*, XXIV, 1921, pp. 241ff.
[2] Church of S. Giovanni Evangelista. Reproduced Waterhouse 1962, pl. 94.

latter in an altarpiece in S. Giacomo Maggiore, Bologna (fig. 50). The city of Genoa, for some reason, proved particularly susceptible to Correggio in the seventeenth century (of their sixteenth-century painters, the most famous, Luca Cambiaso, was probably responsible for the *Venus and Cupid* (now Earl of Radnor) which was long attributed to Correggio). Leading Genoese painters of the period (omitting Baciccio, as he settled in Rome), such as Valerio Castello, G. B. Merano (who actually worked in S. Giovanni Evangelista) and Gregorio de' Ferrari, made the pilgrimage to Parma in their youth and soaked themselves in the study of Correggio. The last of these lived until 1726 and carried his Correggiosity over into the true Rococo in works such as the *Cupid and Psyche* ceiling in Palazzo Granello in Genoa.[1] On the other hand, Baldinucci's name for Cigoli – 'il Tiziano e'l Correggio fiorentino'[2] – has little significance in this context. It was intended partly to designate Cigoli as a colourist, and partly as a compliment.

Though it is outside the scope of this study to explore the interaction of Correggio's influence on seventeenth-century Baroque painting with that of other great sources – Titian and Veronese – or to try to isolate Correggio's contribution – which was certainly not negligible – to the multifarious influences which were profitably absorbed by the young Rubens,[3] something must be said of the attitude of the *seicento* writers. In general, the theorists of this century developed as reverential a view of Correggio as did the practitioners. The most influential of them, Bellori, published no detailed account of him, but he fully recognised his importance in the formation of Annibale and Lanfranco among others, and in one place (page 316 of his *Vite*) he quotes with approval the view of his predecessor, Agucchi. Whereas, in Agucchi's view, the Venetians, headed by Titian, had imitated the beauties of nature, as distinct from Raphael and Michelangelo, who had based themselves on Antique statues, Correggio had imitated nature more acceptably than the Venetians by doing so in a stylish and noble manner ('un modo tenere, facile ed ugualmente nobile').

Nevertheless, it was a writer from the north of the Apennines, Francesco Scannelli, who formulated in effect the view which Bellori merely hinted at and which became dogma for the *cognoscenti* for the best part of two centuries – that Correggio was the second greatest painter who had ever lived, after Raphael but before Titian.[4] This thesis was developed most eloquently

[1] Reproduced Waterhouse 1962, pl. 195.

[2] 'The Titian and the Correggio of Florence.'

[3] Gregory Martin (National Gallery catalogue, *Flemish School, c. 1600–c. 1900*, 1970, p. 150) derives the pose of the Duke of Buckingham in N. G. Rubens, no. 187, from Correggio's Christ at S. Giovanni Evangelista (cupola). The Cremonese, Vincenzo Campi, had already borrowed this figure in a ceiling fresco at S. Paolo, Milan (*Arte Antica e Moderna*, 1965, pl. 54, facing p. 139).

[4] Scannelli 1657, *passim*.

by Mengs in the next century, but it underlies the views held during most of the seventeenth, eighteenth and early nineteenth centuries on the subject.

In the eighteenth century the decline of monumental painting changed the nature of Correggio's continuing influence. Some echoes of the Duomo cupola may sometimes be traced in the last of the great Italian decorators, Tiepolo, and a distant but still recognisable pastiche of it was painted as late as the mid-eighteenth century as far away as Steinhausen in Bavaria. Indeed, no subsequent cupola painter could ever entirely escape it, though at St. Paul's Sir James Thornhill certainly did his best to do so. In cabinet painting, some artists made a special study of Correggio at this time and show it in their work – Benedetto Luti[1] was one, and Mengs[2] reports Sebastiano Ricci as imitating Correggio.

Of non-Italian painters, the young Ribera is noted by Scaramuccia[3] as studying Correggio at Parma, and working in his style at that time. If he had continued doing so it would have been a channel for the transmission of Correggio's influence in Spain, and though something may have passed in this way, with the exception of one category it does not seem to have been much. The exception, inevitably, was cupola painting. The apostolic succession had been established in Naples by Lanfranco's living there in the 1630s and '40s and himself executing a pair of cupolas.[4] From there it spread to Spain through the agency of Corrado Giaquinto and Luca Giordano. Otherwise the only country outside Italy where Correggio exerted substantial influence on important painters was France. Even before the middle of the seventeenth century Correggio would have been a recognisable ingredient in the mixture of Italian Renaissance influences which was concocted by Lubin Baugin. During the second half of the seventeenth century, when French court art was veering towards the Baroque, Correggio's influence on it had been indisputable, but only as one of several foreign forces. Mignard's cupola at the Val-de-Grâce or Charles de La Fosse's at the church of the Assumption (both in Paris), derive ultimately from Correggio but both are filtered through later Roman work. And though painters such as Antoine Coypel or de La Fosse (who was responsible for a canvas called 'La Nature environée par les Graces président à la Naissance du Corrège'[5])[6] included Parma in their itinerary of Italy they also made pilgrimages to Venice and spent most of their stay in Rome. Furthermore, the influence of Rubens in France at the turn of the seventeenth century was as strong as

[1] Richardson, *An Account of...Pictures in Italy*, 1722, p. 182 mentions Luti as a connoisseur in connection with the Borghese *St. Cecilia*, then thought to be Correggio's.

[2] Mengs, *Opere*, 1786 edition, p. 185. See also J. Daniels, *Burlington Magazine*, April 1972, pp. 229ff.

[3] *Finezze de' Pennelli...*, 1674, p. 174.

[4] At the chapel of S. Gennaro in the cathedral and at the Gesù Nuovo. The latter cupola no longer survives.

[5] (Nature and the Graces preside at the birth of Correggio).

[6] L. Dimier, *Les Peintres français du XVIIIᵉ siècle*, I, 1928, p. 62 (quoting the 1741 Crozat sale).

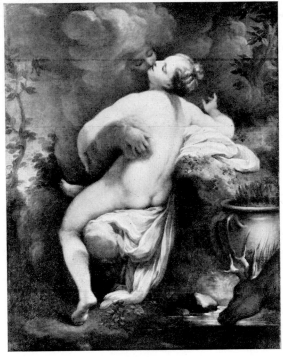

Figure 51
F. Lemoyne, *Io*

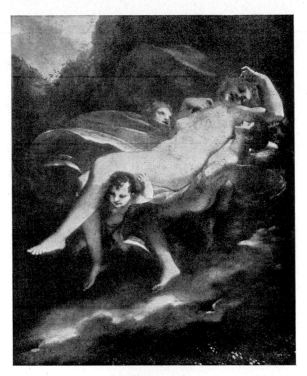

Figure 52
Prud'hon, *Psyche*

any from Italy. But in the next period – roughly from the 1720s to the 1750s – the most characteristic French art (the so-called *style Louis quinze*) seems to show a degree of affinity with Correggio greater than with any previous painter. And though much of this phenomenon would be attributable in some quarters to the *Zeitgeist* it is tempting to point to a concrete factor as contributory. This was the arrival in Paris in 1721 of the collection of Queen Christina, bought by the regent Orléans and sent to Paris from Rome after long delays. It included a number of Correggio's mythologies – the original of the Berlin *Leda* and the Rome *Danaë*, and excellent copies – then thought to be the originals – of the *Io* (Vienna) and the *School of Love* (London). A few years later the then owner, the lunatic duke Louis d'Orléans, mutilated the *Leda* and the *Io* copy. But the few intervening years had been sufficient for François Lemoyne to copy the *Io* copy (now Hermitage) (fig. 51) and soak himself in Correggio. His pupil at this time, the young François Boucher, doubtless did the same. It would therefore be difficult to exaggerate the importance of this highly-charged moment, when much of the character of mid-eighteenth-century French art was laid down. For the rest, the most significant factor was that by this time painting had at last caught up with Correggio, and something of him was almost everywhere –

in every artificial mythology, kittenish Madonna or flirtatious saint, whether the artists were conscious of it or not.

The last painter of consequence to model himself deliberately on Correggio was a Frenchman of a still later age – Pierre-Paul Prud'hon (1758–1823) (fig. 52). But a little of him may also be traced in an older contemporary of his. It is possible that Goya actually visited Parma in 1771. But in any case there can be no doubt that the cupola which he painted in Saragossa cathedral ('El Pilar') a decade later reveals, even if filtered through Giaquinto and Tiepolo, something of the fountain-head of the Parma Duomo.

At the same time, new developments – serious aesthetic criticism and serious scholarly research – affected the treatment of Correggio in literature. Among them, Mengs, who was to publish the most penetrating criticism of Correggio's art – of greater value than the remarks scattered through the writing of Mengs' mentor, Winckelmann – probably symbolises the point of view of many *cognoscenti* of the time. Mengs blames those who single out for special praise Correggio's colouring, rather than his chiaroscuro. It is in the latter, Mengs says, that Correggio surpassed all others, even Raphael. Mengs himself had been christened Anton Raphael after precisely these two painters, and in the event found himself faced with a kind of choice of Hercules. Educated in Rome on a diet of Raphael, his head directed him to that painter and his heart to Correggio. Correggio painted even more beautifully than Raphael, but Raphael was on a higher plane. Some such feelings, as we have seen, had been put into the mouth of Annibale Caracci, long before, by Malvasia; and Mengs' contemporary, Algarotti, expressed them more frankly than anyone else: 'May the divine spirit of Raphael pardon me if, in contemplating this painting (the *Giorno*) I lose faith in him and am tempted to say secretly to Correggio *Tu solo mi Piaci*.'[1]

The second half of the eighteenth century, which saw the publication of Mengs' literary works, also witnessed the activity of Girolamo Tiraboschi. In a short biography the pioneer historian of Italian literature applied himself methodically to the study of Correggio with admirable method and scepticism, sifting the evidence and exposing unfounded pious beliefs. His example was followed by other of his compatriots, Affò, Lanzi, and, most conspicuously, the Abate Luigi Pungileoni, whose detailed but ill-organised monograph (1817–21) remains the principal mine of archival material.

[1] Bottari 1822, VII, pp. 419–22. The presence at Dresden from the mid-eighteenth century of an appreciable portion of Correggio's best work was inevitably a factor in fostering his legend in Germany. But, equally inevitably, Correggio was not the only painter whose influence was increased by the existence of the Dresden gallery. A. C. Quintavalle (1970, pp. 13–14) draws attention to remarks by Hegel and Schopenhauer on Correggio, but these would be likely to have continued to escape notice if made by anyone else.

The high-water mark of Correggio's reputation is probably to be found in the eulogies published by Stendhal in his *Histoire de la Peinture Italienne* (1817). Correggio was one of his idols in a somewhat bizarre triumvirate, whose other members were Mozart and Napoleon. Stendhal also anticipated Pater's criticism of Giorgione by likening the effect of Correggio's paintings to that of music. Before that (in 1811) the Danish writer, A. G. Oehlenschlaeger, had published his tragedy called *Correggio* in which any resemblance to history was accidental, and which projected the image of the starving artist. This well-constructed play enjoyed international popularity for a time.[1] Thereafter Correggio's star started waning. The travel diaries and letters of various eminent men who visited Italy in the first half of the nineteenth century continue to pay lip service to Correggio (an exception was Dickens, who disliked the Duomo cupola),[2] and the progressive publication, in the mid-century, of accurate engravings after Paolo Toschi's watercolour copies of the Parma frescoes (for example, plates 45, 70, 71) diffused knowledge of them over a wide field. But throughout the more perceptive and influential criticism of the nineteenth century one particular point is harped on. Correggio may have been near to perfection (of a kind) in himself. But as soon as the later sixteenth-century Italian painters, and all those of the seventeenth century, became anathema he shared some of it, as being partly responsible. Early in the nineteenth century Friedrich Schlegel characterised him as in effect a siren, one who, with Raphael, Michelangelo and Giulio Romano, brought about the decadence of art.[3] This view was still being voiced by J. A. Symonds at the end of the century.[4] Oddly enough, the views of Ruskin, perhaps the most influential of all, were equivocal on Correggio. Though he never expressed himself on him at length he suggests, in a letter written in 1865, that he had started by disapproving, but in the end his aesthetic judgement for once got the better of his ethical prejudices. Eastlake, on the other hand, permitted himself to censure Correggio's lack of reverence in religious paintings, as well as his embarrassing success in erotic ones.[5]

Such ideas seem not to have been prevalent in France, or at least not expressed by either of the two most perceptive nineteenth-century critics, Baudelaire and Delacroix. Both of these refer to Correggio as one still firmly on his pedestal. Delacroix, indeed (Journal for 16 January 1860)

[1] For the popularity of the romantic image of Correggio in nineteenth-century France see F. Haskell in the *Art Quarterly*, Spring 1971, p. 66.

[2] *Pictures from Italy*, Gadshill edition, 1898, p. 380: 'This cathedral is odorous with the rotting of Correggio's frescoes in the cupola. Heaven knows how beautiful they may have been at one time. Connoisseurs fall into raptures with them now; but such a labyrinth of arms and legs; such heaps of foreshortened limbs, entangled and involved and jumbled together: no operative surgeon gone mad could imagine in his wildest delirium.'

[3] F. Schlegel 1959, IV, pp. 56 and 253–4. Also Mecklenburg 1970, *passim*.

[4] Symonds III, 1899 edition, p. 362.

[5] Ruskin 1909, vol. 36, pp. 490ff. Eastlake, *Materials for a History of Oil Painting*, II, 1869, pp. 209ff.

expresses a remarkably timeless verdict: 'C'est combien les pas que ce grand homme [Correggio] a fait faire à la peinture ont été surprenants, et combien, sous ce rapport, il se rapproche de Michel-Ange lui-même, et a droit à l'admiration des siècles.'[1]

The publication, in 1871, of Julius Meyer's monograph was a landmark in serious Correggio scholarship, containing, as it did, a more detailed catalogue – still useful for the engravings – than had been attempted hitherto. And it seems to have been a fairly modest exhibition held at Parma in 1894 to celebrate the supposed quatercentenary of Correggio's birth which led to the commission – by the London publisher Heinemann – of the first edition of Corrado Ricci's monograph, which appeared in 1896 and immediately established new standards of knowledge, taste and common sense on the subject. The second version, published in 1930, when the author must have been in the region of eighty, took account of a number of developments which had taken place in the long interval since the appearance of the first, and remains the standard general work. Soon after the publication of Ricci's first book a conspicuous exponent of the Viennese school of *Kunstgeschichte*, Josef Strzygowski, published (in 1898) his influential work, *Das Werden des Barock bei Raphael und Correggio* (Raphael and Correggio as pioneers of the Baroque) – expounding a view which has been fairly generally held since. With this book and another published in the same year by Wagner's step-son-in-law, Henry Thode, the rehabilitation of the Baroque swung the pendulum back in Correggio's favour, transforming the siren into the sibyl. In his book Strzygowski agreed with the advocacy of the Rome journey made by Thode. This theme was subsequently taken up with crusader zeal by A. Venturi and Longhi, as also by Gronau (while Berenson's utterances on it were always of oracular ambiguity). Between the wars there was a tendency in Germany to align Correggio with the Mannerists. This was minimised in a recent book by John Shearman (*Mannerism*, 1967). A second commemorative exhibition at Parma, in 1935, followed the publication of a monumental bibliography, compiled by Silvia de Vito Battaglia from material collected by Ricci.

Since the Second World War the sustained fascination of art historians and the reading public with Mannerism has directed more attention to Parmigianino than to Correggio. But the publication in 1957 of A. E. Popham's admirable work on the drawings was an important event. Some short monographs in Italian have also been published in the past two decades, each part of a series.[2] In the third of these the Painter of the Graces is allotted the forty-first place – after, among others, Boccioni (thirty-fourth) and Boldini (thirty-seventh). The scale of values implicit in such a situation needs no comment, other than the expression of a hope that it may prove as

[1] 'That is, how astounding were the advances made by this great man (Correggio) in painting, and how much, in this respect, he approaches Michelangelo himself and deserves the admiration of all ages.'
[2] Bianconi 1953, Bottari 1961, Bevilacqua and A. C. Quintavalle 1970.

ephemeral as it deserves. The frivolity of the second half of the twentieth century, so clearly evident in this alone, will take what superficial view of Correggio it likes. But an artist who was considered so great by so many good judges for so long may not be slighted. And to those who make a serious effort to study the evidence, visual and written, the nature of the verdict is not likely to be in doubt – a colossal individual talent, a pinnacle of cumulative achievement, a great legacy.

APPENDICES
A. A NOTE ON THE COLLECTIONS

The immense desirability of Correggio's paintings and the prestige gained in owning them was becoming increasingly apparent early in the seventeenth century and led to strenuous efforts, legitimate and otherwise, to lay hands on them. Those which he had painted for churches were at first immune. But the action of Cardinal Sfondrati in abusing his position as papal *nipote* to purloin two Raphaels from S. Maria del Popolo in Rome in 1591 seems to have started a kind of rot. Sfondrati's example was soon followed by another *nipote*, Cardinal Scipione Borghese, who, in 1608, removed a celebrated Raphael, the *Entombment*, under strong protest from a church in Perugia. Then it was the turn of Correggio, as the second most highly esteemed Old Master. Appropriately, it was the prince of his own town, Don Siro of Correggio, who took the first step by laying hands on the triptych of *Christ* from the church of the Misericordia in 1613.[1] After the annexation of the town of Correggio by Modena in 1633 the discreditable practice reached its culmination. Between 1638 and the end of his life Duke Francesco I d'Este forcibly seized, together with many by other artists, no fewer than five Correggio altarpieces from churches in his domains – the *Holy Family with St. Francis* (Uffizi) from Correggio, the *Notte* (Dresden) from Reggio, the *Madonna of Albinea*[2] from the church there, and the *Madonna with St. Sebastian* and the *Madonna with St. George* (both Dresden) from oratories in his own capital of Modena. Two of these – presumably the least desirable – were soon got rid of. He exchanged the *Holy Family with St. Francis* with the Medici in Florence. And the *Madonna of Albinea* got lost. The remaining three altarpieces – together with the *Madonna with St. Francis*, *St. Mary Magdalene Reading*,[3] and a dud, which Francesco took from the church at Rio, near Correggio, on the assumption that it was by the master – emigrated to Dresden in the eighteenth century.

Of the smaller religious pictures, the *Noli me Tangere* (Prado), *Agony in the Garden* (London), *Madonna of the Basket* (London), *Marriage of St. Catherine* (Louvre) and *Ecce Homo* (London) all passed through increasingly illustrious hands in the seventeenth century, the first three finding their way at that time to the Spanish royal collection – predictably, since Philip IV was one of the most successful of princely collectors. His great rival, Charles I of England, acquired four great Correggio's with the purchase of the Mantua collection *en bloc* in 1629, together with some others. Three of them went to France and eventually to the Louvre, the fourth to the Alba collection in Spain. In the eighteenth century, such was the extent of princely greed (and such the apprehensiveness of legitimate owners), that special measures had to be taken to ensure that the *Giorno* did not leave Parma.

[1] Catalogue B, page 280. [2] Catalogue B, page 278. [3] Catalogue B, page 279.

The four great mythologies, as perhaps the most desirable of all, have had the most *mouve-menté* career. The set, originally taken by Charles V to Spain, did not stay there long. It was soon split, and in a surprising way. One oblong (the *Danaë*) and one upright (the *Io*) came into the possession of the sculptor, Pompeo Leoni who took them to Milan when he returned, temporarily, from Madrid in 1582. The other upright (*Ganymede*) was given by Philip II to his favourite, Antonio Perez. After Perez' fall from favour, in the 1580s, the Emperor Rudolf II tried to acquire it, but instead it reverted to Philip II. It was not until after Philip's death (1598) that Rudolf succeeded (1603) in getting it, as well as the *Leda*. Two years previously (1601) he had bought the other two from Leoni. After Rudolf's death the partners changed, the *Danaë* being paired with its natural pendant, the *Leda*, to be swept away by the Swedes to Stockholm, and thence via Queen Christina, to the Orléans collection, the *Io* and *Ganymede* remaining in the Imperial collection (they are still at Vienna). The *Leda* and *Danaë* parted company again in the eighteenth century. Both had been in the Orléans collection in Paris. The *Leda*, after mutilation by the Regent's son, passed to the painter, Charles Coypel and thence to Frederick the Great and the Berlin gallery.

The wanderings of the *Danaë* at this time deserve a special word. Of all Correggio's paintings the mythologies are perhaps the most totally successful and the most miraculous. And of the great late group of four the *Danaë* is perhaps the most felicitous. Yet when it came to England in the Orléans collection in the 1790s it was not put aside, like the Titian's and the Raphael's and dozens of lesser works, for the exclusive use of the Duke of Bridgewater and his partners. Instead it was thrown into the sale of the remainder to take its chance with the Schiavone's and the Scarsellino's and the Sacchi's, and even here it fared no better. It was unsold, and later bought privately by Henry Hope. At his sale in 1816 it was knocked down at the derisory price of £175. What had happened? The dirt which may or may not have obscured it at the time would not be sufficient to account for so philistine and idiotic a degree of neglect. Only two factors come to mind. The story of the mutilations of the Duke of Orléans had undoubtedly been widely circulated, and though he appears to have spared this picture it was widely thought he had not. Secondly, an old copy, complete with false provenance, was being hawked round as the original by the Udnys at that very time, and had actually changed hands at a far higher price than the original (£2,050 at the Walsh Porter sale, 14 April 1810) (lot 52). The subsequent wanderings of the original are even now not entirely elucidated.

The Napoleonic wars dispersed some of the Spanish Correggios, the *Agony in the Garden* and the *Basket Madonna* going to London; and the Alba *School of Love*, after a period with another Spanish royal favourite (Godoy), then found its way to Naples where it joined the *Ecce Homo* from Rome. Both then came to London.

At the present time the score of the major works, excluding frescoes, is Dresden, Parma, Paris and London four each (in the case of the last-named divided in the ratio of three to one between the National Gallery and Apsley House), Vienna two, Rome, Berlin, Madrid, Florence and Budapest one each. In addition, there are important early works in London, Milan, Florence, Madrid, Modena, Naples, Hampton Court, Leningrad and Orléans. The United States, which entered the field too late to acquire any of the great works of the artist's maturity, has, in compensation, a relatively large number of the early paintings.

B. A NOTE ON THE CHRONOGRAPHY

As the first systemic student of Correggio, Mengs, in his *Memorie...di Antonio Allegri... Correggio*, shows himself aware of the chronological problems. He specifically deplores the rarity of signed and dated works, and emphasises the consequent difficulty of tracing Correggio's origins as an artist. Occasionally he ventures on dating by stylistic grouping. The Del Bono laterals (Parma) 'sembrano fatti dopo la Cupola'.[1] The Dresden *Madonna with St. Sebastian* is 'molto primo di quello di S. Giorgio'.[2] He assumes the *Notte* (Dresden), though commissioned in 1522, was 'non...finito che nel 1527'[3] (no explanation given). Of particular interest is Mengs' cautionary remark, apropos of the date 1517 on the back of the copy (now Leningrad) of the Naples *Marriage of St. Catherine*: 'se questa scrittura è veridica'.[4] For not only is there no reason to believe that the inscription *is* 'veridica': it is not the only one of its kind. The print of the *Danaë* by Etienne Desrochers (1666–1741) (plate 189A) is inscribed 'Antonius de Alegris Corigiensis pinxit 1531', while Simon François Ravenet did the same thing on three occasions (S. F. Ravenet II, 1748–after 1814). His print of the Del Bono *Lamentation* dates the painting 1523, his print of the *Giorno* dates it 1524 and of the *Scodella* 1529. Finally, J. Johnson added the date 1529 to his print of the *Io* (1743).

As no evidence now exists to confirm any of these dates we must try to decide whether it ever did. It seems, prima facie, very unlikely that any reliable documentation existed as late as the eighteenth century – when these engravings were made – which was unknown to such conscientious archivists as Tiraboschi and Pungileoni. We may therefore conclude that these dates

[1] 'Seem to date from after the cupola.' [2] 'Much earlier than the St. George.'
[3] 'Not finished until 1527.' [4] 'If this inscription is authentic.'

are more likely to be intelligent guesses. In the case of the *Scodella* and the *Lamentation* (both Parma Galleria) the dates could have been arrived at by deducting one year in each case from those on the frame and floor tablet respectively. In this case it would be surprising that no guess was made in respect of the pendant to the *Lamentation*, namely the *Martyrdom* (Parma Galleria). For the *Giorno* (Parma Galleria) it would be possible, though unlikely, that there was a date on the original frame. Alternatively, Ravenet may have produced the date 1524 – which, in my view, is appreciably too early – from a note by Affò which states that Bottari had a drawing for the picture which bore that date (this drawing is also referred to in the Florentine edition of Vasari, 1771, III, page 61). In the case of the *Danaë* the only explanation would seem to be Vasari's statement that it was painted for the Emperor Charles V, and suggests that a mean had been taken between the dates of his visits in 1530 and 1532. What the origin of the inscription on the back of the Leningrad picture may be is unknown to me. Nor do I know if pseudo-scholarship of this kind was applied in the eighteenth century to others than Correggio. But I am inclined to suspect that Padre Resta may be at the bottom of it. By the same token, it is likely that certain engravings, particularly in the eighteenth century, were wrongly inscribed as being after paintings by Correggio.

Of the other eighteenth-century commentators, Tiraboschi, though confused on the subject of the 1514 contract, is factual and accurate elsewhere. He assumes the Dresden *Notte* and the *Scodella* were not finished until 1530, when they were set up, and he states positively that the documents connected with the *Giorno* no longer existed.

His successor, Lanzi, endeavoured to create an intermediate period – between the Dresden *St. Francis* and the mature works – by assuming the authenticity of, and dating to that period, works such as the Metropolitan *Four Saints*, the Uffizi *Holy Family with St. Francis* and *Madonna Adoring*, the Leningrad *Marsyas*[1] and the Prado *Noli me Tangere* which had previously been considered inferior to Correggio's best.

Whereas Mengs had an excellent eye and was also widely travelled, both Tiraboschi and Pungileoni give the impression of having little or no visual judgement. The fact, in addition, that neither of them, nor Lanzi either, can have seen more than about half the pictures they were writing about is also to be borne in mind. Regarding Correggio's chronology Pungileoni seems to place the Louvre *St. Catherine*, the Apsley House *Agony* and the Prado *Noli me Tangere* shortly before 1520 and the London *Ecce Homo* soon afterwards. But he says (I, page 104) that he cannot precisely date more than a few of Correggio's pictures. In the case of the *Madonna with St. Sebastian* Pungileoni accomplishes the feat of assigning to it approximately the right date (in my view) for the wrong reason. Regarding the *Scodella* he says (I, page 164): 'Ad onta

[1] Catalogue C, page 288.

della iscrizione sottoposta nella cornice, credo il lavoro finito assai prima dell'anno in essa seg-nato, troppe cose avendo egli allora per le mani.'[1]

Much of the traditional view of the chronology was retained by Meyer (1871) who assigned the Louvre *St. Catherine*, the Uffizi *Madonna Adoring*, the National Gallery *Basket Madonna* and the Prado *Noli me Tangere* to the years 1517–20. (One cannot help wondering whether the extraordinary tenacity of the pre-1520 dating for the Louvre *St. Catherine* may not be due to associating it, merely through its subject, with the Leningrad copy of the Naples picture and making the one apocryphal date do for two.) Of the great altars, the *St. Sebastian* remained steady at *c.* 1525 through Meyer, Ricci (1896), Gronau, Venturi and Ricci (1930), and the *Giorno* at 1527–28. The present writer approximates to this dating in both cases. Ricci (1896) dated the *Scodella* and the *Notte* after the *Giorno* – *c.* 1529–30 – and this was retained by Gronau and Venturi. The former somewhat eccentrically separated the Del Bono laterals by a number of years and, even more oddly, dated the *Danaë* as impossibly early as *c.* 1526. Of Venturi's chronological innovations the most interesting was his view that the Robinson *Baptist*[2] – and therefore the whole Misericordia triptych[3] – was a late work.

In recent times both the most important contributions to the chronography of Correggio's paintings were published in Popham's book on the drawings (1957) – the dating of the Frankfurt *Madonna* design (Popham 31v) (plate 90B),[4] and therefore of the others associable with it, to the early 1520s, and of the Dresden *St. George* to not later than 1530, thus compressing more of the oeuvre into the decade of the 1520s.

C. A NOTE ON THE ATTRIBUTIONS TO THE EARLY PERIOD

Though the reconstruction of the early Correggio is generally, and rightly, associated with Morelli his own original contributions were small. (Of the non-early works, incidentally, he called the Doria *Virtues* a late seventeenth-century copy – which can now be disproved – and cast doubt – unjustifiably, in my view, – on the then-celebrated Dresden *Magdalen*.[5] He also attributed to Correggio the Munich *Piping Boy*,[6] an attribution which is now universally

[1] 'Despite the inscription on the frame, I think the picture was finished somewhat earlier, as he was very busy at that time.'

[2] Catalogue C, page 282, note 9.

[3] Catalogue B, page 280.

[4] Catalogue B, page 279.

[5] Catalogue B, page 279.

[6] Catalogue C, page 289.

rejected.) Of the early works which he accepted, the New York *Four Saints* had never been called anything but Correggio, while the London *Leave Taking* was attributed to him at least as early as the eighteenth century. The important Detroit *St. Catherine* had been recognised as Correggio long before Morelli's time, but Morelli had missed it. The Washington *St. Catherine*, the Milan *Bolognini Madonna* and the Modena *Campori Madonna* had all been published as Correggio pre-Morelli. The Brera *Nativity* was discovered, or at least published, by Morelli's pupil, Richter, while the most sensational of all, the Brera *Adoration*, was due to Berenson. Two others – the Strasbourg *Judith* and the Johnson (Philadelphia) *Madonna* – were apparently first attributed by the latter's rival, Bode. Morelli's own contribution consisted merely of two small *Madonnas* – the Malaspina (Pavia) and the Uffizi. But in addition – and this was his achievement – he gave his great authority to the others and created an entity out of them.

The fact that among the putative early works only one, the Dresden *St. Francis*, could be authenticated by a contemporary document, and that the image which emerged from the totality of Morelli's early attributions seemed over-remote from the immense virtuosity of the attested works of Correggio's maturity gave rise – after Morelli's death – to various murmurings and revolts. The first in print, apparently, was a short piece in an obscure Munich periodical – the *Monatsberichte für Kunstwissenschaft* (1903) written by a modest German scholar, Wilhelm Schmidt. He roundly re-attributed Morelli's attributions – apparently all of them, with Venturi's *St. Anthony* (Naples) and Thode's *Casalmaggiore Madonna*[1] thrown in for good measure – to Rondani. This was followed by a review of Gronau's monograph published by T. de Wyzewa in the *Revue des Deux Mondes*, 15 July 1907. While likewise attacking the generality of Morelli's attributions the reviewer concentrated his fire on the Brera *Adoration* (which, according to him, was then displayed as prominently as Raphael's *Sposalizio*, in dramatic isolation). Oddly enough, the author of the book under review, Georg Gronau, had himself expressed doubt in it about this particular picture. It is also of some significance that the fiery author of the review was not qualified in any way to pass the judgement that he did. He was no specialist on Correggio, nor even an art historian at all in the accepted sense. He was an intelligent journalist and a prominent figure in the Paris art world. He afterwards became part author of an important book on Mozart.

Both these efforts were put in the shade by an elaborate monograph, originally published in 1914 as a doctoral thesis, under the title *Die Madonna mit dem Heiligen Franziskus und die sogennanten Jugendwerke des Antonio da Correggio*. This was later (1915) reissued under the more aggressive title *Correggio-Apokryphen*. In this case the writer, one Oskar Hagen, was a young professional art historian who later wrote a book on Grünewald. He attempted at great length

[1] Catalogue B, page 279.

to demolish all the Morelli and post-Morelli attributions, with the token exception of the Milan *Bolognini Madonna*. His conclusions found no support, and were obviously invalid. Conversely, Morelli's 'early Correggio', with the exception of the *Piping Boy*, has stood the test of nearly a century.

Early in the present century and continuing up to the 1930s, Adolfo Venturi made a number of attempts to add to Correggio's oeuvre, re-attributing to him the Mantua frescoes and the ruined fresco fragment at Modena,[1] together with a considerable number of even more unlikely others. Of these only the Naples *St. Anthony* has found favour. Otherwise the valid twentieth-century attributions and re-attributions to the earlier period consist of Fairfax Murray's and Gronau's Los Angeles miniature, Longhi's Orléans *Madonna* and Madrid *St. Jerome*, Voss' Vienna *Hellbrunn Madonna*, Longhi's Leningrad *Portrait of a Lady* and the Chicago *Madonna*, first published by Laskin. Another would-be contribution to the early Correggio needs to be considered separately.

In the May 1958 issue of his periodical, *Paragone*, the late Roberto Longhi published about a dozen pictures, mostly unknown, as Correggio. Those who had followed Longhi's work were aware that he had the habit of pulling rabbits out of a hat by publishing obscure pictures as un-known works of great masters. On this occasion he surpassed his previous efforts. Not only were the pictures in question unworthy, in most cases – at least in the photographs as published – of even a third-rate painter. In addition, no possibility existed – or was meant to exist – of checking Longhi's claims, as in most cases the ownership was not specified. Only one picture – the Hermitage *Portrait of a Lady* (plate 26B) – could be accepted without question as Correggio's, and that happens to be signed. Another, the male portrait in the Castello Sforzesco at Milan, is not absolutely impossible but merely unlikely.[2] A third – the St. Catherine, which is No. 3118 (Garafalo) of the National Gallery, London – has, in my opinion, nothing to do with Correggio. The remainder I have had no chance to see.

In the circumstances it is perhaps kindest to the memory of a scholar who in other respects was conspicuously brilliant to ignore this phase of his Correggio attributions, and that is what has been done in this book.

[1] Catalogue C, page 283. [2] Catalogue C, page 288.

D. A NOTE ON CORREGGIO'S TECHNIQUE

In no single respect is Correggio's restless quest for perfection and for setting himself problems more marked than in his frequent changes of technique. His earliest surviving works are in a smooth technique on panel. But both the Metropolitan altarpiece and the London *Leave Taking* appear to have been painted on canvas, and this was an experiment which evidently did not greatly please. For he reverted to panel, the main exceptions being the mythologies, the Del Bono laterals (Parma Galleria) and the Uffizi *Holy Family with St. Francis* and *Madonna Adoring*. These, at least, are on canvas now and may always have been.

Other technical innovations or experiments of Correggio's include a broad technique on a miniature scale (in the Naples *St. Catherine* and London *Madonna of the Basket*), the use of a metal support for a miniature (the *Magdalen* formerly at Dresden),[1] a miniature and very smooth technique in a picture of cabinet size (the Uffizi *Madonna Adoring*), a very fluid technique (the Apsley House *Agony*) and a surprising reversion to tempera (in the Louvre and Doria allegories and Naples *sportelli*). The thick texture and impasto of the Dresden *Notte*, Parma *Giorno*, Louvre *St. Catherine* and London *Ecce Homo* is followed by the incredibly different, smooth and alabaster-like technique of the Dresden *Madonna with St. George* and the four late mythologies.

The cleaning of the *Madonna of the Basket* (by Helmut Ruhemann in 1967) at the National Gallery permitted a prolonged examination with a microscope from which the following details are derived.

Every layer was dry before the next was applied.

The panel was primed with white gesso which was then covered with a transparent raw siena tone, evenly spread over the whole surface. Probably some outline drawing was then carried out, followed by a semi-transparent raw siena and raw umber monochrome modelling of the whole design, painted wet in wet in a broad and sketchy manner without much detail. Then a further monochrome stage in grey, leaving the previous yellow-brown layer to show through, except in the darkest shadows which are almost covered with grey. Then the colours as visible, of which the pink of the Madonna's dress, the lilac of the scarf and the green of the foliage and plants were obtained by the use of glazes.

Of the frescoes, both the cupolas show extensive finishing in tempera over the true fresco underneath.

One of the arguments used since the eighteenth century to refute Vasari's allegations of Correggio's poverty and parsimony was the unusual excellence of his pigments. And it is a fact that many of his pictures remain in better preservation than most other famous works of the period. Of the big ones, the Dresden *Madonna with St. George* is outstanding in this respect as being

[1] Catalogue B, page 279.

almost perfectly preserved, while the *Notte* (Dresden) and the *Scodella* (Parma Galleria) are in better than average condition for works of the kind (both despite unfounded rumours to the contrary). Of the miniatures, both the London *Madonna of the Basket* and *Magdalen* are in nearly perfect state, apart from some inevitable slight oxidisation of the greens. Of the small pictures, the most damaged is probably the Naples *Zingarella* and of the large ones the Dresden *Madonna with St. Sebastian*. Of the four late mythologies the most damaged is probably the *Ganymede* (Vienna) followed by the *Leda* (Berlin). The *Io* (Vienna) is in acceptable condition, as, probably, would be the *Danaë* (Rome), though there the combination of a dangerous old varnish and of a glass over the painting makes it, tragically, semi-invisible at present. (*Passim*, cf. Eastlake, *Materials for a History of Oil Painting*, II, pages 209ff.)

E. THE USE OF THE WORD 'CORO' ('CHORO')

Pungileoni (I, page 136) speaks of the 'coro…Collocato allora giusta l'antico costume sotto la cupola'.[1] He gives no evidence for this statement, and there is sufficient evidence that in an architectural context the word 'coro' was used in the sixteenth century to mean the whole or part of the area between the main dome and the apse – that is the 'choir' in the English architectural sense. Serlio (Book V, 1619 edition, page 214v), for example, speaks of a vaulted bay ('crociera') east of the main cupola in a cruciform church which 'potrà servire per il Choro'.[2] Francesco Giorgi's memorandum of 1535 for S. Francesco dell Vigna at Venice (R. Wittkower, *Architectural Principles in the Age of Humanism*, 1952 edition, pages 136ff) sites the choir east of the 'cappella grande'. The latter was a term which had been regularly used by Vasari among others to denote the central chapel of those which open out to the east side of the transepts in Italian Gothic churches. Francesco Giorgi evidently intended the choir to be a continuation of the 'cappella grande'. But the term 'cappella grande' seems sometimes to have been used in the sixteenth century to mean virtually the same as 'coro' – i.e. the whole area between the crossing and the apse. In Filarete's architectural treatise (Book XI, folio 78v) the 'coro' of the monks in a Benedictine church is situated between the central cupola and the main apse. Finally, a drawing in the British Museum (reproduced Popham, page 205, fig. 72) contains Resta's reconstruction of the east end of the S. Giovanni Evangelista before it was altered in the 1580s. He uses the Latin

[1] '…situated in those days according to ancient practice under the dome.'
[2] 'Could function as the choir.'

forms to label the parts of the building, the area between the main cupola and the main apse being clearly marked 'chorus'. This drawing and another (Popham 24v) contain architectural designs associated by Popham (1957, pages 199ff; see also his Parma volume of the British Museum catalogue, 1967, page 5) with plans by Correggio for the church of the Steccata. But I am not convinced that they are intended either for that context or for any other specific building.

DOCUMENTS

THE SYSTEMATIC SEARCH FOR
contemporary documents relating to Correggio was undertaken with great energy by Tiraboschi
and Affò (among others) in the late eighteenth century, and by Pungileoni early in the nineteenth.
It is doubtful if any other artist, even Raphael, was subjected to so thorough an archival search
at this propitious period. In consequence, the minimum (I think only four documents) has come
to light in the century and a half since the publication of Pungileoni's work, and little attempt
has hitherto been made to check the latter. Even Adolfo Venturi, who had a life-long interest in
documents and brought one of the few new ones to light, seems to have taken Pungileoni
largely on trust; while Laudedeo Testi, who did work through the Correggio documents, died
(in the 1920s) with his research incomplete and unpublished. Owing to the kindness and
detective skill of Dr Alberto Ghidini, Director of the Archivio at Correggio, I have been able
to work from photo-copies of the documents in the archives of the town of Correggio. This has
revealed a few curious slips and misprints on Pungileoni's part, and also a few omissions.

After a good deal of thought I decided to depart from earlier practice to the extent of at-
tempting to transcribe the documents literally – that is, without expanding the contractions.
My reason for this was not only that it is more honest in principle. In practice, in the few cases
where more than one person had attempted an expanded text I found that they had sometimes
expanded the same word differently. This was perhaps not surprising, since there is often an
element of guess-work in expanding a drastically contracted word. When, in addition, the con-
tracted word is carelessly or indistinctly written – as is very often the case with the present
documents, many of which would have been intended merely as scribes' rough copies – the
chances of guessing wrong are considerable. I am afraid that the result is very difficult reading,
but I would remind any reader who may feel disposed to struggle with it that deciphering the
writing in the first place was more difficult still. I have indicated a contraction by a short dash
over a letter. A short dash on the line means one or more letters which I was unable to read.
A row of dots means a more lengthy omission. In all cases I have attempted to transcribe all of
the text which is relevant – that is, with the documents relating to Correggio's paintings given
in full, or nearly. The papers relating to family matters – particularly the law-suits over inheri-
tances in which both he and his wife were involved – are in some cases voluminous and are
merely summarised or given in extract. I have not taken into account in this section documents
which have never been printed verbatim and cannot be found, but which, like those for the
commission of the *Giorno*, were once said to have existed.

INDEX OF DOCUMENTS

1. DOCUMENTS RELATING TO CORREGGIO'S PAINTINGS

I THE ALTARPIECE FOR S. FRANCESCO, CORREGGIO

IA 4 July 1514

Document recording an arrangement consequent on the will of Quirino Zuccardi, whereby Nicolino Selli of Parma, husband of Lucrezia Zuccardi, Quirino's heir, pays to Fra Girolamo Catanio, prior of S. Francesco at Correggio, 95 ducats and 64 soldi to pay for an ancona to be executed within eighteen months. In return he receives the house which Quirino Zuccardi had bequeathed to the monastery of S. Francesco.

Correggio, Archivio. Rogato di Bartolomeo Zuccardi. Extracts from the central section printed by Pungileoni, II, page 66. Re-transcribed from the original.

Mccccxiiij Indt Secda die quarto m̄sis Julij
Cū sit & fuit p̄ q̄d Q̄rinus de Zuchis dicto quirino

bisiolo in eius ultō testō reliquerit c̄uētui & frats̄ s̄ti franc̄i d̄ corrigia ducos centū p̄ facienō & fieri facienō in dicta eccā Anchonā unā ut ut̄s d̄t & p̄ dicto legato r̄quit & ob--uit dicto c̄uētui & fratṡ domū unā p-t̄ in burgo nouo terr̄ corrigie cui c̄su -- nic̄s d̄ bachilis et pet̄s d̄ mazolis d̄ prata publica et borsius to--iarius ha- Ideo Nicolinus q̄d bap̄ta de Sellis d̄ parma hātān̄ corrigie maritus lucretie d̄ Zacardis her̄- dicti q̄rini ibi pres̄ p̄ se & sp-- & dedit tradidit & numāuit in p̄ntia mei notī & testiū prox̄ venī viro d̄ frt Hyeronimo d̄ catanijs d̄ corrigia custodi & p̄ct̄ dicti c̄uētus & frat̄ pr-- & di--os no-- ad se trahētī dūc nonaginta q̄nq̄ --- sexagintaq̄or vz̄ dūc 95 - 64 p̄ legato & p̄-lega-- --- & p̄ facienō & fieri facienō dicta anchonā Quam dictus custos no-- c̄tu p̄misit & solē c̄uenit dicto nic̄o prm̄- stip̄ti p̄ -- facer̄- & seu fieri facer̄ & fabricar̄ hinc ad decem & octo menses px̄s fut̄s dan̄o & c̄cedenō dicto nic̄o ut̄s scripti & stip̄ti licentiā &

potestatem vendeñi alienandi & p̄ se retinēdi dictā
domū ūts relict- & obt- & - ea facieñi p̄ut sibi
placuerit... (a further 14 lines).

IB 30 August 1514

Contract for altarpiece for S. Francesco, Correg-
gio. Antonio Allegri agrees with the Ven. Fra Giro-
lamo Catanio, custodian of S. Francesco at Correggio,
to paint an altarpiece to the value of 100 ducats

Correggio, Archivio. Rogato di Bartolomeo Zuccardi.
Extracts published by Pungileoni, II, page 67. A better
text published by Ricci, 'Il Ritratto del Correggio',
Rassegna d'Arte, 1917, page 65. Re-transcribed from the
original.

1514 Indt 2a die 30 Augti

Antŝ filius p̄rgni d̄ Alegris ibi p̄ns p̄ se & c̄ c̄sensu eius
p̄ris p̄ntis et c̄sensu datis et p̄statis p̄missit & sotr̄
c̄uenit venli viro fri Hyeronymo d̄ catanijs custodi sti
franci de corrigia ordinis frm̄ minor̄ et S̄ Ano Zucho
et S̄ Thoma & Joanes d̄ Affarusijs sindicis dicti c̄uētus
& dicto S̄ Antō ut executori et fideicomissario q̄d
Quirini d̄ Zuchardis p̄ntibs et stiptibs noīe dicti
c̄uētus etc se facer̄ & pinger̄ ac c̄struer̄ anchonā unā
valoris et extimationis ducator̄ centū et plus etc
detractis lignamine et factura dicti lignaminis dicte
anchone quā cū lignamine dictus custos et sindici
teneatr̄ suis somptibs facer̄ & seu fieri facer̄ et hoc
fecit dictus antŝ q̄a dictus custos p̄missit & solr̄ c̄uenit
dare et exbursar̄ dicto Antō p̄nti et stipti p̄ se etc
ducatos q̄nquaginta complecta ip̄a anchona et cū ip̄e
Antŝ ip̄am anchonam valoris utsā p̄ixerit et c̄pleuerit
Et q̄a et̄ dictus custos dedit et actū- n̄ūerauit dicto
anto p̄nte et ad se trahet̄i in pecu- n̄ūeratā ducatos
q̄nqaginta in p̄ntia mei noti et testiū infrast̄ que oīa
p̄mx̄ dictus custos & antŝ sibi inuicem h-r rata etc sub
pena etc et sub refecti dañor̄ etc qua pena etc qua
pena [sic] pro q̄b obus etc r-tes etc insup̄ iurauerunt
v̄z d̄cs custos sup̄ pectus suū & dictus antŝ tactis
script etc roga etc quib oīb & singlis ad instātiam dicti
anti & p̄ ip̄e fidei-c̄onsēs p̄r Actū in burgo v̄ri t-rr
corrigie et in camera c̄ub dicti S̄ Anti ad terrenū
p̄ntib Bt q̄d prosperi d̄ rubeis d̄ villa vi-- districtu
corrigie Bnar-o q̄d Angelli Sogarij et eius filio p̄rgni

d̄ niḡsolis oīb d̄ corrigia testb̄ et Ego B̄ts Zuch̄s notŝ
rogat̄s fui et scripsi

IC 4 October 1514

The Contract for the Panel.

Correggio, Archivio. Rogito di Giovan Gaspare Porta.
Partly transcribed by Pungileoni, II, page 68. Re-trans-
cribed from the original. Pietro Landino commissioned to
construct the panel for the altarpiece for the high altar
within that month.

1514 Indic̄ sēda die quarto oct-b̄r

C̄ostit corā me notjo & testbs instis r̄vdus fr̄ hyeroni-
mus de catanijs de corigia guardianus & p̄curā
c̄uētus & fr̄us sti franci de corrigia & dix -- -- &
exposuit q̄ de mēse p̄to p̄x & ī principio ip̄s mō petrus
de lādinis c̄dux ab n̄ro guardiano & frbs s̄stis se se obit
ad facie- & c̄struen̄ achonā una lignea p̄ capella magna
eccl̄e s̄ste p̄ p̄tio -llo q̄o estimabit -- -- -- dūc q̄adra-
ginta p̄x fut-- icipien̄o -- & finir̄ in seq̄tur Et q̄ mō
negligens est ip̄e petrus cā c̄structionē dc̄t achone qū
ip̄e guardianus frat̄ p̄dc̄t p̄testat siue & p̄testat ip̄e
petro p̄nti q̄ si p̄ totū mēse p̄nte ip̄e petrus nō c̄pleat
opus p̄dc̄m intendit & uult alij dar̄ & locar̄ dc̄t opus
ad facien̄ absq̄ -lla mercede data ip̄i petro....

ID 1515

Payments at S. Francesco.

Correggio, Archivio. Francescani, Case e Sagrestia,
Entrata e Spesa, 1510–1523. Partly transcribed by Pun-
gileoni, II, pages 68–9 (with the year 1515 misprinted as
1514 in the first entry, and other mistakes). Re-transcribed
from the original.

adi 16 de marzo 1515...

E di dare adi 24 in peso...E di dare p̄ tre pexi de
ferro p̄ tare le lige ala casa de lo altare grādo doue - la
anchon tolse luca ferraro moto L 3. ?4
Epui di dare ducati dexe de ore dato al dipintore de
c̄osentimēto de miser Thomas ejh̄no affaroxi sindici
del dito c̄oueto p̄ uno miara de oro qualo posi -l
dipintore ala anchona a noster spexi eran ī tuti
L 40. 0
...

adi sup̄ scrito (4 April 1515) (this is the beginning of
a new page in the account book). San- franc̄o de dare
como apare p̄ il libro d̄ franc̄o pez- p̄ f—lle p̄ fare
lipōti p̄ ornar la capella grāda e p̄ pexi tre e lu-z- 22
de ferr p̄ bisogno de la casa de lanchon moto i tuto
pn̄t- jō faroxi L 6. 0

Edi dare [Pungileoni, II, page 68 misreads these words
as 'A di 4 Aprile'] hebe mō antō de alegro pn̄te
miser thomaso faroxi sindico del c̄ueto et miser jō
ludouigo mōtesino et el p̄ predicatore frā jac̄o de ceua
et el p̄ vic̄o del c̄ueto p̄ manifatura de lanchona de lo
altare grādo ducati c̄eti p̄ mercato facto c̄o lui questi
p̄ ult̄ pagam̄eto
cioue in liuere quatrec̄eto u- L 400. 0
. . .

[April 1515]
Edi dare hebe mō antō p̄ tāto azuro p̄ dare ala casa de
lanchon L 3. -

Edi dare hebe mō piedro landino p̄ c̄oto de lanchona
de legnamo fato al c̄ueto questi p̄ parte de dito pretio
c̄h fu ducati 22 cioue L 88. 2
. . .

[August 1515]
A di 28 p̄ pagā un legno a tal righeto p̄ lanchona
L-14

(Pungileoni has the following entry of which the
original is not traced.)

Mazo 21 (1515) hebe Pieto Landino per ultimo
pagamento de l'anchona presenti Zan Farox e Marco
Tirelli L . . . 12.

2 WORK FOR S. BENEDETTO PO
8 September 1514

Agreement between Correggio and the autho-
rities of the Benedictine monastery of S. Benedetto
Po, near Mantua, to paint the organ doors and po-
dium. Nothing is known of the outcome.
*Archivio di Stato, Mantua. Archivio notarile, Atti
Notaio Pietro Francesco de Borgoforte. First published by*

*Emilio Menegazzo: 'Contributo alla Biografia del
Folengo', in Italia Medioevale e Umanistica, II (1959),
page 383. Re-transcribed from the original.*

V̄r- 8 7ris 1514

m̄ Ants filius m̄ Peregrini dj Alegris pinctor hn̄s in
t—t corigie Convenit c̄u Rd̄o don Bn̄o dj Cremona
sacrista mōn Quod dic̄s m̄ tn̄atur depingere portas
organi et podiū ipsius organi ad laud p—i sol— —. . .
hoc p̄ p-io d̄uc- 50 Termn̄d In p—-res— Testes d̄ m̄ Jo
andreas medicus franc̄s f̄q mer- luchini i Jugo Paulus
filius Jo chauagli i Gurgo

3 ALTARPIECE FOR ALBINEA
3A 12 May 1517

Letter from Giovanni Guidotti di Roncopò,
priest of Albinea, to Alessandro de Malaguzzi con-
cerning Correggio's progress on a picture, now
known only in copies.
*Reggio Emilia, Archivio di Stato (Archivio delle Opere
pie e delle Soppressioni in Reggio Emilia, fondo dell'ab-
bazia dei SS. Pietro e Prospero, serie Malaguzzi). First
published by A. Venturi, Archivio Storico dell'Arte, I,
1888, page 90. Re-transcribed from the original.*

Egregie ac major col̄ede — m̄es alexādre ue p̄go ch p̄
mio amore c̄h scriuate una lettera a quello majstro de
lanchona c̄h p̄ piu dureza sel po c̄h la faza segd̄o me
dicisseue amj sel nō e- tāto i anze ch nō la possa
lasāla: quella sege ha dato pn̄cipio . La madalena gela
mādara - se ha adrizare a m̄ antonio fiolo de pelegrin
de alegri da coreza nō altro a voj me recomādo
1517 die 12 maj
Jouanes albines archip-br - ūe

(Outside addressed to: Egregio viro ac majori colendo
alexandro de malagucijs etc).

3B 14 October 1519
End payment.
From Pungileoni, II, pages 109–110.

M. Antonius filius Peregrini de Alegris de Corrigia
ibi praesens etc finem facit Rev. Domino de Ron-
chogado [Ronchopado] archipresbitero plebis de
Benelia ibi praesenti . . . finem quietationem et pac-

tum liberatorium de aliquid ab eo in futurum non petendo de omni eo et toto in quo dictus Joannes teneretur et obligatus esset et erat dicto magistro Antonio, causa et occasione resti pretii unius Anchonae ut apparet in quodam chirografo scripto manu praedicti D. Joannis. Et hoc ideo fecit dictus M. Antonius, quia in presentia mei notarii...habuit et recepit a dicto D. Joanne ducatos quatuor, liberans... cassans et annulans dicto nomine instrumentum et scripturam publicam, et maxime illum chirografum in quo apparet dictum residuum....

4 THREE WILLS OF MELCHIOR FASSI

1517, 1528 and 1538

Unpublished except for short extracts in Pungileoni. For the connection between them and the altarpiece now in the Metropolitan Museum see the catalogue entry for that picture, and page 37 of the text. By his will of 1517 the testator directed that he be buried in S. Francesco at Correggio. He also bequeathed a *petia* to the hospital of S. Maria Verberator, known as the Misericordia or Hospital of the Poor, the interest of which to be used for the upkeep of the testator's altar in the church of that hospital. A rough note at the end of the will names the church of S. Quirino at Correggio as residuary legatee and enjoins the authorities to make a chapel with an altar in it with an altarpiece with four saints – Leonard, Martha, Peter and Mary Magdalene. Masses to be said on St. Leonard's day and St. Martha's day.

The provisions of the second will, of 1528, included the following:
1. To be buried in S. Maria delle Grazie, at Correggio, near the Porta S. Giovanni.
2. Bequest to the monastery of Corpus Christi. Mass for the dead to be celebrated every year.
3. Bequest to the church and hospital of S. Maria Verberator. Masses to be said at the testator's altar.
4. Bequest to his cousin, one Giovanni Antonio de Zanotis, to revert to the church and hospital of S. Maria Verberator if the legatee has no legitimate issue.
5. Residuary legatee named as the church of S. Domenico dell'Osservanza, of which the fathers are enjoined to erect at the testator's expense a chapel with a beautiful altarpiece on which is to be painted the Virgin, St. Peter, St. Leonard, St. Mary Magdalene and St. Martha. Silver chalice and other things to be provided. A mass to be sung on St. Martha's day, also offices for the dead, if the chapel is constructed by the time of the testator's death. If not, at another altar. If these conditions not observed the bequest reverts to S. Maria Verberator.

The provisions of the third will, of 1538, included the following:
1. To be buried in the church of S. Maria Verberator. Testator's altar called that of St. Martha. Tomb to be on the left of the altar. *Some* residuary to be distributed to S. Maria delle Grazie. Bequests to Corpus Christi, S. Quirino, S. Francesco, S. Sebastiano, S. Giuseppe and S. Domenico.
2. Residuary legatee the church and hospital of S. Maria della Misericordia (S. Maria Verberator). Mass to be said at testator's altar of St. Martha.

The first will consists of just over three pages of writing in fair copy, the rough note at the end occupying another two. The second will is seven pages of fair copy and the third eight. Most of all three wills consists of numerous bequests to specific individuals. The extracts which are transcribed and printed below are mainly those which concern the testator's wishes concerning his burial arrangements.

4A 16 December 1517
Will of Melchior Fassi.

Correggio, Archivio. Rogato di Tommaso Parma. Short extract published by Pungileoni, II, page 94.

In christi noīe am̄ año a natiuit eiusdm̄ d̄mi millis q̄nḡmō septiodeciō ind quinta die sixtodeciō mensis decembr̄- - - - - In primis q̄dm aīa suā humilit̄ ac deuote oīpotenti deo eiusq̄ gloriose m̄re marie semp̄ virgini ac b̄to q̄rino p̄tectori n̄ro totiq̄ celesti curie recomendauit et corporis sui dū aīa et sp̄us ab eo erit sepāta sepultura elegit in ecc̄a sti franci de corrigia in eius sepulcro cuiq̄dm ecc- relq̄t de bois suis ducat̄ decem auri dandos p̄ inst- suū hed- seu h̄rdes et distribuendos in rebus necessarijs et opportunis ad d̄ca ecc̄a

It̄ reliq̄t iui legati hospitali st̄e marie -berator de corrigia petiā unā t-re tab̄ et claux̄ poit- in villa sti Blasij district̄ corrigie cui cf̄n ad—a- via cois at i—

ecc- sta mr̄ magdalene at̄ jō francs de mignanis sū- ac
bōb quatuor ut cā volens et mandans q̄d fructus et
redditus ex dc̄a petia p̄cipier- et q̄ p̄cipientur in fut-m
pro-pm distribuentur in utilitate ip̄ius altaris situat- in
ecc̄a dc̄i hospitalis p̄ sindicū et massari-s dc̄i hospitalis

It̄ reliqt̄ iui legati honeste mulieri dn̄e angole quōn
mri baldesaris de fassis al̄s parmesano et sororis ip̄ius
testatoris nc̄ nō et quōn Bernardini de zanotis petiā
unā t-r̄e tab̄ et —— po-t in t-itorio corrigie in loco dc̄o
zimignola ubi d- al canale cui c̄fin̄ ab̄ via cōis et mr̄
laurentius d̄ alegris pictor at̄ hedes q̄d mr̄i corti—
muratoris sal̄ ac bōb qn̄q et tab̄ triginta octo ut cā aut
quantaqq- sit cadat in —— legato
—

[The following is the portion of the rough copy –
which is illegible in place – of which Pungileoni
printed part]

In oib̄s aūt alijs suis bonis mōb et inmōb iurib̄s
actionib̄s pn̄tis et fut-is ubiq̄ sint et esse repantur suā
hede- uniuersal- instituit fecit et r̄e voluit fabricā sti
q̄rini cū hoc pacto et c̄dictione q̄d agentes dc̄e fabrice
teneantur et obligati sint facere unā capellā cū uno
altare in dc̄a capella cu —— suppl— ad dc-j altare cū
una anchona cū quatuor sanctis v̄z sanctus leonardus
st̄a marta s petrus apl̄os et st̄a maria magdalene et q̄d
de dc̄a hrditas nuq̄ possit vendi neq alienari de ipsis
nisi p̄ necessitate magna ad in-t-- d- dc̄is legatis et an̄
orā an- quam cand- be —— q̄d debeant vendere --

11 die martis mōb -ū pacto et c̄dictione q- cano-
cū duodecim nic- dc̄e fabric- tenea— et obligati sint
—— missa- (two lines of erasures) —— seu canoni-
decembris (?) obligati sint sin—- hebdomade ————
et ultra singlo an—- unu offitiū mortuor in die sti
leonardi ad sua capella c̄struendā p̄ —— -u venerit
solemnite- st̄e marte facere cantare unā missā cū
solemnitat- necessar- cū pacto c̄dictio dc̄us —— facit
hanc volunta- casu — habeat fides- seu fideas voluit
et vult dc- legatu esse nullius momenti ——-

4B 29 August 1528

Will of Melchior Fassi.

Correggio, Archivio. Rogito di Tommaso Parma. Transcribed from the original.

In christi noīe am̄ : Anō a natiuitate eiusdm̄ millio
qn̄gmo vigmo octauo Inde prima die vigmo nono
augusti…vir melchior de fassis al̄s parmesano…In
primis q̄dm testator ip̄e aiā suā creatori suo omipo-
tenti deo eiusq̄ sc̄tissime mr̄e bt̄e marie virgini totiq̄
curie celesti triūphanti com̄endauit et de comissis
cōtra eius diuinā maestat̄e veniā postulati sepulturā
vero sui corporis cū de hac vita migrare cōtigerit
ellegit ordinauit disposuit et esse voluit ad ecclīā et in
ecclīa st̄e marie graz̄ posite et ex p̄pe portū sti johis
castri corrigie et in sepulcro in quo videbit et placuit
pr̄-vicario dc̄i cōuentus ut q̄ p̄ ip̄ia fuerint It̄ reliqt̄ iui
legati monasterio monialiū corporis xi q est ex porta
sti pauli de corrigia petiā unā t-r̄e tab̄ et claūx pō- in
villa albrici district- corrigie in loco dc̄o al albarelo
cui cōfin at̄ dn̄s mapheus de zanotis at̄ mr̄ bn̄us de
gabeteis at̄ -ra cōis sat̄ alijs plurib̄ cōfinib̄ bōb duār
cudio ut circa et quantaq̄ cadat in pn̄ti legato n̄e nō et
aliā petiā t-r̄e ididm̄ p̄pe tab̄ et claūx cui cōfin at̄ dc̄us
testator at̄ mr̄ simon de bordinis at̄ mr̄ michael de
bb̄eris et at̄ johes de gardenis sat̄ alijs pluribs et
verioribs cōfinit bōb sex ut circa grauando dc̄us
monasteriū ad celebrari facier- singl̄o an̄o officiū unū
a mortuis…

It̄ iui legati reliqt̄ et legauit ecclīe st̄e maria verberator
de corrigia ubi sit hospitalitas pauper̄ egeriū petiā unā
t-r̄e tab̄ et claūx po-t in dc̄a villa albrice cui cōfin at̄
johes de gardinis at̄ leonardus de zanotis at̄ ill̄ dn̄s
māfredus de corrigia sat̄ alijs pluribs et —oribs
cōfinibs bōb noue ut circa nec nō et lectū unū de
p-nnis a-sez et lectis ip̄ius testatoris existentibus in do-
mo et h̄itationis eius testatoris Grauans ip̄e testator
ōes gubernatores ip̄ius societatis seu cōfrānitatis ut
agentes dc̄i hospitalis et q̄ p t-ra fuerint q̄ singl̄o an̄o
in die obitus ip̄ius testatoris in ecclīa pt̄a ad suū
altar̄e dici et celebrari faciant unū offiū a mortuis
missar̄ octo p̄ aiā ip̄ius testatoris et parentū suor̄

It reliq̄t iui legati J̄o francō de ferrarijs dcō —lbasso petiā unā t–re tab̄ et clauх̄ po– in villa ardioni district̄ corrigie cui cōfin a quatuor lateribs via co–s sat alijs cōfinibs ac bob̄ viginti ut circa aut quantaq̄ q̄s sit plus ut minus intra pdc–s cōfines cadat in p̄nti legato prohibens et —i prohibuit et vetuit pdc— jō franc– posse ullo unḡ tp̄re p̄ se nec p̄ filios suos dicta bona eiusd̄m legat̄ vende– p–nta obligar̄ donā ne aliqua obligatiō de ip̄a petia t–re nec de aliqua eius p̄te facer̄ ut alio quis titulo alienare ut ad longū tempus locare nō audiat ut psumat quia omnino voluit et vult dc̄a bona deuenire debere ad dictos filios masculos dc̄i jō franci et ip̄is nō exn̄tib̄s ad cōuentū st̄e marie graƶ ordinis p̄dicator̄ p–ē eo cañ aduenienite in instituit et substituit Dicens et asserens j̄dm testator p̄hibitionē p̄missā dcō jō francō et eius filijs fecisse multis —onabilib̄s de causis aīum suū Ad id condigne monetibus quas pro nū– ut dixit nō intendit exprimere tacitando ip̄m jō franc̄m andc– q̄ unq̄ ullo tp̄re nō possit et valeat molestar̄ ne molestari facere hedis suis seu hedes̄ suos inst̄–os in boīs et hedītate suis et caū quo hedes̄ suos molestaret et nollet esse tacitū et cōtentū de legato mō(?) ex —— p̄ ut ex hic et — cōuerso ip̄e testator reuocauit et annullauit ac reuocat et annullat pr̄s legatu et oīa cōtenta in eo q̄u sic fuit et est eius voluntas et intentio

It iui legat reliq̄t et legauit M̄ro J̄o antō quon̄ Mr̄i Bern̄i de zanotis vulgarit̄r dcō M̄ro corsino nepoti suo ex sorore petiā unā t–re tab̄ et clauх̄ p—t– in villa albrice district̄ corrigie cui cōfin at hedes̄ quon̄ zanini de berberis at Laurentius montanarius at franzonus de zanotis et āt m̄r pegrinus de alegris bobca– tr— ut circa—...

Et si dc̄us m̄r– jov̄s ant̄s legatarius andc̄us qn–q̄ decesserit siñ filijs leḡtis et nalib –uc et eo caū voluit et vult dc̄us testator —as petias t–rar̄ ut̄s legatus p̄uenire debere ad dc̄ta ecc̄lia seu hospitale st̄e marie verberator de corrigia andict̄ q̄a sic fuit et est eius voluntas et intentio...

In oīb̄s aut alijs suis boīs mob̄ et immob̄ iurib̄s et actionib̄s p̄ntib̄ et futr̄is ubiq̄q̄ sint et esse repiant

saluis semp̄ firmis manentib̄s legatis p–s sibi hedeuniversalē seu hedes̄ uniuersales instituit fecit et esse voluit ecc̄lia seu monasteriū st̄i dn̄ici de obsūantia q̄ est positū ex –ppe castrū t–re corrigie cū hac — cōdictione lege et pacto fr̄es dc̄i monasterij teneāt et obligati sint eriger̄ et seu erigi facer̄ ac fabricar̄ et seu fabricari facer̄ exp–s hēditatis ip̄ius testatoris capellā unā cū uno altari in dc̄a ecc̄lia st̄i dn̄ici andc̄i cū una anchona pulchra et in ip̄a ancona depingi facer̄ imagines bt̄e marie semp̄ virginis st̄i petri apt̄i st̄i leonardi st̄e marie magdalene et sc̄te marte It legauit iussit et mandauit q̄ dc̄i sui hedes̄ teneāt et obligati sint facer̄ seu fieri facer̄ et costrui facere unū calicē de argenti –eamato unā planetā siue paramentū unū camicē et unū missale et cetera ac q̄lib alia ornamenta cōuenientia et opportuna ac necessaria ad celebrare missas et diuina officia grauando pt̄i fr̄es p̄dicatores dc̄e ecc̄lie st̄i dn̄ici ut q̄ p̄ tp̄re fuerint q̄ adueniente caū q̄ libere gaudeant et usufructuent bona hēditati sue q̄ ip̄i singlo añō impp— teneāt cantare unā missā in die festiuitatis st̄e marte ad laudē dei et gloriosissime virginis marie et st̄e marte andc̄e et singlo m̄ese a mortuis offitium unū p̄ anima ip̄ius testatoris et p̄decessor̄ suor̄ et qualib̄ septimana cuiusq̄u ani unā missam ad capellā suā si fuerit cōstructa tp̄re mortis sue si vero nō fuerit cōstructa ad aliū altarē ubi placuit dc–s f— et si p̄dca pc–sse nō obseruauerint et in aliquo cōtra p̄nt– eius dispositionem c̄fecerint –uc et eo caū adueniente dc̄a hēditas p̄ueneat et p̄ueire debeat ad hospitale st̄e marie verberator de corrigia ubi sit hospitalitas pauperū q̄ h–c et eo caū instituit et substituit...

Actū lectū et publicatū fuit in pr̄s (?) testis in Burgo veteri t–re corrigie in domo dc̄i testatoris et in camera a latere ān̄riori dc̄e domus ubi ip̄e testator In dc̄a camera infirmus jacebat in lecto ibid̄m...

4C 1 April 1538
Will of Melchior Fassi.

Correggio, Archivio. Rogito di Tommaso Parma. Transcribed from the original.

In christi noīe ām̄ Añō a natiuitate eiusd̄m dn̄i millio q̄nḡmo triḡmo octauo Inde undec̄ia Die primo m̄esis

april-…melchior de fassis aīs de parmesanis ciuis corrigie…In primis nāq aīa suā altissimo creatori nrō recomēdauit volens et mādans corpus suū cū de hac migrauerit vita sepeliri debere in ecclia ste mē verberator intitulata la misericordia ubi sit hospitalitas pauperū egeriū in unā archā seu depositū quē seu quā iussit et mādauit cōstrui seu cōstrui facē expis heditatis p̄ti testatoris p -nā pacientiā ip̄ius testatoris ut (?) penes altarē suū fundat in dca ecclia intitulatu ste marte a latere sinistro dci altaris ad cuius corporis sepulturā et humatione voluit ip̄e testator ad esse funalia seu duplecios cere viginti de libris duabs p̄ qlib duplecio -eqbus qdm funalibus seu duplecijs dc̄us testator iussit voluit et mādauit q̄ dimidia dcor duplecior̄ seu funaliū remanere debeant ad dci hospitale seu ecclia p̄ illuminar— corpus dni nr̄i jesu xr̄i et in seplier (?) pauperes residuū vero distribuētur et dispensetur hoc mo — duo ad eius sept— trigesi— et duo ad monasteriū ste mē grāz po-t ex [ink faded] predicatores It alij duo duplecij seu funalia duo ad monasteriū monialiū corporis xr̄i q̄ est po-t ex portam sti pauli de corrigia It unū ad ecclia sti qrinis p̄tectoris nr̄i It unū ad monasteriū sti franci de corrigia It unu ad ecclia sti sebastiani It unū et ultimū dupleciū capelle et cōfrn̄itati sti josephi de corrigia

It eidm̄ monasterio sti dn̄ici et seu couēntu ac frat eiusdm̄ reliq̄t et legauit petiā unā t-re tab et campie po-t in villa ardioni district corrigie in loco dci in- giminiola…In oībs aut alijs suis bonis mob et immob iurib̄s et actionib̄s p̄ntib et futuris ubiq̄ et esse repiant saluis semp̄ firmis manentib̄s legatis —— sibi hed̄es uniuersales instituit fecit et esse voluit ecclia seu hospitale ste marie de la misericordia indc̄e Grauano ipm̄ hospitalē seu agentes p̄ eo statim secuta morte ipius testatoris et -ne p—— — sue indc̄e ad celebrari facier omi et singo ———— unā missā ad suū altarē ste marte p̄to et qlib añō tria officia celebrar̄ facer in ecclia ste marie vē q̄- s̄ a mortuis cū p̄sbiteris dece nec nō teneant et obligati sint dci agentes cantare facere unā missā in die festivitatis ste marte andce unā cū dece missis ad lamorem dei et gloriossime virgini

marie et ste marte andce et si p̄dca p̄cisse nō ob- suauerint et in aliq̄ cōtra p— eius dispositionē cfacerit —— et eo caū aduenienti dc̄a eius heditas p̄veniat et p̄venire debeat ad p——— hospitale cōstruendu —— inst q-o et eo casu instituit et substituit Cū onere grauamine et obligationi indic-s quod q̄dm hospitale ——it voluit iussit et relinquit Itē vult jubet et ordinat in caū indco fac- cōstr-at et edific-et sub titulo ste marte de bonis et heditatis ip̄ius testatoris in quo hospit—is valeant et possint paup̄es et egerii dn̄i nr̄i jesu xr̄i p̄ dn̄os anc—no tre corrig— et executores suos —— (N.B. Similar provisions had been made in an earlier clause, here omitted, concerning a bequest to the testator's widow.)

5 DECORATION OF S. GIOVANNI EVANGELISTA, PARMA

Records of payments.

5A 16 August 1520

The following two entries published by Pungileoni, II, pages 169–70 as from Giornale D (1512–1521). I have not found the originals.

Magistro Antonio da Corezo pictore della cuba del choro debe fare lire cento cinquanta a lui numerate per el P. priore fin adi 6 Jullij videlicet ducati 30 sopra el suo lavorerio L 150

——

Item el soprascritto pictore debe fare lire cento Imperiale videl. Ducati vincti doro a Luy numerati per D. Bernardo sopra la sua opera de pingere la Cuba L 100

5B 27 October 1522

London, British Museum, Egerton MS. 1 (originally Giornale E: 1521–1523). Printed by Pungileoni, II, page 169. Re-transcribed from the original. (The marginal notes are references to the master ledger – Libro Mastro H – still at Parma, of which the relevant entries are printed in section 5F below.)

F 23 R.

In lib. H
mr̄ō ... 86

Mr̄ō Ant̄ō da corezo depintore de dare
dūc 8 p̄ il pretio de uno poledro c̄h hebe
da don stefano cel̄rio adi 28 apl̄lis 1521
c̄mo ap̄are nel lib̄o biāco dela fabricha

—

It̄ de dare ducati vinti doro largi habuti da don
feliciano et da don teophilla a di 18 de ap̄illo fina adi
19 de mazo 1522 c̄mo appare al libro biācho ——

F 23 V

1522 adi 27 de octobr̄

In libō H
mr̄ō ... 86

Mr̄o Antonio da corezo depintore de dare
ducati trenta ecin̄q doro largi siue dūc 35
largi doro n̄ti alui p̄ il pr̄es don luciano
allora priore sopra la pictura de la capela grāda. p̄ due
volte da di 28 de mazo fina adi 28 de luīo 1522

—

In lib H
mr̄ō ... 86

Mr̄ō Ant̄ō sp̄to de dare ducati sey doro
largi n̄ti alui p̄ il pr̄es prior m̄ō p̄ d̄ luciano
p̄ auanto anome del Cel̄rio fu fina del
mexo de apl̄lo 1521

(The above four items are consecutive, the first two
on the bottom of folio 23r, the next two at the top
of the next page, folio 23v.)

5C 8 June 1523

*British Museum, Egerton MS. 1. Printed by Pungileoni,
II, pages 170–1. Re-transcribed from the original.*

F 31 R.

Mr̄ō Ant̄ō da Coreza pictor de la n̄ra eccl̄ia de dar n̄-

In liō m̄ō
fo. 86

alui pr̄t s̄r franco pigo- dūc sesanta doro ī
oro sup̄a la sua m̄cde de dicta pictura
como ap̄e p̄ poliza de sua mane posto in
filza doue si chiamar h̄re recepto in piu poste fino
a q̄sto hora dūc 220 doro Et Jo d̄ Jo maria lo ho
fatto scripto de mia p̄pa mane Como lui resta h̄re p̄
saldo de li soi c̄ti dūc 52

5D 4 January 1524

*British Museum, Egerton MS. 1. Printed by Pungileoni,
II, page 171. Re-transcribed from the original.*

F. 47 R.

die 4 Januarij (1524)

In Lr̄ō mr̄ō
fo. 86

Mr̄ō ant̄ō depintore de dar dūc vincti-
cin̄q doro largi n̄ti alui p̄ el p̄ D̄ J̄o
Maria sopra il suo credito de le picture
fatti nella n̄ra chiesia di s̄to J̄o Euān̄ta come app̄ p̄
una polliza de man sua posta in filza

5E 23 January 1524

Correggio's autograph receipt for S. Giovanni
work.

*British Museum, Egerton MS. 1. Transcribed from the
original.*

F 48R.

Die 23 de Zenaro 1524

Io Antonio lieto da cor̄eggio pictore ho receputo a di
soprascritto da D̄ō Z̄oa-m̄a da Parma monaco et
cellerario dil monasterio de S. ioan̄e Euagelista de

In Lr̄ō
mr̄ō of 86.

Parma Ducati 27 de oro in oro largi in
moneta a nome dil ditto mon̄ō et sono
per integro pagam̄eto et resto de la mer-
cede mia de la pictura fatta in ditta chiesia et cosi mi
chiamo contento et sastifatto [sic] et integram̄ete
pagato presente D̄ō Honorio monaco in ditto monas-
terio et in fede de cio ho scritto la presente de propria
mano

Antonius manu propria

5F Archivio di Stato, Parma

*Pages 85v and 86 of reg. 306 of Monastero di S. Giovanni
Evangelista. Printed by Pungileoni, II, page 171 (Libro
Mastro H 1519–28). Re-transcribed from the original.*

(*It will be seen that the following entries from the master
ledger, with the addition of the list of work at the end,
repeat the substance of those already transcribed from the
British Museum volume.*)

Mr̄. Antonio da Corezo depintore de dare ducatj
trenta siue dūc. 30 doro largi n̄ti a lui p̄ il pr̄e priore

n̄ro p̄ auāto fu fina adi .6. Julij 1520 p̄ principio de pagam̄to de la pictura dela n̄ra Cuba c̄me appare al zornallo D a c̄ 190 dūc 30

Itē de dare adi dūc. vinti doro largi n̄ti a lui p̄ d̄ bnardo c̄me appare— 190 dūc̈ 20

Itē de dare adi 28 de apllo dūc. 8 doro largi n̄ti p̄ il pretio de uno poledro dac̄to a lui p̄ don stefono apare al zornalo F - 17 dūc̄ 8

Itē de dare dūc. vinti siue dūc 20 doro largi n̄ti a lui p̄ don feliciano e p̄ don teophille ī tre post̄. apā — 17 dūc 20 e fu da di 18 de apllo fina a di 19 de mazo 1522

Itē de dare dūc 35 siue ducati trenta e cin̄q doro ī oro n̄ti a lui p̄ il prē don Luciano alhora prior ī due volte da di 28 de mazo fina a di 28 de luio 1522 e furono sopra la pictura de la capela granda c̄mo appare al dicto zornallo E — 18 dūc̄. 35 Itē de dare sub die de apllo 1521 dūc sey doro utā n̄ti a m̄ro Antonio p̄ il prē prior n̄ro p̄r don luciano a nome del cel.rio c̄me apare al zornalo E — 18 dūc̄ 6

Itē de dar̄ adi 20 Jān 1523 n̄ a lui p̄ il - p̄. d̄. Basilio n̄ro prior dūc venti doro l̄g & uno bisilascho dūc 20 - 3 - 16

It di dar̄ adi 13 martij n̄ a lui p̄ il p̄ Prior subscripto līb Centosette sono dūc. vinti doro l̄g dūc 20 -

Itē adi 8 Junij n̄ alui p̄ mi d̄ Jō maria dūc sesanta doro in oro l̄g āpe al z̄or fō 25 dūc 60 - - -

adi s̄st 8 Junij ha fatto una poliza de sua mane doue si c̄ofessa h̄ve rec̄eputo sino al zorno p̄st tutti li s̄st p(?tie) asendano alla sumā di dūc 220 post in filza Et Io li ho fatto poliza de mia mane como lui rest̄i - - dūc 52 doro

Itē die 4 Jān 1524 n̄ alui p̄ pt̄ del suo (?c.d.t.) al zorl̄e fō 41 ap̄ p̄ poliza de sua mane posta in filza dūc 25 l

Itē adi 23 Januarij 1524 n̄ al s̄st m̄r Antio s̄st p̄ integro pagam̄eto de la sua mc̄de p̄ la pictura de la Ecl̄ in tanta moneta dūc vinti sette doro ī oro l̄g al zorl̄e scrip̄ti di sua mane propria fō 42 dūc 27 l̄g
Sa duc 272

[The following is on the sheet facing the one above.]

M̄r Antonio da Corezo depintor c̄scripto de h̄au ducati centi trenta doro largi siue la valuta c̄h li valesse al tempo c̄h se gli dane de volta ī volta p̄ integro pagam̄eto dela mc̄ede sua facta ī la pictura - et ornam̄to dela cuba dela gexia n̄ra appare p̄ una lista de pacti fra il mōrio e lui sotoscripta de la parte dūc 130

Itē de h̄au ducati sesanta e cinque similli p̄ la pictura et ornam̄t de la capela granda appare ī la dicta lista de pacti dūc 65

dē de h̄au dūc cin̄q similli p̄ manufactura de lo oro Itosto ī opā nel friso et cornisonj dela capela granda p̄uc 5

Itē de h̄au p̄ le mazze deli pilonj de la cuba edeli c̄adelerj facti soto epsa c̄h sono octo ī tuto dūc sey dacordio c̄u il dicto prē prior p̄ don luciano dūc 6

Itē de - - p̄ la frixaria circum circa lo corpo de la ēca c̄putato li pilloni archiuoli et ogni al̄ro loco dacordo fatto dicto m̄r Antio col p̄ d̄ Basilio n̄ro priore alla festa de ognisancti de lano 1522 dūc sesanta sei doro la cio d̄ 66 dūc 66
 duc 272

5G 5 October 1525

The following document – British Museum, Egerton MS. 1, F 103 R – is sometimes connected with Correggio, but seems just as likely to refer to someone else. Re-transcribed from the original.

Conto di fabrica L 56. 2 a m̄ro ant̄o pictor p̄ la pictura intorno al choro di fora-11 a la cassa

6 CONTRACT FOR THE 'NOTTE'
14 October 1522

Archivio di Stato, Modena. Repeatedly published, also often reproduced in facsimile. Re-transcribed from the original.

P̄ Questa notta di man mia Jo Alb̄to pratonero faccio fede aciascuno come io p̄metto di dare am̄ro Ant̄o da coreggio pittor libre duc̄eto otti di moneta uecchia

reggiana & q̄sto p̄ pagam̄to d'una tauola c̄h mi
p̄mette di fare i tutta excellētia doue sia depinto la
natiuita d̄l Sr̄e nr̄o co le figure attin̄eti secondo le
misure & grandezza c̄h cappeno nel disegno c̄h m̄ha
puort- esso mr̄o ant̄o di man sua In Reggio alli xiiij
di ot̄ MDXXII Al p̄ giorno gli c̄otai p̄ parte di
pagam̄to libre quar̄ata di moneta uecchia

[followed by an autograph declaration by Correggio]

ET io antonio lieto da correggia mi chiamo haver
receputto al di & milesimo soprascritto quāto è
soprascritto et in segno di cio questo ho scritto di mia
mano

7 DECORATION OF THE DUOMO, PARMA

7A 3 November 1522

The contract

*The documents concerning Correggio's work at the Duomo
have not been available to me, but have often been printed
in the past. The following portion of the contract of 1522,
being in Correggio's hand, was reproduced in facsimile in
Battaglia (facing page 128) and Ricci (1930, facing page
65) from the latter of which the following is re-transcribed:*

Visto diligente il lauoro c̄h per hora sol cō Vr̄e S̄. mi
par piacendo a quelle di patuire c̄h è pigliando quanto
tiene il coro, la cupulla cō suoi archi, e pilli senza le
capelle laterali, et diritto andando al sacramento,
fassa, crosera e nicchia cō le sponde et cio c̄h di
nuovo si uede in la capella insino al pauimento, et
trouatolo circa a 150 pertiche quadre* da ornar di
pitura, cō quelle istorie mi serā data c̄h imitano e il
uiuo o il brōzo o il marmo secōdo rich—de a i suoi
lochi o il douer de la fabrica e le ragioni e uagheza
de essa pitura - cio a mie spese de 100 ducati de oro in
foglio et de colori et de lultima smaltada c̄h sera
quella doue io pingero sopra Nō si potra cō lhonore

* Ricci (1930, p. 101, n.1) gives a pertica as roughly
3·25 metres and thus calculates 150 square pertiche as
487·5 square metres. His dimensions for the cupola
alone are 10·93 × 11·55.

1000
et del loco e nostro fare per manco de ducati ~~1200~~ [sic]
de oro et cō il comodo de queste cose.

1 Prima de i ponti
2 de le inserbature
3 de le calcine da smaltare oltra alo inserbare
4 de ū camarone o capella chiusa per far li disegni

The text of the first part of the contract, to which Correggio's note, given above, is appended, is printed by Pungileoni, II, pages 183–4 (misprinted 284) as follows:

*Milesimo quingentesimo vigesimo secundo Indictione
decima die tertia mensis Novembris.*

*Reverendi D. Pascalius de Baliardis et Galeaz de
Garimbertis o Ambo Canonici Ecclesiae Parmensis D....
Magnificus Eques auratus D. Scipio Dalla Rosa parmensis: omnes Fabricantes Ecclesiae praedictae parmensis et
quilibet ipsorum tenore praesentis publici instrumenti et
omni meliori modo, sic jure et causa, quibus magis et
melius potuerunt et possunt dicto nomine et nomine vice
fabricae predictae parmensis Ecclesiae se se convenerunt et
conventionem fecerunt et faciunt cum magistro Antonio de
Corrigia pictore praesente, conducente stipulante et recipiente pro se suisque haeredibus et successoribus laborerium picturae ecclesiae predictae, hoc modo et cum pactis,
modis et conditionibus infrascriptis, videlicet....*

Primo, che detto Mastro Antonio sia obbligato
quanto tiene il choro, la cupola, co' suoi archi et pilli
senza le capelle laterali et diritto andando al Sacramento, fassa, crosera, et nichie con le sponde, et ciò
che de muro si vede su la capella insino al pavimento,
et trovatolo circha a pertiche 150 vel circha quadre da
ornare de picture cum quelle istorie vi saranno date,
che imitano il vivo, o il bronzo, o il marmoro, secondo richiede a li suoi lochj et il dovere della fabrica
et a ragione e vaghezza de ipsa pictura a sue spese.

Item che predicti Dmni Fabricanti siano obbligato,
et così promettono a dicto Mastro Antonio de dare a
dicto Mastro Antonio ducati cento in foglio per ornar
dicte picture, et opera, et per la mercede sua de dicta
pictura ducati mille de oro et de darge li ponti facti,
et la calcina da insmaltare, et le mure insaldato a le
spese de dicta fabrica. *Ex praedicta omnia efectura
extendantur in forma cum juramento et clausulis consuetis*

de stillo mei Notarii infrascripti et haec omnia in praesentia
Reverendorum

> D. *Jacobi de Colla*
> D. *Floriani Zampironi*
> D. *Latantii de Lallata*
> D. *Eustachi de Ruere*
> D. *Jais Marci de Carissimis*
> D. *Latini de Baliardis*
> D. *Stephani Desa*
> D. *Jois Francisci de la Rosa*
> D. *Antonii de Rianis*
> D. *Camilli de Rianis*
> D. *Paleucci de Garumbertis*
> D. *Ugolini de Lusebris*

Omnium Canonicorum dictae Ecclesiae parmensis
predictis omnibus consentientium ecc.

Peritia quae adest inserta in hoc conventionum instru-
mento est tenoris sequentis scilicet....

7B 23 November 1523

Work on the cupola preparatory to Correggio's
painting of it.

Short extract published by Pungileoni, II, page 186. A
longer one, from a copy made in 1684, is printed by R.
Tassi, 1968, pages 157–8, from which the following text
is taken:

'In nomine Domini nostri Iesu Christi, amen.

Anno a nativitate eiusdem Domini millesimo
quingentesimo vigesimo tertio, indictione undecima,
die vigesimo tertio novembris.

Mag.r Iorius del Herba, filius q. mag.ri Ioannis
Iacobi, murator Parmensis vic. Sancti Francisci de
Prato, sponte et per se concessit et locavit operas suas
rev.dis dd. Paschasio de Beliardis et Galeatio de
Garumbertis, canonicis ecclesie Parmensis, nec non et
mag.co d. Equiti Scipioni Montino de la Rosa,
Fabriceriis dicte ecclesie Parmen. presentibus stipu-
lantibus et recipientibus ac acceptantibus nomine et
vice dicte Fabrice et suorum successorum in ea, ad
faciendum infrascriptas operas et laboreria in dicta
ecclesia, vz.:

Primo, quod teneatur ipse mag.r Iorius, et ita
promisit, facere et fabricare unam fassam super
tiburio seu cubulla existente in medio cruxerii ecclesie
maiori de quintrellis cum calce, super quam poni
debeat tres scaloni de quintrellis incesi de totto puncto
seu ab omni parte et quos scalonos sic incesos ut
supra, facere et fabricare ac ponere in opere supra
dictam cubullam teneatur ipse mag.r Iorius et ita
promisit; ac similiter teneatur ipse mag.r Iorius, et ita
promisit, amovere seu amoveri facere et exportare
sumptibus suis omnes tegulas et ligna et sic tottum
tectum existentem de praesenti super dicta cubulla et
capitello et reponere dicta lignamina et tegulas super
fornicibus seu voltis dicte ecclesie Parmen. ubi
voluerint dicti dd. Fabricerii; et similiter teneatur
ipse mag.r Iorius amovere capitellum existentem
desuper dicta cubulla ac refficere et reparare omnes
pillonos existentes desuper ac circumcirca dictam
cubullam et alios de novo facere et ponere in opere,
vz. illos qui indigent reparatione seu reffectione et in
eo statu gradu et forma et ad instar illorum aliorum
pillonorum qui sunt ibidem integri; et similiter
teneatur ipse mag.r Iorius reponere ibidem omnes
collonas marmoreas desupra dictam cubulam cum
suis bassis et capitellis videlicet illos qui indigent re-
missione seu restauratura, dantibus ipsis dd. Fabri-
ceriis, expensis suis, dictas columnas; et similiter
teneatur ipse mag.r Iorius removere, cum bassis et
capitellis, cum martellina incrustationem quae est ab
intus dictam cubulam supra, ad hoc ut possit fieri
serbatura de novo dicte cubullè ac pontibus ligneis de
presenti existentibus ad dictam cubullam supra et
dictam serbaturam novam similiter facere teneatur
ipse mag.r Iorius, dantibus tamen calcem ipsis dd.
Fabriceriis pro dicta smaltatura fienda a dictis ponti-
bus supra.

Et ita ipse mag.r Iorius promisit predictis dd.
Fabriceriis suprascripta omnia adimplere ac facere
cum eius opera et aliorum operariorum neces-
sariorum.

Et a converso autem pro mercede dictarum opera-
rum, ipsi dd. Fabricerii pro dicta Fabrica promiserunt
et convenerunt dare et solvere eidem mag.ro Ioro

libras ducentas sexaginta imp.prout faciet dictas operas. Et predicta omnia cum iuramento dicti mag.ri Iorii obligatione bonorum suorum ac bonorum dicte Fabrice ei facta, cunctis consuetis et necessariis finibus factis.

Actum in ecclesia maiori Parme presentibus ibidem mag.ro Alexandro de Araldis filio q.d. Christophori vic. Sancti Pauli pro burgo Assidum, Antonio de Cernitoribus filio q.d. Ioannis vic. Sancti Michaelis ab Arcu et Paulo de Fragnano filio q. Petri vic. Sancti Antonini, omnibus testibus probis ac asserentibus et presente etiam Francisco Maria de Puteo pro dicto nomine.'

7C 29 November 1526

First recorded payment

Ricci (1896 and 1930) gives the date of the document as 29 November 1526. Text from Pungileoni, II, page 201.

Egregius vir Dm̄nus Antonius de Allegris fil. Dm̄ni Pelegrini de Corigia pictor Vic. D. Jo. Evang pro Burgo anteriori seu pischario sponte. . .fuit confessus et in concordia cum Venle Dm̄no Nicolao de Gottis . . .Sindico et procuratore dominorum Fabricieriorum Ecclesiae Parmae. . .habuisse et recepisse ducatos septuaginta sex auri et in auro et sol. tredecim Īmpr pro completa solutione ducator. ducen. septuag. qnq. auri et in auro largos in ronem librar. qnq et sol. septem Īmpr pro singulo ducato qui assendn̄t ad summam lib. mille quattuor cētum pro prima paghe seu primo quarterio mercedis picturae capelle et Cate Ecclesiae majoris Parm̄ qm̄ picturam ipse Dm̄nus Ant. pm̄isit facēr et q. tota merces et de ducat. mille cētum avri et in avro largis et p. ut appet Instrō rogato p. dm̄ Stephanum Dodū Not. pm̄ de anno 1522. . . quia habuit a ptō Dnō Nicolao dtō nōje ducatos septuaginta sex et Sol qnq. Īmpr. . .unde fecit finem . . .reservato jure habendi resdum totius dictae mercedis prout pinget. . .et ptā ōja cum jur. Ot. bonor. et aliis clausulis asuetis in forma. . .Actum Parmae studio mei notarj etc.

It may be noted that this document specifies Correggio's current address in Parma. Tassi (op. cit., page 158) prints

the following memorandum of the transaction from the Archivio della Fabrica, cassetto I, no. 13:

Dato a conto di pagamento del Sindaco e Fabbriciere di questa Chiesa Cattedrale al Pittore Antonio Allegri detto il Correggio Ducati no. 76 d'oro in oro, e soldi 13 Imperiali, qual Pittore confessa di averli ricevuti a conto della Prima Paga della pittura della Cuppola

7D 17 November 1530

Last payment at the Duomo

Tassi (op. cit., page 158) prints the following entry from the index to the Cathedral archives:

1530 Dato in pagamento ossia mandato di scudi 175 d'oro spedito dalli Signori Fabbricieri di questa Cattedrale al celeberrimo Pittore Antonio de Corrigia per resto del secondo termine del prezzo convenuto per la pittura della cuppola di questa Cattedrale

He notes that the document itself is missing. A seventeenth-century copy of it, given below, is printed by Pungileoni, II, page 228:

1530 die 17 Novembris
De Mandato Reverendorum et magnificor. dominorum deputatorum ad regimen Fabricae Ecclesiae Majoris Parmae.

Solvat D. Franciscus de Prato Mazzarius dictae Fabbricae Magistro Antonio de Corrigia Pictori ducatos centum septuaginta quinque avri qui ad computum L. 6 pro quolibet ducato constituunt libras mille quinquaginta Impēs et hoc pro resto secundi termini pretii sibi comissi pro pictura per eum fienda in Ecclesia majori praedicta juxta conventiones inter ipsos dd. deputatos et ipsum magistrum Antonium factas videlicet 1500 [for 1050]
 Subscripti
 Camillus Arria [Anianus]
 Bartolameus de Prato
 Stephanus De Sù
 Ugolinus de Lalato
 B. de Prato. . .

Pungileoni (II, pages 232-3) makes the strange statement 'Nel febbrajo del 1531 dovette Antonio restituirsi a

Parma, notizia che ci vien data dai libri della fabbrica di quella Cattedrale.' Though Gronau (page 163), for other reasons, says 'möchte ich um so eher schliessen, Correggio über das Jahr 1530 hinaus…an der Kuppel tätig gewesen'† his argument is unconvincing, and Ricci (1896, page 254, n. 3) had said, reasonably, that Pungileoni 'neither specifies the book nor quotes the passage, and probably made a mistake'.*

7E 1551

Restitution of money to the Duomo by the painter's heirs

From Registro F6, for the year 1551; text from Tassi, page 158:

Heredes quondam magistri Antonii pictoris de Corigia. Debent dare libras centum quadraginta imper. quas ipse vivens habuit de pluri. Cum obierit opere imperfecto cubae ecclesiae maioris Parmensis ut constat in instrumento rogato per d. Stephanum Dodum die 14 novembris 1522

8 ST. MARY MAGDALENE IN THE DESERT

3 September 1528

Veronica Gambara, to Isabella d'Este, describing a painting which cannot be identified.

Archivio di Stato, Mantua. Archivio Gonzaga, serie Autografi.
Cassetta M. 8. First published by Pungileoni, Elogio Storico di Giovanni Santi, 1822, pages 110–1 (mistakenly referring to the addressee as Beatrice d'Este). Re-transcribed from the original.

Illm̄a et Eccellma siḡra mia osserm̄a

Il sōr Don Lope mi scriue per expresso dalla Mirandula ch̄ Ms Thomaso fornaro e arriuato li hieri alle hore 23. Et io per esseguire li p̄ti suoi com̄andamenti le scriuo subito questa mia per aduisarnela. nel Tempo steso crederia di manchar̄ molto del debito mio inuerso di V̄. Ecc.tia se nō mi aduisasi di darle qualch̄

* 'Antonio was due to return to Parma in February 1531 – information from the cathedral ledgers.'

† 'Should therefore rather conclude that Correggio was still engaged on the cupola after 1530.'

notitia intorno al capo d'opra di pictura ch̄ il nostro M̄s. antonio Allegri ha hor hora terminato, sapend'io max̄. ch̄ V̄. Ecc.tia come intend.ma di simili cose molto si dilettar̄. rap.ta il med̄.o la Mad̄alena nel deserto ricourata in un'orrido speco a far̄ penitentia, sta essa genuflexa dal lato dextro con le mani gionte alzate al Cielo in atto di domandar perdono de peccati, il suo bell'atteggiamento, il nobil, et uiuo dolore ch̄ exprime il suo bell.mo uiso la fan̄o mirabil si, ch̄ fa stupore a chi la mira in quest'opra ha expresso tutto il sublime dell'Arte della quale e gran Maestro. Le baso le mani, et quanto piu posso me rac.o da Correggio li iii sep̄bre M.D.XXVIII
D̄ V̄. ecc.tia seruitrice

 Veronica G. de C

(on the back) All' Ill.ma et Excellma. S̄ra et Patrona mia osserm̄a la Signora Marchesa di Mantova

9 ALTARPIECE FOR ALBERTO PANCIROLI

15 June 1534

Town of Correggio
Pellegrino Allegri returns 25 scudi to Panciroli which had been paid to Correggio as an advance for an altarpiece. Document referred to by Tiraboschi (page 297) and partly printed by Pungileoni (II, page 252). The extract below is re-transcribed from the original with the assistance of Dr Gino Corti. (See text, page 123.)

Correggio, Archivio. Rogito di Alfonso Bottoni.

1534 die 15 junij
Polus de buranis de mozanella factor et negotior̄ gestor maḡci dn̄i alb̄ti panziroli…h̄uit recepit et ad se actualr̄…scutos 25 auri…a m̄ro p̄rḡo de alegris de corrigia p̄nte et illos sch̄os 25 d̄ate et solven̄… dcto Paulo…et hoc c̄a et occax̄ alior̄ t̄ator̄ sch̄or uiginti q̄nq̄ et p̄ alijs t̄atis sch̄tis iā datis maḡro anto filio dct̄ maḡri pēḡi p̄ p̄tum dn̄um alb̄tū occasē unius anchone pingende p̄ dct̄ m̄r anto ipsi m̄co alb̄to et ad istan̄ ipsius quā rē minime facere potuit quia mors de p̄to m̄ro anto ictinēti h̄itis dictis scutis viginti q̄nq̄

successit...actū ī burgoūri terra corrigia ī domo dicti d̄ maḡ prḡni.

Tiraboschi (page 297) describes Pancirolo as 'padre del celebre Guido' ('father of the celebrated Guido').

10 THE LOVES OF JUPITER (CARTOONS)

10A 12 September 1534

Federigo Gonzaga (from Marmirolo) to the Governor of Parma, Alessandro Caccia.

Archivio di Stato, Mantua. Archivio Gonzaga, Busta 2971, libro 53. First published by W. Braghirolli, Giornale di Erudizione Artistica, Perugia, 1872, pages 325ff. Retranscribed from the original. (See text, p. 131.)

al S̄r̄ Gouernator̄ di Parma

S̄r̄ Gouernator̄ Per- M̄r̄ Anto̅ da Correza Pictore me lauoraua in molte Cose et semper hauea cinquāta ducati d̄l̄ mio nelle mani qū no̅ ui sia il modo di poterli hauer̄ Prego v̄ s̄ almeno sia contenta oper̄ ch̄ habbi li mei Cartoni nelli quali sono dessignati li amori di Joue Et q̄lli pezzi cominciati ch̄ sono mei et alcuno no̅ ui po hauer̄ ragio̅n sopra ne po far̄ sequestrar̄ il mio Et in q̄to v̄ s̄ me fara singular piacer̄ oltra ch̄ fara cosa ragioneuole offerendomi alli comād̄i soi semper prompto

Mar̄li xij sept̄ 1534

10B 17 September 1534

Alessandro Caccia, from Parma, to Federigo Gonzaga.

Mantua, Archivio di Stato. Archivio Gonzaga, Busta 1376. First published by W. Braghirolli, Giornale di Erudizione Artistica, Perugia, 1872, pages 325ff. Retranscribed from the original.

Illm̄o̅ et Exm̄o̅ S̄o̅r mio oʒʒcrm̄o̅

Hauta la l̄ra di V̄ra̅ extia̅ Per la qual mi ricerca che io li faccia rihauere Certi Cartoni su li quali erono disegnati li amori di Joue di maestro anto̅ da coreggio pittore Ho ricercato diligentemēt doue sieno delle sue Robe & ho trouato che li figluoli o pur fussi suo patre lhanno tutte portate a coreggio excetto due

Casse quali ho fatto aprire & no̅ ui se trouato drento alcuno Cartone Pero e necessario che v̄ra̅ extia̅ volendo rihauerli & recuperare ancora li danari di quali dice esser creditore mandi indetto luogo di coreggio doue intendo essere restato alli eredi buona faculta Se in altro posso fare su̅itio a v̄ra̅ Illm̄a̅ S̄ria̅ quella mi comandi

[the next paragraph is about something else; the letter ends thus]

Da Parma alli xvij di Settem̄ MDXXXIIIJ

Div̄o̅ Illm̄a̅ & Exm̄a̅ S̄ria̅

S̄r̄e Aler̄o Caccia

10C 24 October 1534

Alessandro Caccia to Federigo Gonzaga.

Archivio di Stato, Mantua. Archivio Gonzaga, Busta 1376. First published by W. Braghirolli, Giornale di Erudizione Artistica, Perugia, 1872, pages 325ff. Retranscribed from the original.

Illm̄o̅ so̅r mio ossm̄o̅

Ho uisto quanto me scriue v̄ Illm̄a̅ S̄ per la sua dellj xvij circa i Cartonj del quo̅n Antonio da Correggio pictore Et in risposta gli ho da dire che quando hebbi la prima l̄ra sua per la quale mi ricercaua ch̄ io facessi diligentia di trouargli io fui indirizato al Caualier della Roxa il quale mi dette qualche via di far diligentia di hauergli da quelle personi che si poteua pensare ch̄ gli hauessero et no̅ gli trouando ne scrissi a V̄ Exa̅ Hora dicendomj Lei hauer inteso ch̄ sono in mano di detto Caualiere Io di nuovo ne ho parlato co luj et mi accerta no̅ gli hauere ne saper doue siano Et in uerita io el credo perche lo cognosco per homo tale che quando gli hauesse o sapesse doue fusseno lui istesso gli manderebbe a V̄ Exa̅ et cosi ne sia certa et tanto piu che luj no̅ si dilecta di talj picture Se in altro posso seruir V̄ Exa̅ quella mi comandj che mi sara sempre gratia fargli cosa grata Et humilmente me li racd̄o pregando idio che felicissa̅ la c̄oseruj Da Parma Il giorno xxiiij d'viijbre MDXXXIIIJ

Di V̄a̅ Illm̄a̅ Et Exm̄a̅ S̄r̄e

S̄r̄e Aler̄o Caccia

I 1511

January Town of Correggio

The painter recorded in the baptismal register as godfather, between 17 and 22 January (Pungileoni (II, page 42) wrongly gives the date as 12 January). Re-transcribed from the original. *Correggio, Archivio.*

Antonius uigarini die – cōp Antonius de Alegris cōm Angelica ux̄ m̄ri bernardini de bononia

This is the earliest documentary evidence of the painter's existence.

II 1516

4 October Town of Correggio.

The painter again recorded as godfather. Document not traced. The following text from Pungileoni, II, page 107.

Anastasia Helisabet de Joan Antonio de Tovaliolis compater Antonius de Allegris, comater Clara de Ursis

III 1517

14 July Town of Correggio

Pungileoni (II, page 95) refers to, but does not print, document of this date in which the painter and Melchior Fassi appear as witnesses.

IV 1518

17 March Town of Correggio

The painter again godfather, this time to Rosa, daughter of Francesco Bertoni, otherwise known as Sogari. Document not traced. Reference from Pungileoni, II, pages 115–16 (in the same place Pungileoni notes Antonius de Allegris Peregrini as a witness in January 1518 in the town of Correggio).

V 1519

1 February Town of Correggio

Act of donation to the painter of a furnished house and land from Francesco Ormano, the brother of Correggio's mother. Extract re-transcribed from the original (*Correggio, Archivio,* Rogito di Francesco Alfonso Bottoni). Pungileoni (II, pages 127–8)

quotes the same passage and also mentions another deed, from which he does not quote, of 18 January 1519 (he misprints it 1419) witnessed by the painter, in which his uncle, Francesco Ormano, received his wife's dowry.

Egregius vir frāciscus qn̄d nicol-i de ormano habiti castro uet̄ t̄rra corrigie ibi p̄ns p̄ se suosq̄ her̄des et succ— volens et ītendens ob m̄ita et s̄uitia qua de c̄tinuo h̄uit diusimodo et ī diusis et ī pluribȳ necessitatibȳ suis ab egregio et discreto juuene nepote suo

p̄rs ipsemet / maḡro antō / satisf— et m̄rō antō pictore filio peregrini de alegris de corigia sororis ipsius francī — q̄ m̄r ant̄s p̄ns obtulit et offert se paratissimū velle es̄s s̄b humili et filiali obedientia c̄tinua ipsius fra—i auūculi sui et semper ipsemet franc̄o satisfacere juxta to— desideriū et possibil— debitum et possibilitatem ipsius m̄ri anti... [a further 5½ pages]

This document concludes with a statement that it was signed in the palace of Manfredo of Correggio. The use of the word 'juvene' was adduced in support of the later birth date (1494), but Ricci (1930) claimed that youth extended to the age of thirty-five.

VI 1519

4 September Town of Correggio

Pungileoni (II, page 146) refers to, but does not print, a document of this date in which the painter appeared as witness in the palace of Manfredo.

VII 1521

15 May Parma

Document published by Tiraboschi (page 263) in which the Benedictine monastery of S. Giovanni Evangelista at Parma offers spiritual communion to egregio viro Magistro Antonio Laeto de Corigia, nec non Genitoribus, Consorti ac Liberis suis.

This is the first reference to the painter's wife.

VIII 1521

26 June Town of Correggio

Document concerning the painter's sister, Catarina.

Correggio, Archivio. Rogito di Maffeo Giannotti. Extract printed by Pungileoni, II, page 150. Re-transcribed from the original.

vicentius filius quōn matteo (?) de marianis habitator sāti martini a rio fuit c̄fessus...cō peregrino de alegris ibi p̄sentis stipulāt- — ab eo habuisse nōie dotis d̄me catarine filie dicti peregrini et uxoris de vicentii ducatos cētū...actū est in casino...quōn ill. d̄m giberti de corigia

IX 1521

26 July Town of Correggio

Document concerning marriage settlement. *Correggio, Archivio.* Rogito di Alfonso Bottoni. Extract re-transcribed from the original. Pungileoni (II, page 150) gives a longer extract and also explains (I, page 128) that such transactions were normal even long after the wedding.

maḡ ants de alegris de corrigia filius maḡ peregrini pictor acceperit in uxor̄...honestā muliere̅ dn̄a hieronimā filia qd̄ br̄i merlini armiger̄...

Venturi (*Storia...*, IX, 2, page 465) quotes Pungileoni (II, page 150) as his source for specifying that the *dot* amounted to houses and land to the value of 257 ducats. But Pungileoni says nothing of this in this place.

Pungileoni (II, page 151) found a baptismal entry showing that the painter's wife had been born in 1503, and that her father died soon after she was born (Pungileoni says at the battle on the Taro, but that was in 1495). Also, that she was still unmarried in 1518. In view of the birth of her son, Pomponio, in September 1521, the wedding is likely to have taken place in 1520 or possibly 1519.

X 1521

3 September Town of Correggio

Birth of the painter's son, Pomponio. Pungileoni (III, page 60) quotes the baptismal register of the church of S. Quirino:

Pomponius Quirinus fil. Antonii de Allegris die 3 7bris 1521. Compater Mag. Joan Baptisda de Lombardis, Comater...de Fassis.

The godparents are of interest. Lombardi was a celebrated doctor. The godmother was presumably related to Melchior Fassi (see his three wills, pages 177–80).

XI 1521

8 September Town of Correggio

Pungileoni (I, page 128) mentions, but does not print, a document showing the painter as witness to a deed of Niccolò Mazzucchi.

XII 1521

18 September Town of Correggio

The painter appoints Niccolò Balbi, in place of Francesco Affarosi, as his advocate in the law suit in which Romanello Ormano, nephew (on the male side) of the painter's maternal uncle, Francesco Ormano, disputed the latter's gift to the painter (according to Pungileoni (I, page 129) Francesco Ormano had died on 4 May 1521). *Correggio, Archivio.* Printed by Pungileoni, II, page 167. In this document it is stated that

comparuit m̄r ant de alegris cū c̄sensu et auctoritate peregrini sui pr̄is ibi p̄ntis et c̄sentis

The explanation, since the painter was a married man and himself a father, is presumably that he was still under his father's roof. It may be noted that in the law suits which followed the painter's 'procurator' was one Roberto Orsi. Also that other members of the Affarosi family – Tommaso and Giovanni – are mentioned as 'syndics' of S. Francesco at Correggio in the documents concerning the painter's altarpiece (q.v.).

XIII 1521

10 December Town of Correggio

Sigismondo Augustoni awards the painter possession of his uncle's gift. *Correggio, Archivio.* Sentenza di Sigismondo Augustoni. Extract re-transcribed from the original. Document printed by Pungileoni, II, page 168.

...Nos Sigismōdus Augustonus coniudex in hac ca delegatus et uissis uidendis Quia dicimus pronūtiamus ac reintegramus m̄r antoniū de allegris seu s̄ rubeitū de ursis proc̄ in nōie dti m̄ri antnii in pristinū statū

et in possessione domus de qua in libello et petitione...

On the same day a contrary sentence was pronounced by the other judge, Ascanio Merli (*Correggio, Archivio*). Extract re-transcribed from the original. Document printed by Pungileoni, II, page 168.

Nos Ascanius Merli...ipsū p̄cessū fore fuisse et esse nullū et p̄rea dictū romanellū seu dictū mapheū eius p̄curatorē et p̄ut ī actis dict̄ noīe et (?) obṡuatione p̄ce—s iuditij absoluimus ac libāmus dictū magrū antoniū et seu dictū d̄ rubtū eius p̄curatorē et p̄ut ī actis eidē romanelo et seu dicto eius p̄curatori dicto nōte ī exp̄esis legitime factis eaī taxatione nobis et offitio...

XIV 1522

4 May Town of Correggio

The painter's wife applies to get possession of her share of her father's estate, still held by her uncle, Giovanni Merlini. *Correggio, Archivio*. Abbreviated text printed by Pungileoni, II, page 179.

XV 1522

16 June Town of Correggio

Inventory of the contents of the house of Giovanni Merlini. Mentioned, but not printed, by Pungileoni, II, page 180. Extract re-transcribed from the original. *Correggio, Archivio*. Rogito di Alessandro Pastori della Nucca.

In x̄ri nōe an— 15xx2 ind̄ dcma die sestod̄cmo m̄is junij inventarium bonor̄ et rer̄ mob̄ existen̄- ī domo joanis merlini qui nō fuerūt d̄uisa cū hieronyma et m̄ro antō d̄ allegris et qui remanser̄ ī dca domo dci johā-

[the list which follows consists of some twenty-six items of furniture – una parcheta di ramo, una portella di ramo, una credenza di legno, una credenzina di legno, uno desco di legno, etc etc.]

XVI 1523

26 January Town of Correggio

The painter present in Correggio at the division of goods between his wife and her uncle, Giovanni

Merlini. *Correggio, Archivio*. Rogito de Alessandro Pastori della Nucca. Extract printed by Pungileoni, II, page 186. Following extract re-transcribed from the original.

Joānes q̄d merlinj armigeri habitator ī ter̄ corigie ex p̄te una et hieronyma fil̄ bartī merlinj nepos dicti joanins nec nō m̄r antūs filius p̄egrinj d̄ alegris...ex p̄te alia ibi p̄ntis p̄ se se & dictus m̄r antūs cū c̄sensu dcti eius p̄ris p̄ntis & c̄sentis...et p̄dā hieronyma cū c̄sensu & aucte dicti m̄ri antij eius mariti p̄ntis & c̄sentis...ipsaq̄ hieronyma m̄ri antonij & p̄egrinj volunt- p̄ sua portione ellegit & accepit...la casa dentro infino al posto ch po— la stalla (?) ducati setanta: paia— biolche quatordisi e mezo ducati centi quaranta cinq̄ et co— biolche cinq̄ ducati quaranta a la p̄dexola (?) una biolcha ducati deci

The painter, evidently still under the parental roof while in Correggio, still requires his father's permission. Pungileoni (I, page 144) says Correggio moved his family to Parma in the spring of 1523, but gives no evidence for it. The painter's wife was evidently resident in Parma before December 1524, when a daughter was born there.

XVII 1524

6 December Parma

Birth of a daughter, Francesca Letitia.

filia antonii de Alegris de corigia & hieronymae uxoris nascitur 6 baptizatur 12 decemb.

Document printed by Tiraboschi (VI, page 242) who adds that the girl subsequently married Pompeo Brunori. What was presumably another member of the same family, Annibale Brunori, was reported killed on 18 February 1525 (see below) while a third, Paolo Brunori, is referred to as 'procuratore' of Manfredo of Correggio (see below, December 1532).

XVIII 1525

15 and 18 February Town of Correggio

Pungileoni (II, page 192–3) mentions, but does not print, three separate documents testifying to the painter's presence in the town of Correggio on these dates, first (15 February) as a witness in the presence

of Veronica Gambara and Manfredo, then (18 February) in a continued examination of the legality of his uncle's (Francesco Ormano) gift, and finally (also 18 February) as witness in a trial following the homicide of Annibale Brunori.

XIX 1525
26 August Parma

The painter's name ('Mro Anto da Coregia') occurs first in a list of expert witnesses called in to advise on the stability of the church of the Steccata, then building. Document published by Amadio Ronchini ('La Steccata di Parma' in *Atti e Memorie della R. Deputazione di Storia Patria per le Provincie di Modena e Parma*, I, 1863, pages 182 and 190). Reprinted by Laudedeo Testi, *Santa Maria della Steccata in Parma*, 1922, page 37, n.93. The omission of the patronymic, Allegri, must give ground for caution, but the inclusion in the list of other known painters, such as Anselmi and Araldi, probably clinches the identification.

XX 1526
24 September Parma

A second daughter, Catherina Lucretia.

filia Magistri Antonii de Alegris de Corrigia, & Hieronymae uxoris nascitur 24. baptizatur 26. septemb.'

Document published by Tiraboschi (VI, page 242) who added that this child, and also the next daughter, must have died young as they are not included in the will of Pellegrino Allegri (1538 – q.v.).

XXI 1527
9 March Town of Correggio

Pellegrino Allegri appears on behalf of his son at the settlement (by division of the goods) of the dispute concerning the gift to the latter from his uncle, Francesco Ormano. The other nephew, Romanello Ormano, was now dead, but his interests were represented by his sister, Elisabetta, wife of Rodolfo Mainardi. Partly quoted by Pungileoni (II, page 210). In another document of the same date, quoted by Pungileoni (loc. cit.), Elisabetta Mainardi sold her portion to Pellegrino Allegri, still acting for his son.

XXII 1527
3 October Parma

A third daughter, Anna Geria.

filia Antonii de Allegris & Jacobina uxoris nascitur 3, baptizatur 5. Octob.

Document printed by Tiraboschi (VI, page 242) who pointed out that 'Jacobina' was evidently a slip of the pen for 'Hieronyma' and did not, as had been assumed by Mengs and in Ratti's biography of the painter, constitute evidence that the painter's first wife had already died and that he had married again. As Tiraboschi went on to indicate, the painter's wife, Hieronyma, was still alive in March 1528 (see below).

XXIII 1527
26 December Town of Correggio

Death of the painter's uncle, Lorenzo Allegri. Pungileoni, II, page 209. *Correggio, Archivio*. Re-transcribed from the original.

E adj 26 [December] *sepoltura de mro lorenzo de alegro depentore* L O p 16 – 6

In his will of 1517 (q.v.) Melchior Fassi had remembered Lorenzo Allegri.

XXIV 1528
20 & 22 March Town of Correggio

Documents of these dates referred to by Pungileoni (II, page 227) in connection with the sale of land to Pellegrino Allegri. They refer to 'Dña Hieronyma de Merlinis', and, in connection with Pellegrino, specify that he was acting in 'nomine et vice Hieronimae uxoris eius filij'. These are the last indications that the painter's wife was still alive. She is referred to as dead in the will of Pellegrino Allegri (1538 – q.v.), and Pungileoni (I, page 203) suggests that she is likely to have died at Parma (where the painter is not recorded after the last payment from the Duomo on 17 November 1530) as there is no record of her death in the registers of S. Francesco at Correggio, where, in her will of 1518, she had said she wished to be buried. It may be noted that Veronica Gambara's letter to Isabella d'Este of 3 September 1528 (q.v.) says that the painter was then working in the town of Correggio – that is, at a season when we should expect him to be working at Parma on the Duomo. There would therefore be a fair possibility that his wife had died at Parma during the summer of 1528.

XXV 1530

29 November Town of Correggio

The painter buys a property of 24 *bifolche* and 28 *tavole* from Lucrezia Pusterla in the town of Correggio. *Correggio, Archivio*. Rogito di Nicolo Donati, the documents now half obliterated by damp. Text quoted in part by Pungileoni, II, page 231–2. Coming, as it does, only two weeks after the last payment to the painter from the Duomo at Parma this seems to constitute strong evidence that he was deliberately repatriating himself and forsaking Parma.

XXVI 1532

December Town of Correggio

Pungileoni (I, page 239) mentions, but does not quote, a record of the painter's presence as a witness to a deed by which Manfredo of Correggio nominated his 'procuratore', Paolo Brunori, as envoy to obtain favours from Charles V.

XXVII 1533

7 and 15 January Town of Correggio

The painter again a witness in Manfredo's palace (Pungileoni, II, pages 250–1).

XXVIII 1533

8 September Town of Correggio

The painter buys more land (Pungileoni, II, page 251).

XXIX 1534

24 January Town of Correggio

Antonio da Correggio a witness in the palace of Manfredo to the deed of dowry of Chiara on her marriage to Ippolito da Correggio, son of Veronica Gambara. The fact that the painter died little more than a month after this, together with the wording of the reference to his death in the document connected with Alberto Panciroli's altarpiece (q.v.) is an indication that it occurred suddenly and unexpectedly.

XXX 1534

March Town of Correggio

Death and burial of Correggio.

Correggio, Archivio. Pungileoni, II, page 251. Retranscribed from the original.

1534 de mēsse martij
a di dicto (Friday 6th) p̄ la sepultura de m̄o antonio de alegris depītore...13 8

a di 9 che fu el lunedi fu fato lo septimo de mo antonio di alegri dipītor 13 8

adi 10 che fu el martedi fu fato el tregesimo del sopra scripto 13 8

XXXI 1538

19 November Town of Correggio

Will of the painter's father, Pellegrino Allegri. Bequests to the painter's mother, the painter's daughter, Francesca and the painter's son, Pomponio. Printed by Ratti, *Notizie Storiche...intorno... Correggio*, 1781, pages 130ff. According to Venturi (*Storia...*, IX, 2, page 475) the document itself was shown in the 1894 Correggio exhibition at Parma.

...Magister Peregrinus filius quondam Magistri Antonii de Allegris de Corrigia...recommendavit etc sepulturam sui corporis sibi elegit in Ecclesia Sancti Francisci de Corrigia in sepultura suorum praedecessorum...reliquit...Dominae Bernardinae filiae quondam Domini Nicolai de Avomano (i.e Aromano or Ormano) de Corrigia uxori ipsius testatores dotes suas, quae fuerunt in et de libris centum...legavit...honestae juveni Franciscae eius nepoti, et filiae quondam Magistri Antonii Pictoris filii legitimi, & naturalis praedicti Testatoris, & olim Dominae Hieronymae de Merlinis Jugalium scutos ducentum quinquaginta auri...in omnibus aliis autem suis bonis etc. sibi haeredem universalem instituit etc...discretum Juvenem Pomponium eius nepotem, & filium legitimum & naturalem praedicti Magistri Antonii olim filii praedicti testatoris...

CATALOGUE A. SURVIVING PICTURES

The pictures in the following section are those which are documented as Correggio's or which, though undocumented, are likely, in my opinion, to have issued from his studio as his work. The second section lists destroyed or lost paintings. This is followed by notes on a selection from the many unsupported attributions.

The notes on condition cannot claim any scientific thoroughness since in most cases they were not made in studio conditions. Nevertheless, after many years' experience of such things in the National Gallery in London I venture to hope that what strikes me in ordinary viewing conditions as damage or repaint may, if noted, be of some use to other people.

No attempt at completeness is claimed in listing printed references, which in all cases have been noted selectively. If, therefore, a book reference adds nothing to an earlier one it is usually not mentioned. As justification for this the reader need only consider the impossibility – and the uselessness – of cataloguing every reference in print (in all languages) to works such as the *Notte*. Similarly, it would be virtually impossible to list all the copies and even all the prints. As some degree of compromise was therefore necessary I have tried to note copies mentioned in the older sources, those which I knew whose present ownership is relatively stable, and the older engravings and etchings.

In general the catalogue aims only at stating facts and discussing facts. Unsupported and hypothetical dating by earlier writers is often not mentioned here (see Appendix B). My own views on chronology, where documentation is lacking, are, for this reason, put forward not here but in the text.

Where no source of information is stated regarding a picture's dimensions I have either measured it or had it measured specially.

BERLIN Dahlem, Gemäldegalerie

LEDA

1·52 × 1·91[1] plates 190 to 193

Deliberately mutilated in the eighteenth century, when, among other damages, Leda's head was cut out and lost (see below). The present head is a skilful nineteenth-century restoration by Schlesinger. Duchange's engraving and Caxes' copy in the Prado (see below), both made before the mutilation, show that Leda's head was originally inclined rather farther towards her left shoulder. Varnish dirty (1971). Foliage oxidised in places. Some obvious repaint in the flesh in places. The two girls on the right are the best preserved. Evidently trimmed slightly at the top and bottom.[2]

The presentation is unusual. Of Leonardo's various projects in respect of this subject the most influential was a Leda standing with the swan on her left, a scheme which was followed by other Florentines, such as Sarto and Bacchiacca.[3] Michelangelo's picture, of which Correggio seems to have made a sketch copy,[4] showed Leda reclining, in profile. In none of these works are there other characters, with the exception of the infants emerging from the eggs. The latter are not included in Correggio's painting, but other figures appear – Cupid, two putti (as in the *Danaë* (Rome), q.v., one is winged, the other not) and two female servants. The presence of two more swans and two more naked girls in the background on the right has often been read literally. But the fact that these background episodes illustrate events – an attempt to ward off the swan and a final look at it as it flies away – which would have preceded and followed the actual seduction, as shown in the centre, is a strong argument against this interpretation.

Despite differences in the scale of the figures, evidently a pair to the *Danaë* (Rome), and despite discrepancies with Vasari's description (he had not seen the pictures himself) evidently identical with one of the two pictures which he says were commissioned by Federigo Gonzaga to send to the Emperor, Charles V.[5]

See text, page 130.

PROVENANCE Evidently taken by Charles V to Spain. No. 3997 in the inventory of Philip II, taken after his death (1598).[6] In 1603–4 the Emperor Rudolf II succeeded in buying it and the *Ganymede*[7] (on 19 August 1604 Eugenio Caxes was paid for copying them).[8] Prague inventory, 1621.[9] Taken from Prague with the other pictures from Rudolf's collection to Sweden in 1648 (Skokloster inventory).[10] In Queen Christina's collection (1652 and 1656 inventories).[11] Taken by her to Rome. After her death in 1689 her pictures passed by bequest to Pompeo Azzolini, who sold them to Livio Odescalchi, whose heir, after lengthy negotiations, sold them to the duc d'Orléans, regent of France, in 1721.[12] The regent died in 1723 and was succeeded by his son, Louis, who, after the death of his wife in 1726, became mentally unstable. In the Charles Coypel sale catalogue, 1753 (lot 2), a description of the mutilation of the *Leda*. According to this, the erotic character of the picture, and of a copy of Correggio's *Io* (later at Berlin; the original at Vienna) caused Duke Louis to cut out the heads of the principal figures in both. As he retired to the abbey of Ste Geneviève in 1731 the incident is likely to have occurred between 1726 and then.[13] He generously presented what remained of the pictures to Charles Coypel, his *premier peintre*, who obtained his permission to repair them. According to the sale catalogue, the *Leda* reached Coypel in three pieces; the first, 3 'pieds' square, consisting of the figure of Leda (without her head) and the swan, the other two, '4 pieds, 10 pouces' high by '2 pieds' wide, were said to be intact, and consisted of Cupid and the putti on the one hand, and the figures to the spectator's right of Leda, on the other. A small piece, consisting of the head of the woman nearest Leda, had been cut out and mounted separately. An unpublished note in a copy of the Coypel sale catalogue in the Bibliothèque Nationale in Paris gives the following details in Mariette's handwriting:[14] '16050. M. Pasquier. Il a

eu pour concurrent M. le Baron de Thiers. Ces frag-
mens ont été rapprochés & remis sur toille par la Ve.
(?) Godefroi avec une adresse qui ne laisse point ap-
percevoir les jointures & fait croir que le tableau
d'une seule pièce n'a jamais été coupé en plusieurs
parties. La restauration de la tête, qui manquait, du
paysage etc. n'a pas été fait avec moins de dextérité.
Delyen s'en est parfaitement bien acquitté, & a sur-
passé de beaucoup mon attente & celle de tous les
curieux. Le Roi de Prusse l'a fait acheter depuis à la
vente de Pasquier.'* In the Coypel sale catalogue it is
stated that Coypel had supplied a new head for Leda
and slightly altered the swan.[15] The relevant entry in
the catalogue of this sale gives no over-all dimensions
for the *Leda* at the end, contrary to what is done in
respect of the other pictures. It may therefore be de-
duced that at the time of the Coypel sale the picture
was still in various pieces, the reunification described
by Mariette and the second restoration (by Delyen)
of Leda's head having taken place soon afterwards.
Pasquier, the purchaser at the Coypel sale, is described
as 'Député du Commerce de Rouen' at the time of
his own sale – 10 March 1755. In this sale the Leda is
the first item in the catalogue as reprinted by Blanc.[16]
It was bought by the 'comte d'Epmaille' (Epinaille)
for the King of Prussia (Frederick the Great). De-
scribed by Matthias Oesterreich at Sans Souci (second
edition, 1770).[17] Taken to Paris in 1806 by Napoleon
where Delyen's restorations were redone by Pru-
d'hon.[18] Returned to Germany, 1814. In the Berlin
Museum when it opened in 1830, where Leda's head
was repainted, for at least the fourth time, by Schle-
singer.[19]

* 'M. Pasquier. His rival was the Baron de Thiers.
The fragments were assembled and mounted by the
widow Godefroi with such skill that the joins are
invisible and suggest that the picture was always in
one piece and never cut into sections. The restoration
of the head, which was missing, and the landscape
have been done equally well. Delyen has done
brilliantly, and far surpassed my hopes and those of
all the other collectors. Since then the King of Prussia
has bought the picture at the Pasquier sale.'

ENGRAVINGS G. Duchange (1711) (reversed)
(plate 193B); E. Desrochers, 1713.[20]

COPIES Prado, no. 119, by Eugenio Caxes, 1604
(plate 193A). Rome, Palazzo Rospigliosi (with altera-
tions).[21] Rome, Villa Borghese (small copy of girl
second from right).

REFERENCES [1] Measurements from the Berlin
catalogue. [2] The Prado copy measures 1·65 × 1·93.
See also Tschudi, 'La Leda del Correggio', in *L'Arte*,
I, 1898, p. 219. [3] The picture ascribed to Sarto is in
the Brussels gallery; it has also been attributed to
Franciabigio, Bacchiacca and Puligo. There are
several versions acceptable as Bacchiacca. [4] Popham,
no. 84 (plate 194A). [5] Vasari/Milanesi, IV, p. 115.
[6] F. J. Sánchez Cantón, *Inventarios Reales. Buenos
Muebles que pertenecieron a Felipe II*, 1956–9, vol. II,
p. 234. As the unpublished inventory of Antonio
Pérez' effects (31 January, 1585 – Archivo de Proto-
colos, Madrid, Escribano Antonio Márquez, 1585,
legajo no. 989, folios 472–476v) contain several
references to pictures of Leda, with no artist specified,
it would be possible that the present picture had been
given to Pérez by the King, to whom it would have
reverted after Pérez' disgrace. [7] The documentation
of Rudolf's negotiations, commented on by Urlichs
(*Zeitschrift für bildende Kunst*, 1870, pp. 81–5), is
printed in detail in the Vienna *Jahrbuch*, vol. XIII
(1892), part 2, pp. CXLIII–CLXIII, nos. 9409, 9419,
9433, 9450, 9532, 9583, vol. XV (1894), part 2, pp.
CLXVI–CLXXVIII, nos. 12,494, 12,495, 12,504, 12,542,
12,599 and vol. XIX (1898), part 2, pp. XXI–XLII, nos.
16,224–7, 16,231, 16232, 16,422. [8] Prado catalogue,
under Caxes. [9] O. Granberg, *Galerie de Tableaux
de la Reine Christine...*, 1897, p. 30. Also *Wiener
Jahrbuch*, 25, 1905, Anhang, XLI, no. 990. [10] Gran-
berg, op. cit., Appendix I, p. VII. [11] Granberg, op.
cit., Appendix II, p. XXIX, and J. Denucé, *The Antwerp
Art Galleries in the sixteenth and seventeenth centuries*,
1932, p. 179. [12] Included in the ?1689 inventory of
Christina's collection and in that of 1721 (Granberg,
op. cit., Appendix III, p. LVIII and Appendix IV,
p. XCV). The latter disproves an improbable story
(Buchanan, *Memoirs...*, I, 1824, p. 14) whereby Queen
Christina is said to have presented the *Leda* to Louis
XIV. For a further improbable story associated with
Christina see reference [15] below. [13] See footnote
to publication of a letter of 1791 from François Robert
giving an inaccurate account of the mutilation (*Bul-*

letin de la Société de l'Histoire de Paris, 1887, pp. 125ff.). [14] Reference V réserve 2445. I am most grateful to Monsieur J. Adhémar of the Bibliothèque Nationale for facilitating access to this document whose existence had been mentioned by E. Dacier (Bulletin de la Société de l'Art Français, 1931, pp. 44ff.). [15] Du Bois de Saint Gelais (Description des Tableaux du Palais Royal, 1727, preface, p. xi) claims that various pictures belonging to Queen Christina were mutilated on her orders in order to adapt them as ceiling decorations. Again, Piganiol de la Force (Description historique de la ville de Paris, vol. II, 1765, pp. 329–30) claims that all eleven of the pictures attributed to Correggio in Queen Christina's collection had been used as screens in the stables of the palace at Stockholm until rescued by Sébastien Bourdon. The improbability of both these stories is such that one wonders if they were not put out in an attempt to alleviate, to some degree, any scandal arising from Louis d'Orléans' own criminal action in respect of the Leda and the copy of the Io. It is notable in this context that the 1737 edition of Du Bois de Saint Gelais' catalogue says nothing of the mutilation though it is likely already to have occurred. [16] Charles Blanc, Le Trésor de la Curiosité, I, 1857, p. 74. [17] p. 48, no. 46. Nothing said in this about the mutilation. [18] Lavallée, Galerie du Musée Napoléon, x, 1815, no. 661. Meyer (p. 352) says the Paris restoration was done by 'F. M. Hooghstael'. [19] Meyer, p. 352. [20] For later engravings see Meyer, pp. 490–1. [21] See Antonio Coppi, Notizie di un quadro del Correggio, Dissertazioni della Accademia Romana di Archeologia, XIII (1821), pp. 129–40. The Berlin catalogue mentions another copy in the Hermitage whose existence I cannot confirm. For the Leda subject in general see E. R. Knauer in Jahrbuch der Berliner Museen, II, 1969, pp. 5ff.

BUDAPEST Szepmüveszeti Muzeum

MADONNA AND CHILD WITH AN ANGEL
(La Madonna del Latte)

Panel, 68·5 × 56·8 [1] plate 95

Thin in most places, and some old local repaint in many areas, but general condition very fair. The angel on the right has sometimes been referred to as the Giovannino. But his wings are clearly present in this picture – which is unquestionably the original – as well as in the Leningrad version and other copies and in the engravings of Teresa del Po and Spierre. These engravings show tree trunks and foliage and a bit of landscape in the background. This has been painted over in the present picture but is still visible in places when seen against the light.

The subject is unusual. The Christ child rejects the Madonna's breast in favour of the pears offered by the angel. The present picture, and the Uffizi Madonna Adoring, are virtually the only major works of Correggio's maturity about whose origin, and whose ownership within the sixteenth century, nothing is known. In theory, therefore, either could be identical with the picture of unspecified subject which Vasari says was in Reggio and was then taken to Genoa by Luciano Pallavigino. [2]

See text, page 90.

PROVENANCE The composition agrees with one in the 1603 inventory of Cardinal Pietro Aldobrandini's pictures: 'Una Madonna che alatta il Bambino con un'angelo appresso, d'Antonio da Correggio.' [3] The same picture figures again in the 1626 inventory. [4] According to Ottonelli (1652), it passed from the collection of Cardinal Pietro Aldobrandini to his nephew, Cardinal Ippolito Aldobrandini, then to the Principessa di Rossano, then to Cardinal San Giorgio. [5] It was then bought for 1,300 scudi by Gottifredo Periberti, its owner at the time when Ottonelli wrote. Ottonelli's specification of the high price paid – and of an even higher price offered to Periberti for it subsequently, and refused by him – is

some indication that the picture was the original, and not a copy.[6] Some thirty years after the publication of Ottonelli's book (168– — the last figure is missing in the British Museum impression: I have not traced an intact one) an engraving by Teresa del Po after what is recognisably the composition of the Budapest picture was inscribed with a statement that the original painting belonged at the time to Don Haro y Guzmán, Marqués del Carpio, and that he had bought it when ambassador in Rome from Muzio Orsini. The pictures of the Marqués del Carpio were sent in batches from Italy to Spain between 1679 and 1687. Part of his collection was sold in Madrid after his death in 1687. The rest were retained by his daughter who married the 10th Duke of Alba in 1688.[7]

During the eighteenth century there are two significant references to this composition. The first is by Mengs, who says in his *Memorie...di...Correggio* that some years previously an art dealer in Rome acquired a picture with the Madonna and Child and an angel as in Spierre's print (which, though in a round format, is certainly after the present composition).[8] Mengs says that the painting was at the time obscured by a dark varnish, as a result of which it was bought cheaply by Casanova, who cleaned it and took it to sell at Dresden (where it is known that he went in 1764). Mengs added that he thought it was still at Dresden when he wrote. A nineteenth-century source (Nagler's *Künstler-Lexikon*, 1835) says that this picture was finally bought for Catherine II of Russia on Mengs' advice. This picture could therefore not be identical with one seen by Goethe in Naples long after Mengs wrote. Goethe describes it as follows (*Italienische Reise*, entry for 22 March 1787): 'Heute sahen wir ein Bild von Correggio, das verkäuflich ist, zwar nicht vollkommen erhalten, das aber doch das glücklichste Gepräg des Reizes unausgelöscht mit sich führt. Es stellt eine Mutter Gottes vor, das Kind in dem Augenblicke, da es zwischen der Mutter Brust und einigen Birnen, die ihm ein Engelchen darreicht, zweifelhaft ist. Also eine Entwöhnung Christi. Mir scheint die Idee äusserst zart, die Komposition bewegt, natürlich und glücklich, höchst reizend aus-

geführt. Es erinnert sogleich an das Verlöbnis der heiligen Katharina und scheint mir unzweifelhaft von Correggios Hand.'*[9]

The Esterhazy archives in the Szepmüveszeti Muzeum show that the Budapest picture was bought by Prince Nicolas Esterhazy in Italy from a Duca Crivelli, who had inherited it from his uncle, Cardinal Crivelli, to whom it had been given by a king of Spain. It is catalogued among the Esterhazy pictures in 1812. From its appearance, as already stated, it is acceptable as Correggio's, and, as has also been suggested, it is likely that the Aldobrandini-Periberti version was also. To prove identity between them it would be necessary to assume, in default of evidence, that Periberti's picture had passed to Muzio Orsini, and thence to Carpio and Spain, that it had been acquired by a king of Spain and then given to Cardinal Crivelli who had taken it back to Italy (a Cardinal Ignatius Crivelli was nuncio to Spain in 1773).[10] This could be the picture seen by Goethe in Naples in 1787. None of this would be impossible or even unlikely (and the omission of references to Periberti's picture in the fairly numerous guide books to Rome dating from the end of the seventeenth century and the eighteenth century suggests that wherever it then was it was not in Rome) but there is no linking evidence. Also, Nagler's *Künstler-Lexikon*, and following it various editions of the Hermitage catalogue, confuse the provenance of the Budapest and Hermitage versions by saying that the latter had been in the possession of a Spanish king (which Mengs' statement, assuming that it refers to the picture which

* 'Today we saw a picture by Correggio which is for sale, and though not perfectly preserved nevertheless retains the happiest and most charming appearance. It represents the Madonna and child at the moment when the latter hesitates between the mother's breast and some pears offered by a small angel. In other words, a weaning of Christ. I find the idea very delicate, the composition lively, natural and successful and the whole of delightful execution. It is immediately reminiscent of the Marriage of St. Catherine and seems certainly from Correggio's hand.'

then went to the Hermitage, renders unlikely in respect of that, while the Esterhazy archives prove it in the case of the Budapest picture). Passed to the Szepmüveszeti Muzeum with the Esterhazy collection, 1872. Exhibited London (Royal Academy) 1930 (182); Paris (Petit Palais), 1935 (114).

DRAWINGS Sketches at the Albertina and at Yale, formerly associated with this picture, have now been discredited as Correggio's. A drawing in the Galleria Estense, Modena has been connected, but inconclusively.[11]

ENGRAVINGS By Francesco Spierre (circular format) (with dedication to Padre Oliva) (plate 95C), Teresa del Po (dated 168– — last figure missing in British Museum impression — see above, page 197) (plate 95B) and N. Bazin (with curtain in background and other alterations).

COPIES One by Domenico Gabbiani is mentioned in a letter of 17 February 1673.[12] Ratti mentions one by Gaulli in Palazzo Rosso, Genoa.[13] The one now in the Hermitage, Leningrad, which looks plainly later than the sixteenth century, was catalogued and engraved as in the Hermitage as early as 1805, and is presumably identical with the one taken from Rome to Dresden in 1764 by Mengs' acquaintance, Casanova. Therefore neither it nor the Budapest picture can be identical with the version engraved in the Lucien Bonaparte collection in 1812. Others recorded in the Budapest museum (distinct from the original), Kunsthistorisches Museum (Vienna) Caetani collection,[14] Torlonia collection, Boiano (Campobasso)[15] etc. A fresco copy at Parma,[16] a relief copy[17] and a sketch copy by Van Dyck.[18] A picture said to be after the Hermitage version was lent by 'Colonel Alexander, M.P.' to the Royal Academy, London, 1881 (216).

REFERENCES [1] Measurements from the Budapest catalogue (by A. Pigler), 1967. [2] Vasari/Milanesi, IV, p. 116. [3] Published by Cesare d'Onofrio, *Palatino*, January–March 1964, p. 20, no. 51. [4] Published by Paola Della Pergola, *Arte Antica e Moderna*, 1960, p. 429, no. 39. [5] *Trattato della Pittura e Scultura*..., published under the pseudonym Odo-

menigo Lelonetti. [6] Battaglia (*Correggio Bibliografia*, p. 10) strangely misreads Ottonelli as saying the picture was then in his own possession. In fact Ottonelli specifies it as belonging to Periberti, whom he quotes in *oratio recta* as refusing an offer of sale. Meyer (p. 329, n.24) says Ottonelli's book is equipped 'mit einer schlechten Radierung des Bildes' ('with a bad etching of the picture'). This is not the case with copies I have seen. [7] For the Carpio collection see Pita Andrade in *Archivo Español de Arte*, 1952, pp. 223–36, and two other articles in the same periodical – by Enriqueta Harris (1957, pp. 136–9) and A. E. Pérez Sánchez (1960, pp. 293–5). A document kindly communicated by Enriqueta Frankfort (Florence, Archivio di Stato, Lettere artistiche di... Bandinelli, 1639–60) refers to an audience of the Pope with the Tuscan ambassador 'con un bellissimo Correggio, vi è stato anco l'Ambasciatore di Spagna ma con un Correggio molto minore del nostro' ('with a spendid Correggio. The Spanish ambassador was also there, but his Correggio is greatly inferior to ours') (ref. f.2.14.1.39). [8] Mengs, *Opere*, 1787 edition, p. 189. [9] Also mentioned in Eckermann's *Gespräche mit Goethe*, 13 December 1826. [10] Information kindly supplied by Enriqueta Frankfort. Though Mengs does not mention this picture it may be noted that he is also silent on the Correggio *Madonna and Child with the Giovannino*, now in the Prado. Perhaps both were in the private apartments. No trace of the Budapest picture appears in the Spanish royal inventories of 1700–1746 (kindly checked by Dr A. E. Pérez Sánchez). [11] *La Critica d'Arte*, VIII, 46, 1961, pp. 50ff. [12] G. Bottari, *Raccolta di Lettere*..., V, 1766, p. 189. Pungileoni (II, p. 129) quotes Resta (*Indice del Parnasso*, 1787, p. 63) as mentioning a version chez Marchese Corbella at Milan. [13] Ratti, *Instruzione...in Genova*, 1780, p. 266. [14] Reproduced (attr. Pomponio Allegri) *Bollettino d'Arte*, anno X, serie II, 1931, p. 349. [15] *Il Popolo di Roma*, 2 May 1934. [16] A. O. Quintavalle in catalogue of 1934 Correggio exhibition, p. 88. In his catalogue of the Parma gallery (1939) he attributed it to Rondani. [17] *Burlington Magazine*, May 1922, pp. 140–4. [18] R. A. d'Hulst and H. Vey, *Antoon van Dyck*, 1960, pl. XXXV. Then in a private collection at Bâle. Further copies and references in Pigler, op. cit.

CHICAGO Art Institute

MADONNA AND CHILD AND THE GIOVANNINO

Panel, 0·64 × 0·50[1] plates 16, 17

Excellent condition.

X-rays[2] show *pentimenti* in the Madonna's right hand, and that the edge of her cloak at an earlier stage extended less far towards the right edge of the panel.

See text, page 43.

PROVENANCE Purchased from Messrs Wildenstein by the Chicago Art Institute, 1965, Clyde M. Carr Fund. Stolen soon afterwards and recovered.

REFERENCES [1] Dimensions from notice by Myron Laskin, *Burlington Magazine*, 108, 1966, p. 190. I have not seen this picture. [2] Kindly supplied by John Maxon. See plate 16B.

DETROIT

MARRIAGE OF ST. CATHERINE

Panel, 1·35 × 1·23[1] plates 1 to 4

The reproduction in Gronau's *Klassiker der Kunst* volume on Correggio (1907)[2] shows the picture with later additions at the top and bottom which have since then been removed. Said to have Charles I's monogram and/or a papal seal on the back.[3] In the photograph reproduced in the Castiglioni sale catalogue a painted inventory number, 232, is visible, bottom right. X-ray photographs show a hooded figure standing on the right, above St. Catherine. The saints flanking the Madonna are usually identified with St. Anne and St. Joseph. Suida preferred St. Elizabeth and St. Zacharias.[4]

Attributed at various times to Luini (Van der Doort's inventory of Charles I), Gaudenzio Ferrari (in the Commonwealth inventory), 'School of Raphael and Giulio Romano' (Kaunitz sale) and Rondani.[5] First recognised as Correggio by Rumohr (1838).[6] As School of Correggio in the Adamovicz sale (1856). Not included in Ricci (1896). Published as 'ferraresisch-bolognesisch...aus der Nähe von Correggio' ('Ferrarese-Bolognese, from the neighbourhood of Correggio') by Frimmel (1899)[7] and accepted as Correggio by Ricci soon afterwards.[8] In recent literature universally accepted. Notes on the costumes and hair styles by Stella Mary Newton favour a date not later than *c.* 1511. The styles in question were highly fashionable in the major Italian centres *c.* 1508–9.

See text, page 32.

PROVENANCE Conceivably, but improbably, identical with a Correggio 'Madonna con S. Giovanni e un'altra figura di Santo in piedi'* which was reported in 1592 to Vincenzo I Gonzaga as a possible acquisition. The picture in question was then stated to be in a small chapel near Luzzara.[9] Fairly certainly identi-

* 'And another figure of a standing saint.'

fiable with the 'Madonna sentata, N.S., S. Giovanni, S. Giuseppe et S. Caterina' which was no. 105 in the 1627 Gonzaga inventory (Mantua: no artist's name given)[10] and with an entry in Van der Doort's inventory of Charles I's collection (c. 1639): 'Our Ladie and Christ St John St Ann Joseph and St Katherin 6 Intire figures less then the life saide to be done by Lowino or otherwise by one out of the Schoole of Leonard De Venice.' Headed 'A Mantua peece', with dimensions given as '4 fo.–5/4 fo–o'.[11] In the Commonwealth sale, 29 March 1650, bought by the painter Remigius van Leemput ('Mary, Christ, St Katherine, St John, Elezebeth and Joseph' by 'Godentio Melaneso' sold for £120).[12] Rumohr, republishing it in 1838, says it was then in the Adamovicz collection and had been in the possession of the Chancellor Kaunitz to whom it had been said to have been given by a pope.[13] Rumohr added the name Pius VI with a query and said that there was a seal with papal insignia on the back of the picture. At the Kaunitz sale, Vienna, 13 March and following days, 1820 the picture is identifiable with lot 132 ('Ecole de RAPHAEL et Jules Romain. Sur bois haut 58 pouc, Larg. 45 pouces. Les fiancailles de St. Catherine').* In the Valentin Andreas von Adamovics sale, n.d. (1856), lot 47 ('47–45 Correggio (Schule) Holz. Hoch 60″, br. 47″. Verlobung der heiligen Katharina mit Jesulein. Mit der Galerie-Nummer des Vaticans und dem eingebrannten päpstlichen Siegel. Aus der Sammlung des weiland Fürsten Kaunitz').† Frimmel (1899)[14] says it has the brand of Charles I on the back. Gronau (1907)[15] says it was presented to Kaunitz by Pope Pius VII in 1783 (an unlikely thing: Pius VII was not elected until 1800). The fact that Rumohr and the Adamovicz sale catalogue mention the papal

mark on the back but not that of Charles I, and that the Adamovicz catalogue specifies that this 'papal' mark was branded suggests that the mark was really that of Charles I. Whether there is any other 'evidence' of a papal provenance is unknown. From Adamovicz the picture is said by Frimmel to have passed to Andreas Ritter von Reisinger by inheritance. It was presumably therefore bought in at the Adamovicz sale. Passed from the Reisinger collection to that of Camillo Castiglioni 'about the year 1920'.[16] Castiglioni sale, F. Muller, Amsterdam, 17 November and following days, 1925. Presented by Anna Scripps Whitcomb to the Detroit Institute of Arts, 1926, in memory of her father, James E. Scripps.

REFERENCES [1] Dimensions as given (exclusive of the additions then existing) by W. Suida, *Burlington Magazine*, 14, 1908-9, p. 302. The dimensions in the Van der Doort inventory of c. 1639 are virtually the same as now. Therefore the additions were made between then and the time when the picture was in the Kaunitz collection in the second half of the eighteenth century (Suida, loc. cit., noted Kaunitz' mark on the lower added portion). [2] p. 4. [3] I have not seen the picture since 1960 and have no notes on its condition. Various writers (see below) mention the Charles I mark as branded, as indeed it usually is, but the present cradle of the panel seems to conceal it. [4] Suida, loc. cit. [5] W. Schmidt in *Helbings Monatsberichten*, 1903, p. 47. [6] *Reise durch die östlichen Bundesstaaten in die Lombardey*, pp. 50–1. [7] T. von Frimmel, *Geschichte der Wiener Gemäldesammlungen*, Erster Band, III Capitel, 1899, p. 90. [8] *Rassegna d'Arte*, I, 1901. [9] Luzio, *La Galleria dei Gonzaga...*, 1913, p. 112. He identifies this reference with the Hampton Court *Holy Family*, to which the words 'in piedi' seem totally inapplicable. [10] Luzio, op. cit., p. 96. [11] O. Millar, *Walpole Society*, 1958–60 (1960), p. 21. [12] Information from Oliver Millar. Published in *Walpole Society*, 43, 1972, p. 298. [13] Loc. cit. [14] Loc. cit. [15] Loc. cit. [16] Ricci 1930, p. 151.

* 'School of Raphael and Giulio Romano. Panel, 58 *pouces* high, 45 *pouces* wide. Marriage of St. Catherine.'

† 'Correggio School. Panel, 60″ high, 47″ wide. Marriage of St. Catherine. With the gallery number of the Vatican and the brand of the papal seal. From the collection of the late Prince Kaunitz.'

DRESDEN

MADONNA AND CHILD WITH
SAINTS FRANCIS, ANTHONY OF PADUA,
CATHERINE OF SIENA AND JOHN THE
BAPTIST

Panel, 2·99 × 2·455[1] plates 11 to 15B

Inscribed on the rim of St. Catherine's wheel:

<div align="center">

ANTOIVS

DE

ALEGRIS

.P.

</div>

It has been questioned whether this is an authentic signature. There are five vertical splits in the panel, of which the most conspicuous passes through the Madonna's forehead and her right eye, then down through the support of her throne and the putti. One to the right of this passes through the fingers of St. Catherine's right hand, but otherwise mainly through the sky, where it seems to have been puttied a bit. The other splits pretty clean. Some caking of the paint in places. Varnish very dirty (1971). Scene on base of plinth almost obliterated. In other respects pretty good condition. *Pentimento* in the Baptist's left shoulder. In the oval under the throne Moses with the tables of the law. Under this, in the oblong space, the creation of Adam or Eve (left), Adam and Eve and the serpent (centre) and the Expulsion from Eden (right).

A pillared hall as setting for an altarpiece of the Madonna enthroned with saints had been common in north Italy.[2]

Mengs (*Opere*, II, 1783 edition, page 161) characterises the style as mid-way between Perugino and Leonardo.

By a document dated 4 July 1514, one Quirino Zuccardi bequeathed a house to the convent of S. Francesco at Correggio, the proceeds of which were to pay for an altarpiece.[3] Quirino's heir, Nicolino Selli, a Parmesan then living in Correggio, sold the

house and paid 95 ducats and 64 soldi to the convent for the altarpiece, stipulating that it was to be ready within eighteen months. On 30 August 1514 Antonio Allegri da Correggio undertook to paint the altarpiece (subject not specified), receiving 50 ducats on the spot, and another 50 on completion. The transaction was stated to have been conducted in Correggio's bedroom on the ground floor. From a document of 4 October it emerges that one Pietro Landini was to complete 'anchonam unam ligneam' (the panel on which the picture was to be painted) by the end of that month. Evidently Correggio was to be able to start painting in November. Both this and a document of 24 March 1515 make it clear that the altarpiece was for the high altar of the church. Correggio received final payment on 4 April 1515. He was also responsible for painting the blue ground to the frame and perhaps for gilding it.[4] Though the subject of the S. Francesco altar is not specified in the documents it has always been assumed to be identical with the present picture, partly on account of a mistaken assumption that the pedigree is complete. The present picture is always identified in modern literature on Correggio with one which was stolen from S. Francesco in 1638, evidently on the orders of Duke Francesco I d'Este of Modena, from which collection the present picture certainly came. But this is not the case. The picture which was stolen in 1638 was Correggio's *Holy Family with St. Francis* now in the Uffizi. A document published by Tiraboschi[5] describing the theft says 'il quadro che era sopra l'immagine della Beatissima Vergine della Santissima Concezione di mano del celeberrimo Antonio da Correggio era stato levato, & in suo luoco era stato posta una copia dell'istesso quadro'.* A further document, published by Pungileoni,[6] says 'a dì 12 aprile 1638 è stato portato via il quadro di Antonio da Correggio che era all'altare della Concezione di S.

* 'the picture which was over the image of Our Lady of the Conception by the hand of the celebrated Antonio da Correggio was removed, and in its place has been set up a copy of the same picture.'

Francesco'.* The Uffizi Correggio came from the chapel of Francesco Munari at S. Francesco, and it is known from his first will (6 October 1508) quoted by Pungileoni[7] that this was the chapel of the Conception. The 1514–15 picture, on the other hand, was over the high altar.

Nevertheless the fact that the present picture came from the ducal collection at Modena, that Duke Francesco I of Modena systematically robbed the churches in his domains of every picture worth taking, that Correggio's high altarpiece for S. Francesco at Correggio has long since disappeared from that church, that the size and subject of the present picture would render it suitable for the high altar of a Franciscan church and that its style is consonant with that of Correggio's early period leaves virtually no doubt that it is correctly identified with the picture mentioned in the documents of 1514–15. How it left the church of S. Francesco is another matter. Various modern writers have assumed it did so at the same time as the *Holy Family with St. Francis*, namely in 1638.[8] This, on reflection, seems impossible. The documents recording the theft only speak of one picture, which, of the two, would have been the less important. On the other hand, a letter of 1 June 1638, published by Pungileoni,[9] from the Marchese Montecuccoli, majordomo of Francesco I, to Cavaliere Ottavio Bolognesi says that Don Siro, the last of the indigenous princes of Correggio, 'n'aveva avuto a' tempi passati in varie occasioni due o tre levati di chiese o d'altri luoghi parmi anche senza ricompensa...' ('had had things removed from churches and other places in the past on several occasions seemingly without any compensation'). It is known that Don Siro had in fact appropriated Correggio's triptych of *God the Father* (or *Christ*) flanked by *Saints Bartholomew and John* (see under Lost Paintings, page 280) from the Misericordia in Correggio in 1613. If he had also taken others the present picture

* 'On 12 April 1638 they took away the picture by Antonio da Correggio which was on the altar of the Conception at S. Francesco.'

could have been among them and could have been acquired by Francesco when Don Siro was in exile and in reduced circumstances in the 1630s.[10] This is merely conjecture.[11]

See text, page 42.

PROVENANCE S. Francesco, Correggio. Included in the 100 pictures sold from Modena to Augustus III of Saxony, 1745–6.[12] At Dresden ever since except 1945–55 when it was in Russia.

DRAWING See K. Oberhuber (*Master Drawings*, VIII, 1970, pages 276ff.) for tentative suggestion.

ENGRAVING By Etienne Fessard (1714–77) in *Recueil d'Estampes...de la Galerie de Dresde.*

REFERENCES [1] Measurements from the Dresden catalogues. [2] E.g. Altars by Costa in S. Giacomo Maggiore, S. Petronio and S. Giovanni in Monte at Bologna. Also one by Francia in the Pinacoteca at Bologna. [3] Documents on pages 174–6. Also in Pungileoni, II, pp. 65ff. [4] Venturi (*Storia...*, IX, 2, p. 460) assumes that the words 'anchonam unam ligneam' refer to the frame, but this can be excluded for two reasons. Elsewhere in the documents a different phrase – 'casa de l'anchona' – is used twice, certainly meaning frame. Secondly, the frame for an altarpiece on a high altar would normally be far too elaborate to be constructed in the time specified – one month. Pungileoni's misreading of the final payment as 4 April has been generally followed. [5] *Biblioteca Modenese*, VI, 1786, p. 254. [6] Pungileoni, II, p. 79. [7] Pungileoni, II, p. 74. [8] E.g. Bianconi, *Tutta la Pittura del Correggio*, 1953, p. 34; also R. Lightbown in *Apollo*, September 1963, pp. 193ff. Luzio (*La Galleria dei Gonzaga...*, 1913, p. 112) records an earlier attempt by Vincenzo I Gonzaga in 1598 to remove this or the Uffizi picture. [9] Pungileoni, II, pp. 80–1. [10] See Pungileoni, II, pp. 88ff. [11] Extreme confusion regarding the early history of the present picture prevailed among the early writers. Tiraboschi (*Biblioteca Modenese*, VI, 1786, pp. 253ff.) published the 1514 contract and identified the subject of the contract with the picture which was removed in 1638. He published one of the contemporary accounts of the latter and added an extract from a letter of Annibale Molza, the governor of the city for the Este, in which the writer said he could not understand why the populace of Correggio were complaining of the removal of the picture when

they had made no such protest when the last of their native princes, Don Siro, had removed paintings of *St. Bartholomew* and *St. John* from the same altar by the same painter. Finding a copy of the *Holy Family with St. Francis* (now Uffizi) in a chapel at S. Francesco, Tiraboschi then assumed that this copy was after the picture commissioned in 1514-15 and that the *St. Bartholomew* and the *St. John* had flanked it. Tiraboschi added that copies of the latter two pictures had been in the same place but had been removed by his time. He then printed a document of 1613 in which Don Siro had obtained possession of the triptych by Correggio from the Confraternity of S. Maria or Spedale della Misericordia at Correggio representing God the Father, Saints Bartholomew and John. Tiraboschi assumed that this *St. Bartholomew* and this *St. John* were different from the others and completed the confusion by suggesting that the present picture (which he only knew from Mengs' description) had been painted for Carpi. It is clear that Molza was wrong in saying that the *St. Bartholomew* and *St. John* taken by Don Siro had come from S. Francesco (Tiraboschi may have been confused with Montecuccoli's letter, quoted above, which does not specify the church). Tiraboschi also seemed unaware that there had been two Correggio's at S. Francesco. Pungileoni associated the present picture with the 1514 contract and discounted Tiraboschi's Carpi theory (also ridiculing Bottari's attribution – in his edition of Vasari, vol. 2, 1759, p. 62, n.3 – of the present picture to Fra Bartolommeo), but suggested (II, p. 70) that the picture was removed from S. Francesco during the siege of Correggio in 1557. [12] The present picture is described at Modena by, among others, Richardson 1722, p. 343, and d'Argenville, *Abrégé*, vol. 2, 1762 edition, p. 9.

DRESDEN

MADONNA AND CHILD WITH SAINTS SEBASTIAN, GEMINIAN AND ROCHE

Panel, 2·65 × 1·61[1] plates 100 to 103

Four vertical splits in the panel: (1) down the centre of St. Sebastian's body and through the upraised hands of the angel above him (left). (2) To the spectator's left of the Madonna's face and partly including

it (X-rays published in the *Jahrbuch* of the Dresden gallery, 1968/9, page 311, show much damage to the Madonna's face), through the upraised right arm of the putto underneath her, down to St. Sebastian's left knee. Below that it is less obtrusive. (3) Through the Christ child's left shoulder and left thigh, right arm and part of the body of the putto near the Madonna's right foot. (4) Through the neck and left arm of the angel to the spectator's right of the throne.

These splits seem extensively puttied, an inch or more broad in places, and the X-ray photographs show heavy losses of paint in them. The losses are concealed by repaint. But in most other areas the paint seems in quite good state under very yellow varnish. Certainly, all the high-lit portion of St. Geminian's gold cope, centre foreground, is very well preserved. Also his face, for the most part. The paint of his left hand wrinkled a bit. St. Roche's blue shirt also in good state, and the Madonna's red dress. Some cracking and caking of the paint in St. Sebastian's legs.

An undated, but (?) sixteenth-century document (Venturi, *La Galleria Estense*, 1882-3, page 171) describes it as 'scarfuita' ('flayed'). Pungileoni quotes an entry of 1611 from the Spaccini chronicle[2] which mentions a restoration by Hercoli Abba, or Abbato, who in fact was said to have made the damage worse by putting the picture in the sun, as a result of which some of the colours ran. Malvasia[3] mentions a later restoration by Flaminio Torre, and Mengs[4] notes further damage done on the way to Dresden.

The Madonna and the Child are attended by wingless angels and cherubs. Another wingless figure in the foreground offers the city of Modena to St. Geminian, its patron saint.

Identifiable with a picture mentioned by Vasari (1568)[5] as for the 'Compagnia di San Bastiano' in Modena, in whose oratory visited, in 1595, by Cardinal Brenerio.[6] The Compagnia, or Confraternity, of San Sebastiano had been founded in 1501 in thanksgiving for relief from the plague.[7] The inclusion in the present picture of St. Roche,[8] who was invoked against the plague, as well as the patron saint

of the confraternity (Sebastian) and of the city (Geminian) was therefore understandable. Pungileoni associates the picture with a document of 1524,[9] but it is irrelevant, as it applies to the Confraternity of St. Gimignan (Geminian), which was distinct from that of St. Sebastian.[10]

See text, page 97.

PROVENANCE Confraternity of St. Sebastian, Modena, from which appropriated by Duke Francesco I d'Este and taken to the ducal collection at Modena before 1657, when described there by Scannelli[11] and many later writers. Included in the batch of 100 pictures sold by Francesco III d'Este to Augustus III of Saxony, 1745–6,[12] and taken to Dresden where it has remained except for a period in Russia, 1945–55.

COPIES One in the church of S. Sebastiano (otherwise known as S. Maria Pomposa), Modena; attributed to Boulanger. A copy of the Madonna and Child alone at Stockholm, National Museum. A copy of the head and shoulders of the child who offers the city of Modena was in the Pitti (L. Bardi,...Galleria Pitti, vol. 2, 1839, first item).

ENGRAVINGS C. Bertelli (undated, but sixteenth century – plate 104A). Later ones listed by Meyer (page 478).

REFERENCES [1] Measurements from the Dresden catalogue. [2] Pungileoni, II, pp. 193–4. [3] Felsina Pittrice, 1841, vol. 2, p. 384. [4] Opere, 1783 edition, II, p. 166. [5] Vasari/Milanesi, VI, p. 471. He speaks of it as a 'tavoletta' ('small panel') but despite this there can be no doubt regarding the identification. [6] Cronaca Modenese di Gio. Batt. Spaccini..., 1911, pp. 15–16. Correggio's altar in the Confraternity of S. Sebastiano is also mentioned in a MS. of 1584 (Battaglia, no. 794). [7] Francesco Sossaj, Modena Descritta, second edition, 1841, p. 58. [8] Mrs Jameson (Legends of the Madonna, 1890 edition, p. 99) says of this figure 'there would be an impropriety in exhibiting S. Roch sleeping but for the reference to the legend that, while he slept, an angel healed him...'. [9] Pungileoni, II, p. 193. [10] Cronaca... di...Spaccini, passim, but specially pp. 9 and 10. Woermann (Dresden catalogue, several editions) wrongly speaks of the picture as for a chapel in

Modena cathedral. Spaccini's account of Cardinal Brenerio's visit shows that the oratory of St. Sebastian was distinct from the Duomo. [11] Microcosmo..., p. 287. Tiraboschi (Biblioteca Modenese, VI, 1786, p. 276), drawing for his information on Lazzarelli's unpublished manuscript, says that the Confraternity were compensated not only by a copy of the picture by Boulanger, but also by the choir vault's being painted by Colonna and Mitelli. He attributes all this to Duke Alfonso IV (who ruled from 1658) and Pungileoni (I, p. 159) follows him. But Scannelli's evidence shows that it must have occurred under Francesco I. S. Bottari (Correggio, 1961, p. 121) gives 1654 as the date of the removal of the picture. This would agree with the other evidence, but Bottari does not state his source. [12] For details of this transaction and for Modena inventories of the eighteenth century cf. A. Venturi, La Galleria Estense, 1882–3, passim.

DRESDEN

THE NATIVITY (La Notte)

Panel, 2·565 × 1·88[1] plates 107 to 109

Eastlake thought it had 'suffered from time and cleaning' and quoted Wilkie as regarding it as a 'rubbed-out' picture.[2] Nevertheless it is, relatively speaking, remarkably free of repaint for a picture of its size and age. One vertical crack goes through the Madonna's face, another through the face and right leg of the shepherd on the left. The contract for this painting survives (Modena, Archivio di Stato; text page 182). It is dated from Reggio Emilia, 14 October 1522.[3] In it Alberto Pratonero undertakes to pay Antonio Allegri da Correggio 208 lire for a picture which the latter promised to paint, representing the Nativity according to the size and scale indicated on the drawing which he had supplied. The document adds that 40 lire had been handed over that day as part payment. A tablet let into the right hand wall of the small chapel of the Pratonero family in the nave of the church of S. Prospero at Reggio (fifth on the right from the west end) reads as follows:

ALBERTVS . ET GA
BRIEL PRATONIERII
HAEC DE HIERONY
MI PARENTIS OPTI
MI SENTENTIA FIE
RI VOLVERVNT
ANN : M.D.XXX

The arms of the Pratonero family appear on what is evidently the original frame made for the present picture, which is still in the chapel, framing a copy. Venturi says these arms are a modern addition.[4] It is assumed that the date on the wall tablet – 1530 – commemorates the inauguration of the chapel, including the painting, for whose date of completion it would thus be a *terminus ad quem*. The reconstruction of S. Prospero lasted until 1527.[5] This might explain some of the delay in the execution of the painting.

In his second edition (1568) Vasari describes it as follows: 'E in Reggio medesimamente una tavola, drentovi una Natività di Cristo, ove partendosi da quello uno splendore, fa lume a' pastori e intorno alle figure che lo contemplano; e fra molte considerazioni avute in questo suggetto, vi è una femina che volendo fisamente guardare verso Cristo, e per non potere gli occhi mortali sofferire la luce della sua divinità, che con i raggi par che percuota quella figura, si mette la mano dinanzi agli occhi, tanto bene espressa, che è una maraviglia. Evvi un coro di Angeli sopra la capanna che cantano, che son tanto ben fatti, che par che siano piuttosto piovuti dal cielo, che fatti dalla mano d'un pittore.'[6]*

* 'Also in Reggio a panel, with a Nativity of Christ from whom there radiates a glory which illumines the shepherds and the other onlookers; and among many other features there is a woman who wants reverently to look at Christ, but because mortal eyes cannot bear so celestial a light, whose rays seem to shatter her, she puts her hand to her eyes – the whole so well realised that it is a miracle. And there is a choir of angels over the crib, so well done that they seem rather rained from heaven than made by the hand of a painter.'

Ricci derives the subject of the picture from an apocryphal gospel whereby Joseph, on entering the stable, found it lit up with supernatural radiance.[7] Such, indeed, is described in the Book of James, or Protevangelium, and in the Gospel of Pseudo-Matthew.[8] The idea of the Nativity at night with the Christ child as the source of light had been exemplified in various northern pictures, such as the one ascribed to Geertgen in the National Gallery, London.

See text, pages 87 and 103.

PROVENANCE Reggio Emilia, S. Prospero, Pratonero chapel. In 1587 Alfonso II d'Este tried unsuccessfully to profit by the recent death of two members of the Pratonero family to get the picture for himself.[9] In 1640 Duke Francesco I d'Este removed it to the ducal collection at Modena. The records of S. Prospero contain a document stating that this was done at night to the universal dismay of the citizens and that Francesco's action was considered sacrilegious.[10] The picture was noted at Modena by writers from Scannelli onwards. Included in the 100 pictures sold by Francesco III d'Este to Augustus III of Saxony, 1745–6.[11] At Dresden since except for a period in Russia, 1945–55.

DRAWINGS Cambridge, Fitzwilliam Museum, Popham 72 (as in the collection of L. C. G. Clarke) (plate 109B). Pen and ink and wash over red chalk heightened with white. Early design, in reverse. See text, page 104. Two other drawings (British Museum and formerly Weimar – Popham A50 and A127) were long considered autograph studies for the present picture, but have recently been ascribed, with reserve, by Popham to Tibaldi.

COPIES Reggio Emilia, S. Prospero (in the original frame of the original). Strasbourg, Palais des Rohans. Modena, Galleria Estense. Also Christ Church, Oxford. Pungileoni mentions some of the many others.[12] Pastiche by Lelio Orsi, exh. Reggio, 1950 (14 – its drawing was no. 5 in the same exhibition). Miniature copy by T. C. Maron in the Dresden gallery. A copy 0·54 × 0·41, attributed El Greco, was in 1930 chez Contini-Bonacossi.

ENGRAVINGS Of the early ones, one by H. Vincent is dated 1691. Others listed by Meyer.[13]

REFERENCES [1] Measurements from the Dresden catalogues. [2] *Materials for a History of Oil Painting*, II, 1869, pp. 246–7. Wilkie's views are quoted verbatim in A. Cunningham's biography, II, 1843, p. 428. [3] A. Venturi (*Storia...*, IX, 2, p. 466n.) prints the text but most unfortunately misprints the date as 1512 ('MDXII'). A facsimile is given by Battaglia (facing p. 32) and Ricci 1896 (p. 292). Tiraboschi (1786, p. 267) gives notes on the value of the money contracted for, and on page 266 mentions a letter supposed to have been written on the subject of the picture by Correggio to Lelio Orsi. A letter of 1689 (G. Bottari, *Raccolta di Lettere...*, III, 1759, pp. 338–9) mentions another picture, of unspecified subject, said to have been painted by Correggio for Pratonero. [4] A. Venturi in *L'Arte*, II (1899), pp. 114–16. [5] T.C.I. Guide, *Emilia e Romagna*, 1957, p. 256. [6] Vasari/Milanesi, IV, p. 117. [7] Ricci 1896, p. 289. [8] M. R. James, *The Apocryphal New Testament*, 1926 edition, pp. 46 and 74. [9] B. Catelani, *Due quadri del Correggio*, 1862. [10] Pungileoni, II, p. 212, and Ricci 1896, p. 295. The document published by Pungileoni says clearly 'Kal. Maj Anno a Partu Virginis sexcentesimo quadragesimo supra milesimum Tabula Jesu Christi natalia raprentans opus clarissimi Pictoris Antonii a Corigio ab Ecclesia S. Prosperi noctu ablata...'.* Pungileoni suppressed the words 'quod sacrilegium Francisci Ducis nostri iussu perpetratum'† out of consideration for the feelings of the family (Ricci 1896, p. 295, n.1). Venturi is again wrong, therefore, in giving the date of the event as 1642 (*La Galleria Estense*, 1882–3, p. 226). In the mid-seventeenth century hints were dropped that Philip IV of Spain would be graciously pleased to accept the picture as a gift (Justi, *Velazquez, passim*). Burney (1770) says Frederic the Great refused the offer of it. [11] For details of this transaction and for modern inventories see Venturi, *La Galleria Estense, passim*. [12] I, pp. 196ff. [13] pp. 475–6.

* 'Calends of May, A.D. 1640, the panel representing the nativity of Christ by the very famous painter Antonio da Correggio was taken by night from the church of S. Prospero.'

† 'this sacrilege was perpetrated by order of Francesco, our Duke.'

DRESDEN

MADONNA AND CHILD WITH SAINTS JOHN THE BAPTIST, GEMINIAN, PETER MARTYR AND GEORGE

Panel, 2·85 × 1·9[1] colour plate K, plates 163 to 166
Condition exceptionally good. Three narrow vertical splits have hardly disturbed the paint at all. Identifiable with the 'tavola di San Piero martire' which Vasari mentions at Modena (1568) as painted for 'una Compagnia di Secolari'[2] – in reality the Confraternita di S. Pietro Martire, where Spaccini notes the picture as seen by Cardinal Brenerio in 1595.[3] The Confraternity was the oldest of those in Modena, dating from the thirteenth century.[4] St. Geminian was the patron of Modena, S. Pietro Martire of the Confraternity. The reason for the inclusion of the other two saints is less obvious.[5] The small free copy of the present picture now in the York museum is dated 1530, which is thus a *terminus ad quem* for dating the original. Before attention was recently drawn to the York picture Pungileoni's association of the original with a document of 1532 had been thought to indicate its date.[6]

See text page 119.

PROVENANCE Confraternita di S. Pietro Martire, Modena. Appropriated by Francesco I d'Este of Modena in 1649 in exchange for a replacement to be specially painted by Guercino, containing the same saints, but arranged differently and in a larger format.[7] This did not reach the Confraternity until 1668[8] and is now in the Louvre (fig. 38). Correggio's original remained at Modena in the ducal collection until 1745–6, when it was included in the batch of 100 pictures sold by Francesco III d'Este to Augustus III of Saxony.[9] It has remained at Dresden since except for a period in Russia, 1945–55.

DRAWINGS 1. Dresden, Popham 73 (plate 166A). Pen and ink and wash heightened with white. Study for the entire composition in relation to its frame. It omits the children in the foreground and the one

who in the painting helps St. Geminian to support the model of the city of Modena. Consonant with this, the Christ child in the drawing is not stretching his right arm to St. Geminian but appears to be looking in the opposite direction. There are also differences in the decorative sculpture round the arch, and in the attitude of St. John the Baptist. The indications on the drawing for the frame show a series of forms as though suspended by cords outside the right hand pillar. Similar features figure in the original frame for the *Notte* (still in S. Prospero at Reggio Emilia). Whether Correggio envisaged a carved frame of the same kind for the present picture or, conceivably as Ratti,[10] and, following him, others, have supposed, a painted one in *trompe-l'œil* grisaille, could not be decided.

2. British Museum, Popham 74 (plate 166B). Pen and ink and wash. Study for the arch behind the Madonna (the verso has unconnected drawings, perhaps not by Correggio).

COPIES York, Museum. Panel, 0·508 × 0·323 (plate 166D). Inscribed on the step on which the Baptist's left foot rests: ANTONIVS COREGI.S / .INTOR. The step at the base of the picture inscribed: HIERONYMVS COMIVS MVTINENSIS PINGEBAT. Base of left pillar inscribed: MD. Base of right pillar inscribed: XXX. Outside the painted area is a narrow band of dark paint, perhaps renewed. The right hand X of the date comes close against this. Outside this band the original panel continues, uncut. It is therefore virtually impossible that there was another figure after the last X. The fanciful architecture and other invented details suggest that this painting was made from incomplete sketches of the original. Mantua, S. Barnaba (right wall, in organ loft).

According to documents examined by Pungileoni[11] the members of the Confraternity imposed a ban on further copies of the picture at the end of the sixteenth century. A small scale copy is no. 36 (page 8) in the catalogue of 1839 of the Youssoupoff collection, St. Petersburg. A pastiche by Bartolommeo Passarotti is in S. Giacomo Maggiore, Bologna (fig. 50).

ENGRAVINGS Undated (but sixteenth-century) engraving by C. Bertelli (plate 166C). Etching by G. M. Giovannini, 1696. Other prints listed by Meyer (page 479).

REFERENCES [1] Measurements from Dresden catalogues. [2] Vasari/Milanesi, VI, p. 471. [3] *Cronaca Modenese di Gio. Batt. Spaccini...*, 1911, p. 16. Spaccini gives the painter's surname incorrectly as 'Lucente' instead of Allegri. Mrs Jameson (*Legends of the Madonna*, 1890 edition, pp. 100–1) advances the theory that the picture was painted on the occasion of the flooding of the river Secchia. She gives no evidence for this assertion, and her succeeding one – that the picture was for the Dominican church of St. John – is wrong. Correggio's altar in the Confraternity of S. Pietro Martire is also noted in a MS. of 1584 (Battaglia 794). [4] Girolamo Tiraboschi, *Notizie della Confraternita di S. Pietro Martire in Modena*, 1789, *passim*. [5] Tiraboschi (*Notizie...*, 1789, pp. 41–2) is surprised by the presence of St. George but says that the records of the Confraternity had perished. [6] Pungileoni, II, p. 234. (7) Tiraboschi, *Notizie...*, 1789, p. 42. (8) Tiraboschi, loc. cit. [9] For details cf. A. Venturi, *La Galleria Estense*, 1882–3, *passim*. [10] C. G. Ratti, *Notizie...del... Correggio*, 1781, p. 94. [11] II, p. 235.

DRESDEN (formerly)

for *St. Mary Magdalene Reading* (plate 97C) see Catalogue B, page 279.

FIRLE PLACE (Lewes, Sussex)
Viscount Gage

THE VEIL OF ST. VERONICA

Panel, 0·285 × 0·228 plate 172A

Paint generally in good condition.

Unrecorded in recent Correggio literature. Waagen wrongly assumed it was unfinished.[1] He had not noticed the fringe at the bottom right corner, showing that the image of Christ's head crowned with thorns is imagined as impressed on a piece of cloth.

Obviously related to the National Gallery *Ecce Homo*, the alterations revealed in the latter by the X-rays indicating that the present picture is likely to have followed it rather than to have preceded it. The light is from the left in both cases, and there are certain other similarities – e.g. the sawn-off twig in the crown of thorns, which is on the spectator's right in the National Gallery picture and the spectator's left in the present one. Also, the curling strands at the base of Christ's hair – on the spectator's left in the National Gallery picture and on the spectator's right in the present one. In both pictures, finally, Christ's drapery is wine red. The present picture is much more thinly painted than the National Gallery one. I think it probably autograph and dating from Correggio's last years.

See text, page 123.

PROVENANCE Prince de Talleyrand (on the authority of Waagen (loc. cit.) alone), from whom purchased by Earl Cowper. Exhibited Royal Academy 1881 (140), lent Earl Cowper. Hence by descent (Lady Desborough and Viscountess Gage) to the present owner.

REFERENCE [1] Waagen, *Galleries and Cabinets of Art in Great Britain*, 1857, p. 345.

FLORENCE Uffizi

HOLY FAMILY WITH ST. FRANCIS

Canvas, 1·235 × 1·065. Probably cut down all round. In 1649 its dimensions were given as $2\frac{1}{2} \times 2\frac{1}{3}$ braccia = 1·462 × 1·364[1] plate 89

Excellent condition.

St. Joseph's action in pulling down dates for the Christ child suggests that, like the *Madonna della Scodella* at Parma (q.v.), the subject is perhaps taken from the apocryphal gospel of Pseudo-Matthew, regarding the sojourn of the holy family in Egypt. The gratuitous presence of St. Francis would be partly explicable by the fact that the picture came from the church of S. Francesco (at Correggio). In addition, the patron's christian name may have been Francesco. Pungileoni[2] states that the picture had hung in the chapel of the Munari family in S. Francesco, and thinks that the patron was Francesco Munari. He quotes from two wills of the latter. In the first, dated 6 October 1508, Francesco Munari says he wishes to be buried in the chapel of the Conception (at S. Francesco – the chapel, Pungileoni adds, where the picture hung for over a century). In his second will, of 1520, Francesco Munari bequeathed twenty-five gold ducats for 'massaritiis et adornamentis dictae cappellae' ('furnishing and adornment of the said chapel'). Though this wording is not specific the fact that the Madonna in the present picture is almost the twin of the *Diana* of the Camera di S. Paolo, which is datable probably not before 1519, suggests that the present picture may have been painted in consequence of Francesco Munari's will of 1520, and therefore that it dates from that year, or (on stylistic grounds), from the minimum time afterwards.[3]

See text, page 86.

PROVENANCE Chapel of the Conception, S. Francesco at Correggio. Forcibly replaced by a copy by order of Francesco I d'Este of Modena in 1638.[4] Sent from Modena to Florence, November 1649, as part of an exchange between the Este and the Medici.[5]

In the eighteenth century – until 1788 – attributed to Baroccio.[6] Eastlake[7] and Meyer[8] as a copy. Exhibited Paris, Petit Palais, 1935 (116).

COPY Lisbon (without St. Francis). The copy which replaced the original at Correggio does not seem to be there now.

REFERENCES [1] C. A. Lumini, *Rivista d'Arte*, VI, 1909, pp. 255ff., and G. Poggi in same journal, VIII, 1912, pp. 45–51. Also a short article '"Il Sacrifizio d'Abramo" cambiato con un quadro del Correggio' in *Il Marzocco*, 1930 (article signed 'B.B' which J. Shearman, *Andrea del Sarto*, II, 1965, pp. 280 and 405, identifies with Bernard Berenson, though it does not figure in the latter's bibliography). This article quotes another document of 1649 giving the dimensions as 'alto circa due braccia et largo uno e mezzo incirca' ('about two braccia high and about one and a half wide'). [2] Pungileoni, I, p. 46 and II, p. 74. [3] Ricci (1896) has '1515–18', Gronau 'um 1515'. [4] Tiraboschi, 1786, *Biblioteca Modenese*, vol. VI, pp. 253 ff. for documentary evidence. Tiraboschi's subsequent comment is doubly confused by equating the present picture with the subject of the 1514 contract (in reality the *Madonna with St. Francis* now at Dresden) and by assuming that the Saints Bartholomew and John the Baptist flanked the present picture. Luzio (*La Galleria dei Gonzaga...*, 1913, p. 112) records an earlier attempt by Vincenzo I Gonzaga in 1598 to remove this or the Dresden *Madonna with St. Francis*. [5] Lumini and Poggi, loc. cit. Perhaps the picture mentioned by Scannelli (1657, p. 284) and by Barri (1671, p. 95) as in the Grand Ducal collection at Florence. [6] Lumini, loc. cit. Attributions are also recorded to Vanni (Lanzi, 1822 edition, IV, p. 63) and to Tiarini (Meyer, 1871, p. 99). [7] *Materials for a History of Oil Painting*, II, 1869, p. 232. [8] Meyer, 1871, pp. 318 and 392.

FLORENCE Uffizi

THE MADONNA ADORING THE CHILD

plate 99

Canvas, 0·82 × 0·685 (In certain old photographs the composition is reduced to an upright oval format)

Very well preserved under very yellow varnish (1969). Richardson (1722) said of it that it was then 'preserved, as when 'twas first done'.[1]

Together with the Budapest *Madonna del Latte* the present picture is the only major work dating from Correggio's maturity about whose origin, and whose ownership within the sixteenth century, nothing is known. In theory, therefore, either could be identical with the picture of unspecified subject which Vasari says was in Reggio and was then taken to Genoa by Luciano Pallavigino.[2] Mengs, who did not admire the present picture, noted that it was 'del medesimo stile' ('in the same style') as the Prado *Noli me Tangere*.[3] This comparison was repeated by Bencivenni (1779)[4] and some later writers.

See text, page 92.

PROVENANCE Bencivenni stated that he had found a note in a Medici inventory giving the year 1617 as that of the picture's arrival in Florence. The *Reale Galleria di Firenze illustrata* (1817) states that it was a gift of the Duke of Mantua to Cosimo II de' Medici.[5] Exhibited Parma, 1935 (38).

COPIES Pungileoni mentions various copies and a miniature by Giambattista Stefaneschi.[6] Meyer (page 326) mentions an old copy formerly in Vienna.

ENGRAVINGS Meyer notes a number, including eighteenth-century prints by G. Audran and F. Gregori.

REFERENCES [1] Richardson 1722, p. 58. [2] Vasari/Milanesi, IV, p. 116. [3] Mengs, II, 1783 edition, pp. 173 and 179. [4] *Saggio Istorico della Real Galleria di Firenze*, II, p. 162. [5] Serie I, vol. I, pp. 9–16. Milanesi (Vasari/Milanesi, IV, p. 118), by a slip, gave the donor as the Duke of Modena. Ricci corrected this (Ricci 1930, p. 168). F. Rossi (*The Uffizi and Pitti*, London, 1966, p. 204) gives the date as 6 November 1617. [6] Pungileoni, II, pp. 148–9. In vol. I, pp. 110–11 he claims that Lelio Orsi took the present picture as model for his *Madonna della Ghiaja*.

FLORENCE Uffizi HAMPTON COURT

MADONNA AND CHILD WITH MUSIC- MADONNA AND CHILD WITH ST. JOSEPH
MAKING ANGELS AND ANOTHER MALE SAINT

Panel, 0·20 × 0·165 plate 18c Panel, 0·68 × 0·56 plate 91b
Very good condition. A good deal of local damage and retouching as a
 result of flaking, but general condition acceptable.
 On the back is a brand mark, D G or E G (letters The top of the head of the saint on the left was once
perhaps back to back), surmounted by a crown. In lower. Cleaned, 1949.
the Uffizi catalogues of 1851, 1855 and 1871 as The saint on the left has no attribute. With the
Titian. First attributed to Correggio by Morelli,[1] forefinger of his left hand he points to the right hand
who noted that it had once been called Ferrarese side of his chest, as though indicating a wound. He is
school. The Correggio attribution endorsed by sometimes called St. James and sometimes St. Jerome.
Richter (1879)[2] and generally followed since.[3] The similar saint in Parmigianino's picture in the
 See text, page 43. Uffizi is identified as St. Zachariah in a reliable docu-
 ment. But the absence of the Giovannino in the
PROVENANCE According to Ricci (1930) trans- present picture would be evidence against this.
ferred in 1797 from the Grand Ducal *Guardaroba* to Included by Morelli in his attributions to the young
the Uffizi. Exhibited Parma, 1935 (26). Correggio (1893).[1]
 See text, page 84.
REFERENCES [1] *Die Galerie Borghese* in *Zeitschrift
für bildende Kunst*, 1875. Elaborated in 'Munich and PROVENANCE The mark of Charles I on the back
Dresden', 1880. [2] *Antonio Allegri genannt Correggio*. proves provenance from that collection but not
[3] E. Menegazzo, *Italia Medioevale e Umanistica*, II identifiable in Van der Doort's inventory (*c.* 1639) or
(1959), pp. 383–4 and III (1960), p. 330, tries, in the 1627 Mantua inventory.[2] Probably the 'Mary,
fantastically, to associate the present picture with the Christ and Jerome' by Correggio in the Common-
contract, which he was the first to publish, for the wealth sale, 3 November 1649, where bought by
organ doors and podium at S. Benedetto Po (1514). Proctor.[3] Back in the English royal collection at the
 time of the Charles II MS. inventory (no. 305).
 James II inventory no. 682.[4] Exhibited Royal
 Academy, 1946–7 (246).

FRANKFURT Städelsches Kunstinstitut REFERENCES [1] 'Munich and Dresden', 1893,
for *Madonna and Child with Giovannino* (*Madonna of* p. 152. [2] Luzio (*La Galleria dei Gonzaga venduta in
Casalmaggiore) (plate 90a) see Catalogue B, page 279. Inghilterra*, 1913, p. 112) tries unconvincingly to
 identify it with a picture at Luzzara. See entry for the
 Detroit *Marriage of St. Catherine*. [3] Information
 from Oliver Millar. [4] In the Hampton Court cata-
 logue (by E. Law), 1881, as 'Correggio?'. Battaglia
 (309, p. 98) includes it among Morelli's attributions
 in 1880, but I cannot find it in that edition.

LENINGRAD Hermitage

PORTRAIT OF A LADY

1·03 × 0·875¹ plate 26B

Inscribed: ANTON...LÆT on the tree trunk. The bowl held by the sitter inscribed: ——ON NHΠEN-ΘEΣ AX—— This is identified as a partial quotation from the Odyssey:

αὐτίκ' ἄρ' εἰς οἶνον βάλε φάρμακον, ἔνθεν ἔπινον,
νηπενθές τ' ἄχολόν τε, κακῶν ἐπίληθον ἁπάντων.

(*Odyssey* 4, 220–1. Helen mixes an opiate which relieves pain, removes anger and results in oblivion).²

If the inscription on the tree trunk is genuine it would be the only Correggio signature on a painting, with the exception of the Dresden *Madonna with St. Francis* (whose signature has been questioned) and the Brera copy of the *Albinea Madonna* (see page 278). The inscription on the bowl seems intended to label the contents – nepenthe, a drug used as an antidote to grief.

R. Longhi claimed that what is suspended from the gold chain at the sitter's neck is a scapular, and identified the girdle, part of which is visible on her knee, as that of a Franciscan tertiary. He went on to identify the sitter as Veronica Gambara, soon after the death of her husband in August 1518, and saw in the laurels an allusion to her reputation as poet.³ R. Finzi pointed out that Veronica Gambara was not a Franciscan tertiary (as well as not being beautiful). He identified the sitter instead with Ginevra Rangone, who was a Franciscan tertiary and had married Giangaleazzo da Correggio. She was widowed in 1517 and remarried in 1519. He proposed dating the picture between those years.⁴

Though this identification has found some support⁵ it cannot be regarded as certain. Stella Mary Newton points out that either a widow or a Franciscan tertiary would normally be depicted veiled and less décolletée. She also indicates that while the head-dress and bodice as shown would be in line with fashion around the years 1518–22, the sleeves are of an earlier fashion, c. 1508–12 (as seen, for instance, in Titian's frescoes in the Scuola del Santo at Padua of 1511).⁶ Judging by photographs the present writer agrees with Longhi in regarding the style of the picture as in accord with works of Correggio datable immediately before 1520. The apparent anachronisms in the dress and its religious significance, if any, he cannot elucidate, nor, in consequence, the identity of the sitter.⁷

As Correggio in the 1839 Youssoupoff catalogue. As Lotto (attribution by Alexandre Benois) in the 1909 St. Petersburg exhibition⁸ and published as such by A. Venturi (1929)⁹. As Lotto in the 1958 Hermitage catalogue. Published as Correggio by Longhi (1958).¹⁰

See text, page 58.

PROVENANCE Youssoupoff collection by 1839 (no. 103 in the catalogue – 'Allegri...Portrait d'une Femme'). Exhibited St. Petersburg, 1909. In the Hermitage post-First War.

REFERENCES [1] Measurements from the Hermitage catalogue (1958). I have only seen this picture in indifferent lighting conditions, but even then it was clear that it is much worn and retouched and with the grain of the canvas very evident. [2] Detail photograph of inscription published by R. Longhi in *Paragone*, May 1958, pl. 21. [3] Longhi, loc. cit. [4] R. Finzi, 'Il Ritratto di Gentildonna del Correggio all'Ermitage (*sic*) di Leningrado' in *Nuove Lettere Emiliane*, 1962. [5] E.g. J. Pope-Hennessy, *The Portrait in the Renaissance*, 1966, pp. 218–20. [6] Private communication from Stella Mary Newton. [7] The ivy on the left would accord with the idea of mourning but happens also to be characteristic of Correggio at this time on its own account – cf., for example, the Brera *Adoration* or the National Gallery *Magdalen*. [8] E. de Liphart, commenting on the exhibition in a commemorative volume (*Les Anciennes Ecoles de Peinture dans les Palais et Collections Privées Russes*), published by Van Oest, Brussels, 1910. [9] *Storia...*, IX, 4, pp. 46–7. [10] Loc. cit.

LONDON Apsley House: Wellington
 Museum

THE AGONY IN THE GARDEN

Panel, 0·37 × 0·40 colour plate F, plate 96

The paint has wrinkled in places. The restoration of 1950 revealed that the figures of the sleeping apostles and, in the distance, of Judas and the soldiers, which appeared on the right of the picture up to that time were later repaint. This was then removed revealing the somewhat different apostles as now visible.[1] Evidently the picture had been damaged. Sebastiano Resta (died 1714), in an undated letter, speaks of damage from a lamp which stood in front of the picture,[2] and the back of the panel suggests that it has been cut (on the right of the painted surface). If, as is likely, Bernardino Curti's print (see below) is after the present picture and not after a copy, the damage would have occurred before 1640, as that is the date on the engraving, and it shows the right-hand side as it was before 1950.

Vasari (1568) has the following passage:

'È nella medesima città [Reggio Emilia] un quadretto di grandezza di un piede; la più rara e bella cosa che si possa vedere di suo, di figure piccole; nel quale è un Cristo nell'orto: pittura finta di notte, dove l'Angelo, apparendogli, col lume del suo splendore fa lume a Cristo; che è tanto simile al vero, che non si può nè immaginare nè esprimere meglio. Giuso a piè del monte, in un piano, si veggono tre Apostoli che dormano; sopra' quali fa ombra il monte, dove Cristo ôra, che dà una forza a quelle figure, che non è possibile; e più là in un paese lontano, finto l'apparire dell'aurora, e si veggono venire dall'un de' lati alcuni soldati con Giuda: e nella sua piccolezza questa istoria è tanto bene intesa, che non si può nè di pazienza nè di studio per tanta opera paragonalla.'[3]*

* 'And in the same city [Reggio Emilia] a small picture about a foot in size; the rarest and most beautiful of his productions, with small figures; in which is a Christ in the Garden, a picture with an effect of night, where the angel, appearing to him,

The mention of the small size, of the nocturnal illumination and of the extreme excellence of the picture leaves little or no doubt that it was the present one. Though Vasari does not specify the owner, his mention that it was in Reggio connects it to that extent with a letter of 1584 in which it is stated that an *Agony in the Garden* by Correggio, which Pompeo Leoni had wished to buy for the king of Spain but desisted on account of the price, belonged to one F. M. Signoretti of Reggio,[4] while the fact that the latter was a member of the College of Medicine is a tenuous link with Lomazzo's story (1590) that Correggio's *Agony in the Garden*, painted for an apothecary (*spetiale*) had recently been sold to Count Pirro Visconti (of Milan).[5] The present picture can be traced back with certainty to Visconti possession in the seventeenth century.

It would be possible that Judas and the soldiers, mentioned by Vasari but not apparent since the 1950 restoration, were in the strip which would have been cut off on the right.

See text, page 91.

PROVENANCE Probably Signoretti (Reggio). Sold before 1590 to Pirro Visconti (Milan), and by another member of the family of the same name, shortly before 1657, to the Marchese di Caracena, governor of Milan.[6] Resta[7] and Mengs[8] report that the latter was acting on behalf of the king of Spain, Philip IV. Probably the 'Otra de media vara de alto en quadro pintado en tabla la adoracion del Huerto de mano del Corezo'† which figures in the inven-

illumines Christ with his splendour – the whole thing so true to life that it is impossible to imagine or express it better. Down at the foot of the mount, in a hollow, we see the sleeping apostles, on whom the shadow of the mount falls where Christ prays, and this gives unheard of force to the figures. And farther on, in the distant landscape, the dawn is breaking, and we see soldiers coming in from the side with Judas; and within its limited dimensions this scene is so well realised that it would be impossible to equal the patience and application displayed.'

† 'Another panel half a *vara* high, the Agony in the Garden by Correggio.'

tories of 1666 (no. 640), 1686 (no. 190) and 1700 (no. 41) of the Alcázar in Madrid,[9] where (in the new palace) noted by Mengs.[10] Still in the Madrid palace in the MS. inventories of 1772 and 1789.[11] Captured after the Battle of Vitoria, 1813, on behalf of the first Duke of Wellington, whose ownership confirmed by Ferdinand VII, 1816.[12] In the possession of the Dukes of Wellington (by whom lent to exhibitions: British Institution 1854 (12), Royal Academy 1887 (131) and Royal Academy 1930 (183)) until 1947 when included in the Apsley House gift to the British nation by the seventh Duke.

DRAWING British Museum. Popham 79r (plate 96B). Red chalk. Study for Christ. Verso has a study of Cupid for the *School of Love* (London).

COPIES London, National Gallery (76), acquired as autograph and almost identical with the original as it was before the restoration of 1950. The Commemorative Catalogue of the 1930 Royal Academy exhibition mentions another copy in the possession of the Marquess of Normanby. Another (Christ and the Angel only) said to have been in the Hermitage, St. Petersburg.[13]

ENGRAVINGS By Bernardino Curti 1640,[14] Giovanni Volpato, 1773, and V. Antonelli, 1775 (plate 96C). The upright copy (Christ and the Angel only) later said by Meyer to be in the Hermitage engraved by P. E. Moitte as in the possession of Count Brühl.

REFERENCES [1] See the present writer, *Burlington Magazine*, 92, 1950, pp. 136ff. [2] Letter printed by G. Bottari, *Raccolta di Lettere*, III, 1759, pp. 327–30. [3] Vasari, IV, pp. 117–18. [4] A. Venturi, *Della provenienza di due quadri del Correggio*, Arte e Storia, III, 1884, pp. 26–7. [5] *Idea del Tempio della Pittura*, p. 115. Lomazzo tells the story in the context of an improbable account of Correggio's views on the value of his work. [6] Scannelli, *Microcosmo della Pittura*, 1657, p. 81. [7] Loc. cit. [8] *Opere*, 1787 edition, p. 189. He goes on to deny the story – evidently Resta's – of the damage. [9] Y. Bottineau, 'L'Alcázar de Madrid et l'Inventaire de 1686' in *Bulletin Hispanique*, avril–juin 1958, no. 2, pp. 146–7. The author there identifies the entries with a copy of the *Noli me Tangere*, which is improbable, both on account of the high valuation and because the following item in the inventories is the *Madonna of the Basket*, now in the National Gallery, London, which Mengs describes as in the Madrid palace immediately after a description of what is certainly the present picture. [10] Loc. cit. and p. 313. [11] Apsley House catalogue by Evelyn, Duchess of Wellington, vol. I, 1901, p. 163. [12] Evelyn, Duchess of Wellington, op. cit., pp. xiv–xv. [13] Meyer, 1871, p. 486. [14] With a dedication to Ippolito d'Este, evidently the one who, according to Litta (Este, tav. XV) was Commendatore di Reggio and died in 1647.

LONDON National Gallery

MERCURY INSTRUCTING CUPID BEFORE VENUS (*The School of Love*)

Canvas, 1·55 × 0·915 colour plate D, plates 173 to 176
Evidently cut down, probably on all four sides and at a relatively early date since the measurements given in the 1639 catalogue of Charles I's collection are almost identical with the picture's present dimensions.[1] Cleaned 1969–70.

Condition very unequal. The best-preserved passage in the figures is Cupid's head, wings and part of his chest, which are in fair state. Most of the upper part of Mercury's body (including his head) is somewhat rubbed and repainted and there are numerous worn and retouched areas elsewhere, particularly in the shadows of the flesh. Among other areas of repaint and damage is one to the left of Venus' right foot where in Peter Oliver's miniature copy, the Massias copy, De Jode's engraving and Jan de Bisschop's drawing (see below) a quiver and arrows emerge from behind Venus' leg. During the restoration of 1969–70 parts of the quiver and arrows were uncovered. *Pentimenti* in Venus' right ankle and left foot. Mercury's blue drapery appears at an earlier stage to have extended across (and not, as now, under) his left fore-arm, and (judging from X-ray photographs) to have covered the upper part of his left thigh. It also swept downwards from under his right eye, covering his right shoulder. In addition,

the X-ray photographs show that his face was originally painted almost full face. X-rays also reveal earlier positions of Venus' and Mercury's faces and a different arrangement of Cupid's legs.

The title *School of Love* dates at least from the eighteenth century. Correggio's so-called *Antiope* (*Venus*, Louvre) was in the same collection, namely the Gonzaga, as early as 1627,[2] while earlier still, in 1607, two pictures seeming to answer to the descriptions of these, but perhaps old copies (see PROVENANCE below) were recorded in the Granvella collection.[3] Even at this date the dimensions of the 'Vénus dormante avec un Cupido et un Satyre' (i.e. the *Antiope*) are given as somewhat larger than those of the 'Vénus avec Mercure', as is the case with the Louvre picture and the present one.[4] Despite this, and despite the fact that the Louvre picture seems to reflect a more evolved phase of Correggio's art than does the present one, the association of the two designs from so early a period suggests that they may originally have been intended as pendants, and with this the two subjects would accord well.

Analogies have recently been indicated with a bronze relief of the education of Eros and Anteros and with a description of reliefs flanking a door described in the *Hypnerotomachia Poliphili*, first published in 1499. Neither work corresponds with Correggio's picture in every detail, but both are close enough to show that all three probably derive from the same source. Whatever may be the precise theme in either case, some version of the contrast between sensual love (the Louvre picture) and a more sublimated form of love (the present picture) would emerge clearly from such a juxtaposition. In Van der Doort's inventory of Charles I's collection copies of the two pictures are already referred to as *Venerie Mundano* and *Venerie Coeleste*.[5]

The existence of a study for the Christ in the *Agony in the Garden* (Apsley House) on the verso of a sketch for the Cupid in *The School of Love* (see DRAWINGS below) would normally indicate a similar date of origin for the two paintings. This date is likely to be around the end of the time when Correggio

was decorating S. Giovanni Evangelista, where he worked from 1520 to the beginning of 1524. A drawing in the British Museum for one of the S. Giovanni pendentives (Popham 18) has, on the verso (plate 178C), a sketch associable with the Anteros theme, one aspect of which is probably illustrated in this picture (see Verheyen, quoted in reference 5 above).

See text, page 125.

PROVENANCE Recorded in the inventory of 1627 of the Gonzaga collection at Mantua.[6] Though it cannot be proved that it was not identical with one of the two pictures already mentioned as in the 1607 Granvella inventory it seems more likely that it was not and that the latter were copies for the following reasons. The present picture is undoubtedly an original by Correggio, it was at Mantua in 1627 and Correggio seems to have worked for the Mantuan court during his lifetime. It is therefore more reasonable to assume that it was painted for Mantua and that it stayed there than that it was painted for someone else and reached Mantua between 1607 and 1627. Equally difficult would be the hypothesis that, though painted for Mantua, it got into the Granvella collection at some time later in the sixteenth century and then came back to Mantua between 1607 and 1627. Purchased for Charles I in 1628 and recorded at Whitehall in van der Doort's inventory of 1639.[7] Valued at £800 in the Commonwealth inventory of 1649 and sold for that sum, 23 October 1651, to 'Mr Baggley'.[8] Recorded by Richard Symonds in 1651–2 in the hands of 'the King's Glassier' who was offering it for sale.[9] Purchased, 1653–4, by the Spanish ambassador in London, Alonso de Cárdenas, acting on behalf of the Conde-Duque de Olivares.[10] When, in 1688, the daughter of Olivares' heir, Caspar, married the 10th Duke of Alba she brought to that house the Carpio and Olivares titles and estates, including *The School of Love* which was seen in the possession of the Duke of Alba by Mengs, *c.* 1770, and by Swinburne (book published in 1779).[11] During the litigation between the heirs of the Duchess of Alba, who died in 1802, and the 7th Duke of Berwick and Liria (who

SURVIVING PICTURES (London)

215

then inherited the Alba estates and titles) the picture was sold by order of Charles IV of Spain to his favourite, Emanuel Godoy, 'Prince of the Peace'.[12] It figures in the MS. inventory (dated 1 January 1808) of the latter's collection. After Godoy's arrest in March 1808 his collection was put up for sale in the same year, but on the morning of the day appointed Joachim Murat, then military commandant of Madrid, secured for himself some of the finest pictures including the present picture which he afterwards took with him to Naples.[13] Taken from Naples, apparently on the night of 20 May 1815,[14] to Vienna by Caroline Murat who sold it there, with the *Ecce Homo*, to Baron Stewart, later 3rd Marquess of Londonderry,[15] from whom both were purchased, 1834.

DRAWINGS British Museum (1862-10-11-200) (plate 175D) (Popham, op. cit., no. 79v). Study in red chalk for the Cupid. Another drawing in the British Museum (1900-8-24-119) (Popham, op. cit., no. A71) is a copy from the Cupid in the painting. There is also a drawing in the Uffizi (reproduced Ricci, 1930, pl. CCXLVIb), showing Mercury's head in its present position and, apparently, also his drapery as it now appears. This is also probably a copy from the painting (Popham, op. cit., no. A26 as 'perhaps by Girolamo da Carpi'). There is a wash-drawing copy of the present picture by Jan de Bisschop (Ashmolean, Oxford, no. 111*) (plate 175B) which may have been made from a copy or from de Jode's engraving.

COPIES The most famous copy passed successively through the Queen Christina, Odescalchi, Orléans, Willett and Erard collections and was apparently lot 18 in the Comte de Franqueville sale, Paris, 31 May–2 June 1920. It was engraved by Villain, 1786. What claimed to be it was included in the Queen Christina exhibition, Stockholm, 1966, no. 1168, lent by the duc d'Ursel. Also in the Queen Christina and Orléans collections was a variant of *The School of Love*, attributed to Titian (engraved in the *Galerie du Palais Royal*, vol. 2, no. 11 of Titian),

later with A. L. Nicholson, London (reproduced by Suida, *Tiziano*, 1933, pl. CXIX) and now Kress collection, El Paso, Texas. Another was at Sans Souci, Potsdam (no. 26, larger than the present picture – 1·75 × 1·17). Others were a version formerly in the collection of Baron Massias, Paris[16] and at Ham House and Chenonceaux. Miniature copies at Windsor (signed by Peter Oliver and dated 1634) (plate 175C), at Burghley House and at Sibiu (larger than the present picture). A copy of Cupid alone was no. 1098 in the 1900 edition of the catalogue of the Aeltere Pinakothek, Munich. Various other copies, of uncertain date, could be listed.

ENGRAVING By Arnold de Jode, dated 1667, 'Londini'.[17] (plate 175A).

REFERENCES [1] The dimensions are omitted by Vertue but are specified as 5′ 1″ × 3′ 0″ in the van der Doort MS. (Ashmole 1514). [2] See PROVENANCE and reference no. 8. [3] Auguste Castan, 'Monographie du Palais Granvelle à Besançon' in *Mémoires de la Société d'Emulation du Doubs*, IV series, second vol., 1866, published 1867, p. 126 (à propos the Granvella inventory of 1607): 'Une Vénus dormante avec un Cupido et un Satyre, faitz du Correggio, 6 piedz d'haulteur et quattre de largeur'*...no. 155, and on the same page 'Une Vénus avec Mercure, du Correggio, d'haulteur de 5 piedz et neufz polces, large de 3 piedz 9 polces, fait sur toille'...† no. 156. [4] The truncation of Mercury's left knee in the present picture suggests, irrespective of other considerations, that it has been cut down on the right. Peter Oliver's miniature copy (see COPIES above) in fact shows this area untruncated and is dated 1634. However, as already stated, the present picture was already its present size as early as 1639 and Charles I, who had owned it since 1628, is most unlikely to have permitted it to be cut. As the dimensions of the Granvella picture of 1607 were also smaller than those of the *Antiope* (Louvre) it seems at least possible, whatever the status of the Granvella pictures, that the truncation of the present picture had occurred before

* 'A sleeping Venus, with Cupid and a Satyr, by Correggio, six feet high and four wide...'
† 'Venus with Mercury, by Correggio, five feet, nine *pouces* high and three feet, nine *pouces* wide, canvas...'

Peter Oliver made his copy and that in it he was merely indulging in copyists' licence. [5] See Myron Laskin, *Art Bulletin*, 1965, pp. 543–4. Panofsky, in a letter in the Gallery archives, draws particular attention to the fact that in *The School of Love* Venus is shown winged. This is highly unusual in Italy though not uncommon in the north (Heinrich Kohlhaussen (*Minnekästchen im Mittelalter*, 1928, p. 41) cites various fifteenth century northern representations of winged Venuses in the sense of *Frau Minne*). According to Ficino the *Venus Urania* even corresponds with Christian *Caritas*. For the subject, see also L. Soth (*Art Bulletin*, 1964, pp. 539ff., and 1965, p. 544), E. Verheyen (*Gazette des Beaux-Arts*, sixth period, 1965, vol. 65, pp. 321ff. and *Art Bulletin*, 1965, pp. 542–3) and the present writer (*Burlington Magazine*, 1964, p. 420). Verheyen postulates a connection with a sculpture of Mercury teaching Cupid to read, which is recorded in Isabella d'Este's possession, but of which nothing else is known. [6] Printed by Carlo d'Arco, *Delle Arti...di Mantova...*, 1857, vol. II, p. 154, and by Alessandro Luzio, *La Galleria dei Gonzaga venduta all'Inghilterra nel 1627–28*, 1913, p. 92. [7] The substance of van der Doort's entry is given by Vertue, *A Catalogue and Description of King Charles the First's Capital Collection...*, printed for W. Bathoe, 1757, pp. 106–7. See also O. Millar's edition (*Walpole Society*, 1960). The present picture is also noted at Whitehall by Sandrart, *Lebenslauf und Werke Joachims von Sandrart*, ed. A. R. Peltzer, 1925, p. 24. [8] Public Record Office L.R. 2, 124f., 194, no. 20 and British Museum, Harley 4898, p. 282. [9] Symonds' diary, British Museum, Egerton MSS., no. 1636. [10] H. Léonardon, *Une Dépêche Diplomatique relative à des Tableaux acquis en Angleterre pour Philippe IV* in *Bulletin Hispanique*, 1900, pp. 25–34, also the Duchess of Alba, *Documentos escogidos del Archivo de la casa Alba*, Madrid, 1891. From these works it emerges that Olivares intended to present the picture to Philip IV but kept it for himself when doubts regarding its authenticity were expressed by Velázquez and by Angelo Nardi. [11] Henry Swinburne, *Travels through Spain*, 1779, p. 353. There is also the following contemporary reference in an anonymous and unpublished diary, in 1949 in the possession of Mr John Hanbury Martin: 'Madrid, 1st May 1772...went...to see the Duke of Alba's a fine & elegantly furnished House there is either an Original or Copy of the famous picture of Mercury teaching Cupid to read.' The author of the diary may have been John Skipp (1742–1811). Also A. Conca, *Descrizione odeporica della Spagna*, I, 1793, p. 235 (as in the Alba Palace). [12] A. M. De Barcia, Catalogue of the Alba Collection, 1911, pp. 260–1. [13] W. Buchanan, *Memoirs of Painting*, II, 1824, p. 227. [14] See note 12 to entry for *Ecce Homo* in the present catalogue. [15] See note 13 to entry for *Ecce Homo* in the present catalogue. [16] A line engraving of this picture is published in C. P. Landon's catalogue (1815) of the Massias collection. [17] The engraving is inscribed as done from the original. As de Jode was born as late as 1638 and the present picture had been in Spain since 1654 this statement raises difficulties and there would remain a possibility that the engraving was in fact made from a copy. Peter Oliver's miniature copy of 1634 seems never to have left England but when compared with de Jode's engraving does not seem adequate as sole source. Robin Gibson (*Burlington Magazine*, January 1972, p. 31) publishes a contemporary mezzotint of Nell Gwyn after the Venus in the present picture.

LONDON National Gallery

ECCE HOMO

Poplar, 0·99 × 0·80 colour plate J, plates 161B, 162A
Excellent condition. Cleaned, 1967–8.

Pentimento in the Virgin's face, the lower portion of which was originally covered by the blue mantle in a line continuing to the left that which now constitutes the portion of the drapery on the far side of her face. Christ's pink mantle likewise originally covered considerably more of his flesh including most of his left breast. His hands also were originally in different positions. In addition, X-ray photographs reveal another face close to the Virgin's and only slightly above it – as the mouth is open probably an earlier version of the Virgin's. None of these differences appears in Agostino Carracci's engraving of 1587 (which shows the picture in its present state except for narrow strips added to the bottom and to the right of the picture) and their fundamental character is a good indication, irrespective of the type and quality of the handling, that the present picture is

Correggio's original, and not an early copy as has been claimed.[1] Probably painted in the later 1520s.[2]

The unbiblical inclusion of the Virgin Mary in this scene is apparently an innovation.[3] The turbaned Pilate derives from the same subject in Dürer's *Engraved Passion* (fig. 37).[4]

See text, page 118.

PROVENANCE No. 188 in the 1783 catalogue of the Colonna Gallery, Rome. Before then its history is confused owing to conflicting accounts by the early writers. Agostino Carracci's engraving of 1587 which corresponds closely with the present picture contains the inscribed information that the painting from which the engraving was taken was then in the Prati collection, Parma. Scannelli (1657) mentions such a picture as still in the Prati possession.[5] A second version, apparently of the same design, is first mentioned in 1591 as belonging to Francesco and Lorenzo Salviati in Florence.[6] During the eighteenth and nineteenth centuries the Prati and Salviati pictures are constantly confused. The most probable chain of events is that recorded by Pungileoni[7] who quotes statements to the effect that the Prati picture had been sold to the Colonna between 1675 and 1680, the Prati family retaining a copy which later passed to the Dalla Rosa or Bajardi families with other Prati possessions. An alternative theory current in eighteenth-century Rome maintained that the Colonna picture was a copy, the original having been taken to France,[8] while a third held that it was the Salviati picture and not the Prati one which had been acquired by the Colonna.[9] It is certain that the Colonna picture was not a copy, since it is demonstrably identical with the present picture in which the X-ray evidence would preclude such a possibility, while the third theory is incompatible with a statement in the Udny sale catalogue of 1802 to the effect that the version in that collection had been in the possession of the Salviati family at Florence until it was taken to London.[10]

Sold by the Colonna to Alexander Day and by him, in 1802, to Ferdinand IV of Naples.[11] Taken from Naples by Madame Murat when she fled on the night of 20 May 1815 to Vienna[12] where sold by her about 1822[13] to Lord Stewart, later 3rd Marquess of Londonderry, from whom purchased, 1834.

DRAWINGS Popham (*Correggio's Drawings*, 1957) cites two connected drawings (his no. A144, page 198); he does not accept the first as autograph; the second has disappeared.

COPIES Of the many old copies the most famous is the picture recorded in the Salviati collection at Florence which was later in the Robert Udny sale (19 May 1804) and later still, it was claimed, in the Villa Dusmet sale, Rome, 1955. This picture is discussed in detail under PROVENANCE above. Other old copies are no. 96 of the National Gallery, in the Parma gallery, the Galleria Estense at Modena, the Palazzo Comunale at Rimini (according to Ricci, 1896, page 226), the Palazzo dei Conservatori, Rome (marked '220' on the frame), at Northwick Park (no. 22 in Borenius' catalogue, 1921) and in the Hamilton Palace sale, 1 July 1882, lot 705. See also *Veronica's Veil* at Firle (ex-Panshanger).[14] Numerous other copies of uncertain date could be mentioned. A distant derivative by Sigismondo Coccapani was exhibited Florence (Pitti), *Caravaggio e i Caravaggeschi*, 1970 (63).

ENGRAVING Agostino Carracci, 1587 (Bartsch XVIII, 20) (plate 162B).

REFERENCES [1] E.g. by Louis Viardot, *Les Musées ...d'Angleterre*, Paris, 1843, p. 231, or Julius Meyer, *Correggio*, 1871, pp. 357–62. In the latter work the *Ecce Homo* is catalogued among the doubtful works. [2] Earlier writers have suggested differing dates of origin. Meyer (op. cit., p. 150) and Waagen (*Treasures of Art in Great Britain*, I, 1854, p. 327) agree with Pungileoni (*Memorie Istoriche di Antonio Allegri...*, I, 1817, pp. 111 and 118) in assigning it to 1520. Ricci (*Correggio*, 1896, p. 226) suggests 1521 and in his later book (1930) *c.* 1525 (p. 169). Gronau (*Correggio* in the Klassiker der Kunst series, 1907, p. 121) *c.* 1526–8. [3] Cf. Mrs Jameson, *The History of Our Lord*, fourth edition, 1881, II, p. 98. [4] See the present writer in the *Gazette des Beaux-Arts*, February 1970, p. 109.

[5] Francesco Scannelli, *Il Microcosmo della Pittura*, 1657, pp. 78 and 281–2. [6] Francesco Bocchi, *Le Bellezze della Città di Fiorenza*, 1591, p. 187. Cf. also Scannelli, op. cit., p. 284. Meyer, op. cit., p. 359, quotes the will (1668) of Duke Giacomo Salviati which includes a description of the picture. [7] Pungileoni, op. cit., I, pp. 118–21, and II, pp. 162–5. [8] Perhaps for this reason Ramdohr (*Ueber Mahlerei und Bildhauerarbeit in Rom*, II, 1787, p. 85) goes out of his way to express his belief in the authenticity of the Colonna picture. Cf. also Mengs, *Opere*, 1787 edition, p. 187. C. G. Ratti (*Notizie...intorno la vita...del... pittore...Correggio*, 1781, pp. 116–17) also seems to accept the Colonna picture as identical with the Prati one. The source of the doubts was presumably the rumour, probably long current but published first by Tiraboschi (*Biblioteca Modenese*, VI, 1786, pp. 283–4) according to which the Prati original (not the copy) passed with the Prati possessions to the Dalla Rosa family and that the Marchese Pier Luigi Dalla Rosa sent it by request to Louis XIV who kept it, returning only a copy. In point of fact the only *Ecce Homo* attributed to Correggio which figures in the inventories of the French royal collections from 1683 to 1754 is demonstrably not the Prati picture. It is recorded in the inventory of 1706, Bailly's inventory of 1709–10 (Correggio no. 9) and Lépicié's catalogue of 1754 (Correggio no. 4) and is also described by d'Argenville in 1745 (*Abrégé...*, I, 1745, p. 211). Christ was shown seated on a drapery and had a reed between his hands. Bailly and Lépicié also give dimensions which show that this picture was very small. [9] Advanced by Coppi (*Notizie di un Quadro del Correggio, lette nell'Accademia Romana di Archeologia*, Rome, 1845, note 54) and accepted by Meyer (op. cit., p. 359). It was based on a story to the effect that the Salviati picture passed to the Colonna together with a *Leda* attributed to Correggio about 1718 as a result of a Colonna/Salviati marriage (as was in fact the case with a picture now in the National Gallery – no. 32, ascribed to Damiano Mazza). [10] Cf. Redford, I, p. 91. The 1802 Udny catalogue completes the cycle of confusion by stating that the picture in question had entered the Salviati collection, about 1660, from the Prati. The same mistake is perpetrated in the catalogue of the Udny sale of 19 May 1804 (94), to the extent of associating the picture with Agostino Carracci's engraving. This constitutes confirmation that the Salviati picture was a close replica of the Prati one. [11] On the back of the present picture is the seal of the Venuti family, the seal (monogram) of Carlo Ramette and the following old label: 'No. 114 Quadro in tavola denotante un Cristo avanti Pilato, mezze fig.ª al vero, del Correggio. Esisteva nella Galleria Colonna. Comprato dl (sic) Cav. Venuti per S.M. Il Re di Napoli dal Sig. Alessandro Dey (sic) in Roma l'anno 1802. (signed) Cav: Domenico Venuti.'* The present picture also figures as no. 114 in Tommaso Conca's inventory (of 29 November 1803) of pictures acquired by Venuti (printed in *Le Gallerie Nazionali Italiane*, V, 1902, p. 315 – the article in question contains further material relevant to the history of the picture. This is sufficient to disprove the statement made in the National Gallery catalogue of 1838 and succeeding editions to the effect that the *Ecce Homo* was bought from the Colonna by Sir Simon Clarke who, being unable to remove it from Italy, sold it to Murat. A picture described as an *Ecce Homo* by Correggio, sent in 1806 from the gallery of Francavilla to Palermo, is too small to have been the present picture (no. 18 is the inventory printed on p. 321 in *Le Gallerie Nazionali Italiane*, V). A certain amount of confusion regarding the agents active at the time of the Colonna sales may be assumed to explain a MS. note in a copy of the Colonna catalogue belonging to E. K. Waterhouse which says of the *Ecce Homo*: 'venduto a Giov. de Rossi e da questo al Re di Napoli' ('sold to Giovanni de' Rossi, and by him to the King of Naples'). Meyer (op. cit., p. 359) also mentions Rossi. [12] Marcel Dupont, *Carolina Bonaparte*, n.d. (1937), p. 246. In Stanislao Morelli's *La Pittura Comparata*, 1816, p. 71, the present picture is stated to be still at Capo di Monte, but this is presumably due to a publication time lag or perhaps to ignorance. [13] The issue of the *Tübinger Kunstblatt* which reports this transaction is dated 28 April 1823. But on the back of the present picture (and of *The School of Love*) is the seal of Lord Stewart who succeeded to the marquessate in August 1822 and who resigned his embassy to Vienna at the end of that year, in consequence of which the *Kunstblatt* notice is presumably retrospective. The same issue of the *Kunstblatt* seems to imply (wrongly) that, like *The*

* 'No. 114, panel, representing Christ before Pilate, half length, by Correggio. Formerly in the Colonna gallery. Bought by the Cavaliere Venuti for H.M. the King of Naples from Signor Alexander Day in Rome, 1802.'

School of Love, Ecce Homo had belonged to the Duke of Alba. This account is followed by J. D. Passavant (*Die Christliche Kunst in Spanien*, 1853, p. 152). It may be noted that J. J. Angerstein had tried to buy *The School of Love* and the present picture but without success (see D. E. Williams, *The Life and Correspondence of Sir Thomas Lawrence*, II, 1831, pp. 169–71 and 273–6). [14] A version of the head and shoulders of Christ, certified as Correggio by A. Venturi and G. Fiocco, was reported in 1958. Another (with the rope round his neck) is in the Ambrosiana, Milan. An *Ecce Homo*, attributed to Correggio, figures in the 1627 inventory of the Mantua gallery where it is described as 'N.S. Ecce Homo mezza figura di mano del Correggio' (cf. Carlo d'Arco, *Degli Arti...di Mantova*, 1857, p. 160), but such a description is inadequate to establish whether the design was the same as that of the Prati and Salviati versions.

LONDON National Gallery

THE MADONNA OF THE BASKET

Panel, 0·33 × 0·25 colour plate E, plate 97A
Some of the surface quality has probably been lost through rubbing but in general well preserved. Some retouching on both hands of the Madonna and stippled over the Child's waist and thighs; also, more particularly, on both the faces.[1] Cleaned 1967–8.

In the background St. Joseph is seen at work.[2]

Always accepted as the original of a design which was engraved within the sixteenth century and of which numerous painted copies were made.[3] Such fame in so small a picture as the present, together with the fact that some of the replicas are larger, might in theory give cause for doubting this assumption. Nevertheless, no other version has yet been produced which appears so convincingly autograph, while if Correggio's original *had* been larger it would have been uncharacteristic of him to paint a smaller replica of it himself.

Probably identical with a picture described by Vasari in his life of Girolamo da Carpi as 'di mano del Correggio, nel quale la Nostra Donna mette una camiscia indosso a Cristo fanciulletto'.[4]* He says that this picture belonged to the Cavaliere Boiardo in Parma and that Girolamo da Carpi copied not only it but also a Parmigianino in the Certosa di Pavia. Bottari, in his edition of Vasari (1760),[5] claims a two-fold confusion on Vasari's part, alleging that the Baiardo (not Boiardo) picture was the Parmigianino Cupid, now at Vienna, and that it was the Correggio which had been at the Certosa di Pavia. He added that the latter picture was in his day in Spain and that it had been engraved by Francesco Aquila. The present picture (or a hypothetical identical replica) was indeed engraved by Francesco Aquila (see EN-GRAVINGS below) and was in fact in Spain from at least the mid-seventeenth century to the beginning of the nineteenth. But in view of its boudoir size it would be surprising had it ever been in the Certosa di Pavia. Moreover an alternative identification of Vasari's picture was advanced by Pungileoni[6] who claimed that it was not the Baiardo one (which he confirmed had been in Spain) but another, now known only from engravings and copies.[7] In it, in addition to the motive of the Madonna putting a shirt on the Child, St. Joseph was offering the latter some cherries (a feature of which Vasari made no mention).[8] The identity of the present picture with the Baiardi one is nevertheless virtually proved by the Baiardi inventory of *c.* 1561, in which no. 11 is a Correggio *Madonna* of approximately the dimensions of this one. See text, page 89.

PROVENANCE Probably Baiardi collection, Parma in the sixteenth century; then recorded in the 1666 inventory of the Alcázar, Madrid and then in subsequent royal inventories up to that of 1789.[9] Next recorded in 1813 among pictures which Wallis was bringing from Spain to Buchanan in England. In Buchanan's list of that year stated to have come from 'The first collection at Madrid'.[10] Exactly how or in what circumstances it left the Spanish royal collection is not known, and contrary to what is generally

* 'by Correggio, in which the Madonna puts a shirt on the Christ child.'

stated it is unlikely that it was ever in Godoy's possession.[11] Nevertheless, the fact that Wallis was able to acquire it must be attributed to the upheavals consequent on the Peninsular War. Buchanan and Wallis having failed to find a buyer in England, the picture was taken back to the continent and by 1820 was in the possession of M. Lapeyrière at Paris.[12] No. 16 in the sale of the latter's possessions, Paris, 19 April 1825, where bought by the elder Nieuwenhuys, from whose son purchased, June 1825.[13]

DRAWING Popham (op. cit., pages 193–4, no. A119) lists one at the Albertina, Vienna which he considers a seventeenth-century pastiche.

COPIES Girolamo da Carpi's version, mentioned by Vasari, might in theory be identical with one of the many existing old copies. Of these, mention may be made of those in the galleries of Dresden (no. 156 in the 1908 catalogue) the Prado (no. 116 in the 1910 catalogue) and Dulwich (no. 246 in the 1914 catalogue) and one which passed through the Orléans,[14] Bridgewater, Stafford and Ellesmere collections and in 1950 was the property of Mrs Hewer of Bristol. These are all of approximately the same size as the present picture. Larger versions are in the Hunterian collection of Glasgow University, in the Ambrosiana at Milan and in the collection of the Duke of Buccleuch at Drumlanrig. Another was in the collection of Lord Radstock (no. 54 in the second day's sale, 13 May 1826). This was given as $35\frac{1}{2} \times 24\frac{1}{4}$ and though Redford (II, page 226) says it passed to the Northwick collection, a version which claimed to be ex-Northwick (successively Alan Fenwick sale, Christie's, 21 July 1950, lot 30, and anonymous sale, Sotheby's, 28 February 1951, lot 96) was not identical with it, being of the same size as the present picture.[15] Another is at Detroit (Institute). A version from the Colloredo family was the subject of a short monograph published by Carlo Marin in 1830. One was engraved in the Stroganoff Gallery, 1807 (13).

ENGRAVINGS Diana Mantuana (Rome, 1577) (plate 97B) and Francesco Aquila (dedicated to G. P. Bellori, 1691). For further engravings see Julius Meyer, Correggio, 1871, page 482.

REFERENCES [1] Julius Meyer (Correggio, 1871, p. 327) and following him Corrado Ricci (Correggio, 1896, p. 181, and 1930, p. 167) say the picture was overcleaned when in Godoy's possession. In fact it is highly unlikely that it ever belonged to Godoy. For a suggested explanation of this anomaly see reference 11. [2] A. E. Popham (Correggio's Drawings, 1957, p. 17, n.2) sees 'Düreresque inspiration' in the background. [3] Waagen (Treasures of Art in Great Britain, I, 1854, p. 330) assigns it to 'the later period of Correggio'. Meyer (op. cit., p. 326) suggested 1520 tentatively, Gronau (Correggio in the Klassiker der Kunst series, 1907, pp. 85 and 162) about 1522 and Ricci 1519–20 (1896, p. 396) and about 1523–4 (1930, p. 167). [4] Vasari/Milanesi, VI, p. 477. [5] Vol. 3, note (at the end of the volume) to p. 12. [6] Memorie Istoriche di Antonio Allegri detto Il Correggio, I (1817), pp. 111–12, II (1818), p. 155 (but giving a false reference to p. 206 of vol. I instead of pp. 111–12), III (1821), pp. 141, 145, 151. [7] An engraving is reproduced on p. 181 of Ricci's monograph (English edition) of 1896. [8] The original of this picture had belonged, according to Tiraboschi (Biblioteca Modenese, VI (1786), pp. 285–6) to the Abate Carlo Bianconi who, at the time of publication of Tiraboschi's book, still possessed a sketch for it (still owned by the Bianconi family in 1854 – no. 2 in their catalogue of that year). Pungileoni (loc. cit.) further confuses the matter by referring at some length to a picture owned by Padre Resta at the end of the seventeenth century which may either have been a copy of the present picture or the Bianconi picture or a copy of the latter. [9] These inventories which are preserved in the Royal Palace at Madrid are unpublished. The relevant entries are as follows: 1666 'no. 641 [old numeration] media vara de alta y un pie de ancho de una Nra. Sra. del mismo Corezo en 3,000 dus'.* 1686 inventory (under heading 'Passillo que llaman de la Madona'† – no inventory number) 'otra de media vara de alto, de una tercia de ancho, de una Nuestra Señora con el Niño original de mano del Corezo'.‡ 1700 inventory

* 'half a vara high and a foot wide, representing Our Lady, also by Correggio, value 3,000 ducats.'
† 'Corridor called that of the Madonna.'
‡ 'Another of half a vara high, and a third of a vara wide, of a Madonna and Child, original by Correggio.'

(under heading 'Passillo de la Madona [old numeration] 42') 'Item, otra de media vara de alto y una tercia de ancho; de una Nuestra Señora con el Niño: original del mano del mismo Corezo, tasada en mil y quinientos doblones'.* A 'media vara' is about 16½ inches and a 'pie' or 'tercia vara' about 11 inches. The inventories of 1772 and 1789 repeat the measurements of '½ vara' high and '⅓ vara' wide. The fact that the present picture does not figure in the inventory of 1636 might be thought to indicate that it was among the important Italian paintings bought by Velázquez during his visit to Italy in 1648–51, but no positive evidence on this point has come to light. Furthermore, there is at least a possibility that the present picture was the one seen by Jusepe Martinez (who died in 1682) in the possession of a certain Conde de San Clemente at Saragossa. The following passage is from his *Discursos Practicables*, datable around 1675, published by F. J. Sánchez Cantón in vol. 3 of *Fuentes Literarias* (1934), p. 28: 'En esta ciudad da Zaragoza se halla un cuadrito, en poder del Sr. Conde de San Clemente, de una tabla de roble de grandeza de poco más o menas de una tercia, pintada una imagen de Nuestra Señora que muda la camisa al Niño Jesus y en lejos San José trabajando su oficio.'† It is to be noted that the present picture is on poplar, not on oak, and in consequence it may not have been identical with the Saragossa picture. The present picture was seen in Madrid by Mengs who published descriptions of it (Mengs, *Opere*, 1787 edition, pp. 190 and 312), and it was also described by Antonio Conca (*Descrizione Odeporica della Spagna*, vol. I, 1793, pp. 128, 129) in the Madrid palace. The Baiardi inventory of *c.* 1561 was printed by A. E. Popham, *Catalogue of the Drawings of Parmigianino*, 1971, p. 264. [10] W. Buchanan, *Memoirs of Painting*, vol. 2, 1824, pp. 225ff., 243, 246–7. [11] In the National Gallery catalogue of 1838 and in almost all subsequent works on the

subject the present picture is stated to have been given by Charles IV of Spain to Emanuel Godoy, the 'Prince of the Peace' (1767–1851). This seems very doubtful. There is no mention of Godoy in any of the (fairly circumstantial) accounts of the picture's pedigree which were published between Mengs' and the 1838 catalogue – viz. Buchanan (op. cit.), George Yeates (letter of 19 January 1814, to Thomas Penrice, published with the latter's correspondence), the Lapeyrière sale catalogue of 1825, Passavant (*Kunstreise durch England und Belgien*, 1833, p. 11), Nieuwenhuys (*Review of the Lives and Works of some of the most Eminent Painters*, 1834, p. 48), Ottley's National Gallery catalogues of 1832 and 1835 or the *Tübinger Kunstblatt* of 17 May 1836. Above all, the MS. inventory of Godoy's collection dated 1 January 1808 (only two and a half months before his arrest) contains no mention of any picture corresponding with the present one. The explanation of the error seems to be that the compiler of the 1838 National Gallery catalogue confused the history of *The School of Love* and the present picture, stating that the former passed from the Alba collection direct to that of Murat (whereas in fact it belonged to Godoy in between) and including Godoy's collection in the pedigree of the present picture. Waagen (loc. cit.), in following this account, says 'unhappily this gem, presented by Charles IV to the Prince of the Peace, has been injured in some parts by cleaning' and Meyer (loc. cit.), embroidering this story, says that the picture suffered through cleaning *while* it was in Godoy's possession. Meyer's version was swallowed by Ricci (both editions). The resulting gap in the pedigree of the present picture is awkward but there seems no doubt that it really is the one described by Mengs and recorded in the Spanish royal inventories, since Mengs gives a detailed description and accepts it as autograph, while the inventory dimensions tally well enough. It is significant too that the valuations in the inventories (quoted in reference 9) are exceptionally high for so small a picture. [12] Cf. C. J. Nieuwenhuys, *A Review of the Lives and Works of some of the most Eminent Painters*, 1834, p. 48. Also Buchanan, loc. cit., and *Le Cabinet de l'Amateur*, I, 1842, p. 528. [13] Nieuwenhuys, loc. cit. On the back of the picture is a seal which is also found on the following other pictures in the National Gallery: Cuyp 823, Heyden 866, Hobbema 831 and 833, van de Velde 871. Of these, all but Cuyp 823 and Hobbema 833 are known to have been at one time in the

* 'Corridor of the Madonna...Item, another of half a *vara* high and a third of a *vara* wide; of Our Lady with the Child: original by the hand of Correggio, valued at 1,500 doubloons.'

† 'In this city of Saragossa there is a small picture in the possession of the Count of San Clemente on an oak panel measuring not much more than a third of a vara, painted with an image of Our Lady who puts a shirt on the Christ child, and in the distance St. Joseph busy in his workshop.'

possession of a Nieuwenhuys. [14] Page 59 of the Orléans catalogue of 1727 by Du Bois de Saint Gelais. [15] Redford, II, p. 225, also wrongly identifies a version at the Panné sale, Christie's, 29 March 1819 (lot 63) with the present picture.

LONDON National Gallery

ST. MARY MAGDALENE

Canvas. Painted area approximately 0·381 × 0·305
 plate 24B
General condition quite good. Flesh somewhat rubbed in parts. The darks of the drapery and of the landscape appear to have 'sunk' a little. There is a *pentimento* in her left ankle. Some disturbance visible above her right breast – apparently at an earlier stage more of this area was covered by falling hair. This would be evidence against Longhi's suggestion (*Paragone*, 1958) that the picture is a copy.

Other versions cited by Ricci in the Chigi-Saracini collection (Siena), 'Rome, Bologna, Parma, Milan and elsewhere'.[1] The design of the present picture is acceptably Correggesque and on the balance of evidence it seems to the author to be the original and an autograph work. Of modern writers it is accepted as such by Ricci[2] and by Berenson.[3]

See text, page 59.

PROVENANCE A Magdalen attributed to Correggio and measuring about 1·027 × 0·77 m. is recorded in the collection of the Duke of Savoy at Turin in 1631[4] and Vertue describes a version 18 inches high by 15 inches broad in Charles I's collection in which the Magdalen is 'standing and leaning, being a little intire figure, which has been too much washed'.[5] But it is doubtful whether either of these entries is relevant to the present picture. Both sets of dimensions are too large, and it seems that this picture has not been cut down, since round the painted area there is an un-primed strip, about a quarter of an inch wide, of what appears to be the original canvas.

Apparently no. 25 in the Ravaisson-Mollien sale, Paris (Hôtel Drouot) 23 November 1903, bought by Christian de Marinitsch.[6] Next recorded in England, in 1907, in the possession of George Salting (by whom lent to the Burlington Fine Arts Club exhibition, 1907 (32)). Although on the strength of a reproduction in colour of lot no. 25 in the Ravaisson-Mollien sale catalogue there can be little or no doubt that the present picture is identical with that one, its history during the intermediate period of four years is not satisfactorily accounted for. On the one hand it is stated by Herbert Cook that the picture came to England from Italy in 1907 and was then purchased by Salting.[7] On the other, a picture of the Virgin and Child with two Angels (now National Gallery, no. 2608, (?) after 'Campin') which had also been bought by Christian de Marinitsch at the Ravaisson-Mollien sale had entered Salting's collection by 1904. Salting Bequest, 1910.

COPIES See above. A small line drawing at Mannheim (no. 1731). Further copies in the Uffizi and the Prado. A version with slightly different background with Graziano Papa, Lugano, 1972.

REFERENCES [1] Corrado Ricci, *Correggio*, 1930, pp. 156-7. [2] Op. cit. [3] Bernard Berenson, *Pitture Italiane del Rinascimento*, Milan, 1936, p. 132. [4] G. Campori, *Raccolta di cataloghi ed inventarii inediti*, Modena, 1870, p. 76. Ricci (op. cit., p. 156) gives the dimensions wrongly. It is specified in Campori that the unit of measurement is the 'Piede Liprando' which is larger than an English foot. [5] George Vertue, *A Catalogue and Description of King Charles the First's Capital Collection...*, London, 1757, p. 125. [6] Letter in the National Gallery archives. [7] Article in *L'Arte*, 1908, p. 57.

LONDON National Gallery

CHRIST TAKING LEAVE OF HIS MOTHER

Canvas, 0·87 × 0·77 plates 7A, B
The paint is worn and thin over some of the area. Something of the original surface quality survives in

St. John's left sleeve and in the folds of his robe above the waist. Cleaned 1971.

The subject, which does not figure in any of the four Gospels, is rare in Italian Renaissance painting. X-ray photographs show that fundamental alterations were made by Correggio during the course of work on the picture. Thus Christ seems originally to have been conceived standing, not kneeling, and at one stage there was a third Mary between St. John and the Virgin – features which suggest that Correggio was acquainted with Dürer's wood-cut of this subject in *Das Marienleben*.[1]

See text, page 35.

PROVENANCE Probably identical with the picture mentioned in 1786 (with a detailed iconographic and stylistic description) by Tiraboschi, who states that his informant was the Abate Carlo Bianconi.[2] The picture is stated to belong to 'a certain Signor Rossi' in Milan. Tiraboschi's description was reproduced almost verbatim by Fiorillo in 1801.[3] Pungileoni[4] says that in his day the picture was in the possession, at Milan, of 'Signor D. Antonio Rossi, one of the heirs of the Rossi mentioned by Bianconi'. He adds that a certain Signor Jesi, writing to him in 1815 from Milan, complained that the picture had been so drastically restored that the grain of the canvas was visible even from some distance. In view of the fact that, later in the nineteenth century, there is a gap of some twenty years in the picture's pedigree, this information on the condition of the Rossi picture increases the probability that it is the present picture. Tiraboschi's reference to Bianconi is also quoted in Lanzi.[5] What was presumably the same picture was seen in Milan on 1 December 1856, by Mündler in the possession of an unspecified lady.[6] The picture was discovered by Dr J. P. Richter about 1879 in the possession (at Brixton) of Professor Vitale de Tivoli. The latter stated that he had acquired it from the widow of Professor Parlatore in Florence.[7] Professor Parlatore, who died in 1877, had married, in 1860, a certain Eugenia Crippa of Milan, and it may have been in this way that the picture entered into his possession.

It was purchased, soon after 1882, by Fairfax Murray, who took it back to Florence[8] and later sold it to R. H. Benson. Purchased from the latter by Sir Joseph (later Lord) Duveen, who presented it, 1927. Exhibited Burlington Fine Arts Club, 1894 (50); Royal Academy, 1896 (131); Grafton Galleries, 1909–10 (72); Manchester, 1927 (30).

COPY A Correggesque picture of the same subject was in the Farrer collection in 1901. What may be the same was with Steinmeyer, Lucerne, in 1924.

REFERENCES [1] Cecil Gould, 'A Probable Adaptation by Correggio of Dürer's Iconography' in *The Burlington Magazine*, October 1948. [2] Girolamo Tiraboschi, *Biblioteca Modenese...*, Modena, 1781–6, vol. VI (1786), p. 287. [3] J. D. Fiorillo, *Geschichte der zeichnenden Künste, I, Geschichte der Mahlerey*, Göttingen, 1798–1808, vol. II (1801), p. 306. [4] Luigi Pungileoni, *Memorie Istoriche di Antonio Allegri detto Il Correggio*, Parma, 1817–21, vol. III (1821), p. 155. [5] Luigi Lanzi, *Storia Pittorica della Italia*, fourth edition, Florence, 1822, vol. IV, p. 59. [6] The diaries of Otto Mündler, travelling agent for the National Gallery in the early years of Sir Charles Eastlake's tenure as Director, are in the National Gallery archives. [7] Letter in the National Gallery archives. [8] See *Italienische Malerei der Renaissance im Briefwechsel von Giovanni Morelli und Jean Paul Richter, 1876–1891*, 1960, pp. 74, 99, 360, 387–8, 465.

LONDON National Gallery

for fragments from the apse of S. Giovanni Evangelista (plates 38B, C, D) see under PARMA, page 246.

LOS ANGELES County Museum MADRID Prado

MADONNA AND CHILD WITH ST. JOSEPH AND THE GIOVANNINO

Canvas, evidently transferred from panel, 0·265 × 0·21 [1] colour plate A, plates 18A, B

Not well preserved for a small picture. Many small local losses but none affecting whole features.

Photographs published by Gronau and Ricci (1930) do not make it clear that the background on the right (above St. Joseph) is a hedge.

See text, page 43.

PROVENANCE Charles Fairfax Murray, London, who sold it in 1903 to Edward Forbes of Cambridge, Massachusetts, who lent it to the Fogg Art Museum. Forbes sold it, c. 1905–6, back to Fairfax Murray.[2] Published by Gronau (1907)[3] as chez Fairfax Murray and by Berenson (1907) as on loan to the Fogg Museum.[4] Sold by Fairfax Murray, or his heir, to Mrs Edward D. Brandegee, Boston, Massachusetts.[5] Bought by the Los Angeles County Museum with funds donated by William Randolph Hearst, 1946. Lent to the North Carolina Museum of Art, W. R. Valentiner Memorial exhibition, 1959.

REFERENCES [1] Dimensions supplied by the Los Angeles County Museum. I have not seen this picture but was given excellent detail photographs and an X-ray by the Museum. [2] Information from the archivist of the Fogg Museum, kindly communicated by Agnes Mongan. The present picture cannot be identical with one mentioned by Pungileoni (II, pp. 41–2), Meyer, 1871 (p. 378) and Quirino Bigi, 1880 (p. 41, no. 2), which appeared at two General Sir John Murray sales, Christie's, 17 July 1851 (16) and 19 June 1852 (43). Pungileoni describes the Madonna in this as seated on the ground, with the Christ child's left arm in her right and the Giovannino placing his right arm on her left shoulder. [3] Klassiker der Kunst volume on Correggio, p. 10. [4] North Italian Painters, p. 199. [5] Date uncertain. Ricci (1930) wrongly says it was acquired by the Fogg in 1923.

NOLI ME TANGERE

Canvas, transferred from panel, 1·3 × 1·03 [1] plate 98

Old photographs show an inventory number – 809 – bottom left. The flesh areas in general are worn and retouched. Extensive restoration in the shadowed areas of Christ's upraised arm and in the shadows of his flesh elsewhere. Mary Magdalene's draperies, and more especially the landscape, in good condition. Further draperies had been added when the picture was at the Escorial; these were removed when it was transferred to the Prado in the nineteenth century.[2]

The Prado catalogues up to the edition of 1942 describe it as on panel; thereafter as 'panel transferred to canvas'. St. Mary Magdalene throws herself on her knees to Christ. On the ground, right, the gardener's implements, hoe, spade and hat. Demonstrable, from the pedigree, as identical with the picture described by Vasari[3] in the possession of the Hercolani family at Bologna, who may have commissioned it.

See text, page 000.

PROVENANCE. Hercolani, Bologna, where noted by Pietro Lamo (1560)[4] and Vasari (1568). A note printed by Pungileoni reads as follows: 'Il quadro degli Arcolani fu poi del Cardinale Aldobrandino e al presente è dell'illussᵐo Ludovisio, nella cui camera è stato con altri q. maravigliosi attaccato in mia presenza hoggi 2 marzo 1621.'[5]* Therefore identifiable with no. 6 in the inventory (by Agucchi) of 1603 of the collection of Cardinal Pietro Aldobrandini: 'Un Christo con la Maddalena Noli me tangere, d'Antonio da Correggio'.† This entry is

* 'The Hercolani picture was later with Cardinal Aldobrandino and is now with the illustrious Ludovisi, in whose room it was hung (?)‡ with other marvellous pictures (?) in my presence, this day 2 March 1621.' [‡ Note. The word is 'attaccato' – which can mean either attached or attacked.]

† 'A Christ with the Magdalen, Noli me Tangere, by Correggio.'

cancelled in the MS. with the following note: 'Il controscritto quadro del n.o 6 fu donato dall' Ecc.ma Sig.ra al S.re Card.le Lodovisio l'anno 1621'* followed by: 'questa donatione l'offatta ad istantia delli miei figli. Olimpia Aldobrandini.'[6†] No. 31 in the 1633 Ludovisi inventory: 'Un noli me tangere alto pmi sei, cornice dorata...di mano del Correggio.'[7‡] The owner, Cardinal Ludovico Ludovisi, had died in 1632. A further (undated) Ludovisi inventory contains the following entry: 'Mano del Correggio. Un Cristo in forma d'hortolano e S. Maria Maddalena nel sepolcro alt. 5, larg. 4 palmi.'[8§] The mention of the 'sepolcro', which does not figure in the Prado picture, together with the different height from that given in the 1633 inventory (six palmi as opposed to five) would suggest that two different pictures may have been involved.[9] The height of the one in the 1633 inventory – which was certainly the ex-Hercolani picture – would agree with that of the Prado picture (6 palmi = $52\frac{1}{2}$ in. = 1.33 m.). The Hercolani/Ludovisi picture was acquired in Italy soon afterwards by one of the Spanish viceroys at Naples. The complicated evidence is as follows.

Francisco de los Santos (1657)[10] mentions that a *Noli me Tangere* by Correggio in the Escorial – which is certainly identical with the Prado picture – together with a *Flight into Egypt*, a *Purification of the Virgin* and others (unspecified) were given to the King (Philip IV) by Don Ramiro Nuñez de Guzmán, Duque de Medina de las Torres, when he returned from Italy. He did this in 1644 (he had been Viceroy at Naples). De los Santos in another place indicates that the *Flight into Egypt* was a Titian – identifiable

with the former no. 435 of the Prado (now Escorial) – and that the *Purification of the Virgin* was a Veronese now lost, but known in a copy.[11] In yet another place de los Santos describes a Titian *Marriage of St. Catherine* in the Escorial which is identifiable with no. 635 of the National Gallery.[12] Three of these four pictures – the Correggio, the Veronese and the Titian *Marriage of St. Catherine* – seem to correspond with three in the 1633 Ludovisi inventory (nos. 31, 33 and 44).[13]

The conflicting element is a statement of Pungileoni's that the Prado *Noli me Tangere*, went to England,[14] together with a statement in the Prado catalogues that it bore the seal of Charles I (as well as the letters A and R) on the back. The latter cannot be checked, since the picture was transferred to canvas. There is no mention of the picture in Van der Doort's inventory of 1639 of Charles I's collection, and this is only five years before the Duque de Medina de las Torres returned to Spain. And even if the picture was acquired by Charles after 1639 and got rid of by him before 1644 it is very unlikely that it would then have rejoined two of its former fellows from the Ludovisi collection. More probably the picture was never in Charles' possession. In this case it is possible that de los Santos confused the Duque de Medina de las Torres with his predecessor as viceroy at Naples – the Conde de Monterrey, since the latter brought with him to Spain the two Titian bacchanals which had also been ex-Aldobrandini and ex-Ludovisi.

Described by Conca in the Escorial in the eighteenth century.[15] Transferred to the Prado 1839.

COPIES Pungileoni (II, page 152) mentions copies by Tiarini and Lorenzo Sabbatini.

REFERENCES [1] Measurements from the Prado catalogue. [2] See L. Viardot, *Les Musées d'Espagne* etc., 1843, p. 19, and P. de Madrazo's Prado catalogue, 1872, p. 73. [3] IV, p. 116 and VI, p. 470. The latter reference (in the *Life of Girolamo da Carpi*) says that Girolamo was at Bologna when the picture arrived there and describes the effect it had on him. This may indicate that the picture had been commissioned by the Hercolani, and would give an indication of its date but for the fact that we do not know

* 'The picture in question, no. 6, was presented by the illustrious lady to Cardinal Ludovisi in the year 1621.'

† 'This gift was made at the suggestion of my sons.'

‡ 'A Noli me Tangere, 6 palmi high, gilded frame...by Correggio.'

§ 'By the hand of Correggio. Christ as gardener and Mary Magdalene at the sepulchre, 5 × 4 *palmi*.'

when Girolamo arrived in Bologna. Doubts on the picture's authenticity expressed by Meyer (p. 356) are groundless. [4] *Graticola di Bologna*, p. 13. [5] Vol. III, p. vi. Pungileoni attributes the note to Federigo Zuccaro, who had died in 1609: but the note itself gives every indication of being authentic. [6] Printed by Cesare d'Onofrio in *Palatino*, January–March 1964, p. 18. [7] Printed by Klara Garas in *Burlington Magazine*, 1967, vol. 109, p. 343. [8] Printed by L.-G. Pélissier in *Mémoires de la Société Nationale des Antiquaires de France*, sixth series, vol. 3, 1893. [9] Another *Noli me Tangere*, attributed to Correggio, was of slightly different design and figured in the Queen Christina and Orléans collections. It was smaller – four and three quarter palmi high, according to the inventory after Christina's death. [10] *Descripción de San Lorenzo del Escorial*, ed. Sánchez Cantón, 1933, p. 239. The so-called *Memoriale* of Velázquez is also cited, sometimes, in this context, but its authenticity has been questioned. [11] Op. cit., p. 232: also Garas, op. cit. [12] Op. cit., p. 239. [13] Garas, op. cit. [14] Vol. 1, pp. 103ff. [15] *Descrizione Odeporica...*, II, 1793, p. 48.

MADRID Prado

MADONNA AND CHILD WITH THE GIOVANNINO

Panel, 0·48 × 0·37[1] plates 27A, B

Somewhat worn, and many small retouchings. But basically very fair condition.

No reed cross is shown, and the Madonna's arm is more conspicuously round the child on the spectator's left. Nevertheless, the child on the spectator's right reappears in the Hampton Court *Holy Family* almost exactly, and in the Uffizi *Holy Family with St. Francis* in a similar form, in each case as the Christ child. For that reason that is probably who he is in the present picture.

See text, page 58.

PROVENANCE Recorded in 1746 among Isabella Farnese's possessions at La Granja.[2] In 1714 she had come to Spain from Parma as second wife to Philip V.

REFERENCES [1] Measurements from the Prado catalogue. [2] Y. Bottineau, *L'Art de Cour dans l'Espagne de Philippe V, 1700–1746*, 1960, p. 462. Also the Prado catalogue.

MADRID Academia de Bellas Artes de San Fernando

ST. JEROME

Panel, 0·64 × 0·51[1] plates 19B, 20

Cleaned 1967. A good deal of retouching visible before that on the flesh areas. St. Jerome's right elbow rests on a red drapery.

See text, page 38.

PROVENANCE Probably the 'S. Geronimo che contempla con una testa di morto, mezza figura, opera del Correggio'* in the 1627 Mantua catalogue[2] which is certainly identical with Van der Doort's 'St Jeronimus leaning uppon his right arme and with his left houlding a dead Scull upon his booke saide to be of Corrigio...' (inventory of *c.* 1639 of Charles I's collection).[3] In the Commonwealth inventory as at St. James's Palace; sold to Leemput, 26 March 1650.[4] Probably the picture described by Ponz (1787) as at La Granja.[5] In the Real Academia de San Fernando, Madrid by 1818, when catalogued as Sebastiano del Piombo (114). Published by Longhi, 1921 as Correggio.[6]

REFERENCES [1] Measurements from San Fernando catalogue, 1965. [2] Luzio 1913, p. 115; also p. 151. Pungileoni (I, p. 59) draws attention to a passage in Ridolfi's *Maraviglie...* (1648, Ridolfi/Hadeln II, p. 56) where a 'San Girolamo di mezzana forma che stà meditando il crocefisso, opera singolare di Antonio da Correggio'† is described in the Renieri collection in Venice. In a footnote Hadeln links this with the entry in Campori (*Raccolta di Cataloghi*, 1870 edition, p. 444) in which the St. Jerome is

* 'St. Jerome contemplating a skull, half length, by Correggio.'
† 'St. Jerome at half length meditating on a crucifix, fine work by Correggio.'

catalogued as Leonardo but 'pare mano del Correggio'. This cannot be identical with the present picture. [3] Oliver Millar in the *Walpole Society*, 1958–60 (1960), p. 41; also p. 202. Dr E. Pérez Sánchez (personal communication) says there is no Charles I brand on the back of the present picture. [4] Communication from Oliver Millar. [5] *Viaje de España*, vol. x, p. 147: 'Un San Gerónimo, no sé con qual fundamento atribuido á Corregio.'* [6] *L'Arte*, xxiv. Also T. Borenius in *Burlington Magazine*, 53, 1928, p. 243.

* 'A St. Jerome attributed on unspecified grounds to Correggio.'

MILAN Brera

ADORATION OF THE KINGS

Canvas, perhaps from panel, 0·84 × 1·08[1] plate 22B

A good deal of damage, worst in the flying putti on the left and in the Madonna's right hand and adjoining areas of the Child's body. As Scarsellino until the 1890s.[2] The Correggio attribution, apparently first made by Berenson,[3] was not generally accepted at first[4] but later became universal.

Popham suggests derivation of the horse from Dürer's engraving called the *Great Horse*,[5] but the resemblance is not close. He also mentions the possibility that a drawing in the Metropolitan Museum may be an early idea for the present picture.[6] If it were, it would be necessary to assume vital intermediate – and now lost – stages, as the design is quite different.

See text, page 43.

PROVENANCE One of a group of pictures and drawings bequeathed in 1650 by Cardinal Cesare Monti to the city of Milan, to be housed in the archbishop's palace. After much discussion the present picture was included in a number transferred to the Brera in 1895.[7] Exhibited Parma, 1935 (29).

REFERENCES [1] Dimensions from Ricci (1930). [2] Battaglia (*Correggio Bibliografia*, no. 430) quotes an attribution to Mazzolino and a claim on behalf of G. Bertini for credit for the attribution to Correggio. [3] Preface to *Study and Criticism of Italian Art* (first series), 1901 (p. vi of 1908 edition). First published as Correggio by Corrado Ricci, *Per l'Arte* (Parma), 11 October, 1896. [4] E.g. Gronau (1907, p. 158) expresses some doubt. [5] Popham 1957, p. 56. [6] Popham 1957, pp. 16–17. [7] G. Bertini, 'I Sedici Quadri del Legato Monti' in *Le Gallerie Nazionali Italiane*, III, 1897, pp. 112ff.

MILAN Brera

THE NATIVITY WITH ST. ELIZABETH
AND THE GIOVANNINO

Panel, 0·79 × 1·00 plate 22A

Distant landscape somewhat damaged.

In the background the shepherds are arriving, led
by an angel. The inclusion of St. Elizabeth and the
Giovannino at a Nativity of Christ is highly unusual.

First attributed to Correggio by J. P. Richter in
1883.[1] Previously attributed variously to the school
of Dosso Dossi and to Savoldo. The Correggio attri-
bution confirmed by Morelli[2] and later writers.

See text, page 43.

PROVENANCE Perhaps the 'Nativita di Christo alta
pmi. 4 longa pmi. cinque...del Correggio della
prima Maniera'* which was no. 223 in the inventory
of 1633 of the Ludovisi collection in Rome.[3] Sir J. C.
Robinson, London by 1883. Sold by him to J. P.
Richter who sent it to Milan in 1885[4] where he sold
it to the industrialist, Crespi, 1887.[5] Given by the
Crespi family to the Brera, 1913. Exhibited Parma,
1935 (28).

REFERENCES [1] Letter of 25 November 1883 to
Morelli: '...bei Robinson habe ich ein höchst
merkwürdiges Bild angetroffen, etwa so gross wie
Ihr Franciabigio. Der Madonna-Typus ganz wie in
Frizzonis Correggio [the *Marriage of St. Catherine*,
now at Washington]. Die Hände durchaus wie in
den Frühwerken Correggios, besonders wie in den
sog. Tizian, Uffizien Nr. 1001 [Correggio: *Madonna
and Child and Music-making Angels*]...Robinson gibt
es für Savoldo aus...',† printed in *Italienische
Malerei der Renaissance im Briefwechsel von Giovanni
Morelli und Jean Paul Richter 1876–1891*, 1960, p. 293.

* 'Nativity, four by five *palmi*, by Correggio in
his early manner.'

† 'Chez Robinson I found a most remarkable
picture, about the size of your Franciabigio, the
Madonna of exactly the same type as Frizzoni's
Correggio [now Washington]. The hands as always
in the early Correggio, particularly as in the so-called
Titian in the Uffizi. Robinson calls it Savoldo.'

Also pp. 301, 418, 419, 421, 449, 458, 508–10, 512,
525. [2] Morelli/Richter correspondence *passim* and
'Munich and Dresden', Leipzig edition, 1891,
pp. 194, 217, 290. [3] Klara Garas in *Burlington
Magazine*, 109, 1967, p. 346. She points out that the
dimensions are not quite the same. But the combina-
tion of the oblong proportions and the specification
of 'prima maniera' is suggestive. [4] Morelli/
Richter correspondence, p. 419. [5] Morelli/Richter
correspondence, p. 510. Richter had previously
hoped to sell the picture to the Brera.

MILAN Castello Sforzesco

MADONNA AND CHILD WITH THE
GIOVANNINO (*Madonna Bolognini*)

Canvas, transferred from panel, 0·68 × 0·49.[1]

 plate 19A

A good deal of damage and restoration, particularly
in the landscape. The marble relief painted on the left
of the picture shows a usual type of early Renaissance
decoration and is similar to one on the main portal of
the palace of Francesca of Brandenburg in the town
of Correggio.

First exhibited in the Ambrosiana as School of
Parma.[2] First attributed to Correggio by Frizzoni.[3]
Attribution confirmed by Morelli (1880)[4] and later
writers.

See text, page 43.

PROVENANCE Bequeathed by Conte Bolognini
Attendolo, 1865 to the city of Milan. Hung first in
the Ambrosiana. From 1900 in the Castello Sfor-
zesco. Exhibited Parma, 1935 (31).

REFERENCES [1] Measurements from Ricci, 1930
(with misprint corrected). Meyer 1871 (p. 373,
no. 3) gives it as still on panel. [2] Meyer, loc. cit.
[3] Quoted by Meyer, loc. cit. [4] 'Munich and
Dresden', edition of 1880, p. 147.

MODENA Galleria Estense

MADONNA AND CHILD
(*Campori Madonna*)

Panel, 0·58 × 0·45[1] plate 26A

Many small retouchings. The background consists of dense foliage, but this has sunk so as to be almost invisible. Some restorations recorded in 1852 and 1936.[2]

First published as Correggio by the painter, Vincenzo Rasori (1852).[3] Attribution confirmed by Meyer,[4] Morelli[5] and later writers.

See text, page 57.

PROVENANCE From the Castello di Soliera, near Modena, which was owned from 1636 by the Campori family.[6] Later in Modena. Presented to the city of Modena by the Marchese Giuseppe Campori, 1894. Exhibited Parma, 1935 (35); San Francisco, 1939 (27).

REFERENCES [1] Dimensions from R. Pallucchini, *La Galleria Estense*, 1945, p. 106. [2] Pallucchini, loc. cit. [3] 'Riflessioni sopra un dipinto finora incognito del Correggio...', *Monitore Toscano*, 24 December 1852 (Battaglia 219). [4] Meyer 1871, p. 379, under 'angeblich' section. [5] 'Munich and Dresden', Leipzig, 1880, p. 147. [6] Rasori, loc. cit.

NAPLES Galleria Nazionale

MADONNA AND CHILD (*La Zingarella*)

Panel, 0·465 × 0·375[1] plates 23A to 24A

Restored, c. 1934, when many features were removed. Photographs published prior to that date show an extra angel, immediately above the Madonna's head, and larger than any of those now visible. He was pulling down palm leaves, as in the Uffizi *Holy Family with St. Francis* and in the *Madonna della Scodella* (Parma). The Christ child also was totally different from the one now visible – his head was turned towards the Madonna so that his face was in profile to the spectator, his left arm extended down to the Madonna's knee, and both his feet were different (most of his right concealed by the Madonna's right hand). The Madonna's right sleeve was creased differently, there was a rabbit in the lower left corner, and considerably more of the trunk of the palm tree was visible on the left. No sky or distant landscape was visible on the right. These features (whose style was reminiscent of Alessandro Mazzola) dated from at least the seventeenth century, as the rabbit and the angel pulling down palms occur in Striglioni's print and are mentioned in the inventory of c. 1680 (see below). A further restoration, in 1965, revealed the sky and landscape on the right. As a result of these multiple changes the pigment now visible is very worn in many places. The picture's bad condition and overpainting was noted by Mengs.[2] X-rays reveal a Pietà underneath.

Despite the absence of St. Joseph the subject is supposed to represent the Rest on the Flight into Egypt. Not mentioned in any of the early writers prior to 1587. Despite this and its present damaged condition its authenticity can hardly be doubted.[3]

See text, page 44.

PROVENANCE Identifiable in the inventory of 1587 of Ranuccio Farnese: 'Un ritratto della Madonna in habito di Cingana di mano del Correggio.'[4]*

* 'A picture of the Madonna as a gypsy by Correggio.'

Bequeathed by Ranuccio to his sister, Margherita (Maura) by his will of 23 July 1607[5]: '...Tabellam, vulgo dictam, un quadretto, cum Imagine Beatissimae Virginis Mariae, pictam manu Antonii Corriggii, iam pictoris celeberrimi, nuncupatam la Cingara...'* Evidently reverted to the ducal collection at Parma after Ranuccio's sister's death, as noted there by Scannelli,[6] Scaramuccia[7], Barri[8] and Richardson,[9] among others. Also in the inventories of c. 1680,[10] 1708[11] and an undated one.[12] Transferred to Naples, 1734. At Palermo, 1798–1815. Thereafter Naples again. Exhibited London (Royal Academy), 1930 (172); Paris (Petit Palais), 1935 (115).

PRINTS Meyer (page 481) lists a number, of which the dated ones are all nineteenth century. His no. 278 omits the rabbit, but this may be due to its narrow format rather than having been done before the rabbit was added to the painting. None of the prints known to the present writer show the painting in its original state.

VERSIONS Copy noted in the inventory of Philip II of Spain.[13] One was in the Ottley sale, 25 May 1811, 36 or 37, also Glasgow, Prague, Potsdam (Sans Souci), Milan (Ambrosiana) and elsewhere.

REFERENCES [1] Measurements from the Naples catalogues. [2] Mengs, 1787 edition, p. 185. For the 1965 and 1935 restorations see R. Causa, 'Deux Inédits du Corrège' in L'Œil, January 1968. [3] Ricci (1930, p. 40) seems to include it with the Uffizi Holy Family with St. Francis as having been attributed to Baroccio, Francesco Vanni and Tiarini. But he may only mean the Uffizi picture. [4] G. Campori, Raccolta di Cataloghi..., 1870, p. 52. The document in question is at Parma, but it is not stated where the objects in the inventory were located. [5] P. Martini, Studi intorno il Correggio, 1865, pp. 128–9. [6] Scannelli, 1657, p. 276. [7] Scaramuccia, 1674, p. 177. [8] Barri, 1671, p. 104. [9] Richardson, 1722, p. 334. [10] Campori, op. cit., p. 225. The rabbit is mentioned as 'alla destra' ('on the right'), perhaps mean-

* 'Panel, called in the vulgar tongue a small picture, with the image of the Blessed Virgin Mary, painted by Correggio, a celebrated painter, called the Gypsy Madonna.'

ing from the Madonna's point of view. [11] Le Gallerie Nazionali Italiane, v, 1902, p. 278 (no. 30). The dimensions differ somewhat from those in the inventory of c. 1680. [12] Loc. cit., p. 281, no. 33. [13] Ed. Sánchez Cantón, Bienes Muebles que pertenecieron a Felipe II, 1956–9, I, p. 26, note.

NAPLES Galleria Nazionale

THE MARRIAGE OF ST. CATHERINE

Panel, 0·285 × 0·235[1] plates 92A, B

Good condition. Restored 1965. The paint in the shadows has sunk somewhat.

A version of the design was engraved as by Correggio in 1620 (the much earlier print by Giorgio Ghisi (Mantovano) does not specify the painter's name). As Correggio in descriptions of the Farnese collections, and in the inventories, from 1657. In modern times the authenticity as Correggio has been denied by Morelli,[2] Berenson,[3] Ricci (1896)[4] (who suggested it was a copy by Annibale Carracci) and A. L. Mayer (who thought it a copy by El Greco).[5] Ricci (1930) accepted it,[6] as did Venturi.[7] An inscription formerly visible on the back of the old copy in the Hermitage, Leningrad stated among other things that the picture was painted in 1517.[8] This, which is certainly an invention, may have influenced modern views on the dating, which concur as between that year and 1519. The present writer accepts the attribution to Correggio and would take the view that a date soon after 1520 is the most likely. X-rays reveal a large head (? of the Madonna) upside down from the existing composition (plate 92B).

See text, page 88.

PROVENANCE Probably the smaller of the two Correggios of the Marriage of St. Catherine noted in the ducal palace at Parma by Scannelli (1657).[9] Also the 'sposalitio di Santa Caterina' seen there by Barri (1671)[10] and the 'piccolo sposalizio di S. Caterina del Correggio' in the inventory of c. 1680 of the Palazzo del Giardino at Parma.[11] Also noted there

by Richardson[12] and in the inventories of 1703[13] and an undated one.[14] Transferred with the Farnese collection to Naples, 1734. Taken to Palermo, 1798. Returned to Naples, 1815.

VERSIONS In the Hermitage, Leningrad (ex-Brühl), the John G. Johnson collection (Philadelphia) and innumerable others, of which one, formerly in the Fabrizi collection, Rome, was for a time thought the original.

PRINTS By Giorgio Ghisi Mantovano (plate 92C), re-issued by Lafreri (1575) and Marelli (1580 and 1602). Mengs, probably wrongly, mentions one by Ugo da Carpi; but there is an early chiaroscuro (in reverse: Bartsch, vol. XII, page 61, no. 19). Etching of 1620 by G. B. Mercati (plate 92D) already mentioned, with dedication to Lelio Guidiccioni, stated to have been a former owner of the picture (whichever version it was). Also A. Capellan, Rome 1772, and an etching by Angelica Kauffmann, published 1780.

REFERENCES [1] Dimensions from the Naples catalogues. See also R. Causa, 'Deux Inédits du Corrège', in L'Œil, January 1968. [2] Morelli/Richter correspondence, 1950, p. 9. [3] Never included in his Lists. [4] p. 170. F. Guibert's print is inscribed 'peint par Louis Carrache'. [5] Burlington Magazine, vol. 74, 1939, p. 33. [6] pp. 40 and 157. [7] Storia..., IX, 2, p. 520. [8] Hermitage catalogue, Italian and Spanish schools, 1891, p. 10 gives the inscription as 'Laus Deo per Donna Mathilda d'Este Antonio Lieto da Correggio fece il presente quadretto per divozione Ao. 1517'. The same catalogue states that this inscription was covered in 1838 when the picture was mounted on panel. It has often been pointed out that no member of the Este family by the name of Mathilda is recorded at the period in question. The inscription is comparable with the invented dates of origin placed by Ravenet on his engravings after Correggio. [9] Microcosmo, p. 276. Conceivably identical with 'un quadro del Correggio chiamato il Sposalizio di S. Caterina, piccolo, una gioia di estrema bellezza'* offered in 1596 to Duke Vincenzo Gonzaga by Contessa Barbara Sanseverino

* 'a picture by Correggio called Marriage of St. Catherine, small, a jewel of great beauty.'

Sanvitale of Salò (Luzio, La Galleria dei Gonzaga venduta all'Inghilterra..., 1913, p. 98, n.1). [10] Viaggio Pittoresco..., p. 105. [11] Campori, Raccolta di Cataloghi..., 1870, p. 215. On p. 241 a copy is listed. [12] Richardson 1722, p. 334. [13] Le Gallerie Nazionali Italiane, V, 1902, p. 278, no. 27. [14] Loc. cit., p. 281, no. 12.

NAPLES Galleria Nazionale

ST. ANTHONY ABBOT

Panel, 0·49 × 0·32[1] plate 10B

Traces of flaking, but otherwise in good state.

Attributed to Andrea da Salerno when in the Chiesa dei Gerolomini, Naples. First attributed to Correggio by A. Venturi in 1901.[2] Transferred to the Naples Gallery, 1905. Attribution accepted by Berenson (1932 onwards) and Ricci (1930).

See text, page 38.

PROVENANCE Chiesa dei Gerolomini, Naples. Exhibited Parma, 1935 (34).

REFERENCES [1] Dimensions from Ricci (1930). [2] 'Nuovi Quadri del Correggio' in L'Arte, 1902, pp. 32–3. See also T. Borenius in Burlington Magazine, 53, 1928, p. 243, and A. de Rinaldis' catalogue of the Naples gallery, 1928.

NAPLES Galleria Nazionale

A MALE SAINT AND A DONOR

Two pictures, tempera on linen, each 1·65 × 0·64

plates 167 to 170

Inscribed (left picture): DIE.VI.IVLI.
 (right picture): M.D.XXVIIII.

Traces of pentimenti in dress of right-hand figure. Paint always thin, and now very worn in places.

The attribution to Correggio dates from 1671 (Barri),[1] which is also the earliest mention of the pictures. Mentioned by various eighteenth-century

writers and by Pungileoni[2] (quoting an earlier reference) but not again until 1957, when republished by F. Bologna[3] who had found them in the depot of the Naples gallery. The attribution to Correggio is acceptable to the present writer.

Barri speaks of the subjects merely as 'due figure' ('two figures'). The 1680 Parma inventory has 'S. Giuseppe' and 'un vecchio…che si crede S. Gioachino' ('an old man thought to be St. Joachim').[4] This is followed in the Descrizione…di Cento Quadri…nella Galleria Farnese di Parma' (1725)[5] and in the 1736 inventory[6] and by Tiraboschi (1786).[7] The saint probably is St. Joseph. The prominence of the date – and its precision to a day – suggests that the pictures were ordered to commemorate a special event in the life of the man represented on the right, such as, perhaps, his death, or the birth or death of a relative or close friend. Bologna (loc. cit.) advances a fairly convincing case for identifying him with Conte Guido da Correggio, who had died in 1528 and was interested in the cult of St. Joseph.

See text, page 123.

PROVENANCE With the Farnese collections at Parma (see above). Presumably transferred with them to Naples, 1734.

REFERENCES [1] *Viaggio Pittoresco d'Italia*, p. 105. [2] Vol. 1, p. 204. [3] *Paragone*, 91 (1957), pp. 9ff. He omits the references to Barri and Tiraboschi. See also T. Ferrari in *Parma per l'Arte*, May–August 1964. [4] Campori, *Raccolta de' Cataloghi*, 1870 edition, p. 228. [5] pp. 18–19. [6] Unpublished extract printed by F. Bologna, op. cit., p. 22, n.4. [7] p. 273.

NEW YORK Metropolitan Museum of Art

ALTARPIECE, SAINTS PETER, MARTHA, MARY MAGDALENE AND LEONARD

Canvas, 2·217 × 1·619[1] plates 8 and 9

Despite measures said to have been taken (probably in the seventeenth century) to simulate a ruined appearance (see below) the picture seems on the whole to be in good state.[2]

St. Peter has the keys, St. Martha, the dragon, St. Mary Magdalene, the pot of ointment and St. Leonard, the fetters. The combination of these four saints is so highly unusual that it has long been assumed that the picture is connected (despite some uncertainty in its pedigree) with a series of wills which specify them. They were made by one Melchior Fassi of the town of Correggio.[3] No painter's name is given in the wills, but the painter Correggio was demonstrably acquainted with Fassi, both being cited as witnesses in an unconnected document dated 14 July 1517[4] (see page 188). And with the present transcriptions of longer extracts of Fassi's wills than were printed by Pungileoni (see page 177) it is now revealed that Fassi's acquaintance with the painter's family was closer still. He made provision for a bequest to Antonio's uncle, Lorenzo Allegri, in his first will, and to Antonio's father, Pellegrino, in his second. The first will is of 1517, the second of 1528 and the third of 1538 (Pungileoni overlooked the date of the last, but said it was later than the other two).

In the will of 1517 Melchior Fassi specified that he wished to be buried in S. Francesco at Correggio, and, in an addendum to the body of the will, existing only in a rough copy, named the church of S. Quirino at Correggio as residuary legatee, enjoining the church authorities to make a chapel with an altar and with an altarpiece of four saints – Leonard, Martha, Peter and Mary Magdalene. In the 1528 will the testator wishes to be buried in S. Maria delle Grazie at Correggio, and names the church of S. Domenico as residuary legatee, enjoining the fathers to erect a

chapel with an altarpiece on which is to be depicted the Virgin with St. Peter, St. Leonard, St. Mary Magdalene and St. Martha. In the final will (1538) the testator says he wishes to be buried to the left of his altar of St. Martha in the church of S. Maria Verberator, known as the Misericordia or Hospital of the Poor. The latter institution is also named as residuary legatee.

Two interpretations of these wills have been made in the past. One has assumed that the Metropolitan Museum picture was commissioned in accordance with the will of 1517 and therefore that it dates from then or soon after.[5] The other has indicated the difference in the wording between the references to the pictures in the 1517 and 1528 wills (of which only the latter specifies that the picture is to be painted *ad hoc*) to suggest that the 1517 will envisaged incorporating in the new chapel at S. Quirino a picture which already existed.

Though the latter possibility could not be entirely discounted the present writer thinks that, like the first, it is probably wrong. The style of the Metropolitan Museum picture, which lacks the Roman quotations found in the St. Francis altar of 1514–15, seems to him, for that reason alone, appreciably earlier than that date. In addition, we can now see that at the time of the 1517 will Melchior Fassi already had an altar in the Misericordia ('in utilitate ipsius altaris situati in ecclesia dictae hospitalis')* – evidently the one referred to in his final will of 1538 as his altar of St. Martha.

The proposal for a chapel with an altarpiece of four saints in the 1517 will was linked with the nomination of the church of S. Quirino (which in fact was being rebuilt at the time)[6] as residuary legatee. This bequest was cancelled by the 1528 will, in which a different church – S. Domenico – is specified as residuary legatee, this time linked with the commissioning of what was certainly not an existing picture ('in ipsa ancona depingi facere') ('to cause to be painted in that picture') representing the same four saints with the addition of the Virgin. This in its turn was cancelled in the 1538 will, which specified the hospital of the Misericordia as residuary legatee and made no provision for a new altarpiece or chapel.

It is therefore likely that the present picture – for whose provenance from the hospital of the Misericordia at Correggio there is some evidence (see PROVENANCE below) – was painted for the Misericordia some time before 1517, and probably before 1514, and remained there until the eighteenth century.

See text, page 37.

PROVENANCE Probably the former church of S. Maria della Misericordia at Correggio. A marginal note in a copy of the 1550 edition of Vasari, stated by Ricci to be in a seventeenth-century hand,[7] mentions a picture of Saints Peter, Leonard, Martha and Mary Magdalene by Correggio 'in the church of S. Maria known as li Bastardini' at Correggio. A further MS. note – in the Zuccardi chronicle (pre-1690) – published by Pungileoni[8] says 'in S. Maria è il quadro del Correggio, ruinato però per timore fosse anch'esso asportato'.† In view of later references to the varnish this probably refers to the present picture and presumably alludes to the marauding activities of Francesco I d'Este in the 1630s, '40s and '50s (see Appendix A). A letter of 1776, published by Pungileoni,[9] says the picture was then still in the Misericordia, and mentions the varnish – evidently a dark varnish put on to discourage attempts at theft. Tiraboschi (1786)[10] quotes Resta on the subject, but both are confused. Lanzi (1789)[11] indicates Tiraboschi's confusion of the original with a copy (presumably the one now in S. Francesco at Correggio, in which, as Tiraboschi says, the St. Mary Magdalene is changed into a St. Ursula) Lanzi adds that the original at the time of writing was with 'Signor Antonio Armanno' who had successfully cleaned it, and that the copy had replaced it in the church.

* 'situated in the church of the said hospital.'

† 'in S. Maria is the Correggio, but spoilt through fear that it would be stolen.'

A note by Michelangelo Gualandi[12] says that Armandi (evidently the same as Lanzi's 'Armanno') was a dealer who had sold the copy of Correggio's *Christ*, now in the Vatican, to Count Marescalchi. A letter from the poet Shelley[13] described what is pretty certainly identical with the latter picture as being, together with what was undoubtedly the present one, in a palace at Bologna of which he had forgotten the name. Though he names Palazzo Marescalchi immediately afterwards in a different context it does seem more likely that it was there that he saw the present picture rather than Palazzo Hercolani, which is where Waagen (1838), who saw the present picture in London, says it came from.[14] In addition, a note published by Martini[15] mentions the present picture as having been in Casa Marescalchi at Bologna. In Waagen's day it was already in the collection of Lord Ashburton in London, where it was described by, among others, Morelli (1875).[16] Sold by Lord Ashburton (the fifth Baron) to a consortium of Agnew's, Sulley, and another, 1907, and by Agnew's to the Metropolitan Museum, 1912 (Kennedy Fund).

COPIES Correggio, S. Francesco. The figure who is St. Mary Magdalene in the Metropolitan picture here holds a tall banner and is identified by Tiraboschi and Pungileoni as St. Ursula. Pungileoni also cites another copy, in his day in Casa Gerez at Correggio.[17]

REFERENCES [1] Dimensions from the Metropolitan Museum catalogue, 1940. [2] Mr Everett Fahy informs me there is no indication that the picture has been transferred from panel, and virtual certainty that it has not. [3] Pungileoni, II, pp. 94–5. [4] Pungileoni, loc. cit. [5] Most recently, notably Popham, 1957, p. 11. [6] Pungileoni, loc. cit. [7] Ricci, 1930, p. 152. [8] Loc. cit. [9] Vol. III, pp. 201–2. [10] Tiraboschi 1786, pp. 256–7. [11] Lanzi, *Storia Pittorica della Italia*, fourth edition, 1822, vol. 4, p. 62. [12] Printed by P. Martini, *Studi intorno il Correggio*, 1865, p. 67. [13] Dated 9 November 1818, addressed to Peacock. [14] *Kunstwerke und Künstler in England*, II, p. 80. [15] Op. cit., p. 72. The Marescalchi provenance is now confirmed by an entry listing the present picture in an unpublished inventory taken after Marescalchi's death in 1816 to which my attention was kindly drawn by Mrs Elizabeth Gardner, who found it in the Archiginnasio at Bologna in 1966. [16] 'Die Galerie Borghese' in *Zeitschrift für bildende Kunst*. Also in *Die Werke Italienischer Meister in den Galerien von München, Dresden und Berlin*, 1880, p. 147. Meyer (1871, p. 395) had dismissed the picture on inadequate grounds. [17] Op. cit., I, p. 64.

NEW YORK Dr and Mrs Rudolf
Heinemann (intended bequest to the
Museum of Fine Arts, Boston,
Massachusetts)

PIETÀ

Panel, 0·34 × 0·29 plate 21A

The two other painted versions and the print (see below) suggest that some cutting has taken place on the left. (By conflating my visual recollection and the evidence of the photographs and X-rays I conclude that this picture is the original. But I emphasise that it is eleven years since I saw it.)

See text, page 50.

PROVENANCE A *Pietà* by Correggio, specified as small, was mentioned at Mantua in 1627.[1] Others, or the same, mentioned in the Commonwealth inventory of Charles I's collection, and at Ferrara in 1734.[2] There would be no means of knowing if either of these was identical with the present picture. This one first published by E. Tietze-Conrat (1916) as in a private collection in Vienna.[3] Specified by Gronau[4] and Schottmüller,[5] 1917, as in the Moll collection, Vienna. Moll sale, 20 March 1917. What was evidently the same picture mentioned by Venturi as in the Eissler collection, Vienna.[6] Reproduced by Ricci (1930) with the mistaken ownership of Lord Lee of Fareham (which was another version – see below). Passed from the possession of Eissler to that of his adopted daughter, Mrs Morelli, Vienna, and from her to Dr and Mrs Heinemann. Exhibited Boston, Massachusetts, Centennial Exhibition, 1970 (37).[7]

VERSIONS (1) Parma, S. Sepolcro. East altar of south aisle. Large old copy. (2) London, Courtauld Institute. Published by Roger Fry (1928) as in the collection of Viscount Lee of Fareham.[8] This is very damaged and markedly inferior to the Heinemann picture. It has more space on the left, and more complex branches of a tree seen against the light on the right. One of these versions engraved (as Correggio) by J. B. P. Lebrun, 1809.[9]

REFERENCES [1] A. Luzio, *La Galleria dei Gonzaga* ..., 1913, p. 140. [2] O. Miller. *Walpole Society*, vol. 43, 1972, p. 218: 'Marie with a dead Christ in her lapp per Correggio'. J. Agnelli, *Galleria di Pitture del Cardinale Tommaso Ruffo*, Ferrara, 1734, pp. 44-5. This one specified as 2 × 3 palmi and as formerly in the Del Carpio collection. [3] *Yearbook of the Zentralkommission*, Vienna, 1916, pp. 174-9. [4] 'Die Wiener Sammlung Moll' in *Zeitschrift für bildende Kunst*, 1917, p. 127. [5] 'Die Gemäldesammlung Oskar Moll' in *Der Cicerone*, February 1917, pp. 101-10. [6] Venturi 1926. [7] Reproduced Berenson, *Lists*, 1968, pl. 1791. [8] *Burlington Magazine*, 52, 1928, p. 109. [9] *Recueil de Gravures au Trait*, 1, no. 61 'hauteur 17 ponces ½, Largeur 14 ponces, sur bois'.

ORLEANS Musée des Beaux-Arts

MADONNA AND CHILD WITH ST. JOSEPH AND THE GIOVANNINO

Panel, 0·64 × 0·53 plate 91A

Lépicié's catalogue of the French royal collection (vol. 2, 1754) calls it damaged by 'le temps & les prétendues restaurations ('time and so-called restoration') but says the heads of the St. Joseph and of the Virgin were then well preserved, together with part of the Christ child. The latter is taking the reed cross from the Giovannino. There are now obvious worn passages in the Christ child's body, and the heads of St. Joseph and of the Virgin (and also of the Giovannino and both the Virgin's hands) are unconvincing in effect, presumably through retouching, though in gallery lighting the pigment is not obvious as retouching.

Behind the Madonna a hedge, the handling of which is convincing as Correggio.

The reverse has the brand of Charles I and the collector's mark of Jabach.[1]

As 'manière du Corrège' in Le Brun's inventory (1683).[2] As 'estimé du Corrège' in Bailly's inventory (1709-10).[3] Lépicié has it under Correggio. In Villot's Louvre catalogue (1854, no. 530) among the anonymous. The catalogue of the Petit Palais exhibition, 1965-6 quotes Waagen as following the anti-Correggio line which was general in the nineteenth century. At Orléans from 1872 as 'inconnu de l'Ecole lombarde' ('anonymous Lombard school'). Republished as Correggio by Longhi (1921).[4]

See text, page 84.

PROVENANCE Charles I (on the strength of the brand, but not in Van der Doort's catalogue of *c.* 1639). Could be the 'Mary, Christ and Joseph' by Correggio (from Greenwich) which was sold to 'Mr Baggley and others' 23 October 1651, or the 'Mary, Joseph and ye Boy' of Correggio, which was sold to 'De Critz and others', 23 October 1651.[5] Thence, via Jabach (on the strength of the mark) to Louis XIV. No. 94 in Le Brun's inventory (1683).[6] At Versailles

from 1695.[7] No. 5 of the Ecole Lombard in Bailly's inventory (1709–10).[8] No. 1 of the Correggios in Lépicié's catalogue, vol. 2 (1754). At the Louvre after the Revolution. Sent to Orléans, 1872. Exhibited Paris, Petit Palais (*Le xvi^e Siècle Européen*), 1965–6 (89).[9]

REFERENCES [1] A. Hulftegger, 'Notes sur la Formation des Collections de Peintures de Louis XIV' in *Bulletin de la Société de l'Histoire de l'Art français*, 1954, p. 131, n.2: 'la marque de Charles I et un débris de cachet qui est celui de Jabach' ('the mark of Charles I and the remains of a seal identifiable with Jabach's'). [2] Quoted by F. Engerand, *Inventaire des Tableaux du Roy...*, 1899, pp. 129–30. [3] Engerand, loc. cit. [4] *L'Arte*, pp. 1–6. [5] Information from Oliver Millar. [6] Engerand, loc. cit. [7] Engerand, loc. cit. [8] Engerand, loc. cit. [9] Catalogue has further bibliographical references.

PARIS Louvre

THE MARRIAGE OF ST. CATHERINE

Panel, 1·05 × 1·02[1] colour plate I, plate 161A

St. Catherine's face and the Madonna's neck evidently a little worn but the picture probably fairly well preserved in general. *Pentimento* in the outline of the Christ child's stomach. Cleaned in the 1960s.

St. Sebastian, top right. His martyrdom is seen top left, in which his body, tied to a tree with his arms outstretched, more or less repeats an attitude which Correggio had worked out for a Cupid tied to a tree (Popham 18v) (plate 178c). Centre background, the martyrdom of St. Catherine of Alexandria.

Identifiable with a picture described by Vasari as painted for a close friend, the doctor Francesco Grillenzoni of Modena: '...un gran quadro, che è cosa divina, nel quale è una Nostra Donna che ha un putto in collo, il quale sposa Santa Caterina, un San Bastiano, ed altre figure, con arie di teste tanto belle, che paiono fatte in paradiso; nè è possibile vedere i più bei capegli nè le più belle mani, o altro colorito più vago e naturale. Essendo stato dunque da messer Francesco Grillenzoni, dottore e padrone del quadro, il quale fu amicissimo del Correggio...'*[2]

See text, page 117.

PROVENANCE Despite some uncertainty concerning the picture's movements in the seventeenth century Vasari's mention that Francesco Grillenzoni's Correggio of the *Marriage of St. Catherine* included St. Sebastian suffices to identify it with the present picture. Two letters of 1582 published by A. Venturi[3] demonstrate that in that year Cardinal Luigi d'Este

* '...a big picture, a most divine thing, in which the Madonna has the child in her lap, who is wedding St. Catherine, also a St. Sebastian and other figures, whose heads are so beautifully painted that they might have been done in paradise. Nor is it possible to find more beautiful hair or hands or finer or more naturalistic colouring. It is with Francesco Grillenzone, a doctor, who ordered the picture, and was a close friend of Correggio's.'

exerted pressure on Iacopo Grillenzoni to surrender the picture to Caterina Nobile Sforza, Contessa di Santa Fiora. A document of 1595 mentions it in the possession of Contessa Santa Fiora in Rome ('una Madonna con Santa Caterina e San Sebastiano di Correggio').[4]

In 1614 said to be recorded in the possession of Cardinal Sforza in Rome.[5] The latter died in 1624.[6] A letter of 1628 from Daniel Nys to Endymion Porter says 'Hora tratto a Roma per avere il quadro di Sta Catarina del Correggio, et spero mi riuscirà'[7]* – which may or may not refer to this picture. Sandrart gives a fanciful account of the origin of the Grillenzoni picture, but describes it correctly as including St. Sebastian 'und andern halben Bildern, Lebensgrösse'[†] and says he himself saw it in 1634 chez Cardinal Scipione Borghese who had bought it for a great sum and refused large offers for it.[8] Cardinal Scipione had died in October 1633, but Sandrart's account suggests that he knew what he was talking about and that his information in general is probably correct. What was certainly the present picture was evidently acquired soon afterwards by Cardinal Antonio Barberini who took it to France (he fled there in 1646) and presented it to Cardinal Mazarin.[9] Mazarin inventory, 1661, no. 1211.[10] Bought from Mazarin's heirs by Louis XIV. No. 149 in Le Brun's inventory (1683). In 1695 at Versailles. Bailly's inventory, 1709-10.[11] In 1715 in the duc d'Antin's private residence in Paris. Back at Versailles, 1737. Described by Piganiol de la Force and Lépicié. In the Louvre catalogue of '25 Messidor an IX' = 14 July 1801, no. 756. Exhibited Paris, Petit Palais (Cimabue à Tiepolo), 1935 (117).

COPIES Vasari records one by Girolamo da Carpi, others by Annibale and Agostino Carracci, Bernardino Gatti and Cigoli (the last-named reported by Ricci II in the Orphans' Home at Pistoia). De los Santos reports a copy in the Escorial attributed to El Greco.[12] Copies are recorded in the Capitoline and Dresden museums. One was in the collection of Charles I.[13] One was in the Bridgewater House collection. I saw one in an antique shop at Châteauneuf-de-Grasse in 1969 with a 'signature' and the date, 1530 – another invented date. Innumerable others.

ENGRAVINGS By Et. Picart and F. F. Aquila.

REFERENCES [1] Measurements from the Louvre catalogue. [2] Vasari, VI, pp. 470-1 (life of Garofalo and Girolamo da Carpi). In his life of Correggio (IV, 116) Vasari speaks of a Correggio *Madonna* in Modena considered the best picture there. This could have been the present picture or the *Madonna with St. Sebastian* or the *Madonna with St. George*. [3] A. Venturi, *Un quadro del Correggio* (Per le Nozze... Laura Gazzoli...Francesco Cugini), 1882. This includes an exposé of the successive fanciful accounts of the circumstances of the picture's origin. In a further article ('Il Correggio a Modena', *Il Panaro*, Modena, 26 June 1887) (Battaglia 344) Venturi suggests an imaginary date (1520) for the picture, and implies, without evidence, that tendencies of the Grillenzoni in favour of the Reformation influenced Correggio. [4] L. Urlichs, in *Zeitschrift für bildende Kunst*, 1870, pp. 47ff. [5] F. Villot, *Notice des Tableaux...du Louvre*, 16th edition, 1869, p. 14. [6] Tiraboschi, p. 278. [7] Luzio, pp. 154-5. [8] Sandrart, *Teutsche Academie*, book 2, part 2, f. 91b, ed. Peltzer, 1925, p. 269. [9] Villot, loc. cit. Mengs, II, p. 150 says it was given by Cardinal Antonio Barberini to Cardinal Mazarin, but he mistakenly includes the Louvre *Virtues* and *Vices* in the same gift. After Cardinal Scipione Borghese's death his collection was put under an entail. If the present picture really did belong to him Cardinal Antonio Barberini would have had to move quickly to get hold of it before the entail became effective. [10] *Les Richesses du Palais Mazarin*, ed. Cosnac, second edition, 1885, p. 334. [11] N. Bailly, (ed. Engerand), *Inventaire de Tableaux du Roy*, 1899, pp. 126-7. [12] *Descripción...del Escorial*, ed. Sánchez Cantón, 1933, p. 247. [13] Van der Doort's inventory, ed. O. Millar, *Walpole Society*, 1960, p. 26, no. 18.

* 'Now I'm negotiating in Rome for the St. Catherine of Correggio and hope to succeed.'
† 'and other half length pictures, life size.'

PARIS Louvre

VENUS, CUPID AND A SATYR

Canvas, 1·885 × 1·255 plates 176 to 178

Cleaned c. 1780 ('L'Antiope endormie par le Cor-
rège, avoir occupé six jours pour nettoyer ledit
tableau, 100 livres')* and in 1786 ('L'Antiope du
Corrège, pour l'avoir netoyé [sic] et levé les anciens
repeins en grande quantité sur les parties lumineuses,
avoir gratté le plus de gersures possibles et les plus
apparentes pour éviter d'y refaire des repeins qui ont
été seulement obligés à la hanche et à quelques parties
du col et au corps de l'enfant, 200 livres').¹†

Present condition (1971) appears basically good
under very yellow varnish.

In modern literature called *Antiope*. However, the
presence of the torch indicates Venus, and the bow
and quiver and arrows show that the winged child is
Cupid, who has no place in the seduction of Antiope
by Jupiter, in which, moreover, Antiope is not said
to be asleep. Furthermore the Antiope identification
only dates from the eighteenth century.² The earliest
reference to the present picture, of 1627, describes it
as 'Venere et Cupido che dorme et uno Satiro'‡
(evidently this picture, though the painter's name is
omitted).³ The final indication that the foreground
figures are intended for Venus and Cupid comes from
the consideration that the picture was evidently
painted as pair to *The School of Love* (London) which
certainly portrays Venus and Cupid (with Mercury).
The originals are first recorded (at Mantua) together
(in 1627) and what were evidently old copies are
noted together (at Besançon) even earlier, in 1607.⁴

* 'Antiope asleep, by Correggio, to spending six
days cleaning the picture, 100 livres.'

† 'The Antiope of Correggio, to cleaning it, and
removing old repaints in great quantity from the
luminous portions, as many of the cracks as possible,
and the most noticeable ones, being scraped to avoid
re-doing the repaints which were only necessary in
the hip and several places in the neck and in the
child's body – 200 livres.'

‡ 'Venus and Cupid, asleep, and a satyr.'

Another pair of copies is recorded in the collection of
Charles I and referred to there as *Venerie Coeleste* (the
London picture) and *Venerie Mundano* (the Louvre
one).⁵ The contrast between two forms of love,
intellectual and carnal, is thus fairly clear, however
many subdivisions the subtlety of the original pro-
gramme adviser or of twentieth-century iconologists
might make.

See text, page 126.

PROVENANCE Mantua, 1627 inventory.⁶ Van der
Doort's inventory of Charles I's collection, London,
c. 1638.⁷ Commonwealth sale, 23 October 1651, sold
to 'Mr Murray'.⁸ Then seen by R. Symonds with
Knightly.⁹ Said to have been acquired by Jabach,
Paris, and passed from him to Mazarin.¹⁰ Mazarin
inventory, 1661, no. 978 ('...Corrège...une Vénus
nue dans un paysage, un petit Cupidon pres d'elle
dormans, hault de cinq piedz neuf poulces').§ 1683
Le Brun inventory ('122 Une Venus avec un satir et
un amour').¹¹ At Versailles, 1695, in store. In 1706
in the office at Versailles of the Surintendance. Bailly's
inventory (1709–10) as *Antiope*. In 1715 in the resi-
dence of the duc d'Antin in Paris. Then in the Louvre
but returned to the office of the Surintendance in
1737. 1750 in the Luxembourg. Lépicié's inventory
(1752) (as *Antiope*). At the Louvre from 1785.
Exhibited Petit Palais, Paris, 1935 (Exposition de
l'Art italien de Cimabue à Tiepolo, no. 118).

DRAWING Windsor. Popham 81 (plate 178B). Red
chalk. Study for Venus, rather more upright than in
the painting. Popham admits that his no. 80 might be
an early idea for the present picture, but this would
be difficult to reconcile with the fact that the intended
format of the painting – indicated by a rectangle on
the drawing – is quite different from the proportions
of both the painting and its pair. It seems inconceiv-
able that anyone should truncate a figure at the knees
(as is done on the drawing) if the format of the
painting is to be tall and narrow.

§ '...a naked Venus in a landscape, a small Cupid
asleep at her side, five feet, nine *pouces* high.'

COPIES For old recorded copies see above. One to hand is at Saltram (Devon), with rather more surround. Miniature copy by Peter Oliver, dated 1633, in the collection of H.M. The Queen.

ENGRAVINGS By F. Basan (plate 178A), J. Godefroy and P. Audouin.

REFERENCES [1] F. Engerand, *Inventaire des Tableaux du Roy rédigé en 1709 et 1710 par Nicolas Bailly*, 1899, p. 129. The painter, J.-L. David, delivered an attack on the restoration of this picture among others (see J. L. J. David, *Le Peintre Louis David*, 1880, pp. 171–2. [2] Bailly's inventory, ed. Engerand, p. 129. See *passim* Lauren Soth, 'Two Paintings by Correggio' in *Art Bulletin*, XLVI, 1964, pp. 539ff. and XLVII, 1965, pp. 542–4 (letters from him, E. Verheyen and M. Laskin). Also Verheyen, 'Eros et Anteros' in *Gazette des Beaux-Arts*, sixth period, vol. 65, 1965, pp. 321ff. Soth drew attention to a woodcut in the *Hypnerotomachia Poliphili* as source for the present picture. Though the motive of the satyr lifting a curtain from the sleeping nymph in the present picture may owe something to this idea, the relationship of the figures to each other in a formal sense seems to derive from Michelangelo's *Temptation of Adam and Eve*, as suggested by Wilde to Popham (Popham, 1957, p. 91). Popham's suggestion that Correggio might even have modelled a figure from Michelangelo's design and turned it round for use in the present picture would not accord with the angle of the head. But he astutely drew attention to Parmigianino's *Martyrdom of St. Agatha*, in S. Giovanni Evangelista, suggesting that this also may derive from Michelangelo's Eve by way of a drawing by Correggio. Verheyen's article suggests, among other things, that the Cupid in the present picture is based on an antique marble of a sleeping Cupid attributed to Praxiteles, which is recorded in Isabella d'Este's possession. This would be possible but the point cannot be demonstrated. Verheyen might have added in this context that Isabella also owned a sculpture of a sleeping Cupid by Michelangelo, described (in a letter of 1496 by A. M. de Mirandola) as 'si ghiace et dorme posato in su una sua mano' ('lying asleep on one hand') – which would fit the pose of the Cupid in the present picture. Verheyen also drew attention to the sketch in the British Museum (Popham 18v) (plate 178C) of Cupid bound to a tree (on the back of a study for the pendentive of Saints Matthew and

Jerome in S. Giovanni Evangelista) and suggested, in accordance with his reading of the Eros/Anteros theme, that this was the original subject of the present picture and that the theme was then changed. This also is plausible but not demonstrable. [3] A. Luzio, *La Galleria Gonzaga...*, 1913, p. 90. [4] See entry for *Mercury instructing Cupid before Venus* in the National Gallery, London. [5] See reference 4. [6] Luzio, loc. cit. [7] Ed. O. Millar, *Walpole Society*, 1958–60, p. 22, no. 12. [8] Information kindly supplied by Oliver Millar. [9] British Museum, Egerton MSS. no. 1636. [10] L. Clément de Ris, *Les Amateurs d'Autrefois*, 1877, p. 138. [11] F. Engerand, loc. cit. and for further information on the picture's movements in the Paris area.

PARIS Louvre

ALLEGORY OF VIRTUE

Canvas, 1·41 × 0·86 plates 180, 181

In a letter of 1628 (see PROVENANCE) described as 'tempera'; in Van der Doort's catalogue of Charles I's collection as 'water cullers'. Lépicié's French royal catalogue of 1751–4 has 'à détrempe' and the 1926 Louvre catalogue 'gouache'.

Apparently very good condition; perhaps a little less good than the *Allegory of Vice* (Louvre).

On the left, a seated woman with a serpent in her hair holds a bridle in her left hand and a sword in her right (resting over her knees, on a lion's skin). The woman seated in the centre holds a broken shaft in her right hand and a helmet in her left. The aegis (shield with the head of Medusa) is at her feet, mixed up with a wolfish head and a serpent's tail. On the right, a third woman squats, holding a pair of dividers in her right hand above a globe, and pointing with her left into the background. A naked child stands touching her right thigh. A winged female, behind the central seated woman, extends a laurel wreath with her right hand, and holds a palm with her left. Above, a fully dressed winged figure hovers in the air on the left, holding a lyre. A second, centre, with her left

breast revealed, has her right hand on the lyre and holds a trumpet with her left, the other end of which is also held by a third, nearly naked flying figure.

In the earliest reference to this picture – the inventory of 1542 of the 'studio che è in Corte Vecchia appresso la grotta'* (of Isabella d'Este in the palace at Mantua) it is assumed that the figures in the foreground are three of the four cardinal virtues – Justice, Temperance and Courage.[1] But it has been pointed out that the one on the left has attributes associated with all four – serpent, sword, bridle and lion's skin.[2] In consequence, though the general theme of the picture, alike intrinsically, in contrast with its pair, and in relation to the other pictures (by Mantegna, Costa and Perugino) from Isabella d'Este's studio, certainly pertains to the virtues, the exact and specific significance of each component element is likely to remain in dispute. The broken shaft held by the central figure recurs (held by Minerva) in Mantegna's *Minerva expelling the Vices* (Louvre, from Isabella's studio), in which there are also arbours similar to the one in the present picture, and also three of the cardinal virtues (in the sky). Wind (loc. cit.) assumed the two pictures hung next each other. In the 1542 inventory the present picture and its companion are noted as flanking the door. The inventory starts by listing the pictures clockwise from the window and describes the *Vices* before the present picture. The natural deduction from this would therefore be that the *Vices* hung on the left of the door and the *Virtues* on the right – which would indeed bring the *Virtues* next to Mantegna's *Minerva*, as first on the next wall. If this was in fact the case it would have to be assumed that Correggio misunderstood the destined placing of his two pictures, as the lighting in the present one is from the right, and in the *Vices* from the left. As the window is opposite the door there can be no doubt – and the design of both pictures supports this – that the artist intended the *Virtues* to hang on the left and the *Vices* on the right. But it is not certain that the inventory means this. It does not specify

right and left, and in the succeeding entries departs from its original clockwise sequence. The fact, as shown by the Suida drawing (see below) that at one time Correggio toyed with the composition of the present picture in the reverse sense and with reverse lighting renders a mistake by him in the final painting unlikely.

See text, page 128.

PROVENANCE Isabella d'Este, 1542. Mentioned in a letter of 27 March 1627 from Daniel Nys, in connection with the sale of the Mantua pictures to Charles I: 'Duo quadri del Coregio nella Grotta: Marsio e Apollo et a l'imposto tre deita.'[3]* In letters from Nys to Endymion Porter he says 'Il Si.r Lanier parte questa sera con duo quadri del Corregio, li piu belli che siano al mondo, et queli soli vagliono li danari che si ha pagato del tutto'† (27 April 1628) and 'Lui [Lanier] porta con lui duo quadri del Correggio a tempera...liquali sono gli piu belli quadri che si va al mondo.'[4]‡ In Van der Doort's inventory of Charles I's collection noted among those kept in store.[5] In the Commonwealth sale sold for £1,000 to De Kritz and others (23 October 1651) and seen by R. Symonds chez De Kritz.[6] Apparently then passed from Jabach to Louis XIV,[7] No. 55 in the Le Brun inventory of Louis XIV's pictures (1683).[8] At Versailles by 1695, where protected by glass in the depot. In the Petite Galerie du Roy, Versailles, in Bailly's inventory (1709–10). Noted by Richardson (1722) among 'The French King's Pictures in Coypel's House' (in Paris).[9] Back in the Petite Galerie at Versailles, 1737. In the Département des Dessins of the Louvre at the time of Engerand's edition of

* 'studio in the Corte Vecchia near the grotto.'

* 'Two pictures by Correggio in the grotto: Apollo and Marsyas and on the other side three deities.'

† Signor Lanier leaves this evening with two pictures by Correggio, the loveliest things on earth, and these two alone are worth what has been paid for the whole lot.'

‡ 'He brings with him two pictures by Correggio in tempera...which are the most beautiful pictures in the world.'

Bailly (1899). Exhibited Parma, Correggio exhibition, 1935 (45).

DRAWINGS Louvre, Popham 89r (plate 181A) and v. Pen and ink and wash. Two early designs for main figures.

Formerly Professor W. Suida, New York. Popham 90 (plate 181B). Pen and ink and wash. Later than above. Study in reverse (and with opposite lighting, i.e. from the left) for the two left hand figures in the painting.

VERSION Rome, Doria gallery (unfinished), q.v.

COPIES Recorded as made by Rubens at Mantua in 1605 for the Emperor Rudolf.[10] Not at present identifiable. One is in the Walters Gallery, Baltimore.

ENGRAVINGS E. Picart, 1672; L. Surugue, 1720.

REFERENCES [1] Published by A. Luzio, 1908. Also by Carlo D'Arco, *Delle Arti e degli Artefici di Mantova*, II, 1857, p. 134. [2] E. Wind, *Bellini's Feast of the Gods*, 1948, p. 52, and Lauren Soth, 'A Note on Correggio's Allegories of Virtue and Vice', *Gazette des Beaux-Arts*, sixth period, vol. 64, 1964, pp. 297ff. See also Popham 1957, p. 99, and E. Verheyen, *The Paintings in the Studiolo of Isabella d'Este at Mantua*, 1971. K. M. Swoboda, *Neue Aufgaben der Kunstgeschichte*, n.d., Vienna, p. 103, denies Correggio's execution of this picture and its pair. [3] A. Luzio, *La Galleria dei Gonzaga venduta all'Inghilterra nel 1627–28*, 1913, p. 139. [4] Luzio, op. cit., p. 155. [5] Ed. O. Millar, *Walpole Society, 1958–60*, pp. 156–7. [6] Information kindly supplied by Oliver Millar. [7] L. Clément de Ris, *Les Amateurs d'Autrefois*, 1877, p. 138. [8] F. Engerand, *Inventaire des Tableaux du Roy rédigé en 1709 et 1710 par Nicolas Bailly*, 1899, pp. 127–9. Also for subsequent information on the picture's movements except for Richardson's. [9] Richardson, *An Account of...Pictures in Italy*, 1722, p. 15. [10] Luzio, op. cit., p. 113.

PARIS Louvre

ALLEGORY OF VICE

Canvas, 1·41 × 0·86 plates 181, 182

For statements on the medium see preceding entry.

In gallery lighting and under glass the condition seems almost perfect. The shadows of the flesh show more stippling than in the *Virtues*. Some *pentimenti* in the right leg of the central figure.

In the centre a naked bearded man sprawls, his hands bound to the branches of a tree behind him. On both sides of him and behind three nearly naked women, each with serpents in her hair, torment him. The one behind blows a pipe in his ear, the one on the left extends snakes towards him, and the one on the right binds his left leg. In the centre, below, the head and shoulders and hands of a boy holding grapes.

In the 1542 Isabella d'Este inventory,[1] and in Daniel Nys' letter of 27 March 1627,[2] as *Apollo and Marsyas*. Presumably the figure on the left was identified as Apollo, but the breasts are female, and Apollo would not have serpents in his hair. Nor is it likely that what the woman on the right is doing to the man is flaying him.[3] Both his wrists and the upper part of his right arm are already bound, and she is doing the same to his left ankle. Though some doubt must remain both as to the identity of the figures and to the exact meaning of the allegory, its general sense and its relation to the other pictures in Isabella d'Este's studio (see entry for preceding picture) leave no doubt of the applicability of the traditional title of *Allegory of Vice*. The absence of the boy in the foreground from the otherwise fully developed study in the British Museum suggests a certain flexibility in illustrating the iconographic programme.

See text, page 128.

PROVENANCE The same as the preceding picture except, apparently, for a time after both pictures were said to have been acquired by Jabach after the Commonwealth sale. Then the *Allegory of Virtue* is stated to have gone direct to the king, and the present picture to have passed first to Mazarin.[4] It

was no. 994 in the Mazarin inventory of 1661.⁵ No. 46 in the Correggio exhibition, Parma, 1935.

DRAWING British Museum, Popham 91 (plate 181c). Red chalk. Finished study for whole composition but omitting boy in the foreground.

COPIES Recorded as by Rubens (see preceding entry). A copy is in the Walters Gallery, Baltimore.

ENGRAVINGS E. Picart 1676; L. Surugue, 1720.

REFERENCES [1] Published by A. Luzio, 1908. Also by Carlo d'Arco, *Delle Arti e degli Artefici di Mantova*, II, 1857, p. 134. [2] A. Luzio, *La Galleria dei Gonzaga...*, 1913, p. 139. [3] L. Soth, *Gazette des Beaux-Arts*, sixth period, vol. 64, 1964, pp. 297ff. sees the male figure as a combination of Marsyas and Silenus, and indicates analogies with the left-hand side of the relief shown in Titian's votive picture of *Jacopo Pesaro* (Antwerp). E. Verheyen (*The Paintings in the Studiolo of Isabella d'Este at Mantua*, 1971) tentatively identifies the central figure as Vulcan and adduces an analogy (in Alciati's *Emblemata*) for a vine encircling a tree. He also makes the claim that the central figure in the *Vices* 'dwells in darkness' whereas the central figure in the *Virtues* 'lives in light'. The relevance of this to Correggio's paintings escapes me. [4] Engerand's edition of Bailly's inventory, 1899, p. 127. [5] Le Comte de Cosnac, *Les Richesses du Palais Mazarin*, second edition, 1885, p. 302.

PARMA
CAMERA DI S. PAOLO

colour plate B, plates 28 to 37

Fresco decoration of vault, wall lunettes and chimney-piece of a room c. 6·5 × 6 metres, formerly one of the abbess's private apartments in the Benedictine nunnery of S. Paolo. Now a show place. Restored, 1972. This revealed very good condition on the whole, except for a few patches in the foliage towards the top, which have been left unrestored.

Undocumented. The room is part of a suite whose construction was undertaken on behalf of Gioanna da Piacenza, who was abbess from 1507 until her death in 1524. Not mentioned by Vasari or in any other sixteenth-century published work. The first printed reference to it seems to be in Barri's *Viaggio Pittoresco* (1671), but there are MS. descriptions by Smeraldo Smeraldi (1598)¹ and Maurizio Zappata (c. 1700).² Despite the lack of documentation never doubted as Correggio's work.

Sixteen vaulting ribs (painted to represent double reeds or bamboos) divide the vault into a corresponding number of tall, concave compartments. A series of knots round the crown of the vault (which bears the abbess's arms) are imagined as suspending bunches of fruit in each compartment, in front of trellises of reeds or bamboo, through which foliage is seen. Towards the base of each compartment oval openings, outlined by wreaths of flowers and leaves, are painted, through which putti are seen against the open air. At the base of each compartment is a structural lunette whose curve is painted with a shell moulding (this occurs, among other places, on the Sistine ceiling). Painted figures simulating sculpture in the centre of each lunette. At the bases of the lunettes are painted cornices which appear to project forwards from the wall to connect with similar cornices painted at the bases of the (structural) ribs. The painted perspective of these is differential, calculated from the centre of each wall. Under the ribs, pairs of rams' heads (with beads hanging from their horns in

some cases) are painted, suspending cloths, in front of which metal vessels are painted. Narrow painted moulding at bottom of all.

CHIMNEY-PIECE

DIANA IN HER CHARIOT plates 33, 34

As analogy Ricci (1930) reproduces (pl. 3) part of an antique relief at Mantua.

SOUTH WALL plate 30

(In all the following sections the compartments are catalogued from left to right. For references to literature, see concluding paragraph.)

s1 Lunette: Seated bearded man, an ear of corn in his outstretched right hand. Affò, as symbol of tranquillity. Ricci quotes various interpretations – viz. Riposo, Meditazione and A Philosopher. Barilli, as the infant in Lunette s4 become old.
 Above: Two putti holding a long pole (? lance). Part of a third putto is seen on the right.
 Below: A pitcher.

s2 Lunette: End view of Classical temple with four Tuscan or Doric columns, a seated statue seen through the doorway. Affò, as Temple of Jupiter. Also Ricci and Panofsky. Barilli, as Religion triumphant over Death. Ricci (1930) reproduces coin of Domitian.
 Above: A putto with a bow on his knee (centre). Head and arm of another behind him. Part of a third, holding a spear (?), right.
 Below: Dish, with slender, inclined vase (?) in centre, and sprig of leaves to left.

s3 Lunette: The three Fates spinning (all are winged). See Panofsky, pages 36ff.
 Above: Three putti restrain a large white dog with a bridle.
 Below: Dish seen from the back. Sprig of leaves to left of it, axe head to the right.

s4 Lunette: Woman running to right, a child in her arms. Affò, as Vesta with the infant Jupiter. Meyer, as Ino Leucothea (nurse of Bacchus). Ricci, as that or Vesta. Barilli, as Levana. Panofsky, as Rhea.
 Above: Two putti with a brown dog.
 Below: Pitcher, tipped to right.

WEST WALL plate 32

w1 Lunette: Draped woman turning to left, torch in left hand, sphere in right. Ricci, as Ceres (1930, alternatively as Providenza). Ricci (1930) reproduces coin of the elder Faustina. Barilli, as Amore Onesto. Panofsky, as Diana Lucifera.
 Above: A putto, left, tries to blow the horn slung from the shoulders of the central one. A third, right, puts his hands to his ears, looking to right.
 Below: Pitcher.

w2 Lunette: Goat-legged and horned figure blowing conch. Ricci, as a satyr. Barilli, as Lussuria. Panofsky, as Pan.
 Above: A putto, right, blows a horn into the ears of another, left, who blocks his ears with his hands.
 Below: Dish seen from the back.

w3 Lunette: Woman facing left holding bird in outstretched right hand. Affò and Ricci, as Chastity. Ricci (1930) reproduces coin of Spes of Claudius I. Barilli, as Purity. Panofsky, as Confident Integrity.
 Above: Putto, centre, holds stag's head. Head of a white dog, right. Another putto, left.
 Below: Dish seen from front.

w4 Lunette: Woman holding lily in outstretched right hand. Ricci, Barilli and Panofsky, as Virginity.
 Above: Three putti, central one holding wreath.
 Below: Pitcher.

NORTH WALL plates 29, 36

n1 Lunette: Woman, facing left, with cornucopia in right hand, and rudder (resting on sphere) in left. Ricci and Panofsky, as Fortuna. Ricci (1930) repro-

duces coin of Tiberius Sempronius Gracchus. Barilli, as Fortuna or Buon Governo.

Above: One putto clutches another. No accessories.

Below: Nothing (because of window).

N2 Lunette: Woman, facing right, helmet on head, spear in right hand, torch in left. Ricci and Barilli, as Minerva. Ricci (1930) reproduces coin of Vibius Varus. Panofsky, as Bellona.

Above: Two putti struggling. One has pole, and thrusts his leg through the opening.

Below: Dish seen from front.

N3 Lunette: The three Graces. Popham (British Museum Catalogue, *Sixteenth-Century Parmesan drawings*, 1967, page 11) associates a drawing in the British Museum with the central figure in this lunette. But the pose is not the same: nor is the direction of the light.

N4 Lunette: Youth, naked, staff in right hand. Ricci and Barilli (latter with reserve), as Adonis. Panofsky, as Virtue. Panofsky reproduces detail of statue in Raphael's *School of Athens*, and other analogies.

Above: Two putti struggling. One, seen from the back, reaches up to pull down the ribbon hanging from the fruit above.

Below: Nothing (because of window).

EAST WALL colour plate B, plates 31, 35, 37

E1 Lunette: Young man, facing left, cornucopia in left arm, pours libation with his right on an altar, the ornamentation of which was revealed in 1972 as in low relief. Ricci, as Genius Populi Romani or Bonus Eventus. Ricci (1930) reproduces coin of Diocletian. Barilli, as 'Ricchezza bene adoperata' ('Riches well used'). Panofsky, as Genius. Drawing in the British Museum (Popham 9) (plate 37C). Model is a child.

Above: Putto with pole in left hand, a gold drapery over his right shoulder and left knee and a large stone on his head. Second putto, behind, puts his hands on a golden diadem worn by the first under the stone.

Below: Pitcher, sprig of leaves behind.

E2 Lunette: Seated woman, facing left, cornucopia in left hand, scorpion in right, a basket in front. Affò, as 'L'Affluenza dei beni' ('Affluence of goods'). Ricci, as Terra or Africa. Ricci (1930) reproduces coin of Hadrian. Barilli, as 'Ricchezza vana e superba' ('Proud and arrogant riches'). Panofsky, as Tellus. Drawing in the British Museum (Popham 9) (plate 37C).

Above: Putto with mask of Medusa. Second putto, right, clutches him. Drawing in the British Museum, in which the putti (three in number) are arranged differently (Popham 8) (plate 37B).

Below: Dish seen from front.

E3 Lunette: Young woman, naked, her hands bound above her head with gold band, her feet dragged down by two gold anvils. Affò and all later writers, as Punishment of Hera (from Homer).

Above: Putto, right, has arm round white dog. Putto, left, runs away.

Below: Dish seen from front.

E4 Lunette: Woman, facing left, long torch (?) in left hand, pours libation on altar (the ornamentation in low relief) with right. Ricci and Barilli, as Vesta or a Vestal. Ricci (1930) reproduces coin of the Elder Faustina. Panofsky, as Vesta.

Above: Putto, right, takes arrow from quiver. Second putto, left, watches.

Below: Pitcher. Sprig of leaves behind it.

Of the numerous commentators only four – Affò,[3] Ricci,[4] Barilli[5] and Panofsky[6] – have made serious constructive attempts to interpret all or most of the various features of the room. Affò's pioneer essay assumed derivation of the lunettes from antique medals, and listed collectors of them in Parma at the time. He suggested Philostratus as one textual source and Giorgio Anselmi as programme adviser. He interpreted the lunette (E3) of the Punishment of Hera as a warning to errant nuns. This idea was revived by, among others, Jean Seznec,[7] but the fact that the Camera was one of the *private* apartments of the abbess militates against it. Like Affò, Ricci prudently made no attempt at a general interpretation of

the allegory, while making pertinent observations on details. Arnaldo Barilli, on the other hand, published an elaborate one. According to him the centre of the wall facing the chimney-piece is the start of the cycle which then proceeds clockwise. The ovals of s3 to w4 refer to hunting, n1 to n4 to agriculture, e1 to e3 to civilisation and progress, and e4 to s2 to war. He therefore deduces from this an allusion to the Ovidian Four Ages of the World. The lunettes correspondingly begin with the three Fates in the centre of the south wall (s3) and end with the Temple (s2), the progression symbolising the course of human life. Barilli's ideas were opposed by his fellow Parmesan, Luigi de Giorgi, who assumed the cycle started on the north wall over the chimney-piece.[8] Panofsky began the cycle at the second compartment from the left on the west wall. He interpreted the west wall (minus, of necessity, the first compartment) as 'the panic terror defied', the northern as 'strife and concord, fortune and virtue', the southern (with the first compartment of the western) as 'no one escapes from what is ordained' and the eastern as 'the four elements'. Panofsky's complicated argument assumed certain allusions in the fresco to the abbess's current problems. Of other writers, Hagen tried to derive various features of the room from Raphael's Loggie and thus to bolster his view of the Rome journey.[9] Edgar Wind published some specific observations on the Three Graces and Three Fates in the Camera.[10] In 1811 Vivant Denon is said to have tried unsuccessfully to transfer the frescoes.[11]

See text, pages 51ff.

ENGRAVINGS Set by Rosaspina, from drawings by Vieira, with text by Gherardo de' Rossi published by Bodoni, Parma, 1800. Other editions and other prints later.

REFERENCES [1] Quoted by Ricci, 1896, p. 159. [2] Battaglia, no. 799. [3] *Ragionamento sopra una Stanza depinta...*, 1794. [4] Op. cit. [5] *L'Allegoria della Vita umana nel dipinto correggesco della Camera di S. Paolo in Parma*, 1906. Reprinted 1934. [6] *The Iconography of Correggio's Camera di S. Paolo*, 1961. [7] *La Survivance des Dieux Antiques*, 1940, pp. 104-5.

[8] 'La Camera di S. Paolo', contribution to *Il Correggio*, published by *Aurea Parma*, 1934, pp. 29ff. [9] 'Correggio und Rom' in *Zeitschrift für bildende Kunst*, 1917. Also same writer's contribution to *Festschrift H. Wölfflin*, 1924. [10] *Pagan Mysteries in the Renaissance*, 1958, pp. 36, 45, 51. [11] M.-L. Blumer, 'La Mission de Denon en Italie (1811)' in *Revue des Etudes Napoléoniennes*, 1934, II, p. 244.

PARMA
S. GIOVANNI EVANGELISTA

Decoration of the tympanum of north transept door, apse, choir, cupola (with its frieze, pendentives and arch soffit paintings), nave and Del Bono chapel.

plates 38 to 78

No contract survives. Payments to Correggio recorded from 6 July 1520 to 23 January 1524. The latter is specified as an end payment. A possible extra payment was made on 5 October 1525 (see page 182). Text of documents, page 180.

See commentary, pages 60ff.

Pungileoni speaks of the painting, attributed to Correggio, of a small dome in the monastic buildings (dormitorio) illustrating St. Benedict's ascent to heaven.[1] The attribution is unconfirmed and the work no longer exists. Pungileoni also attributed to Correggio (likewise unconfirmed) the decoration of a niche in the monastery garden, traces of which survive. Vasari is confused between Correggio's painting at S. Giovanni Evangelista and at the Duomo.

For the documentation of the building of the existing church see Mario Salmi, 'Bernardino Zaccagni e l'Architettura del Rinascimento a Parma' in *Bollettino d'Arte*, 1918, pages 85ff. For the alterations to the interior of the church in the seventeenth century see I. Mannocci, 'L'Abbazia di S. Giovanni Evangelista nella seconda metà del secolo XVII' in *Archivio per le Provincie Parmensi*, 1951, pages 123ff. The cupola frescoes were restored most recently in 1959–62, of which a report is printed by A. G. Quintavalle (*Gli Affreschi del Correggio in S. Giovanni Evangelista a Parma*, 1962, pages 37–49). An earlier report is printed by Ricci (1930, pages 162–3).

REFERENCE [1] Pungileoni, I, p. 90 and II, p. 126. Tiraboschi (p. 259) quoted the Abate Mazza as saying that payment had been made to Correggio as early as 1519.

TYMPANUM ON THE CHURCH SIDE OF A DOOR AT THE EAST END OF THE NORTH WALL OF THE NORTH TRANSEPT

ST. JOHN THE EVANGELIST WRITING HIS GOSPEL (lunette)

Fresco, 0·79 × 1·60[1] plate 38A

Pungileoni rebukes Ratti for exaggerating the damage to this work and says it was only restored in the saint's right arm.[2] Ricci II speaks of it as very dirty before it was restored in 1894 and covered with glass.[3] A photograph taken during the restoration of 1959–62, published by A. G. Quintavalle, shows that in the interval it had again become very much discoloured.[4]

Not mentioned in the documents. Mentioned by Barri (1671).[5] Mengs comments on the Raphaelesque style of the figure.[6]

See text, page 63.

ENGRAVINGS Ravenet, Rosaspina (1794).

REFERENCES [1] Dimensions from Ricci (1930). [2] Pungileoni, I, p. 146. [3] Ricci, 1930, p. 165. [4] *Gli Affreschi del Correggio in S. Giovanni Evangelista a Parma*, 1962, fig. 41, p. 48. [5] *Viaggio Pittoresco...*, p. 101: 'Sopra una porta piccola...un San Giovanni Evangelista dipinto a fresco di mano del Correggio'.* [6] Mengs, *Opere*, II, 1783 edition, p. 153.

APSE FRESCO
THE CORONATION OF THE VIRGIN

plates 38B to 43D

Destroyed c. 1586 when the choir was enlarged. The existing copy painted immediately afterwards by Cesare Aretusi[1] from (according to Malvasia and Ruta) copies of the original made by Agostino and Annibale Carracci.[2] The rescued central section of

* 'Over a small door a fresco by Correggio of St. John the Evangelist.'

the original (plate 40A) is recorded in 1706 in the collection of the Duke of Parma and was for many years set into the Biblioteca Palatina there. It is now in the Galleria Nazionale, Parma. Other small fragments from, or claiming to be from, the apse fresco are dispersed. Three (one of two small angels and two single ones) are in the National Gallery, London (nos. 3,920, 3,921, 4,067) (plates 38B, C, D), others in the Museum of Fine Arts, Boston, Massachusetts, and the Lechi collection at Brescia. The central section – of which A. G. Quintavalle notes that the top paint, *a secco*, is lost[3] – consists merely of the upper portions – from the knees up – of Christ and the Virgin, with the Dove. Its sinopia (differing in certain details, such as the lack of a sceptre) remains in the Biblioteca Palatina (plate 40B).[4]

To judge from Aretusi's painted copy (plate 39A) and from a copy drawing in the Uffizi (plate 39B), St. John the Evangelist knelt on the spectator's left, and the Baptist was seated on the right. The spaces between these two and the central pair were filled by two kneeling bearded sages in dark habits, set farther back and equipped with mitres and croziers (in front of them). They are plausibly identified with Saints Benedict and Maurus. Massed angels at both sides, and angels' heads above the clouds higher up. In Aretusi's copy the centre of the half dome at the top has a two-tiered arbour. The practice which Correggio followed here of including in *The Coronation of the Virgin* saints who would not physically have witnessed it had been exemplified in altarpieces of the same subject by, for instance, Costa (at S. Giovanni in Monte, Bologna) and Francia (in the Duomo at Ferrara and at S. Frediano, Lucca). See text, page 63.

DRAWINGS
(a) For Christ and the Virgin:
 Rotterdam. Popham 22 (plate 42C). Brush in brown, over red chalk.
(b) For Christ alone:
 Seilern collection, London (plate 42A). Red chalk over black chalk. Squared.[5]
 Louvre. Popham 25 (plate 41B). Red chalk.

Poitiers. Popham 23 (plate 42B). Pen and ink over red chalk. Squared.
Oxford, Ashmolean. Popham 24r (plate 41A). Red chalk.
Budapest (plates 41C, D). Double-sided sheet. Red chalk (recto) and ink over red chalk (verso).[6]
(c) For the Virgin alone:
 Louvre. Popham 26 (plate 43B). Red chalk, once reinforced with pen and ink.
 Louvre. Popham 29 (plate 43A). Red chalk, heightened with white. Squared. Facing in the opposite direction, and therefore not certainly connected.
 Budapest (plate 43C). Red chalk.[6]
(d) For the Baptist:
 Colonel Weld collection (from Ince Blundell Hall). Popham 27 (plate 42D). Red chalk. Squared.
(e) For background angels:
 Louvre. Popham 28r (plate 43D). Centre group, pen and ink and wash. Upper and lower groups, red chalk.

COPIES
(a) Of whole:
 Parma, S. Giovanni Evangelista, by Cesare Aretusi, *in situ* (more or less) (plate 39A). Florence, Uffizi, no. 14714 (drawing) (plate 39B).
(b) Of sections:
 Barri (1671) in his description of the Palazzo del Giardino at Parma, mentions (page 105) 'due copie di S. Giouanni, copiate da opere del Coreggio [sic] per un Valent'huomo'* and later (pages 108–9) speaks of a picture of flying angels, one of the Baptist, one of St. John the Evangelist with many angels, and finally pictures of St. Benedict and St. Maurus with angels, all by Annibale Car-

* 'two copies of St. John, copied from works of Coreggio [sic] for a gentleman.'

racci, and all rather larger than life. These
are not specified as after Correggio, but
obviously were. At about the same time
Bellori (1672)[7] mentions two large pictures
of Christ and the Virgin, copied by Anni-
bale Carracci from Correggio at S. Giovan-
ni Evangelista and then in Palazzo Farnese
in Rome. In his guide to Parma, Ruta (1752)[8]
mentions that Annibale's copies had been
taken to Naples. They do not figure in
recent catalogues, but Ricci (1930) repro-
duced five of them.[9] Eight other copies of
sections are in the Galleria Nazionale, Parma
and two more (ex-Queen Christina) in the
National Gallery, London (nos. 7 and 37).

REFERENCES [1] Tiraboschi (1786, p. 306) quotes
from the text of Aretusi's contract of 12 August
1586: 'ch'egli sia obligato di copiare con ogni dili-
genza quella Madonna coronata con quel Cristo che
sono nel nicchio di mano già di M. Antonio da Cor-
reggio con l'architrave, cornice, e fregio circostanti
nel detto nicchio, e tradurla, e trasportarlo nel
nicchio nuovo'.* [2] Malvasia, Felsina Pittrice, 1678,
I, p. 334. Ruta, Guida...di Parma, 1752 edition, pp.
57–8. Meyer 1871, p. 301, n.2 says that Malvasia's
view that Aretusi exploited the Carracci in this con-
nection is implausible. [3] A. G. Quintavalle, 1962,
commentary to pl. XL. [4] A. O. Quintavalle, 'Un
Disegno del Correggio scoperto...', Bollettino d'Arte
XXXI, 1937, pp. 80ff. [5] Catalogued in Italian
Paintings and Drawings at 56 Princes Gate, London
S.W. 7., Addenda, privately printed, London, 1969,
no. 352. [6] Published by Iván Fenyö, Burlington
Magazine, 101, 1959, pp. 421ff. [7] Le Vite de'
Pittori..., p. 23. [8] Guida...di Parma, 1752 edition,
p. 58. [9] Ricci, 1930, pls. CXXVIII, CXXIX, CXXX,
CXXXI, CXXXII.

* 'that he must copy diligently the Coronation of
the Virgin in the apse by the hand of...Correggio
with the architrave, cornice and frieze which goes
round the apse, and translate and transport it into the
new apse.'

DECORATION OF THE RIBS OF THE VAULT OF THE CHOIR BAY NEAREST THE CROSSING

plate 69

A contract of 11 July 1588, for the decoration of the
vault and side walls of this bay instructs the painter,
Innocenzo Martini, not to touch the existing paint-
ings on the vault ('nella volta non moverà quelli
fati'). As his own contribution was specified as a
putto in each of the triangular spaces ('nelli triango-
lari...uno sfondato con un putto dentro') it follows
that the surrounding decorative borders already
existed at that time.[1] In a MS. said to be of 1780 by
Padre Romualdo Baistrocchi,[2] and in Donati's guide
to Parma (1824)[3] these borders are attributed to
Correggio. The attribution was revived by A. G.
Quintavalle (1965). The photographs published by
her convincingly suggest Correggio's authorship of
the design. To what extent, if any, the execution may
also be his could not be settled. The twelve strips of
decoration – enclosing the four triangles of a single
quadripartite vault – basically repeat the same design,
with suitable reversings. A. G. Quintavalle associates
the work with a document of 5 October 1525, pub-
lished by Pungileoni.[4] His reading of it is: '...a mas-
tro Antonio da Correggio L.56.2 per la pittura fatta
al Choro all'intorno p. di fuori'.† In point of fact, the
original document, which is in the British Museum,
and which is reproduced in facsimile by A. G. Quin-
tavalle, reads: 'Conto di fabrica L 56.2 a mro. anto.
pictor per la pittura intorno al choro di fora.'5‡ The
omission of the words 'da Correggio' in the original,
and the invention of them by Pungileoni, may be
crucial. As this entry refers to a period nearly two
years after the end payment to Correggio, and as
there may well have been other painters with the
christian name of Antonio, no connection between

† 'To Master Antonio da Correggio L.56.2 in
respect of the painting done in the choir, around and
outside it.'
‡ 'Building account, L 56.2, to the painter Master
Antonio for painting round the choir outside.'

the document and the choir vault can be assumed. The work could well have come under the general heading of 'la pictura della capela granda', or, in another place, 'pictura et ornamento della capela granda'* as mentioned in the documents, one of which, in addition, refers to gilding on the 'friso et cornisoni' ('frieze and cornice'). It would seem at least open to argument whether the word 'cornisoni' might not refer on this occasion to the painting of the ribs of the vault.

REFERENCES [1] Document printed by A. G. Quintavalle in *Bollettino d'Arte*, 1965, p. 198. [2] Quoted by A. G. Quintavalle, loc. cit. [3] *Nuova Descrizione di Parma*, p. 41. A cryptic statement by Barri (*Viaggio Pittoresco...*, 1671, p. 101) – 'La Volta del Choro sono opere copiate dal Correggio di mano del baglione, però ritoccata da lui'† – was interpreted by Malvasia (Battaglia, 1934, no. 184) as referring to the apse. [4] II, p. 174. [5] A. G. Quintavalle (op. cit., p. 196) says that Pungileoni assumes the document referred to work on the old (destroyed) apse. Actually it is Popham (1957, p. 50) who suggests this. Pungileoni advanced a theory that it referred to work on an internal low wall surrounding the choir and situated under the main dome (see Appendix E). In general, see also the catalogue of the exhibition *Arte in Emilia 4*, Parma, 1971–2, no. 43.

REMAINS OF FRIEZE FROM SIDE WALLS OF THE CHOIR BAY NEAREST THE CROSSING

plate 68

Hidden by the organ-cases installed in 1636,[1] and unpublished until 1965.[2] Shortly before then two sections had been revealed when the organ-cases had been temporarily removed. The frieze fragments were then detached from the wall and are now in the monastery building. This frieze may have been in-

* 'painting of the choir chapel'...'painting and decoration of the choir chapel'.
† 'The choir vault are works copied from Correggio by Baglione and retouched by him.'

cluded in the vague wording of the documents – 'pictura et ornamento de la capela granda' (see above) – and may also be what is referred to as the 'friso' in the payment for gilding the 'friso et cornisoni de la capela granda'. A. G. Quintavalle identifies the subject as 'Christian Sacrifice', as distinct from the 'Pagan Sacrifice' and 'Jewish Sacrifice' which alternate on the nave frieze. The design is clearly comparable with that of the nave frieze – for which there are preliminary autograph drawings by Correggio. Whether, as A. G. Quintavalle claims, Correggio was also involved in the execution of the choir frieze would be questionable.

Exhibited *Arte in Emilia 4*, 1971–2, nos. 41–2 (Parma).

DRAWING Popham 28v (Louvre) (plate 68c) contains an architectural sketch of a triforium, evidently to be painted in *trompe-l'œil*, with a monk walking through it. Popham thought it might be a 'discarded plan' for the nave frieze, and positively identified another, very slight, sketch on the same sheet as for the nave frieze. In this little sketch the inscribed tablets are not held by the figures, as they are in the painting, but are indicated as on the 'capitals' of the pilaster strips. At the time when Popham's book was published (1957) attention had not been drawn to the remains of the choir frieze. The fact that the Louvre drawing in question has, on the recto, a sketch for the background of the *Coronation* in the apse prompts the question, in view of the relative chronology proposed in this book, whether one or both frieze designs on the verso may have been intended not for the nave but for the choir. The design for the *trompe-l'œil* triforium cannot be discussed further as nothing came of it. The remaining fragments of the choir frieze do not include seated figures at the sides, as, in the form of the prophets and sibyls, is the case with the nave frieze, but as they break off before the ends it cannot be established if they ever existed. In the quick sketch the feet of the seated figures extend up to the altar which can never have been the case with the choir frieze, but is not so with any of the strips of the nave

frieze either. And it may be significant that there are three figures in de Bisschop's etched series (plate 67C) which are not accounted for by any of the figures on the nave frieze and which in consequence may derive from Correggio's designs for the choir frieze.[3] (Two drawings – Popham 36v and 37v – also do not connect with existing figures in the nave frieze, but, being on the back of some which do, are probably discarded ideas for some in that series). Nevertheless no conclusion seems possible.

REFERENCES [1] A. G. Quintavalle in *Bollettino d'Arte*, 1965, p. 198, n.3. I. Mannocci, 'L'Abbazia di S. Giovanni Evangelista di Parma nella seconda metà del secolo XVII' in *Archivio Storico per le Provincie Parmensi*, 1951, p. 126 says a new organ was built 1651–4. [2] A. G. Quintavalle, op. cit. [3] Popham 1957, p. 48, nos. A, E and F.

DECORATION OF THE CUPOLA

THE VISION OF ST. JOHN ON PATMOS OF THE RISEN CHRIST AND THE OTHER APOSTLES[1]

colour plate C, plates 44 to 55

Slightly oval. Ricci (1930) gives the dimensions as 9·66 metres (on the axis of the nave) and 8·88 (on the axis of the transept). A. G. Quintavalle says the figure of Christ in the centre measures about 4 metres in length.[2]

The removal by the French in the Napoleonic period of the copper which covered the cupola led to serious damage, worst in the south-west pendentive (Saints Mark and Gregory). Ricci (1930) reproduces the report on the condition of the fresco after a partial restoration in 1900–1. For the restoration of 1959–62 see A. G. Quintavalle, op. cit. The numerous small patches, and some long streaks, where the original paint is missing in the cupola are quite apparent in the plates in that work.

For the identity of the apostles it has been suggested that it follows the order in which they are named in the Mass, starting with St. Peter, the only one who is given an attribute. But even this has not produced unanimity of identification.

See text, page 67.

DRAWINGS Vienna, Albertina, Popham 11 (plate 54C). Beardless study for bearded apostle on spectator's left of St. Peter. Red chalk. Squared. Another at Düsseldorf, published by K. Oberhuber, 1970 (plate 54B).

Louvre, Popham 12 (plate 49A). For beardless apostle whose head appears below Christ's feet. Red chalk.

Berlin, Popham 13r (plate 49B). For group of apostles below, and to the spectator's right of, Christ's feet. Red chalk.

Louvre, Popham 14 (plate 54A). For St. Peter and bearded apostle (beardless in this drawing) on the spectator's left of him. Red chalk, with some white. Popham 1957 (page 32) derives the left-hand apostle in the drawing from Michelangelo's Adam in the *Creation of Adam* on the Sistine ceiling.

Popham 15 (British Museum) may be an idea for one of the apostles, but does not exactly correspond with any of them. See also copy drawings by Parmigianino (Popham, *Catalogue...*, 1971, 64v and 330r and v).

ENGRAVINGS In eleven plates and a title page, inscribed 'Jacobus Maria jovanninus Bononniensis sculpsit Parmae Anno M.DCC'. Also in eight plates by S. F. Ravenet.

REFERENCES [1] L. Testi, 'Virgilio Pignoli, La Cupola di S. Giovanni Evangelista a Parma' in *Archivio Storico di Parma*, 1916. This postulates the Vision of St. John before his death (as given in the Golden Legend) as the subject. The work by Pignoli referred to had appeared in 1913 (Battaglia 1934, no. 577) and had affirmed the subject as the death of St. John. This view was supported by Luigi Di Giorgi, 1918 (Battaglia 1934, no. 609). [2] 1962, notes to pl. III.

THE FRIEZE OF THE DRUM OF THE CUPOLA
plates 60, 61

In brown monochrome, between the upper and lower cornices. Divided into four sections by the four circular windows. Each section contains the emblems of the four Evangelists, each of which occurs twice in different combinations of two – namely, angel and lion, eagle and angel, lion and bull, bull and eagle. An elaborate pattern of leaves and tendrils is reversed on the two sides of each pair and the combination repeated in all four pairs.

DRAWING Louvre. Popham 16 (plate 60B). Red chalk. Two studies, superimposed, for eagle and angel and for angel and lion (copy of latter at Dublin, attributed to Parmigianino – see A. E. Popham, *Catalogue of the Drawings of Parmigianino*, 1971, no. 64).

ENGRAVINGS At the end of the second volume of Pungileoni. In his first volume (page 139) he says they were from drawings by Biagio Martini.

THE PENDENTIVES OF THE CUPOLA

Each of the four consists of a group of two seated figures – an Evangelist and a Father of the Church, together with attributes and small angels playing in and out of clouds. At the corners of each pendentive putti recline with palm leaves or swags. At the top of each arch, between the pendentives, are winged figures of which no adequate photographs seem to have been published hitherto (three of them are just visible in figs. 3 and 40 of A. G. Quintavalle 1962).

SOUTH-WEST PENDENTIVE:

SAINTS MARK AND GREGORY (plate 75A)

The most damaged of the four, and half ruined. St. Gregory is identifiable by his triple tiara.

DRAWING Louvre. Popham 21 (plate 75B) (by a slip he publishes a photograph of the pendentive of Saints John and Augustine instead of Saints Mark and Gregory). Pen and ink, wash, black chalk. Squared. This is considerably more legible than the painting in its present state.

NORTH-EAST PENDENTIVE:

SAINTS JOHN THE EVANGELIST AND AUGUSTINE (plate 72)

St. John has his eagle, St. Augustine a mitre and crozier.

SOUTH-EAST PENDENTIVE:

SAINTS JEROME AND MATTHEW (plate 73)

St. Matthew's angel (considerably damaged) holds his book for him. St. Jerome's cardinal's hat is to the left.

DRAWINGS Hammer collection (for eventual presentation to Washington (plate 74A). Pen and ink and wash. An early stage. St. Matthew looks to the right, not to the left (verso has very early study for the *Scodella*, see page 264).
British Museum. Popham 18r (plate 74C). Red chalk. Verso has Cupid tied to a tree (plate 178C).
Milan, Conte Rasini. Popham 20 (plate 74E). Red chalk. Squared.
Munich. Popham 17 (plate 74B). Red chalk. Differences in St. Jerome and in the angel.
Uffizi. Popham 19 (plate 74D). Red chalk.
Rotterdam. Popham 34v (plate 76B). Pen and ink and wash. Study for the putto who holds St. Jerome's hat (recto has study for nave frieze).

NORTH-WEST PENDENTIVE:

SAINTS LUKE AND AMBROSE (plate 76A)

St. Luke has his bull, St. Ambrose a mitre and a whip.

SOFFIT PAINTINGS OF THE CROSSING ARCHES
plates 56 to 59

Brown monochrome. Old Testament figures, most if not all of whom were considered to prefigure Christ.

The north-west pier has, on its south and east faces respectively, the *Sacrifice of Isaac* and *Cain and Abel*. The north-east pier has *Daniel* (or *Enoch*) and *Elijah*. The south-east pier has *Aaron* and *Moses*, and the south-west *Jonah* and *Samson*.

The octagonal *trompe-l'œil* rosettes above and below these figures are presumably of the period and therefore due to Correggio or his school. Those on the soffits of the nave arches are similar.

See text, page 76.

NAVE FRIEZE AND PILASTER STRIPS

plates 62 to 67

Above the entablatures of the piers of the crossing and nave are vertical pilaster strips painted with arabesque candelabra in grisaille (each one the same in the crossing; in the nave two variants alternate), surmounted by 'capitals' painted with pairs of putti. The eight of the crossing piers are in grisaille, those of the nave in flesh colours. The grisaille putti of the crossing piers hold no tablets. There are two designs for the eight 'capitals' here, one of each on each of the four piers. These two designs appear to be the basis of the coloured putti on the nave 'capitals', but here there are considerable variations, owing to the different positions of the tablets which they hold. Connecting these 'capitals' are strips of frieze over each of the six bays of the nave on both sides of the church, and continuing across the west wall. At the two ends of each strip of frieze there are seated figures, male on the left and female on the right in all cases. Each one of these is slightly different from all the others, and all are painted in colours. All hold tablets inscribed in Latin (the men) or Greek (the women). The area between them is painted in grisaille and represents *trompe-l'œil* reliefs. There are two kinds, centring round altars inscribed 'Deo ignoto' on the one hand and one on which a sheep is being sacrificially burnt on the other. These two designs alternate on the side walls and are combined in the long

stretch on the west wall (Popham – 1957, page 47, note 4 – suggests that this section may date from after Correggio's time). Modern literature has identified the grisaille scenes as respectively pagan and Jewish sacrifice (to which the recent re-discovery of fragments of the choir frieze has added a third term in the form of Christian sacrifice) and the seated figures as prophets and sibyls. All this is plausible, but it should be pointed out that none of the seated figures is labelled, and that the fragmentary inscriptions which they hold are of considerable obscurity. The Latin ones held by the male figures were run to earth by Popham as drawn from Revelation, Hebrews, Lamentations, Isaiah and Psalms. The Greek ones were identified by L. Ettlinger as being mainly from Lactantius (*Divinae Institutiones*). The aim of whoever collected and allocated the quotations was evidently to find as close parallels as possible in each pair of Latin and Greek texts. In addition, most of the putti who appear in pairs on the 'capitals' hold inscribed tablets, which appear to be invocations to Christ under a wide variety of names. While the inscriptions on the friezes accord well with the prophetic function of prophets and sibyls it should be borne in mind that there would be no guarantee that these texts are original as those now visible appear to be repainted throughout.

The number of prophets and sibyls who were included in Renaissance decorative schemes was not constant but flexible enough to adapt itself to the number of spaces available on the site in question. In the Sistine chapel there were twelve spaces and on them Michelangelo painted seven prophets and five sibyls. At S. Maria della Pace Raphael had only space for four of each. Perugino had included six of each at the Cambio at Perugia. At S. Giovanni Evangelista there are thirteen of each, but if the west wall is later there would only be twelve of each.

Very little attention was paid to this frieze until Popham investigated it in detail in his work on Correggio's drawings. It is apparently first mentioned in critical literature by Resta (1707), who stated that it

was executed by Rondani and one Torelli (or Tonelli) on Correggio's designs, and Richardson (1722) whose father had a drawing for it.[1] Tiraboschi (1786) re-attributed it to Correggio by publishing the relevant portion of the subsidiary contract of 1522, which specifies 'la frixeria circum lo corpo de la Ecclesia' ('the frieze round the body of the church').[2] Ricci I reiterated Rondani as executant, but allowed Correggio the stretch of frieze 'fourth on the right'. Unfortunately he omitted to specify if this was the fourth from the west end or from the east, and in any case in his second book he thought better of whatever he was trying to say in his first and attributed the design as well as the execution of the frieze to Rondani. Popham assumed Ricci was referring to the frieze of the fourth bay from the west on the south side, but added that he (Popham) could see no difference between this one and those flanking it. A complication was then added by S. Zamboni (1958) who attributed to Correggio the execution of part of the fifth bay from the west on the south side (the second from the transept).[3]

By authenticating as Correggio's a number of preliminary drawings for sections of the frieze Popham placed Correggio's responsibility for the design of it beyond doubt. He also drew attention to a series of etchings made in the seventeenth century by Jan de Bisschop and inscribed as after Correggio, which reproduce some of the prophets and sibyls with minor variations. Though Correggio's assistants may have executed some portions of the grisaille decorations, there is no reason to assume participation by Rondani, who was then in his thirties. As the documents mention the 'Candelerj' Correggio was presumably responsible for their design.

The nave frieze can be dated rather more precisely than other portions of the S. Giovanni Evangelista decoration. According to the documents it was only commissioned in November 1522, and it was presumably finished before the end payment of January 1524.[4] It would therefore probably have been executed during the summer of 1523. Popham sees his no. 28v as an early idea for it, but see above, under

choir frieze (page 249). Popham 30 is a design for the 'Jewish' section of the grisailles.

REFERENCES [1] Resta, *Indice del Libro intitolato Parnaso de' Pittori*, notes to no. 110, and Richardson, *An Account of...Pictures in Italy*, p. 330. [2] p. 261. [3] Review of Popham's book, *Arte Antica e Moderna*, II, 1958, pp. 194ff. [4] The arabesques of the nave vault are attributed to Anselmi and dated *c.* 1520. Tiraboschi, op. cit., p. 260, assumes Correggio's nave frieze was not included in the end payment, but I cannot follow his reasoning.

FRIEZE AND CAPITALS

For reference purposes the six bays of the nave are numbered from the west. The catalogue starts at the sixth bay from the west on the south side (s6). It then proceeds clockwise – namely from s6 westwards to s1, then across the west wall and finally the north side, starting from the bay nearest the west wall (N1). Jan de Bisschop's sheet of etchings of eight prophets and sibyls (reversed) are arranged on the sheet in four superimposed rows of two each, and are here numbered from 1 to 8, nos. 1 and 2 being the left and right respectively in the top row, and so on downwards. There are no capitals next the west wall. On the south side, therefore, the capitals catalogued under a given bay are those to the left of the relevant section of frieze and on the north side to the right of it.

SOUTH WALL

s6 (plate 62A)

Capital No tablet
Frieze Prophet's tablet inscribed:

PRIMVS.E
NOVISSIMVS

[Revelation 1, 17: Noli timere; ego sum primus et novissimus (fear not; I am the first and the last).]
 Drawing for prophet, Frankfurt (Popham 36) (plate 62B). Etching, de Bisschop 8 (plate 67C).
 Sibyl's tablet inscribed:

ΆΛΦΑ·ΚΑΙ
·Ω

[Cf. Revelation I, 8: Ego sum alpha et omega.]

Popham associates a sketch in the British Museum (Popham 30) (plate 67A) with this section of the frieze.

s5 (plate 62C)
Capital Tablets inscribed:

$$
\begin{array}{ccc}
\cdot O \cdot & & NA \\
AD & \text{and} & Y. \\
O & &
\end{array}
$$

Frieze Prophet's tablet inscribed:

SINE. PA
TRE. E. S
INE. MAT
RE.

[Hebrews VII, 3: Sine patre, sine matre, sine genealogia (without father, without mother, without ancestry).]

Drawing for prophet, Rotterdam (Popham 35) (plate 62D).

Altar inscribed:

DEO
IGNOTO

Sibyl's tablet inscribed:

ΑΡΆΤΩ (sic)
Ρ.ΚΑΙ.Α
ΜΉΤΩΡ

[Lactantius IV, 13, 2: ἀπάτωρ atque ἀμήτωρ (without father and without mother).]

s4 (plate 63A)
Capital Tablets inscribed:

$$
\begin{array}{ccc}
\cdot \tilde{\Omega} \cdot \Theta & \text{and} & ΤΌ \\
ΕΟ & & ΚΕ
\end{array}
$$

Frieze Prophet's tablet inscribed:

POST . HÆC
Ī . ERRIS.
VISVS . Ē

Sibyl's tablet inscribed:

·ΛΌΓΟΣ
·ἈΟΡΑΤΟΣ
ΨΗΛΑΦΉ
ΣΕΤΕ·

Drawing for sibyl, Rotterdam (Popham 32) (plate 63B).

Etching, De Bisschop 3 (plate 67C).

s3 (plate 63C)
Capital Tablets inscribed:

$$
\begin{array}{ccc}
\cdot O \cdot & \text{and} & IS- \\
DV & & RA- \\
X & & EL.
\end{array}
$$

Frieze Prophet's tablet inscribed:

OPPRO:
BRIIS . SAT:

[Lamentations III, 30: Saturabitur opprobriis (he will be filled full with reproach).]

Altar inscribed:

DEO
IGNOTO

Sibyl's tablet inscribed:

ΚΟΛΑΦΙΖΌ
ΜΕΝ.ΣΙΓΉ
ΣΕΙ-

[Lactantius IV, 18, 17: καὶ κολαφιζόμενος σιγήσει (and being beaten he shall be silent).]

Drawing for sibyl, Rotterdam (Popham 33) (plate 63D).

s2 (plate 64A)
Capital Tablets inscribed:

Ω
῎Α and Τ Ε
ΧΡΑ

Frieze Prophets' tablet inscribed:

CON-
SVMA-
TIO.
AB-
BRE:
ĪNVN:

[Isaiah x, 22: Consummatio abbreviata inundabit justitiam (the consumption decreed shall overflow with righteousness).]

Etching of prophet, de Bisschop 7 (plate 67C).
Sibyl's tablet inscribed:

ΕΙΣ. ΑΎΤΟΝ.
FᾹΣ. ΛΥΣΕ:
ΤΑΙ. ΝῸ:
ΜΟΣ-

[Lactantius iv, 17, 4: εἰς αὐτὸν τότε πᾶς λύεται νόμος (then all the law is fulfilled with respect to him).]

si (plate 64B)
Capital Tablets inscribed:

O.R. IES-
AD. and SA-
IX E.

Frieze Prophet's tablet inscribed:

CORONᾹ.
SPINEAM.
PORTA.

Drawing for prophet, Rotterdam (Popham 34) (plate 64C).
Altar inscribed:

DEO
IGNOTO

Sibyl's tablet inscribed:

.ΣΤΕ
ΦΑΝΟΝ.
ΚΑΝ.

[Lactantius iv, 18, 17: καὶ στέφανον φορέσει τὸν ἀκάνθινον (and he shall wear the crown of thorns).]

WEST WALL (plates 64D, 65A)

Frieze Prophet's tablets inscribed:

CV̄ RE
.SCELE and PVTA
RᾹIS.

[Isaiah liii, 12: Cum sceleratis reputatus est (He was numbered with the transgressors).]

Altar inscribed:

.DEO.
IGNOTO

Sibyl's tablet inscribed:

ΕΙΣ.
᾿ΑΝΟΜ
ΧΕΙΡΑ
῾ΗΞΕΙ.

[Lactantius iv, 18, 15: εἰς ἀνόμους χεῖρας [καὶ ἀπίστων ὕστερον] ἥξει (he shall afterwards come into the hands of the unjust and the faithless).]

NORTH WALL

ni (plate 65B)

Frieze Prophet's tablet inscribed:

DEDE
RVNT
IN.ES.
CᾹ.MEᾹ
FEL.

[Psalms lxviii, 22 (Authorised Version lxix, 21): Dederunt in escam meam fel (they gave me also gall for my meat).]

Sibyl's tablet inscribed:

ΕΙΣ. ΒΡΩ-
ΜΑ. ΧΟΛΙΝ

[Lactantius IV, 18, 19: εἰς δὲ τὸ βρῶμα χολὴν (they gave me gall for my food).]
Capital Tablets inscribed:

XAI-		ΣΩ-
PE.	and	TI-
'H-		PI-
ΓΎ-		᾽ΑΣ
ΛΙ		

N2 (plate 65C)
Frieze Prophet's tablet inscribed:

IN. SITI.
ΜEA. PO. ΜE

[Psalms LXVIII, 22 (Authorised Version LXIX, 21): In siti mea potaverunt me aceto (in my thirst they gave me vinegar to drink).]
Etching of prophet, de Bisschop 2 (plate 67C).
Altar inscribed:

.DEO.
.IGNOTO.

Sibyl's tablet inscribed:

ΕΙΣ. ΔΙ.
ΨΑΝ. Ŏ
ΖΟΣ. Ĕ
ΔΟΚΆ.

[Lactantius IV, 18, 19: κεἰς δίψαν ὄξος ἔδωκαν (and for my thirst they gave vinegar).]
Capital Tablets inscribed:

O:	and	DA.
CLA-		VID
VIS		

N3 (plate 65D)
Frieze Prophet's tablet inscribed:

OS. NŌ
CŌ MINV
ẼIŚ.

[John XIX, 36: Os non comminuetis ex eo (you shall not break a bone of him).]
Drawing for prophet, Frankfurt (Popham 37) (plate 66A).
Sibyl's tablet inscribed:

ΚΩΛΙẔ
᾽ΟΥ.ÆΓ-
ΤΥΓΕΤΙ (?)

Capital Tablets inscribed:

	ω	
IO-	and	IΎΝΗ
ΛΟΥ		

N4 (plate 66B)
Frieze Prophet's tablet inscribed:

VELVM
ẼMPLI
SCIN-
DEVR.

[Matthew XXVII, 51, Mark XV, 38, Luke XXIII, 45: Velum templi scissum est (the veil of the Temple was rent).]
Altar inscribed:

.DEO.
IGNOTO.

Sibyl's tablet inscribed:

ΠΕΑΣ
ΜΑ. ΝΑ.
ΟΎ. ΣΧΙΣ
ΩΙẼ (?)

[Lactantius IV, 19, 5: ναοῦ δὲ σχισθῇ τὸ πέτασμα (and the veil of the temple was rent).]
Capital Tablets inscribed:

.O. and NO-
LE. SER
GI-
FER

N5 (plate 66c)
Frieze Prophet's tablet inscribed:

MOR
ẼIS-
F̄Ā̄V.FI·
NIE

Etching of prophet, de Bisschop 4 (plate 67c)
Sibyl's tablet inscribed:

ΘΛΝΑΟΥ·
ΜΟΙΡΛΝ.
ἘΛΕΣΕΙ.

[Lactantius IV, 19, 10: καὶ θανάτου μοῖραν τελέσει (he shall put an end to the fate of death).]
Drawing for sibyl, British Museum (Popham 38).
Capital Tablets inscribed:

'Ω. Ᾰ and ΤΕ
ΧΡΛΝ

N6 (plate 66D)
Frieze Prophet's tablet inscribed:

TRIDV
— SOPI-
TVS

Altar inscribed:

.DEO
IGNOTO.

Sibyl's tablet inscribed:

ΤΡΙ
Τ.ΗΜΑΡ.
ΥΓΝΩΣΑΣ

[Lactantius IV, 19, 10: τρίτον ἦμαρ ὑπνώσας (after sleeping three days).]
Capital No tablets.

17

ARCH OF THE DEL BONO CHAPEL

plate 77, 78

The chapel is the fifth from the west wall of the nave on the south side. The arch separating it from the south aisle of the nave consists of a narrower outer band (nearest the nave aisle) and a broader, and slightly higher, inner one (nearest the altar of the chapel). The outer band is frescoed, on the crown, with a paschal lamb (framed in a circle set in a diamond) and with two small angels – not identical – who stand at each side as the arch descends to vertical. They hold up painted coats of arms – on the east side that of the Del Bono family, with the letters P E – or P F – on one side of a painted rope and B O N on the other. Those of an unidentified family, with the letters G Z, on the west side.

The inner arch has, on the crown, *Christ* in a roundel, the roundel supported by four putti, two each on the east and west sides. Both pairs stand on the tops of frames (which are part of the fresco) of upright paintings – *Conversion of Saul* on the east, *Saints John and Peter healing the Cripple* on the west. The three drawings – at Chatsworth – by Correggio for the roundel and its surround are the only available evidence – in default of all documents – for connecting Correggio with the arch.

The chapel to the east of the present one was completed as early as 1492, that to the west by 1497.[1] The rebuilding of the church had only just started at this date. Popham assumes (from the initials on the arch) that the patron of the chapel was Pietro Del Bono, and that he acquired it between 1492 and 1502.[2] The chapel bears the following inscription, let into the floor:

ANTIQVISSᴬᴱ FAM. DEL BONO
ILL. I.V.D. D. BARTᵛˢ BONVS
Fˢ Q. ILL. D. PETRI. I.V.D
REFECIT
M.D.C.XXIIII.

This inscription, surprisingly overlooked in most of

the Correggio literature, and (astoundingly) mis-quoted by Popham, shows that the restorer of the chapel was not Placido Del Bono, as Affò implies, but Bartolommeo, another son of Pietro Del Bono. Ruta (1739) says that the chapel was dedicated to the Virgin and that the *Conversion of Saul* was by Rondani.[3] Affò (1796) has the 'arco a fresco, che vuolsi del Rondani' ('fresco on the arch, supposed to be by Rondani').[4] Donati (1824) repeats the Rondani attribution for both side scenes.[5] Attention was first drawn to the Chatsworth drawings by A. Venturi.[6] He attributed them to Correggio, but said the paintings had been executed by others. Popham attributed the execution to Correggio himself, and, on the strength of deriving Pordenone's *Conversion of Paul* at Spilimbergo, which is known to have existed in May, 1524, from the Del Bono fresco of the same subject, dated the latter before then (this despite the fact, admitted by Popham, that the most prominent feature – the horse – in both works is likely to derive from an Antique prototype and that Pordenone himself might have used it in one of his own earlier works). A. G. Quintavalle attributed the execution of the arch frescoes to Anselmi, assisted by Rondani.[7]

See text, page 77.

DRAWINGS Chatsworth. Popham 44 (plate 78C). Christ in roundel. Red chalk, heightened with white. Squared.

Chatsworth. Popham 45 (plate 78A). Two putti supporting (blank) roundel. Red chalk, heightened with white. Squared.

Chatsworth. Popham 46 (plate 78B). Two putti supporting roundel. Popham sees the figure in the roundel as the Madonna and assumes it was then changed to Christ, but the figure could be, and probably already is, Christ. Red chalk, heightened with white. Squared.

REFERENCES [1] Popham 1957, p. 52. [2] Popham, loc. cit. He draws attention to a large picture frame, now at Pedrignano, near Parma, but stated to have come from the Del Bono chapel and to have borne the date 1502. [3] Ruta, *Guida di Parma*, 1739, p. 39. Popham suggests (op. cit., p. 58, n.1) that the chapel was dedicated to Saints Peter and Paul *and* to the Virgin. [4] *Il Parmigiano Servitor di Piazza*, p. 119. [5] *Nuova Descrizione...di Parma*, 1824, p. 39. [6] A. Venturi, *Storia dell'Arte Italiana*, IX, ii, pp. 602–3. [7] A. G. Quintavalle, *Michelangelo Anselmi*, second edition, 1960, pp. 105–6. J. Shearman, 1961, p. 146, had supported the Correggio attribution.

PARMA

DUOMO

Decoration of the cupola, with squinches, frieze and under-arch paintings on the north, south and west sides.

Documents. Contract: 3 November 1522.
 Payments: 29 November 1526.[1]
 17 November 1530

Text of documents, page 183.

REFERENCE [1] Affò (*Il Parmigianino Servitor di Piazza*, 1796, p. 22) had wrongly given the month as September. R. Tassi (1968, p. 158) has '23 November, 1326'.

CUPOLA

THE ASSUMPTION OF THE VIRGIN
colour plates G and H, plates 110 to 139

Dimensions given in Ricci (1930, page 173) as 10·93 (on the axis of the church) × 11·55 (on the axis of the transept). Ricci (1896, page 268) reported a document whereby the roof of the cupola was covered with copper and lead as protection for the painting in the years 1533–9. In his second book (English edition, pages 173–5) he prints a long account of the condition of the painting by the restorer who worked on it in the years 1913–16. Like Correggio's other murals it is in mixed technique, with a quantity of tempera painting *a secco* on top of the true fresco. Like some other reports by restorers or physicians it is possible that the account of the ailments has been heightened somewhat in order to induce increased admiration for the cure. The restorer said he had found parts of the paint raised from the structure and in danger of falling off.[1] The excellent colour plates published by R. Tassi[2] give a good idea of the present state of the work. The conspicuous band of angels escorting the Virgin seems in very good condition, though the dress of the Virgin herself has faded. The worst damage is lower down on

the curvature where the top of the painted parapet meets the sky. In this zone several of the heads of the apostles and several of the torch-tending youths are almost effaced, particularly on the east side, under the Virgin.

REFERENCES [1] This had been observed, with gloomy foreboding, as early as the seventeenth century by Scaramuccia (*Le Finezze de' Pennelli Italiani*, 1674, p. 174). [2] R. Tassi 1968, *passim*.

DRAWINGS (1) For the parapet:

1. Oxford, Ashmolean Museum. Popham 50r and v (plate 122A, B). Red chalk. Curved at the sides to correspond with a sector of the cupola. In this drawing the *trompe-l'œil* parapet to be painted round the real circular windows is more elaborately treated – with pilasters of various kinds, and ornamental carving – than in the final version. There are also seated figures and sphinxes in the angles. See page 109.

2. Haarlem, Teylers Stichting. Popham 52v (plate 122C). Pen and ink over red chalk. Popham, as perhaps a development of his 50r (Oxford) and as representing the next stage in a plan to treat the angles of the painted parapet with painted half columns. Recto has study for Eve.

(2) For Eve:

1. London, British Museum. Popham 51r (plate 118C). Red chalk. Early design, with her right hand on her throat and her left arm down. An angel behind, left. A putto holding Eve's apple, lower left. Verso has slight sketch identified by Popham as a fallen warrior and connected by him with a Conversion of Saul. The latter need not be the only possibility.

2. Haarlem, Teylers Stichting. Popham 52r (plate 118B). Pen and ink over red chalk. Eve as in the British Museum drawing above. No angel behind her. The putto holding the apple more evolved.

3. Paris, Louvre. Popham 53 (plate 118A). Red chalk heightened with white. Later stage. Eve now holds the apple in her extended left hand, as in the fresco.

(3) For the figures round Eve (on the spectator's right of the Virgin):

Frankfurt-am-Main, Städelsches Kunstinstitut. Popham 54 (plate 115A). Red chalk, partly gone over in pen and ink. Squared in red chalk, the squaring on the right inclined at an angle to that on the left to indicate an angle in the cupola. Evidently a late stage. Eve is on the left. Popham (page 72) identifies the woman on the right as Judith and the figure to the spectator's left of her as her handmaid holding the head of Holofernes. R. Tassi (1968, pl. 66) calls the woman on the right Martha and the other figure David with the head of Goliath.

(4) For the Virgin:

1. London, British Museum. Popham 57 (plate 115C). Red chalk. Close to the final version except that the legs are outrageously wide apart.

2. Dresden. Popham 56r and v (plate 115D). Recto (black chalk, pen and ink) closer to the fresco than Popham 57 to the extent that the Virgin's left leg is retracted and brought nearer her right. Verso is traced through from recto.

(5) For the figures to the spectator's left of the Virgin (Abraham, Isaac, Adam):

Windsor Castle. Popham 55 (plate 115B). Pen and brown ink over red chalk. The male figure, right centre in the drawing, is evidently Adam through being in the same relative position to the spectator's left of the Virgin (in the fresco) as Eve to the right. Ricci and Popham call the other figures Abraham and Isaac. As the animal is a lamb and not a ram a more likely identification would be Abel.

(6) For the ephebes:

1. Florence, Uffizi. Popham 58r and v (plate 134A). Recto pen and ink and some red chalk and white, verso red chalk. Early ideas for the torch-tending youths.

2 and 3. Paris, Louvre. Popham 59 and 60 (plates 134B, C). Both red chalk, and squared in red chalk. Two youths on each drawing. The two on Popham 59 are both identifiable in the fresco though with variations. The one on the left of Popham 60 is also identifiable though partly concealed by an apostle. Popham makes the point that the one on the right of

this sheet is nowhere identifiable and assumes that the apostle completely hides him. See page 110.

4. Lisbon. Popham 61 (plate 134D). Red chalk and pen and ink. Two boys who correspond with two in the fresco.

(7) For the Apostles:

1 and 2. Lausanne, M. Strolin. Popham 64 and 65 (plate 139B). Both red chalk. Slight sketches for heads of apostles.

3. Lisbon. Popham 63 (plate 122D). Red chalk. Nearly full length.

4. Location unknown. Popham 62r (plate 139A). Slight sketch for standing apostle. Another for prostrate figure and a third apparently for a frieze. See page 106.

N.B. A large series of large drawings in the Louvre were formerly considered to be Correggio's cartoons. Popham (1957, page 6) gives his reasons for thinking that they 'can hardly be of earlier date than the seventeenth or eighteenth century'.

THE SQUINCHES

South-west, ST. THOMAS (plates 145, 146)
South-east, ST. HILARY (plates 147, 148)
North-east, ST. JOHN THE BAPTIST

 (plates 143, 144)
North-west, ST. BERNARD (plates 141, 142)
(R. Tassi (1968) gives the wrong locations in all four cases. Ricci had given them correctly.)

None of them as damaged as the worst of the pendentives at S. Giovanni. The *St. Thomas* squinch is the most obviously damaged. A piece of paint half the size of his head is missing (from underneath his mouth to half way down his chest).

DRAWINGS 1–4. Paris, Louvre. One relatively finished drawing for each. Popham 66–9 (plates 151B, 151A, 150A, 149A). All red chalk. All very close. Main differences:

St. Hilary squinch: angel on the right, with the book, is slightly higher in the drawing, so there

is a gap on the page of the book between his right hand and the left hand of the central angel.

St. *Thomas* squinch: angel seated on cloud, right centre, is swivelled rather farther upwards in the drawing.

5. London, British Museum. Popham 70 (plate 149B). Outline drawing for *St. Bernard* squinch. Red chalk. Angel on left holds the crozier in his right hand instead of in his left.

6. Paris, Ecole des Beaux-Arts. Popham 71 (plate 150B). Black chalk. Fragment of a cartoon. Perhaps for head of angel who holds the saint's left leg in the St. *Thomas* squinch.

THE PRINTS

Large wood cuts, apparently sixteenth century, of the heads of St. Thomas and of St. Bernard from the squinches, Meyer, 45 and 46. Six etchings by Sisto Badalocchio (1581–1647) of the apostles and torch-tending youths, Bartsch, 27–32. The whole cupola etched by G. B. Vanni in fifteen sections, 1642, Bartsch 1–15 (re-done from Vanni's drawings, by D. Bonaveri, 1697). Twelve engraved plates by S. F. Ravenet.

THE FRIEZE plates 140, 152, 153

The four sections of wall, north, south, east and west, between the squinches are decorated in grisaille and brown monochrome, all four the same apart from slight variations. Each of the four walls has a (real) round-headed opening in the middle, surmounted by a (painted) sphinx who extends her head through the (painted) pediment, looking upwards. Her paws rest on the (painted) frame of the (real) openings. They hold long garlands whose ends hang down on both sides. To the left of the opening in each case is painted a putto holding a snake and striding a dolphin. An elaborate swag of flowers and leaves curls decoratively to the left of the putto. On the right of the openings in each case the same design is repeated in reverse except that the putto does not hold a snake.

THE UNDER-ARCH PAINTINGS

plates 154 to 156

At the base of the north, south and west crossing arches are six lightly draped grisaille figures, three male and three female, holding swags similar to those held by the sphinxes higher up.

PARMA Galleria Nazionale

MADONNA AND CHILD WITH SAINTS
JEROME AND MARY MAGDALENE AND
ANGELS (*Il Giorno*)

Panel, 2·05 × 1·41[1] plates 157 to 160
Traces of a small kneeling figure, middle distance,
between the Virgin's face and the angel's left wing.
The faces of the Madonna, of the Child and of the
Magdalen seem somewhat rubbed and retouched in
places. The shadows of the child's body are also
suspect. But the existing (1971) yellowed varnish
does not facilitate an estimate of the picture's condi-
tion. In view of its age, however, and of its forced
journey to Paris and back this is probably quite good.
There was a correspondence on the picture's con-
dition in *Rassegna d'Arte*, May–July, 1904.

Pungileoni says that the scroll held by St. Jerome
in his hand is inscribed in Hebrew characters 'sia
gloria a Dio' ('Glory be to God').[2]

In his first edition (1550) Vasari described the
picture as follows: 'In Santo Antonio ancora di
quella città dipinse una tavola nella quale è una
Nostra donna & Santa Caterina con San Girolamo
colorita di maniera si maravigliosa & stupenda; che
i pittori ammirano quella per colorito mirabile, & che
non si possa quasi dipignere meglio.'[3]*

In his second edition (1568) Vasari corrected St.
Catherine to St. Mary Magdalene and added further
details:

'In Sant'Antonio ancora di quella città dipinse una
tavola, nella qual'è una Nostra Donna e Santa Maria
Maddalena; ed appresso vi è un putto che ride, che
tiene a guisa di angioletto un libro in mano, il quale
par che rida tanto naturalmente, che muove a riso chi
lo guarda, nè lo vede persona di natura malinconica,
che non si rallegri. Evvi ancora un San Girolamo; ed
è colorita di maniera si maravigliosa e stupenda, che i
pittori ammirano quella per colorito mirabile, e che
non si possa quasi dipignere meglio.'[4]†

Scannelli misquotes Vasari and alleges without reason
that he never saw the picture himself.[5]

For the circumstances of the commission Tira-
boschi (1786)[6] says that according to documents
which even then no longer existed it was ordered in
1523 by one Donna Briseide Colla, widow of Ora-
zio, or Ottaviano, Bergonzi for a price of 400 lire,
and that Correggio finished it in six months. The
lady was thereupon so pleased that despite having
kept the painter in her house during work on it she
gave him a bonus of two loads of wood, several
bushels of wheat and a pig, the choice of these
presents being his. Pungileoni adds that the pious lady
presented the picture to her family chapel in S.
Antonio, Parma in 1528, the year of her death.[7]

For the iconography compare Raphael's *Madonna
of the Fish* (Prado) where an angel presents Tobias to
the Madonna and Child, the latter having his hand
on the book presented by St. Jerome.

See text, page 115.

PROVENANCE Church of S. Antonio, Parma. In
1712 the church was demolished in order to be re-
built, and the picture was moved to the abbot's
lodging. According to Ratti,[8] work on the new
church was halted on the death of Cardinal Sanvitale
(which occurred in 1714). Ricci says that the latter
had been financing the rebuilding and publishes a

* 'In S. Antonio, likewise in that town, he painted
a panel in which there is a Madonna and St. Catherine
with St. Jerome, painted in so marvellous and stu-
pendous a way that painters admire it for its miracu-
lous technique and because it would not be possible
to paint better.'

† 'In S. Antonio, likewise in that town, he painted
a panel in which there is a Madonna and St. Mary
Magdalene; and with them is a smiling child who, in
the guise of an angel, holds a book in his hand and
who seems to smile so naturally that it makes the
spectator smile also, nor could anyone, no matter
how melancholic, see it without cheering up. There
is also a St. Jerome painted in so marvellous and
stupendous a way that painters admire it for its
miraculous technique and because it would not be
possible to paint better.'

fragment of an undated letter from Duke Francesco Farnese (died 1727) forbidding the export of the picture.[9] The idea had been to sell it in order to continue rebuilding the church, the potential buyer being 'Monsieur Crosat' (sic). In 1749 renewed rumours of a sale resulted in the picture's being moved from the abbot's lodging to a room in the cathedral. In 1756 it was taken to the ducal palace of Colorno, and in 1757 to the newly founded Academy of Fine Arts of Parma.[10] When the rebuilding of the church of S. Antonio was virtually complete, in 1764, the priests asked for the picture back, but the Bourbon ruler obtained a sanction from the Pope to buy it on behalf of the Academy. Ratti says that in 1772 Frederic the Great offered 25,000 zecchini for the picture.[11] Taken by the French to Paris, 1796-7. Returned 1815. In the Parma gallery since then. No. 42 in the Correggio exhibition, 1935.

DRAWING Christ Church, Oxford. Popham 75 (plate 160A). Pen and ink over red chalk. See text, page 115. Probably an early idea for the present picture. A sketch recently found by Mr James Byam Shaw in the Accademia at Venice (where marked 'Parmigianino') (plate 160D) is in a rapid pen and ink technique comparable with the Louvre sketches for the Louvre *Virtues* (Popham 89r and v) and may have been made in this connection.

COPIES Richardson (1722)[12] mentions ten altarpiece copies in Parma alone, of which 'several' were 'very fine'. One ascribed to Baroccio is in the Pitti. One (ascribed to Annibale Carracci) was in the Orléans collection.[13] One by R. H. de Séry at Strasbourg (Palais des Rohans). One at Glasgow (McLellan Bequest) is ascribed to Cignani. There is one in the church of S. Vitale at Parma, and one in the Galleria Estense, Modena. Miniature copy by T. C. Maron, Dresden Gallery. A copy in the Musée de Lyon has the Baptist and a donor on the left instead of St. Jerome.

ENGRAVINGS By Agostino Carracci, 1586 (plate 160E); another, signed C. Cart. (Cartari) and a third by Fr. Villamena of the same year. Undated engraving by Adriaen Collaert. Etching by G. M. Giovannini. Eighteenth-century engravings by Strange (1763) and Ravenet (1783). The latter bears the fanciful date 1524 as that of the picture's origin (see Appendix B). Further prints listed by Meyer, pages 477-8. Pungileoni mentions a print by Denon in oval format.[14]

REFERENCES [1] Height sometimes wrongly given as 2·35. [2] Pungileoni, I, p. 184. [3] Vasari, I, p. 583. [4] Vasari/Milanesi, IV, p. 114. [5] Scannelli, *Microcosmo*, pp. 278-9. [6] Tiraboschi 1786, pp. 267-8. [7] Pungileoni, I, p. 185. [8] Ratti, p. 81. [9] Ricci 1896, p. 278. [10] The documentation of the brouhaha is given at greatest length by Martini (*Studi intorno il Correggio*, 1865, pp. 153ff.). Ratti's account (loc. cit.) is corrected by Tiraboschi (1786, pp. 267ff.). Among other differences, Ratti gives the prospective buyer as Augustus III of Saxony, and Tiraboschi as the King of Portugal. Martini's documents support the latter. [11] Ratti, op. cit., p. 82, n. See also E. Colombi in *Parma per l'Arte*, May-August 1955. [12] Richardson, p. 331. [13] D'Argenville, *Voyage Pictoresque de Paris*, 1749, p. 55. [14] Pungileoni, I, p. 180.

PARMA Galleria Nazionale

THE HOLY FAMILY (*Madonna della Scodella*)

Panel, 2·18 × 1·37[1] plates 104 to 106, 171

There was a correspondence on the picture's condition in *Rassegna d'Arte*, May-July 1904. Tiraboschi[2] and Pungileoni[3] say that Mengs' allegation that the picture had been ruined by a Spanish painter who cleaned it before copying it was an exaggeration, Pungileoni adding that Mengs' letter to his pupil Barranco itself refuted it. It is true that in this letter, which is dated 20 December 1768, Mengs says of the picture 'quando lo vidi era molto ben conservato' ('when I saw it, it was very well preserved'). However it was not Mengs himself, but Azara, one of his annotators, who had alleged damage in the first place which he said took place in the year of Mengs' letter – 1768. A second annotation, by Fea, says that

it was Barranco – Mengs' correspondent – who had himself caused the damage.[4] There can, in any case, be no doubt that Fea's word in this context – 'rovinato' ('ruined') – is a gross exaggeration. The picture on the whole is well preserved.

Briefly mentioned by Vasari (1568)[5] in his life of Girolamo da Carpi in the context of works of Correggio at Parma which Girolamo studied and copied – 'le maravigliose figure che sono nella chiesa di San Sepolcro alla cappella di San Ioseffo, tavola di pittura divina.'* Scannelli (1657)[6] is more detailed: 'nella Chiesa de' Padri Seruiti, detta di S. Sepolcro nell'entrare a mano sinistra vi è la Tauola, che dimostra quando la B. Vergine con Christo fanciullo, e. S. Gioseffo ritornauano d'Egitto in Nazaret, d'ond'erano fuggiti per la persecutione d'Erode, e vennero a fermare per strada in mezo ad vna campagna, nella quale si ritrouaua vna Palma con Dattili, doue si vede per sodisfare il Santo Putto procurare il buon vecchio S. Gioseffo di questi frutti'.† The Gospel of Pseudo-Matthew, in the context of the sojourn of the holy family in Egypt, but not, apparently, specifically in that of their return from it, describes how Mary saw a palm with fruit on it and told Joseph she would like some of it, how the child Christ told the palm to give Mary some of its fruit – which it did – and also water – whereupon a spring came forth. Finally on leaving the spot next day Christ rewarded the palm by giving one of its branches to one of his angels.[7] By including the latter episode in the present picture – unlike the earlier picture of the subject in the Uffizi – Correggio leaves little doubt that this was the version which was being illustrated.

* 'the marvellous figures in the church of S. Sepolcro in the chapel of St. Joseph, a divine painting.'
† 'in the Servite church called S. Sepolcro on the left-hand side as you enter is the picture showing how the Madonna with the Christ child and St. Joseph were returning from Egypt to Nazareth, where they had taken refuge from Herod's persecution, and how they had come to a halt by the road side where there was a palm tree with dates and how the good old St. Joseph took some of the fruit to nourish the Christ child.'

The frame of the picture, which is evidently the original,[8] is inscribed:

DIVO IOSEPPO DEIPARAE VIRGINIS
CVSTODI
FIDISS . COELITVSQ DESTINATO .
HVIVSCE
ARAE COMVNI AERE ERECTORES .
DEVOTI
ALACRESQ EREXERE MD.XXX
DIE . II . IVNII[9]

Ricci argues that since this date – 2 June – is not that of the feast of St. Joseph – whose altar the picture adorned – or of the Virgin, it is likely to be that of the unveiling of the picture and thus the *terminus ad quem* for dating its execution. Though the date of the commission is unknown it was certainly some years before this. Pungileoni refers to the will of one Cristoforo Bondini who bequeathed a small sum (15 lire imperiali) in 1524 towards the public subscription for it.[10] The Hammer drawing (plate 104B) shows the composition at an early stage and is probably datable before 1524, since on the verso is a study for one of the pendentives at S. Giovanni Evangelista, which, on the chronology advanced here, would have been among the latest of Correggio's works in that church. This – the year 1523 – may therefore approximate to the date of the Scodella commission. It has been suggested in the text (page 102) that the lower half of the picture may have been painted around the mid-1520s, and the angels at the top around 1529–30.

See text, page 101.

PROVENANCE S. Sepolcro, Parma. Tiraboschi records unsuccessful attempts to buy it in the mid-eighteenth century.[11] In the letter of 20 December, already quoted, Mengs said he was hoping to be involved in the sale of it. In France 1796/7–1815. Thereafter in the Parma Gallery. Replaced in its original frame, 1893. No. 43 in the Correggio exhibition, Parma, 1935.

DRAWINGS 1. Hammer Collection, for eventual presentation to Washington, National Gallery of Art

(plate 104B). Pen and ink and wash over red chalk. Very early composition study. The Madonna seated and St. Joseph standing in much the same relationship as in the finished painting, but both attitudes, and that of the Child Christ different. Joseph faces inwards and turns over his left shoulder. The Madonna is not scooping up the water with her right hand but has her whole right arm across her body in order to hold the child, who is smaller than in the painting, and facing in the opposite direction. The angels overhead, similarly, are much smaller than in the painting.

2. Florence, Uffizi (Popham 76) (plate 104C). Pen and ink and wash over red and black chalk, heightened with white. Madonna, Child and Joseph. Closer to the finished picture than the Washington drawing but differences in Mary's and Joseph's draperies, and the Christ child nearly naked.

3. Rugby School. Popham 77 (plate 171B). Studies of angels. Popham considers all the figures on the sheet were drawn from the same inanimate model.

COPIES Parma, S. Sepolcro. Replacing the original. Another, by R. H. de Séry, at Strasbourg (Palais des Rohans). Another in the Prado (115). Three fragments of a full-size copy, Christ Church, Oxford. Pungileoni mentions others at Cremona and (attributed to Annibale Carracci) in the Farnese collection.[12]

ENGRAVINGS By Francesco Brizzi (died 1623) and Ravenet 1778. The latter inscribed 'Correggio pinxit 1529'. For this and other fanciful dates see Appendix B. Further anonymous prints listed by Meyer (pages 476–7).

REFERENCES [1] Measurements from the Parma catalogue. [2] Tiraboschi 1786, pp. 269–70. [3] II, p. 199. [4] Mengs, *Opere*, 1787 edition, p. 174, note b. Ratti (1781, p. 80) says that Mengs himself had gently cleaned the picture. [5] Vasari/Milanesi, VI, p. 472. [6] p. 275. [7] M. R. James, *The Apocryphal New Testament*, 1926 edition, p. 75. [8] C. Ricci in *Per L'Arte* (Parma), VI, 17 June 1894. [9] 'To St. Joseph, most faithful guardian of the Virgin mother of God and a man destined from Heaven, those who set up this altar at their common expense, did so gladly and with devotion on 2 June 1530'. I am grateful to

Brigid Brophy and to John Sparrow for assistance with translating this text. [10] II, p. 198. In the same place Pungileoni says the church 'somministrò… diversi generi di cose' ('supplied various kinds of things') to Correggio. [11] Tiraboschi 1786, p. 270. [12] II, p. 199. On the preceding page to this Pungileoni had mentioned a vague tradition that the picture was painted in 1527–8.

PARMA Galleria Nazionale

MARTYRDOM OF FOUR SAINTS

Canvas, 1·57 × 1·82 plates 79 to 83

Better preserved than the *Lamentation*, but the handling seems less sensitive. Cleaned, 1972–3.

Though mentioned, together with its pair, the *Lamentation* (Parma, Galleria Nazionale) (q.v.), by Vasari,[1] Borghini,[2] Scannelli,[3] Scaramuccia[4] and Barri[5] as in S. Giovanni Evangelista, Parma, none of them identifies the saints. Resta calls it *Martirio di S. Placido*,[6] Ruta *Il Martirio di S. Placido e S. Flavia sua Sorella*.[7] Mengs has *Il Martirio di San Placido e di Santa Flavia, con altri Santi*,[8] and Tiraboschi repeats this.[9] Resta had added that the present picture and the *Lamentation* had been 'fatte ad instanza d'un Padre Abbate D. Placido' ('done to the order of a certain abbot D. Placido') (who, as Popham points out,[10] was never abbot of S. Giovanni Evangelista). Affò states that the Del Bono chapel, from which both pictures certainly came, was founded by Padre Don Placido Del Bono 'monaco Cassinese Parmigiano' ('Benedictine monk of Parma').[11] This is not strictly true, as the chapel existed earlier. The inscription let into the floor (see Parma, S. Giovanni Evangelista, Arch of the Del Bono chapel) says that it was Pietro Del Bono's son, Bartolommeo, who restored the chapel in 1524. A Placido Del Bono, however, did exist at this period. He is referred to in a document of 1522 as being then a monk of S. Giovanni Evangelista.[12] Owing to the subject of the martyrdom (St. Placido) Placido Del Bono was presumably also involved in

the restoration of the chapel, including the commissions of the two paintings. The choice of subject, being of interest to Benedictines (Saints Placido and Flavia were disciples of St. Benedict) would in any case be a natural one for a Benedictine church. Probably around 1521, Anselmi had painted the fresco in the apse of the south transept of S. Giovanni Evangelista, with St. Benedict flanked by Saints Placido and Flavia on one side and Saints Mauro and Scholastica on the other. In the present picture the two child martyrs, already decapitated and lying on the ground, are evidently the younger brothers, Eutychius and Victorinus. The martyrdom took place, by order of a pirate, at Messina on 5 October 541 or 542, after prolonged tortures.[13]

Popham sees influence of Marcantonio's engraving after Raphael of the *Massacre of the Innocents*, and also of Marcantonio's *Martyrdom of S. Cecilia*.[14] A. Venturi, eccentrically, as mainly studio execution and as the same hand as the Sanvitale portrait (Parma, Galleria Nazionale).[15] Gronau sees the present picture as several years later than the *Lamentation*.[16]

See text, page 77.

PROVENANCE Del Bono chapel, S. Giovanni Evangelista, Parma. Taken to Paris, 1796. Returned 1816. Thereafter at the Galleria. 1935 Correggio exhibition, no. 39.

COPIES Del Bono chapel of S. Giovanni Evangelista, replacing the original. Prado, no. 118, 0·39 × 0·47 (from the Carlo Maratti collection). Another was published in *Arte Antica e Moderna*, 1958, pages 177–9 and fig. 64; attributed to Lelio Orsi for reasons which are not apparent in the reproduction. A small copy at Metz museum (Campana collection).

DRAWINGS Louvre, Popham 40 (plate 82B). Red chalk and some white. Elaborate finished drawing for the whole composition at an earlier stage. The two youthful martyrs decapitated, centre, Saints Placido and Flavia to left and right and an angel with the rewards of martyrdom, upper centre.

2. Louvre, Popham 41 (plate 83A). Red chalk. Study for St. Placido in the reverse sense.

3. Louvre, Popham 42 (plate 83B). Red chalk. Study for the execution of the two youthful martyrs.

4. Location unknown, Popham 62. Red chalk. Perhaps for one of the youthful martyrs, on sheet with other studies – apparently for an apostle in the Duomo and for a frieze.

5. Popham (1957, page 61) mentions that his no. 7 might be connected with this picture, or could be for an adoration of the Magi. It looks as though it might also be for a Virgin Annuntiate.

ENGRAVINGS Francesco Dus (etching) (plate 83C) (in reverse); G. B. Vanni, 1638 (etching) (plate 83D); and S. F. Ravenet.

REFERENCES [1] Vasari, 1550, p. 583; 1568, IV, p. 112 and VI, p. 481. [2] *Il Riposo*, p. 374. [3] *Il Microcosmo...*, p. 275. [4] *Le Finezze...*, p. 176. [5] *Viaggio...*, p. 101. [6] MS. published by Popham, *Correggio in Roma*, 1958, p. 35. [7] *Guida...di Parma*, second edition, 1752, p. 52. [8] Mengs, *Opere*, II, 1783 edition, p. 154. [9] Tiraboschi 1786, p. 261. [10] *Correggio in Roma*, p. 64, n.35. [11] *Il Parmigiano Servitor di Piazza*, p. 85. [12] A. O. Quintavalle, *Il Parmigianino*, 1948, p. 49, n.12. [13] *Les Petits Bollandistes*, 5 October. [14] Popham 1957, p. 60. [15] *Storia...*, IX, 2, p. 603 n. [16] *Correggio*, Klassiker der Kunst, 1907, p. 122. Also, in this context, Frimmel (Battaglia, *Correggio Bibliografia*, no. 514). Roger Fry (*Apollo*, May 1969 – a posthumously published lecture) used the picture in support of one of his current aesthetic theories.

PARMA　　　　　　　　Galleria Nazionale

LAMENTATION

Canvas, 1·57 × 1·82　　　　　　plates 84 to 88

Flesh areas rather worn. Pentimento in upper outline of Christ's right leg, below the knee. Some damage to the Virgin's left hand is recorded during copying by Giuseppe Turchi in 1792.[1] Cleaned, 1972–3. Mentioned, together with the *Martyrdom of Four Saints* (Parma, Galleria Nazionale) (q.v.) as in S. Giovanni Evangelista, Parma by Vasari,[2] Borghini,[3] Scannelli[4] (who particularly praises the figure

of the Magdalene and quotes Guercino's praise of it), Scaramuccia,[5] Barri,[6] Resta,[7] Ruta,[8] Mengs[9] and Tiraboschi,[10] among others. A. Venturi, as mainly studio and as same hand as the Sanvitale portrait (Parma, Galleria Nazionale).[11] Gronau, as several years earlier than the *Martyrdom*.[12]

See text, page 77.

PROVENANCE Del Bono chapel, S. Giovanni Evangelista, Parma. Taken to Paris, 1796. Returned 1816. Thereafter at the Galleria. 1935 Correggio exhibition, no. 40.

COPIES Del Bono chapel of S. Giovanni Evangelista, replacing the original. Prado, no. 117, 0·39 × 0·47 (from the Carlo Maratti collection). Sketch copy by J.-J. Henner, Paris, Musée J.-J. Henner.

DRAWING British Museum, Popham 43 (plate 88B). Pen and ink. Probably an early design for the whole.

ENGRAVINGS Francesco Dus (etching), and S. F. Ravenet, 1780 (with invented date, 1523 – see Appendix B).

REFERENCES [1] A. Romani in *Per L'Arte*, VI, Parma, 1894. [2] Vasari, 1550, p. 583; 1568, IV, p. 112 and VI, p. 481. [3] *Il Riposo*, p. 374. [4] *Il Microcosmo*..., pp. 277–8. [5] *Le Finezze*..., p. 176. [6] *Viaggio*..., p. 101. [7] MS. published by Popham, *Correggio in Roma*, 1958, p. 35. [8] *Guida...di Parma*, second edition, 1752, p. 52. [9] *Opere*, II, 1783 edition, p. 154. [10] 1786, p. 261. [11] *Storia*..., IX, 2, 603 n. [12] *Correggio*, Klassiker der Kunst, 1907, p. 86. Also, in this context, Frimmel (Battaglia, *Correggio Bibliografia*, no. 514).

PARMA　　　　　　　Galleria Nazionale

MADONNA DELLA SCALA

Fresco, detached in 1812 and transferred to canvas 1948.[1] Irregular shape. Dimensions given as 1·6 × 1·1.[2]

plate 93

Since the restoration of 1968 no attempt has been made to repaint the areas where the original paint is missing. The most serious loss is the whole of the Madonna's forehead and head from just above her eyebrows upwards. This damage was probably caused by a silver crown which had been fastened to the fresco before the mid-eighteenth century and which was deplored by Ruta[3] and Pungileoni.[4] Elsewhere, quite good state. Before 1948 painted additions had shown the figures enclosed in a kind of canopy with inclined sides. This was removed in the restoration of that year, which uncovered the remains of the original flanking pillars but did not reveal the losses in the Madonna's forehead. It did, however, show the top of the white mitre in the foreground. A. G. Quintavalle (loc. cit.) suggested that this was evidence that a large piece had been removed from the base of the painting, which would have depicted one of the patron saints of Parma adoring the Madonna. This is improbable. If anyone were wearing the mitre it would be unlikely to be exactly upright, as it is, and it would be surprising that Vasari and other writers who saw the painting before it was detached should have omitted to mention such a figure or that the early engravers should not have included it. More probably the mitre was shown resting on a ledge in the foreground, as in the Moretto altarpiece (no. 625 of the National Gallery, London), or Gandino del Grano's altarpiece in the Parma gallery.

Vasari describes the present painting as being 'sopra una porta' ('over a gate') of Parma.[5] It was in fact the east gate, variously known as the Porta Romana or Porta di S. Michele. In 1554 the gates of Parma were rebuilt for defensive purposes in such a way as no longer to be in line with the main roads. A small church was built on this occasion round Correggio's fresco which was approached by a staircase which gave its name to the painting.[6] The church was demolished in 1812 and the fresco detached and removed to the Gallery. No. 37 in the 1935 exhibition, Parma.

See text, page 89.

PROVENANCE See above.

COPY Leningrad, Hermitage.

PRINTS Etching by B. Bonvicini, 1700. Engraving by S. F. Ravenet (with invented date for painting, 1530).[7]

REFERENCES [1] A. G. Quintavalle in *Paragone*, September 1968, pp. 66ff. (with further references). [2] A. C. Quintavalle, 1970, p. 102, no. 55. [3] *Guida...di Parma*, 1751 edition, pp. 72–3. [4] Pungileoni, I, p. 117. [5] Vasari/Milanesi, IV, p. 114. [6] A. G. Quintavalle, loc. cit. (with eighteenth-century print of the exterior of the church). See also Tiraboschi, VI, p. 271, correcting various mis-statements by earlier writers. [7] Meyer (p. 474) lists other prints.

PARMA Galleria Nazionale

THE ANNUNCIATION

Fresco, detached. Lunette, 1·57 × 3·15[1] plate 94

The condition of the work before the restoration of c. 1939 is apparent from the reproductions in Ricci (1930) or the 1935 exhibition catalogue (no. 41). The Madonna's face is probably the least damaged portion. Elsewhere gravely damaged.

Mâle stresses the novelty of the putti in the cloud accompanying the angel Gabriel.[2] As comment on this it must be pointed out that Correggio had evidently acquired the habit, at S. Giovanni Evangelista, of not painting a cloud without one or more putti lurking in it.

See text, page 89.

PROVENANCE Despite some lack of continuity in the pedigree, always and rightly associated with Vasari's description, in his second edition, of Correggio's fresco of *The Annunciation* which was painted for the Frati de' Zoccoli di San Francesco at Parma. Vasari speaks of its removal from the wall, but does not say that the reason was the demolition of the church in 1546 by Pier Luigi Farnese to make way for fortifications.[3] Stated to be recorded in 1602 in the new church of the Annunziata on the other side of the river ('Capo di Ponte') at Parma, where also noted by Scaramuccia (1674).[4] The Correggio

literature seems to have overlooked the passage in Barri (1671) which says 'sopra il Camino si ammira un'Annunciata, figure più grandi del naturale. Opera singolare del gran Correggio'* as in the Palazzo al Giardino at Parma.[5] Owing to the difficulty of transporting a fresco, even if once detached, this is perhaps another work, but there would remain a faint possibility that it was the same. Entered the Parma gallery in 1875, after an unsuccessful attempt had been made to acquire it in 1832. Exhibited Parma, 1935 (41).

COPY Parma, SS. Annunziata, left of porch (replacing the original).

PRINTS By S. F. Ravenet (engraving) (rectangular format). Etching by B. Bossi, 1784.

DRAWING New York, Metropolitan Museum. Popham 49 (plate 94B) (from Wilton House). Black and red washes on paper tinted pink, heavily heightened with white. Squared in red chalk. Ascanio Alessandri (see reference 4) published as a *modello* what seems to be a copy (also sketch copies of parts of the S. Giovanni Evangelista frescoes).

REFERENCES [1] Dimensions from Ricci (1930). The 1934 exhibition catalogue gives 1·57 × 1·15! [2] E. Mâle, 'La représentation de l'Evangile dans l'art' in *Revue des Deux Mondes*, 1931 (quoted in the Parma exhibition catalogue, 1935, p. 60). [3] Vasari, IV, pp. 113–14 and Tiraboschi, VI, p. 271. Also C. Ruta, *Guida...di Parma*, 1751 edition, pp. 18–19. [4] See Ascanio Alessandri, 'Intorno particolarmente all'annunciazione del Correggio, e a due Tavolette con Schizzi ed un Bozzetto di lui' in *Crisopoli*, Jan./Feb., 1935. Also Scaramuccia, 1674, p. 175. [5] *Viaggio Pittoresco...*, p. 108.

* 'over the chimney-piece may be admired an Annunciation, figures larger than life. Excellent work of the great Correggio.'

PAVIA Museo Comunale
 (reported stolen, 1971)

MADONNA AND CHILD WITH THE
GIOVANNINO, ST. JOSEPH AND ST.
ELIZABETH

Panel, 0·27 × 0·21 [1] plate 5C
Varnish very discoloured (1970) and amount of
damage therefore very difficult to estimate accurately.

 As Francia until attributed to Correggio by Mo-
relli (1880).[2] The latter calls the saint on the right St.
Anne, despite the fact that she is shown behind the
Giovannino.

 See text, page 34.

PROVENANCE Marchese Luigi Malaspina, whose
collection passed to the Museo Civico, Pavia by his
will of 3 June 1833.

REFERENCES [1] Dimensions from Ricci (1930).
[2] 'Munich and Dresden', 1880, p. 146. S. Freedberg
(*Painting in Italy, 1500–1600*, 1970, p. 491, n.7) seems
to deny the attribution to Correggio.

PHILADELPHIA John G. Johnson
 Collection

MADONNA AND CHILD WITH THE
GIOVANNINO AND ST. ELIZABETH

Panel, 0·61 × 0·48 [1] plate 6A
Much damaged.
 See text, page 33.

PROVENANCE Prince Hohenzollern-Sigmaringen
(for whom said to have been bought by Bode in
London in 1888).[2] Accepted as Correggio by
Morelli (1891 and 1893)[3] and later writers. Bought
by John G. Johnson *c.* 1914.[4]

REFERENCES [1] Dimensions from Ricci (1930).
[2] Battaglia, no. 372. Gronau 1907, p. 158. *Archivio
Storico dell'Arte*, VI, 1893, p. 390. [3] 'Munich and
Dresden', 1891, pp. 194, 217, 290; 1893, pp. 151–2.
[4] *Art in America*, II, February 1914, pp. 158–9.

ROME Villa Borghese

DANAE

Canvas, 1·61 × 1·93[1] plates 188, 189

Condition difficult to estimate under glass under old varnish which is tending to drag the paint. Much dirt in the cracks, but considerable areas are likely to be free of repaint.

Vasari, describing from hearsay what was evidently this picture, in the context of two which he says were commissioned by Federigo Gonzaga to send to the Emperor Charles V, mentions the two infants and describes them as testing arrows of gold and lead on a touchstone.[2] Of these infants, the one on the spectator's right has wings, the one on the left has not. Mengs points out that the one on the left is examining one of the golden drops, while it is the other – on the right – who tests the arrowhead. He notes that the latter appears more robust than the former, and concludes that love comes from the arrow and its ruin from gold.[3] The adolescent Cupid on the bed is called Hymen by Mengs.

Jupiter's visit to Danaë in the form of a shower of gold is told by Ovid.[4] The subject would have been rare in Italian painting when Correggio painted it. Titian's representations of it date from later.

See text, page 130.

PROVENANCE Evidently taken to Spain by Charles V. In his *Trattato*, published by Lomazzo in 1584, the *Danaë* and the *Io* (Vienna) are reported in Milan in the possession of Leone Leoni.[5] Lomazzo adds that they had been sent from Spain by Leone Leoni's son, Pompeo. In point of fact Pompeo Leoni was himself in Milan on a visit from Spain in 1584 (he was there from 1582 to 1591). If Lomazzo is correct in saying that the pictures were *sent* from Spain it must therefore have occurred before 1582. But in either case – whether the pictures were sent or whether Pompeo brought them with him – it would militate against their having belonged to Antonio Pérez, as is often stated. Pérez undoubtedly owned the *Ganymede* (Vienna). He was in disgrace from 1579 but the

auction of his collection did not take place until 1585–6. Though it would be possible that he had had the *Danaë* and the *Io* and had sold them to Pompeo Leoni before 1582 it would be more probable that Leoni had been given them by Philip II, perhaps on the occasion of his return to Italy and calculated to make him more likely to fulfil his promise to return to Spain. During the negotiations with Rudolf II, who wished to buy both pictures, as well as the *Ganymede* and the *Leda* (Berlin), Pompeo Leoni specified (letter of 25 April 1601) that the *Danaë* and the *Io* had belonged to Charles V. Rudolf finally succeeded in buying the two latter in 1601.[6] The *Danaë* is in the Prague inventory, 1621.[7] Taken from Prague with the other pictures from Rudolf's collection to Sweden in 1648 (Skokloster inventory).[8] In Queen Christina's inventories of 1652 and 1656.[9] Taken by her to Rome. After her death in 1689 her pictures passed by bequest to Pompeo Azzolini, who sold them to Livio Odescalchi, whose heir, after lengthy negotiations, sold them to the duc d'Orléans, regent of France, in 1721.[10] The regent died in 1723, but the *Danaë* seems to have escaped the mutilation which was meted out to the *Leda* by his successor, the lunatic duke Louis. Included in Du Bois de Saint Gelais' catalogue of the Orléans collection (1727) (page 55), and in the illustrated edition of 1786 and Thiéry's Paris *Guide* of 1787 (vol. I, page 259). Passed in 1792 with the Orléans collection through Walkuers and Laborde de Méréville to England.[11] Exhibited for sale with part of the Orléans collection at the Lyceum, London from 26 December 1798, lot 186 (marked 'not sold').[12] According to Buchanan it was bought 'later' by Henry Hope.[13] Henry Hope sale, Christie's, 3rd day, 29 June 1816, lot 96 ('from the Orléans collection').[14] (Lot 88 in the Ph. Panné sale, Christie's, 3rd day, 29 March 1819 is there said to be ex-Orléans, but probably wrongly, as Panné had bought the Udny/Walsh Porter copy.)[15] Recorded by Nagler (*Künstler-Lexikon*, I, 1835) as in Villa Borghese, and as bought in Paris. Recorded in Palazzo Borghese by Melchiorre (1837–8),[16] and by Platner, Bunsen, etc. (1842) (as bought by Prince Camillo

Borghese in Paris).[17] This was evidently not later than 1827, when Pietro Camuccini restored it. Transferred with the rest of the pictures from Palazzo Borghese to Villa Borghese, 1891.

DRAWINGS Popham 82 and 83 (plates 189B, C). Two red chalk drawings at Besançon, one perhaps for Danaë, the other perhaps for the right hand putto.

ENGRAVINGS By Duchange (in reverse), Desrochers (plate 189A), Trière and Cunego. Desrochers' print bears the inscription 'Antonius de Alegris Corigiensis pinxit 1531'. This has been thought to constitute an authentic date but it is difficult (to say the least) to imagine an authentic tradition which was known in the eighteenth century but not recorded either before or since. Similar dates attached to prints by Ravenet (see Parma, *Madonna della Scodella* and *Madonna and Child with St. Jerome*) and Moette (see Naples, *Marriage of St. Catherine*) suggest that such things were merely the result of an intelligent guess (see Appendix B).

COPIES An old copy was successively in the Robert Udny sale, Christie's, 2nd day, 19 May 1804, lot 99 (with an impossible story claiming it as the original and as having been mutilated at the same time as the *Io* copy and the *Leda* and as having thereafter left the Orléans collection), and Walsh Porter sales, Christie's, 14 April 1810, lot 52 and 6 April 1816, lot 93 ('formerly in the Udney [sic] collection') (Messrs Christie's copy says 'bt. Panné').

REFERENCES [1] Measurements from the Villa Borghese catalogue. [2] Vasari/Milanesi, IV, p. 115. [3] Mengs, *Opere*, vol. 2, 1783 edition, p. 148. [4] Ovid, *Metamorphoses*, IV, 611; VI, 113. [5] Lomazzo, *Trattato*, 1584, p. 212. [6] The documentation of Rudolf's negotiations, commented on by Urlichs (*Zeitschrift für bildende Kunst*, 1870, pp. 81–5), is printed in detail in the Vienna *Jahrbuch*, vol. XIII (1892), part 2, pp. CXLIII–CLXIII, nos. 9,409, 9,419, 9,433, 9,450, 9,532, 9,583, vol. XV (1894), part 2, pp. CLXVI–CLXXVIII, nos. 12,494, 12,495, 12,504, 12,542, 12,599 and vol. XIX (1898), part 2, pp. XXI–XLII, nos. 16,224–7, 16,231, 16,232, 16,433. [7] Olof Granberg, *Kejsar Rudolf II's Konstkammare...*, 1902, Bilaga I, p. V, no. 67. Also *Wiener Jahrbuch*, 25, 1905, Anhang

XXXIX, no. 894. [8] Olof Granberg, *La Galerie de Tableaux de la Reine Christine*, 1897, Appendice I, p. vii, no. 149. [9] Granberg, op. cit., 1897, Appendice II, p. XXIX, no. 81, and J. Denucé, *The Antwerp Art Galleries...in the Sixteenth and Seventeenth Centuries*, 1932, p. 178. [10] 1689 (?) Christina inventory (Granberg, 1897, Appendice III, p. LVII, no. 25; 1721 inventory (Granberg, 1897, Appendice IV, p. XCV, no. 35). Boschini (*La Carta del Navegar...*, 1660, p. 302) mentions the *Danaë* as in the Imperial collection, but his information was out of date. [11] For details of the transaction see W. Buchanan, *Memoirs of Painting*, vol. 1 (1824), pp. 9ff. [12] Note in a copy of the sale catalogue in the library of the National Gallery, London. [13] Op. cit., I, p. 62. A note in the National Gallery typescript copy of the Udny sale catalogue says the Orléans version of *Danaë* (i.e. the original) was 'bought out of the Orléans collection by W. Bryant and sold by him for 600 guineas to Mr Hope, Cavendish Square'. [14] Messrs Christie's copy of the sale catalogue has the buyer's name as 'Plimpton' with query. Elsewhere in the catalogue 'Priddle Plimpton' occurs more than once. [15] It would be possible, but does not seem demonstrable, that Panné had owned both the original (i.e. Orléans picture) and the Udny copy. [16] *Guide Méthodique de Rome...*, pp. 620–1 ('attribué au Corrège' (!). [17] *Beschreibung der Stadt Rom*, vol. 3, part 3, p. 297. In *Il museo e la Galleria Borghese* (1893, p. 95) A. Venturi gives 1823 as the date of the purchase by Prince Borghese.

ROME Villa Borghese

for copy of *Madonna and Child with Giovannino* (plate 6B) see Catalogue B, page 278.

ROME Capitoline Museum

for copy of *Madonna and Child with Saints Mary Magdalen and Lucy* (*Madonna of Albinea*) (plate 25) see Catalogue B, page 278.

ROME Palazzo Doria

ALLEGORY OF VIRTUE (unfinished)

Canvas. Tempera, 1·5 × 0·86[1] plate 179

The central figure is painted in grisaille. The flesh of the others is flesh-coloured. See text, page 129.

Morelli published the present picture as a French copy dating from the seventeenth century.[2] It does not seem to have been pointed out hitherto that it is possible to trace its history back with certainty to the Aldobrandini inventory of 1603, where it already is listed as Correggio. Though this disposes of Morelli's theory it would not in itself guarantee the attribution, which, in modern times, was not accepted by Berenson, but which remains acceptable to the present writer. Presumably the present picture was a try-out for the one in the Louvre. Though it has been suggested[3] that the difference in height (the Louvre picture is 8 cm. less high) explains why the present picture would have been abandoned it is difficult to believe that so small a difference could have been decisive, or that the present picture could not have been cut down to the height of the Louvre one (though the latter and its companion are less high than the contributions of Mantegna, Costa and Perugino there is no other reason to assume that they have been correspondingly reduced in height while the elaborate British Museum drawing for the *Vice* (Louvre) would constitute evidence against the idea). More probable would be some miscalculation in the use of the unusual medium. The differences in the composition of the two pictures may be tabulated as follows:

1. The central figure is nearly naked (but was evidently intended to be clothed) in the Doria picture, clothed in the Louvre one.
2. The lower part of the right leg (from the knee down) of the central figure is concealed in the Louvre picture, revealed in the Doria one.
3. The central figure looks at the spectator in the Louvre picture, and looks over her right shoulder in the Doria one.
4. The broken spear held by the central figure is more upright in the Doria picture than in the Louvre one.
5. The two left-hand flying figures in the Louvre do not exist in the Doria picture; the drawn lines which *do* exist there do not correspond with them.
6. The mountains to the right are different in the two pictures.

PROVENANCE Through the detailed nature of the description by Scannelli (1657)[4] of a picture in the Aldobrandini collection at the Rome Villa ('Magnanapoli...un Quadro...del Correggio...con picciole figure una tal historia, la quale se bene non sia per lo più dall'osseruatore compresa...e se bene ...non si manifesti di total compimento...')* identifiable with entries in the 1603 Aldobrandini inventory ('245. Un concerto di varie figure di donne di mano de Antonio da Correggio')[5]† and in the Olimpia Aldobrandini inventory (before 1665) ('245. Un quadro in tela con concerto di varie figure di donne alto p. sei...non è finito...di...Antonio da Correggio').[6]‡ Also in the 1626 and 1682 Aldobrandini inventories.[7] Described in detail in Palazzo Doria (to which many of the Aldobrandini pictures came in the eighteenth century) by Mengs,[8] and mentioned there by Ratti,[9] Tiraboschi[10] and Vasi[11] *inter alios*. Exhibited Parma, 1935 (47).

COPY A painted copy, panel 39½ × 32½ inches, itself unfinished, was lot 95, Sir Giles Sebright sale, Christie's, 2 July 1937, and later (1951) with the dealer, A. L. Nicholson. It was noted by Waagen[12] in the Sebright collection and as formerly Altieri and David Wilkie. It can therefore be identified with the

* 'Magnanapoli...a picture...by Correggio...a scene with small figures, which although not fully comprehensible to the spectator...and despite... being evidently not entirely finished.'

† 'A group of various female figures by Antonio da Correggio.'

‡ 'A canvas with a group of various female figures 6p. high...not finished...by Antonio da Correggio.'

picture mentioned by Pungileoni[13] as noted by Resta chez Altieri, and probably also the one mentioned by Tiraboschi.[14] It corresponded with the Doria picture, rather than the Louvre one, in all essentials, and was finished except for the central figure, which was only a lay-in.

REFERENCES [1] Dimensions from the catalogue of the Doria pictures by E. Sestieri (1942). [2] *Italian Painters...Borghese and Doria-Pamfili Galleries...*, 1892, pp. 312ff. Popham (1957, p. 99, n.2) also (strangely), as a copy. [3] E.g. by Ricci, 1930, p. 119. [4] p. 284. [5] Published in *Palatino*, 1964, p. 207. [6] *Palatino*, loc. cit. [7] Published in *Arte Antica e Moderna*, 1960 (pp. 425ff.), 1962 (pp. 316ff.) and 1963 (pp. 61ff. and 175ff.); no. 120 in the 1626 inventory and no. 292 in the 1682 inventory. [8] *Opere*, 1787 edition, p. 187. [9] p. 53. [10] pp. 278 and 284. [11] *Itinerario...*, 1791, p. 88. [12] *Galleries and Cabinets of Art in Great Britain*, 1857, p. 328. [13] II, p. 249. [14] pp. 278 and 284.

STRASBOURG

JUDITH WITH THE HEAD OF HOLOFERNES

Panel, 0·27 × 0·20[1] plate 5A

Some damage in two vertical lines towards the bottom, from just to left of Holofernes' head downwards; and downwards from his hair hanging on the right. Otherwise good condition.

First catalogued (Strasbourg, 1899) as Correggio.[2] Not included in Ricci (1896) nor in the first edition of Berenson's *North Italian Painters* (1907). Attribution attacked by C. Loeser,[3] but confirmed by A. Venturi (1900)[4] and Gronau (1907), and generally since. See text, page 33.

PROVENANCE Charles Fairfax-Murray, London, from whom bought by Bode for Strasbourg, 1892.[5] Exhibited Parma, 1935 (27); Paris, Petit Palais, 1965–6 (*Le XVIe Siècle Européen...*) (88).

REFERENCES [1] Dimensions from the Strasbourg catalogue (1938). [2] No. 609 in the 1627 Mantua inventory (Luzio, *La Galleria dei Gonzaga venduta all'Inghilterra*, 1913, p. 130) is a Judith 'mezza figura, finta di notte' ('half length, night effect') which suggests the present picture. But though there are various versions of this subject in Van der Doort's inventory of Charles I's collection, none corresponds with it. An *Erodiade* by Correggio is said to have passed from Don Siro of Correggio through Grimani to Renieri (Pungileoni, I, p. 58. See also under Attributions). [3] *Archivio Storico dell'Arte*, second series, II, 1896, p. 284. [4] Crespi catalogue, pp. 5ff. [5] Strasbourg catalogues, 1899 and 1938.

VIENNA Kunsthistorisches Museum

GANYMEDE

1·635 × 0·705.[1] The dimensions of the old copy in the Prado (1·75 × 0·72 – see below) may imply that the original has been cut. plates 186, 187
More damaged than its pendant, the *Io* (Vienna) (q.v.). The lower half is worse than the upper, but no sizable intact areas anywhere. The eagle's head and neck, and Ganymede's head and left arm are not too badly preserved. The foliage has oxidised to yellow. Cleaned 1959. The authenticity of this picture was questioned by Tschudi[2] and others[3] on the grounds that it repeats a figure in the north-west squinch of the cupola of Parma cathedral (an angel under St. Bernard). Nevertheless, Correggio frequently repeated his own motives, and the present picture is obviously the pendant to the *Io*. Any remaining doubts regarding its authenticity should be removed by the recent cleaning of the picture. Though the *Ganymede* and the *Io* are not described by Vasari, it is assumed that like the *Danaë* (Rome) and the *Leda* (Berlin) they were given by Federigo Gonzaga to Charles V.

The model for the face of Correggio's Ganymede seems the same as that in the *Io*. The engraver Beatrizet introduced a similar dog to the one in this picture into his print of Michelangelo's design of the same subject.[4]

See text, page 130.

PROVENANCE Evidently taken by Charles V to Spain. Referred to as in the forthcoming auction of Antonio Pérez' effects in correspondence from December 1585 between the Emperor Rudolf II and his ambassador in Madrid, Hans Khevenhüller.[5] Reference is made at the same time to Parmigianino's *Cupid*, and though the *Ganymede* is also referred to as by him, subsequent events leave no doubt that it was in fact this Correggio. The Emperor wished to buy both pictures, but was later told they had reverted to the possession of King Philip II (who had presumably given them to his then favourite, Antonio Pérez,

in the first place). At that time Rudolf had to be content with copies. After King Philip's death (1598) he renewed negotiations and finally succeeded in buying the *Ganymede*, together with the *Leda*, in 1603–4 (on 19 August 1604, Eugenio Caxes was paid for copying them).[6] Recorded in Inventory G (*c.* 1612–18) of the Imperial pictures at Vienna.[7] The fact that like the *Io*, and unlike the *Danaë* and the *Leda*, it was not looted by the Swedes from Prague in 1648 suggests that it remained in Vienna, where it is mentioned by Zeno Apostolo (1724)[8] and where it has remained virtually ever since. Exhibited Paris, Petit Palais, 1935, no. 119; and in various capitals in northern Europe and North America, 1946/7–1952.

DRAWING A drawing then at Weimar was published by Ricci as an autograph study but considered by Popham (A 130) to be by a seventeenth-century artist.[9]

COPY Prado, no. 119 (by Eugenio Caxes, 1604). Another in the Parma gallery.

ENGRAVING By Fr. van den Steen (*c.* 1625–72) after N. van Hoy's drawing (in reverse) (plate 185B).

REFERENCES [1] Dimensions from the Vienna catalogue. [2] H. von Tschudi, *Correggios Mythologische Darstellungen*, 1880. [3] E.g. Ricci, 1896, pp. 319–21. Swoboda (1931, p. 97) suggested the lower half by another hand. [4] Reproduced by Mario Rotili, *Fortuna di Michelangelo nell'incisione*, 1964, pl. 18. For some discussion of the symbolism of the dog see E. Verheyen in *Journal of the Warburg and Courtauld Institutes*, 29, 1966, p. 187. He also proposes Bernardo's commentary on Petrarch's *Trionfo d'Amore* as source for the picture in general. [5] The documentation of Rudolf's negotiations, commented on by Urlichs (*Zeitschrift für bildende Kunst*, 1870, pp. 81–5) is printed in detail in the Vienna *Jahrbuch*, vol. XIII (1892), part 2, pp. CXLIII–CLXIII, nos. 9,409, 9,419, 9,433, 9,450, 9,532, 9,583, vol. XV (1894) part 2, pp. CLXVI–CLXXVIII, nos. 12,494, 12,495, 12,504, 12,542, 12,599 and vol. XIX (1898), part 2, pp. XXI–XLII, nos. 16,224–7, 16,231, 16,232, 16,433. A picture of this subject, with no artist's name specified, occurs in the Pérez inventory (see reference no. 6 in the entry for the Berlin *Leda*). [6] Prado catalogue. [7] Vienna catalogue. The *Ganymede* is mentioned

as in the Imperial possession by Boschini (*La Carta del Navegar Pitoresco*, 1660, p. 302). [8] *Lettere nelle quali si contengono molte notizie attinenti all'istoria letteraria de' suoi tempi*, book published 1752. [9] Ricci 1930, pl. CCXCI.

VIENNA Kunsthistorisches Museum

IO

Canvas, 1·635 × 0·74 (of which 2 cm. on each side is an addition)[1] colour plate L, plates 183, 184

The dimensions of the old copy formerly at Berlin (1·38 × 0·83) may imply that the Vienna picture, before the existing narrow strips were added to right and left, may have been cut down at the sides (the Berlin copy may itself have been cut at the top and bottom). The rather tight fit and the evidence of the companion picture, the *Ganymede* (Vienna) (q.v.) supports this conclusion.

Less damaged than the *Ganymede*. Io's hair and the upper part of her face in good state. Also her white drapery, both under her right arm and under her buttocks. All the leaves have now oxidised to yellow. Repaint visible (1969) in the shadowed area of her body under the piece of cloud enclosing the lover's right hand. Also in the shadowed area of her buttocks.

Despite a claim that part of Vasari's description – the mention of the stream running amid stones – of the pictures which, he said, Federigo Gonzaga commissioned of Correggio to send to the Emperor Charles V, corresponds better with the *Io* than with the *Leda* (Berlin), it seems certain that Vasari was trying to describe two pictures only, the *Danaë* (Rome) and the *Leda*.[2] Nevertheless, the fact that the *Io*, and also the *Ganymede*, accord well with the other two, both in subject – the loves of Jupiter – and in style, and that both pictures are first reported in Spain (the *Ganymede*) or as having recently been there and as having belonged to Charles V (the *Io*) leaves no reasonable doubt that all four were originally a series.

The story of Io is told by Ovid.[3] She was a nymph who had inspired Jupiter's desire, which he satisfied under cover of a cloud. He then transformed her, for a time, into a white heifer. The subject was rare in Italian Renaissance art. The model for the face in Correggio's picture seems the same as for the *Ganymede*. The stag on the right is not mentioned by Ovid. Mengs suggested, plausibly, that it was a poetic addition of Correggio's, the stag slaking its thirst being intended as a symbolic commentary on the action shown in the painting.[4] A comparable interpolation – in the form of a dog – occurs in the *Ganymede*.

See text, page 130.

PROVENANCE Evidently taken to Spain by Charles V. In his *Trattato*, published by Lomazzo in 1584, the *Danaë* and the *Io* are reported in Milan in the possession of Leone Leoni.[5] Lomazzo adds that they had been sent from Spain by Leone Leoni's son, Pompeo. In point of fact Pompeo Leoni was himself in Milan on a visit from Spain in 1584 (he was there from 1582 to 1591). If Lomazzo is correct in saying that the pictures were *sent* from Spain it must therefore have occurred before 1582. But in either case – whether the pictures were sent or whether Pompeo brought them with him – it would militate against their having belonged to Antonio Pérez, as is often stated. Pérez undoubtedly owned the *Ganymede*. He was in disgrace from 1579, but the auction of his collection did not take place until 1585–6. Though it would be possible that he had had the *Danaë* and the *Io* and had sold them to Pompeo Leoni before 1582 it would be more probable that Leoni had been given them by Philip II, perhaps on the occasion of his return to Italy and calculated to make him more likely to fulfil his promise to return to Spain. During the negotiations with Rudolf II, who wished to buy both pictures – the *Io* and *Danaë* – as well as the *Leda* and the *Ganymede* – Pompeo Leoni specified (letter of 25 April 1601) that the *Danaë* and the *Io* had belonged to Charles V. Rudolf finally succeeded in buying the two latter in 1601.[6] The *Io* is in Inventory G (c. 1612–18) of the Imperial pictures at Vienna.[7] The fact that like the *Ganymede* and unlike the *Danaë*

18-2

and the *Leda*, the *Io* was not looted by the Swedes from Prague in 1648 suggests that it remained in Vienna, where it is mentioned by Zeno Apostolo (1724)[8] and where it has remained virtually ever since. (Exhibited at various capitals in Europe and North America, 1946/7–1952).

COPY Formerly Berlin, Kaiser Friedrich Museum (said to have been destroyed in the Second World War). This (from Queen Christina's collection) was mutilated by Duc Louis d'Orléans at the same time as the original of the *Leda* (q.v.). Before that it had been copied by Lemoyne (now Hermitage) (fig. 51). A small copy in the Galleria Borghese. Another stated to be in the Museum at Montepulciano (E. Verheyen, *Journal of the Warburg and Courtauld Institutes*, 29, 1966, p. 161, n.6).

ENGRAVINGS By Fr. van den Steen (*c.* 1625–72) (in reverse) (plate 185A) after N. van Hoy's drawing. Also prints after the Orléans-Berlin copy by Duchange (1705) (in reverse), Desrochers, J. Johnson (1743) and others. The Johnson print bears the following verse: 'Let the Severe condemn poor Io's Case / That She submitted to the warm embrace; / But 'twas a God; a God, who pleaded Love: / What Woman could withstand ye Clasps of Jove? / He came in Cloud, and hovered o'er her Head; / Intranc'd Her first, and then usurped her Bed. / If this be fiction, Oh! be tender, Fame: / Not Io, but Correggio, is to blame.' An eighteenth-century print by G. D. D. Sornique transforms Io into a Diana.

A version of the *Io* appears among the pictures in no. 4 (*The Countess' Morning Levée*) of Hogarth's *Marriage à la Mode* (London, National Gallery). Hogarth could never have seen the original and was presumably working from one of the engravings.

REFERENCES [1] Measurements from the Vienna catalogue. [2] Vasari/Milanesi, IV, p. 115. [3] *Metamorphoses*, I, 583ff. E. Verheyen (*Journal of the Warburg and Courtauld Institutes*, 29, 1966, p. 184) proposes Bernardo's commentary on Petrarch's *Trionfo d'Amore* as a source). [4] Mengs, *Opere*, 1783 edition, p. 149. Also Verheyen, op. cit., p. 186. [5] Lomazzo, *Trattato*, 1584, p. 212. [6] The documentation of

Rudolf's negotiations, commented on by Urlichs (*Zeitschrift für bildende Kunst*, 1870, pp. 81–5), is printed in detail in the Vienna *Jahrbuch*, vol. XIII (1892), part 2, pp. CXLIII–CLXIII, nos. 9,409, 9,419, 9,433, 9,450, 9,532, 9,583, vol. XV (1894), part 2, pp. CLXVI–CLXXVIII, nos. 12,494, 12,495, 12,504, 12,542, 12,599 and vol. XIX (1898), part 2, pp. XXI–XLII, nos. 16,224–7, 16,231, 16,232, 16,433. [7] Vienna catalogue. [8] *Lettere nelle quali si contengono molte notizie attinenti all'istoria letteraria de' suoi tempi*, book published 1752.

VIENNA Kunsthistorisches Museum

MADONNA AND CHILD
(*Madonna of Hellbrunn*)

Panel, 0·66 × 0·55[1] plate 21B

Severely damaged. Rubbed and retouched almost everywhere. Recognised as Correggio by H. Voss at Schloss Hellbrunn in 1926.[2] Attribution to Correggio accepted by Ricci (1930). Not accepted by Berenson, but acceptable to the present writer as close to the Brera *Adoration*.

See text, page 44.

PROVENANCE Schloss Hellbrunn (near Salzburg). Kunsthistorisches Museum from 1928. Exhibited Parma, 1935 (30).

REFERENCES [1] Dimensions from Vienna catalogue. [2] Published in the *Kunstwanderer*, 1926 (not read by the present writer). See also *Pantheon*, I, 1928, pp. 270ff. and XIII, 1934, p. 128 which refers to the picture as recently exhibited 'zum erstenmal' ('for the first time') and as possibly from Wolf Dietrich's collection.

WASHINGTON National Gallery of Art

MARRIAGE OF ST. CATHERINE; ALSO
SAINTS FRANCIS AND DOMINIC

Panel, 0·28 × 0·215 [1] plate 5B

Some damage in the faces of the Madonna and of St. Anne. The photographs reproduced in Ricci (1896) and Ricci (1930) seem to indicate large cracks at that time in the pigment of the Madonna's cloak. Cleaned 1959. The relief on the base of the throne shows the decapitation of St. Catherine, whose sword, crown and wheel are on the step. The inclusion of Saints Francis and Dominic is exceptional and presumably at the patron's request. In the fourth section (1841) of Laderchi's catalogue of the Costabili collection at Ferrara it appears as Fra Bartolommeo (no. 442) with the statement that it had also been attributed to Raphael, and that 'Teofilo Geyser', artist and connoisseur from Leipzig, had attributed it to the young Correggio. An unpublished note by Otto Mündler, who saw it in 1858 in the Costabili collection, says 'disposition like Fra Bartolommeo, but the whole looks like a juvenile work of Correggio'. [2] Attribution to Correggio confirmed by Morelli (1880), [3] who mentioned (1885) an alternative attribution to Mazzolino. [4] Attribution to Correggio usual since.

See text, page 34.

PROVENANCE Costabili collection, Ferrara. Sold before 1880 (Morelli, loc. cit.) to Frizzoni, Milan. Passed by inheritance to the Ginouliac family, Milan, 1919, [5] under whose name it was exhibited, R.A., London, 1930 (173). Despite this said to have been sold in 1929 to Ing. Bonomi, Milan, [6] Exhibited Parma, 1935 (24) lent Kress, to whom it had been sold through Contini-Bonacossi. [7] At Washington (Kress collection) since 1941. [8]

REFERENCES [1] Dimensions from the Washington catalogue. [2] In the library of the National Gallery, London. [3] 'Munich and Dresden', 1880, p. 145. [4] Morelli/Richter correspondence, 1960, p. 449. [5] Catalogue of the 1935 exhibition at Parma. [6] Ricci (1930) and 1935 Parma catalogue. [7] 1935 Parma catalogue (Contini misprinted 'Conini'). [8] Washington catalogue (by F. R. Shapley), 1968, with further references.

WASHINGTON National Gallery of Art

THE YOUNG CHRIST

Panel, 0·426 × 0·333 [1] plate 5D

Very good condition. Cleaned 1959.

Attributed to Leonardo da Pistoia (Berenson, 1932). Shown by Colnaghi's, London, 1947 as Correggio. Clearly the same sitter as the Baptist in the *Madonna and Child with St. Francis* (Dresden) at a slightly younger age, and therefore either an early work of Correggio (of *c.* 1512) or, less probably, an old copy. A comparable picture, of inscrutable status, was one of Longhi's candidates. [2] A picture of similar subject by Mantegna is in the town of Correggio and may have been there in Antonio da Correggio's time. [3]

Called 'Salvator Mundi' in the Kress catalogue, but the presentation suggests rather a Christ in the Temple without the other figures.

See text, page 39.

PROVENANCE Lord Kinnaird, Rossie Priory, Inchture, Scotland. Bought (privately) from him by Colnaghi's, 1946. Sold by them, 1954, to A. H. Schwabe. [4] Exported to the United States, 1956. Kress acquisition by Washington, 1957. [5]

REFERENCES [1] Dimensions from the Washington (Kress) catalogue. [2] *Paragone*, no. 101, 1958. R. Finzi (*Nuove Lettere Emiliane*, 3, 1963) claims the Dresden Baptist as a self-portrait. [3] Catalogue of the 1935 Parma exhibition, no. 17. [4] Information from Messrs Colnaghi. [5] For further references cf. F. R. Shapley's catalogue of fifteenth- and sixteenth-century Italian paintings at Washington (Kress collection), 1968, p. 83.

B. LOST PICTURES

The compositions catalogued in this section are those of which no certain original is agreed to be extant, but which, on the evidence of existing copies, or documents, or both, may be assumed to have been painted by Correggio. A few other compositions, supposed on insufficient grounds to be after Correggio, are included in the notes on attributions, which follow the present section (Section C).

N.B. For the apse decoration of S. Giovanni Evangelista at Parma see under Section A of the catalogue on page 246.

MADONNA AND CHILD WITH THE GIOVANNINO

A version now in the National Gallery of Art, Washington (Timken Bequest) measures 0·691 × 0·51 and was published by Venturi (*L'Arte*, XXIV, 1921, pp. 172–3) as then in the Kunsthistorisches Museum, Vienna. It is stated to have come from Schloss Ambras. The catalogue of the 1935 Parma Correggio exhibition states (page 46) that the Kunsthistorisches Museum got rid of this picture on acquiring the *Hellbrunn Madonna* (in 1928). In the previous year (1927) another version had been found in the Fochessati di Bagno collection at Mantua and had been bought for the Borghese Gallery, Rome, in whose possession it remains. It is on canvas (? from panel), 0·73 × 0·52 (plate 6B) and is much repainted. It was published as Correggio's original by Ricci (*Bollettino d'Arte*, November 1929) and was exhibited at Parma, 1935 (32). The Vienna version was bought by one Van Diemen who sold it in 1930 to W. R. Timken of New York (cf. W. Valentiner, *Unknown Masterpieces*, 1930, no. 21). I have not seen the Washington picture. The condition of the Rome one is too bad to judge if it was ever the original. Despite lack of confirmation of the design the forms accord so well with those of the London *Leave Taking* that I have no doubt there was once an original dating from that period. A copy of the *Madonna* is at San Diego (California). A late copy on canvas was lot 54 ('Luini') in the Lt.-Col. A. E. Jelf-Reveley sale, Christie's, 9 June 1972.

See text, page 37.

Formerly ALBINEA (Reggio Emilia), Parrocchiale

MADONNA AND CHILD WITH SAINTS MARY MAGDALENE AND LUCY

In a letter of 12 May 1517, published by A. Venturi[1] (see page 176), Giovanni Guidotti di Roncopò, priest of Albinea, wrote to his friend, Alessandro de Malaguzzi, asking him to write to instruct the painter to be addressed as 'Messer Antonio fiolo de Pellegrin de Alegri de Coreza' to take certain unspecified measures as already discussed by the two correspondents to ensure greater durability in the 'ancona' on which he was working, provided that the work was not too far advanced to permit of it. This is some evidence against the tradition reported by Pungileoni[2] to the effect that Correggio worked on the picture in Albinea at the expense of the parish. An end payment of 4 ducats for the work, published by Pungileoni, is dated 14 October 1519.[3] The subject of the altarpiece is not specified in these documents. The mention of a 'madalena' in the letter of 1517 misled certain writers on this score, until it was explained that this

was a local word meaning a cask of wine.[4] An un-
dated document published by Pietro Martini (1865)[5]
refers to the picture as a 'Natività di B.V. Maria'.
Subsequent writers such as Meyer (1871) and Quirino
Bigi (1880) accepted this as its subject. But the exis-
tence in the church of two separate pictures, evidently
copies after the same early-ish Correggio, is strong
evidence in the contrary sense. Ricci (1896) ac-
counted for the reference in Martini's document by
pointing out that the church is dedicated to the
Nativity of the Virgin. It has been suggested that a
reference of 1557 to the people of Albinea taking
their 'Madonna' to S. Rocco at Reggio for safety
during hostilities was to this picture.[6] Martini's
document gives the date 1647 as that when Duke
Francesco I d'Este removed the picture by force from
the church at Albinea.[7] Since then it is not known
what became of it. In addition to the two copies re-
maining in the church there is one in the Parma
gallery (on loan from the Brera) which bears the
signature 'Antonus [sic] Laetus faciebat', another in
the Capitoline Museum, Rome (plate 25) and others
recorded in private collections.[8]

See text, page 57.

REFERENCES [1] A. Venturi, *Archivio Storico
dell'Arte*, I, 1888, p. 90. Also transcribed on page 176
of the present book. [2] Pungileoni, II, p. 108. [3]
Pungileoni, II, pp. 109–10. [4] Giovanni Saccani,
La Storia d'un Capolavoro, 1915. It may have been this
'madalena' which was subscribed for by the parishio-
ners of Albinea and which led to the tradition that the
painter had been kept by the parish on the spot. [5]
Studi intorno il Correggio, p. 71. [6] Pungileoni, II,
p. 112. [7] Ricci (1896 and 1930) describes the sub-
sequent litigation. [8] Ricci 1930, p. 156.

MADONNA AND CHILD WITH THE GIOVANNINO

A version in the Städelsches Kunstinstitut, Frankfurt-
am-Main on canvas (? from panel) (plate 90A) mea-
sures 0·905 × 0·722. It is now so damaged that it is not
possible to say if it was once Correggio's original.
This version was first published, briefly, by H. Thode
in the *Frankfurter Zeitung*, 31 May 1890, in which he
proposed to identify it with the so-called *Madonna of
Casalmaggiore*. The Frankfurt picture had been
bought in Milan in 1889 from the collection of a
Mrs Gray at Varese. Doubts on its authenticity were
immediately published by Frizzoni (*Archivio Storico
dell'Arte*, III, 1890, page 408) and in the *Kunstchronik*
(II, 1890–1, note 7). In an elaborate article (*Prussian
Jahrbuch*, XII, 1891, pages 104ff.) Thode retraced the
Madonna of Casalmaggiore (taken from there by
Francesco I d'Este) through various Modena inven-
tories and proposed a dating close to that of the
Uffizi so-called *Rest on the Flight* (*Holy Family with
St. Francis*). In *La R. Galleria di Parma* (1896, page
339) Ricci favoured 1515 as the date, but in his first
monograph (Ricci 1896, page 119) he says 'dated
1517'. This is probably a misprint or translator's
error. Nevertheless it is repeated in all editions of
Berenson's *Lists*. Ricci (1930) has '1515?'. In his
monograph (1898, page 54) Thode himself changes
his view on the dating to after 1520. This date, and
convincing proof of Correggio's authorship of the
design, was confirmed when Popham published a
sketch for it (plate 90B) on the same sheet as a study
for the S. Giovanni Evangelista nave frieze, which
was not commissioned until November 1522.
Another version of the design is said to have been
chez A. L. Nicholson, London. See text, page 84.

Formerly DRESDEN

ST. MARY MAGDALENE READING

Copper, 0·29 × 0·395[1] plate 97C

Probably identical with a picture mentioned by
Baldinucci[2] (died 1696) as having been collected by
'il cavaliere Gaddi' in the time of the Grand Duke
Francesco [de' Medici] (1541–87). Baldinucci de-
scribes the composition minutely and adds that
Cristofano Allori (1577–1621) had frequently copied

it and his pupils had copied his copies. Not recorded again until 1682, when what was demonstrably the Dresden picture was in the Este collection at Modena.[3] From then until the second half of the nineteenth century it was consistently considered one of Correggio's supreme achievements.[4] Woermann[5] records doubts regarding Correggio's authorship expressed in 1854 by Quandt, and in 1875 Morelli (Lermolieff) roundly declared it not by Correggio.[6] His most specific objection – that it was on copper – was largely irrelevant, since, as he himself admitted, a contemporary of Correggio's, Sebastiano del Piombo, is reported by Vasari to have experimented with it as support.[7] The cogency of Morelli's further suggestion that the Dresden picture was the work of Adriaen van der Werff was diminished when Adolfo Venturi pointed out that it was described as early as 1682 as 'famosissimo', at which date van der Werff was only twenty-three years of age.[8] It may be considered a curiosity of art history that the prestige of Morelli was able, on shaky premises, to reverse the considered judgements of all the best connoisseurs of the preceding two centuries. Since then only Adolfo Venturi has upheld the authenticity of the Dresden picture in print.[9] The present writer never saw the picture, but the considerations stated above strongly suggest to him that it was probably Correggio's original.

See text, page 93.

PROVENANCE Gaddi collection, Florence (?). Este collection, Modena from at least 1682. Included in the batch of 100 pictures which were sold in 1745–6 by Francesco III d'Este to Augustus III of Saxony.[10] Thereafter at Dresden (from which stolen for a short time in 1788). Missing after the Second World War.

COPIES Innumerable (see above). One in the Pitti (attributed C. Allori) is perhaps the most famous.

REFERENCES [1] Measurements from the Dresden catalogues. [2] *Notizie de' Professori del Disegno*, XII, p. 35. [3] A. Venturi, *La Galleria Estense*, 1882–3, *passim*. [4] E.g. successive Este inventories (Venturi, op. cit.), Richardson, Tessin, d'Argenville, Mengs etc. [5] Dresden catalogue, several editions. [6] *Die Galerien Roms*, also later editions. [7] Vasari/Milanesi,

v, 580: 'ha mostrato, come si possa dipignere sopra l'argento, rame, stagno, e altri metalli'.* [8] Venturi, op. cit. [9] Kenneth Clark, who knew the Dresden gallery well in the 1920s, tells me he always considered the *Magdalen* to be Correggio's original. [10] For details of the transaction cf. Venturi, op. cit.

ST. MARY MAGDALENE IN THE DESERT

Described in a letter of 3 September 1528, from Veronica Gambara as 'la Madalena nel deserto ricoverata in orrido speco a far penitentia; sta essa genuflexa dal lato dextro con le mani gionte alzate al Cielo in atto di domandar perdona de' peccati; il suo bell'atteggiamento il nobil e vivo dolore ch'exprime il suo bell.mo viso la fanno mirabil si che fa stupore a chi la mira...'† This letter was first printed by Pungileoni (*Elogio Storico di Giovanni Santi*, 1822, page 110) together with a speculative claim to identify the picture with one then available. He gives the recipient as 'Beatrice d'Este, Marchesa di Mantova' – presumably in error for Isabella. Venturi (*Storia...*, IX, II, p. 470) has a better text (a fresh transcription is printed on page 186 of this book).

Formerly CORREGGIO

S. MARIA DELLA MISERICORDIA
Triptych

A document published by Tiraboschi (1786) states that on 23 November 1613 the last prince of Correggio, Don Siro, received from the officials of the Confraternita di S. Maria, known as the Spedale della

* 'has shown how to paint on silver, bronze, pewter and other metals.'

† 'The Magdalen in penitence in the desert in a fearsome cavern, kneeling on the right with her hands clasped and raised to the heavens to implore pardon for her sins; her admirable posture, the noble and lively grief on her most beautiful face are so marvellous as to stupefy the spectator.'

Misericordia at Correggio 'tres imagines seu effigies pictas manu qu. egregii Viri Antonii de Corrigio Pictoris famosissimi, S. Dei Patris Omnipotentis, S. Johannis & S. Bartholomei.'[1]* Copies of them had been made by one Jacopo Borboni of Novellara and had been given to the confraternity. A further extract from this document and extracts from others were published by Pungileoni, from which it emerged that the three pictures had adorned the same altar (specified as the high altar of the church of the confraternity) in consequence of which they would have formed a triptych.[2] On 18 December 1612, Giacomo Borbone had valued the originals at 100 ducats (800 lire) each, or 300 ducats for the three. In this document he referred to them as 'le tre figure ciove di S. Giovanni, S. Bartolomeo e del Signor Dio Padre'.[3]† On the other hand, a letter of 6 March 1613 (misprinted 1713 by Pungileoni)[4] from the Bishop of Reggio, Conte Claudio Rangoni, raising certain objections to the sale, described them as 'un Christo, un San Giovanni Battista et un San Bartolomeo', thus specifying that the 'St. John' was the Baptist and naming Christ instead of God the Father.

A document of 5 June 1635[5] says that in the preceding winter three pictures by Correggio, probably identical with the Misericordia ones, but the subjects not specified, had been deposited by the Prince of Correggio with one Vincenzo Calcagni to be transmitted to the Conte Alessandro Gonzaga of Novellara for safe keeping. On 17 May 1644 Don Siro wrote to Conte Alessandro to inform him that he was having to withdraw his pictures by Correggio,[6] and in a further letter – 20 May 1644[7] – one Conte Francesco Bonsi told Conte Alessandro that a man was coming to pack Don Siro's pictures which the latter was proposing to sell and which he, Conte Francesco Bonsi, thought he might buy. Don Siro

died in the following year – 25 October 1645. Contrary to what is sometimes stated it is not known whether or not he had succeeded in regaining possession of the Correggios.

It may be noted that there is no authority earlier than 1612 for attributing to Correggio the triptych in S. Maria Misericordia as that is the earliest extant mention of it. The fact that it was there, however, and that it was evidently sufficiently highly prized for its ownership to be fought over would be some confirmation of its authenticity. The subsequent history of the originals cannot be followed.

A *Christ in Glory*, now in the Vatican, formerly in the Marescalchi collection, Bologna (plate 172B) and stated to have been acquired from the Gritti family and to have been in the Renieri collection at Venice in the seventeenth century, has been identified since the early nineteenth century with the centre picture from the Misericordia triptych or a copy of it.[8] A *St. John Baptist*, known in several versions, has likewise been claimed to represent one of the wings.[9] The latter claim can be considered to be established on the strength of a note by Gualandi that one of them (apparently the version now in the Campori collection at Modena) corresponded exactly with the appropriate figure in Borboni's copy of the triptych which was then still *in situ* in Correggio ('portato a Correggio, e messo a riscontro della copia del Borboni, che quivi allora esisteva, fu trovato corrispondergli esattamente, salvoche nel merito').[10]‡

Gualandi's note does not mention whether the design of the Vatican *Christ* also corresponded with that of the central picture in Borboni's copy of the Misericordia triptych. Its cloudy background would not accord well with the architectural one in nearly all the versions of the Baptist.[11] But though there would be no need for copies to be the same size as the originals it does seem a fact that the height of the Vatican *Christ* is approximately the same as that of

* 'three images or painted figures by the hand of the late master Antonio da Correggio, a very famous painter, of the Almighty, St. John and St. Bartholomew.'

† 'the three figures, namely St. John, St. Bartholomew and the Almighty.'

‡ 'taken to Correggio and put alongside Borboni's copy which was then still there it was found to correspond exactly except in quality.'

several of the versions of the Baptist.[12] And if, on the strength of Gualandi's assurance, Bishop Rangoni's description of the Baptist wing was more accurate than the two relevant documents written by the painter Borbone and by the notary employed by the authorities of the Misericordia (which do not specify which of the two Saints John was shown) he may also have been the more correct in describing the central element as a Christ and not a God the Father. Though a beardless God the Father would be odd it would perhaps not be inconceivable that someone might apply that identification to the design of the Vatican picture. Unlike the Baptist, though, it cannot be taken as certain that the Vatican Christ reproduces a panel of the Misericordia triptych, though this seems very possible.

If the Vatican picture is in fact after Correggio it cannot have been an early work, as is usually supposed. The draperies alone show that it must have been post-S. Giovanni Evangelista, perhaps even dating from the last years of Correggio's life.[13] Its derivation from the Christ in Raphael's *Disputa* seems clear. An earlier derivation from the same figure – Giulio Romano's picture for S. Paolo, Parma (now Parma gallery) may have been in Parma in Correggio's day. The copies of all three pictures which replaced the originals in the church of the Misericordia at Correggio are stated to have been bought, probably at the very beginning of the nineteenth century, by the dealer Armanni,[14] who had also acquired the Christ now in the Vatican.

See text, page 123.

REFERENCES [1] Tiraboschi, 1786, p. 255. [2] Pungileoni, II, pp. 83–4. [3] Pungileoni, loc. cit. [4] Pungileoni, III, pp. 174–5. [5] Pungileoni, II, p. 89, and III, p. 204. [6] Pungileoni, III, p. 205. [7] Pungileoni, III, pp. 205–6. [8] Marescalchi's own account is printed in Pungileoni, III, p. 174. A memorandum by Gualandi is printed by P. Martini, *Studi intorno il Correggio*, 1865, p. 67. The entry in the Renieri inventory of 1666 is printed in Pungileoni, II, p. 96 and by S. Savini-Branca, *Il Collezionismo Veneziano nel '600*, 1965, p. 102. Sansovino (*Venetia Città Nobilissima*, 1663, p. 377) had mentioned a Correggio of *Christ* 'sopra l'iride' ('on the rainbow') chez Renieri. The poet Shelley describes the *Risen Christ* in a letter of 9 November 1818 from Bologna. The Vatican picture shows alterations but the present writer does not think it the original. [9] Michelangelo Gualandi, *Memorie Originali Italiane Risguardanti le Belle Arti*, second series, 1841, pp. 163ff. In this essay the author draws attention to an undated inventory, supposed to be of the late sixteenth century, concerning pictures by Correggio at Novellara (Pungileoni, III, pp. 178ff.). One is of a standing Baptist. Gualandi identifies this with a picture of the same subject which was stated to have passed from the castle of Novellara in 1797 to the Panelli collection (Pungileoni, III, p. 159) and thence to the Bianconi collection, where it was when Gualandi wrote. This version is identified with one now in the Campori gallery at Modena (cf. F. Tencajoli in *Rassegna d'Arte*, May 1907 and G. Copertini, *Note sul Correggio*, 1925, p. 18). If the early Novellara inventory really was of the sixteenth century the picture could not be the original which would then have been at Correggio. The version formerly in the J. C. Robinson collection was accepted as autograph by Ricci (1930) and Venturi. At least one other is in the British royal collection. Another was sold at Christie's, 25 July 1969, 271. [10] Gualandi, *Memorie...*, p. 166. [11] The Hampton Court version has some landscape in the background. [12] Vatican *Christ* 1·4 in height, Campori picture 1·55, Windsor originally 1·55 (subsequently heightened), Hampton Court 1·563. Version at Christie's (1969) 1·578. [13] A. Venturi (*Storia...*, IX, II, p. 607) has the ex-Robinson Baptist as 'late'. [14] Pungileoni, II, p. 97.

C. NOTES ON SOME ATTRIBUTED PICTURES

The works listed in the following section are mainly those whose attribution to Correggio has been proposed, or at least still held, within the present century. A few hoary and long-discredited attributions have been included for convenience of reference, if they occur very frequently in the older literature. But no attempt has been made to collect all the very numerous, mainly uncheckable and presumably mainly untenable attributions to Correggio found in inventories and catalogues of the seventeenth, eighteenth and early nineteenth centuries (an attempt to do so is in Meyer, 1871, pages 355–416, and the index to Battaglia serves the same purpose). Nor are all of Adolfo Venturi's wilder suggestions included, nor those of Roberto Longhi (see Appendix C, page 169).

Regarding the true authorship of pictures in this section I would go no farther than saying that I have yet to be convinced that any is by Correggio, but in a few particularly difficult cases I have tried to explain the precise nature of the problem.

FRESCOES

MANTUA, S. Andrea. Mortuary chapel of Andrea Mantegna. Pendentives of the four *Evangelists*. Attributed to Correggio by Donesmondi (1612–16). Repeated by Cadioli (1763). Attribution revived by A. Venturi (1915), Ricci (1930) and others. See text, page 30.

MANTUA, S. Andrea. Roundels of the *Madonna and Child with the Giovannino and Saints Joseph and Elizabeth* and of the *Entombment*. Detached (with the sinopia of the *Entombment*) from the portico. A cartoon fragment in the Pierpont Morgan Library, New York, for the woman's head towards the right in the *Entombment* was accepted as Correggio by Popham (1957). But its attribution depends on accepting the attribution to him of the painting (which is a ruin). Its style of draughtsmanship bears no relation to that of any accepted drawing by Correggio. Vagaries of attribution as for the four pendentives above. See text, page 30.

MODENA, Galleria Estense. *Madonna and Child with an angel, St. Quirino* (supporting the city of Correggio) *and St. Francis*, 1·11 × 0·945. Inscribed: ABdNDF/

MCCCCCXI. From S. Quirino in Correggio, via the Misericordia there to the Modena gallery. Pungileoni (I, pages 16–17) implies traditionally Bartolotti until attributed to Correggio in the 1787 Modena catalogue. The Bartolotti attribution was revived by Dall'Olio (1811) (with the possibility of collaboration by Correggio) and the inscription plausibly interpreted as 'Antonio Bartolotti da Novellara Dipintore Fecit'. The attribution to Correggio revived by A. Venturi (*L'Arte*, IV, 1901), followed by Gronau (1907) and Ricci (1930). It is impossible to believe that this miserable daub ever had anything to do with Correggio. See text, page 169.

MADONNAS

BOLOGNA, Bianconi collection (in the eighteenth century). *Holy Family*. Described in detail by Tiraboschi (1786, page 285–6) as having once been in the Modena gallery, and then as having belonged to Bianconi, who still had a sketch for or after it. Tiraboschi mentions two prints of it (one, by Aspar, reproduced Gronau 1907, page 83) and various

painted copies, suggesting that the composition was famous. The motive of the Madonna putting a shirt on the Child is the same as in the *Basket Madonna* (London), but treated differently and with Joseph offering cherries to the Child. Though the Joseph also recalls the same saint in the Orléans *Holy Family* there would be no guarantee that there was ever an original by Correggio of this design.

DETROIT, Museum. *Madonna and Child (Mater Amabilis* or *Crespi Madonna*). Panel, 0·295 × 0·21. Published with reproduction by Gronau (1907, pages 26 and 160) as identical with the one listed by Meyer (1871, page 404, no. 93) as ex-Bertioli and Francesco Monti. Suida (*Burlington Magazine*, 14, 1908–9) as old copy after Correggio. Ricci (1930) and in the *Bollettino d'Arte*, 1931, page 352) as Pomponio Allegri. Venturi (Crespi catalogue, 1914) as Correggio.

DRESDEN, Gallery. Altarpiece. *Madonna and Child with St. George*, 1·565 × 1·33. From the church at Rio, near Correggio, via Modena to Dresden. In Woermann's Dresden catalogue (1902, page 84) as Mazzola Bedoli, with further references.

FERRARA, Massari Ricasoli collection (in 1935). *Madonna and Child with Saints Joseph and Nicholas of Tolentino*. Panel, 0·40 × 0·32. Attributed by A. Venturi (1898) to a follower of Mantegna, and by N. Barbantini (1910) to Mantegna. Exhibited Parma, 1935 as Correggio (22) (where reproduced) with other opinions cited in support.

FLORENCE, Contini Bonacossi collection (formerly). *Madonna and Child with the Giovannino and a Friar Saint*, full length.

FLORENCE, Uffizi (on loan to the Istituto Madonnina del Grappa, Rifredi, Florence) (as Annibale Carracci). *Madonna and Child with the Giovannino and Saints Christopher and Michael*. Mengs (1783 edition, II, page 172) mentions a 'Madonna col Bambino in braccio, il quale ha il globo del Mondo in mano, e San Cristoforo in atto di volerlo ricevere su le spalle. A' piedi della Madonna evvi San Giovanni Battista,

e al lato opposto a San Cristoforo v'è San Michele'.* Mengs adds that this picture had always been called Correggio, but that he himself doubted it. Tiraboschi (1786, page 283) quotes this. Also mentioned by Ratti (1781, page 114) who speaks of an engraving of it by Padre Lorenzini (included in the *Raccolta di quadri dipinti…posseduti da S.A.R. Pietro Leopoldo*, 1778). Also Meyer, page 403, no. 89. The latter draws attention to an exactly similar picture described in 1690 as belonging to the Boscoli family at Parma (inventory in Campori, *Raccolta di Cataloghi…*, 1870, page 397) which is evidently the identical picture (see D. Posner, *Annibale Carracci*, II, 1971, page 7).

ISOLA BELLA, Palazzo Borromeo. *Madonna suckling the Child*. Attributed Correggio by A. Venturi (1926) (where reproduced). Irene Kunze (Battaglia 651) pointed out derivation from a print attributed F. Brizio, itself derived, according to Malvasia, from a Carraccesque drawing. Ricci (1930, page 181) attributed to Agostino Carracci. For the Madonna cf. A. Solario, *Rest on the Flight* (Milan, Poldi Pezzoli).

LENINGRAD, Hermitage (81). *Madonna and Child with the Giovannino*. 0·69 × 0·57. Attributed Correggio by Berenson (Lists, 1932 and 1936). Copy of Budapest *Madonna del Latte*.

MILAN, Orombelli collection (in 1948). *Holy Family with Saints Elizabeth and the Giovannino*. Panel, 0·49 × 0·37. From the Villa and Guiscardi Barbò collections. Reproduced Ricci (1930). Attributed Correggio by A. Venturi (1926). It is after a print by Giovanni Antonio da Brescia, itself presumably after Mantegna (Hind, *Early Italian Engraving*, part II, vol. V, 1948, page 38, no. 4, reproduced vol. VI, pl. 529). The print includes no landscape. Exhibited London (R.A.), 1930 (398) and Parma, 1935 (23).

* 'Madonna with the child in her arms, who has the globe in his hand, and St. Christopher looking as though he wished to take him on his shoulders. At the feet of the Madonna is St. John Baptist, and on the other side to St. Christopher is St. Michael.'

MUNICH, Alte Pinakothek. *Madonna and Child with Saints Ildefonso and Jerome and an Angel* (1095). 1·12 × 0·76. Ruined and cut down from a larger format. Berenson consistently as Correggio.

MUNICH, Alte Pinakothek. *Madonna and Child in Glory with Saints Jerome and James and a Donor* (1096). Panel, 2·03 × 1·36. More recently attributed to Rondani, Anselmi and others.

PARIS, Louvre. *Madonna and Child*, 0·71 × 0·48. Ex-collections Facchini, Nievo (Mantua), Aquila, Brooks. Meyer (1871) page 373, no. 1. Louvre catalogue (1926) and Berenson (1932) as Caroto.

PETWORTH. *Holy Family.* Panel, 0·325 × 0·244. In Collins Baker's catalogue (1920, page 91) as 'School of Parma...formerly attributed to Correggio'. A similar small panel was lot 61, Lord Desborough sale, Christie's, 9 April 1954. The Petworth picture is extraordinarily similar to the *Basket Madonna* (London) in details such as the Madonna's right hand, the child's feet and the white crinkly draperies, yet unacceptable as Correggio's. Probably a deliberate imitation dating from not later than the seventeenth century. A miniature copy of the Petworth composition signed by Peter Oliver and dated 1630 was sold at Christie's 15 December 1964 (12).

ROME, Palazzo Corsini. *Madonna and Child with the Giovannino.* Attributed Correggio by Testi (*Bollettino d'Arte*, II, 1908, pages 37–8). Ricci (1930, p. 181) suggested Francesco di Simone da Santacroce (cf. also Battaglia 533 and 571).

WASHINGTON D.C., National Gallery of Art, Kress collection. *Madonna and Child (Barrymore Madonna).* Canvas, 0·56 × 0·41. Exhibited London, 1909–10 (Grafton Galleries, no. 88, lent Lord Barrymore). Included as Correggio by Ricci (1930) and (verbally) by E. K. Waterhouse. Kress catalogue, 1959 as Mantegna (1968 as 'Circle of Mantegna (possibly Correggio)').

UNKNOWN (formerly Swiss private collection). *Madonna and Child.* Full length. Attributed Correggio by A. Venturi, who reproduced it, 1926, pl. 193. Included with query by Ricci, 1930.

SAINTS

BUCHAREST. *The Four Evangelists.* Panel, 0·759 × 1·095. Said to bear monogram (unspecified) and date 1521. Published (with other even more impossible ones) by A. Busuioceanu, *Gazette des Beaux-Arts*, 6th period, vol. 19, 1938, pages 13–26.

DETROIT. *St. John the Baptist.* Canvas, 1·05 × 0·75. From the Grand Ducal collection of Oldenburg. Attributed to Correggio by Venturi.

DRESDEN. *St. Margaret Reading.* Panel, 0·685 × 0·53. Duc de Tallard sale, Paris, 1756, no. 39, as from the Chataignerie collection. Catalogued as School of Correggio since the mid-nineteenth century. A pastiche of the Madonna in the Louvre *Marriage of St. Catherine*, and similar in type to the Hampton Court *St. Catherine Reading* (below).

DUBLIN. *Head of St. Catherine.* Purchased 1881, reproduced in the *Dublin Illustrations*, 1963. In the 1971 catalogue as 'after Correggio' which is not the case.

HAMPTON COURT. *St. Catherine Reading.* Canvas (? from panel), 0·64 × 0·52. Inventory number 392, left lower corner. In the royal collection since the James II inventory. Similar in type to the Dresden *St. Margaret* (above). In its present damaged condition impossible to tell whether of studio execution or a later pastiche, but no indication of Correggio's own touch. The puritanical simplicity of the saint's tunic would be uncharacteristic of Correggio at any time in his maturity. A full length version, reproduced by Gronau (1907, page 150) as then in Rome (Donna Lina Corsini). Another reported at Ivybridge, Devon in 1952. The Hampton Court picture is sometimes associated with a letter of 1628 from Daniel Nys to Endymion Porter, but this is more likely to refer to the Louvre *Marriage of St. Catherine*.

MILAN, private collection. *St. Sebastian*. Published by Giovanni Testori, *Paragone*, September 1966, page 43.

PARIS, Aguado collection (in the nineteenth century). *Death of St. Francis*. Engraving suggests Schedone or Badalocchio (there were many other pictures called Correggio in the Aguado collection, most of which would probably have been copies).

UNKNOWN. *St. Jerome and St. Joseph*. Two recumbent figures known from prints in the Parma Library. Ricci (1930) to the Carracci.

CHRIST

BERLIN, Kaiser Friedrich Musum (formerly). *Veronica's Veil*. Silk, 0·43 × 0·56. No. 207A in the 1921 catalogue as 'Milanese c. 1600' and as formerly Correggio.

LONDON (with Weitzner, 1971). *Dead Christ supported by Joseph of Arimathea*. Panel, 0·76 × 0·54. Successively F. A. Drey, London and Major E. O. Kay, Droitwich. Sales Sotheby's, 16 November 1955 (146), Christie's, 20 July 1956 (74), Sotheby's, 12 December 1962 (173), Christie's, 26 March 1971 (60). Perhaps Parmesan of the 1530s or 1540s. The neighbourhood of Sarto has also been suggested. Other versions are reported.

LUXEMBOURG. *Dead Christ with Angels*. Canvas, 1·22 × 1·04. Published by Suida in *Belvedere*, 1932, page 116. Corresponds with a Gaspare Massi print as after Correggio. A similar painting, but not of identical design, was in the Lady P. Benton sale, Sotheby's, 26 April 1950 (130).

NAPLES. *Dead Christ*. Canvas, 0·66 × 1·40. Reproduced in De Rinaldis' catalogue of the Naples Gallery, 1928, fig. 113.

PARMA, Gallery. *Procession to Calvary*. Panel, arched top, 2·91 × 1·93. From S. Pietro Martire, Parma. Mentioned by Algarotti (*Opere*, VI, 1765, pages 65–7) as being transitional from Correggio's Mantegnesque period to maturity. Exhibited Parma, 1935 (67) as 'School of Parma, sixteenth century'.

PARMA, private collection. *Christ bearing the Cross*. Attributed Correggio by A. G. Quintavalle, 1963. Also reproduced A. C. Quintavalle, 1970, page 93.

MISCELLANEOUS RELIGIOUS SUBJECTS

COLUMBUS, Ohio. *The Young Man fleeing from the Captors of Christ*. Panel, 0·609 × 0·463. The composition is apparently not mentioned as Correggio's before the 1660s (see below). The principal figure – the young man – has much in common with the sequence of six grisaille figures on the Parma Duomo arches, and is also similar to the figure on the left of the Louvre *Vice*. On the other hand, the soldier and the scene of the capture of Christ in the background strongly suggest Lelio Orsi. I have not seen the Columbus picture but remain unconvinced either that it is by Correggio or that there was ever a Correggio of this design.

The subject, described in Mark XIV, 51–2, is highly unusual as a foreground theme in a painting, but it occurs in the background of Dürer's prints of the *Capture of Christ*, both in the *Large Passion* (1510) and in the *Engraved Passion*. In the Correggesque picture the capture of Christ in the background bears some similarity to Dürer's arrangement of it in the *Little Passion*. The character of male rape inherent in the present composition was recognised by Mengs ('il soldato, che lo vuol arrestare...pare che voglia persuaderlo amorevolmente a non fuggire'* (Mengs, *Opere*, vol. 2, 1783 edition, page 175). Mengs also saw the influence of the elder of Laocoön's sons in the Vatican group in the young man in the present picture.

A version of this picture was stated by Félibien (*Entretiens*, I, 1666, page 234) to have been chez Cardinal Antonio Barberini in Rome. A letter of 2 June 1663 (Battaglia, no. 594) mentions this or

* 'the soldier who is trying to arrest him seems as though he would rather persuade him amorously not to run away.'

SOME ATTRIBUTED PICTURES 287

another version as for sale. *Roma...Antica e Moderna*, 1687, page 32, has a reference, perhaps even then out of date, to a picture in Palazzo Barberini. Another reference to a picture of this description is included in lot 167 in the Carlo Maratta inventory (1712). The latter picture was claimed to be identical with one in the Delahante sale (2nd day, 4 June 1814, lot 78) where bought Sir Mark Sykes. This was included in the Sir Mark Masterman Sykes sale, Christie's, 5 May 1848, lot 13. Mengs reported that Cardinal Barberini's picture was said to have gone to England, and that another version, on canvas, was in his day in the hands of an Englishman in Rome. Ratti (1781) repeated this. Lanzi (1795–6) mentioned a version at Milan in the 'Keweniller' (sic) collection. The Columbus picture was published by A. Venturi (1934) as ex- J. A. M. Meade and D. Rothschild collections in England. It was exhibited Parma, 1935 (48) as from the von Frey collection, Paris (and as on canvas). Mrs E. Andriesse sale, Parke-Bernet, 24 February 1949 (65). Then Schumacher. An inferior version in the Parma Gallery. Antonio Conca (*Descrizione... della Spagna*, 1793, II, page 216) mentions a *Capture of Christ* at La Granja, attributed Correggio but possibly a copy.

ROME, Baron Michele Lazzaroni (formerly). *Sibyl.* Reproduced Venturi, 1926, pl. 31.

LONDON (formerly), A. L. Nicholson. *Eve.* Reproduced Venturi, 1926, pl. 194. Later Cambo collection, Barcelona. Attributed by Voss to Furini (Battaglia 661).

UNKNOWN. *Salome with the Head of the Baptist.* Sansovino (1663) (Battaglia 1122) mentions a picture of this subject chez Nicolò Renieri at Venice, which is identifiable with one listed in the Renieri collection in 1666 (Battaglia, 1123). This may or may not have been identical with one mentioned in a MS. of Brunorio (Pungileoni, II, page 96) as having once belonged to the Lords of Correggio and currently to the Grimani, a copy being specified as in Correggio with Carlo Zuccardi. Ricci (1896, page 121) quotes (and discounts) the legend that the *Salome* was once in the church of the Misericordia at Correggio, and Bigi (1880, page 49) mentions a version with Enrico Mariani of Stiolo, supposed to be identical with Zuccardi's copy.

PORTRAITS

DRESDEN. *Portrait of a Doctor.* Panel, 0·825 × 0·69. As Correggio from at least 1638 (A. Venturi, *La Galleria Estense*, 1882, page 226) when in possession of Bishop Coccapani at Reggio. Appropriated by Francesco I d'Este, 1642, thence to Dresden, 1746. As Correggio in all the literature until Meyer and Morelli in the nineteenth century. Attribution to Correggio universally discounted since then.

LENINGRAD, Hermitage. *Portrait of a Man.* Venturi (*Studi dal Vero*, 1927) attributed it to Correggio and said it was previously called *Studio of Veronese*.

CAMBRIDGE, England, Lord Butler. *Portrait of a Man.* Canvas, 0·54 × 0·438. Published as Correggio by Venturi (*L'Arte*, 1926, vol. XXIX) as chez Grassi in Rome and as being close to the *Danaë*. Copertini (*Archivio Storico per le Provincie Parmensi*, 1928) expressed doubts on the attribution which Venturi reaffirmed elsewhere (e.g. *Studi dal Vero*, 1927). Published as Correggio independently by Roger Fry (*Burlington Magazine*, 52, 1928, pages 3ff.) as Correggio's self-portrait. By this time the picture was in the possession of Viscount Lee of Fareham. Fry based the attribution on the similarity of craquelure to that of the *Ganymede* (Vienna). Exhibited Royal Academy, 1930 (413) (lent Lee) of which the souvenir volume added Brückenthal (Vienna), Adamovics (Vienna) and Richard Bosch to the provenance. Mention was also made of a Maratta drawing in the Albertina. Included by Ricci, 1930, pl. CLV (he, and W. G. Constable – *International Studio*, February 1930 – opposed the idea of its being a self-portrait). P. Bucarelli (*La Critica d'Arte*, 1937, pages 175ff.) quoted various attributions – A. L. Mayer to Lotto, Toesca to Veronese or the Brescian school, Longhi to the Venetian school, Colasanti to the young Parmigianino.

She herself identified the sitter with that of a portrait attributed to Leandro Bassano. Douglas Cooper (catalogue of the Courtauld collection, 1954, page 180) added the Adamovics sale, Vienna, 1856, lot 84 (School of Titian) and A. von Reisinger (Vienna) to the pedigree. F. Bologna (*Paragone*, 91, 1957, pages 9ff.) identified the sitter with Conte Guido da Correggio and assumed identity with the sitter of the right hand *sportello* in the Naples diptych. However, Bucarelli had already identified the sitter differently, and a third likeness has also been seen with the Annibale Carracci self-portraits at Parma and in the Uffizi (reproduced D. Posner, *Annibale Carracci*, 1971). In the possession of Samuel Courtauld by 1945 (articles by him on it, *Apollo*, 1946, no. 43, pages 99–103 and 127–31). Thence to his daughter, Mrs R. A. Butler and then to the latter's husband, Lord Butler.

LUGANO, Thyssen-Bornemisza collection. *Portrait of a Man.* Canvas, 0·55 × 0·4. Full bibliography in *The Thyssen–Bornemisza Collection*, 1969, pages 78–9. From the Zampieri (Bologna), Somzée (Brussels) and von Weber (Hamburg) collections. Exhibited Parma, 1935 (44). Generally attributed to Correggio except by H. Hymans (to El Greco) and Berenson (Lists, 1968) (to Giulio Campi). The present writer would tentatively suggest an attribution to Lotto.

MILAN, Castello Sforzesco. *Portrait of a Man.* Canvas, 0·6 × 0·43. From the collection of Contessa Morando Bolognini. 1945 to the Castello Sforzesco. Exhibited Zürich, 1949 (C. Baroni in *Burlington Magazine* (91, 1949, page 68) mentions the attribution to Correggio by Longhi). Longhi in *Paragone*, 101, 1958 (with illustrations). In the present writer's opinion, not by Correggio, but not far from the young Parmigianino. See text, page 169.

MINNEAPOLIS, Institute of Arts. *Portrait of a Cardinal.* Panel, 0·81 × 0·76. As Costa in the Kincaid Lennox sale, Sotheby's, 26 June 1957 (24), and in Berenson's *Lists* (1968, where reproduced). Attributed Correggio by Everett Fahy (*Bulletin of Minneapolis Institute of Arts*, LIX, 1970) who indicated the rams' heads as in the Camera di S. Paolo. This motive also occurs on

the Sistine ceiling, among other places. The type of trees alone is enough to exclude Correggio. The Costa attribution – as a late work – seems unexceptionable. A possible sitter would be Ercole Gonzaga, created Cardinal in 1527.

PARMA, Gallery. *Portrait of a Man* (? Nicola Maria Quirico Sanvitale). Panel, 0·62 × 0·47. Traditionally Correggio until the present century. Exhibited Parma, 1935 (75) as Parmesan school, sixteenth century.

STOCKHOLM, National Gallery. *Portrait of a Man.* Canvas, 0·85 × 0·71. From the Queen Christina and Orléans collections, as *Cesare Borgia* by Correggio. Currently attributed to Romanino and tentatively identified as Girolamo Marretti. Queen Christina Exhibition, Stockholm, 1966 (1178) (reproduced).

WASHINGTON, Kress collection. *Portrait of a Young Lady.* Panel, 0·445 × 0·337. Fern Rusk Shapley's Kress catalogue, Italian Schools, fifteenth to sixteenth century (1968, page 83), has further details.

YORK, City Art Gallery. *Portrait of a Man with a Book.* 0·7 × 0·52. At York as Parmigianino. Attributed Correggio by Copertini (*Parma per l'Arte*, 1962). Perhaps Mazzola Bedoli.

OTHER NON-RELIGIOUS SUBJECTS

BOSTON, Massachusetts, Isabella Stewart Gardner Museum. *Venus.* Canvas, 0·94 × 0·69. Reproduced Venturi, 1926, pl. 45. Also by Ricci, 1930, pl. xxx. Venturi (loc. cit.) claims derivation from Marco Dente print. Also similar to Marcantonio (Bartsch 297).

LENINGRAD, Hermitage. *Apollo and Marsyas.* Canvas, from panel, 0·48 × 1·19. An engraving of this design (0·52 × 1·235), with the addition of part of Raphael's *Parnassus* in the background and other interpolations which do not figure in the Leningrad painting, was dated 1562 by G. Sanuto and inscribed as being from a painting of the same size by Correggio. The en-

graving was dedicated to Alfonso d'Este, but the ownership of the painting is not specified. The engraving is rectangular. A painting of this subject by Correggio is mentioned by Dolce (1565). The Leningrad picture has had a triangular piece added at the top left to make up a rectangle, and as early as 1786 when it was in the Litta collection in Milan it was stated (by Tiraboschi) that it had served as the lid of a harpsichord. A representation of this subject on a harpsichord is described by Borghini (*Riposo*, 1584, page 534) as painted by Bronzino for Guidobaldo of Urbino. The same was mentioned by Vasari (1568) without specifying the subject. Since the date of the engraving, 1562, is very early evidence of Correggio's authorship of the design, and since the subject, as a musical contest, would be natural on a musical instrument, it would be possible that Correggio painted a picture, now lost, of this design which was engraved by Sanuto, that the painting, or the engraving, was copied by an unidentified painter on the harpsichord panel now at Leningrad, and that Bronzino's harpsichord panel was unconnected. Red chalk sketch for piping man, Louvre (Popham 10). See H. Voss in the Prussian *Jahrbuch*, 1913, page 314ff., and Popham, 1957, page 22. Though the Leningrad painting is not closely comparable in type and scale with any known work of Bronzino, it is nevertheless not far from the early *Pygmalion and Galatea* (Rome, Galleria Nazionale) and as unlike any known painting by Correggio as the Louvre sketch is unlike any of his authentic drawings. Despite the inscription on the engraving I conclude that the Leningrad painting is probably an early Bronzino. See text, page 124.

LONGFORD CASTLE, near Salisbury. *Venus disarming Cupid*. Canvas, 1·49 × 1·06. In Sir William Hamilton's collection in the eighteenth century as Correggio. Probably Cambiaso. B. Suida Manning and W.

Suida (*Luca Cambiaso*, 1958, page 153 and fig. 268) publish another version at Merkenau, near Strasbourg, and note still others.

MODENA, Galleria Estense. *Ganymede*. Fresco, remounted on canvas, octagonal, 1·46. From the Rocca di Novellara. Attributed to Orsi in the seventeenth century, and to Correggio in the nineteenth. Generally to Orsi again in the twentieth. Full bibliography in Pallucchini's catalogue of the Galleria Estense, 1945.

MUNICH, Alte Pinakothek. *Piping Boy*. Panel, 0·2 × 0·16. Variously as Lotto, Correggio (Morelli, Gronau, Venturi), Giorgione, the young Titian, Dosso and Palma Vecchio. The last correct in the present writer's opinion. See text, page 167.

OXFORD, Christ Church. *Olympus*. 0·296 × 0·22. Attributed to Correggio in the eighteenth century, and recently by F. Bologna (1957) but this attribution refuted by Byam Shaw (Christ Church catalogue, 1967).

ROME, Giuseppe Maria Fiammingo (formerly). *Sleeping Venus*. Reproduced Venturi, 1926, pl. 56.

UNKNOWN. *Sigismonda*. Canvas, 0·73 × 0·59. Sold in London in 1758 as Correggio. Appeared at Christie's, 31 March 1939 (11) as Furini (correctly). Bought on that occasion by the Duke of Newcastle. Its only interest is that it inspired Hogarth's picture of the same subject (Tate).

UNKNOWN. *The Inn Sign* or *The Muleteer*. Canvas, 0·66 × 0·91. From Queen Christina's collection as Correggio (1689 and 1721 inventories). Then Orléans and Duke of Sutherland. Many eighteenth- and nineteenth-century references. Photograph published in the 1910 catalogue of Stafford House (by Lord Ronald Sutherland Gower) suggests a seicento painter, not far from Feti.

The aim of the following section is to list items of research concerning Correggio which have been published since Battaglia's bibliography (1934). It is selective to the extent that it does not reckon to include all the peripheral or ephemeral publications or those which add nothing to what is already known. (See also Bibliographical Abbreviations, page 295.)

1934

BATTAGLIA, Silvia de Vito, *Correggio Bibliografia*. The standard work. Apart from a very few errors of detail the only fault which can be found is that it often misses references to Correggio in general – i.e. non-art historical – literature. (Reviews in *Il Correggio* (see below), *L'Amour de l'Art*, November 1934, and *Burlington Magazine*, 66, April 1935, p. 196.)

DELOGU, G., Review of exhibition of drawings – *Correggio and his influence in France* – at the Orangerie, Paris in *Emporium*, 80, p. 263. (Further notices of the exhibition, *Beaux-Arts*, 5 October and 12 October.)

MORPURGO, Enrico, Review of Italian exhibition at Amsterdam (including the Thyssen-Bornemisza portrait) in *Emporium*, 80, p. 310.

Il Correggio. Raccolta di Studi e Memorie in Onore di Antonio Allegri (published by *Aurea Parma*):
 COPERTINI, G., 'Il Nostro Messer Antonio Allegri'.
 RIGILLO, M., 'Il Pittore Sacro'.
 DE GIORGI, L., 'La Camera di S. Paolo'.
 COPERTINI, G., 'La Favola di Apollo, Marsia e Mida attribuita al Correggio'.
 BOSELLI, A., 'Il Correggio giudicato da alcuni Scrittori francesi'.
 ZORZANELLO, P., 'La Bibliografia del Correggio'.
 MAUCERI, E., 'Lorenzo Sabattini nella luce del Correggio'.
 FINZI, R., 'Documenti intorno al Correggio'.
 FORATTI, A., 'Influssi del Correggio sui Carracci'.
 PETTORELLI, A., 'Il Correggio nella Critica del Berenson'. (Review, *Arte*, 6 July 1935, p. 330.)

1934/36

SUIDA, W., 'Über Correggios Zingarella', *Belvedere*, Heft 7/8, pp. 134ff. Starts with gloomy reference to the cleaning of the Naples picture, and continues with publication of replica on canvas from Lanckoronski collection.

1935

ALESSANDRI, A., 'Intorno particolarmente all'Annunciazione del Correggio...', *Crisopoli*, January/February.

BRANDI, C., 'Die Correggio-Ausstellung zu Parma', *Pantheon*, 16, p. 296.

CAVALIERE, D., 'Giudizi accademici su opere...del Correggio', *Aurea Parma*.

DEGENHART, B., 'Notizen und Nachrichten', *Zeitschrift für Kunstgeschichte*, 4, pp. 180ff. Notice of catalogue of Parma exhibition and of articles in periodicals.

FIORI, E., 'Il Correggio e il Parmigianino nella interpretazione Toschiana', *Aurea Parma*.

QUINTAVALLE, A. O., 'Problemi e Spunti critici alla Mostra del Correggio', *Emporium*, 81, pp. 350–63.

VALENTINER, W. R., 'St. John in the Wilderness by Correggio', *Detroit Institute Bulletin*, 14, pp. 69ff.

1936

Manifestazioni Parmensi nel IV Centenaio della Morte del Correggio.
 VENTURI, A., 'La Gloria del Correggio'.
 MORASSI, A., 'La Fortuna del Correggio'.
 SUIDA, W., 'Correggio e Tiziano'.
 MAZZONI, G., 'Sul "Correggio" dramma dell'Oehlenschläger'.
 FORATTI, A., 'Impressioni Michelangiolesche sul Correggio'.
 PORCELLA, A., 'Il Correggio ritrattista e l'influenza correggesca nel campo del ritratto'.
 BATTELLI, G., 'Una "Deposizione" del Bronzino ispirata dal Correggio' (in the Accademia, Florence).
 MARCHETTI, M. A., 'Il Correggio e i Veneti'.
 ZONTA, G., 'Il Correggio e la Rinascita'.
 ARNHOLT, R., 'L'Arte religiosa nelle opere del Correggio'.

DE GIORGI, L., 'Umanesimo e Cristianesimo nel Correggio'.

BERZERO, G., 'Riflessi correggeschi in Luca Cambiaso'.

FONTANESI, G., 'Il Segreto animatore dell'arte del Correggio'.

FINZI, R., 'L'Anima di Antonio Allegri attraverso le scene storiche di Giovan Battista Fantuzzi'.

COPERTINI, G., 'I Primi Conseguenti del Correggio nell'Emilia e nelle Marche'.

GOLZIO, V., 'Il Correggio nella Critica d'arte del secolo XIX'.

ALESSANDRI, A., 'Un curioso cimelio correggesco nella Pinacoteca civica di Faenza', *Aurea Parma*.

BENESCH, O., 'Meisterzeichnungen aus dem oberitalienischen Kunstkreis: Skizzenblatt mit Cupidostudien', *Die Graphischen Künste*, NS 1, no. 2, pp. 64ff. Sheet of studies not accepted by Popham 1957.

SCHEYER, E., 'Drawings by Correggio', *Detroit Institute Bulletin*, 15, pp. 103ff. Publishes sketch of Madonna and Child not accepted by Popham 1957.

VERGNET-RUIZ, J., 'Problèmes de l'art ancien: le Corrège novateur', *L'Amour de l'Art*, 17, pp. 299ff.

1937

BUCARELLI, P., 'Di un Ritratto attribuito al Correggio', *La Critica d'Arte*, pp. 175ff. Concerning the Lee/Butler portrait. She publishes it as representing a member of the Mocenigo family also portrayed by Leandro Bassano, and therefore not by Correggio.

LUZZATO, G. L., 'La Fortuna del Correggio dai suoi tempi all'inizio della critica moderna', *La Bibliofilia*, pp. 440ff. (not seen).

MONGAN, A., *Fogg Museum Bulletin*, 6, pp. 29ff. Publishes a drawing lent by Richard Wheatland of the Holy Family. Not accepted by Popham 1957.

QUINTAVALLE, A. O., 'Un Disegno del Correggio scoperto nello stacco dell'Affresco dell'Incoronata', *Bollettino d'Arte*, 31, pp. 80ff. (sinopia discovered when the fresco was removed from the Biblioteca Palatina).

QUINTAVALLE, A. O., 'Precisazioni e Restauri nella Riordinata Galleria di Parma', *Bollettino d'Arte*, 31, pp. 217ff. (restoration of Annunciation fresco).

VENTURI, A., 'Il Primo Ritratto del Correggio', *L'Arte*, NS 8, pp. 132ff. (the Kress Lady).

VENTURI, A., 'Per il Correggio: San Francesco', *L'Arte*, NS 8, pp. 318ff. Half length *St. Francis* with crucifix, strikingly uncharacteristic of Correggio.

1938

BUSUIOCEANU, A., 'Trois Tableaux ignorés du Corrège', *Gazette des Beaux-Arts*, VI, 5, 19, pp. 13ff. Publishes four *Evangelists*, *Adoration of the Kings* (brown monochrome), half length *Madonna* without Child, all then in the Roumanian royal collection and all impossible.

HUYGHE, R., 'Sur une toile attribuée à Correggio', *Beaux Arts*, 25 November. Complains that a sale catalogue had suggested he had given a certificate for a so-called Correggio. In a reply by G. Isarlo (issue of 9 December) it appeared that the picture was a copy of one by G. C. Procaccini at Grenoble.

VENTURI, A., *Arte*, NS 9, p. 55. Publishes another impossible candidate – *Madonna* with sleeping child.

1939

DAZZI, G., 'Un Nuovo Correggio?', *Emporium*, 89, pp. 231ff. *Dead Christ with Saints*, then with a Parma dealer.

GLÜCK, G., 'Notes on Van Dyck's stay in Italy', *Burlington Magazine*, 74, pp. 207ff. Sketch copy of the Magdalene from the *Giorno* chez Dr A. Popper of Amsterdam, attributed to Correggio (no provenance given).

TIETZE, H. and TIETZE-CONRAT, E., 'Un Dessin de Jeunesse du Corrège', *Gazette des Beaux-Arts*, VI, 5, 21, pp. 118ff. Drawing supposed to be for the Brera *Adoration*, but not accepted by Popham 1957.

1940

SANDFORD MARINUCCI, S., 'Gli Scolari del Correggio', *Bollettino dell'Associazione Archeologica Romana*, II (not seen).

1942

BODMER, H., *Correggio und die Malerei der Emilia*. Short general survey.

1945

PETROVICH, R., 'Correggio and Michelangelo', *Gazette des Beaux-Arts*, 27, pp. 327ff. Attempt to

authenticate a drawing belonging to the writer of the article.

1946

IÑIGUEZ, D. Angulo, 'Una "Expertisse" de Goya sobre un supuesto dibujo del Correggio', *Archivo Español de Arte*, pp. 169ff.

1947

ALLEGRI TASSONI, G., 'La Vertenza fra il Governo Francese ed il vescovo di Parma per la Camera di S. Paolo', *Aurea Parma*.

ROS-THEILER, A., *A. da Correggio, Bildnisse* (not seen).

VALENTINER, W. R., 'The Holy Family by Correggio' (the Los Angeles miniature), *Art Quarterly*, 10, pp. 75ff.

1948

GOULD, C., 'A Probable Adaptation by Correggio of Dürer's Iconography' (X-ray photograph of the London *Christ Taking Leave*), *Burlington Magazine*, 90, p. 286.

1950

GOULD, C., 'A Correggio Discovery', *Burlington Magazine*, 92, pp. 136ff. Restoration of the Apsley House *Agony in the Garden*.

1951

CAVALIERE, D., 'La Lezione del Correggio a Roma ad opera del Lanfranco', *Parma per l'Arte*, May–August.

POUNCEY, P. M. R., 'An Unknown early Drawing by Correggio in the Louvre' (a Pope baptising), *Burlington Magazine*, 93, p. 84.

1952

CHRISTOFFEL, U., 'Leonardo, Correggio und die Manier', *Wallraf-Richartz Jahrbuch*, XIV.

GOULD, C., Catalogue of art section of quincentenary exhibition of Leonardo da Vinci, Royal Academy, London. Draws attention to relation between the Baptist in the Detroit *Marriage* and Leonardo drawing, Windsor 12,572.

1953

BIANCONI, P., *Tutta la Pittura del Correggio* (second edition, 1960).

1954

FINZI, R., *Le Sembianze del Correggio* (not seen).

FINZI, R., 'Divagazioni correggesche I & II', *Parma per l'Arte*, January–April and May–August.

HEATON-SESSIONS, C., 'Drawings attributed to Correggio at the Metropolitan Museum of Art', *Art Bulletin*, 36, pp. 224ff.

1955

COLOMBI, E., 'Il "San Girolamo" del Correggio e Don Ferdinando di Borbone', *Parma per l'Arte*, May–August.

1956

FINZI, R., 'L'ultima immagine del Correggio', *Parma per l'Arte*, May–August.

LONGHI, R., *Il Correggio e la Camera di San Paolo a Parma* (good illustrations).

PETRONILLI, G., 'Cielo del Correggio', *Parma per l'Arte*, September–December.

1957

BOLOGNA, F., 'Ritrovamento di due Tele del Correggio' (Naples *St. Joseph and Donor* and Christ Church *Olympus*), *Paragone*, no. 91, pp. 9ff.

COPERTINI, G., 'La "forma mentis" del Correggio e il clima culturale artistico di Parma rinascimentale', *Parma per l'Arte*, May–August and September–December.

GOULD, C., *An Introduction to Italian Renaissance Painting*.

POPHAM, A. E., *Correggio's Drawings*. The standard work. (Reviews in *Burlington Magazine*, 102, 1960, p. 168 (by J. Bean: he added a *Scene of Sacrifice* in the Louvre which was itself rejected by R. M. Arb in the *Gazette des Beaux-Arts*, VI, 60, 1962, p. 401) and in *Arte Antica e Moderna*, 1958, pp. 191ff. (by S. Zamboni).)

1958

BOTTARI, S., Article on Correggio in *Enciclopedia universale dell'Arte*.

COPERTINI, G., 'La forma mentis...', *Parma per l'Arte*, May–August and September–December.

LONGHI, R., 'Le Fasi del Correggio giovine e l'Esigenza del suo Viaggio Romano', *Paragone*, no. 101,

pp. 34ff. Containing the notorious so-called early Correggios.

RESTA, S. (ed. Popham) *Correggio in Roma*. (Review (by C. Gould) in *Burlington Magazine*, 101, 1959, pp. 464–5.)

VOLPE, C., 'Una Copia da Correggio di Lelio Orsi' (old copy of the Del Bono *Martyrdom*), *Arte Antica e Moderna*, pp. 177ff.

JAHN, J., *Correggio und die Wandlung seiner Kunst*, Dresden. Essay on the Dresden altarpieces.

1959

FENYÖ, I., 'Some newly-discovered Drawings by Correggio', *Burlington Magazine*, 101, pp. 421ff. Important publication of three drawings at Budapest for the S. Giovanni Evangelista *Coronation*, and one other drawing.

MENEGAZZO, E., *Italia Medioevale e Umanistica*, II, pp. 383f. and III (1960), p. 329. Documentation of work for S. Benedetto Po.

1960

COPERTINI, G., 'La forma mentis...', *Parma per l'Arte*, January–April and September–December.

QUINTAVALLE, A. G., *Michelangelo Anselmi*. Useful monograph.

1961

BOTTARI, S., *Correggio* (in series *Collana d'Arte*).

COPERTINI, G., 'La forma mentis...', *Parma per l'Arte*, January–April, May–August, September–December.

FREEDBERG, S., *Painting of the High Renaissance in Rome and Florence*.

PANOFSKY, E., *The Iconography of Correggio's Camera di S. Paolo*. (Reviews: *Apollo*, June, 1962, p. 325 (G. Calmann). *Burlington Magazine*, 105, 1963, pp. 334ff. (G. Copertini). *Zeitschrift für Kunstgeschichte*, 25, 1962, pp. 85–7 (R. Klein). *Art Bulletin*, 45, 1964, pp. 280ff. (W. Stechow). The latter makes an original suggestion re 'lost' drawing but omits to say it had been re-discovered and published by I. Fenyö in 1959.)

QUINTAVALLE, A. G., 'La Cupola restaurata di S. Giovanni Evangelista a Parma', *Bollettino d'Arte*, IV, 46, pp. 343ff.

1962

ALESSANDRI, A., Articles in *Parma per l'Arte*, January–April and May–August.

ARB, R. M., 'A Little-known drawing in Dresden attributed to the young Correggio' (triumph wagon), *Gazette des Beaux-Arts*, VI, 60, pp. 401ff. *En passant* she rejects Popham's attribution of the *Pan* and Bean's of the *Sacrifice* (both Louvre).

COPERTINI, G., 'La forma mentis...', *Parma per l'Arte, passim*. In the May–August issue also attributes male portrait at York to Correggio.

FINZI, R., 'Il Ritratto di Gentildonna del Correggio...', *Nuove Lettere Emiliane*.

GOULD, C., Catalogue of the Sixteenth-Century Italian Schools (excluding the Venetian) in the National Gallery, London.

QUINTAVALLE, A. G., *Gli Affreschi del Correggio in S. Giovanni Evangelista a Parma* (fine illustrations after cleaning).

1963

COPERTINI, G., 'La forma mentis...', *Parma per l'Arte, passim*. Issue of January–April also has article by P. Stanislao Gibertini on the Del Bono chapel.

FERRARI, T., 'Disegni del Correggio per la Cupola di S. Giovanni Evangelista in Parma', *Parma per l'Arte*, January–April.

FINZI, R., 'Nuovi studi sulle sembianze del Correggio', *Nuove Lettere Emiliane*, 3.

LIGHTBOWN, R., 'Princely Pleasures 2. Francesco I d'Este and Correggio', *Apollo*, September, pp. 193ff.

1964

COPERTINI, G., 'La forma mentis...', *Parma per l'Arte, passim*.

LIGHTBOWN, R., 'Correggio and Begarelli: A Study in Correggio Criticism', *Art Bulletin*, 46, pp. 7ff. Valuable details of the Correggio legend.

BACOU, R., Catalogue of exhibition of Parmesan drawings, Paris (Louvre).

GOULD, C., 'An X-ray Mosaic of Correggio's *School of Love*', *Burlington Magazine*, 106, p. 420.

SOTH, L., 'A Note on Correggio's Allegories of Virtue and Vice', *Gazette des Beaux-Arts*, VI, 64, pp. 297ff.

SOTH, L., 'Two Paintings by Correggio' (Louvre *Venus* and London *School of Love*), *Art Bulletin*, 46, pp. 539ff. Draws attention to passage in the *Hypnerotomachia Poliphili*. Followed by letters in vol. 47 (1965), pp. 542ff. from E. Verheyen, Myron Laskin and Lauren Soth.

FERRARI, T., 'Brevi note sul "dittico" di Capodimonte attribuito al Correggio', *Parma per l'Arte*, May–August.

1965

COPERTINI, G., Further instalment in *Parma per l'Arte*, January–April.

DE L'EPINOIS, S. 'Louis XIV, Corrège et l'Appréciation des Œuvres d'Art' (Presentation by Tessin to Louis XIV of so-called sketch of St. Jerome for the *Giorno*), *Gazette des Beaux-Arts*, VI, 66, pp. 103ff. For this see also *Les Relations artistiques entre la France et la Suède, 1693–1718* (Tessin–Cronström correspondence), ed. R.-A. Weigert and C. Hernmarck, 1964.

VERHEYEN, E., 'Eros et Anteros: L'Education de Cupidon et la Prétendue Antiope du Corrège', *Gazette des Beaux-Arts*, VI, 65, pp. 321ff.

FRIEDLÄNDER, W., 'Titian and Pordenone. I. The Salute Paintings', *Art Bulletin*, 47, pp. 118ff.

FERRARI, T., Article in *Parma per l'Arte*, January–April, attempting to discredit the Budapest drawings.

QUINTAVALLE, A. G., 'Ignorati Affreschi del Correggio in S. Giovanni Evangelista a Parma', *Bollettino d'Arte*, pp. 193ff. Important publication of overlooked choir vault and frieze.

1966

COPERTINI, G., Continuation of his *roman fleuve* in *Parma per l'Arte*; includes catalogue.

GOULD, C., 'Correggio and Rome', *Apollo*, pp. 329ff. Superseded by the relevant chapter in the present book.

FERRARI, T., Article in *Parma per l'Arte* on the Naples *Zingarella*.

LASKIN, M., 'A New Correggio for Chicago' (the *Madonna*), *Burlington Magazine*, 108, p. 190.

PIZZAROTTI, G. C., 'Antonio Raffaele Mengs e il Correggio', *Parma per l'Arte*, May–December.

1967

LASKIN, M., 'A Note on Correggio and Pordenone', *Burlington Magazine*, 109, pp. 355ff. Identifies a Metropolitan Museum drawing published by Popham as Correggio as a study for the Pallavicini chapel by Pordenone at Cortemaggiore.

POPHAM, A. E., *Italian Drawings...in the British Museum*. 'Artists workings in Parma in the 16th century.'

SCHULZ, J. 'Pordenone's Cupolas.' *Studies...presented to Anthony Blunt*.

1968

BERENSON, B., *Italian Pictures...Central and North Italian Schools*.

CAUSA, R., 'Deux Inédits du Corrège', *L'Œil*, 157, 12–17 January. Important publication of the X-rays of the Naples *Zingarella* and *Marriage of St. Catherine*, and of details pertaining to the 1935 cleaning of the former.

QUINTAVALLE, A. G., 'L'Incoronata del Correggio', *Bollettino d'Arte*, V, 1, pp. 31ff. Recent cleaning of the centre of the S. Giovanni Evangelista apse fresco.

TASSI, R., *La Cupola del Correggio nel Duomo di Parma*. Excellent colour plates.

1969

KNAUER, E. R., 'Leda', *Jahrbuch der Berliner Museen*, 11, pp. 5ff. Useful survey of illustrations of the subject.

(Count A. Seilern), *Italian Paintings and Drawings at 56 Princes' Gate, London S.W. 7*, Addenda, Study for Christ in the S. Giovanni Evangelista apse and for putto. (Review by C. Gould, *Burlington Magazine*, 1970, 112, p. 764.)

FRY, R., 'The Double Nature of Painting', *Apollo*, May, pp. 362ff. A lecture delivered in 1933 and hitherto unpublished. Roger Fry draws attention to antagonism between brutal subject and elegant treatment of the Del Bono *Martyrdom* (Parma, Galleria).

1970

FAHY, E., 'A Portrait of a Renaissance Cardinal as St. Jerome', *Minneapolis Institute of Arts Bulletin*, LIX. See page 288 of the present catalogue.

FREEDBERG, S., *Painting in Italy 1500-1600*.

GOULD, C., '*The School of Love' and Correggio's Mythologies. Pièce d'occasion* published by the National Gallery after the cleaning of the picture.

GOULD, C., 'On Dürer's Graphic and Italian Painting', *Gazette des Beaux-Arts*, pp. 103ff.

KNAUER, E. R., 'Zu Correggios *Io* und *Ganymed*', *Zeitschrift für Kunstgeschichte*, 33, pp. 61ff.

MECKLENBURG, Carl Gregor, Herzog zu, *Correggio in der deutschen Kunstanschauung in der Zeit von 1750 bis 1850 (mit besonderer Berücksichtigung der Frühromantik)*.

QUINTAVALLE, A. C., *L'Opera Completa del Correggio* (presentazione di Alberto Bevilacqua).

OBERHUBER, K., 'Drawings by Artists working in Parma in the sixteenth century', *Master Drawings*, VIII, pp. 276ff. Review of A. E. Popham's Parma catalogue, 1967. Also published double-sided drawing for the *Madonna della Scodella* (Parma) and S. Giovanni pendentive which since this article has been bought by Dr Hammer for Washington, and also a drawing at Düsseldorf for one of the prophets on the S. Giovanni cupola. Rejects Popham's no. 17 (after sculpture) and no. 3 (kneeling figure). Suggests tentatively sketch of putto on verso of no. 2 might be for one of the putti in the Dresden *Madonna with St. Francis*.

1971

VERHEYEN, E., *The Paintings in the Studiolo of Isabella d'Este at Mantua*.

1972

GIBSON, R., 'Correggio's *School of Love* and Nell Gwyn', *Burlington Magazine*, January.

GOULD, C., 'Correggio's Altarpieces', The Selwyn Brinton Lecture, 1972, *Journal of the Royal Society of Arts*, London, April 1972.

WHITE, C., 'The Armand Hammer Collection: Drawings', *Apollo*, June.

BIBLIOGRAPHICAL ABBREVIATIONS

References to literature quoted in the Catalogue are appended to individual catalogue entries; for further bibliography refer to Silvia de Vito Battaglia, *Correggio Bibliografia*, 1934, and see page 290 for a select bibliography since 1934.

Affò 1794 = Ireneo Affò, *Raggionamento sopra una stanza dipinta dal celeberrimo Antonio Allegri da Correggio nel Monistero di S. Paolo in Parma*.

Affò 1796 = Ireneo Affò, *Il Parmigianino Servitor di Piazza*.

Anderson 1961 = Emily Anderson, *The Letters of Beethoven*.

d'Argenville = d'Argenville, *Abrégé de la vie des... peintres...*, 1745-52, 3 vols.

Barri 1671 = Giacomo Barri, *Viaggio Pittoresco....*

Bartsch = Adam Bartsch, *Le Peintre Graveur*, 1803- .

Battaglia = S. de Vito Battaglia, *Correggio Bibliografia*, 1934.

Bellori, 1672 = G. P. Bellori, *Vite de' Pittori, Scultori et Architetti Moderni*.

Berenson 1901 = Bernhard Berenson, *The Study and Criticism of Italian Art* (second edition, 1908).

Berenson 1932 = Bernhard Berenson, Lists.

Bevilacqua and A. C. Quintavalle 1970 = Alberto Bevilacqua and A. C. Quintavalle, *L'Opera Completa del Correggio*.

Bianconi 1953 = Piero Bianconi, *Tutta la Pittura del Correggio*.

Bigi 1880 = Quirino Bigi, *...Della Vita...di...Correggio*, 1880-81.

Borghini = Raffaelo Borghini, *Il Riposo*, 1584.

Boschini 1660 = Marco Boschini, *La Carta del Navegar Pitoresco*.

Bottari 1822 = M. G. Bottari and S. Ticozzi, *Raccolta di Lettere sulla Pittura…*

Bottari 1961 = Stefano Bottari, *Correggio*.

Braghirolli 1872 = Willelmo Braghirolli, 'Dei Rapporti di Federigo II Gonzaga con Antonio Allegri da Correggio', *Giornale di Erudizione Artistica*, Perugia, 1872.

Burney 1770 = Dr Charles Burney, Journal.

De Piles 1699 = Roger de Piles, *Abrégé de la Vie des Peintres*.

Dolce 1565 = Lodovico Dolce, *Dialogo dei Colori*.

Donesmondi 1616 = Ippolito Donesmondi, *Dell'Istoria ecclesiastica di Mantova*.

Enggass 1964 = Robert Enggass, *The Painting of Baciccio*.

Fischel 1948 = Oskar Fischel, *Raphael* (English edition).

Gronau 1907 = G. Gronau, *Correggio* (Klassiker der Kunst).

Landi 1552 = Ortensio Landi, *Sette libri di Cathaloghi a' varie cose appartenenti*.

Lanzi 1795–6 = Luigi Lanzi, *Storia pittorica della Italia*.

Laskin 1966 = Myron Laskin Jr, 'A new Correggio for Chicago' in *Burlington Magazine*, 108, p. 190.

Longhi 1958 = Roberto Longhi, 'La Fasi del Correggio giovane e l'Esigenza del suo Viaggio Romano' in *Paragone*, May 1958, p. 34.

Luzio 1913 = Alessandro Luzio, *La Galleria dei Gonzaga venduta all'Inghilterra nel 1627–8*.

Martini 1865 = Pietro Martini, *Studi intorno il Correggio*.

Mecklenburg 1970 = Carl Gregor Herzog zu Mecklenburg, *Correggio in der deutschen Kunstanchauung in der Zeit von 1750 bis 1850*.

Meder 1919 = Josef Meder, *Die Handzeichnung*.

Mengs, *Opere* = Antonio Raffaello Mengs, *Opere*, first edition (Italian) 1780 (various other editions in different languages).

Meyer 1871 = Julius Meyer, *Correggio*.

Morelli 1875 = Ivan Lermolieff, *Die Galerien Roms*.

Morelli 1880 = Ivan Lermolieff, *Die Werke italienischer Meister in den Galerien von München, Dresden und Berlin* ('Munich and Dresden').

Oberhuber 1962 = Konrad Oberhuber, 'Die Fresken der Stanza dell'Incendio im Werk Raffaels' in *Wiener Jahrbuch*, vol. 58, 1962.

Olsen 1962 = Harald Olsen, *Federico Barocci*.

Panofsky 1961 = Erwin Panofsky, *The Iconography of Correggio's Camera di San Paolo*.

Popham 1957 = A. E. Popham, *Correggio's Drawings*.

Pungileoni 1817–21 = Luigi Pungileoni, *Memorie Istoriche di Antonio Allegri detto il Correggio*, 3 vols.

Quintavalle, A. G., 1960 = Augusta Ghidiglia Quintavalle, *Michelangelo Anselmi*.

Quintavalle, A. G., 1965 = Augusta Ghidiglia Quintavalle, 'Ignorati Affreschi del Correggio in S. Giovanni Evangelista a Parma in *Bollettino d'Arte*, serie v, pp. 193ff.

Quintavalle, A. O., 1935 = Armando Ottaviano Quintavalle, *Mostra del Correggio, Catalogo*.

Ratti = Carlo Giuseppe Ratti, *Notizie storiche…del …Correggio*, 1781.

Redford = George Redford, *Art Sales*, 1888.

Resta 1958 = Padre Sebastiano Resta, ed. A. E. Popham, *Correggio in Roma*.

Ricci 1896 = Corrado Ricci, *Antonio Allegri da Correggio*, 1896.

Ricci, 1930 = Corrado Ricci, *Correggio*, 1930.

Richardson 1722 = Jonathan Richardson (father and son). *An Account of…Pictures in Italy*.

Ridolfi/Hadeln = Carlo Ridolfi, *Le Maraviglie dell'Arte*, 1648, ed. Hadeln, 1914–24.

Roi 1921 = Pia Roi, *Il Correggio*.

Rumohr 1831 = C. F. von Rumohr, *Italienische Forschungen*, vol. III.

Ruskin 1909 = *The Works of John Ruskin*, Library Edition.

Salmi 1918 = Mario Salmi, 'Bernardino Zaccagni e l'Architettura del Rinascimento a Parma' in *Bollettino d'Arte*, pp. 85ff.

Scannelli 1657 = Francesco Scannelli, *Il Microcosmo della Pittura*.

Scaramuccia 1674 = Luigi Scaramuccia, *Le Finezze dei Pennelli...*, 1674.

Schlegel, F., 1959 = Friedrich Schlegel, ed. H Eichner, *Ansichten und Ideen von der christlichen Kunst.*

Schleier 1962 = E. Schleier, 'Lanfranco's "Notte" for the Marchese Sannesi...' in *Burlington Magazine*, vol. 104, pp. 246ff.

Schulz 1968 = Juergen Schulz, *Venetian Painted Ceilings of the Renaissance.*

Shearman 1961 = John Shearman, 'The Chigi Chapel in S. Maria del Popolo' in *Journal of the Warburg and Courtauld Institutes*, XXIV, 3-4, 1961, pp. 129ff.

Soth 1964 = Lauren Soth, 'Two Paintings by Correggio' in *Art Bulletin*, XLVI, pp. 539ff. (also *Art Bulletin*, XLVII, 1965, p. 544).

Suida 1936 = Wilhelm Suida, 'Correggio e Tiziano' in *Manifestazioni Parmensi nel IV centenario della morte del Correggio.*

Swoboda 1935 = K. M. Swoboda, 'Die Io und Ganymede des Correggio in der Wiener Gemäldegalerie' in *Neue Wege der Kunstgeschichte.*

Symonds 1899 = J. A. Symonds, *The Renaissance in Italy.*

Tassi 1968 = R. Tassi, *La Cupola del Correggio nel Duomo di Parma.*

Testi 1922 = Laudedeo Testi, 'Quando nacque il Correggio?' in *Archivio Storico per le Provincie Parmensi*, nuova serie, XXII bis.

Thode 1898 = Henry Thode, *Correggio.*

Tiraboschi 1786 = Girolamo Tiraboschi, *Biblioteca Modenese*, VI.

Tschudi 1880 = H. von Tschudi, *Correggios mythologische Darstellungen.*

Vasari/Milanesi = Giorgio Vasari, *Le Vite de' piu eccelenti Pittori, Scultori ed Architettori*, ed. Gaetano Milanesi, 1878-85, 9 vols.

Vedriani 1662 = Ludovic Vedriani, *Raccolta de' Pittori, Scultori et Architetti.*

Venturi 1926 = Adolfo Venturi, *Il Correggio* (elephant folio).

Venturi, *Storia* = Adolfo Venturi, *Storia dell'Arte Italiana*, IX, II.

Venturi, A., 1915 = Adolfo Venturi, 'Note sul Correggio' in *L'Arte*, 1915, pp. 405ff.

Verheyen 1965 = Egon Verheyen, 'Eros et Anteros' in *Gazette des Beaux-Arts*, 6th period, vol. 65, pp. 321ff. (also *Art Bulletin*, XLVII, 1965, pp. 542-3).

Verheyen 1966 = Egon Verheyen, 'Correggio's Amori di Giove' in *Journal of the Warburg and Courtauld Institutes*, 29, pp. 160ff.

Waterhouse 1962 = Ellis Waterhouse, *Italian Baroque Painting.*

Wölfflin 1924 = Heinrich Wölfflin, *Die Klassische Kunst*, 1924 edition.

ACKNOWLEDGEMENTS

In the period of more than twenty years during which I have been thinking about writing the present book, and the four when I have been trying to do so, I have drawn freely on the work of many others. To any student of Correggio the images of Vasari, Scannelli, Mengs, Tiraboschi, Pungileoni, Meyer, Ricci, Battaglia and Popham assume something of the quality of the Muses', both indispensable and unapproachable. Of my contemporaries and colleagues three deserve special and specific thanks. Dr Alberto Ghidini, librarian and archivist to the town of Correggio, undertook, for the honour of the painter's native place, the laborious task of tracing the documents published by Pungileoni a century and a half ago, most of which had not been consulted by art historians in the meantime. Mr Michael Jaffé took it on himself to suggest I might stop thinking about the book and start writing it. If he had not, I never should. And Dr Myron Laskin has sustained me throughout with his incomparable knowledge of the subject. In the case of the numerous others I cannot attempt to define the nature of my debt but content myself with gratefully recording their names:

Madame Sylvie Béguin
Mrs Quentin Bell
Miss Brigid Brophy
Mr James Byam Shaw
Dr Raffaello Causa
Dr Marco Chiarini
Lord Clark of Saltwood
Mr Malcolm Cormack
Dr Bernice Davidson
Dr Paola Della Pergola
Mr Roger Ellis
Mr Everett Fahy
Mrs Enriqueta Frankfort
Dr Klara Garas
Mr Kenneth Garlick
Professor Myron P. Gilmore
Mrs Grace Ginnis

The late Dr Rudolf Heinemann
Dr Michael Hirst
Mr John Ingamells
Lady Jamieson
Mr Lee Johnson
Mr Michael Levey
Lady Dorothy Lygon
Mr Denis Mahon
Mr John Maxon
Dr Amalia Mezzetti
Sir Oliver Millar
Miss Agnes Mongan
Mrs Eric Newton
Sir John Pope-Hennessy
Signora Augusta Ghidiglia
 Quintavalle
The late Mr Helmut Ruhemann

Dr Franco Russoli
Dr A. E. Pérez Sánchez
Monsieur Maurice Sérullaz
Dr John Shearman
Mr Alistair Smith
Mr John Sparrow
Miss Margaret Stewart
Miss Barbara Sweeny
Miss Ina Vincent
Dr Angelo Walther
Mr John Ward-Perkins
Sir Ellis Waterhouse
Mrs V. Wilson
The late Professor R. Wittkower
The late Dr Francis Wormald

In addition to these I should like to express gratitude to both publishers and printers for the patience with which they received wave after wave of afterthoughts, additions and corrections.

London, March 1972 C.G.

A NOTE ON THE REPRODUCTIONS
AND FORMAT

The fact that a number of Correggio's paintings measure no more than about 30 cm in height, that his altarpieces average around 2 metres and that the cupola frescoes are naturally bigger still raises difficulties of juxtaposition in reproduction. Few factors are liable to give a more misleading impression than the juxtaposition, in reproductions of approximately the same scale, of paintings whose actual scale is widely disparate. For this reason the miniatures are here reproduced on the scale of four to a page (with the exception of some which are reproduced in colour nearly full size, and these have been kept separate from the rest). Drawings and engravings have also, in most cases, been reproduced four to the page, and cabinet pictures two to the page. Altarpieces, mythologies and frescoes are given a whole page. Details, whether in black and white or colour, are also given a whole page, but captioned, as such, and 'bled' into the spine in order to suggest continuity. X-ray photographs are normally reproduced on the same scale as the relevant painting.

Plates 115B, 175C and 178B are reproduced by gracious permission of Her Majesty The Queen.

INDEX OF FORMER OWNERS

This index covers pictures in section A of the catalogue
and refers to the present locations as listed there. If only one place name is given,
it means the main museum there: e.g. 'London' = National Gallery.

Adamovics, Valentin Andreas von
 Marriage of St. Catherine – Detroit
Alba, Dukes of
 School of Love – London
Aldobrandini
 Madonna and Child and Angel – Budapest (?)
 Noli me Tangere – Madrid
 Allegory – Rome (Doria)
Armandi
 Four Saints – New York
Ashburton, Lord
 Four Saints – New York
Augustus III of Saxony
 Madonna with St. Francis – Dresden
 Madonna with St. Sebastian – Dresden
 Madonna with St. George – Dresden
 Nativity ('Notte') – Dresden
 Magdalen Reading – Dresden (formerly)
Azzolini, Pompeo
 Leda – Berlin
 Danaë – Rome (Borghese)

Baiardi (Parma)
 Madonna of the Basket – London
Barberini, Cardinal Antonio
 Marriage of St. Catherine – Paris
Benson, R. H.
 Christ taking Leave – London
Bolognini Attendolo, Conte
 Madonna and Child – Milan (Castello)
Bonomi
 Marriage of St. Catherine – Washington
Borghese, Cardinal Scipione
 Marriage of St. Catherine – Paris (?)
Brandegee, Mrs Edward D.
 Madonna and Child – Los Angeles
Buchanan, W.
 Madonna of the Basket – London

Campori
 Madonna and Child – Modena
Caracena, Marchese di
 Agony in the Garden – London (Apsley House)
Carpio, Marques del (?)
 Madonna and Child and Angel – Budapest
Castiglioni, Camille
 Marriage of St. Catherine – Detroit

Charles I, King of England
 Marriage of St. Catherine – Detroit
 Holy Family – Hampton Court
 Madonna and Child – Orléans
 School of Love – London
 St. Jerome – Madrid (Academia)
 Venus – Paris
 Virtue – Paris
 Vice – Paris
Charles V, Emperor
 Leda – Berlin
 Danaë – Rome (Borghese)
 Ganymede – Vienna
 Io – Vienna
Christina, Queen of Sweden
 Leda – Berlin
 Danaë – Rome (Borghese)
Colonna
 Ecce Homo – London
Contini-Bonacossi
 Marriage of St. Catherine – Washington
Correggio, Church of S. Francesco
 Madonna with St. Francis – Dresden
 Holy Family with St. Francis – Florence
 (Uffizi)
Correggio, Church of S. Maria della Misericordia
 Four Saints – New York
Costabili (Ferrara)
 Marriage of St. Catherine – Washington
Cowper, Earl
 Veronica's Veil – Firle
Coypel, Charles
 Leda – Berlin
Crespi
 Nativity – Milan (Brera)

Day, Alexander
 Ecce Homo – London
Desborough, Lady
 Veronica's Veil – Firle
Duveen, Sir J. (Lord Duveen)
 Christ taking Leave – London

Eissler
 Pietà – New York (Heinemann)
Epinaille, Comte d'
 Leda – Berlin

Naples, Church of the Gerolomini
 St. Anthony Abbot – Naples
Nieuwenhuys
 Madonna of the Basket – London

Odescalchi, Livio
 Leda – Berlin
 Danaë – Rome (Borghese)
Olivares, Conde-Duque
 School of Love – London
Orléans
 Leda – Berlin
 Danaë – Rome (Borghese)
Orsini, Muzio (?)
 Madonna and Child and Angel – Budapest

Parlatore (Florence)
 Christ taking Leave – London
Parma, Church of S. Antonio
 'Giorno' – Parma
Parma, Church of S. Giovanni Evangelista
 Martyrdom – Parma
 Lamentation – Parma
Parma, Church of S. Sepolcro
 Madonna della Scodella – Parma
Pasquier
 Leda – Berlin
Perez, Antonio
 Ganymede – Vienna
Periberti, Gottifredo (?)
 Madonna and Child and Angel – Budapest
Philip II, King of Spain
 Leda – Berlin
 Danaë – Rome (Borghese)
 Ganymede – Vienna
 Io – Vienna
Philip IV, King of Spain
 Agony in the Garden – London (Apsley
 House)
 Madonna of the Basket – London
 Noli me Tangere – Madrid
Prati (?)
 Ecce Homo – London
Pratonero, Alberto
 Nativity (Notte) – Dresden

Ravaisson-Mollien
 St. Mary Magdalene – London

Reggio Emilia, Church of S. Prospero
 Nativity (Notte) – Dresden
Reisinger, Andreas von
 Marriage of St. Catherine – Detroit
Richter, J. P.
 Nativity – Milan (Brera)
Robinson, Sir J. C.
 Nativity – Milan (Brera)
Rossano, Principessa di (?)
 Madonna and Child and Angel – Budapest
Rossi (Milan)
 Christ taking Leave – London
Rudolf II, Emperor
 Leda – Berlin
 Danaë – Rome (Borghese)
 Ganymede – Vienna
 Io – Vienna

Salting, George
 St. Mary Magdalene – London
San Giorgio, Cardinal (?)
 Madonna and Child and Angel – Budapest
Santa Fiora
 Marriage of St. Catherine – Paris
Schwabe, A. H.
 Young Christ – Washington
Sforza (Rome)
 Marriage of St. Catherine – Paris
Signoretti, Reggio Emilia
 Agony in the Garden – London, Apsley House
Stewart, Lord
 see Londonderry, Marquess of

Talleyrand, Prince de
 Veronica's Veil – Firle

Visconti, Pirro
 Agony in the Garden – London (Apsley House)
Vitale de Tivoli
 Christ taking Leave – London

Wellington, 1st Duke of
 Agony in the Garden – London (Apsley House)
Whitcomb, Anna Scripps
 Marriage of St. Catherine – Detroit

Youssoupoff, St. Petersburg
 Female Portrait – Leningrad

GENERAL INDEX

THE MONOCHROME PLATES

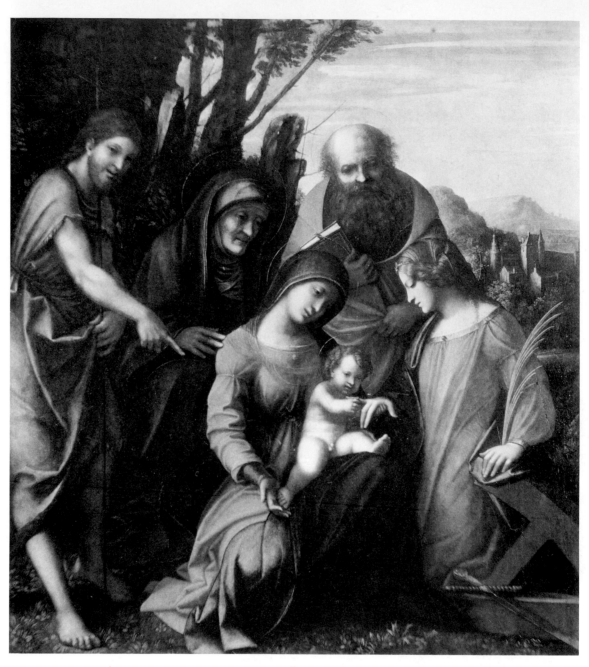

I

The Marriage of St. Catherine
Detroit. See page 32

2

The Marriage of St. Catherine. X-ray
Detroit. See page 32

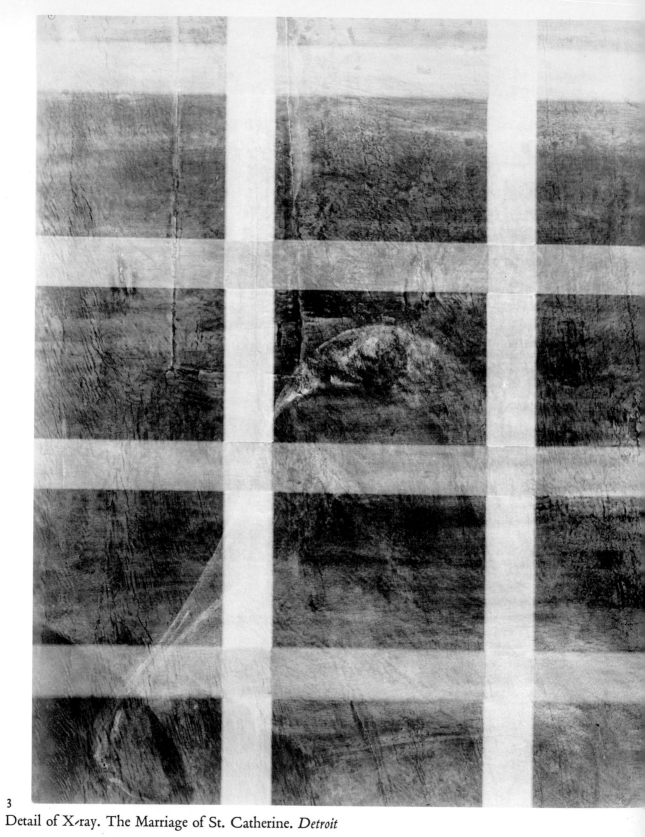

3

Detail of X-ray. The Marriage of St. Catherine. *Detroit*

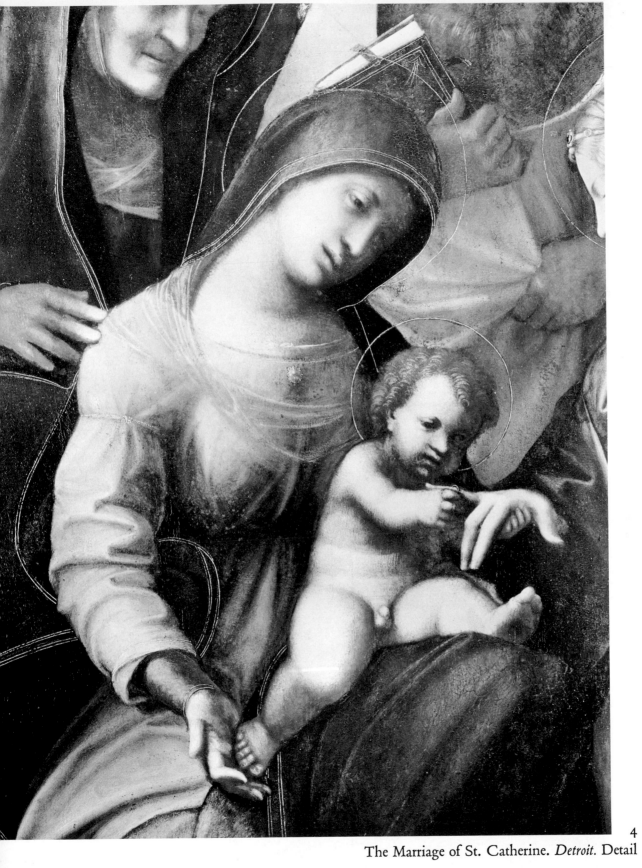

4

The Marriage of St. Catherine. *Detroit*. Detail

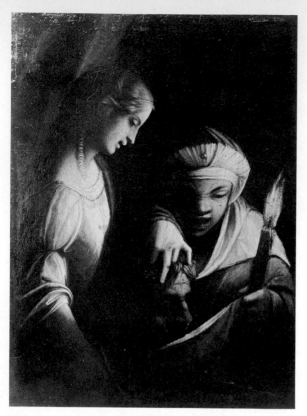

5A
Judith with the Head of Holofernes
Strasbourg. See page 33

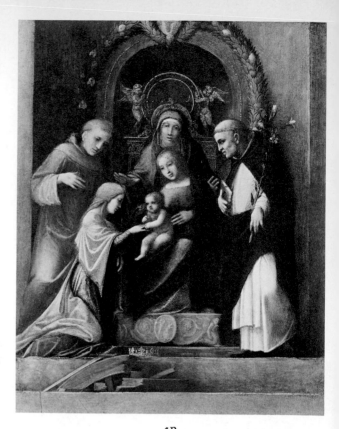

5B
The Marriage of St. Catherine; also Saints
Francis and Dominic
Washington, National Gallery of Art. See page 33

5C
Madonna and Child with the Giovannino,
St. Joseph and St. Elizabeth
Pavia, Museo Communale. See page 34

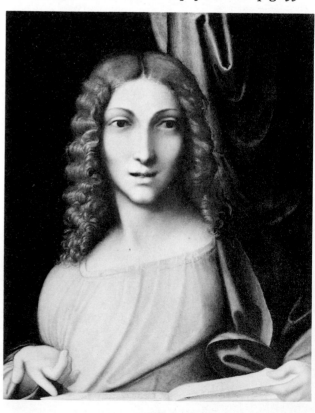

5D
The Young Christ
Washington, National Gallery of Art. See page 39

6B

Copy of Madonna and Child with Giovannino
Rome, Villa Borghese. See page 37

6A

Madonna and Child with Giovannino and St. Elizabeth
Philadelphia, John G. Johnson collection. See page 33

7B
Christ taking Leave of His Mother. X-ray

7A
Christ taking Leave of His Mother
London, National Gallery. See page 35

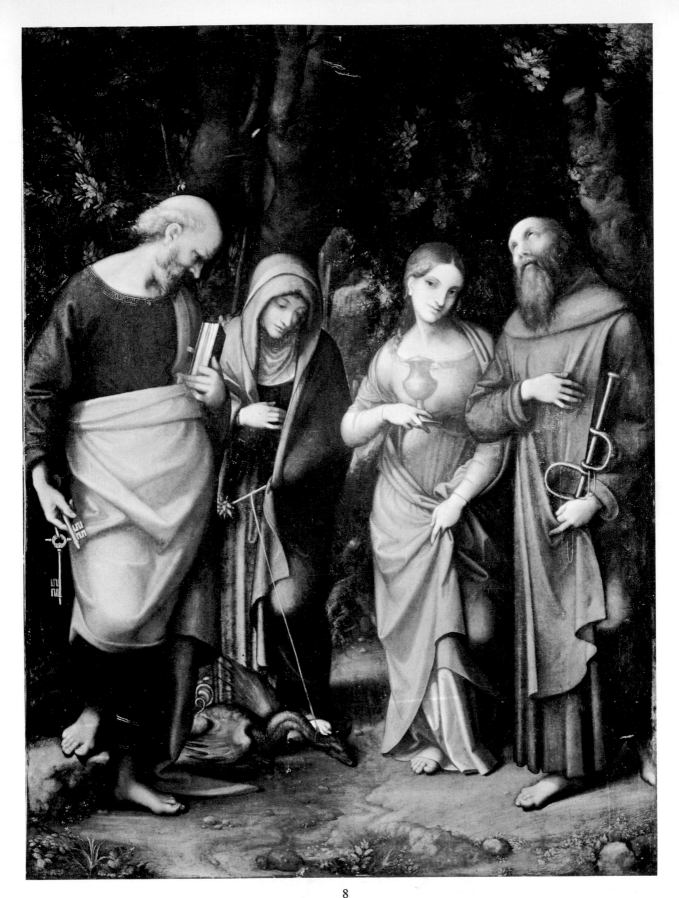

8

Saints Peter, Martha, Mary Magdalene and Leonard
New York, Metropolitan Museum of Art. See page 37

9
Detail of Saints Peter, Martha, Mary Magdalene and Leonard
New York, Metropolitan Museum of Art

10A

St. Sebastian, a Pope and other figures
Paris, Louvre (Popham 4). See page 39

10B

St. Anthony Abbott
Naples, Galleria Nazionale. See page 38

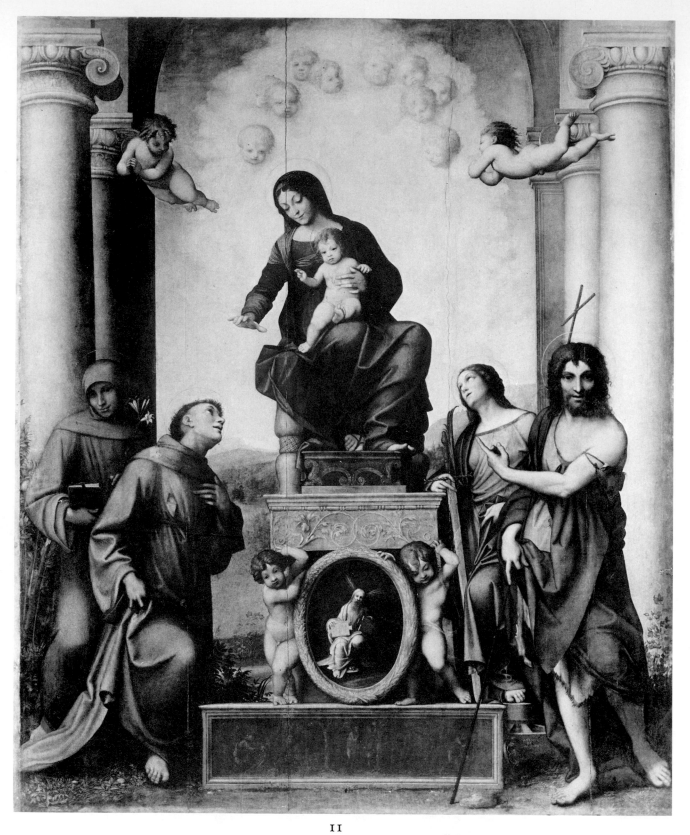

II

Madonna and Child with Saints Francis, Anthony of Padua, Catherine of Siena and John the Baptist
Dresden. See page 42

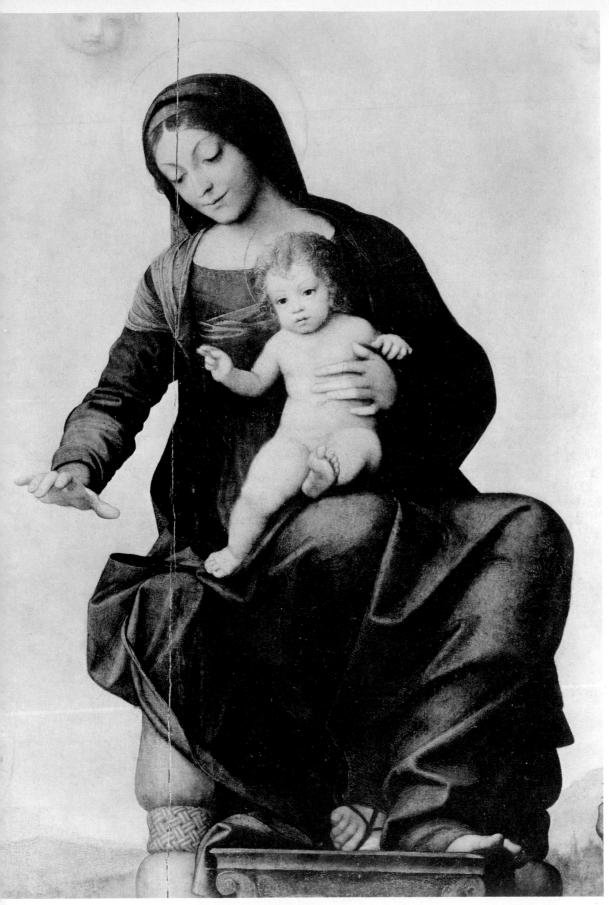

12

Madonna and Child with Saint Francis and other Saints. *Dresden*. Detail

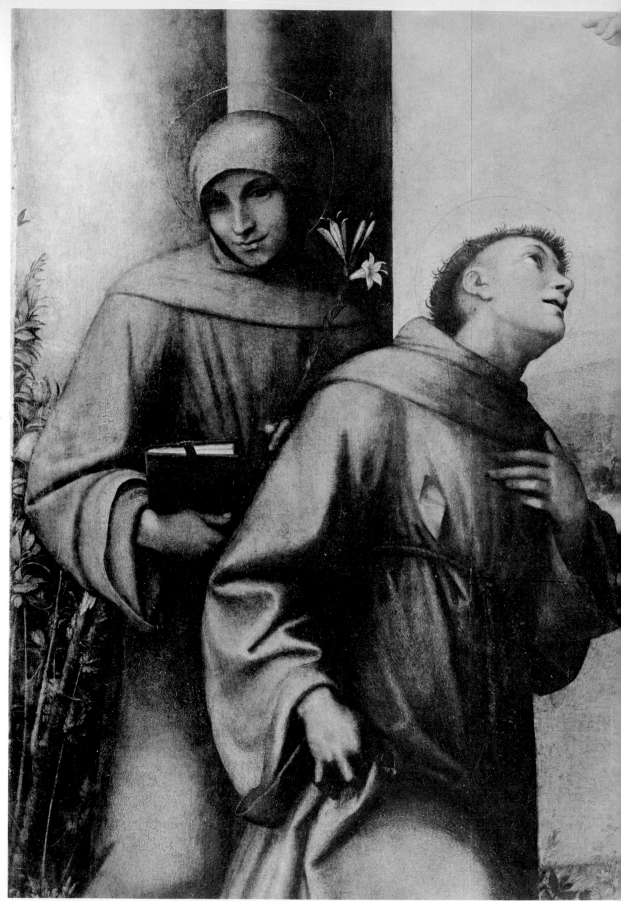

13

Detail of Madonna and Child with Saint Francis and other Saints. *Dresden*

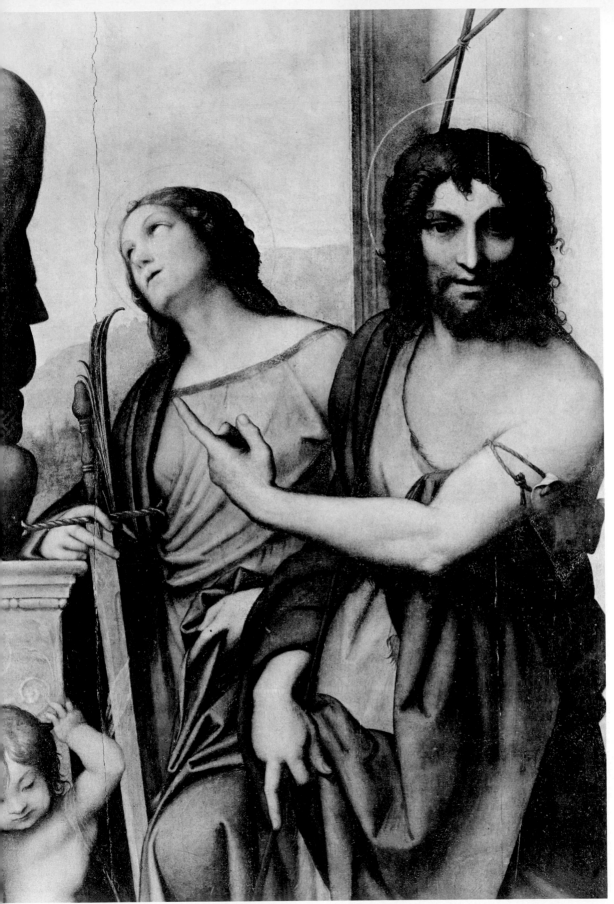

14

Madonna and Child with Saint Francis and other Saints. *Dresden*. Detail. *See page 42*

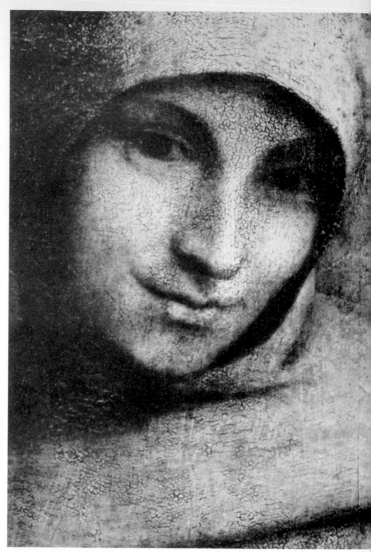

15A
Reversed detail of Madonna and Child with Saint Francis and other Saints. *Dresden. See page 42*

15B
Detail of Madonna and Child with Saint Francis and other Saints. *Dresden*

16B

Madonna and Child and the Giovannino. X-ray

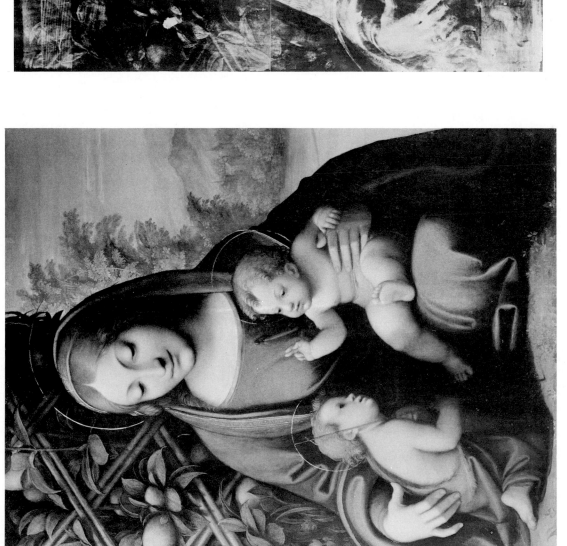

16A

Madonna and Child and the Giovannino
Chicago, Art Institute. See page 43

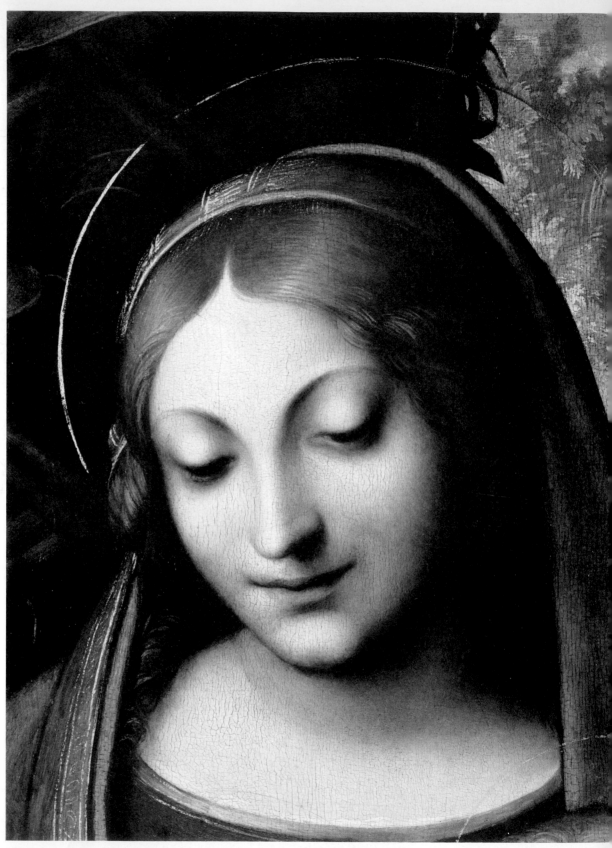

17

Detail of Madonna and Child and the Giovannino. *Chicago, Art Institute*

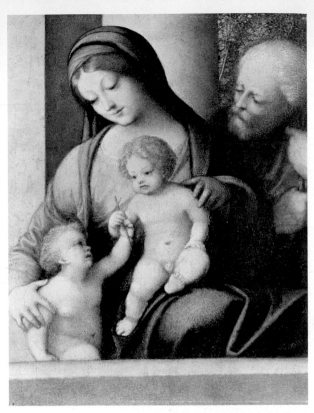

18A

Madonna and Child with St. Joseph and the
Giovannino.
Los Angeles, County Museum. See page 43

18B

Madonna and Child with St. Joseph and
the Giovannino. X-ray

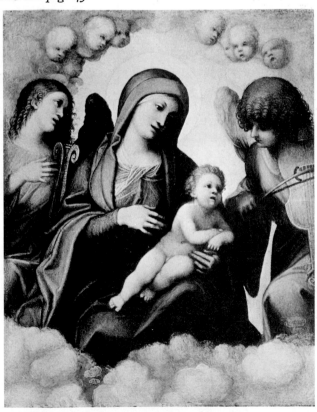

18C

Madonna and Child with Music-making Angels
Florence, Uffizi. See page 43

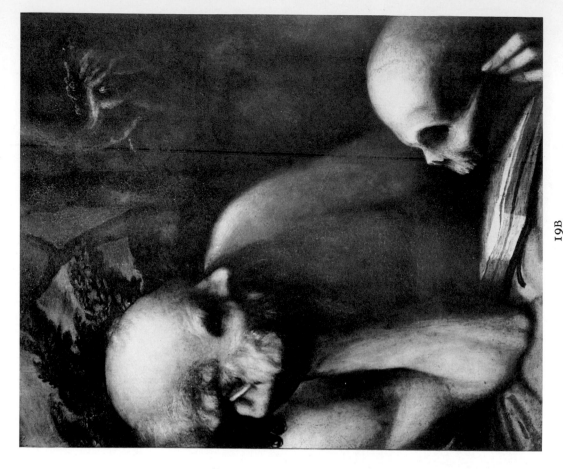

19B
St. Jerome. *Madrid, Academia de S. Fernando. See page 38*

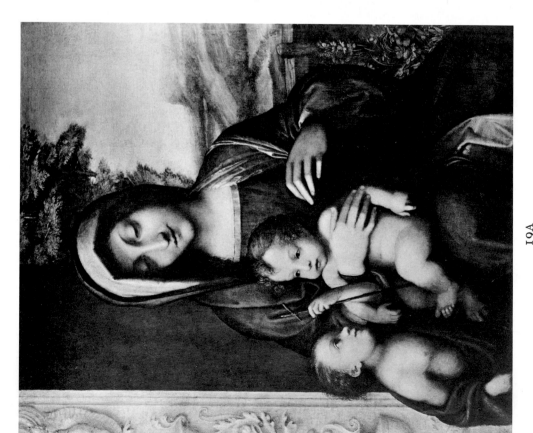

19A
Madonna and Child with the Giovannino
Milan, Castello Sforzesco. See page 43

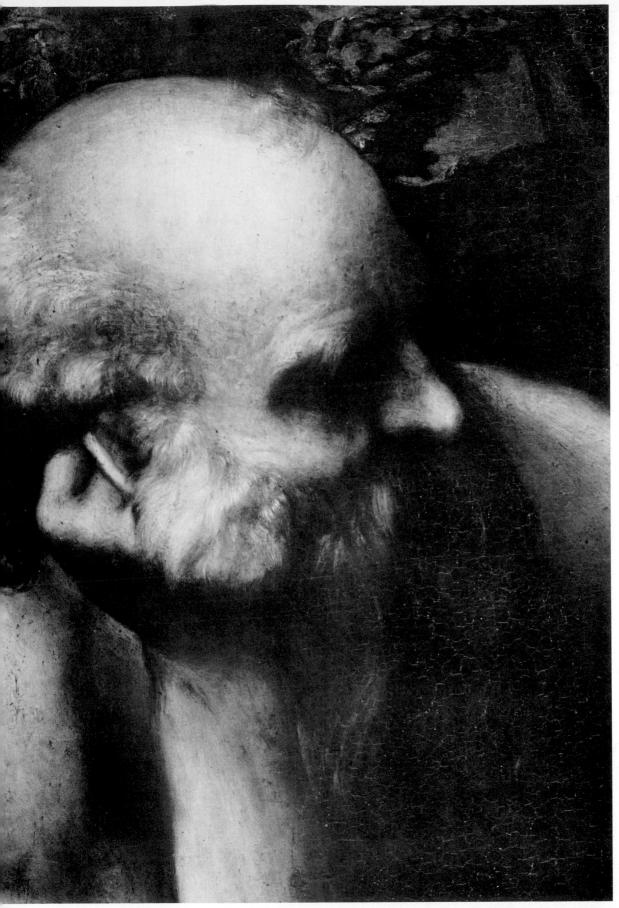

20

St. Jerome. *Madrid, Academia de S. Fernando.* Detail

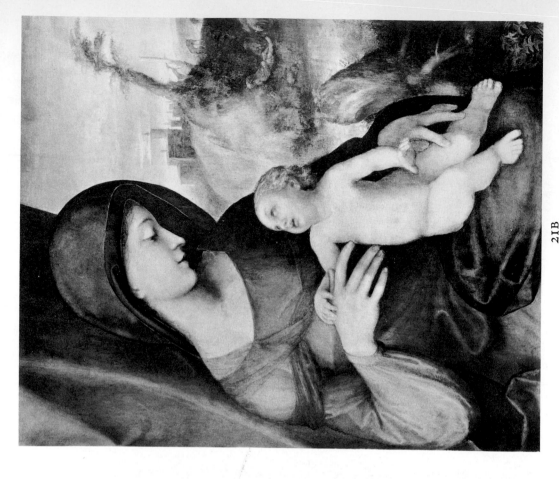

21B
Madonna and Child (Madonna of Hellbrunn)
Vienna, Kunsthistorisches Museum. See page 44

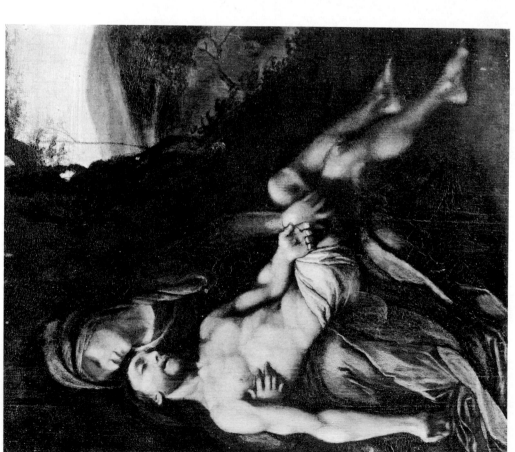

21A
Pietà
New York, Dr and Mrs Rudolf Heinemann. See page 50

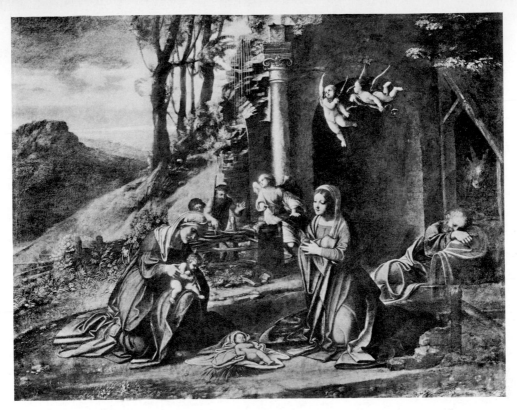

22A

The Nativity, with St. Elizabeth and the Giovannino
Milan, Brera. See page 43

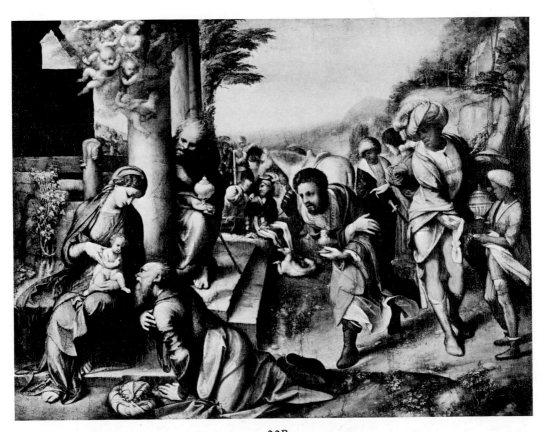

22B

The Adoration of the Kings
Milan, Brera. See page 43

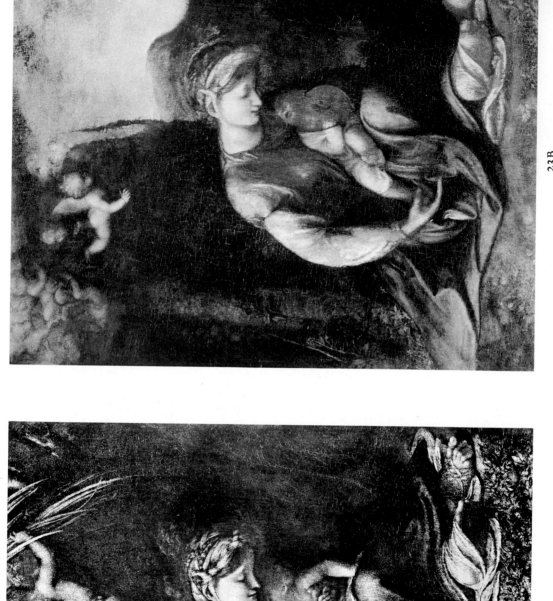

23B

Madonna and Child (La Zingarella). *After restoration of 1965*
Naples, Galleria Nazionale

23A

Madonna and Child (La Zingarella). *Before restoration of c. 1934*
Naples, Galleria Nazionale. See page 44

24A
Madonna and Child (La Zingarella). X-ray
Naples, Galleria Nazionale

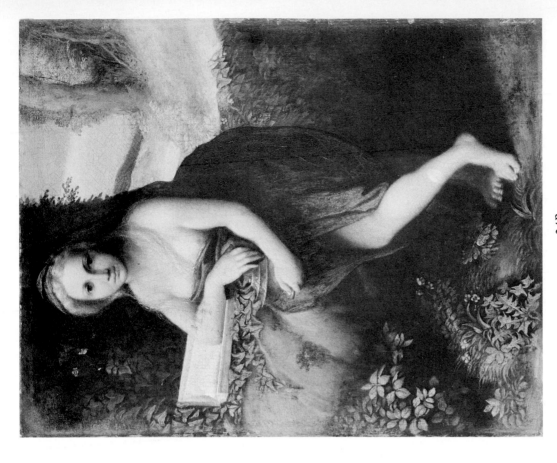

24B
St. Mary Magdalene
London, National Gallery. See page 59

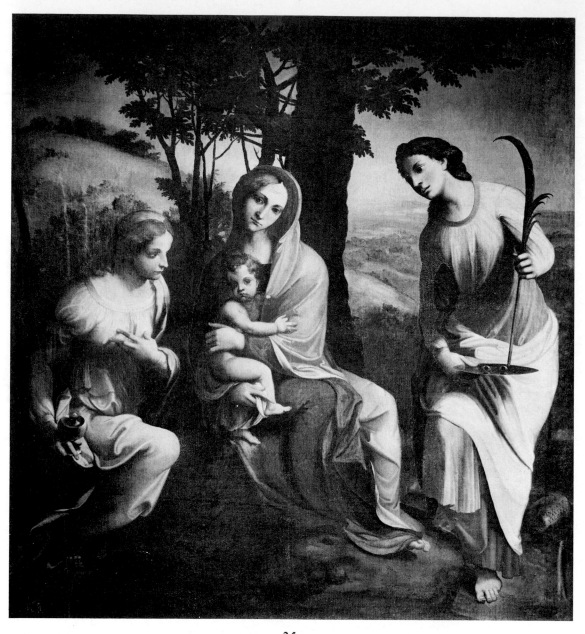

25
Copy of Madonna and Child with Saints Mary Magdalene and Lucy (Madonna of Albinea)
Rome, Capitoline Museum. See page 57

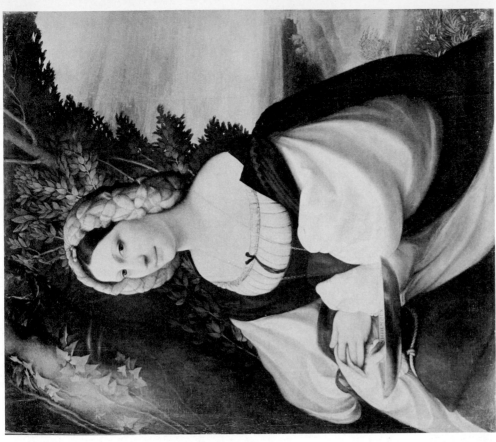

26B
Portrait of a Lady
Leningrad, Hermitage. See page 58

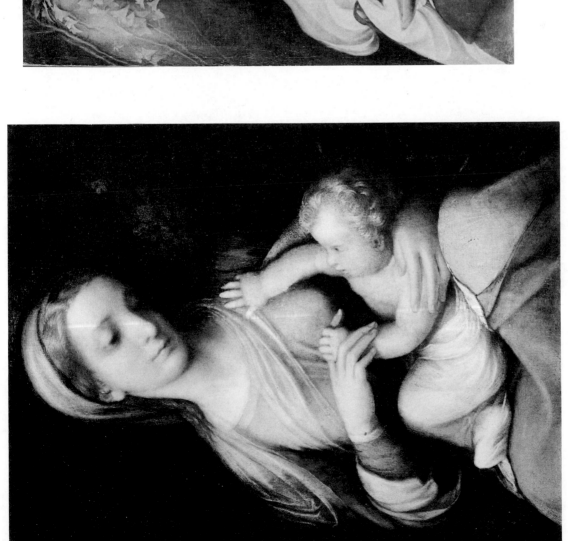

26A
Madonna and Child (Campori Madonna)
Modena, Galleria Estense. See page 57

27B
Madonna and Child with the Giovannino. X-ray

28↓
Camera di S. Paolo. Ceiling, after 1972 restoration

27A
Madonna and Child with the Giovannino
Madrid, Prado. See page 58

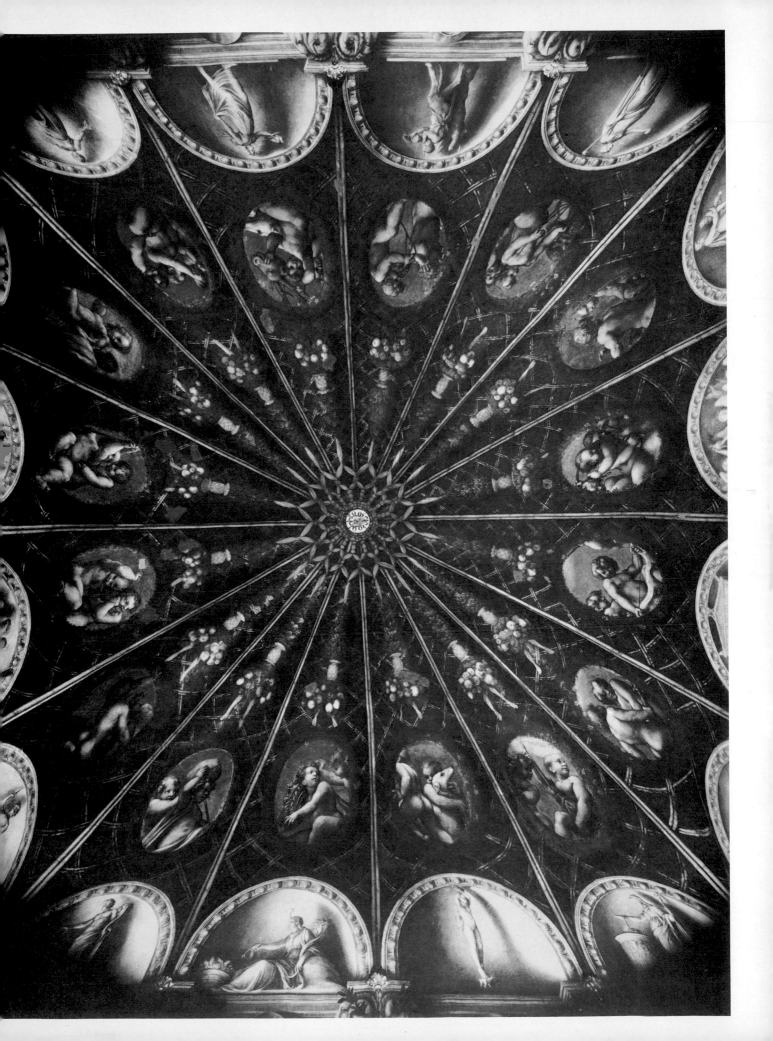

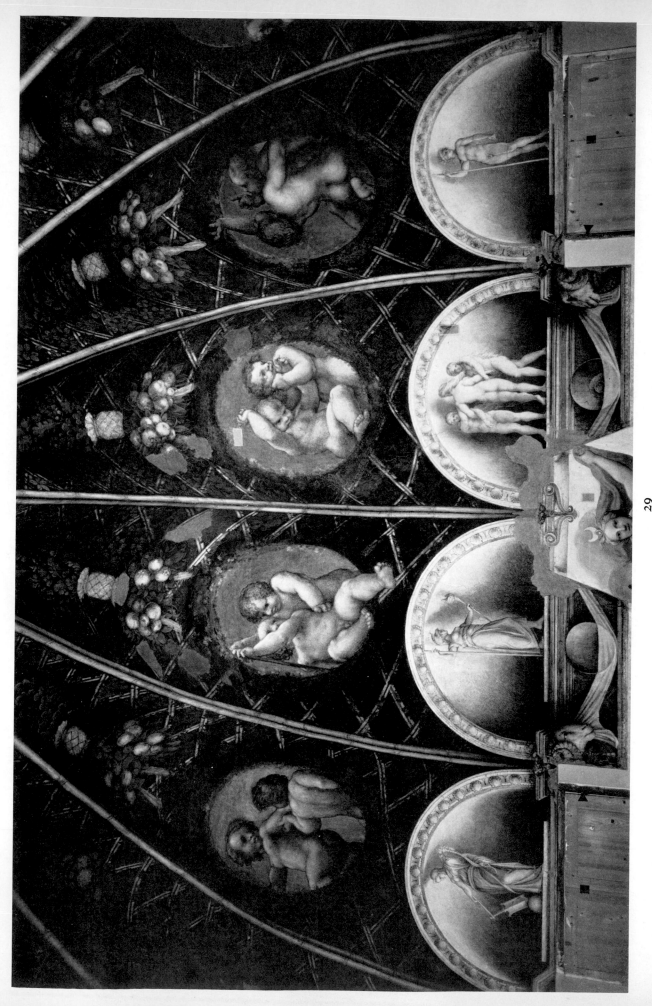

29

Camera di S. Paolo. North wall, after 1972 restoration
Parma. See page 51

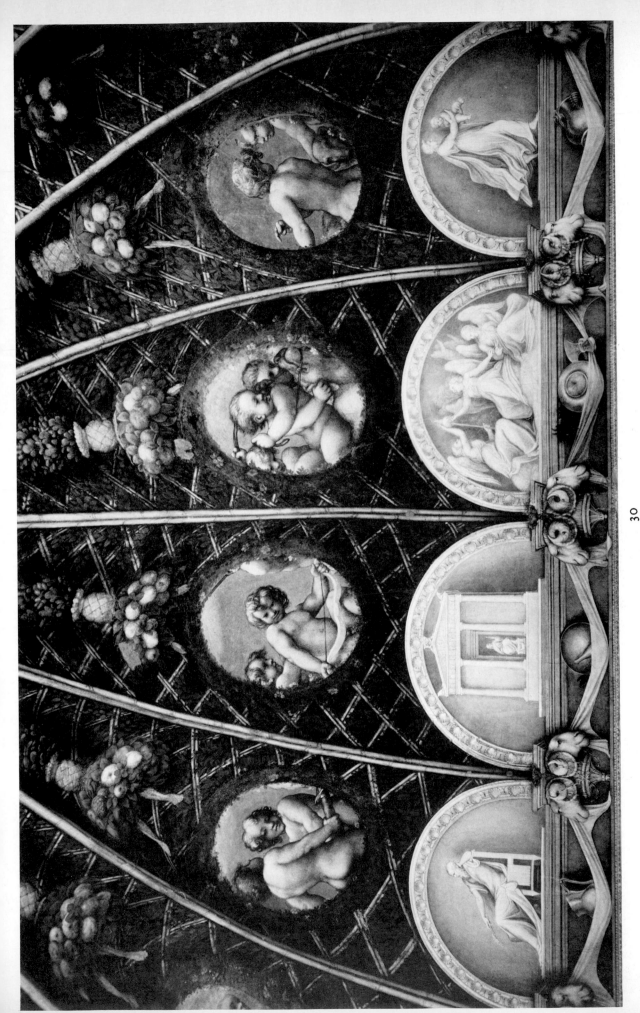

30

Camera di S. Paolo. South wall, after 1972 restoration
Parma. See page 51

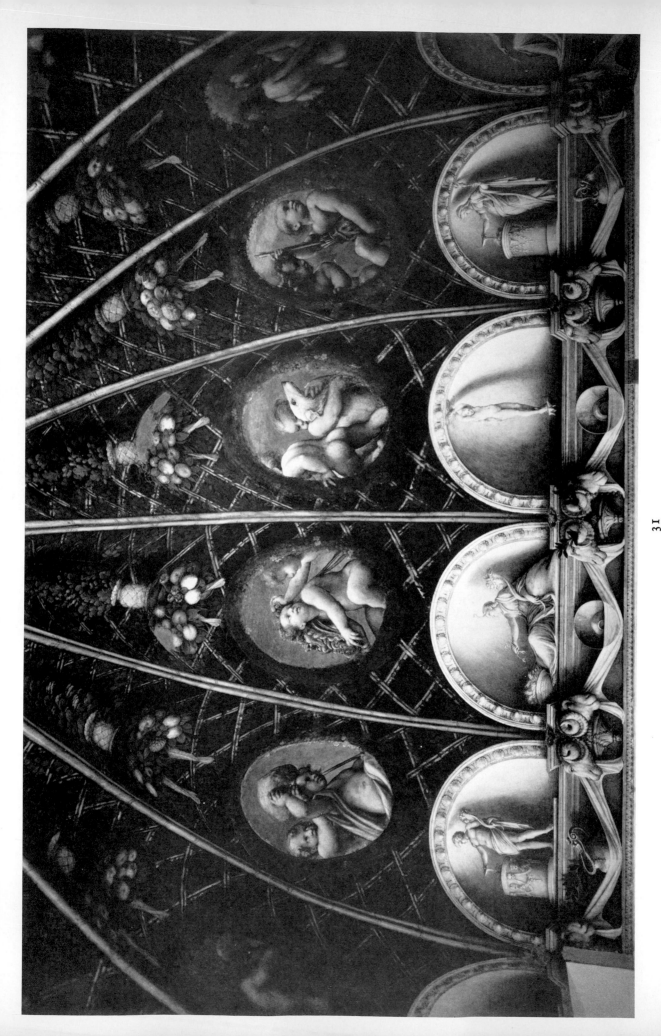

31

Camera di S. Paolo. East wall, after 1972 restoration
Parma. See page 51

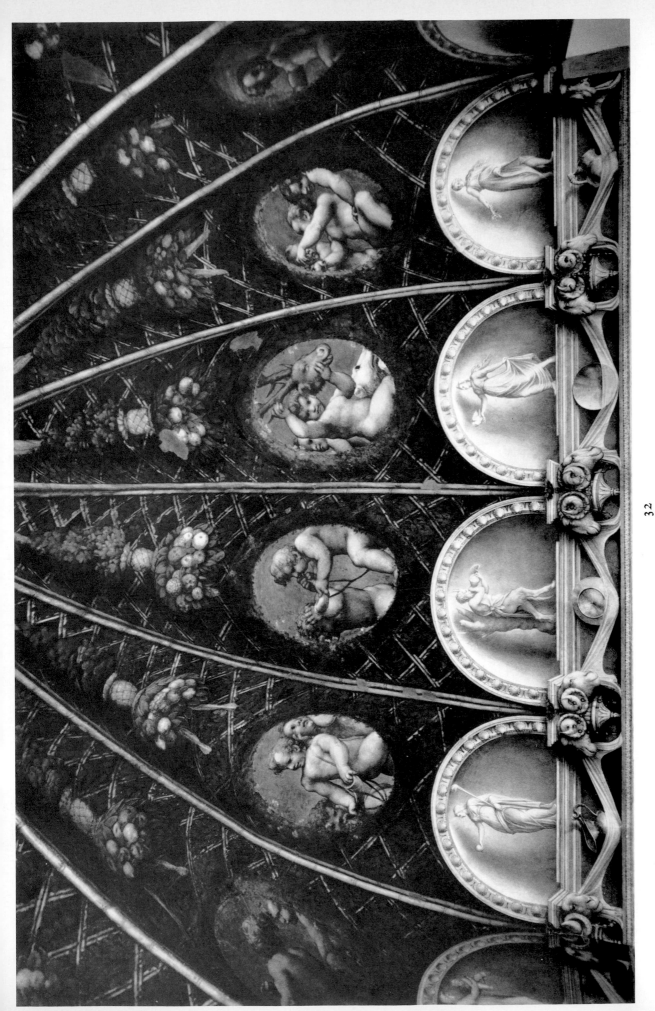

32

Camera di S. Paolo. West wall, after 1972 restoration
Parma. See page 51

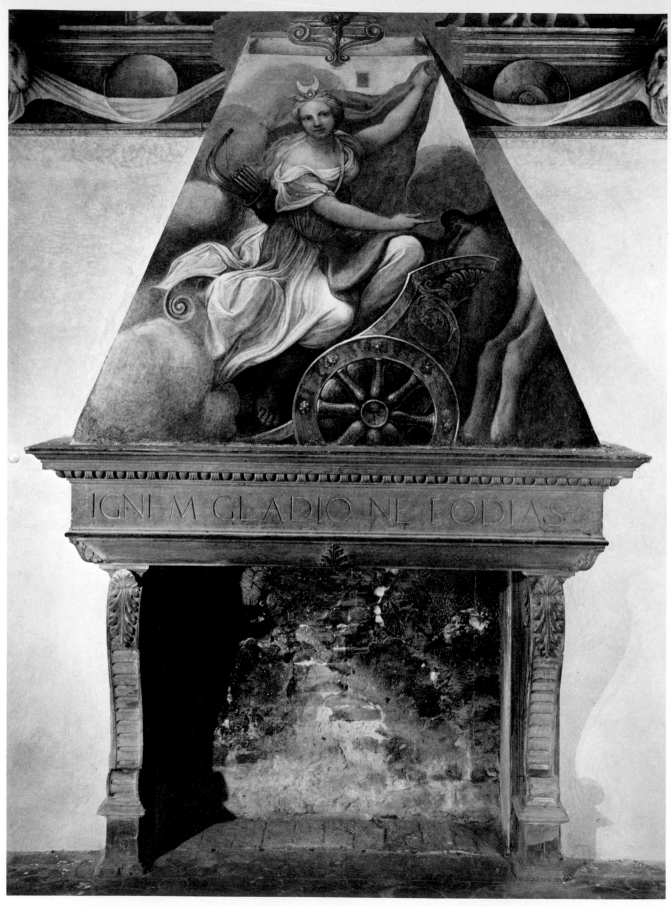

33
Diana in her Chariot. Camera di S. Paolo, chimney-piece, after 1972 restoration
Parma. See page 51

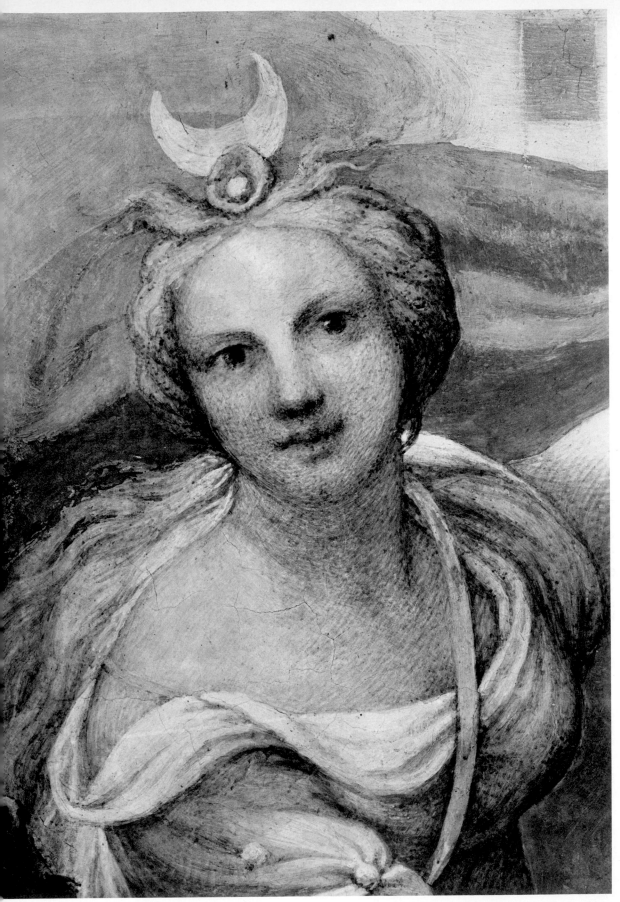

34

Chimney-piece fresco. Camera di S. Paolo. *Parma*. Detail

35

Camera di S. Paolo. Lunette E3, after 1972 restoration
Parma. See page 51

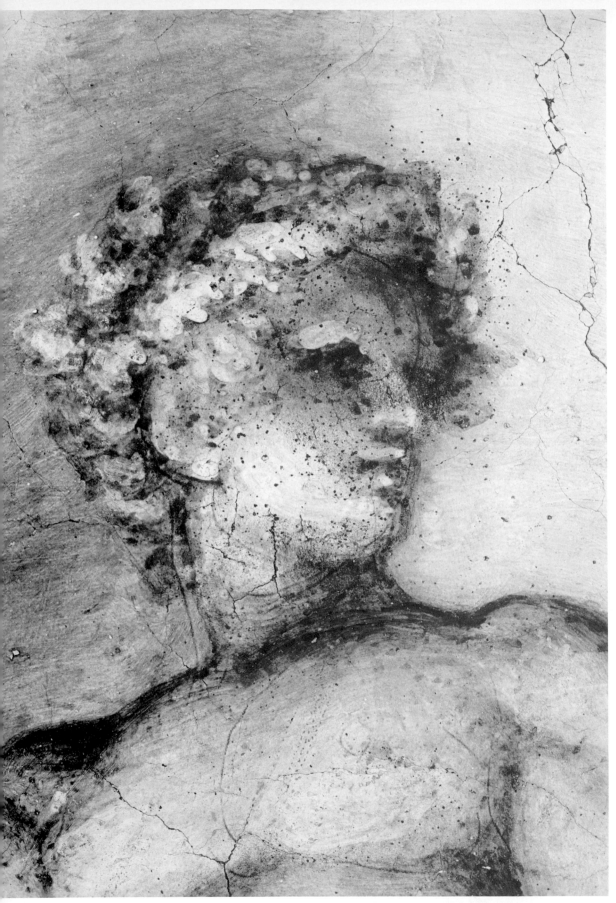

36

Camera di S. Paolo. Lunette N4, after 1972 restoration. Detail
(Approximately actual size.) *Parma. See page 51*

37A

Detail of still life, after 1972 restoration. Camera di S. Paolo. *Parma.*
See page 51

37B–C
Studies for east wall, Camera di S. Paolo
B. *London, British Museum (Popham 8). See page 51*
C. *London, British Museum (Popham 9). See page 51*

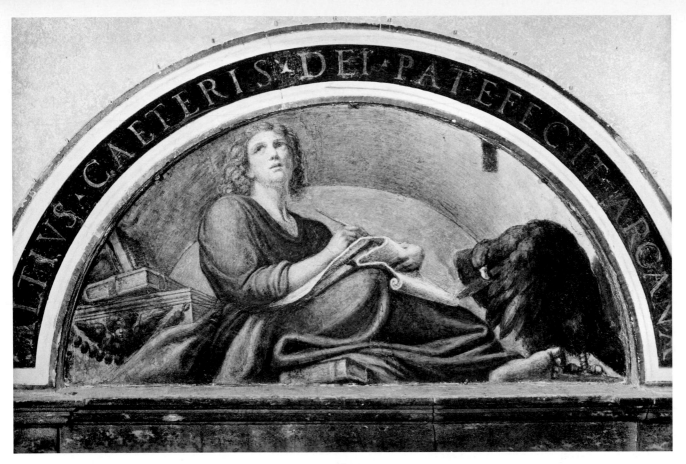

38A
St. John the Evangelist writing his Gospel (lunette)
Parma, S. Giovanni Evangelista. See page 63

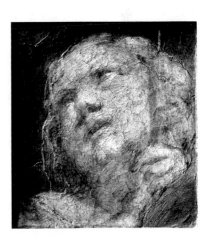

38B–D
Fragments from the apse of S. Giovanni Evangelista
B. Two angels on the left
C. Head of an angel reclining at the feet of St. John, left
D. Angel holding the crozier, left
London, National Gallery. See page 63

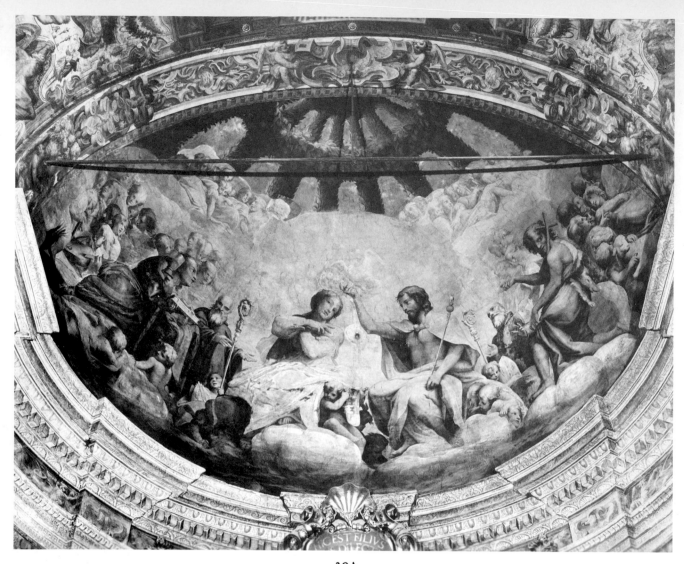

39A

CESARE ARETUSI, The Coronation of the Virgin. Copy of Correggio's S. Giovanni Evangelista apse fresco
Parma, S. Giovanni Evangelista. See page 63

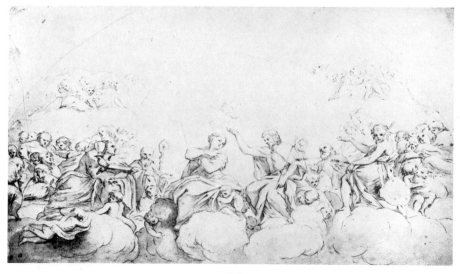

39B

Sketch copy after Correggio's apse fresco at S. Giovanni Evangelista
Florence, Uffizi

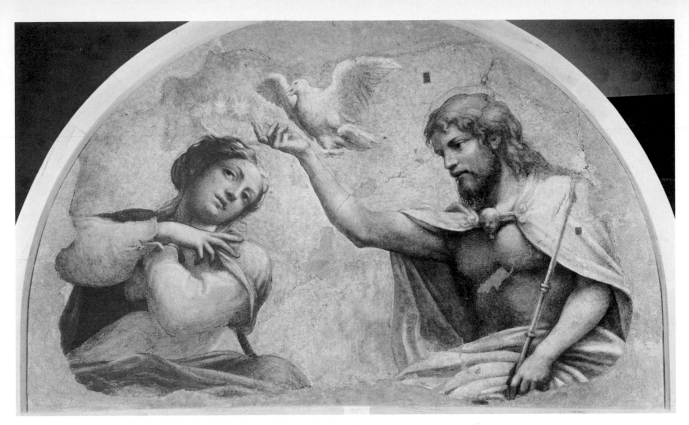

40A

The Coronation of the Virgin. Centre fragment of S. Giovanni Evangelista apse fresco
Parma, Galleria Nazionale. See page 63

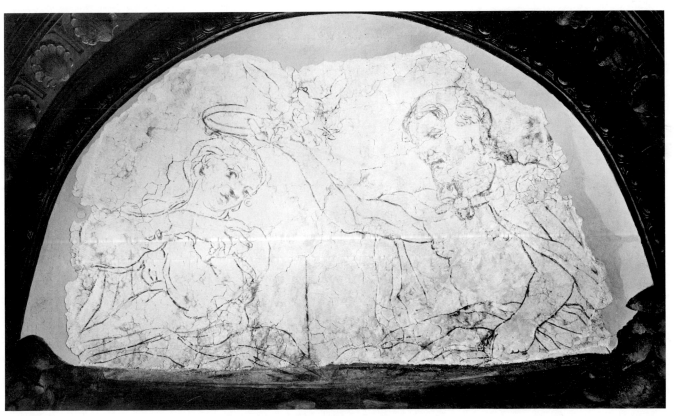

40B

Sinopia of centre fragment of apse fresco
Parma, Biblioteca Palatina

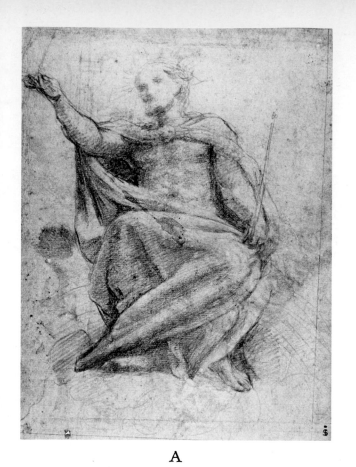

A

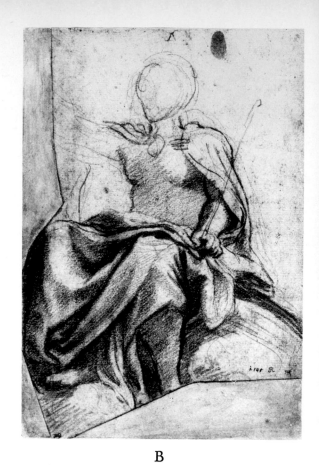

B

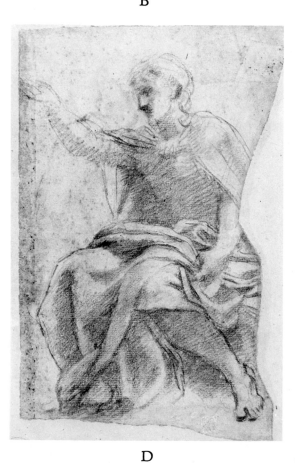

C

D

41

Studies for Christ in the S. Giovanni Evangelista apse fresco. *See page 63*

A. *Oxford, Ashmolean (Popham 24r)* C. *Budapest*

B. *Paris, Louvre (Popham 25)* D. *Budapest*

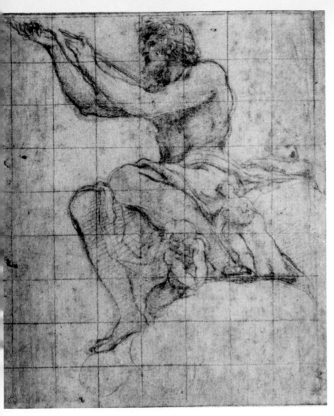

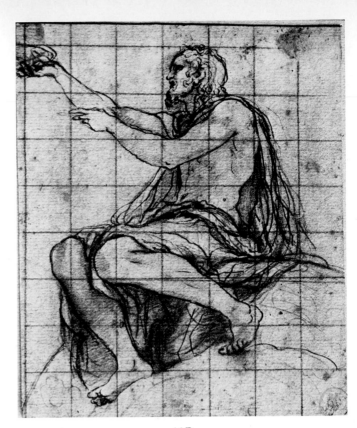

42A
Study for Christ in the S. Giovanni Evangelista
apse fresco
London, Seilern collection. See page 63

42B
Study for Christ in the S. Giovanni Evangelista
apse fresco
Poitiers (Popham 23)

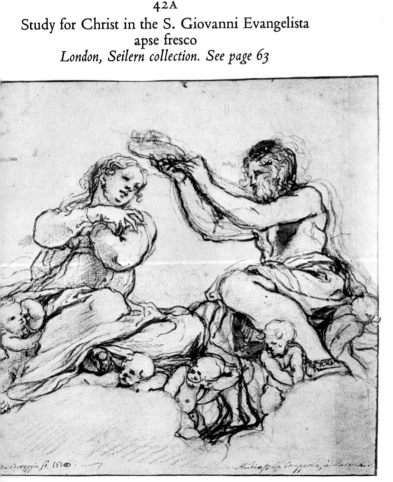

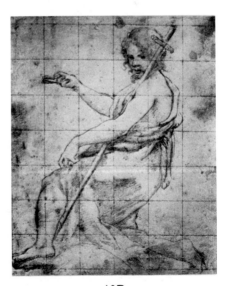

42D
Study for the Baptist in the S. Giovanni
Evangelista apse fresco
*Ince Blundell Hall, Colonel Weld collection
(Popham 27). See page 63*

42C
Study for Christ and the Virgin in the
S. Giovanni Evangelista apse fresco
Rotterdam (Popham 22). See page 63

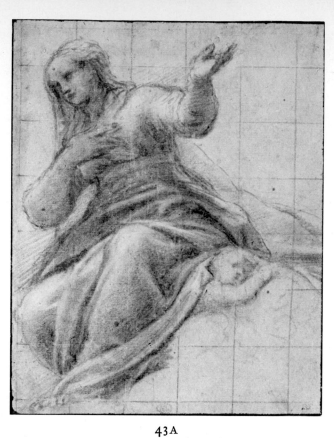

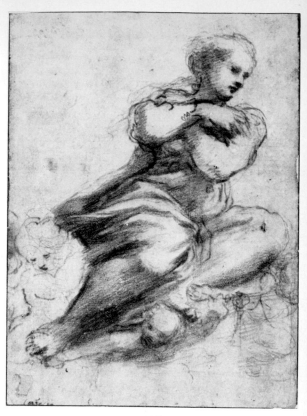

43A

(?) Study for the Virgin in the S. Giovanni
Evangelista apse fresco
Paris, Louvre (Popham 29). See page 63

43B

Study for the Virgin in the S. Giovanni
Evangelista apse fresco
Paris, Louvre (Popham 26)

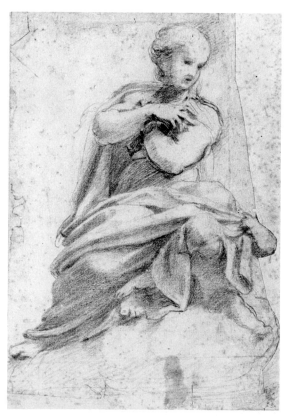

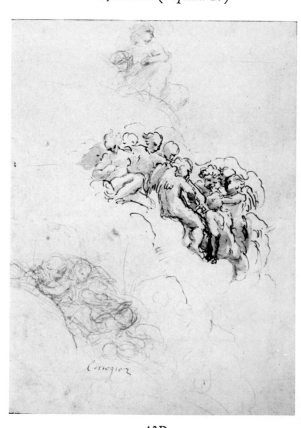

43C

Study for the Virgin in the S. Giovanni
Evangelista apse fresco
Budapest

43D

Study for background angels in the S. Giovanni
Evangelista apse fresco
Paris, Louvre (Popham 28r)

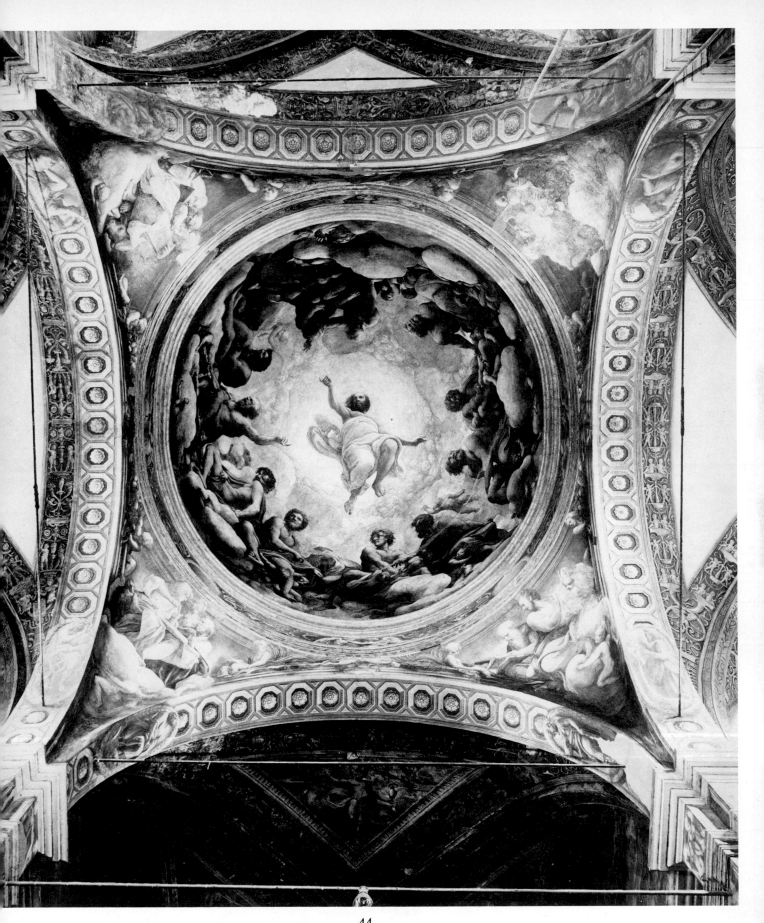

44
The Vision of St. John on Patmos of the Risen Christ and the other Apostles
Cupola and pendentives, S. Giovanni Evangelista
Parma. See page 67

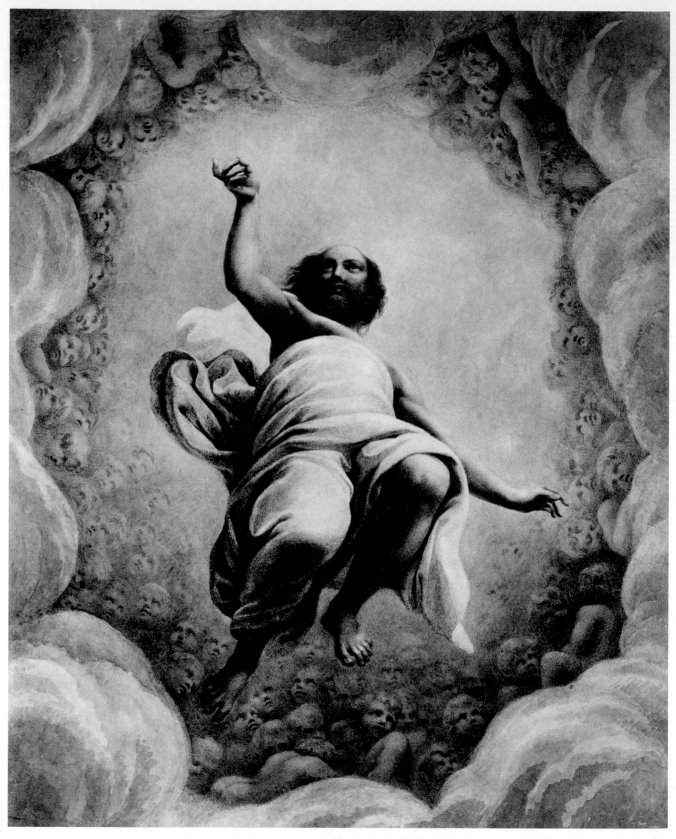

45

P. TOSCHI, copy of Christ. Centre of cupola, S. Giovanni Evangelista
Parma, Galleria Nazionale. See page 67

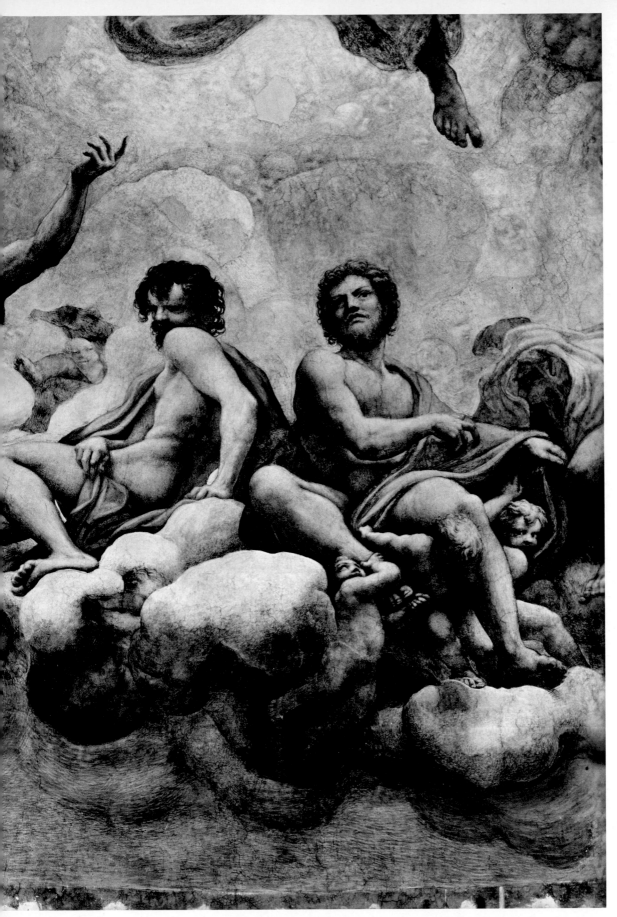

46

Apostles, from cupola of S. Giovanni Evangelista. *Parma. See page 67*

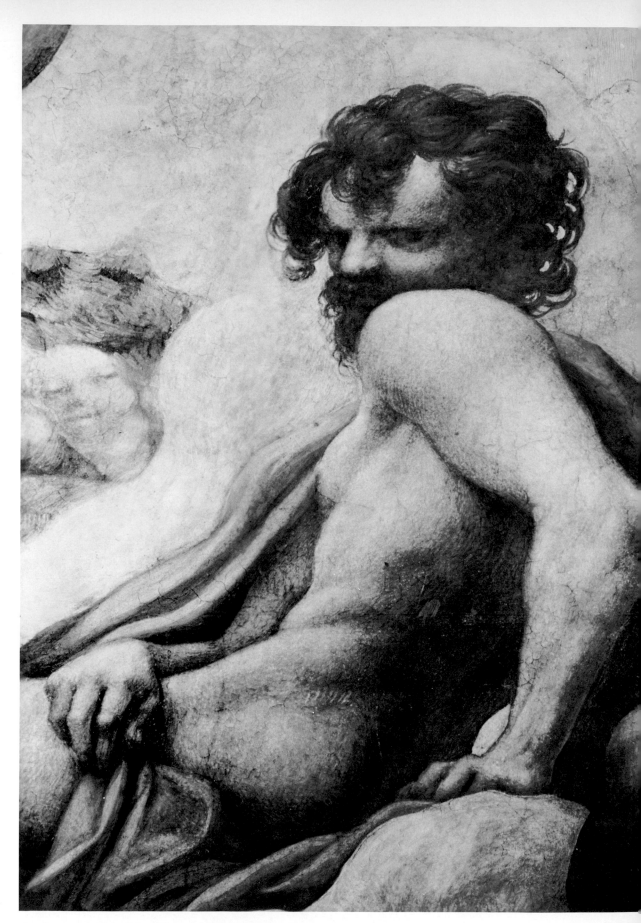

47

Apostle, from cupola of S. Giovanni Evangelista. *Parma. See page 67*

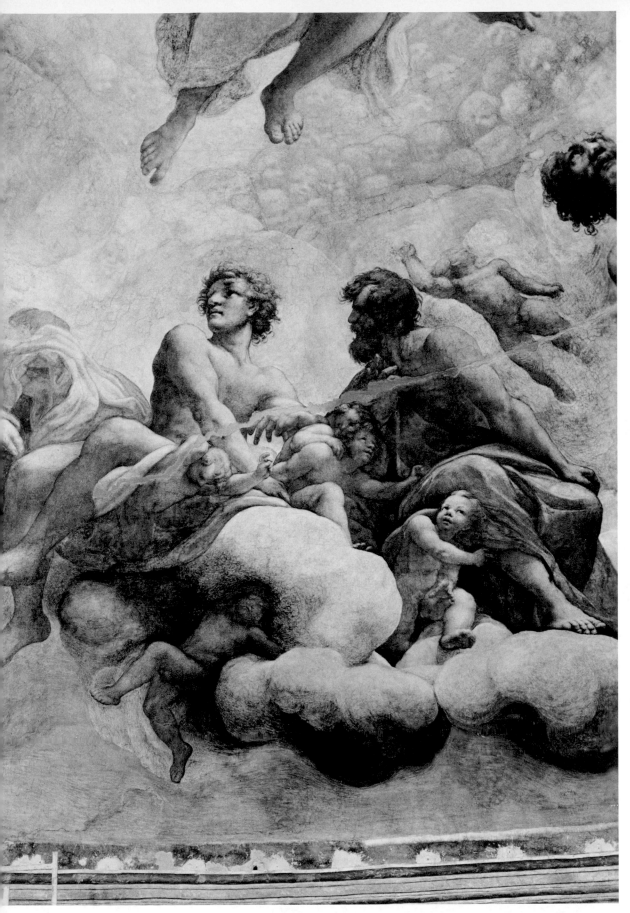

48

Apostles, from cupola of S. Giovanni Evangelista. *Parma. See page 67*

49A
Study for apostle, for S. Giovanni Evangelista cupola
Paris, Louvre (Popham 12). See page 67

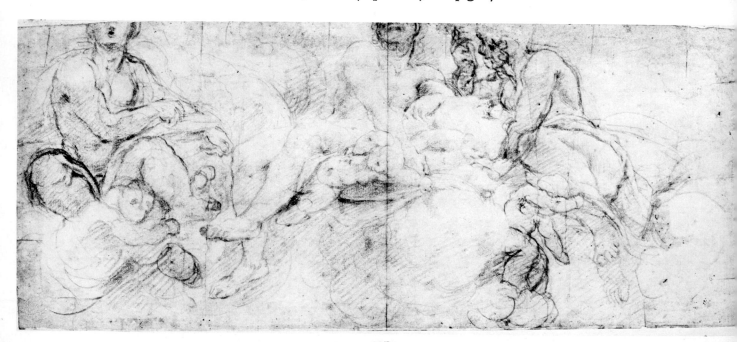

49B
Study for apostles, for S. Giovanni Evangelista cupola
Berlin (Popham 13r)

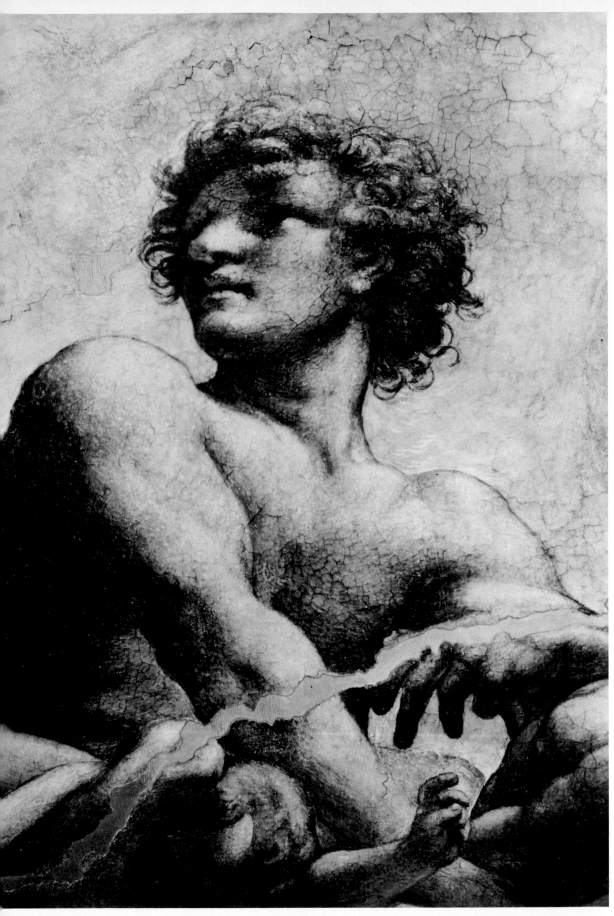

50

Apostle, from cupola of S. Giovanni Evangelista. *Parma. See page 67*

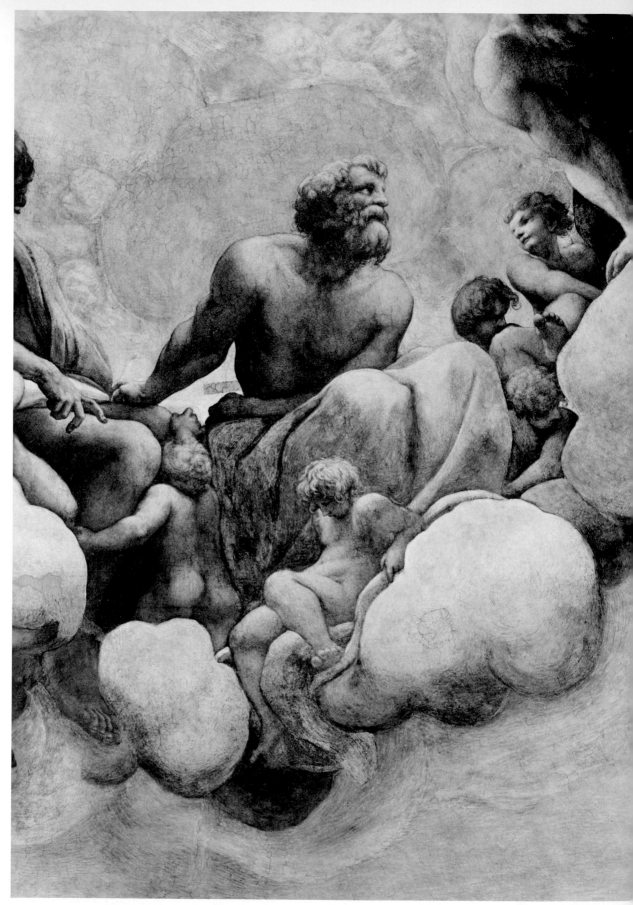

51

Apostle, from cupola of S. Giovanni Evangelista. *Parma. See page 67*

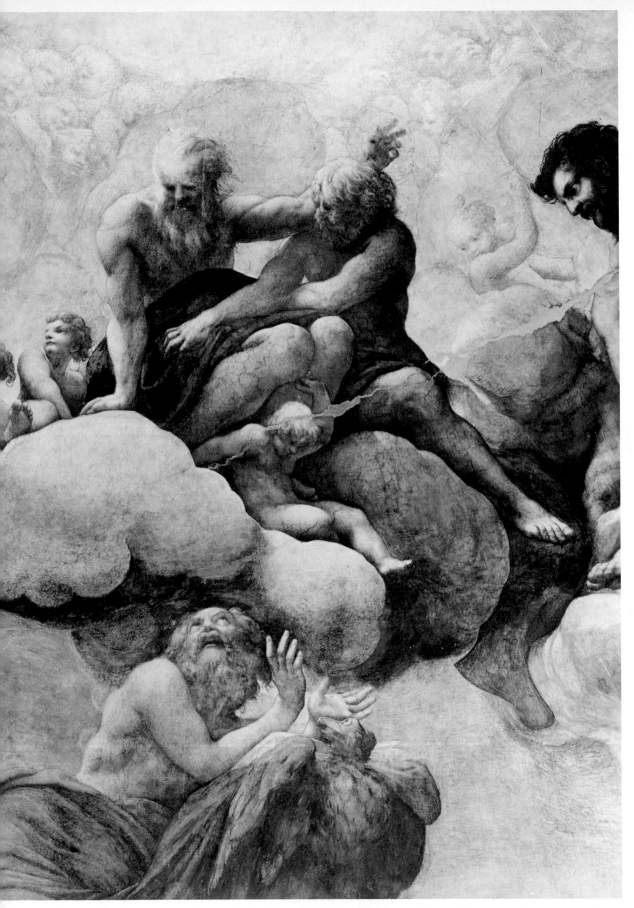

52

Apostles, from cupola of S. Giovanni Evangelista. *Parma. See page 67*

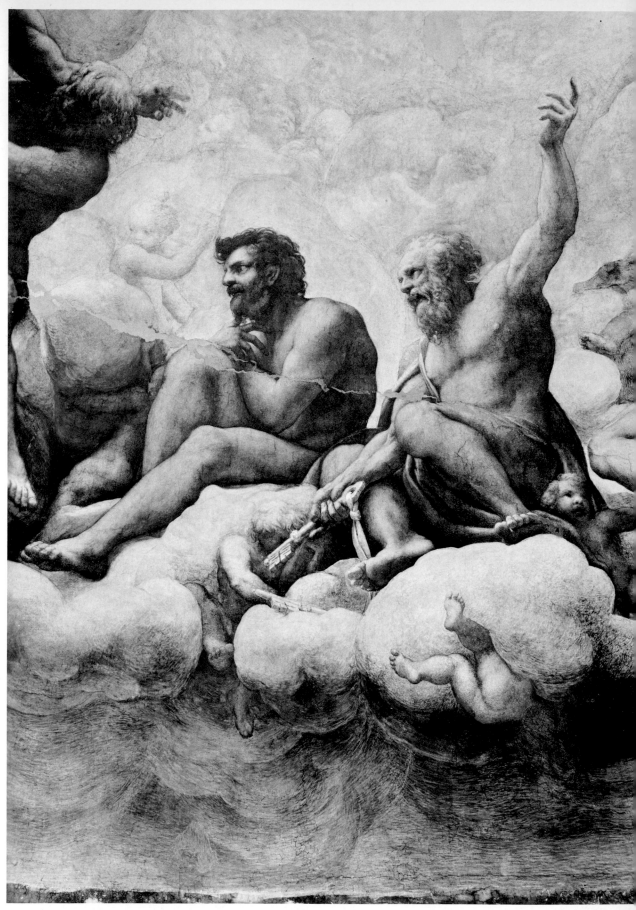

53
Apostles, from cupola of S. Giovanni Evangelista. *Parma. See page 67*

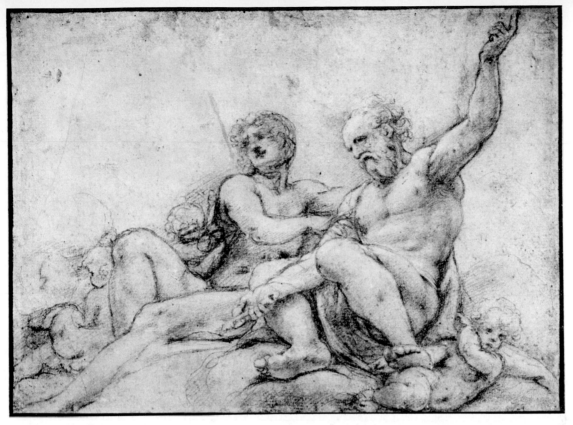

A

B

C

54

Studies for apostles, for cupola of S. Giovanni Evangelista
A. *Paris, Louvre (Popham 14)*
B. *Düsseldorf*
C. *Vienna, Albertina (Popham 11)*
See page 67

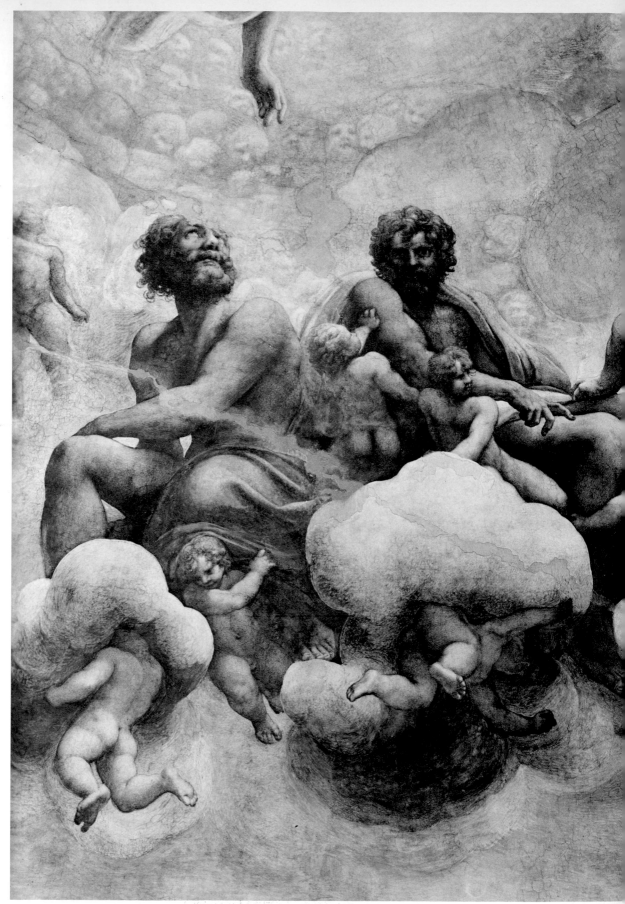

55

Apostles, from cupola of S. Giovanni Evangelista. *Parma. See page 67*

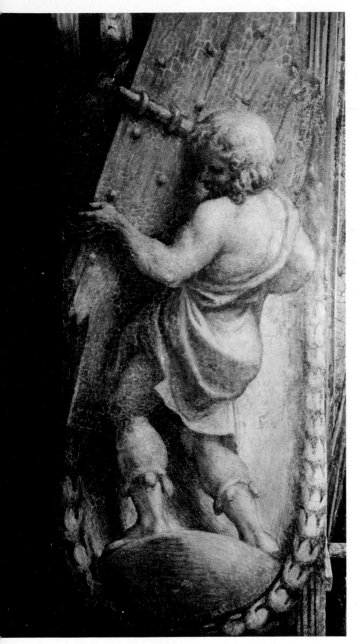

56A
Samson
South-west pier, S. Giovanni Evangelista
Parma. See page 67

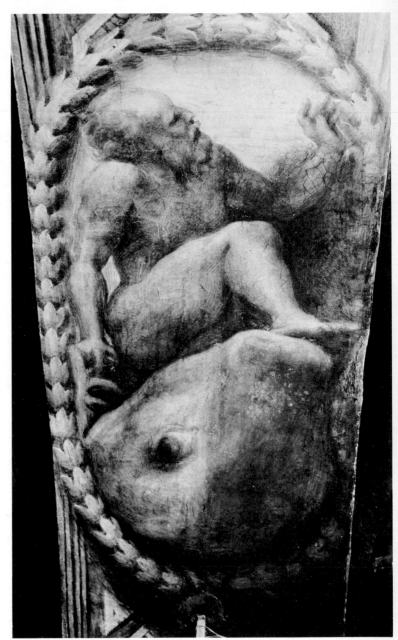

56B
Jonah
South-west pier, S. Giovanni Evangelista
Parma. See page 67

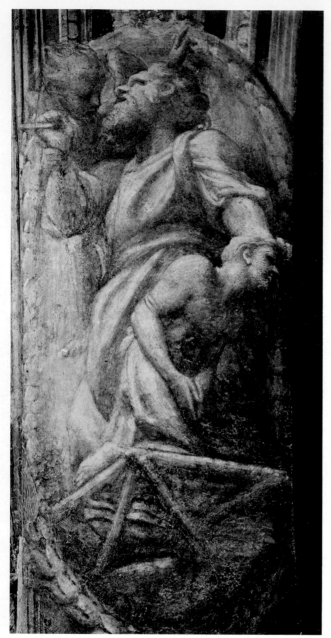

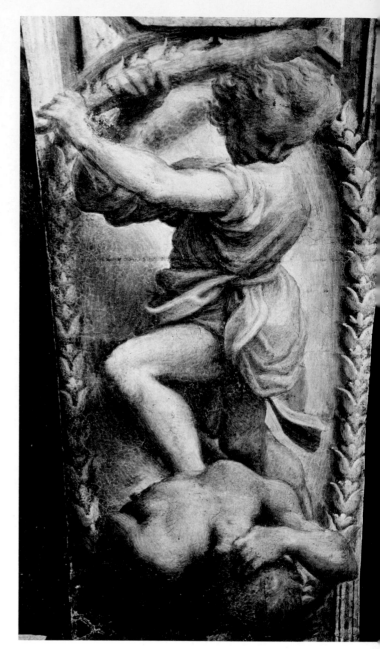

57A
The Sacrifice of Isaac
South face of north-west pier, S. Giovanni Evangelista
Parma. See page 67

57B
Cain and Abel
East face of north-west pier, S. Giovanni Evangelista
Parma. See page 67

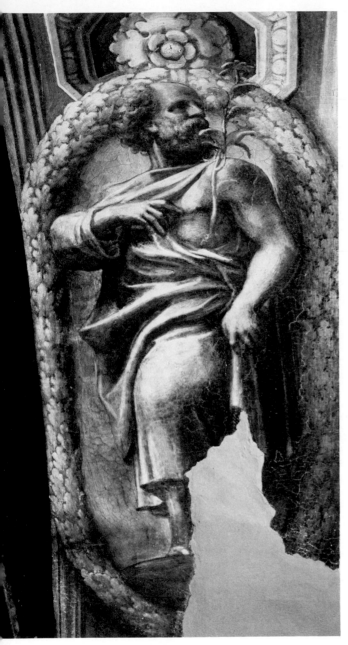

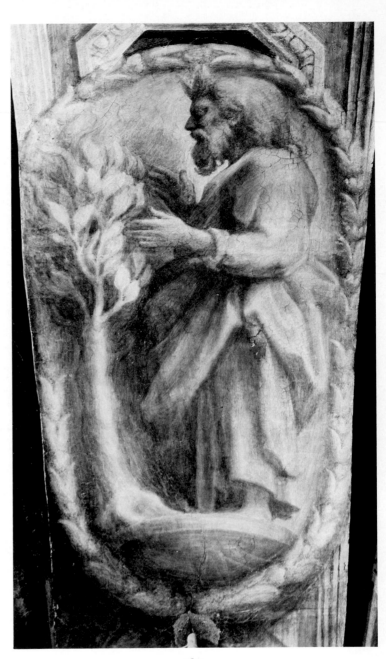

58A
Aaron
South-east pier, S. Giovanni Evangelista
Parma. See page 67

58B
Moses
South-east pier, S. Giovanni Evangelista
Parma. See page 67

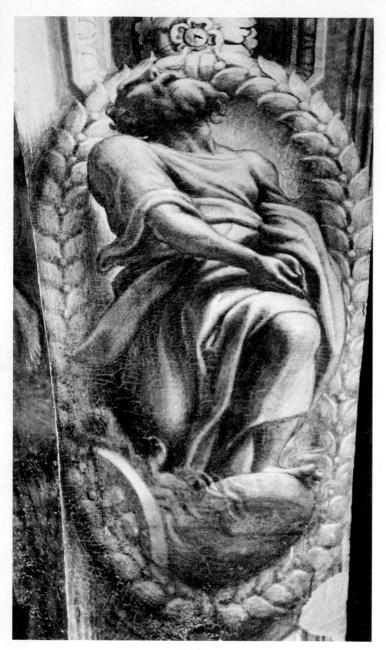

59A
Elijah
North-east pier, S. Giovanni Evangelista
Parma. See page 67

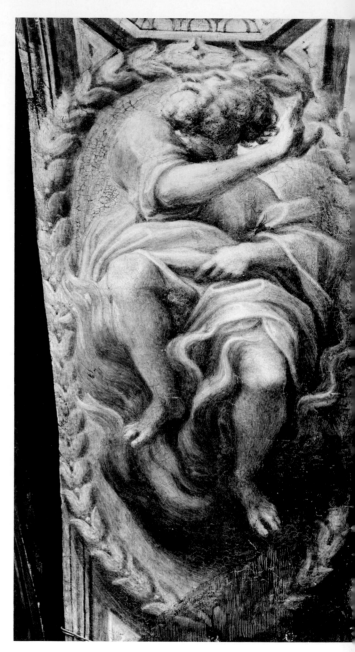

59B
Daniel (or Enoch)
North-east pier, S. Giovanni Evangelista
Parma. See page 67

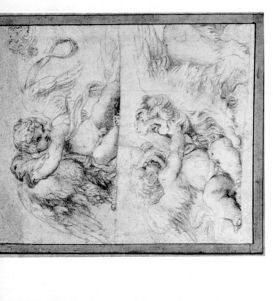

60B

Studies for frieze of the drum
Paris, Louvre (Popham 16)

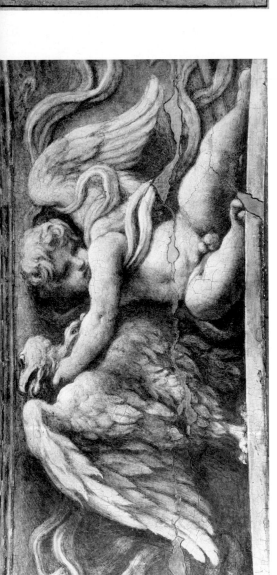

60A

Frieze of drum of the cupola, S. Giovanni Evangelista
Parma. See page 75

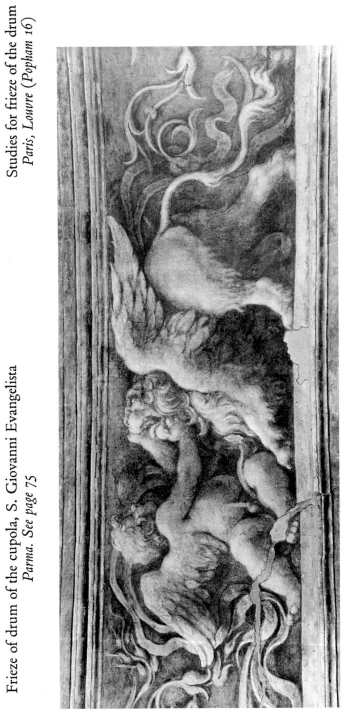

60C

Frieze of drum of the cupola, S. Giovanni Evangelista. *Parma. See page 75*

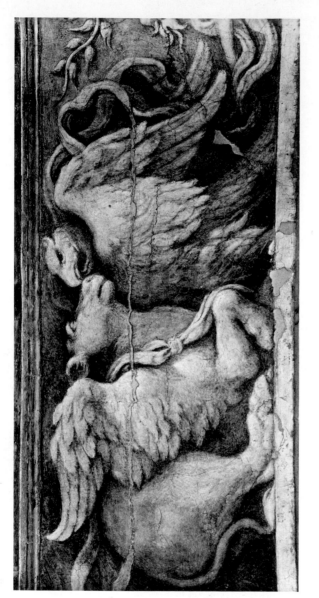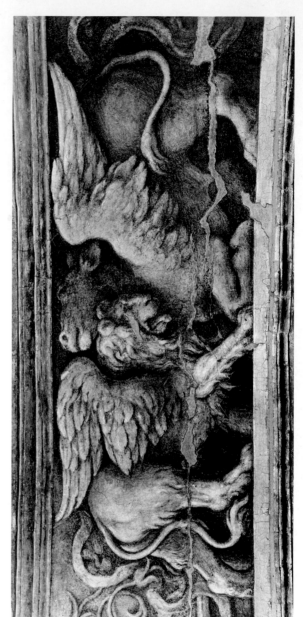

Frieze of drum of the cupola, S. Giovanni Evangelista
Parma. See page 75

62A

Frieze of the nave (south wall, sixth bay from
west)
S. Giovanni Evangelista
Parma. See page 75

62B

Study for prophet for frieze (left of bay)
Frankfurt (Popham 36r)

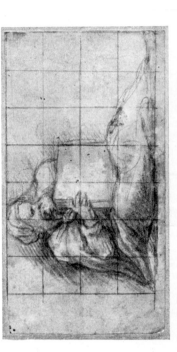

62C

Frieze of the nave (south wall,
fifth bay from west)

62D

Study for prophet for frieze (left of bay)
Rotterdam (Popham 35)

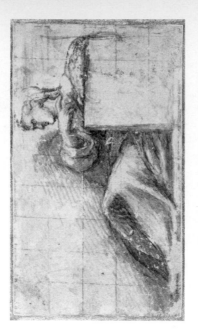

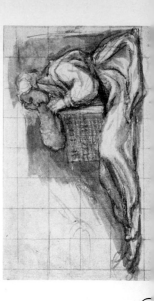

63A

Frieze of the nave (south wall, fourth bay from
west)
S. Giovanni Evangelista
Parma. See page 75

63B
Study for sibyl for frieze (right of bay)
Rotterdam (Popham 32)

63C
Frieze of the nave (south wall,
third bay from west)

63D
Study for sibyl for frieze (right of bay)

64A–B
Frieze of the nave (south wall; A, second bay from
west; B, first bay from west)
S. Giovanni Evangelista
Parma. See page 75

64C
Study for prophet for frieze (left of bay)
Rotterdam (Popham 34)

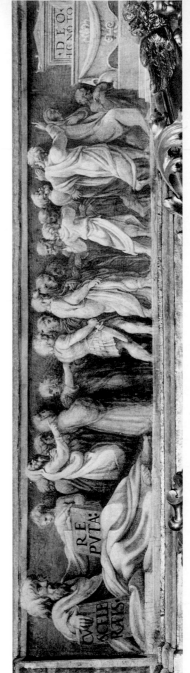

64D
Frieze of the nave (west wall, left half)

65A

Frieze of the nave (west wall, right half)
S. Giovanni Evangelista
Parma. See page 75

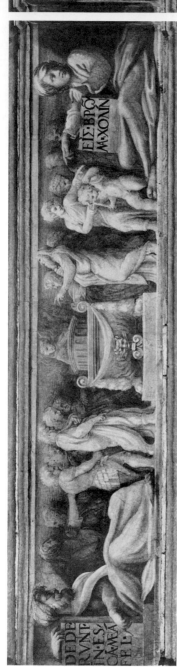

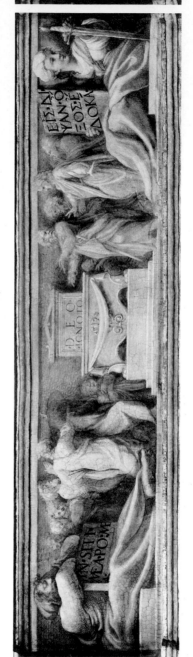

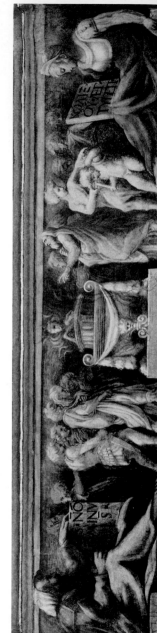

65B–D

Frieze of the nave (north wall; B, first bay;
C, second bay; D, third bay from west)

Study for prophet for frieze of nave (left of bay),
S. Giovanni Evangelista
Frankfurt (Popham 37)

66B–D
Frieze of the nave (north wall; B, fourth bay;
c, fifth bay; D, sixth bay from west)
S. Giovanni Evangelista
Parma. See page 75

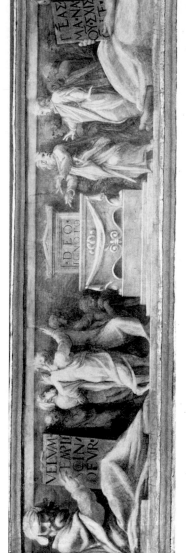

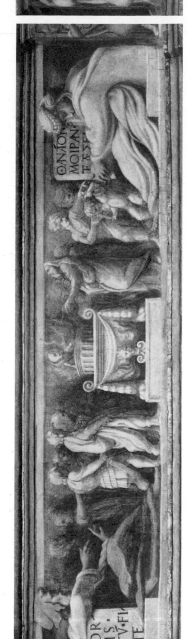

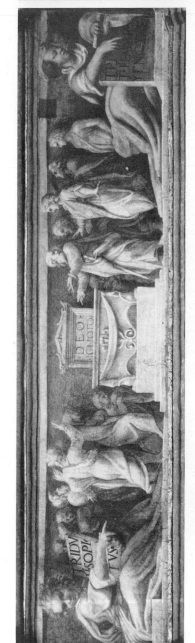

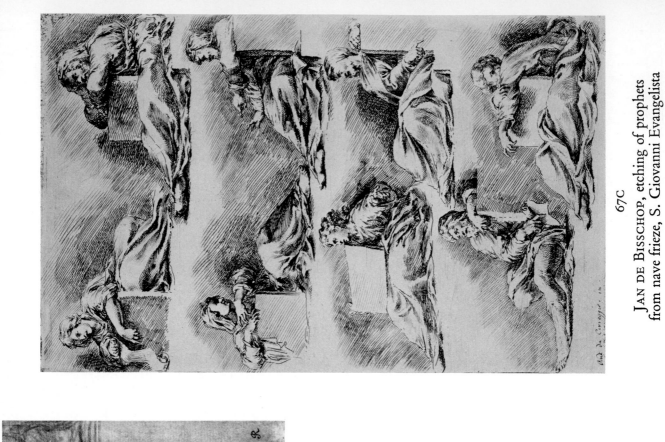

67C

JAN DE BISSCHOP, etching of prophets
from nave frieze, S. Giovanni Evangelista

67A

Study for nave frieze, S. Giovanni Evangelista
London, British Museum (Popham 30). See page 75

67B

Studies for nave frieze, S. Giovanni Evangelista
London, British Museum (Popham 31r)

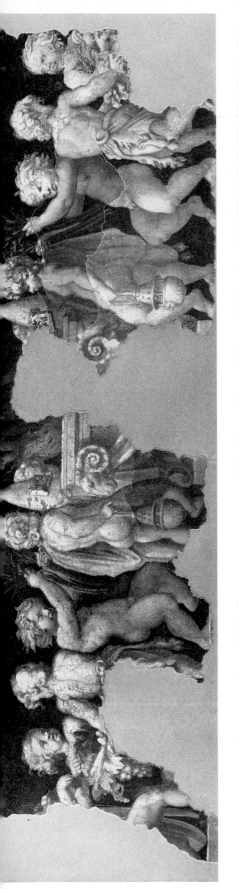

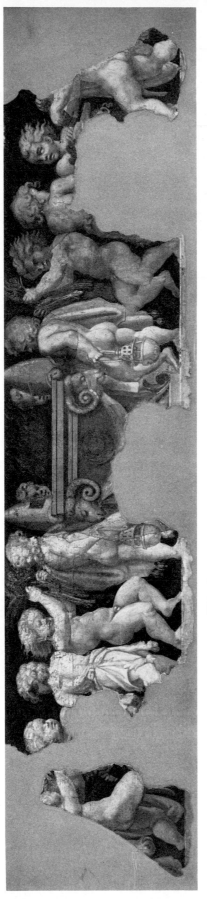

68A–B

Frieze of choir, S. Giovanni Evangelista
Parma. See page 74

68C→

Studies for choir frieze, S. Giovanni Evangelista
Paris, Louvre (Popham 28v)

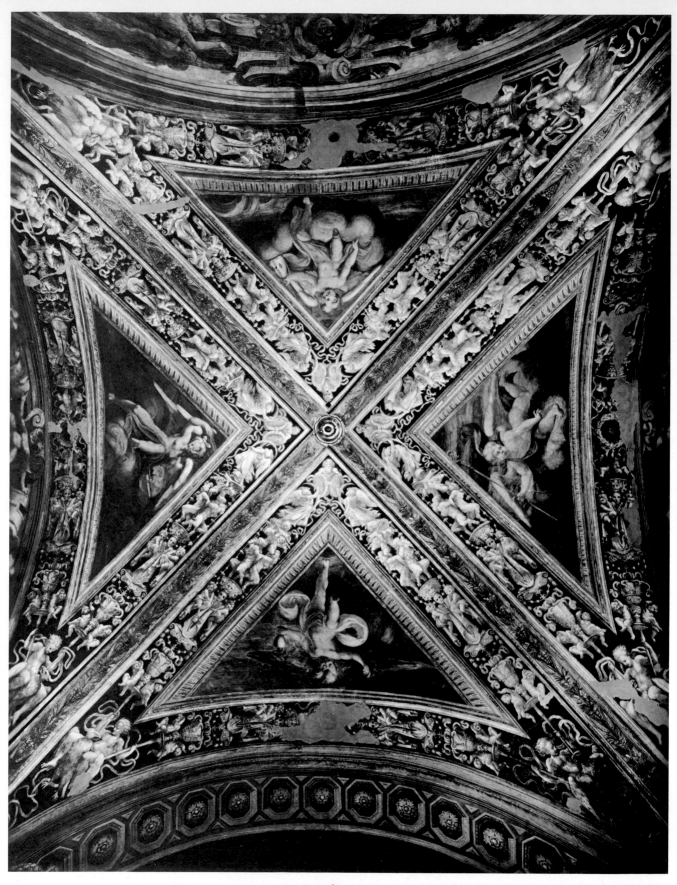

69

Choir vault, S. Giovanni Evangelista
(painting in triangular spaces post-Correggio)
Parma. See page 74

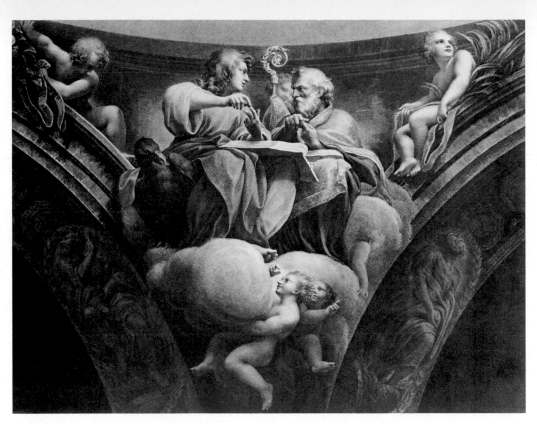

70A

P. Toschi, copy of St. John the Evangelist and St. Augustine
(north-east pendentive of S. Giovanni Evangelista)
Parma, Galleria Nazionale. See page 72

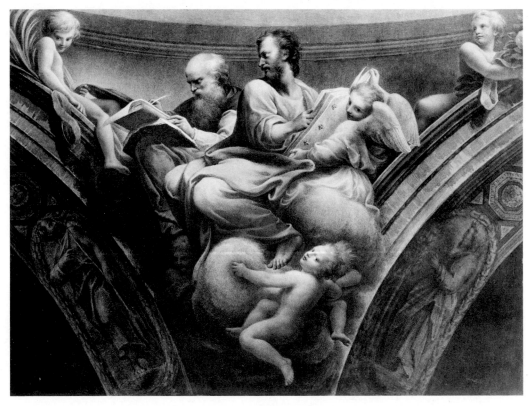

70B

P. Toschi, copy of Saints Jerome and Matthew
(south-east pendentive of S. Giovanni Evangelista)
Parma, Galleria Nazionale. See page 72

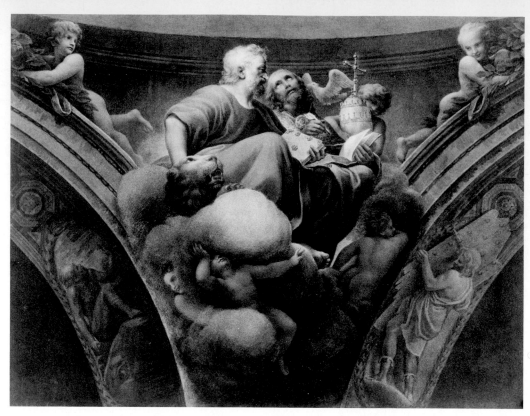

71A

P. TOSCHI, copy of Saints Mark and Gregory
(south-west pendentive of S. Giovanni Evangelista)
Parma, Galleria Nazionale. See page 72

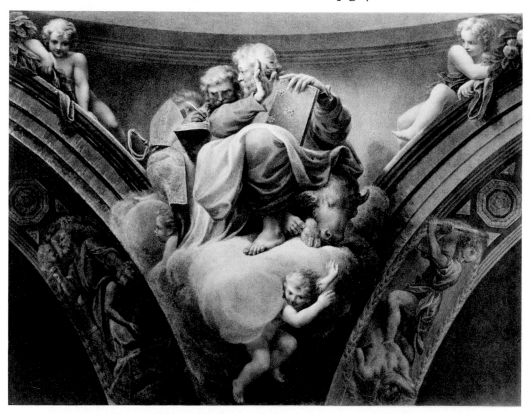

71B

P. TOSCHI, copy of Saints Ambrose and Luke
(north-west pendentive of S. Giovanni Evangelista)
Parma, Galleria Nazionale. See page 72

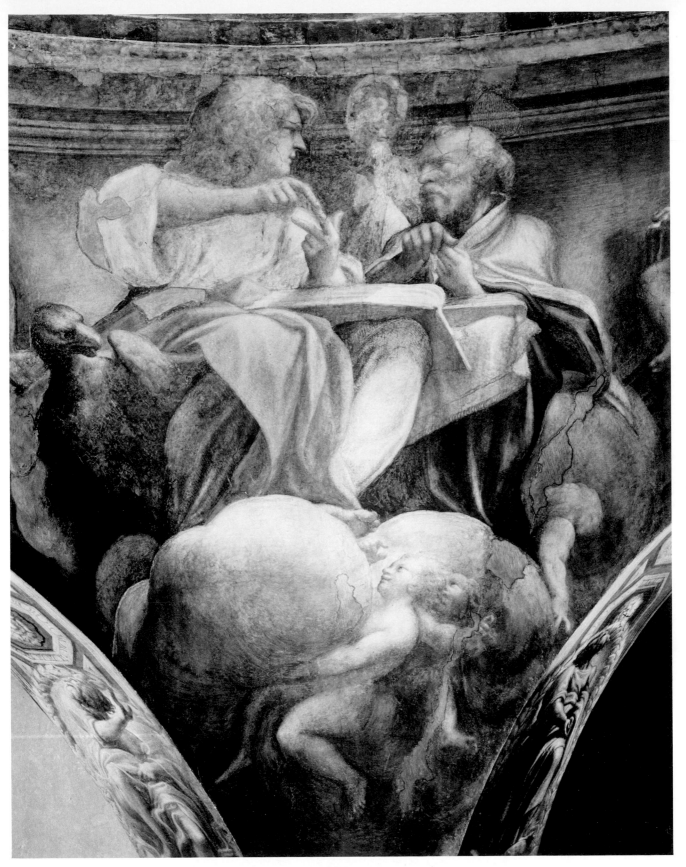

72
St. John the Evangelist and St. Augustine.
North-east pendentive, S. Giovanni Evangelista
Parma. See page 72

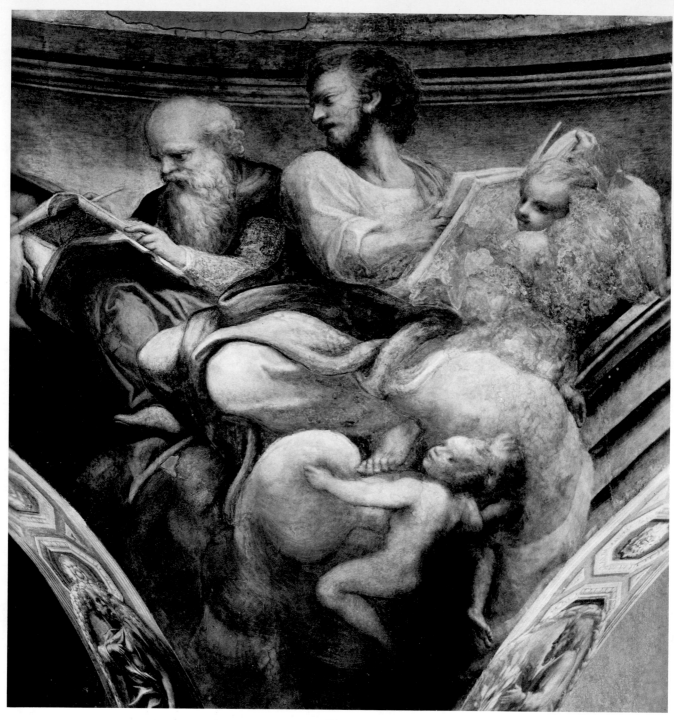

73
Saints Jerome and Matthew.
South-east pendentive, S. Giovanni Evangelista
Parma. See page 72

A

D

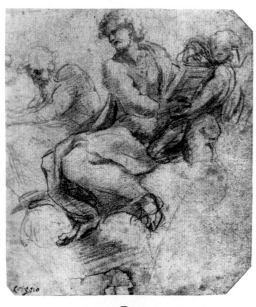

B

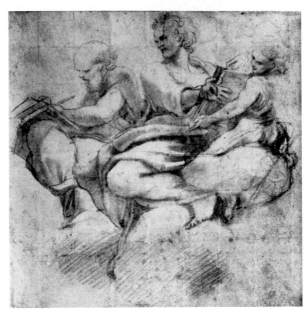

E

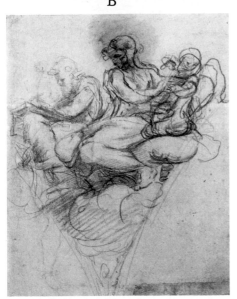

C

74
Studies for Saints Jerome and Matthew,
south-east pendentive, S. Giovanni Evangelista

A. *Dr A. Hammer*
B. *Munich (Popham 17)*
C. *London, British Museum (Popham 18r)*
D. *Florence, Uffizi (Popham 19)*
E. *Milan, Conte Rasini (Popham 20)*

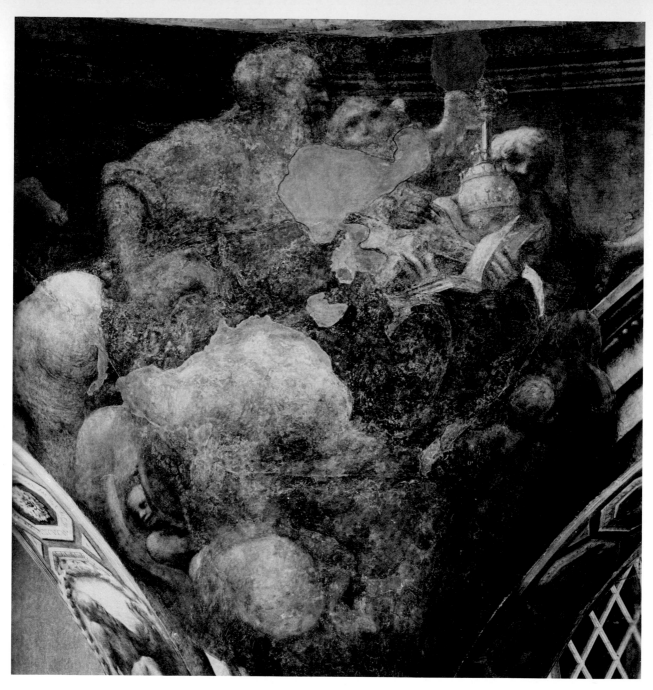

75A
Saints Mark and Gregory.
South-west pendentive, S. Giovanni Evangelista
Parma. See page 72

75B
Study for Saints Mark and Gregory
Paris, Louvre (Popham 21)

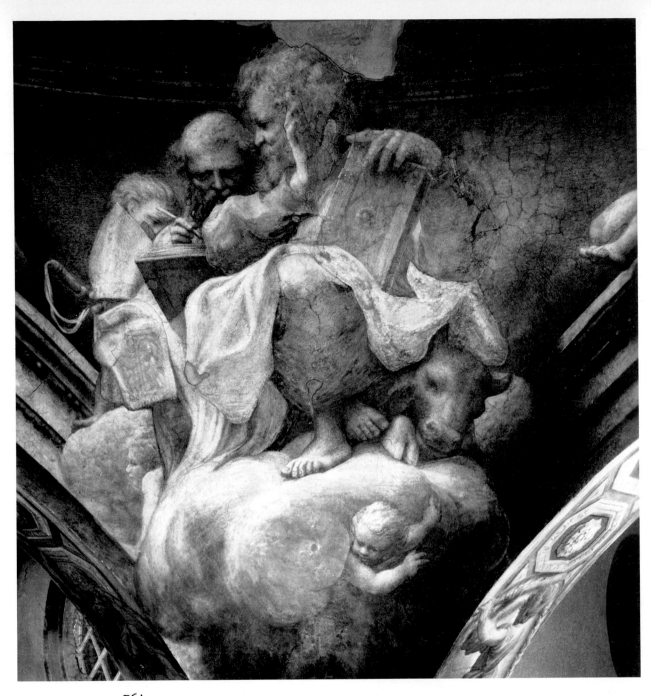

76A
Saints Ambrose and Luke.
North-west pendentive, S. Giovanni Evangelista
Parma. See page 72

76B
Study for putto who holds St. Jerome's hat,
south-east pendentive
Rotterdam (Popham 34v)

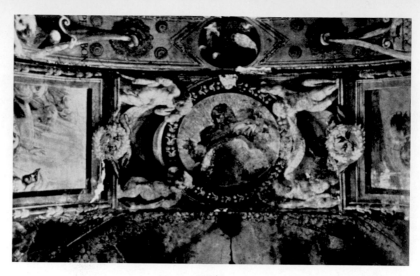

77A
Christ.
Arch of Del Bono Chapel, S. Giovanni Evangelista
Parma. See page 79

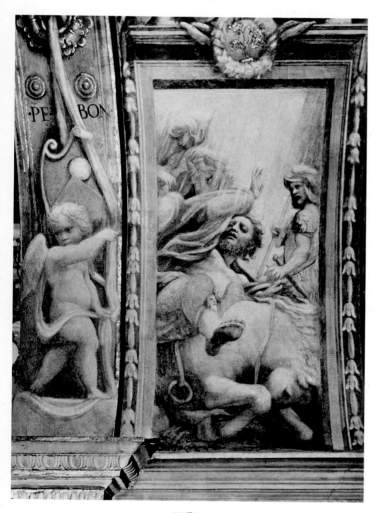

77B
The Conversion of Saul.
Arch of Del Bono Chapel, S. Giovanni
Evangelista
Parma. See page 79

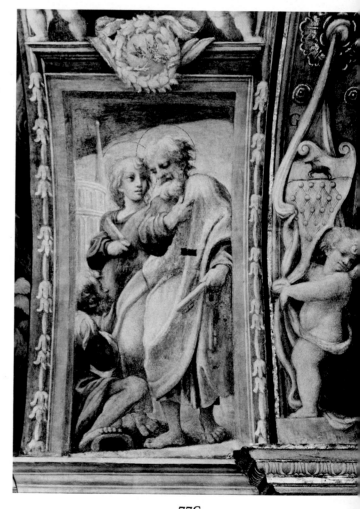

77C
Saints John and Peter healing the Cripple.
Arch of Del Bono Chapel, S. Giovanni
Evangelista
Parma. See page 79

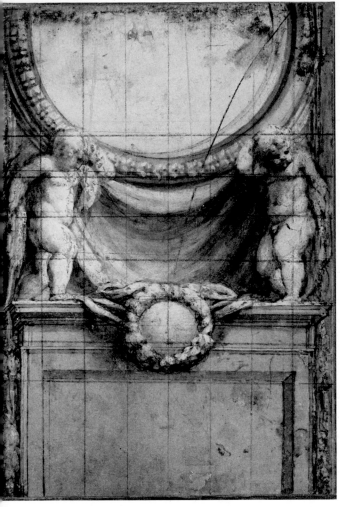

A

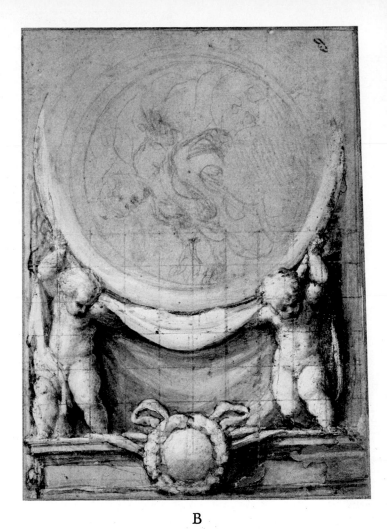

B

78
Studies for the arch of Del Bono Chapel,
S. Giovanni Evangelista
Chatsworth (Popham 45, 46 and 44). See page 79

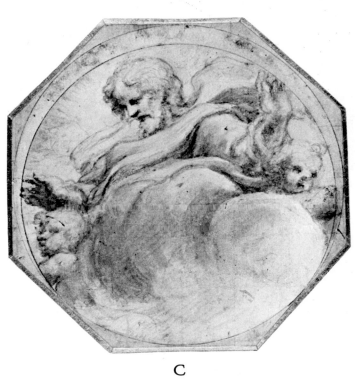

C

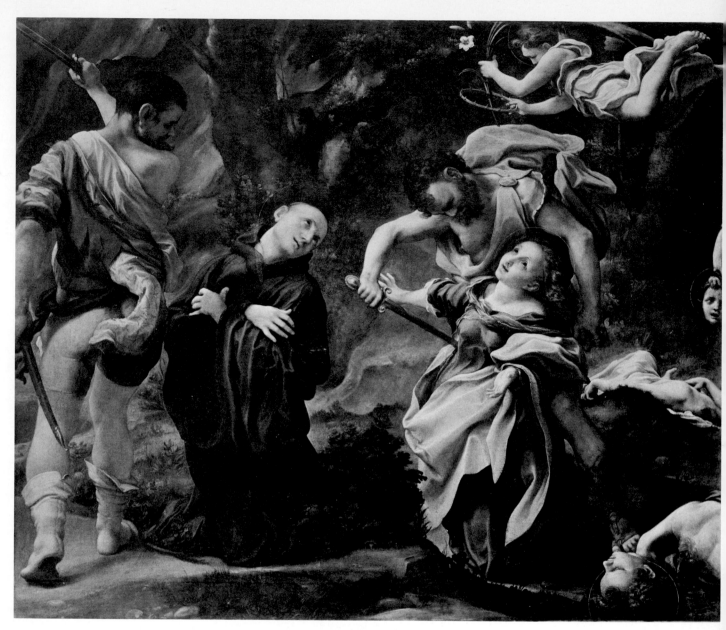

79
Martyrdom of Four Saints, from Del Bono Chapel,
S. Giovanni Evangelista
Parma, Galleria Nazionale. See page 81

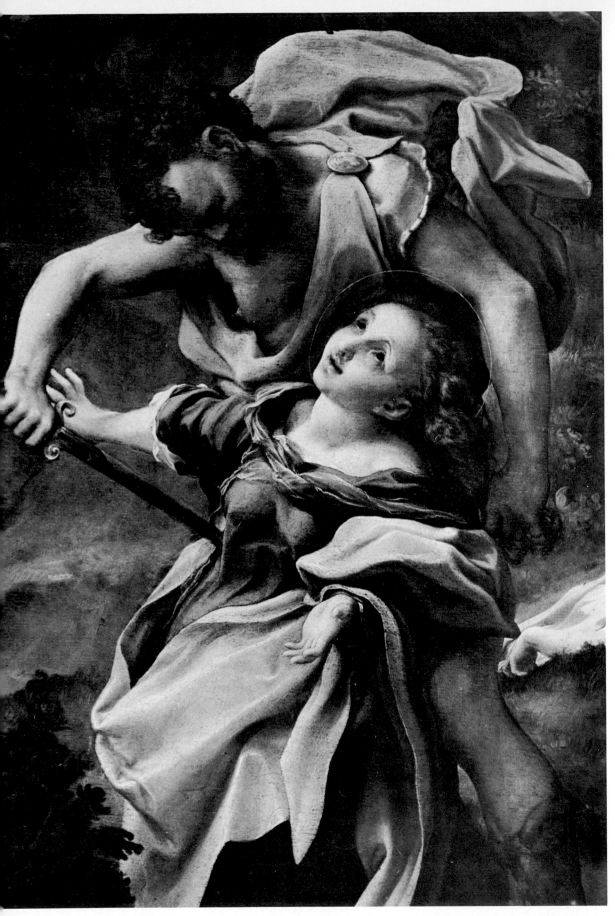

Martyrdom of Four Saints, from Del Bono Chapel, S. Giovanni Evangelista. Detail
Parma, Galleria Nazionale

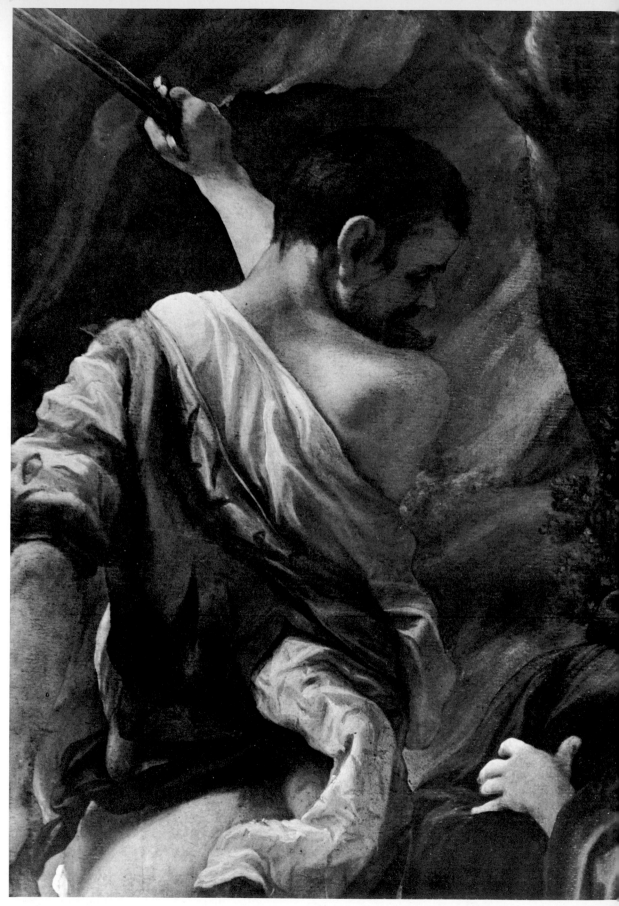

81

Detail of Martyrdom of Four Saints, from Del Bono Chapel, S. Giovanni Evangelista
Parma, Galleria Nazionale

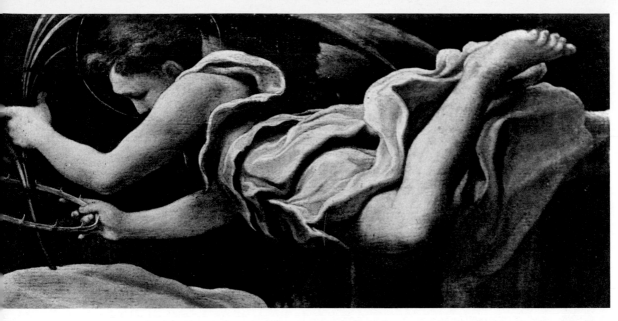

82A

Martyrdom of Four Saints, from Del Bono Chapel, S. Giovanni Evangelista. Detail
Parma, Galleria Nazionale

82B
Study for Martyrdom of Four Saints
Paris, Louvre (Popham 40). See page 81

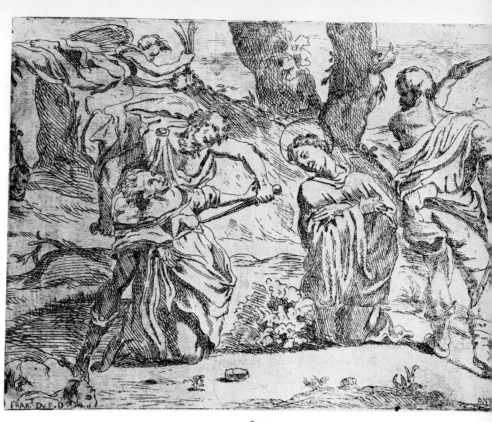

83C
FRANCESCO DUS, print after Del Bono
Martyrdom of Four Saints

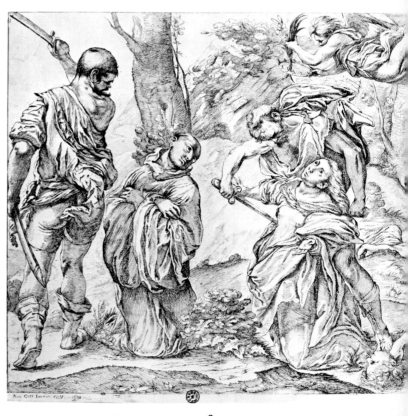

83 A–B
Studies for the Martyrdom of Four Saints
Paris, Louvre (Popham 41 and 42). See page 81

83D
G. B. VANNI, print after Del Bono
Martyrdom of Four Saints

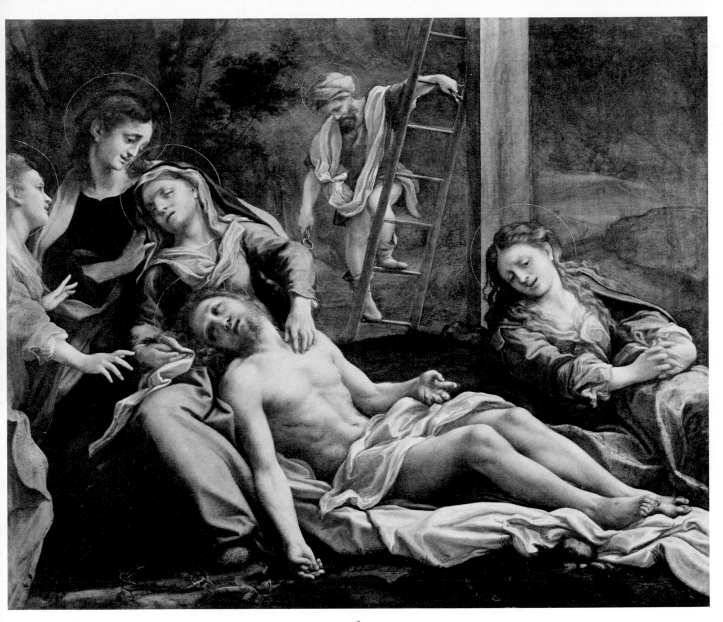

84
Lamentation from Del Bono Chapel, S. Giovanni Evangelista
Parma, Galleria Nazionale. See page 81

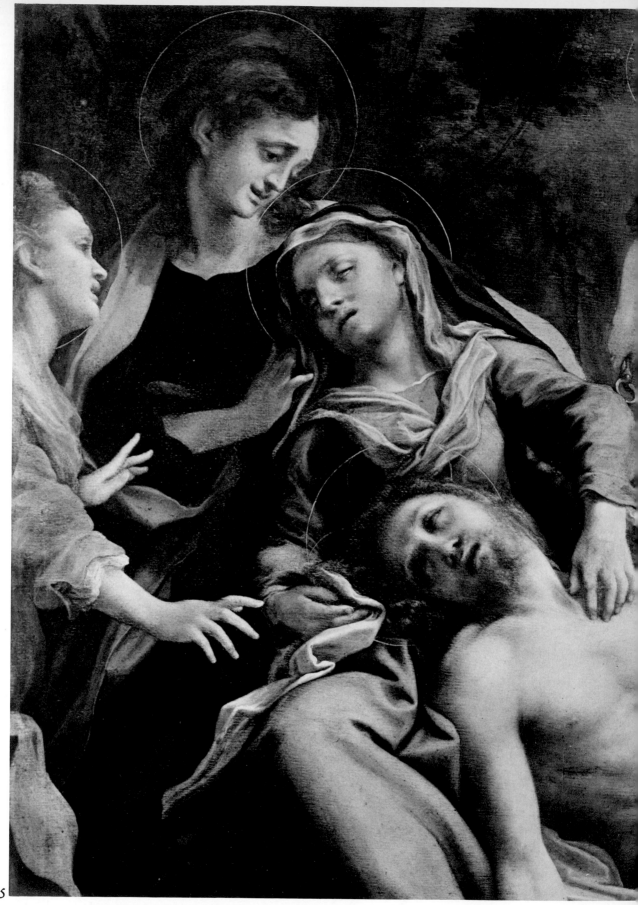

85

Detail of Lamentation from Del Bono Chapel, S. Giovanni Evangelista. *Parma, Galleria Nazionale*

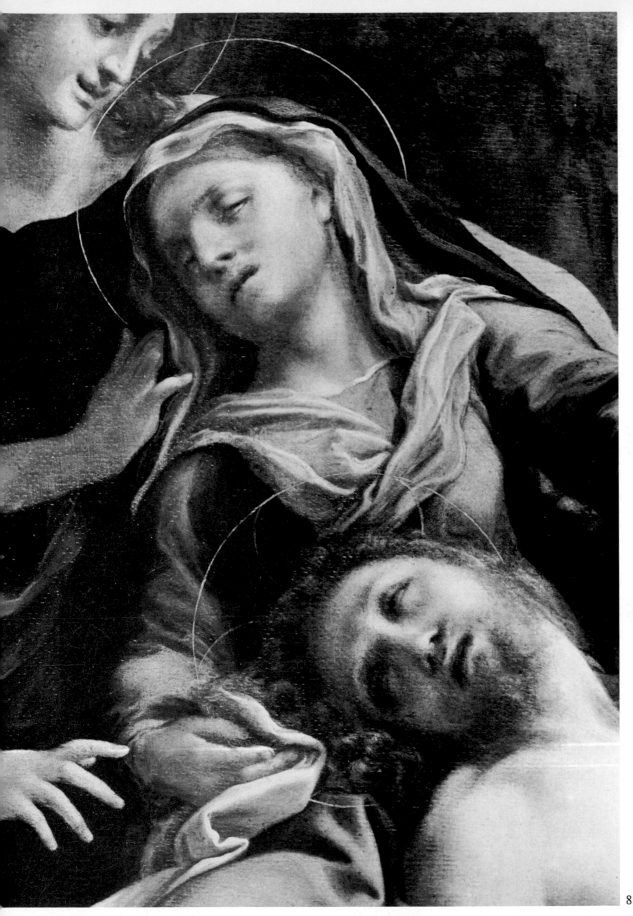

86

Lamentation from Del Bono Chapel, S. Giovanni Evangelista. *Parma, Galleria Nazionale*. Detail

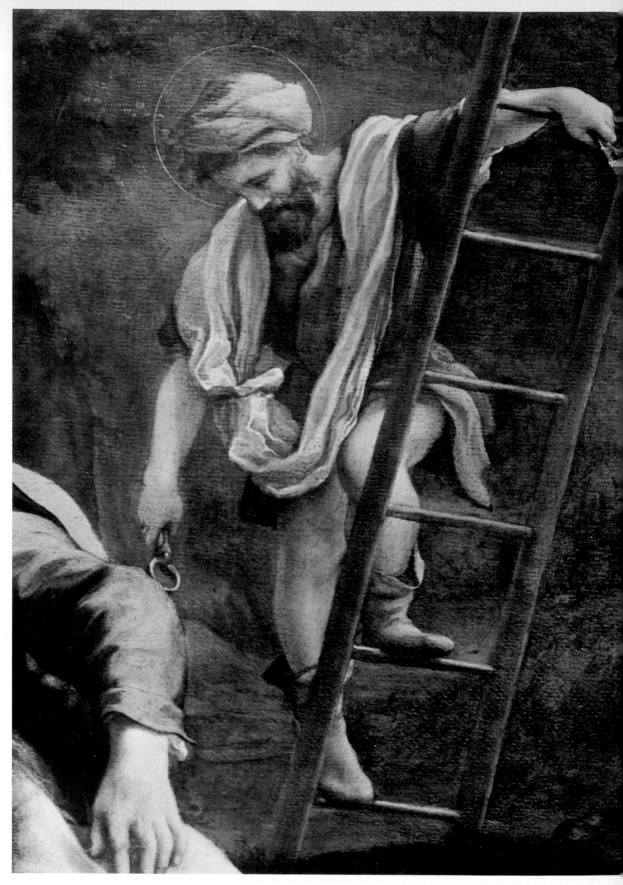

Detail of Lamentation from Del Bono Chapel, S. Giovanni Evangelista. *Parma, Galleria Nazionale*

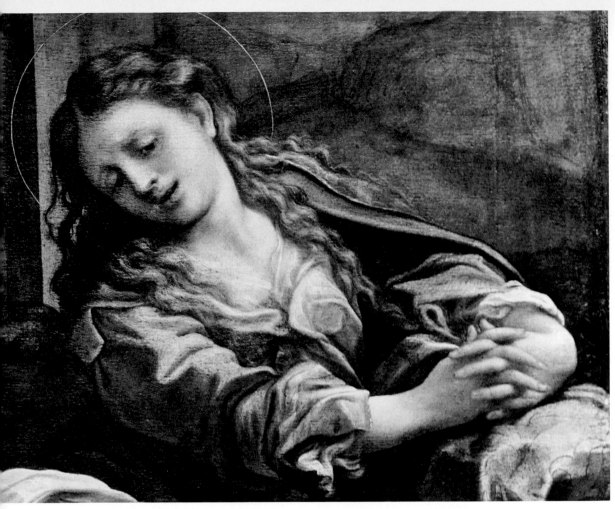

88A

Lamentation from Del Bono Chapel, S. Giovanni Evangelista. *Parma, Galleria Nazionale.* Detail

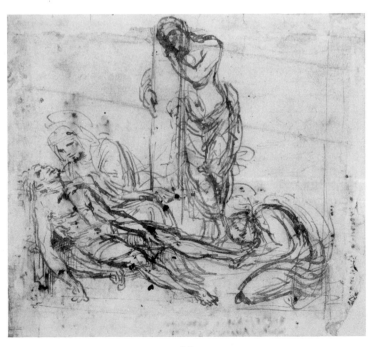

88B
Study for Lamentation
London, British Museum (Popham 43). See page 81

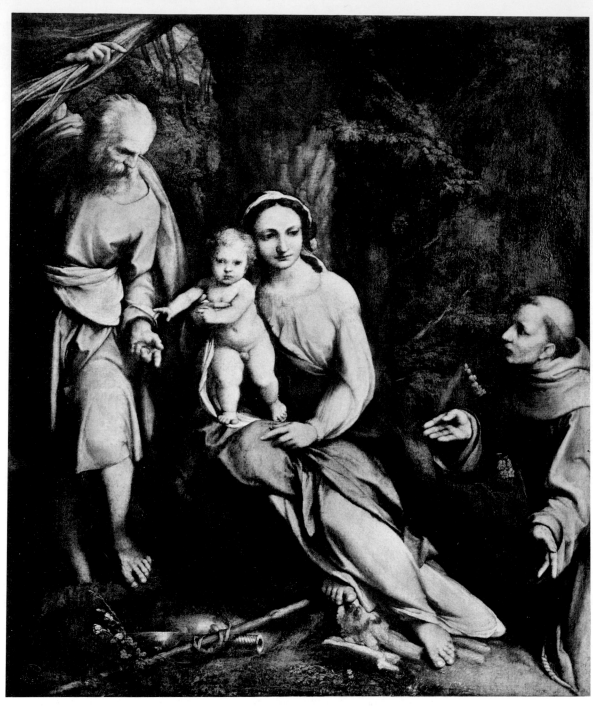

89
The Holy Family with St. Francis
Florence, Uffizi. See page 86

90B

Studies for Frankfurt composition and
S. Giovanni Evangelista frieze
London, British Museum (Popham 31v). See page 84

90A

Madonna and Child with Giovannino (Madonna of Casalmaggiore)
Frankfurt, Städelsches Kunstinstitut. See pages 84 and 86

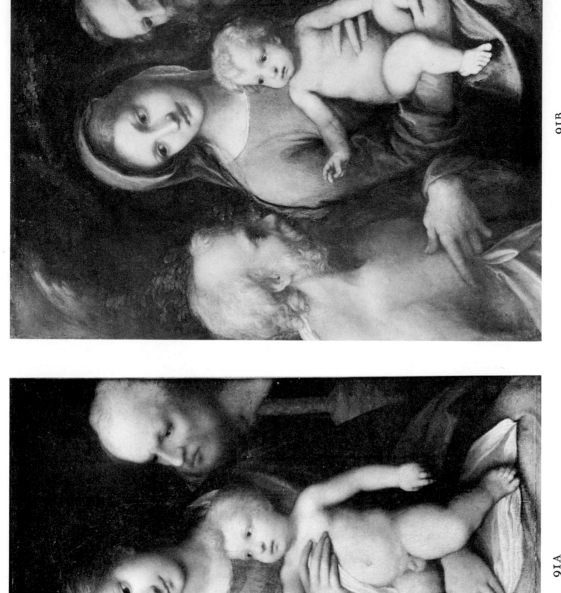

91B
Madonna and Child with St. Joseph and another male Saint
Hampton Court (by gracious permission of Her Majesty the Queen).
See page 85

91A
Madonna and Child with St. Joseph and the Giovannino
Orléans, Musée des Beaux-Arts. See page 86

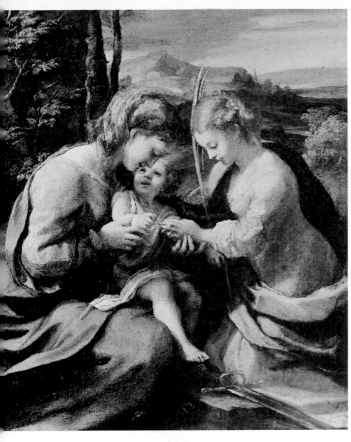

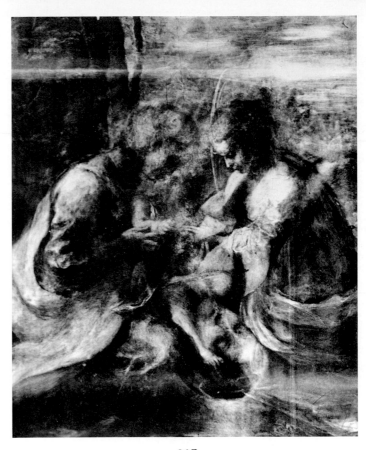

92A

The Marriage of St. Catherine

Naples. See page 88

92B

The Marriage of St. Catherine. X-ray

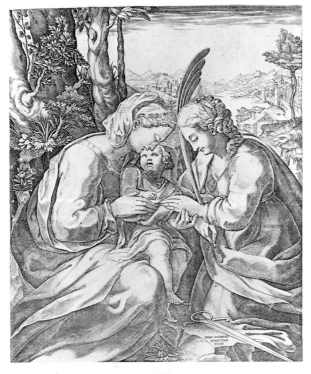

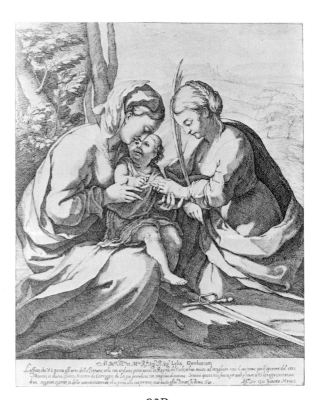

92C

GHISI, print after
Marriage of St. Catherine

92D

MERCATI, print after
Marriage of St. Catherine

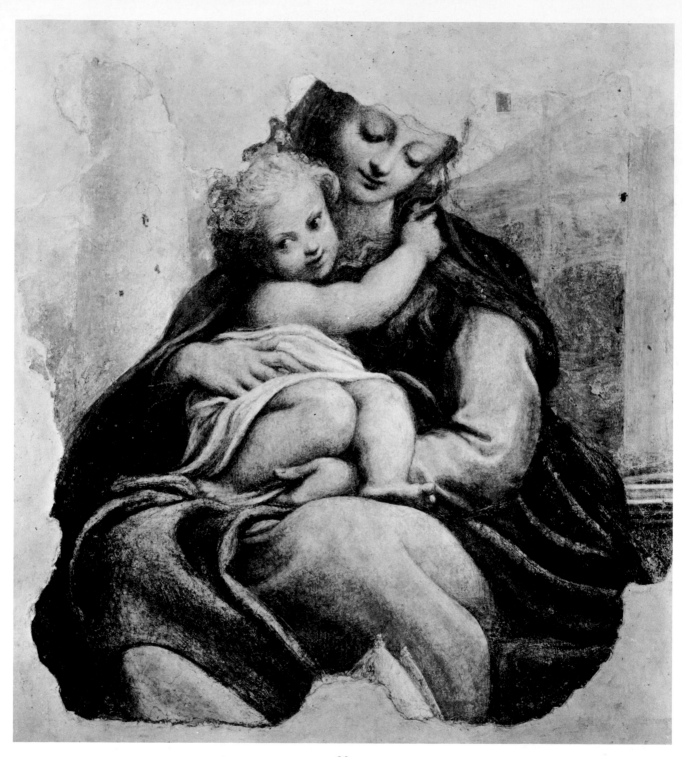

93
The Madonna della Scala
Parma, Galleria Nazionale. See page 89

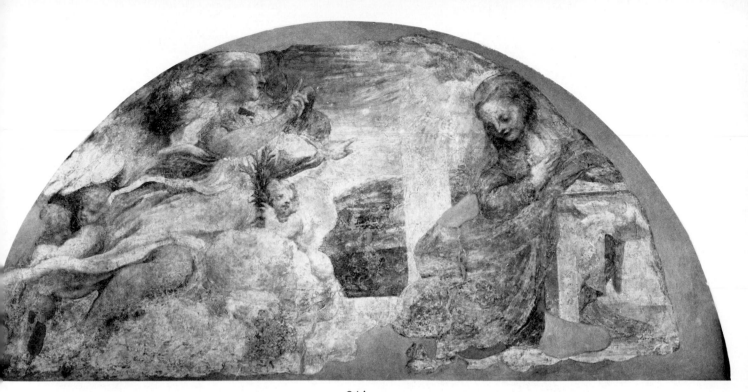

94A
The Annunciation
Parma, Galleria Nazionale. See page 89

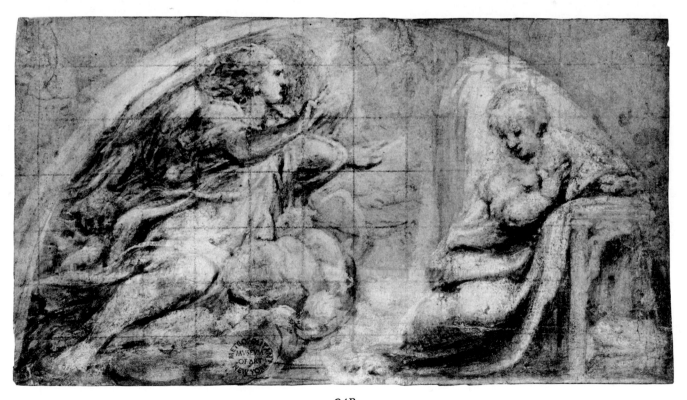

94B
Study for The Annunciation
New York, Metropolitan Museum (Popham 49)

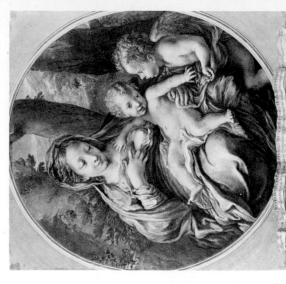

95B
TERESA DEL PO, print after Budapest Madonna

95C
F. SPIERRE, print after Budapest Madonna

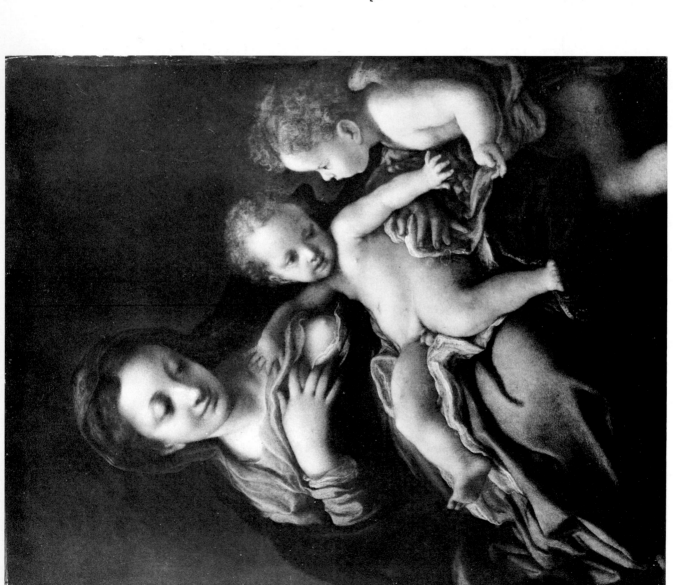

95A
Madonna and Child and an Angel (La Madonna del Latte)
Budapest, Szepművészeti Múzeum. See page 90

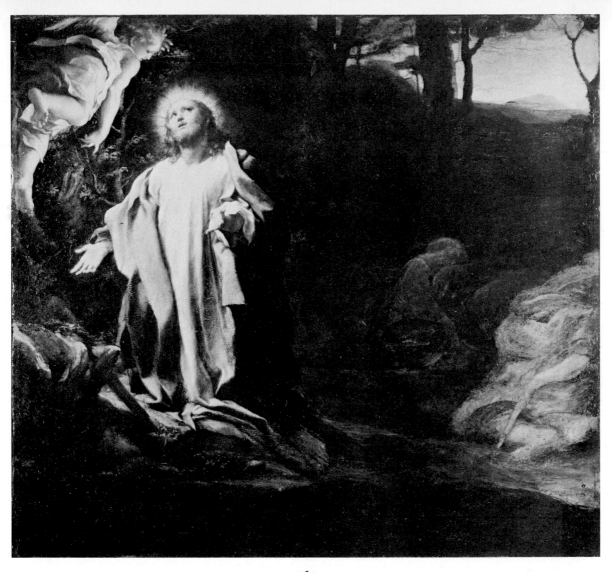

96A
The Agony in the Garden
London, Apsley House. See page 91

96B
Study for The Agony in the Garden
London, British Museum (Popham 79r)

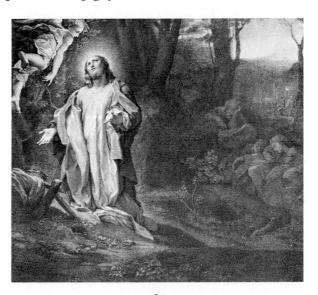

96C
G. VOLPATO, print after
The Agony in the Garden

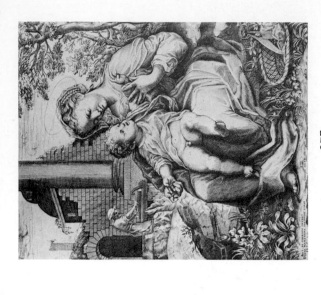

97B
D. MANTUANA, print after
the Madonna of the Basket

97C
St. Mary Magdalene Reading

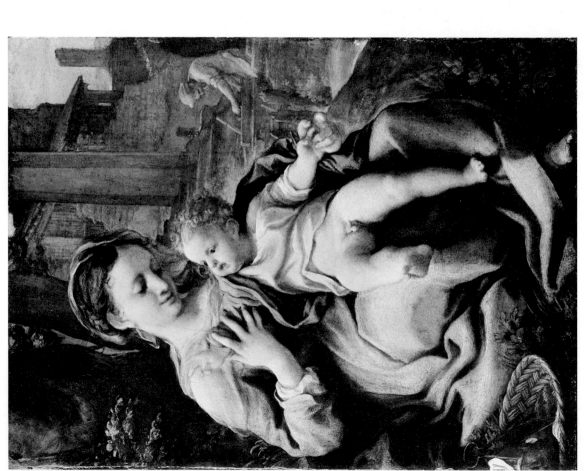

97A
The Madonna of the Basket
London, National Gallery. See page 89

98B
Noli me Tangere. X-ray of Christ

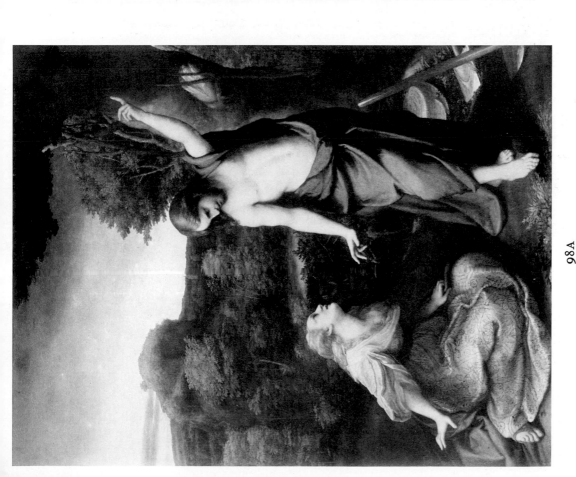

98A
Noli me Tangere
Madrid, Prado. See page 88

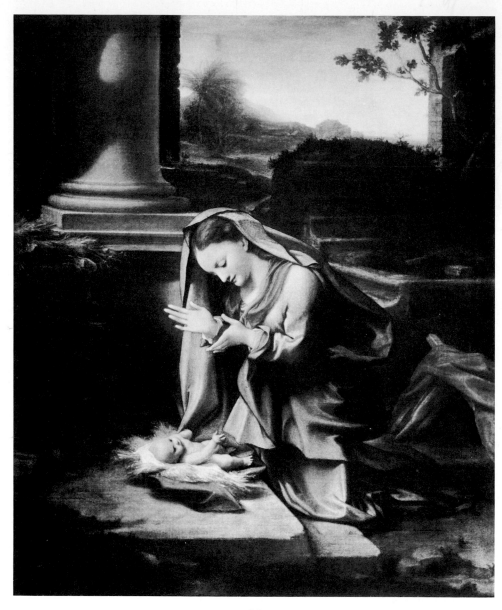

99
Madonna adoring the Child
Florence, Uffizi. See page 92

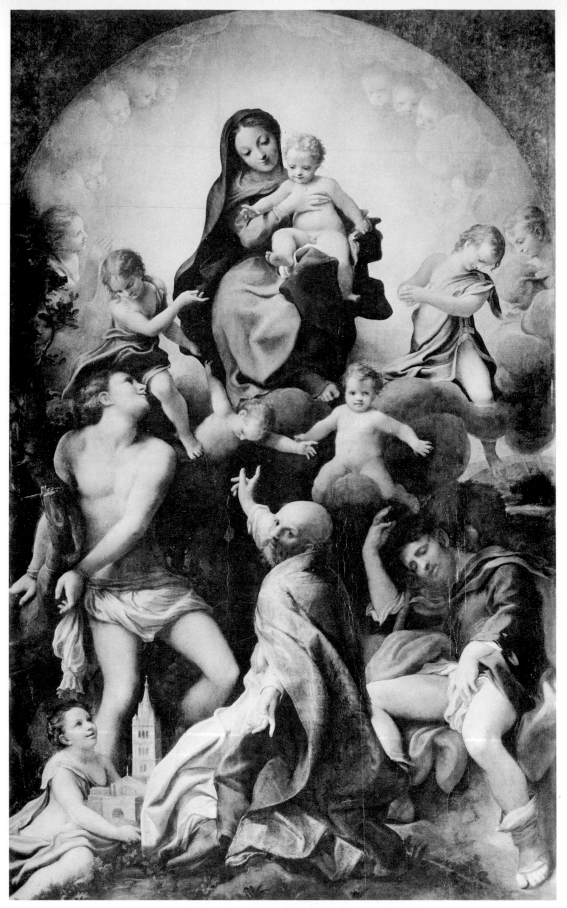

100

Madonna and Child with Saints Sebastian, Geminian and Roche
Dresden. See page 97

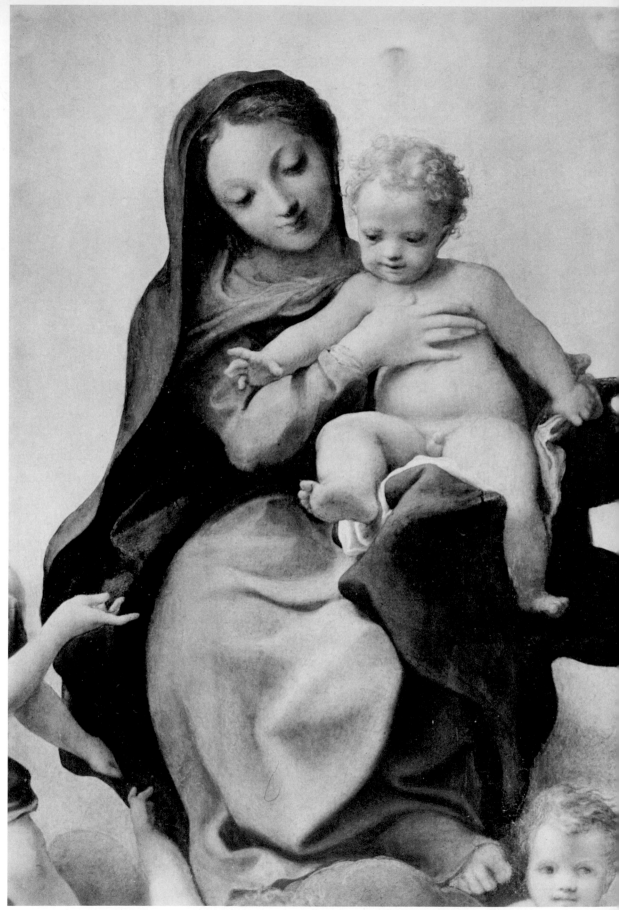

101

Detail of Madonna and Child with Saints Sebastian, Geminian and Roche. *Dresden*

Madonna and Child with Saints Sebastian, Geminian and Roche. *Dresden*. Detail

103

Detail of Madonna and Child with Saints Sebastian, Geminian and Roche. *Dresden*

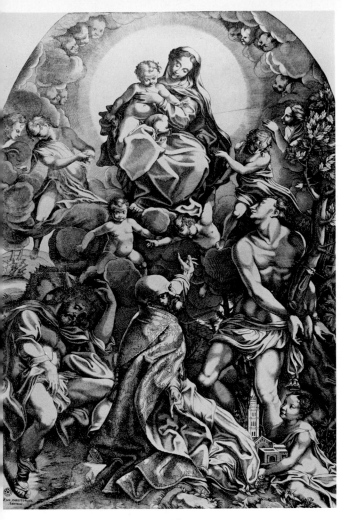

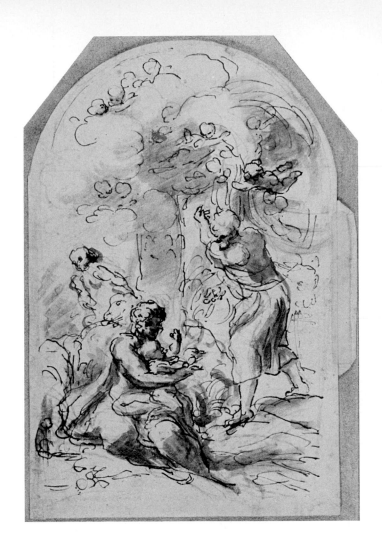

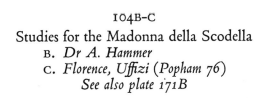

104A
C. Bertelli, print after
Madonna and Child with Saints Sebastian,
Geminian and Roche

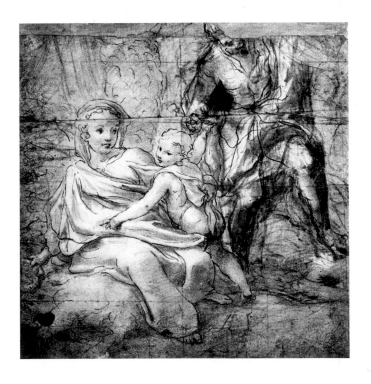

104B–C
Studies for the Madonna della Scodella
B. *Dr A. Hammer*
C. *Florence, Uffizi (Popham 76)*
See also plate 171B

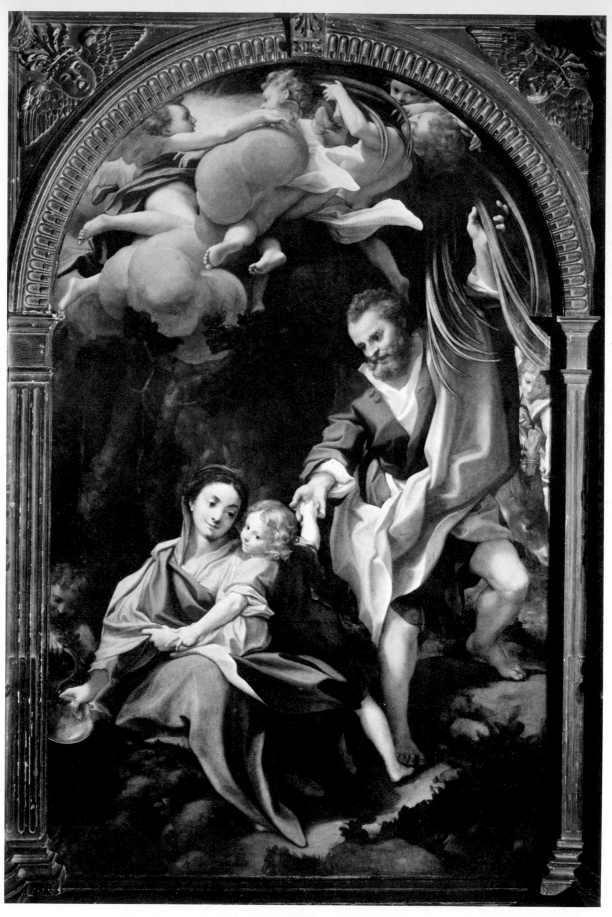

105

The Madonna della Scodella

Parma, Galleria Nazionale. See page 101

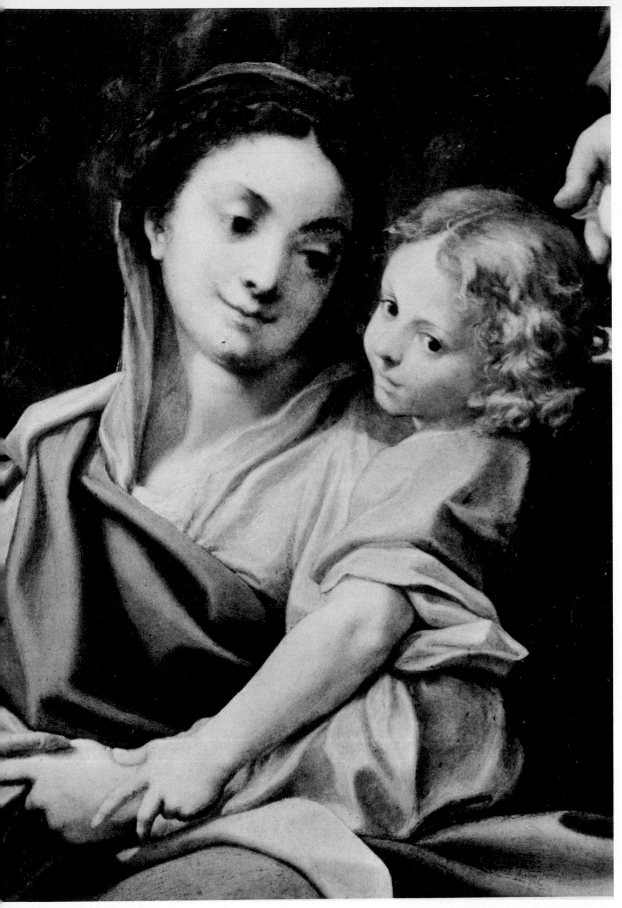

Madonna della Scodella. Detail
Parma, Galleria Nazionale. See also plate 171A

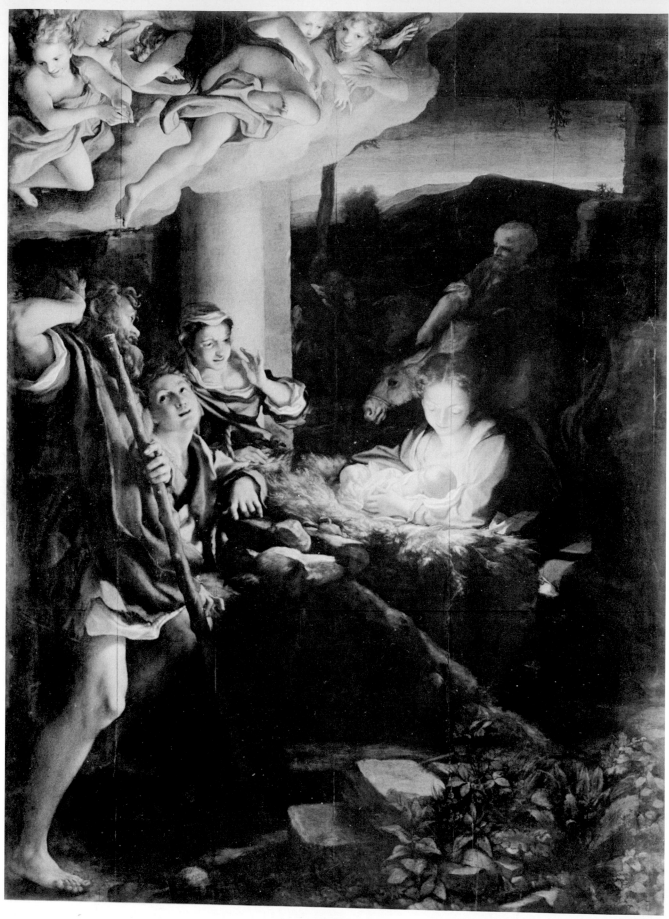

107
La Notte
Dresden. See page 104

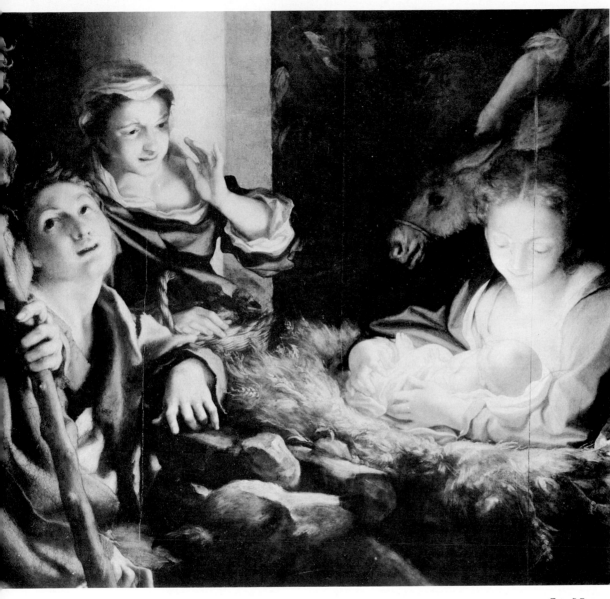

108
La Notte. Detail
Dresden

109A
Detail of La Notte
Dresden

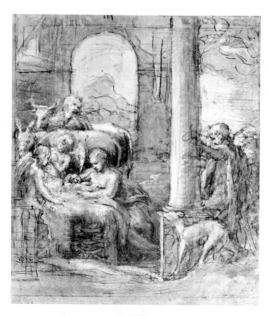

109B
Study for La Notte
Cambridge, Fitzwilliam Museum (Popham 72)

110→
The Assumption of the Virgin
Cupola of the Duomo
(the section in the centre of the base of this
photograph is north)
Parma. See page 106

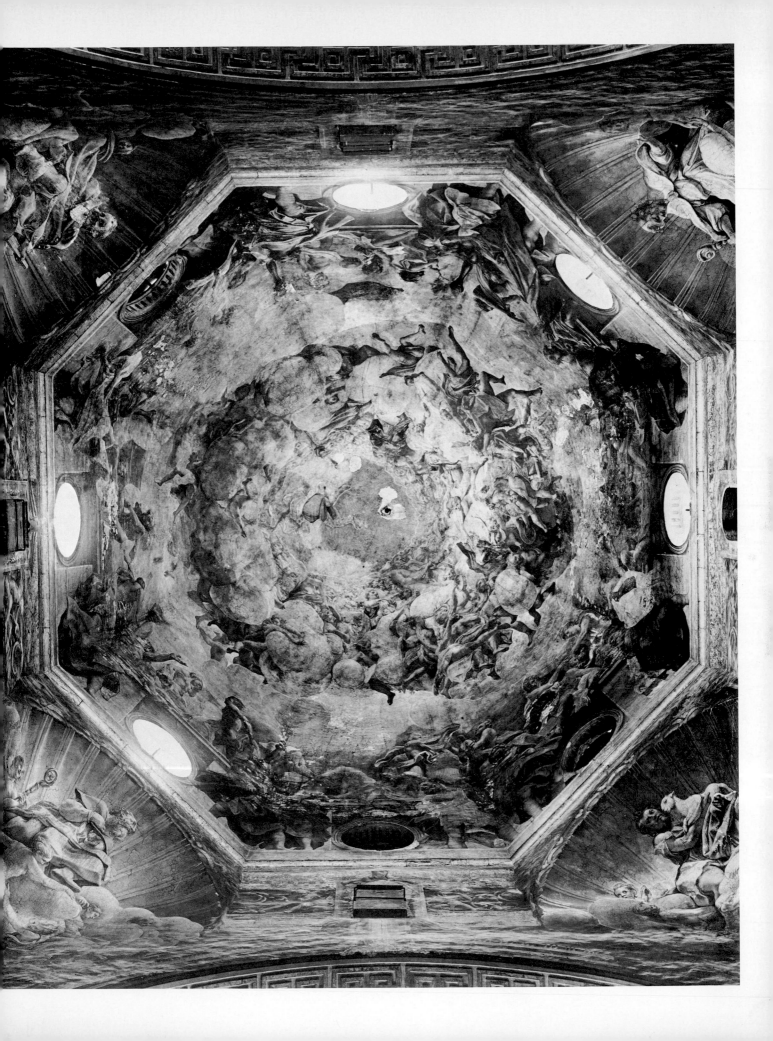

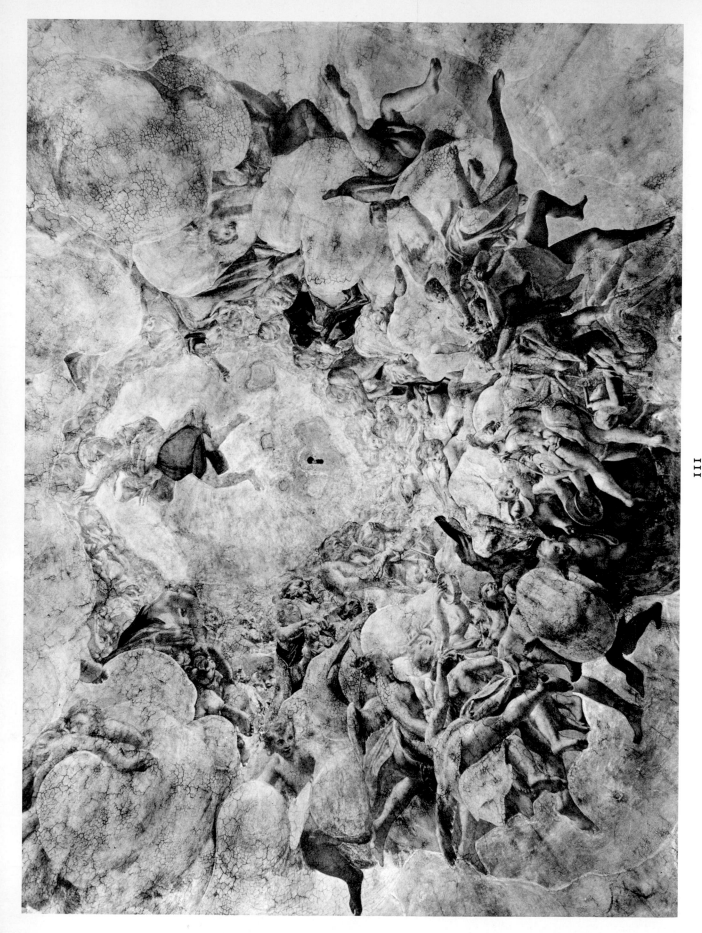

III

The Assumption of the Virgin. Cupola of the Duomo (centre section), *Parma*

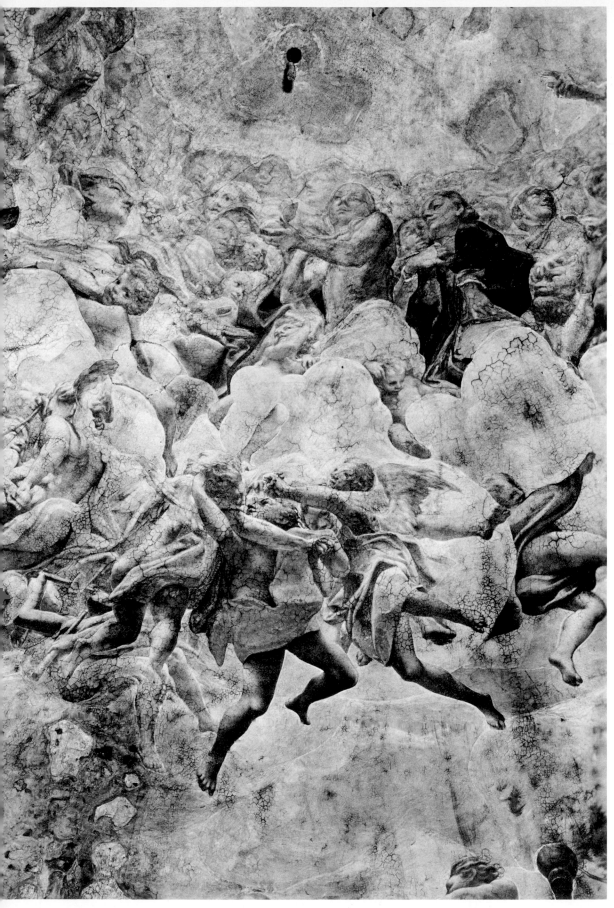

112

Cupola of the Duomo, *Parma*. The Virgin and escort. Detail

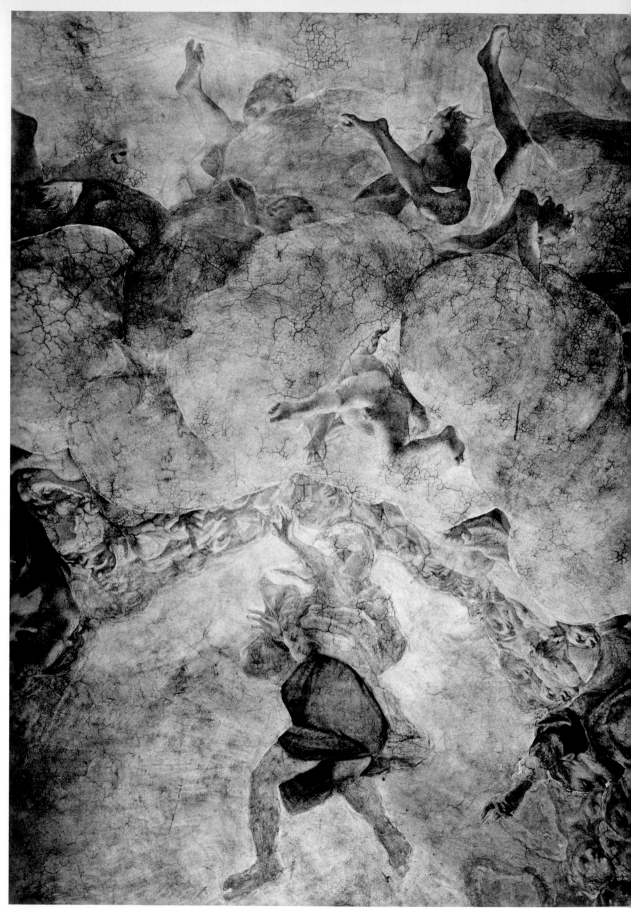

113

Detail of Christ descending. Cupola of the Duomo. *Parma*

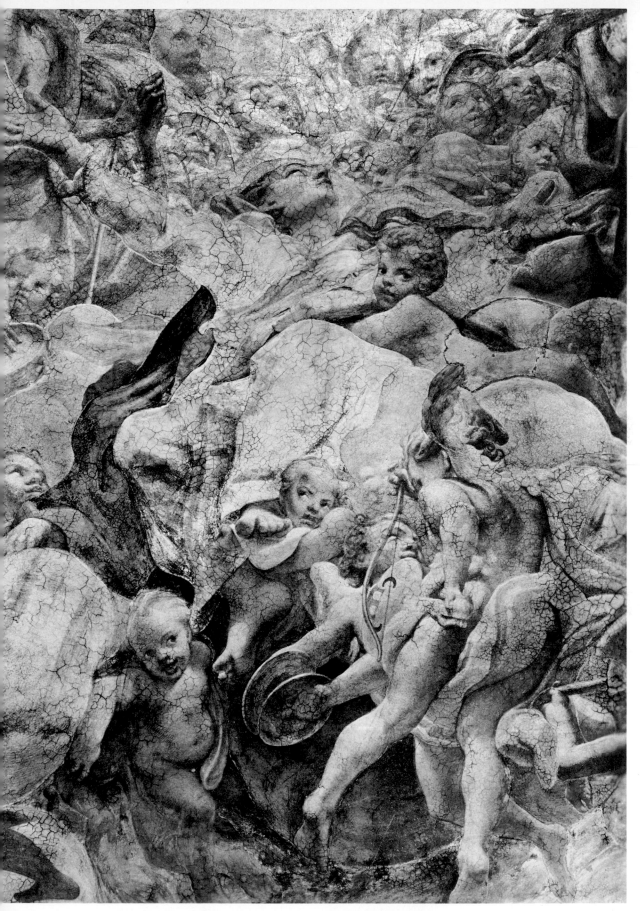

114

Cupola of the Duomo, *Parma*. The Virgin rising. Detail

115A
Study for Eve and other figures, for the Duomo cupola
Frankfurt (Popham 54)

115B
Study for Abraham, Isaac and Adam, for
Duomo cupola
Windsor (Popham 55)

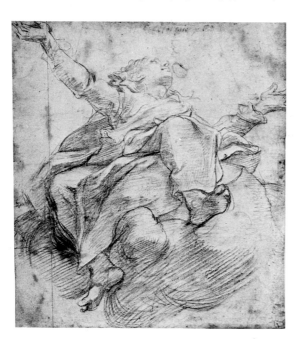

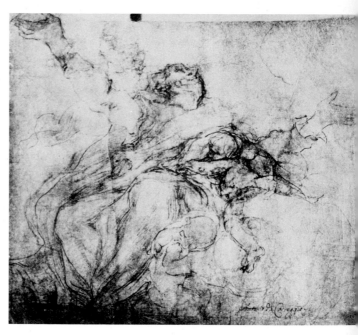

115C
Study for the Virgin,
for the Duomo cupola
London, British Museum (Popham 57)

115D
Study for the Virgin,
for the Duomo cupola
Dresden (Popham 56r)

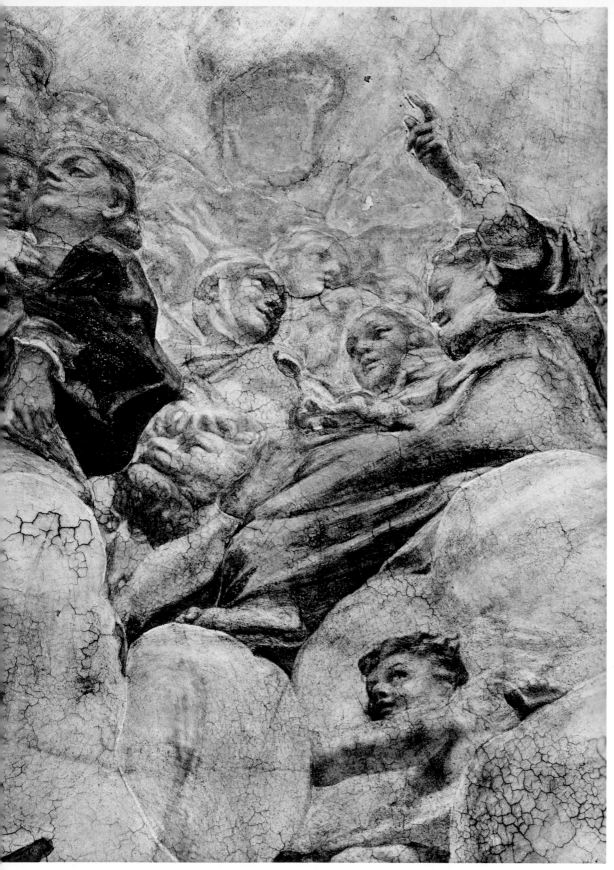

116

Cupola of the Duomo, *Parma*. The Assumption of the Virgin. Detail

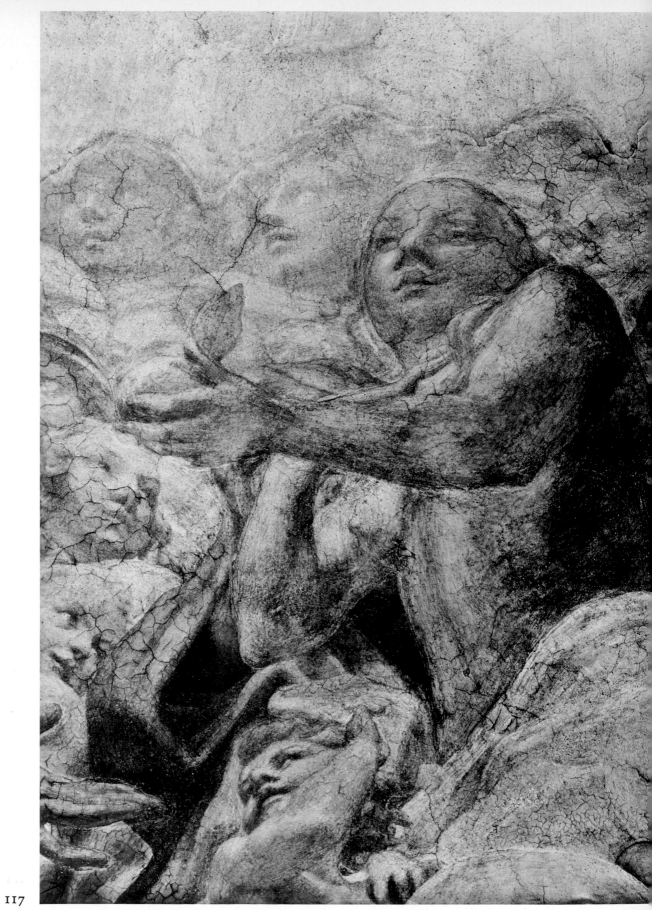

117

Detail of Eve. The Assumption of the Virgin. Cupola of the Duomo, *Parma*

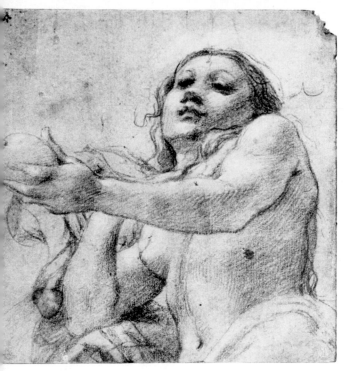

A

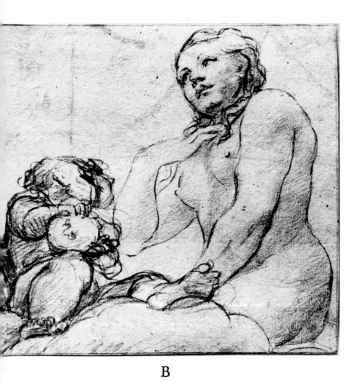

B

C

118

Studies for Eve, for the cupola of the Duomo
A. *Paris, Louvre (Popham 53)*
B. *Haarlem, Teylers Stichting (Popham 52r)*
C. *London, British Museum (Popham 51r)*

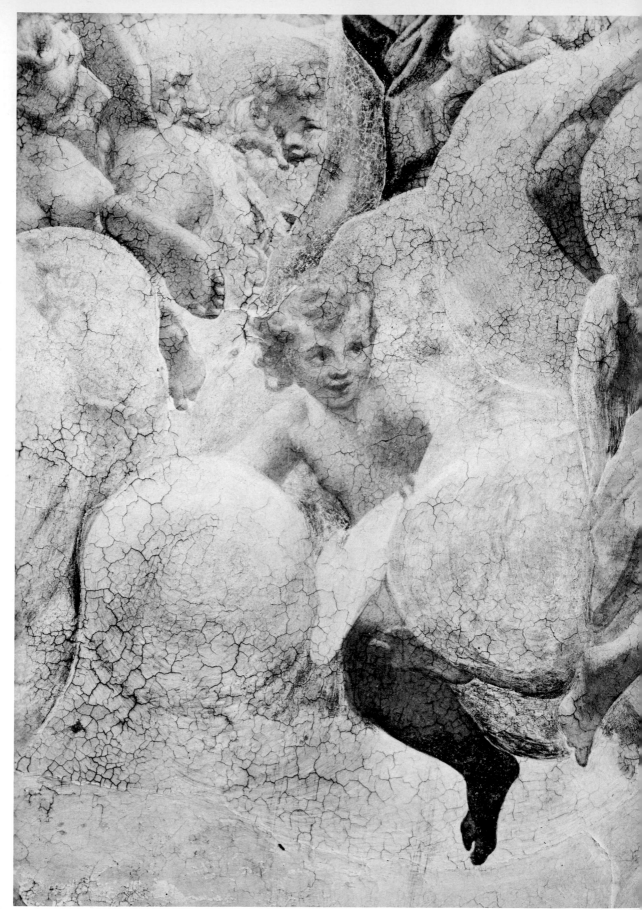

119

Detail. The Assumption of the Virgin. Cupola of the Duomo, *Parma*

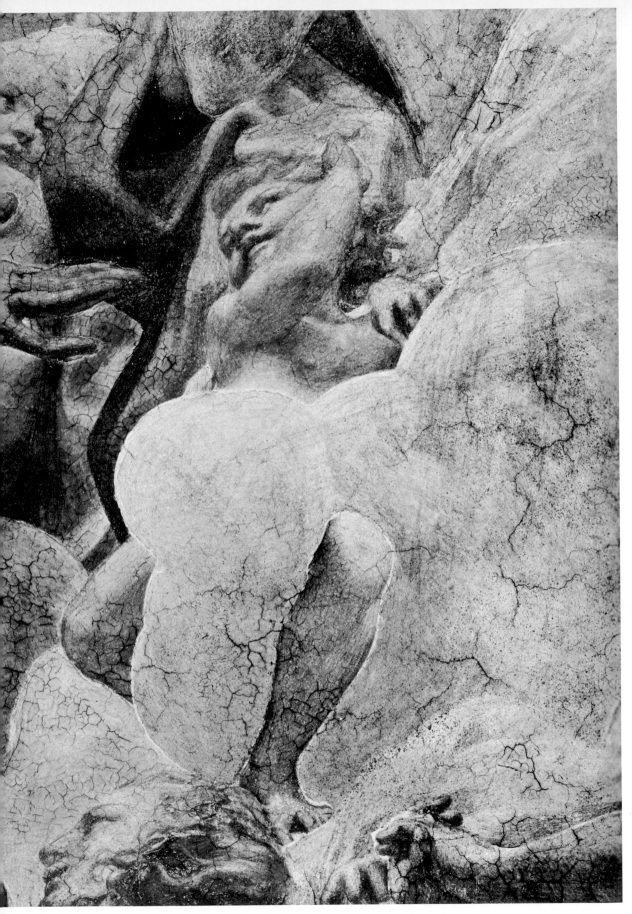

The Assumption of the Virgin. Cupola of the Duomo, *Parma*. Detail

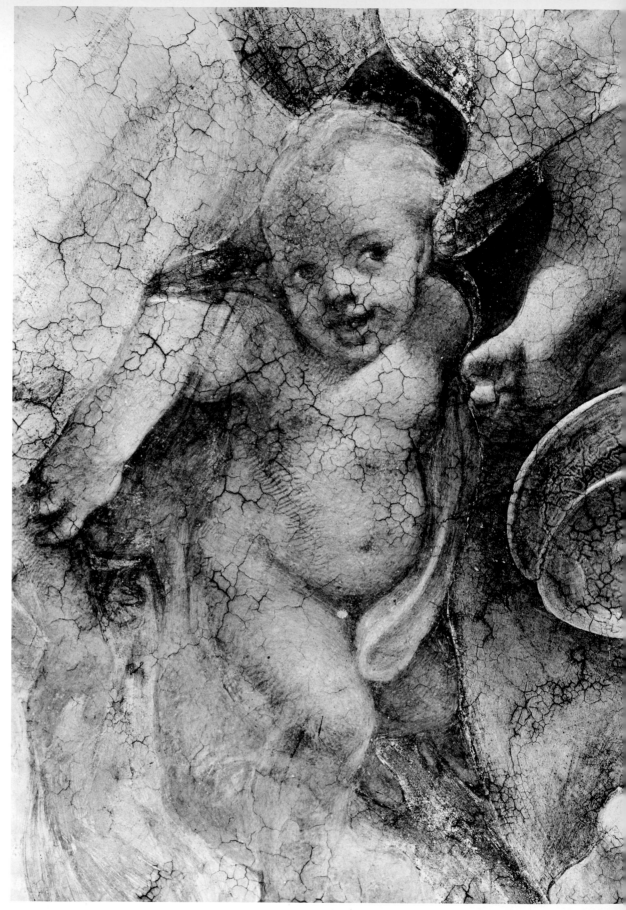

121

Detail. The Assumption of the Virgin. Cupola of the Duomo, *Parma*

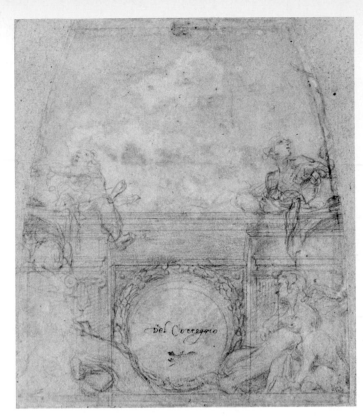

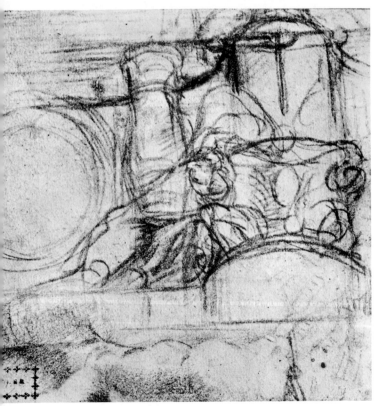

122A–C
Studies for the parapet of the Duomo
A. *Oxford, Ashmolean Museum (Popham 50r)*
B. *Oxford, Ashmolean Museum (Popham 50v)*
C. *Haarlem, Teylers Stichting (Popham 52v)*

122D
Study for an apostle, for the Duomo parapet
Lisbon (Popham 63)

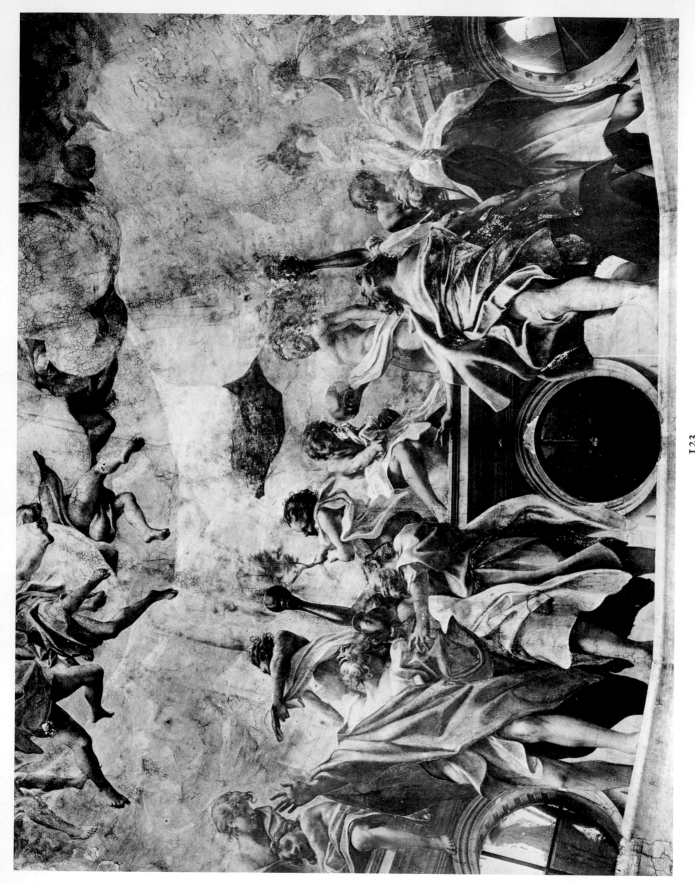

123
Parapet of the Duomo, south side
Parma. See page 106

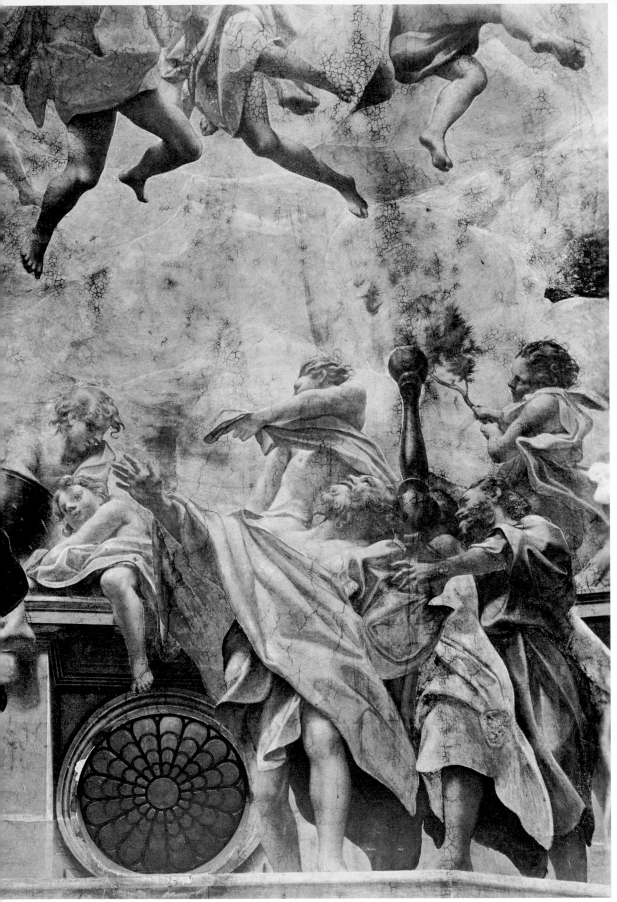

124

Apostles on the Duomo parapet. *Parma.* Detail

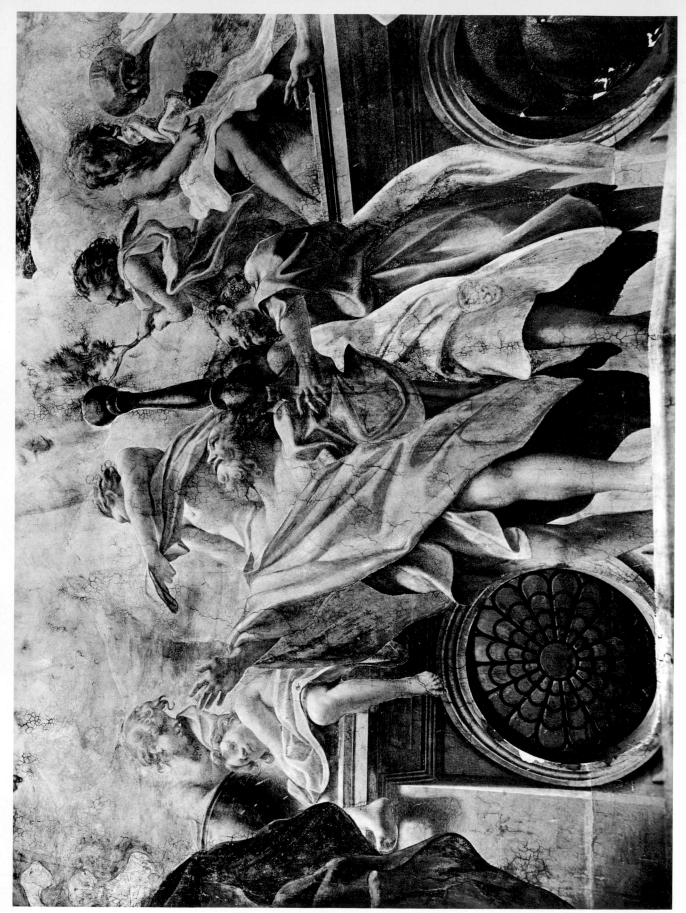

125

Detail of apostles on the Duomo parapet. *Parma*

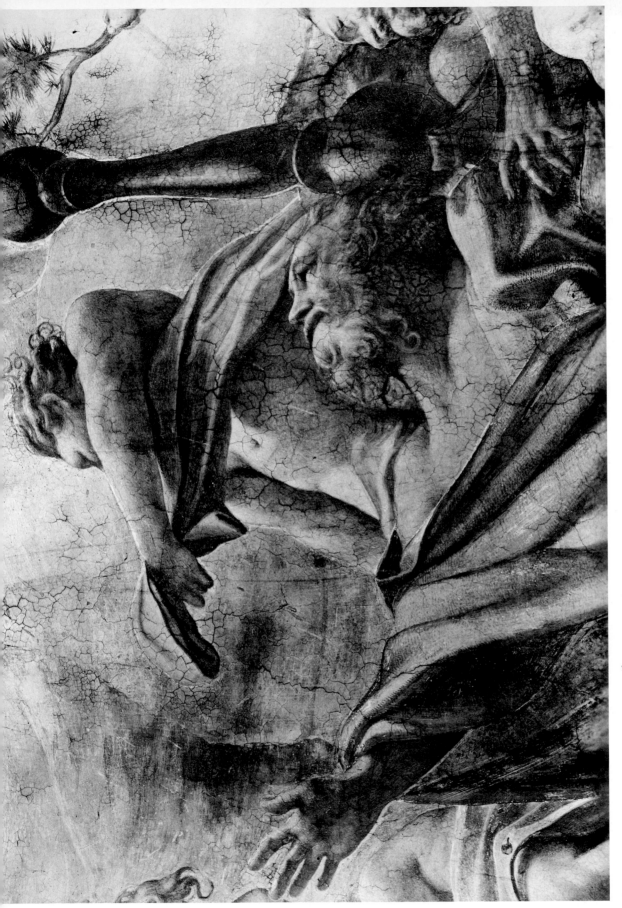

Youths on the Duomo parapet. *Parma.* Detail

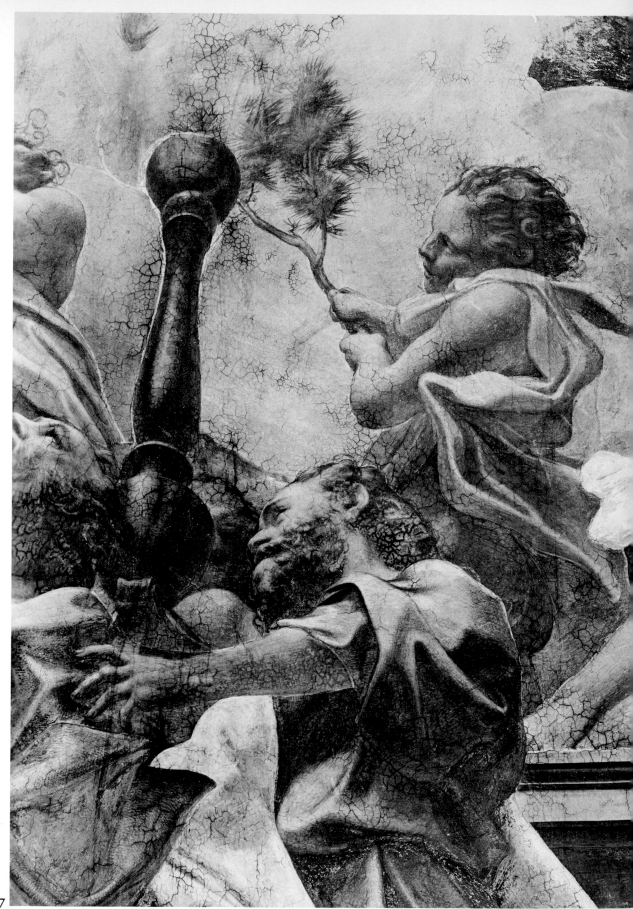

127

Detail of youths on the Duomo parapet. *Parma*

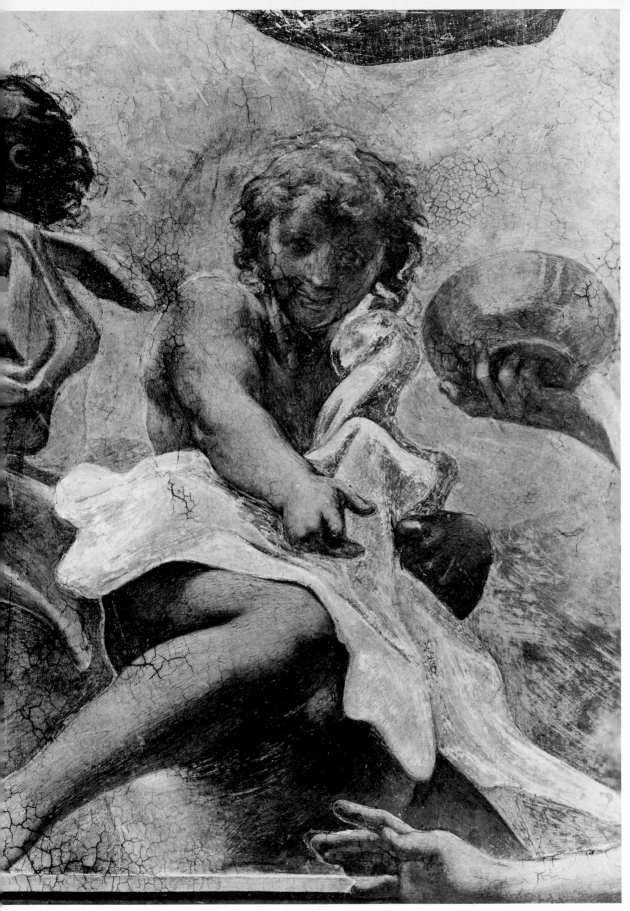

Youths on the Duomo parapet. *Parma*. Detail

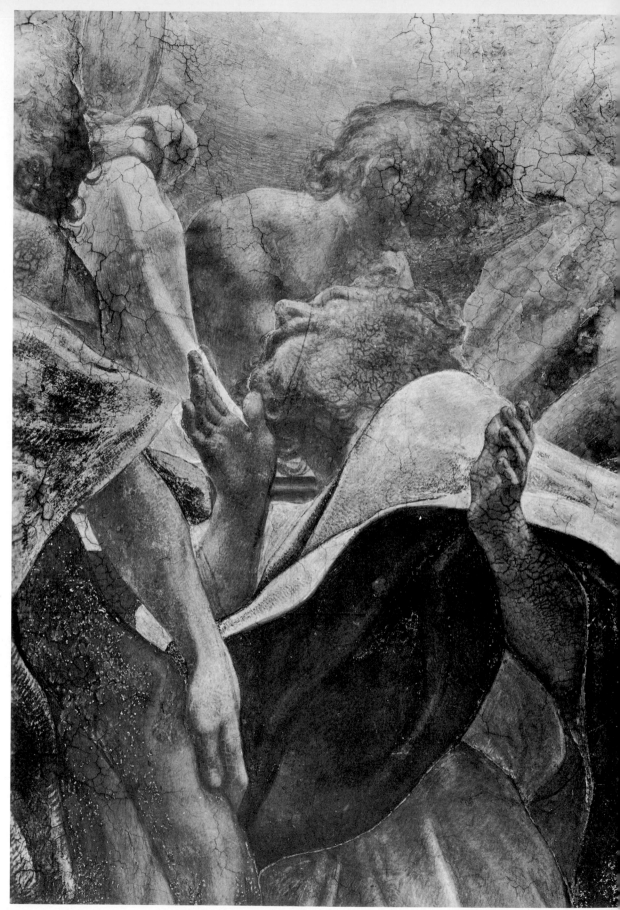

129

Detail of youths on the Duomo parapet. *Parma*

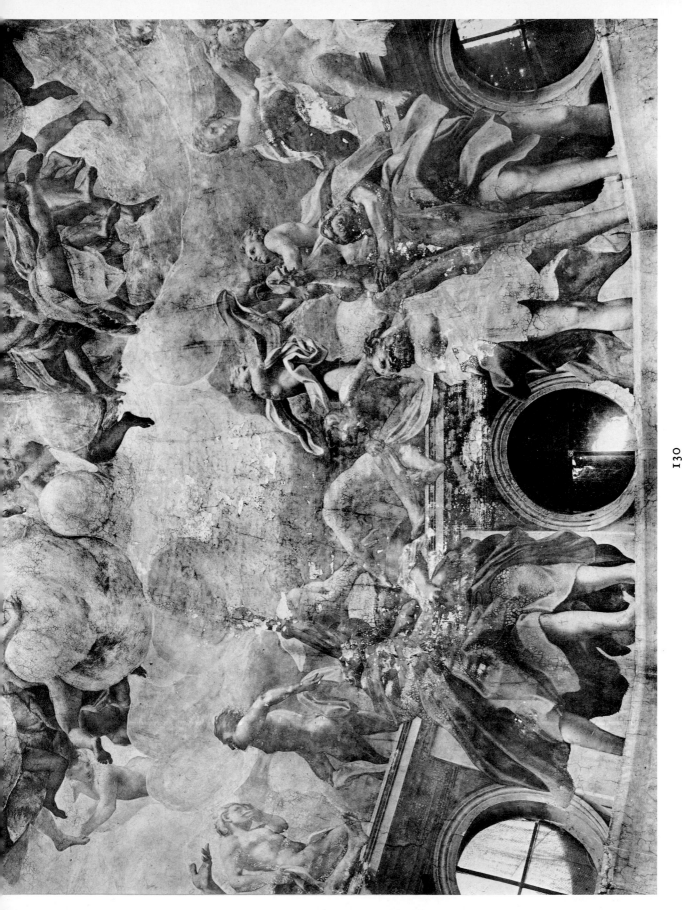

130

Parapet of the Duomo. North side
Parma. See page 106

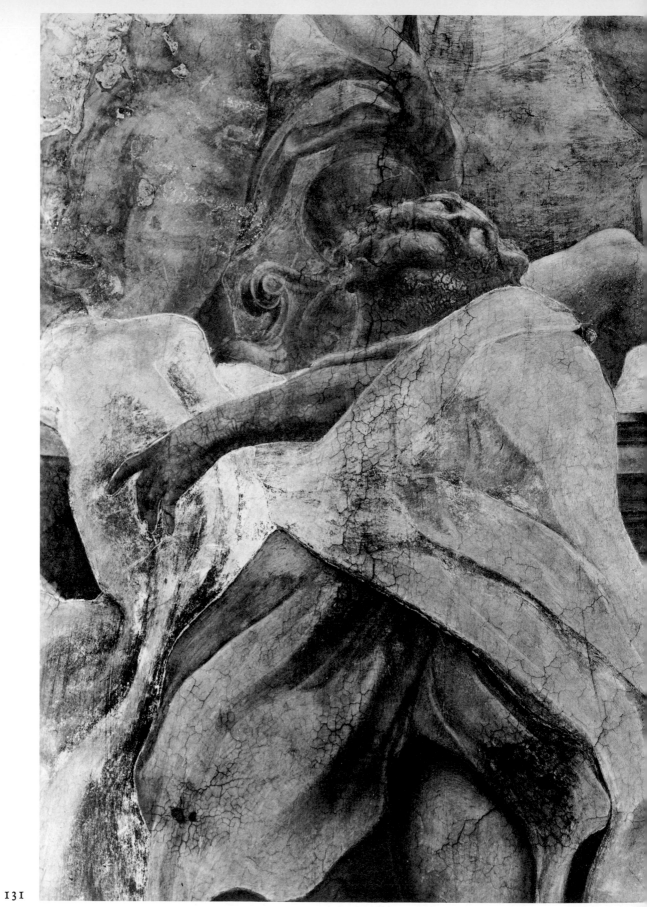

131

Detail of the Duomo parapet. *Parma*

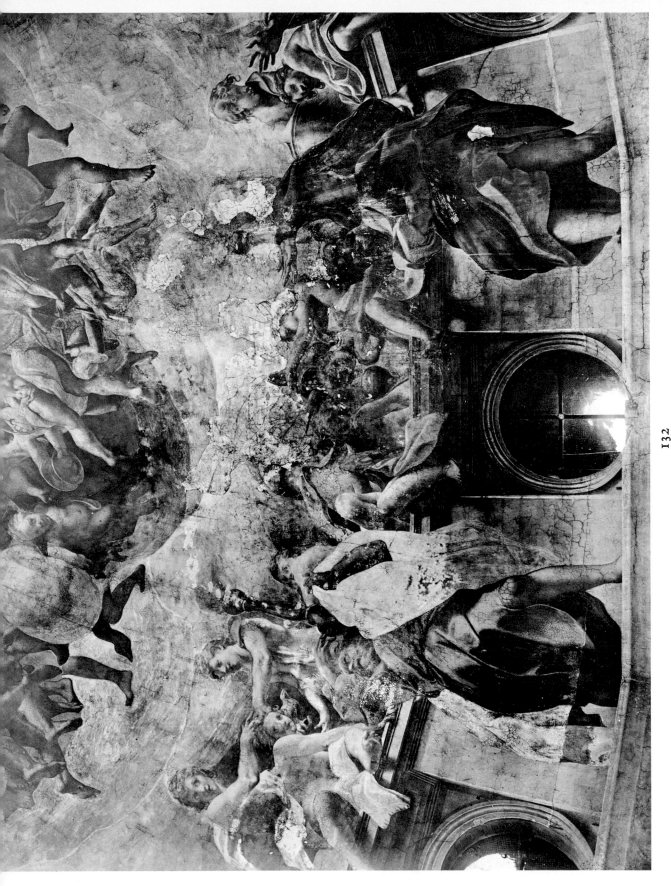

132
Parapet of the Duomo. East side
Parma. See page 106

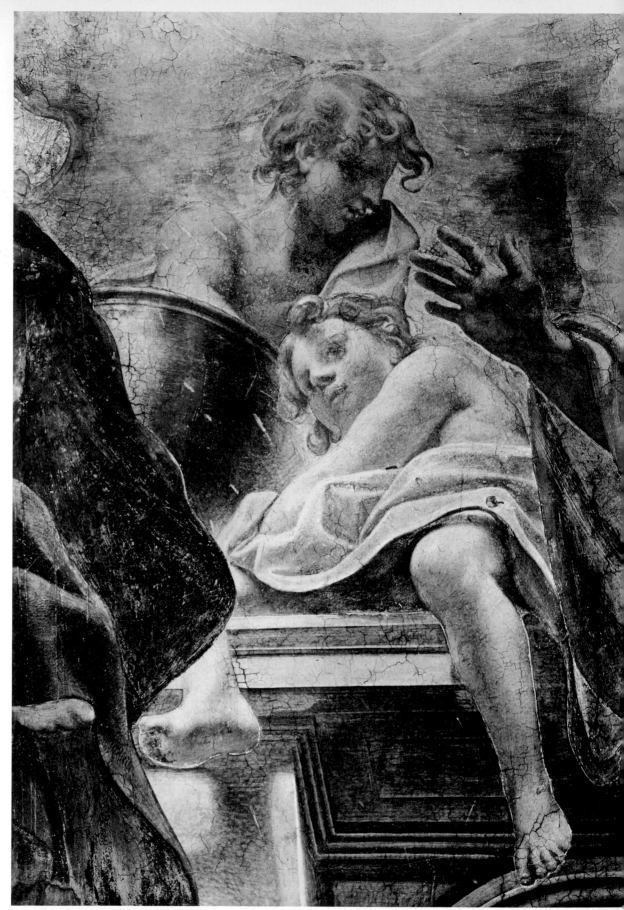

133

Detail of youths on the Duomo parapet. *Parma*

A

B

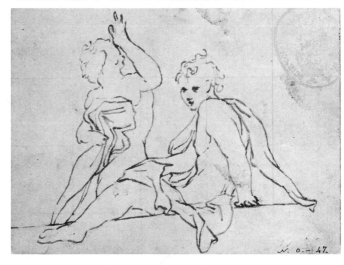

D

C

134
Studies for youths on the Duomo parapet
A. *Florence, Uffizi (Popham 58r)*
B. *Paris, Louvre (Popham 59)*
C. *Paris, Louvre (Popham 60)*
D. *Lisbon (Popham 61)*

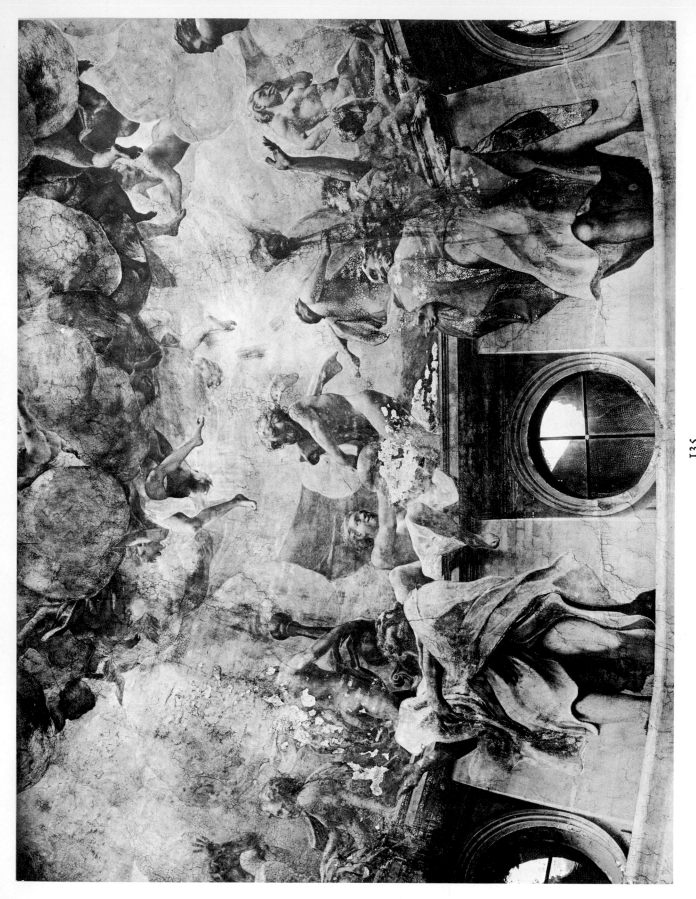

135
Parapet of the Duomo, west side
Parma. See page 106

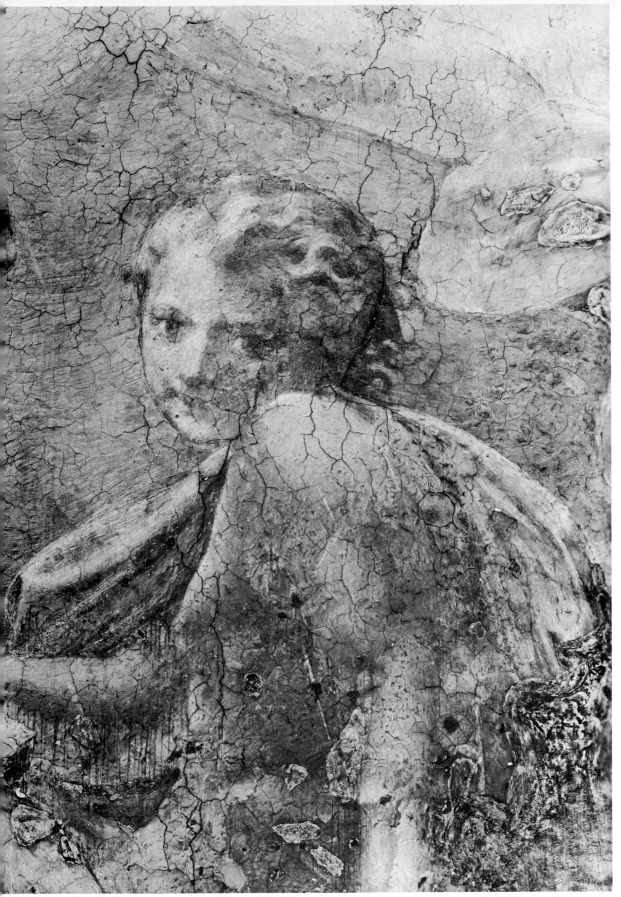

136

The Duomo parapet. *Parma*. Detail

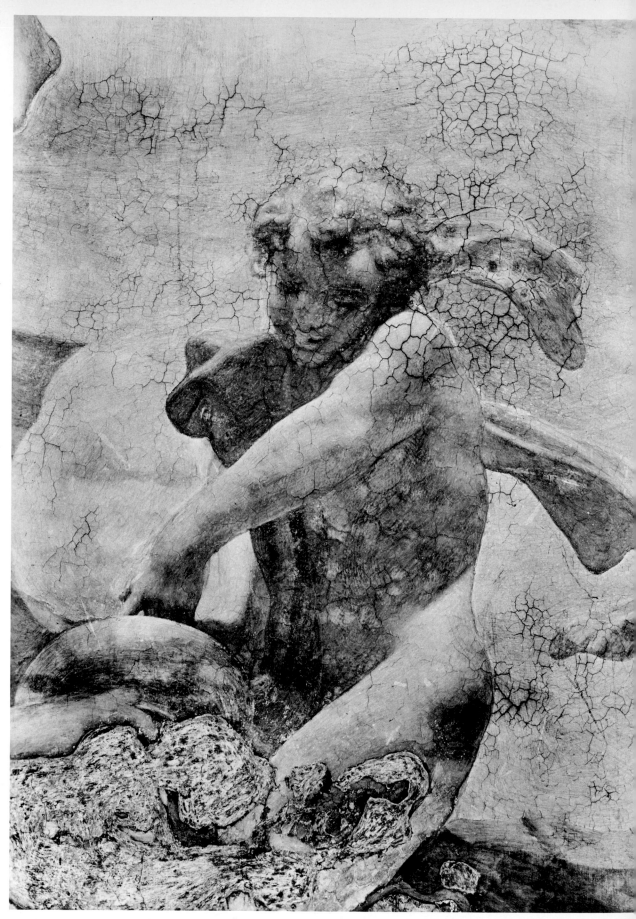

137

Detail of the Duomo parapet. *Parma*

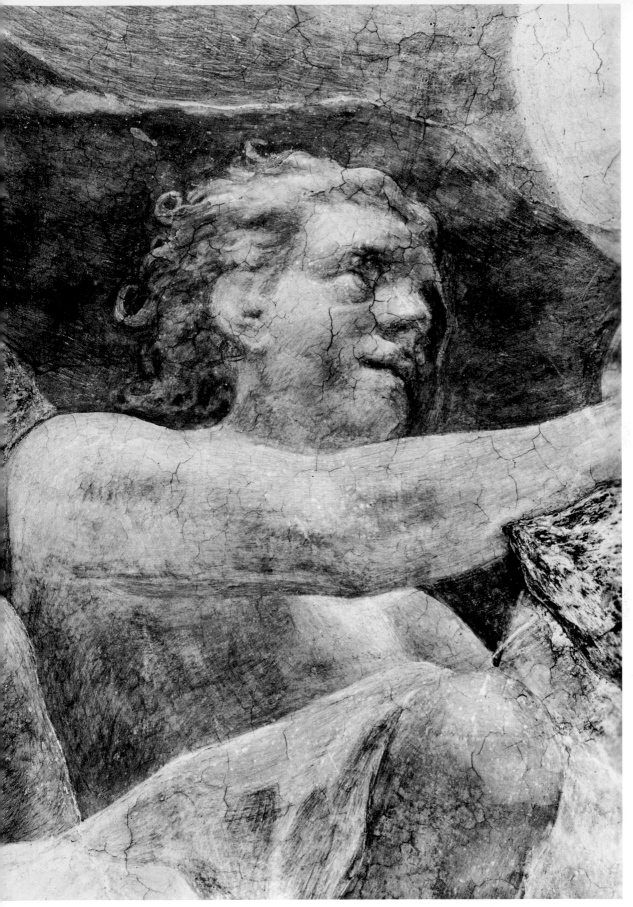

138

The Duomo parapet. *Parma.* Detail

I39A

Studies for an apostle, a frieze and (?) a martyr, for the Duomo
Formerly Trivulzio collection (Popham 62r). See page 106

I39B

Study for an apostle, for the Duomo parapet
Lausanne, Strolin collection (Popham 65)

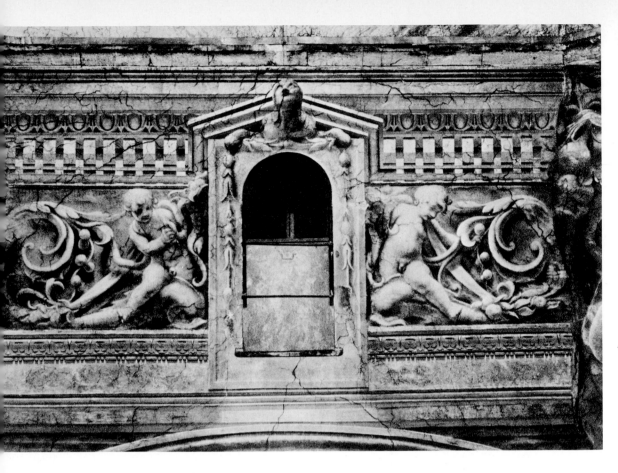

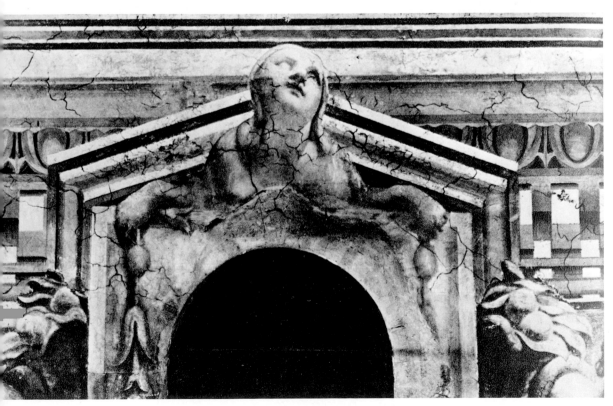

Frieze of the drum of the Duomo, *Parma. See page 113*. Details

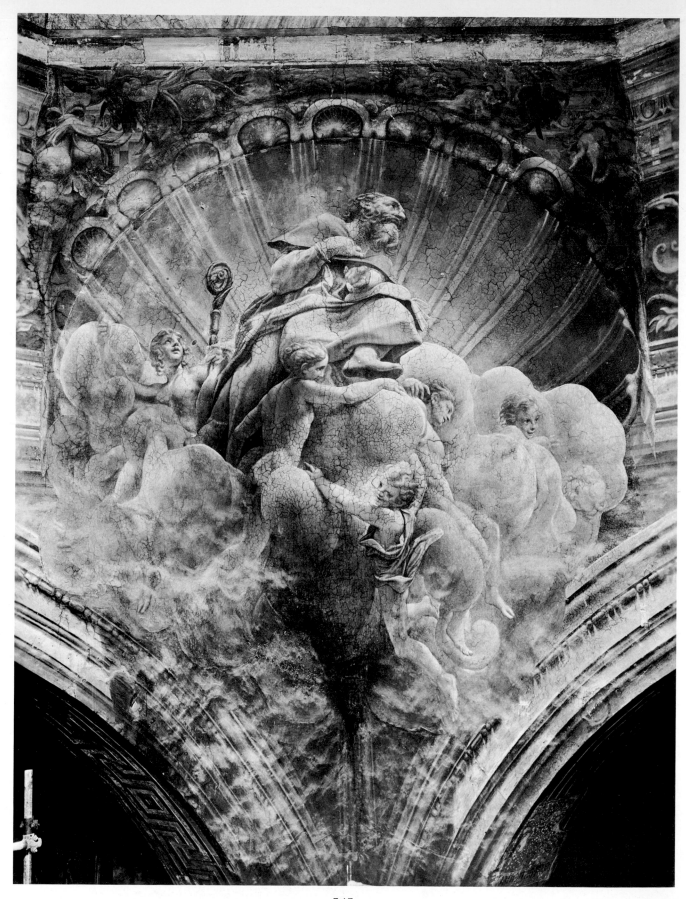

141
St. Bernard. North-west squinch of the Duomo
Parma. See page 114

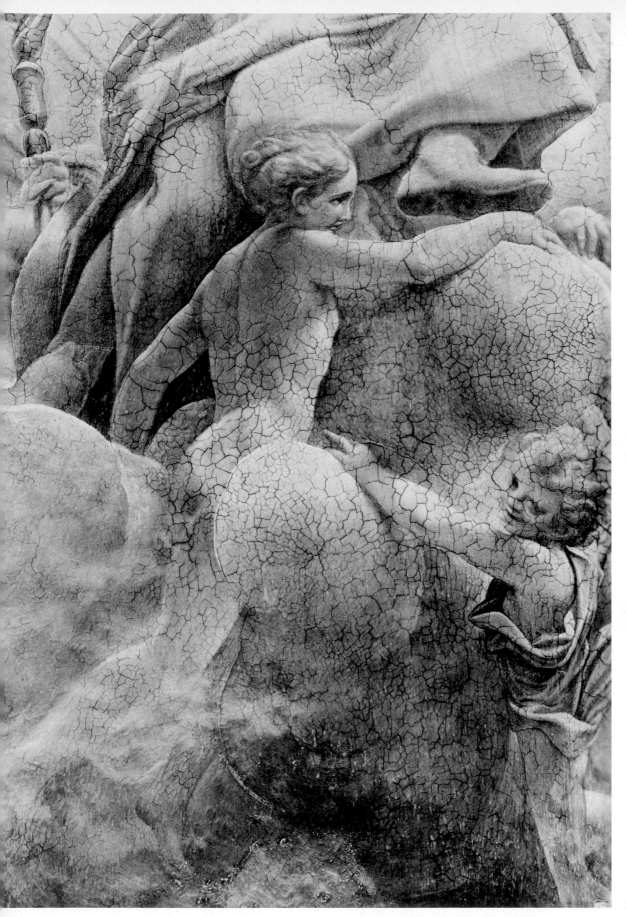

North-west squinch of the Duomo, *Parma*. Detail

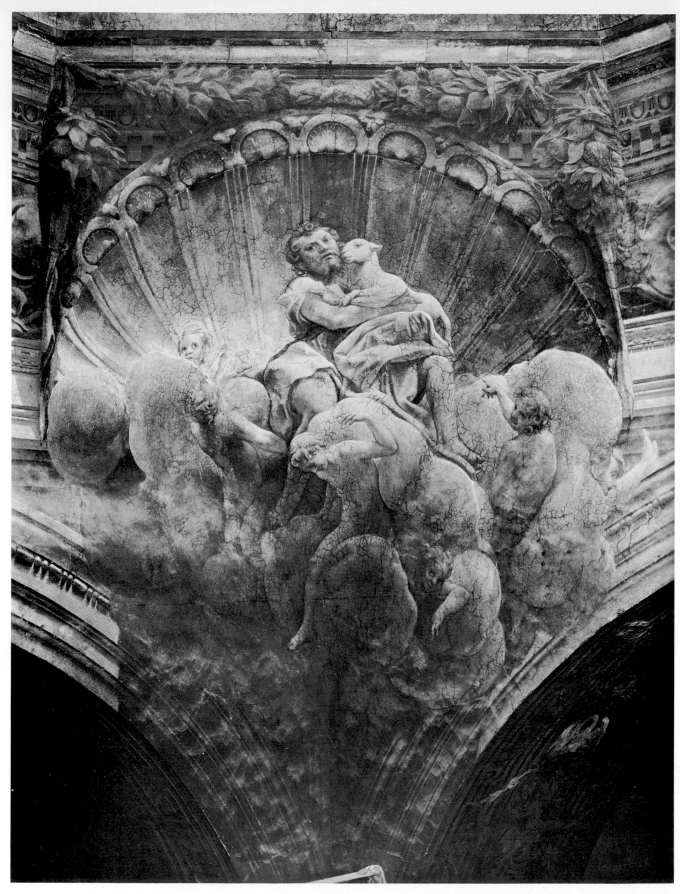

143
St. John the Baptist. North-east squinch of the Duomo
Parma. See page 114

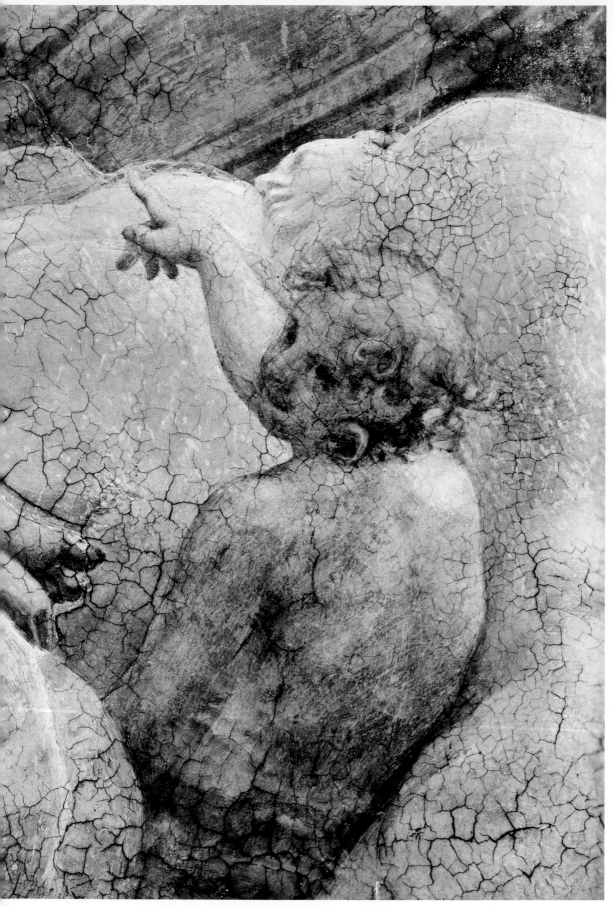

144

North-east squinch of the Duomo, *Parma*. Detail

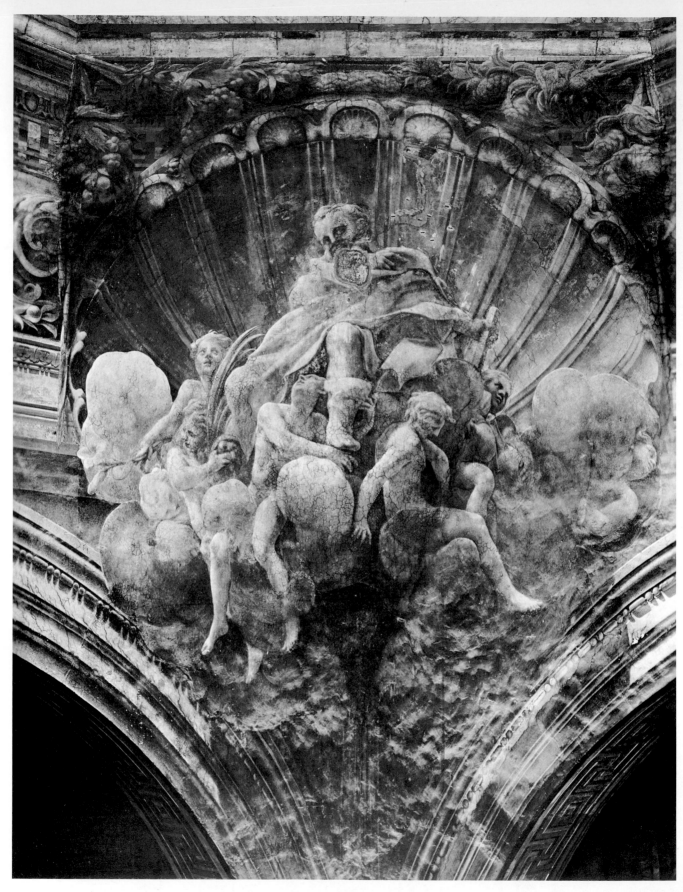

145
St. Thomas. South-west squinch of the Duomo
Parma. See page 114

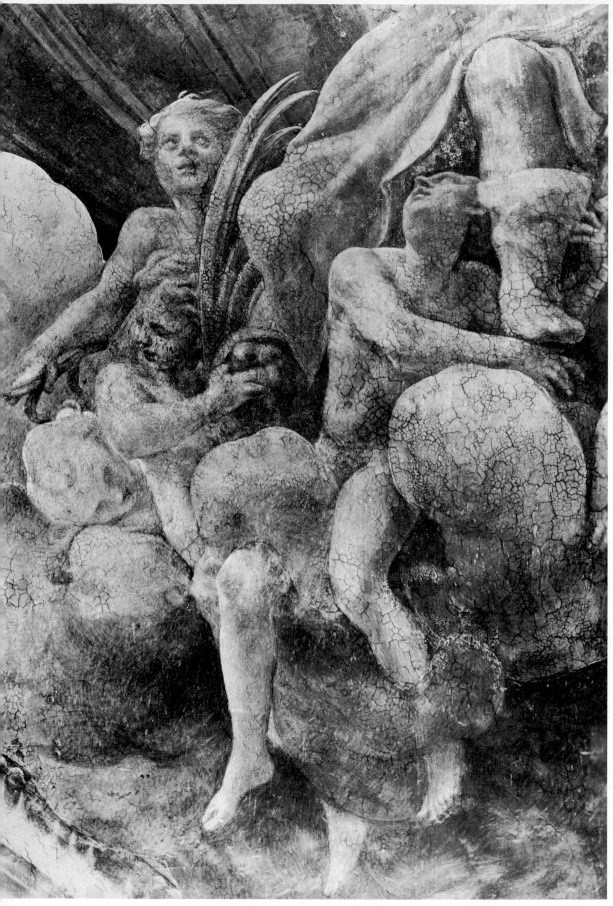

146

South-west squinch of the Duomo, *Parma*. Detail

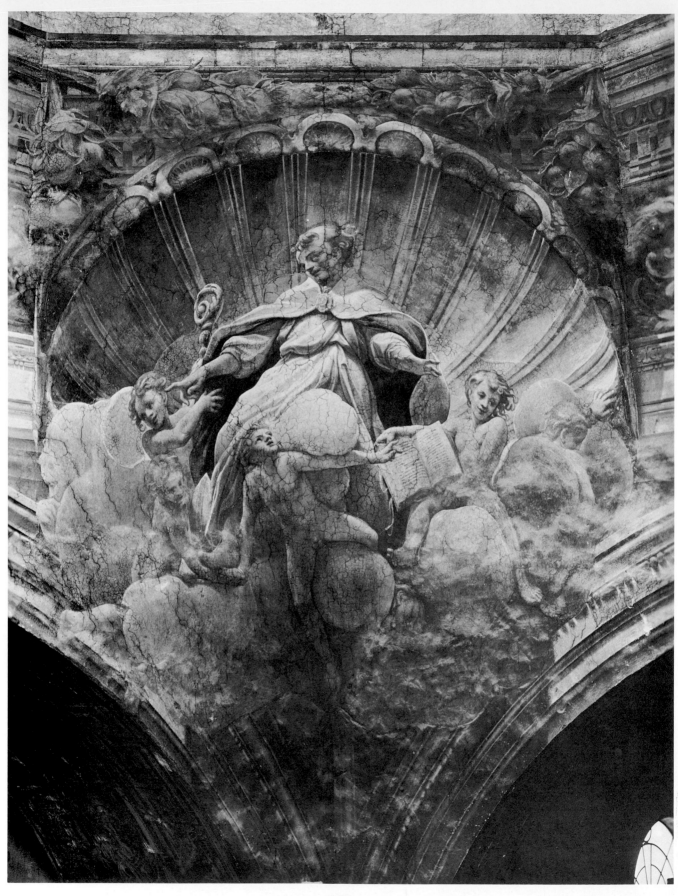

147
St. Hilary. South-east squinch of the Duomo
Parma. See page 114

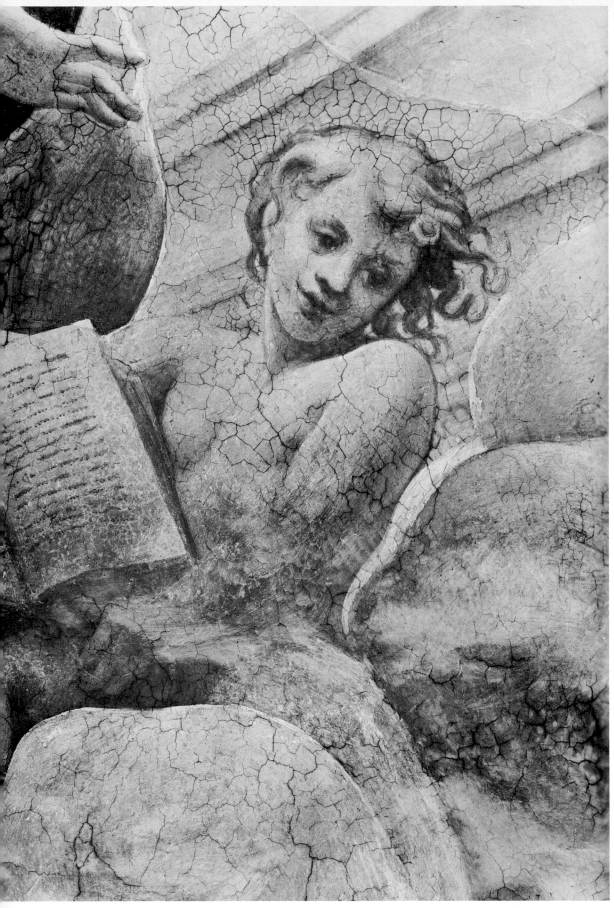

148

South-east squinch of the Duomo, *Parma*. Detail

149

Studies for north-west squinch of the Duomo

A. *Paris, Louvre (Popham 69)*
B. *London, British Museum (Popham 70)*

150A

Study for south-west squinch of the Duomo
Paris, Louvre (Popham 68)

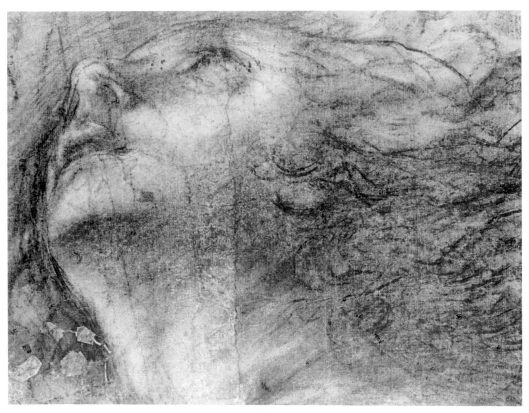

150B

Cartoon (?) for south-west squinch of the
Duomo
Paris, Ecole des Beaux-Arts (Popham 71)

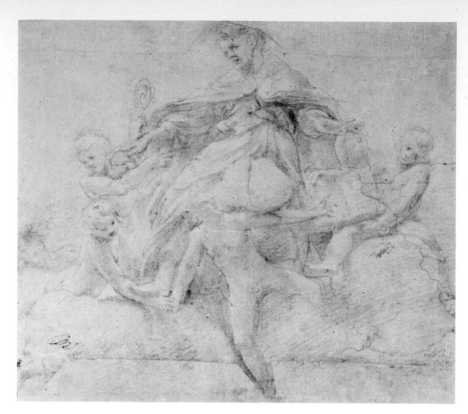

151A
Study for south-east squinch of the Duomo
Paris, Louvre (Popham 67)

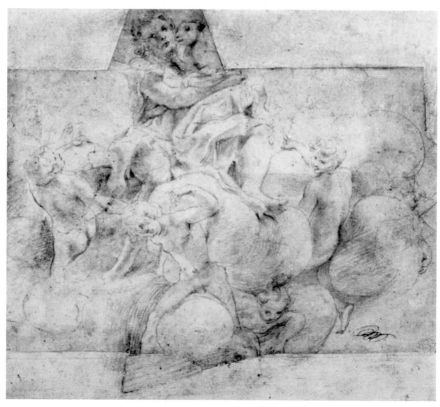

151B
Study for north-east squinch of the Duomo
Paris, Louvre (Popham 66)

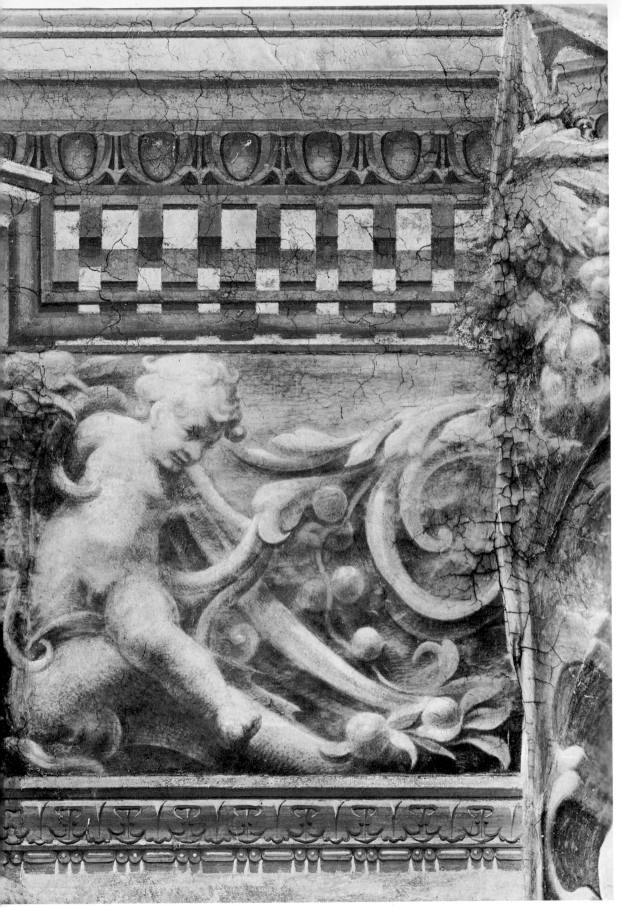

152

Frieze of the drum of the Duomo, *Parma. See page 113.* Detail

153

Details of frieze of the drum of the Duomo, *Parma. See page 113*

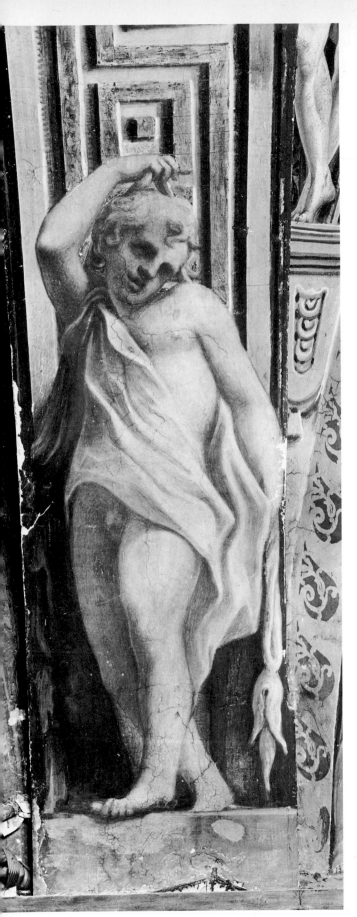
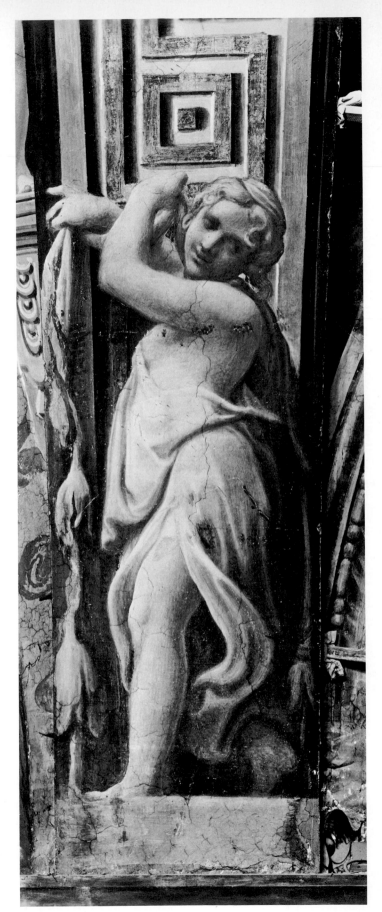

154

Grisaille under-arch figures. Duomo

Parma. See page 113

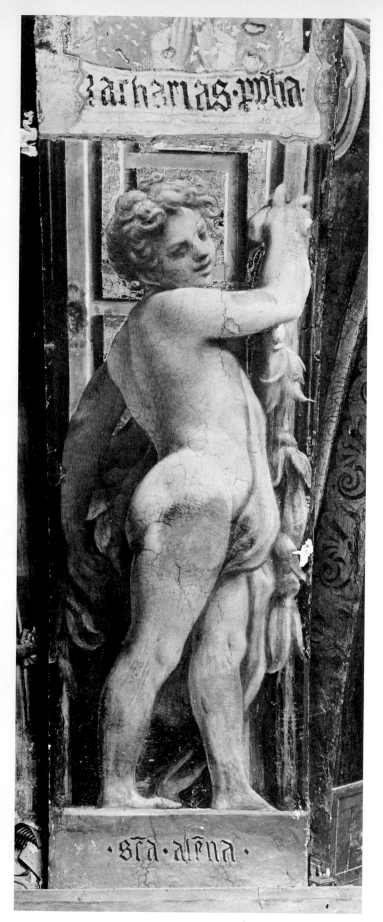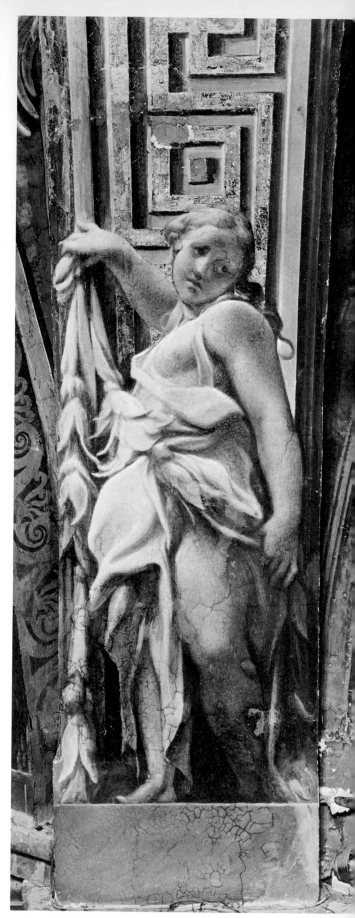

155
Grisaille under-arch figures. Duomo
Parma. See page 113

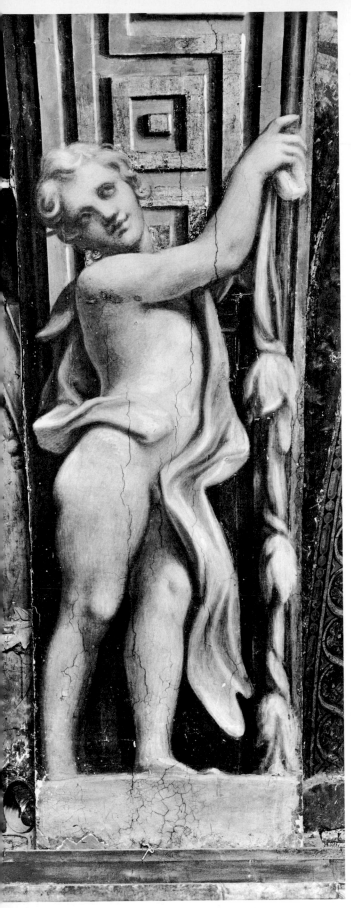
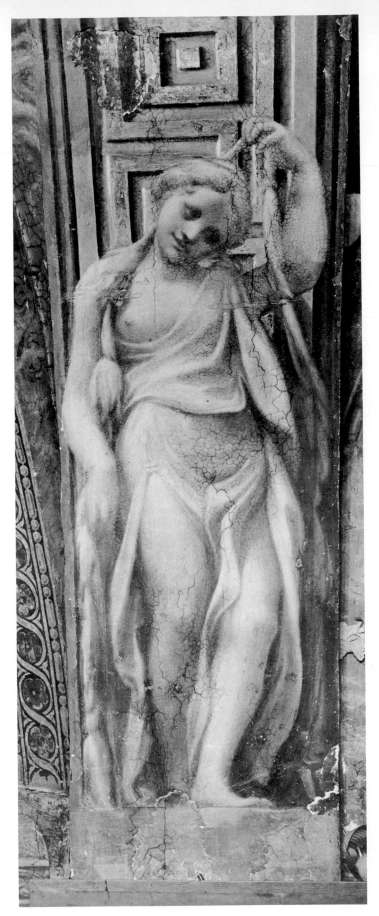

156
Grisaille under-arch figures. Duomo
Parma. See page 113

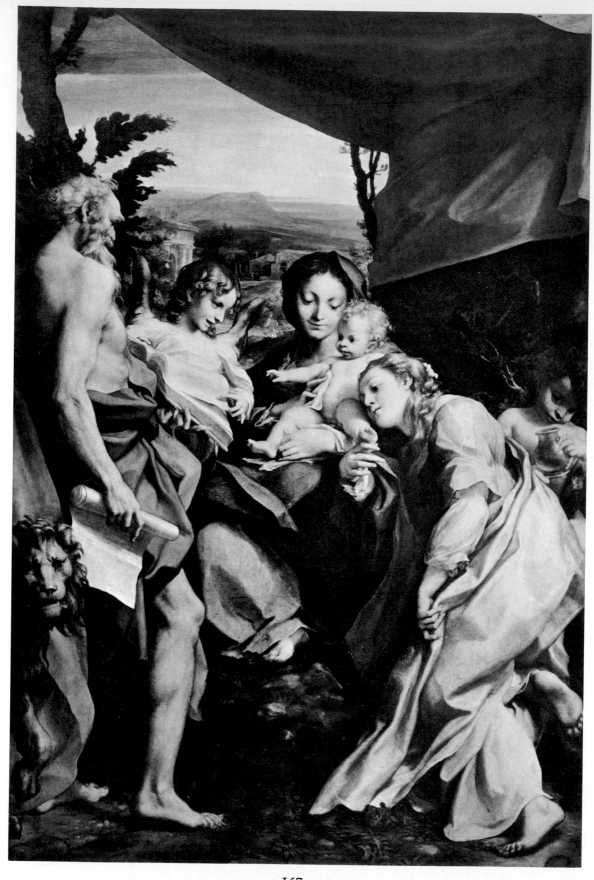

157
Madonna and Child with Saints Jerome and Mary Magdalene and Angels (Il Giorno)
Parma, Galleria Nazionale. See page 115

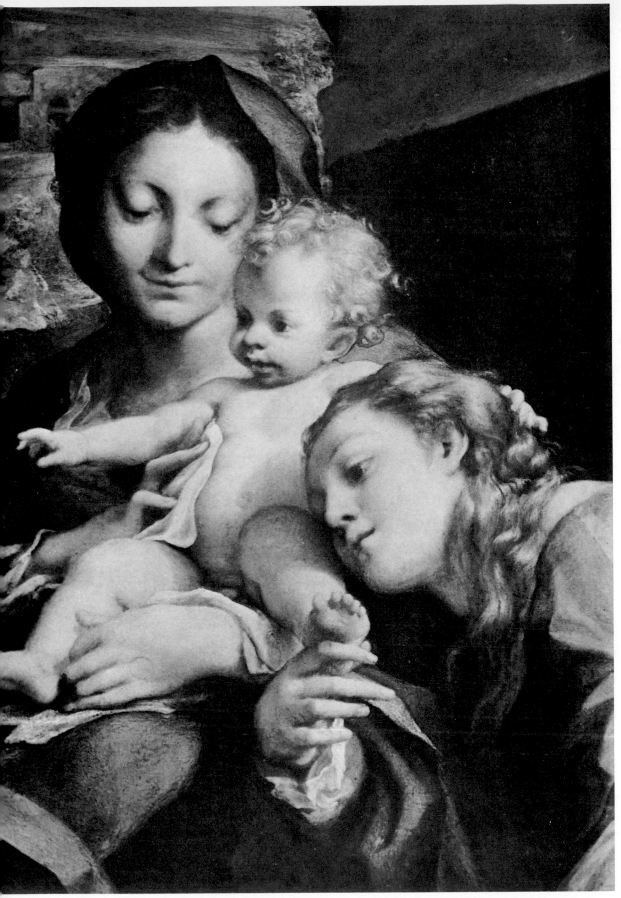

158

Il Giorno. Detail
Parma, Galleria Nazionale

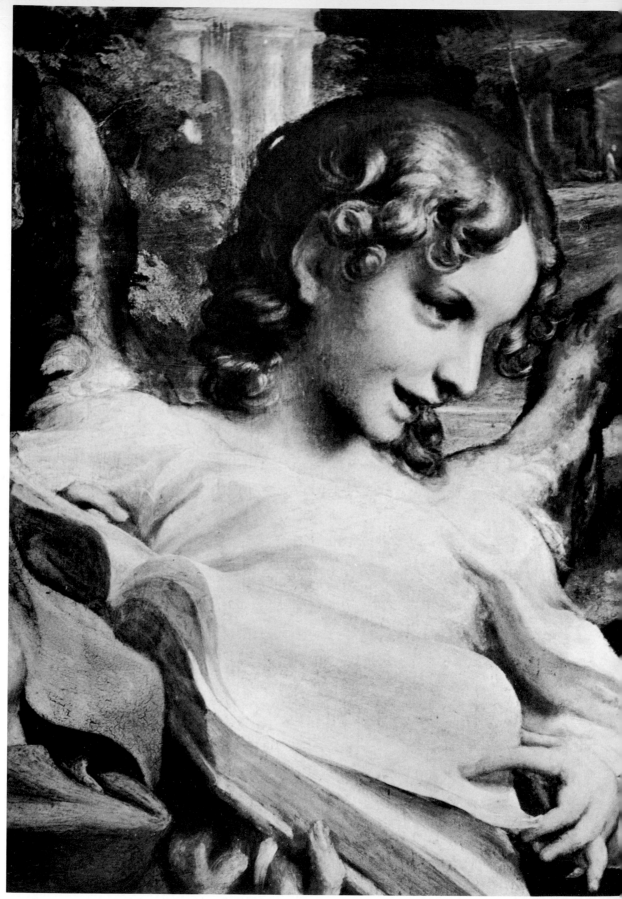

159

Detail of Il Giorno
Parma, Galleria Nazionale

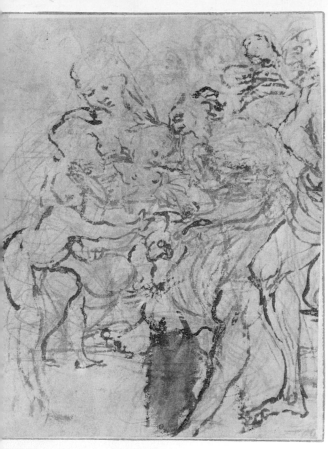

160A
Study for Il Giorno
Oxford, Christ Church (Popham 75)

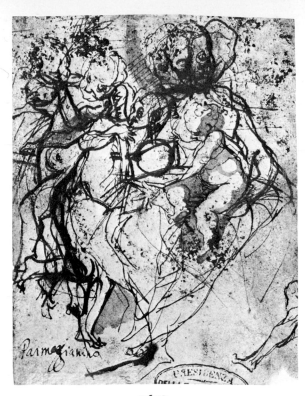

160D
(?) Study for Il Giorno
Venice, Accademia

160B Diagram 160C Diagram
rno, pre-penultimate stage Il Giorno, penultimate stage
(elucidation of successive stages
shown in the Christ Church drawing)

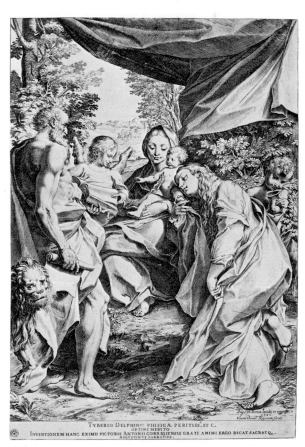

160E
AGOSTINO CARRACCI, print after Il Giorno

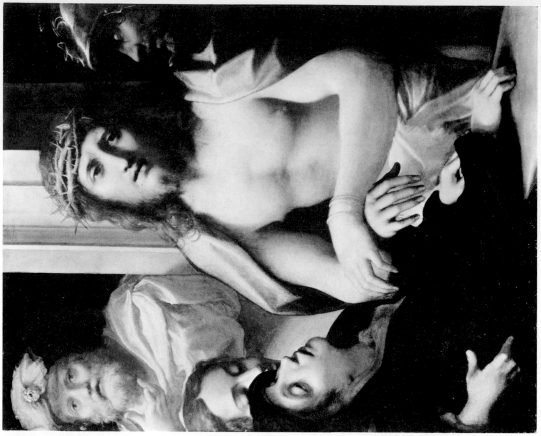

161B
Ecce Homo
London, National Gallery. See page 118

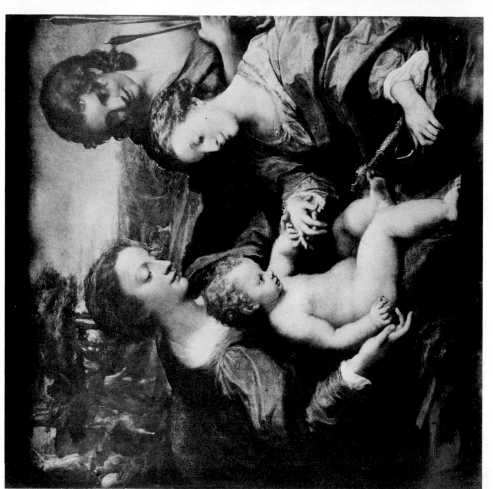

161A
Marriage of St. Catherine
Paris, Louvre. See page 117

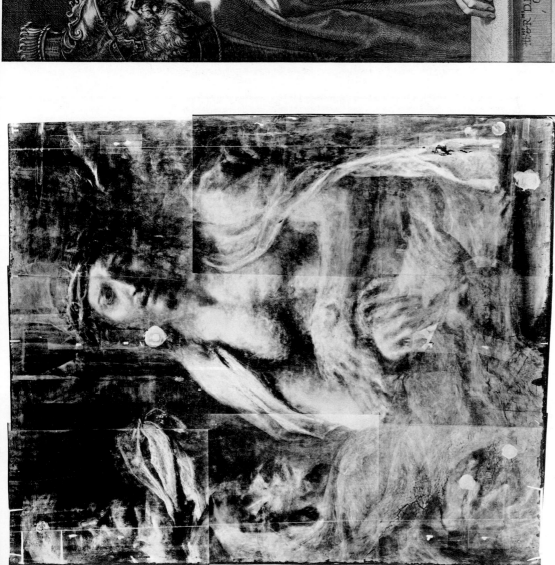

162A
Ecce Homo. X-ray
London, National Gallery

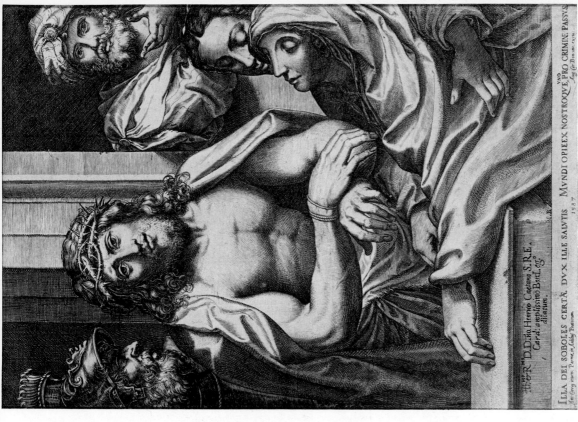

162B
Agostino Carracci, print after Ecce Homo

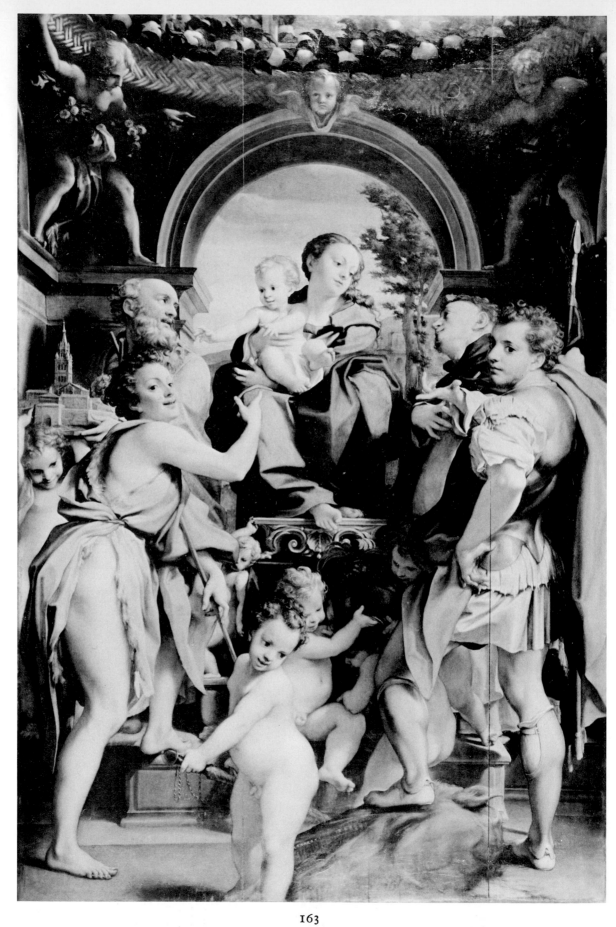

163
Madonna and Child with Saints John the Baptist, Geminian, Peter Martyr and George
Dresden. See page 119

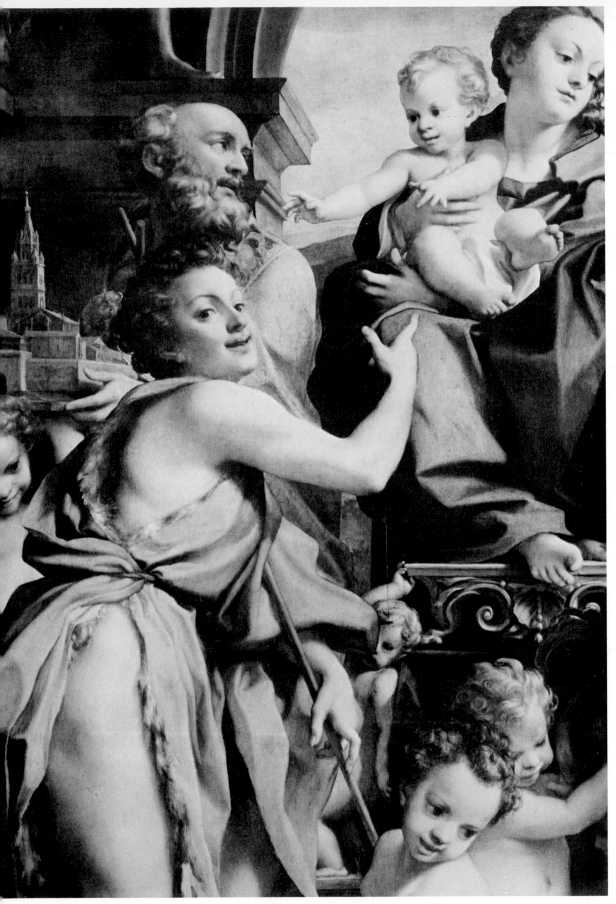

164

Madonna and Child with Saints John the Baptist, Geminian, Peter Martyr and George.
Dresden. Detail

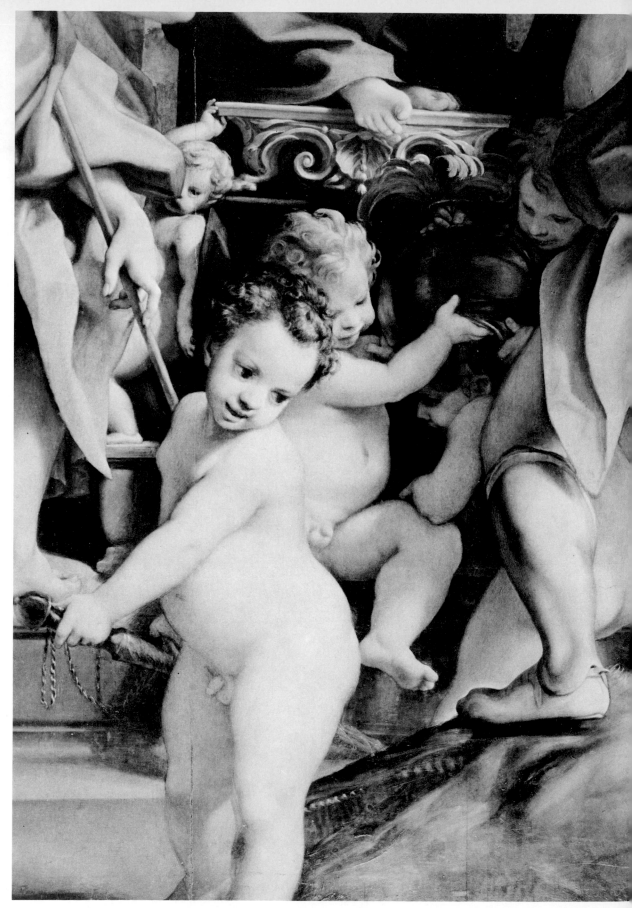

165

Detail of Madonna and Child with Saints John the Baptist, Geminian, Peter Martyr and George. *Dresden*

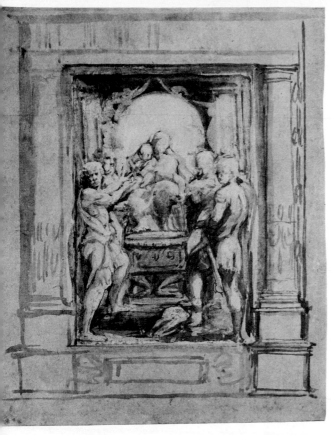

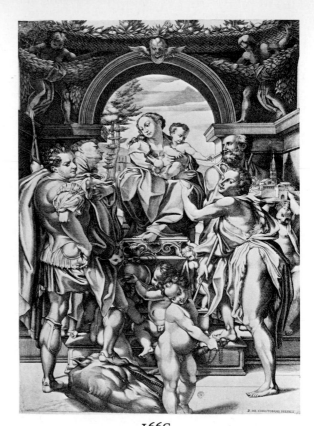

C. Bertelli, print after
the St. George Madonna

166A–B

Studies for the St. George Madonna
A. *Dresden* (*Popham 73*)
B. *London, British Museum* (*Popham 74*)

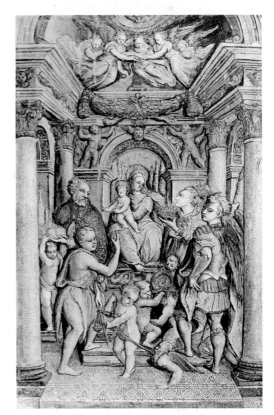

166D

G. Comi, copy of
the St. George Madonna
York, City Art Gallery

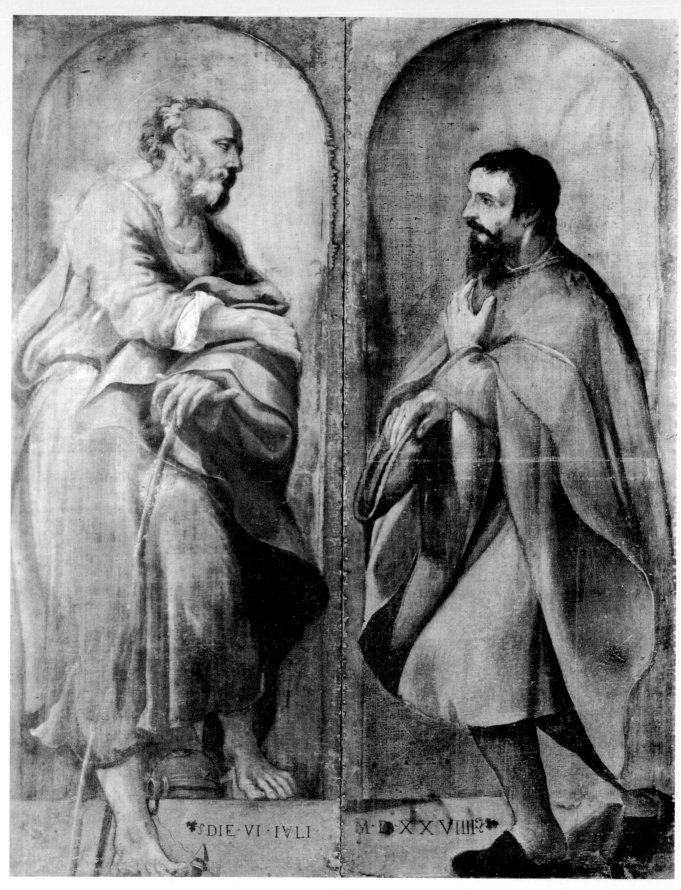

167

A Male Saint and a Donor

Naples. See page 123

168

A Male Saint and a Donor. *Naples*. Detail of Saint

169

Detail of Saint. A Male Saint and a Donor. *Naples*

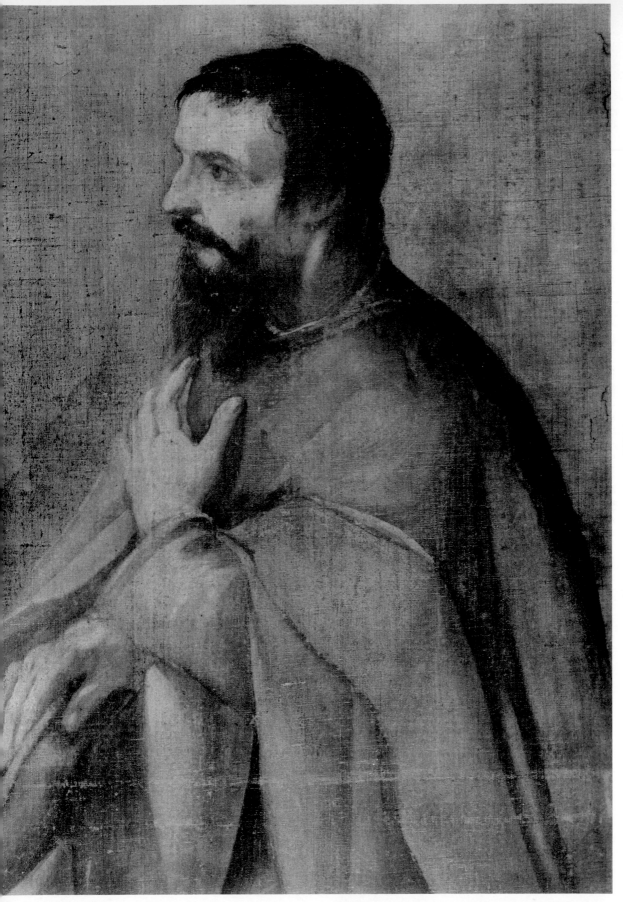

170

A Male Saint and a Donor. *Naples*. Detail of Donor

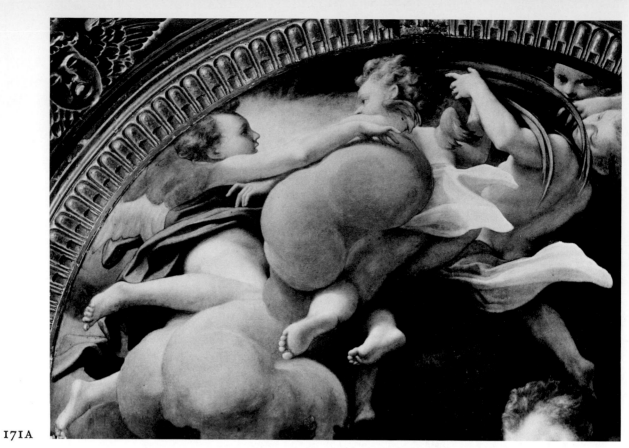

171A

Detail of the Madonna della Scodella. *Parma, Galleria Nazionale. See page 101 and plate 105*

171B

Study for the Madonna della Scodella. *Rugby School (Popham 77)*

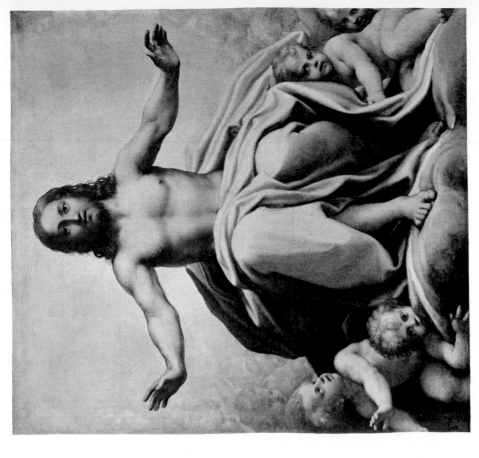

172B
Copy of Christ in Glory
Vatican. See pages 123

172A
The Veil of St. Veronica
Firle Place, Viscount Gage. See page 123

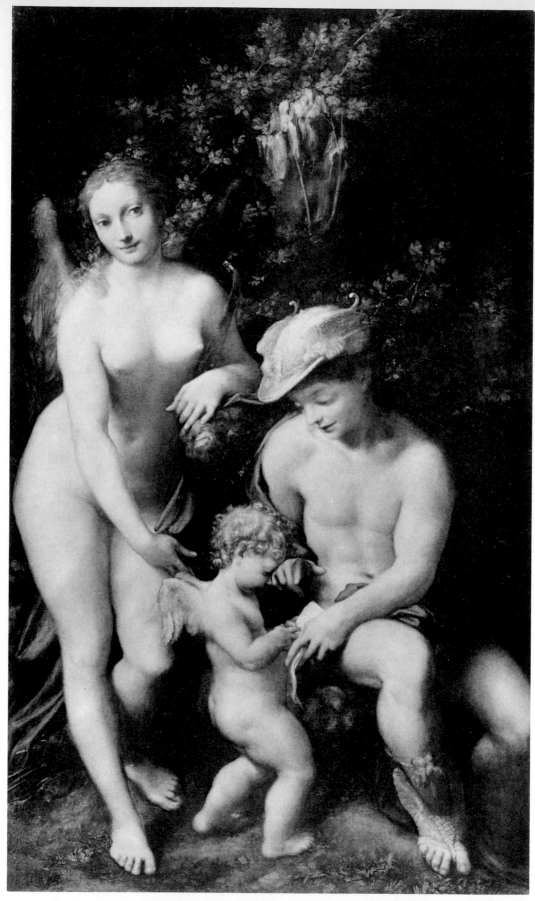

173
Mercury instructing Cupid before Venus (School of Love)
London, National Gallery. See page 124

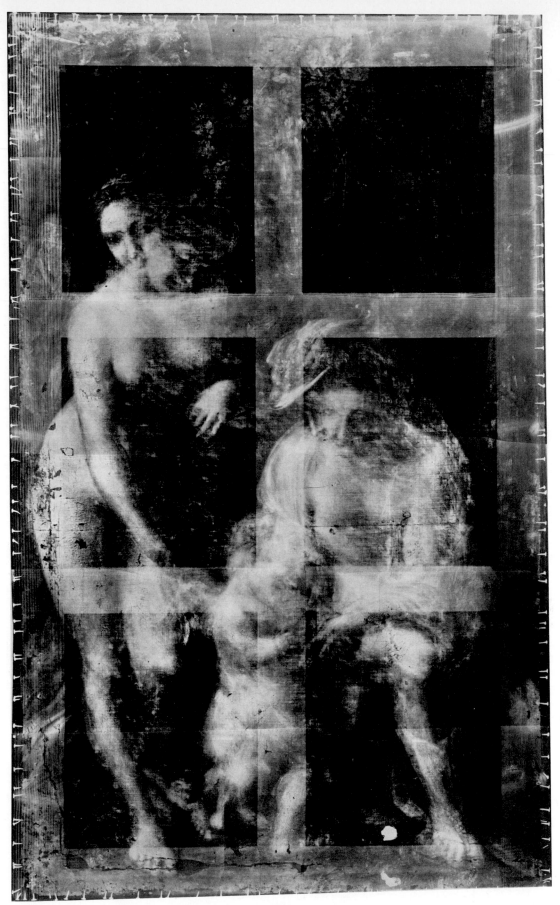

174
Mercury instructing Cupid before Venus (School of Love). X-ray
London, National Gallery

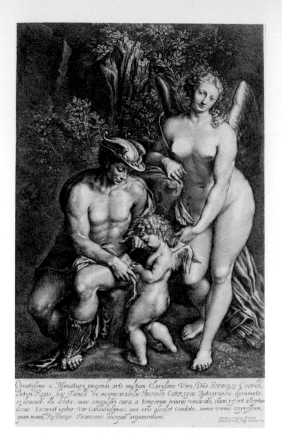

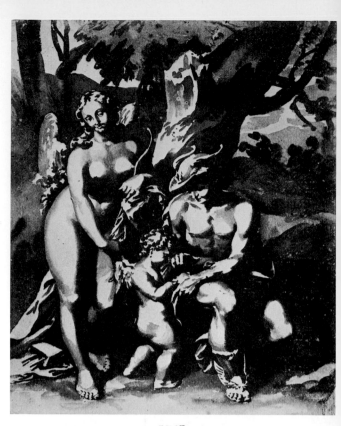

175A
A. DE JODE, print after the School of Love

175B
J. DE BISSCHOP, copy of
the School of Love
Oxford, Ashmolean

175C
PETER OLIVER, copy of
the School of Love
Windsor

175D
Study for the School of Love
London, British Museum (Popham 79v)

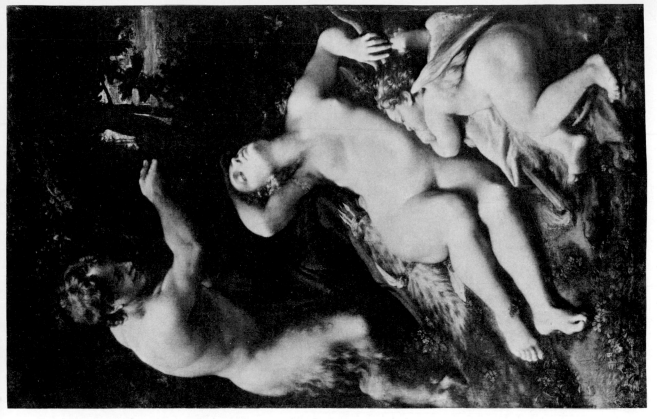

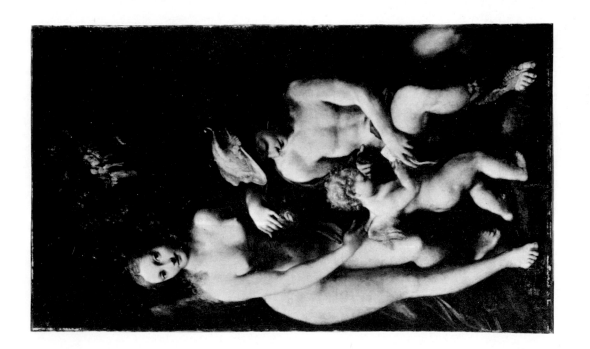

176

The School of Love (*London, National Gallery*) and Venus, Cupid and a Satyr (*Paris, Louvre*) reproduced on the same scale

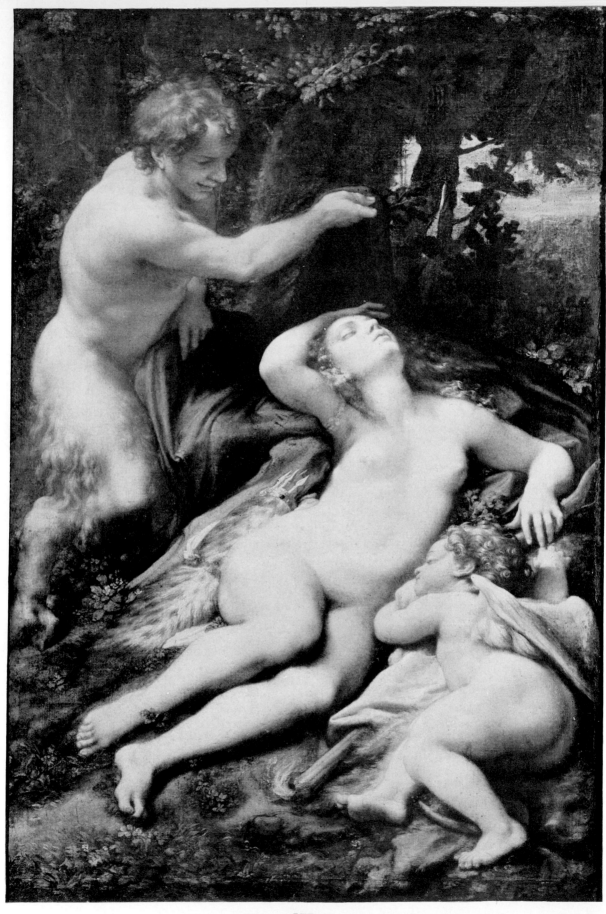

177
Venus, Cupid and a Satyr
Paris, Louvre. See page 125

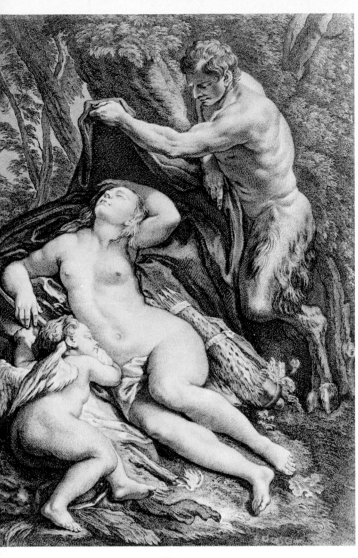

178A
F. BASAN, print after Venus,
Cupid and a Satyr

178B
Study for Venus, Cupid and a Satyr
Windsor (Popham 81)

178C
Study for Cupid Bound
*London, British Museum (Popham 18v). See pages
62 and 124*

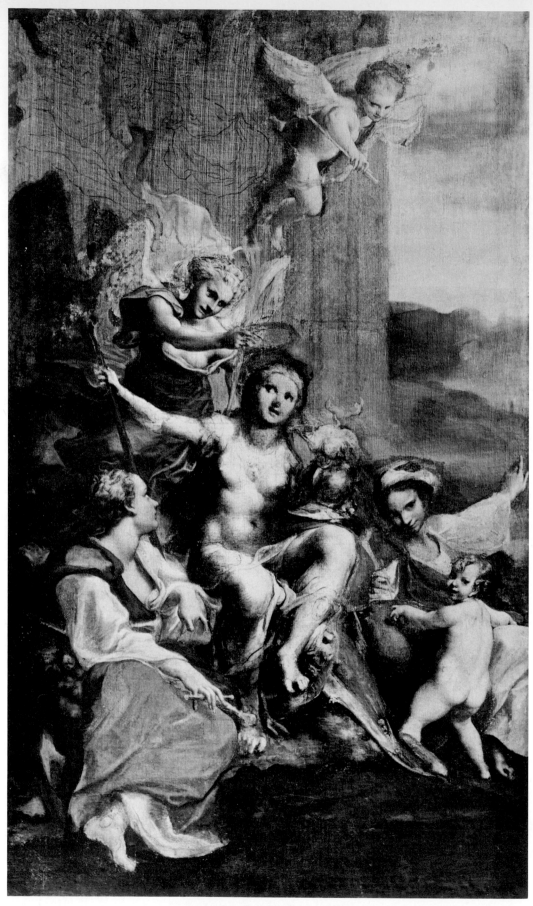

179
Allegory of Virtue (unfinished)
Rome, Palazzo Doria. See page 103

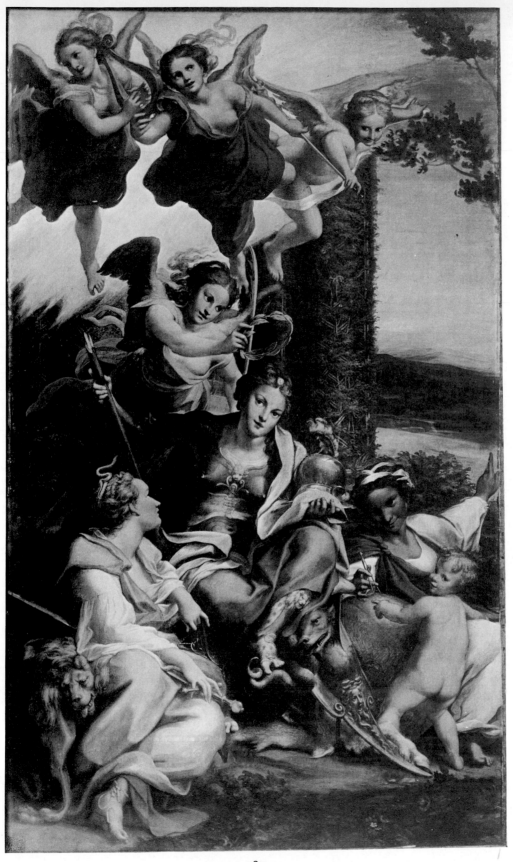

180
Allegory of Virtue
Paris, Louvre. See page 127

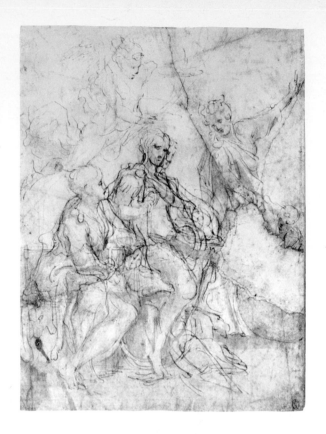

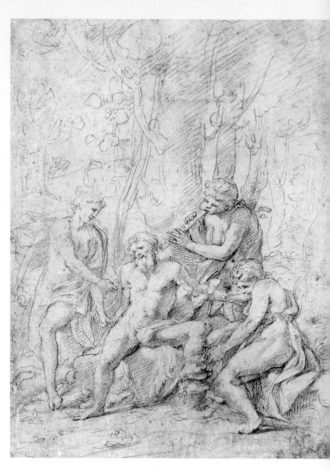

181C
Study for Allegory of Vice
London, British Museum (Popham 91)

181A–B
Studies for Allegory of Virtue
A. *Paris, Louvre (Popham 89r)*
B. *Formerly New York, Suida collection (Popham 90)*

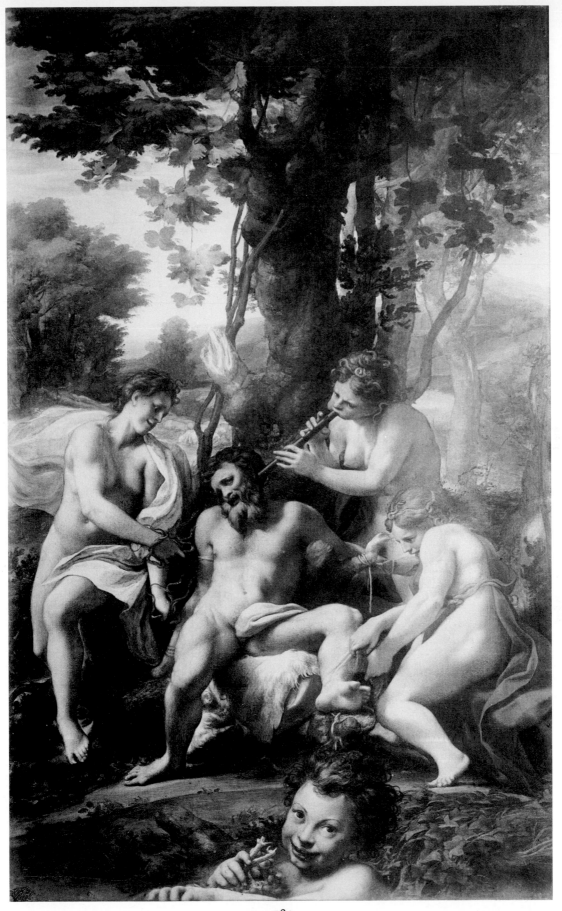

182

Allegory of Vice

Paris, Louvre. See page 127

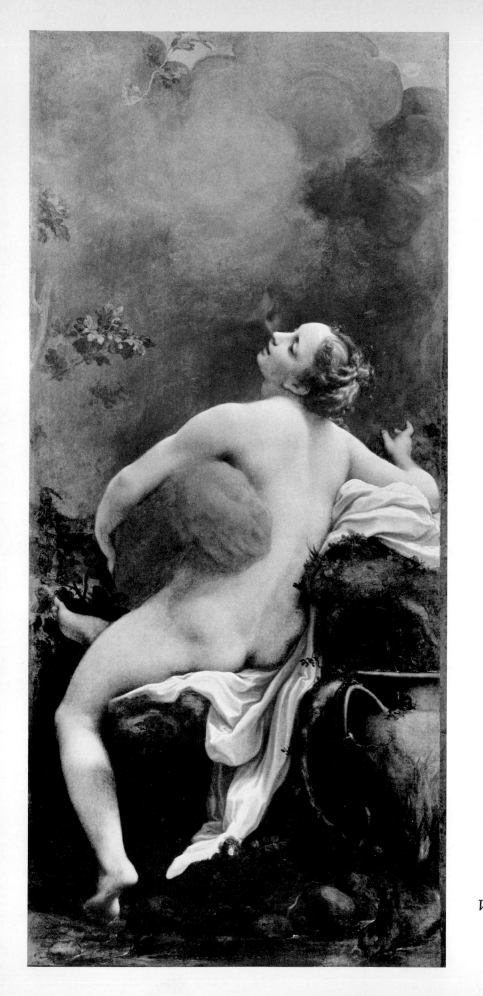

183
Io
Vienna, Kunsthistorisches Museum. See page 130

184

Io. *Vienna, Kunsthistorisches Museum.* Detail

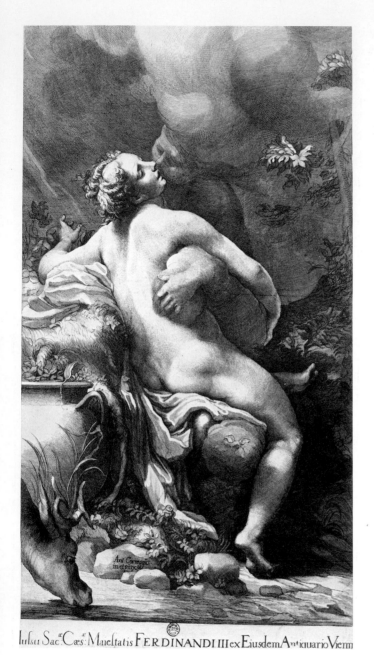

185A

F. van den Steen, print after Io

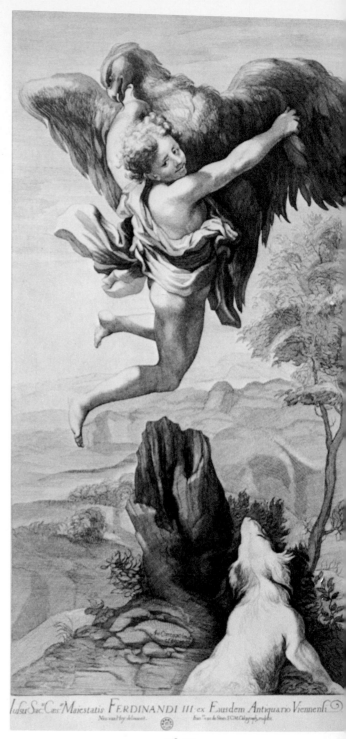

185B

F. van den Steen, print after Ganymede

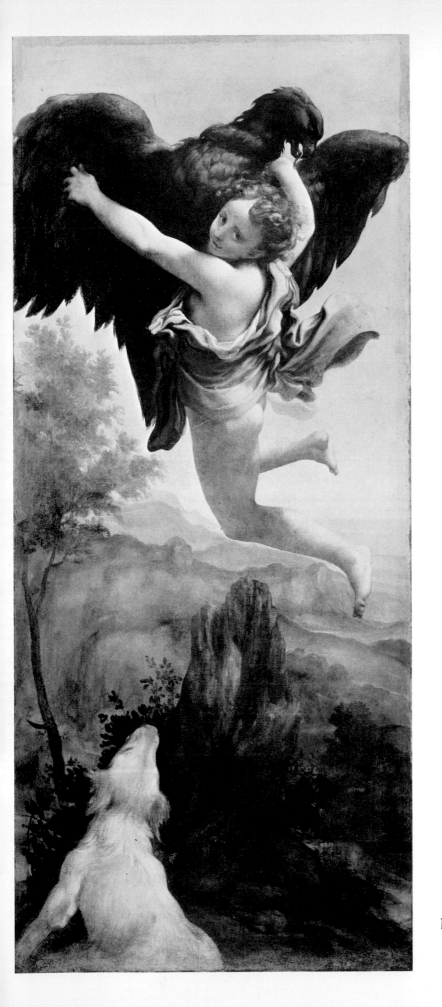

186
Ganymede
Vienna, Kunsthistorisches Museum. See page 130

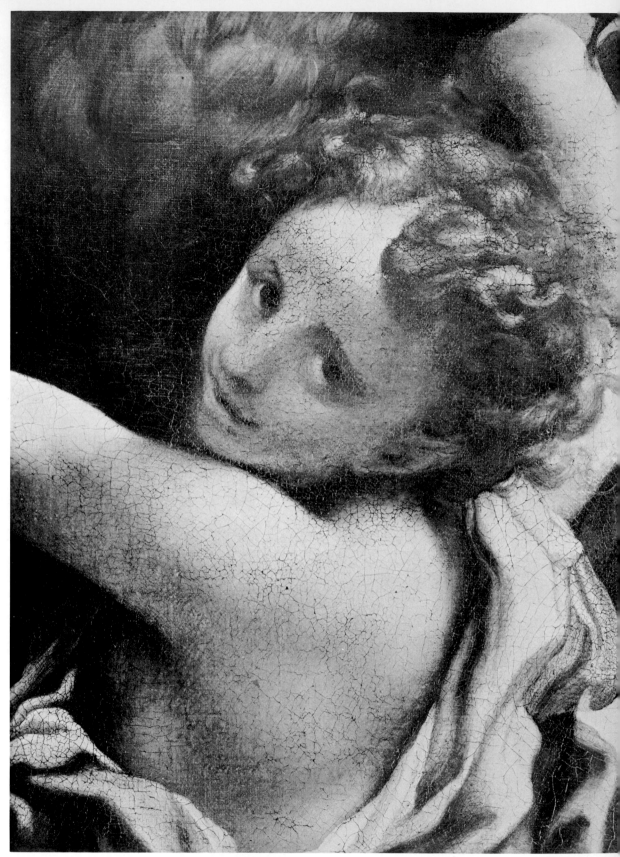

187
Detail of Ganymede. *Vienna, Kunsthistorisches Museum.*

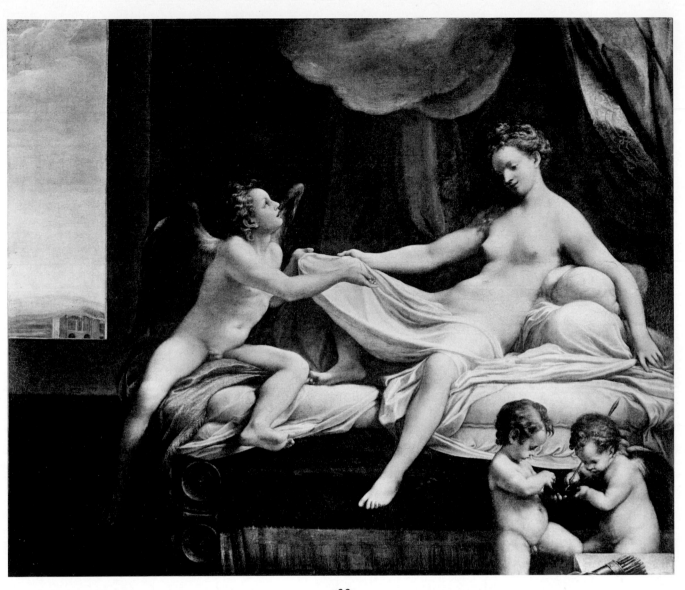

188
Danaë
Rome, Villa Borghese. See page 130

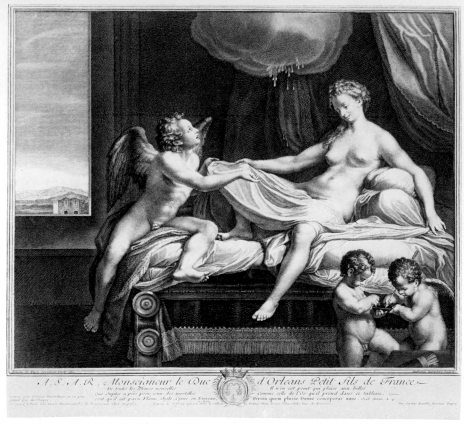

189A

DESROCHERS, print after Danaë

189B–C

Studies for Danaë

Besançon (Popham 82, 83)

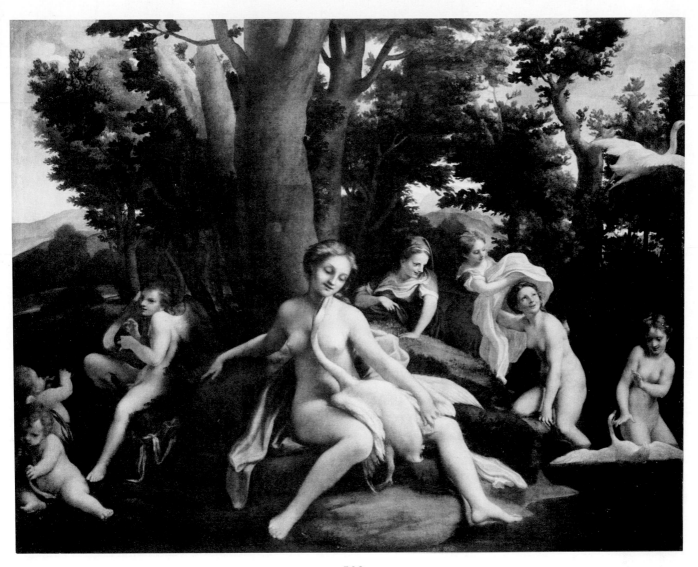

190
Leda
Berlin, Dahlem Gemäldegalerie. See page 130

191
Leda. X-ray
Berlin, Dahlem Gemäldegalerie

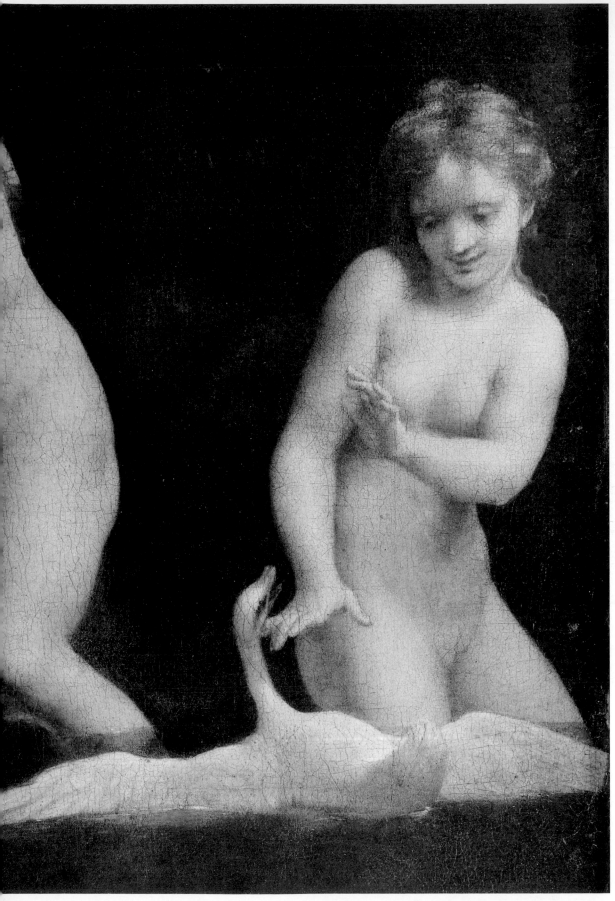

192

Leda. *Berlin, Dahlem Gemäldegalerie.* Detail

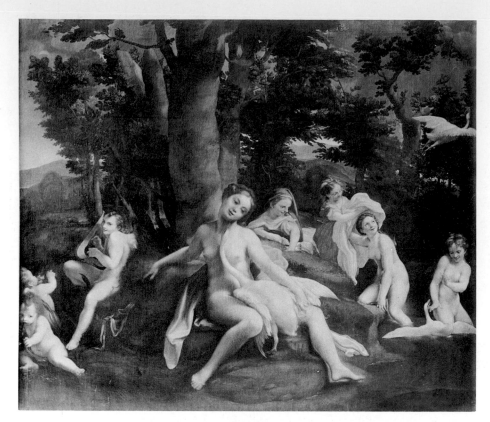

193A

E. CAXES, copy after Leda before mutilation of original
Madrid, Prado

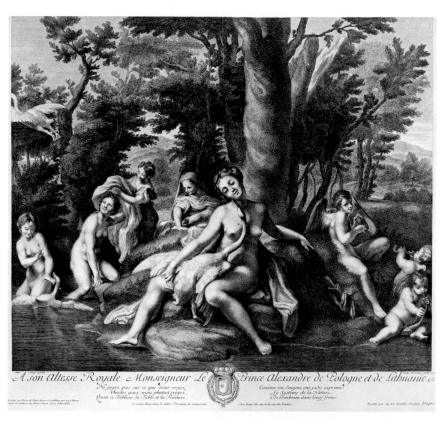

A son Altesse Royale Mon.seigneur Le Prince Alexandre de Pologne et de Lithuanie &

193B

G. DUCHANGE, print after Leda before mutilation of original

194A

Study by Correggio after Michelangelo's Leda
Paris, Louvre (Popham 84). See page 134

194B

Study for altarpiece of four saints
Florence, Uffizi (Popham 78r). See page 123